The
Child's Conception
of Space

Jean Piaget
and
Bärbel Inhelder

Translated by
F. J. Langdon and J. L. Lunzer

Routledge
Taylor & Francis Group

LONDON AND NEW YORK

First published 1948

English translation first published 1956
by Routledge

Reprinted 1997
by Routledge
2 Park Square, Milton Park, Abingdon, Oxon, OX14 4RN
711 Third Avenue, New York, NY 10017

Routledge is an imprint of the Taylor & Francis Group, an informa business

Transferred to Digital Printing 2006

First issued in paperback 2013

English translation © 1956 F. J. Langdon and J. L. Lunzer

This is a reprint of the 1956 edition

British Library Cataloguing in Publication Data
A catalogue record for this book is available from the British Library

Library of Congress Cataloguing in Publication Data
A catalogue record for this book has been requested

ISBN 978-0-415-16889-2 (Hardback)
ISBN 978-0-415-84646-2 (Paperback)

Publisher's Note
The publisher has gone to great lengths to ensure the
quality of this reprint but points out that some
imperfections in the original may be apparent

CONTENTS

PART THREE

THE TRANSITION FROM PROJECTIVE TO EUCLIDEAN SPACE

PREFACE

THE study of the concept of space, or rather, of the innumerable ideas involved in the concept of space, is for many reasons an indispensable part of child psychology.

To begin with, it is clear that if the development of various aspects of child thought can tell us anything about the mechanism of intelligence and the nature of human thought in general, then the problem of space must surely rank as of the highest importance.

Philosophers and psychologists have argued about the nature of space for centuries. They have debated whether it is an empirical concept derived from perception or from images, whether it is innate to thought and consciousness, or whether it is operational in character, and so on. Surely here if anywhere is cause for resorting to experimental psychology, since only the actual data of mental evolution can reveal the true factors operative in the development of the notion of space.

One question in particular invited enquiry. Geometry primers are almost unanimous in presenting the fundamental ideas of space as resting upon euclidean concepts such as straight lines, angles, squares, circles, measurements, and the like. And this view would appear to derive support from studies in perception of visual and tactile 'gestalten'. On the other hand, abstract geometrical analysis tends to show that fundamental spatial concepts are not euclidean at all, but 'topological'. That is to say, based entirely on qualitative or 'bi-continuous' correspondences involving concepts like proximity and separation, order and enclosure. And indeed, we shall find that the child's space, which is essentially of an active and operational character, invariably begins with this simple topological type of relationship long before it becomes projective or euclidean.

It need hardly be said that a further reason for devoting special attention to the question of the development of spatial concepts, is that any reasonably thoroughgoing investigation in this field is certain to suggest immediate practical applications. The teaching of geometry could hardly fail to profit from keeping to the natural pattern of development of geometrical thought, especially since this process is, to our way of thinking, in much closer conformity with the logic of mathematical construction than are most of the so-called 'elementary' textbooks. It has been said that Cantor's theory of sets might well be taught in primary school, and we must confess to thinking much the same about the elements of topology.

Before proceeding further, we must apologize to our 'indulgent reader' (as he used to be addressed) for the lengthiness of the text that

follows.[1] Even so, we must state that it by no means exhausts our original programme of research, but is followed by a second volume dealing with metric concepts and problems of euclidean measurement.[2] It is simply the case that the problem of space is one of such complexity that we were compelled to undertake a large number of experiments before feeling competent to offer any general solution. Although the elucidation of this particular problem has long been our intended aim, we had first of all to clear the ground through a preliminary study of the concepts of speed, movement, and time,[3] a knowledge of whose workings, besides being easier to come by, governs the understanding of actions concerned with displacements, and the various types of operation performed on objects, which together form the basis of spatial concepts.

In bringing this work to a successful conclusion we must express our thanks to Mlle Alina Szeminska. Mlle Szeminska assisted in our earliest studies of space, and the results of a number of her experiments appear in Volume II. Our thanks are also due to M. Hans Aebli of the Psychological Laboratory of Geneva, to whom we are indebted for preparing the illustrations to this work.[4]

JEAN PIAGET and BÄRBEL INHELDER

[1] Though we are only dealing with conceptual or representational space, not sensorimotor space. This has already been discussed in Chapters I and II of *The Child's Construction of Reality*, London, 1955.

[2] *La Géométrie Spontanée de l'Enfant*, Paris, 1948.

[3] See *Le Développement de la Notion de Temps chez l'Enfant* and *Les Notions de Mouvement et de Vitesse chez l'Enfant*, Paris, 1946.

[4] To have done this fully we should have had to illustrate nearly every response, which would have doubled the size and format of the book. As it is, we have had to content ourselves with summarized versions of typical drawings at the beginning of each chapter together with a verbal description of individual drawings.

TRANSLATORS' NOTES

ALTHOUGH most of the terms listed below are defined and explained in the text, these notes may be found helpful for reference. A short list of works giving an exhaustive treatment of these terms is appended to the notes.

ACCOMMODATION The transformations induced in the subject's existing schemata, or patterns of behaviour, by the environment. Accommodation may be regarded as the opposite process to *assimilation* (q.v.), in so far as the environment affects the subject's behaviour pattern in some way, whereas in the case of assimilation it is the environment which is transformed by being made a part of the subject's schemata.

AFFINITIES AND AFFINE RELATIONS Affine geometry, as distinct from projective geometry, involves a definition of parallelism. On the other hand, if the definitions of length and angular measurement are excluded from Euclidean plane geometry, what remains constitutes an affine geometry. Affine geometry may therefore be regarded as transitional between projective and Euclidean geometry.

Affine relations may be defined in terms of affine groups; that is to say, the set of projective plane collineations which leave the straight line invariant. Thus the affine transformations undergone by the family of parallelograms may be taken as an example of affine relations.

ASSIMILATION The opposite process to accommodation. The mental incorporation of objects into patterns of behaviour, the manner in which the object as such is transformed and made to correspond with the subject's schemata. It may therefore be seen that biological adaptation is defined by Piaget in terms of a dynamic equilibrium between assimilation and accommodation.

DEVELOPABLE SURFACES The surfaces obtained from a solid by plane rotation, without either cutting or stretching the surface. Such surfaces are either cylinders or cones, or those composed of all the tangents to a curve in space.

GROUPING An organization of propositions which satisfies the law of a commutative group. A logical grouping is defined by the operations of composition, inversion, identity, and associativity and, unlike a mathematical grouping, is restricted by the condition of tautology. Thus:

1. $A+A'=B; B+B'=C$ (Composition)
2. $A-A'=B$; hence $A=B-A'$ and $A'=B-A$ (Inversion)
3. $A-A=O$ (Identity)

4. $A+(A'+B')=(A+A')+B'$; but $A+(A-A)\neq(A+A)-A$
 (Associativity)
5. $A+A=A$, hence $A+B=B$ (Tautology)

The structure of such a grouping corresponds to a semi-lattice in Boolean algebra, since the *meets* between classes of the same rank are null (i.e., $A\times A'=O$, $B\times B'=O$, etc.) and similarly, the *join* between component classes is null. The reader is referred to Piaget's *Traité de Logique* for an exhaustive treatment of this subject.

HAPTIC PERCEPTION Perception of an object by means of the sense of touch, in the absence of visual stimulation. We have employed this expression, originally introduced by Revèsz (*Psychology and Art of the Blind*. London. 1950. q.v.), since there is no current equivalent of the French term 'stereognostique' in English.

HOMEOMORPHISM Two spaces which are equivalent from the standpoint of topology are termed homeomorphic. Thus two point sets are homeomorphic if their points are in one-one correspondence. Hence all closed curves are homeomorphic with one another and with all closed euclidean figures such as the square, triangle, circle, etc.

HOMOLOGY The relation of two geometrical figures such that to every point in one there corresponds a point in the other.

JORDAN CURVE Any simple closed curve homeomorphic with the circle. It is defined as the curve of bounded variation.

KNOTS, OVERHAND AND TREFOIL A knot may be defined as any simple closed curve which never passes more than once through the same point of space. The overhand knot is the simplest practical knot, and is formed by passing the end of a string forming a loop, through the loop. The trefoil is the name usually given to an overhand knot whose ends are joined together. Here it means merely an overhand knot whose interlacing sections are enlarged to form projecting loops.

LOGICAL MULTIPLICATION The operation involved in considering two attributes simultaneously.

OPERATION An action which has become, first of all, internalized as an image, and later completely abstract by being grouped; i.e., by being incorporated in a reversible combination or grouping as defined above. For Piaget, the operation is the final equilibrium attained by thought.

QUANTITY, EXTENSIVE AND INTENSIVE An extensive quantity is a magnitude capable of actual addition, whereas intensive quantity is not. Examples of the two are mass as opposed to temperature.

SYNCRETIC A global or unanalysed whole; that is to say, one whose elements are not related to each other in operational fashion. In previous

works, Piaget has defined the child's world as composed of syncretic wholes, one in which everything is linked with everything else whilst at the same time nothing is related to anything (cf. *The Child's Conception of Physical Causality*, 1930; *The Child's Conception of the World*, 1951).

TOPOLOGY (ANALYSIS SITUS) is therefore basically the study of homeomorphisms; that is to say, spatial equivalences other than those of size and shape. The subject matter of topology is not distance, angle or straightness, but the property of being *connected* or *bounded*. Such a geometry does not distinguish between circles, ellipses or polygons, nor between cubes and spheres, but between, for example, a sphere and a torus. For any closed loop on the surface of a sphere bounds part of the sphere, whereas there are closed loops on the surface of a torus which do not (i.e. sections of the mid-line).

The most important property dealt with by topology may be said to be *proximity*. This relationship can be stated only by introducing the notion of *limit point*. If S denotes the collection of points in the euclidean plane, a point P is termed the limit point of the collection of points M, if every circle whose centre is a point encloses at least one point distinct from that point. Proximities are therefore sub-sets of points which satisfy the following axioms:

1. A point belongs to each of its neighbours.
2. The intersection of two neighbourhoods of the same point contains a third neighbourhood of the point.
3. Any point in a given neighbourhood possesses a neighbourhood contained in the given neighbourhood.

For Reference:

What is Mathematics? R. Courant and H. Robbins. 1941. New York.
A Survey of Modern Algebra. G. Birkhoff and S. MacLane. New York.
Logic and Psychology. J. Piaget. With an introduction by W. Mays. Manchester. 1953.
Traité de Logique. J. Piaget. Paris. 1949.

SUMMARY

TO approach the study of how the child thinks about space with as few presuppositions as possible, we shall begin with two introductory chapters. These deal with two types of behaviour commonplace enough in themselves, though indicative of the kind of spatial ideas operative at the start of the evolutionary process.

Firstly, in Chapter One, we shall study how the child recognizes various objects by sense of touch alone, or by what has been termed 'haptic perception'.[1] Secondly, in Chapter Two, we shall examine the drawing of geometrical figures. Both these investigations will show that prior to organizing a projective and euclidean space, the child starts by building up and using certain primitive relationships such as proximity and separation, order and enclosure. Such relationships correspond to those termed 'topological' by geometricians, and similarly regarded by them as elementary from the standpoint of the theoretical reconstruction of space.

These findings prompted us to complete our introductory section by making a more detailed study of three of these relationships. As a result, Chapter Three deals with *order*, entirely from the point of view of spatial proximity and separation. Chapter Four is concerned with *enclosure* or *surrounding*, in terms of the understanding of them derived, for example, from a working knowledge of knots. Chapter Five is devoted to the problem of *continuity* and the gradual subdivision of lines and surfaces into smaller units, and ultimately into points.

Thus the two introductory and three detail chapters constituting Book One are chiefly concerned with showing the vital importance of the most intuitive topological relationships for the subsequent development of spatial representation.

[1] See Translators' Notes.

PART ONE

TOPOLOGICAL SPACE

Chapter One

PERCEPTUAL SPACE, REPRESENTATIONAL SPACE, AND THE HAPTIC PERCEPTION OF SHAPE[1]

THE chief obstacle to any developmental study of the psychology of space derives from the circumstance that the evolution of spatial relations proceeds at two different levels. It is a process which takes place at the perceptual level and at the level of thought or imagination.

The commonsense approach to the problem, which is also that adopted by many mathematicians, assumes that the idea of space develops under the influence of motor and perceptual mechanisms; and so far as it goes this is quite correct. But this view goes on to assume that representational images and geometrical ideas are no more than a mere copy of existing sensori-motor constructs. This, however, over-simplifies and completely misrepresents the facts.

Kant considered space an *a priori* structure of 'sensibility', the function of thought being merely to submit the data of space perception to a process of logical deduction capable of analysing them indefinitely without ever exhausting their content. Poincaré too, ascribed the formation of spatial concepts to sensory impressions, endeavouring to apply his theories on the group of displacements to the interplay of actual sensations, as if sensori-motor space furnished the basis for geometrical thought whilst the intellect elaborated this previously prepared material.

Now it is perfectly true that such a sensori-motor space begins to evolve right from the child's birth, and together with perception and motor activity it undergoes considerable development up until the appearance of speech and symbolic images, i.e., the symbolic functions in general. This sensori-motor space is superimposed upon various pre-existing spaces such as the postural, etc., though it is by no means a simple reflection or repetition of them. On the contrary, it has its own course of development which can be traced fairly easily, and in addition, the spatial organization of sensori-motor behaviour results in new mental constructs, complete with their own laws.[2]

At this juncture, however, there appears a rather curious phenomenon which tends to complicate the task of analysis. Though in a sense profiting from the achievements of perception and motor activity (which at their own level provide experience of straight lines, angles, circles,

[1] In collaboration with Mlles. E. de Jongh, U. Galluser, B. Demetriades, and M. A. Morf.
[2] See *The Child's Construction of Reality*, London, 1955, Chapters I and II (here referred to as C.R.).

3

squares, projective systems and so on), representational thought or imagination at first appears to ignore metric and perspective relationships, proportions, etc. Consequently, it is forced to reconstruct space from the most primitive notions such as the topological relationships of proximity, separation, order, enclosure, etc., applying them to the metric and projective figures yielded by perception at a level higher than that of these primitive relationships themselves.

Through failing to observe the discrepancy between the form of these initial relationships and the perceptual content to which they refer, outwardly at a more advanced stage, one tends to reduce everything to one common level and imagine that geometrical concepts are based directly on sense data.

Moreover, during the development of representational space, representational activity is, in a manner of speaking, reflected or projected back on to perceptual activity. Thus, beginning with the stage at which representation can arrange all spatial figures in co-ordinate systems (in line with the vertical-horizontal axes derived from physical experience but developed geometrically), perception itself begins to locate the partial configurations it has achieved within such systems, whereas formerly it was content with a far more limited degree of structurization.

Knowing nothing of the stages which led up to this transformation, the adult assumes that perception involves co-ordinate systems or vertical-horizontal relations right from the outset, when in fact such systems are extremely complicated and are only fully developed by the age of 8 or 9. And such an illusion naturally tends to reinforce the misconception mentioned earlier, regarding the way perception is related to representation, a misconception which has influenced current explanations of geometrical concepts.

So deep-rooted is this misconception that we offer no apology for the length of this first volume in trying to eradicate it. In the present chapter we will merely outline the problem. In the first part we shall try to give a very brief summary of the facts relating to sensori-motor and perceptual space. In the second part we shall introduce the study of representational space by examining some of the very simplest sensed spatial notions constituting an image, namely, those relating to the shape of objects. In neurology and experimental psychology, tactile recognition of solids (relative to unseen objects) is often called 'haptic perception'. This term, which has become general, is nevertheless incorrect; for these so-called perceptions go far beyond the limits of the purely perceptual and usually presuppose the translation of tactile perceptions and movements into visual images. But quite apart from the question of terminology, it is precisely this mixed character which pertains to the facts of 'haptics' that will interest us here. For it gives us the opportunity of observing in the raw the actual process of development from the perception of

shapes to their representation, in children between the ages of 2–7 years. Taken together with the study of drawing, which marks the transition from visual perception to ideo-motor representation, the study of 'haptics' provides a very natural introduction to the study of representational space.

SECTION I—PERCEPTUAL OR SENSORI-MOTOR SPACE

The subject of the present work is not the development of space in general, but only that of representational space, and therefore the analysis of perceptual space goes beyond our set limits. But since the perceptual sensori-motor structures, or frames of reference, constitute both the point of departure and the foundation of the entire representational construction of space, it is as well to start by going over what is at present known on this subject. We will be very brief as regards sensori-motor space, since we have elsewhere endeavoured to trace its origin (C.R. Chs. I and II) during the first eighteen months of life, and it is this earlier outline that we shall refer to here.

§1. *Spatial perception prior to representation*

According to currently accepted explanations of the perceptual process, every perceptual 'field', from the most elementary to the most highly developed, is organized in accordance with the same types of 'structure'. This organization is supposed to be of a geometrical character right from the start, quite apart from the effects of the laws of 'good gestalt', and to involve the immediate formation of perceptual constancies of shape and size. This would mean that at any age a baby could recognize the shape of an object independent of perspective, and its size apart from its distance. Thus there would be from the very outset a perception of relationships at once spatial and metric. If this hypothesis were correct it would only be necessary to call to mind the laws of spatial configurations in order to describe perceptual space.

But we have already shown in the work referred to above that the constancy of the shape of objects is far from being complete at the outset, since at 7 or 8 months a child has no idea of the permanence of objects, and does not dream of reversing a feeding bottle presented to him wrong way round (C.R. pp. 128–9). Since then we have shown, together with Lambercier, that as regards size constancy, great differences still persist between an 8-year-old child and an adult,[1] whilst Brunswik and Cruikshank[2] have demonstrated its absence during the first six

[1] See Piaget and Lambercier, 'Le problème de la comparaison visualle en profondeur et l'erreur systématique de l'étalon', *Arch. Psychol.*, 1942, and Lambercier, 'La constance des grandeurs en comparaison seriale', *Arch. Psychol.*, 1947.

[2] Brunswik and Cruikshank, 'Perceptual size constancy in early infancy', *Psychol. Bull.*, 34, 713.

months of existence. It is thus by no means absurd to suppose that perceptual relationships of a projective order (perspective) and of a metric order (estimation of size at varying distance) should appear later than these more elementary spatial relationships whose nature has first to be defined. It is also quite obvious that the perception of space involves a gradual construction and certainly does not exist ready made at the outset of mental development.

What does this construction consist of? We shall try to sketch its main outlines during the three periods of sensori-motor development, from birth to the commencement of representation. The first period consists of two stages, that of the pure reflexes, and that of the acquisition of primary habits. The second period is also marked by two stages; namely, the stage of 'secondary circular reactions' (beginning of manipulation of objects, about 4–5 months), and that of the first fully intelligent behaviour, i.e., extending to the end of the first year. Finally, the third period covering the stage of 'tertiary circular reactions' (beginning of experimentation) and the first 'internalized co-ordinations' (rapid comprehension of novel situations).[1]

First period. The first two stages of development are marked by an absence of co-ordination between the various sensory spaces, and in particular by lack of co-ordination between vision and grasping—visual and tactile-kinaesthetic space are not yet related to one another as a whole. Thus it is hardly surprising that at this level there exists as yet neither permanence of solid objects, nor perceptual constancy of shape and size. (Cf. C.R. Ch. I.)

It is therefore necessary, difficult as the task may seem, to try to reconstruct the spatial relations which arise in primitive or rudimentary perception (e.g., in the exercise of the reflexes of sucking, touching, seeing patches of light, etc., and the earliest habits superimposed on these reflexes). But since these initial perceptions fail to attain constancy of size and shape, what sort of relations go to make up such a space?

1. The most elementary spatial relationship which can be grasped by perception would seem to be that of 'proximity', corresponding to the simplest type of perceptual structurization, namely, the 'nearby-ness' of elements belonging to the same perceptual field. Following the work of the Gestalt School, it is well known that the primary factor in the organization of structures is undoubtedly the proximity of structural elements. However, it should be noted that this relationship alters as the child grows older. The younger the child, the greater the importance of proximity as compared with other factors of organization (resemblance, symmetry, etc.). Conversely, as the child develops so this ascendancy is lost, and the elements which make up the perceptual

[1] For the six stages which we set out again here in three periods, see, besides the work cited, *The Origin of Intelligence in the Child*, London, 1953.

whole can be brought into relation with one another over greater and greater distances.[1]

2. A second elementary spatial relationship is that of *separation*. Two neighbouring elements may be partly blended and confused. To introduce between them the relationship of separation has the effect of dissociating, or at least of providing the means of dissociating them. But once again, such a spatial relation corresponds to a very primitive function; one involved in the segregation of units, or in a general way, the analysis of elements making up a global or syncretic whole. In a syncretic perception, such as that experienced by a baby when it sees some object leaning against the wall, appearing as a patch scarcely distinct from its surroundings, there is proximity without clear separation. The more analytic perception becomes, the more marked is the relationship of separation. Since the child tends more and more to analyse objects as he grows older, this relationship too undergoes development. But it should not be concluded that the evolution of 'separation' and 'proximity' pursue divergent paths, so that the importance of 'separation' simply increases with age, while that of 'proximity' declines. On the contrary, just as his progress in analysis enables the child to establish ever more numerous 'separations' between elements as yet undifferentiated, so they lead him, in constructing perceived figures, to take account of different degrees of 'proximity' operating over larger areas, instead of being confined to the relation of immediate proximity.

3. A third essential relationship is established when two neighbouring though separate elements are ranged one before another. This is the relation of *order* (or spatial *succession*). It undoubtedly appears very early on in the child's life, not merely when the baby's gaze or touch passes over a series of elements ranged in some fixed order (such as the rungs of his cot), but also when a series of habitual movements is guided by perception according to organized points of reference. For example, the sight of a door opening, a figure appearing, and certain movements indicative of a forthcoming meal, form a series of perceptions organized in space and time, intimately related to the sucking habits. Inasmuch as the relations of order appear very early it is hardly necessary to point out that they are capable of considerable development, in terms of the growing complexities of wholes. In the perceptual realm there is one relation in particular, of which order constitutes a fundamental part. This is the relation of symmetry, represented in the simplest case by the double order ... CBA/ABC ... , whose role is well known

[1] See Meili, R., 'Les perceptions des enfants et la psychologie de la Gestalt', *Arch. de Psychol.*, Vol. XXIII, pp. 25–44 (1931).

See also Piaget and Lambercier, 'Comparaisons à distance, etc.', *Arch., de Psychol.*, Vol. XXIX, pp. 173–254, on the formation of figures with greater distances between their elements, in terms of age.

in the construction of 'good configurations', or familiar 'empirical' forms such as a face.

4. A fourth spatial relationship present in elementary perception is that of *enclosure* (or *surrounding*). In an organized series ABC, the element B is perceived as being 'between' A and C which form an enclosure along one dimension. On a surface one element may be perceived as surrounded by others; such as the nose framed by the rest of the face. In three dimensions enclosure takes the form of the relation of 'insideness', as in the case of an object in a closed box. But it is clear that although the relationship of 'enclosure' is originally a perceptual given, no sooner do the factors of 'proximity', 'separation' and various types of 'order' become organized, than 'enclosure' undergoes a complex process of evolution, particularly as regards three dimensions. Thus the partial disappearance of an object behind a screen results, not in a true perception of what in fact takes place, but rather in the perception of something like the re-absorption of the object within the screen. Again, still about the age of one year, when the child attempts to replace a ring which encircles a stick, he contents himself with pushing it against the stick as if encirclement could be brought about simply by contact and did not involve the act of passing the ring over the stick.[1]

5. Lastly, it is obvious that in the case of lines and surfaces there is right from the start a relationship of *continuity*. But it is a question of knowing in precisely what sense the whole of the perceptual field constitutes a continuous spatial field. For quite apart from the fact that the various initial qualitative spaces (such as the buccal, tactile, visual, etc.) are not for a long time co-ordinated among themselves, it has not been shown in any particular field, such as the visual, that perceptual continuity retains the same character at all levels of development. Poincaré linked empirical continuity with the following formula: in a series ABCDE etc., in which the adjacent elements are confused or perceived without being distinguished (thus A=B; B=C etc.), but where A and C or B and D are distinguished (thus A C; B D etc.), the subject has an impression of continuity throughout the process. Köhler describes in a similar way the differential thresholds occurring under Weber's Law. Thus we may say that the perception of continuities is modified in terms of the increasing fineness of the thresholds of sensitivity, and consequently by the evolution of the relationships of proximity and separation.

Generally speaking, it is also true that the basic perceptual relationships analysed by Gestalt theory under the headings of proximity, segregation of elements, ordered regularity, etc., correspond to these equally elementary spatial relationships. And they are none other than those relations which the geometricians tell us are of a primitive

[1] See *The Origin of Intelligence in the Child*, p. 320 (obs. 174).

character, forming that part of geometry called Topology, foreign to notions of rigid shapes, distances, and angles, or to mensuration and projective relations. To adopt the hypothesis that constancy of shape and size are not the direct outcome of rudimentary perception, immediately brings perceptually primitive space back into line with what topology rightly regards as the basic data of geometrical construction. Furthermore, if during the first few months of existence the child's universe is really one lacking permanent objects, as we have elsewhere tried to show (C.R. Ch. I), this means that perceived figures simply appear and disappear like moving tableaux and exhibit a series of changing shapes in between, so that change of state cannot be distinguished from change of position. However, one can say that from the age of 5–6 weeks, following the appearance of smiling, the young baby is capable of recognition. Thus it recognizes a familiar face despite changes in distance or the effects of perspective.

From the spatial point of view, this recognition of a face throughout the course of various transformations constitutes a term-for-term (or 'bi-univocal') correspondence between the elements given in successive states of the figure (for example, when the baby finds the same eyes, the same nose, and so on, in each new position of the face). But what can be the structure of such a correspondence? What can one call the principle involved in this elementary perceptual transposition? It cannot be an euclidean structure since there is as yet neither constancy of size, nor any organization of the movements of objects, as distinct from changes of physical state. And it can hardly be a projective structure since there is not yet constancy of shape, nor are changes due to perspective perceived as such; that is, as connected with changes in point of view.

The face is perceived in a manner only comparable to the plastic and flexible structures envisaged by topology; and the resemblance of the face to itself throughout all its transformations may be reduced to a kind of 'homeomorphism'. That is, a simple topological correspondence, 'bi-univocal' and 'bi-continuous'; but necessarily one which is entirely intuitive and without any precise operation, since it is the work of perception alone.

Second period. The third and fourth stages of sensori-motor development are marked by the co-ordination of vision with grasping or prehension, and consequently by the construction of numerous manipulatory schemas under visual control (third stage). But these stages are above all distinguished by the general co-ordination of actions (fourth stage, beginning of the intelligent relation of means to ends). At this point there occurs a complete transformation of perceptual space, due to the systematization of movements which are guided by vision and which consequently react back upon it.

9

The handling of objects leads in practice to the analysis of figures, or of shapes. An object passed from one hand to the other, turned over in all directions, touched at the same time as it is looked at, is from a spatial point of view an entirely different thing from the same object seen from a distance, or merely touched without being seen. It acquires the consistency of a solid, as opposed to the flexible and elastic figures of the first period. To the extent that the permanence of objects develops through the co-ordination of actions there is, therefore, a simultaneous construction both of euclidean figures (as a result of the object being ascribed a constant size, which remains the same during changes of position) and projective figures (as a result of co-ordinating different views of the object, i.e., perspective).

Thus the special character of this second period (from 4–5 to 10–12 months) consists in the building up of figures and the development of perceptual constancy of shape and size. In opposition to the main hypothesis of the Gestalt theory, we believe (for reasons advanced in §2.) that the perception of 'good configurations' (or simple euclidean forms) itself evolves with age as a result of sensori-motor activity. Eye movements, tactile exploration, imitative analysis, active transpositions, etc., all play a fundamental part in this development. The fact that good configurations stand out clearly in tachistoscopic vision when eye movements are not possible, proves nothing in itself; because although the acquired schemas may in this case give way to an immediate recognition this simply brings in an earlier construction.[1] As for the greater stability of good configurations, it can just as well result from the laws of sensori-motor activity as from those of pure perception.

Nor can we say that a baby is able to perceive a straight line earlier than this present period. In the first place, we may well ask what is an objectively straight line for the jerky and fluttering eye movements of the first few months? In the second place, such things as isolated straight lines hardly exist in a baby's perceptual world. In order to perceive a line as such the child must first of all abstract it from the boundaries of some complete figure, such as a table, a bed, a door, etc. As these figures are not yet assumed to indicate the presence of permanent objects with fixed shapes and dimensions, how can one imagine such an abstraction being made? On the other hand, towards 8–10 months one sees a whole series of explorations concerned with movements of objects and the recognition of their shapes, tending to bring them into relation with perspective (see C.R. pp. 167–9 and 159–64). The line then takes on functional significance as a trajectory, as the

[1] Cf. the 'empirical Gestalt' of Brunswik. When a form is presented tachistoscopically, intermediate between a symmetrical five-fingered structure and an ordinary human hand, the subject perceives a 'hand' just as easily as the symmetrical form.

intersection of two planes, as the sole aspect of shape which is retained in perspective, etc.

Along with the construction of the principal perceptual forms (lines, circles, angles, etc.) the most important acquisition of this period is undoubtedly that of the constancies of shape and size. Both apparently assume the organization of projective and metrical relationships. For instance, in the case of shape constancy, recognizing a square which appears lozenge-shaped as a result of perspective implies reconstructing the figure seen head on, when it is in fact turned obliquely. This reconstruction entails a projective correspondence between two distinct perspectives, but it also involves recognizing a figure having equal angles and equal sides, which constitutes a metrical correspondence. On the other hand, to perceive the true dimensions of an object at a distance involves reconstructing constant size (and thus metric) from a figure diminished by perspective (and thus a projective shape), consequently uniting in one whole both projective and euclidean vision. It would therefore appear that both projective and metrical relationships are developed jointly and are interdependent.

In fact, the constancy of shapes results from their sensori-motor construction at the time of the co-ordination of perspectives. During the first period described above, when objects change their perspective such alterations are perceived not as changes in the point of view of the subject relative to the object, but as actual transformations of the objects themselves. The baby waggling his head before a hanging object behaves as if he acted upon it by jerking about, and it is not until the age of about 8–9 months that he really explores the perspective effects of actual displacements. Now it is just about this age that he is first able, for instance, to reverse a feeding bottle presented to him wrong way round. That is, to attribute a fixed shape to a permanent solid.

As for size constancy, it is linked with the co-ordination of perceptually controlled movements. All through the first period, the child makes no distinction between movements of the object and those of his body. At this stage the baby is incapable of 'grouping' objective changes of position or attributing permanence to objects which remain unseen (this permanence is linked with the movement of return which, together with that of the detour, constitutes the essentials of the practical group of changes of position). In the course of the second period the subject begins to distinguish his own movements from those of the object. Here are found the beginnings of reversibility in movements, and of searching for objects when they disappear. It is in terms of this grouping of movements, and the permanence attributed to the object, that the latter acquires fixed dimensions and its size is estimated more or less correctly, regardless of whether it is near or distant.

In conclusion, the space of the first period appears to admit only of

pre-perspective and pre-euclidean relationships akin to elementary topological relations. But it is essentially a perceptual and motor topology and one which is, above all else, completely egocentric in the sense that the perceived relationships are not distinguished from the activity of the subject himself. Whether changes in shape result from movements of the object or movements of his body, the child has no means of distinguishing. In the course of the second period, however, the progressive decentration of sensori-motor space as a result of the subject increasingly co-ordinating his movements leads to the formation of both projective and metric relationships, whose synthesis results in the constancies of shape and size. The first of these arises from projective correspondences capable of co-ordinating perspective projections, and also from the masking of objects (objects partly hidden by screens).

The second type of relationship arises from the progressive grouping of movements, displacement of objects by the hands, or eye movements bringing about estimates of size; and also from the transposition of dimensional relations (similarities). In this way the development of perceptual constancies is evidence of a complete elaboration of space, both projective and euclidean, on the single level of sensori-motor activity.

Third period. From the beginning of the second year sensori-motor activity is enriched by systematic observation and enquiry, by tentative efforts at experimentation (stage 5), and finally by fully intelligent practical activity through the internal co-ordination of relationships (stage 6). This progress reacts on the development of sensori-motor space in the following way. Whereas the achievements of the second period are essentially relative to the shape and dimensions of objects, those of the third period consist in bringing out the relationships of objects to each other. Thus the 'group' of movements is extended to an increasing number of successive positions, including (by stage 6) the effects of movements not directly perceived. Illustrating this stage we have the very striking analysis, by the 12–16 month baby, of visible movements (C.R. p. 187), of positions (pp. 190–2), the relations of container to contained (pp. 92–3), and the rotations and reversals of objects, not only relative to the body but in relation to one another (pp. 194–5), etc.

Lastly, in the second half of this period (stage 6), with the appearance of the rapid internalized co-ordinations which denote the fully intelligent act, there comes into being for the first time, the mental image which makes possible delayed imitation and, as a result of this, the first attempts at drawing.[1] The symbolic function thus evolved facilitates the acquisition of language or a system of collective signs. Hence from being purely perceptual, space has become partly representational and we

[1] See *Play, Dreams and Imitation in Childhood*, London, 1951.

have thus reached the lower frontiers of the territory we intend to explore in the course of this work.

§2. *Perception and movement: the role of 'perceptual activity'*

The bare statement that sensori-motor structures anticipate in many ways the future achievements of spatial representation, whilst being a necessary preliminary, is not enough to indicate just exactly where the perceptual data discussed above stand in relation to representational space.

Thus the child can already perceive things projectively and grasp certain metric relationships by perception alone, long before he can deal with perspective in thought, or measure objects through operations. In addition, his ability to perceive forms in this way (straight lines, curves, squares, circles, etc.) is far in advance of his capacity to reconstruct them at the level of mental images or representational thought.

Thus thought has the task of reproducing at its own level (of representation as distinct from direct perception) everything that perception has so far achieved within the limited field of direct contact with the object. Besides this, there is a gap of several years separating the two constructions. For it is not until after 7–8 years of age that measurement, conceptual co-ordination of perspective, understanding of proportions, etc., result in the construction of a conceptual space marking a real advance on perceptual space. All the same, it is worth noting that despite their differences and the time lag which separates them, both perceptual and representational construction are to some extent repetitive and possess a factor in common. This common factor is motor activity. Having already been the governing factor in representational images and, in all probability, the most elementary perceptions, motor activity now becomes the fountain-head of the operations themselves. The fact of its continuous existence through all the stages renders motor activity of enormous importance for the understanding of spatial thinking.

At each level, spatial thinking appears in two quite distinct forms. Sometimes it concentrates on static patterns, as when a triangle or a straight line is conjured up, at other times it expresses possible transformations, such as a change in shape of the triangle or a rotation of the line about its middle. Are these two forms indissolubly linked together, or does one precede the other? Are they of equal importance, or does one govern the other? These are questions of the utmost importance, for our characterization of geometrical thought depends entirely on how they are answered. We may regard geometrical thought as 'intuitive' in the usual etymological sense; as the contemplation of quasi-sensuous images. Or we may take it in the sense of something

13

active and constructive, pre-operational at the outset but culminating finally with the *operation* as its specific form of equilibrium.

At each stage of development we shall see that it is the second interpretation which appears correct. For although the figural element and the purely motor element in spatial thinking are always associated and always co-present, we shall notice that it is always the latter which controls the former and not the reverse.

Are sensation and movement two independent physiological realities? It is common knowledge that a whole school of neurology nowadays maintains that they are fundamentally and necessarily interconnected.[1] We have no desire to take sides in the strictly physiological field, but even if it were shown that they were independent, and that their 'association' was only of a secondary character, this would still prove nothing as far as psychology is concerned. For the task of psychology is not the explanation of the working of the nervous system in terms of consciousness or behaviour, but rather the analysis of the evolution of behaviour. That is to say, the way in which a perception, for example, depends on past perceptions and conditions subsequent ones. And from this standpoint there can be no movement occurring in any conceivable type of behaviour which does not rest on perception. Neither can there be a perception taking place without activity which involves motor elements. It is the total 'sensori-motor schema' which must constitute the starting point for the analysis of behaviour, and not perception or movement considered in isolation.

From this point of view, a perception (such as the sight of a feeding bottle turned wrong way round) is a system of relationships organized in an immediate whole. But the equilibrium of this whole depends not only upon real (i.e., actually perceived) relations but also, like a mechanical equilibrium, upon virtual relations which refer to earlier or contingent perceptions (for instance, anticipation of the result of semi-rotation of the feeding bottle). The intervention of such virtual relationships presupposes motor activity, since it is always this last which dictates the transition from one perception to the next.

But what, in fact, is a movement? Gestalt psychology, it is true, noted its close linkage with perception, but only in the sense of being determined by perception. This point of view has been put very clearly by Guillaume[2]: "*Sensorium* and *motorium* constitute a single mechanism, and the dynamic play of the reaction is directly linked to that of the receptor field." Contrary to this view, however, we believe that if movement really marks the transition from one perception to another, then one must recognize the existence of reciprocity between a transformation as such—namely, movement; and successive states arising from the trans-

[1] Von Weiszacker, *Die Gestaltkreis*, Stuttgart, 1947.

[2] P. Guillaume, *La psychologie de la forme*, p. 126, Paris, 1937.

formation—namely, perception. In this sense, every movement may be regarded as a transformation of the perceptual field and every perceptual field as a group of relationships determined by movements.

Thus an 8–10 month baby seeing half of a toy as it emerges from beneath a blanket will tend to lift the blanket to see the whole object. This movement transforms the first perceptual field (which gave only a partial view of the object) into a second field (one including the toy and the blanket which now covers other things). In all probability the movement of lifting the blanket was itself determined by the disequilibrium of the field, relative to the needs of the subject; or simply because of the perceptual disequilibrium occasioned by seeing only half of the object (hence an asymmetry and tension resolved by movement, reestablishing symmetry and equilibrium). This is the aspect of the situation stressed by Gestalt theory. But this formulation still leaves unanswered the question of whether such states, including those of equilibrium, can be conceived of, independent of the transformations leading from one to another, i.e., independent of the movements themselves.

Actually the whole process of development, starting out with perception and culminating in intelligence, demonstrates clearly that transformations continually increase in importance, as opposed to the original predominance of static perceptual forms.

But we go further than this and maintain that from the commencement of perception itself it is necessary to analyse most carefully the function of movement. For our interpretation of spatial thought depends entirely on the relation of figural to motor elements. Take, for example, a cube seen in perspective so that none of the sides appears as a square. The moment an observer grasps the fact of constancy of shape in this object it is impossible for him to perceive it without the intervention, in the present perception, of the movements he could make in obtaining a head-on view of the cube. In this way, even for direct perceptual recognition of objects, movements are involved in the guise of virtual relationships intimately linked with the real relationships. These movements, essential to the construction of shape constancy in general, cannot be ignored in the resultant perception, since they condition its equilibrium (in the same way as a mechanical equilibrium presupposes virtual speeds and displacements). In this sense, every perception implies a sensori-motor schema which brings the sum total of previous constructions to bear on the actual situation.

The perception of a simple plane figure such as a rectangle gives rise to similar considerations. To the extent that vision is centred on one point rather than another, or is centred to one side or one relationship rather than another, the width or the height will be overestimated, etc.[1]

[1] Together with Lambercier we have shown that every area on which vision is centred is, so to speak, dilated, so that centration of vision results in the relative overestimation of

The shape of the figure as such, thus implies some optimal point of fixation or *centration* involving the minimum of distortion, and in this sense perception does determine eye movements. But conversely, the actual point chosen is only a matter of greater or lesser probability and one can calculate the probable perceptual effect of a particular shape relative to the different combinations of possible points of fixation.[1] Hence we find visual perception itself made up of a system of relationships determined by probable movements of the eyes, and we shall find in the same chapter the exact analogy to these processes in connection with tactile exploration as it occurs in 'haptic' perception.

Generally speaking, side by side with purely passive perception such as results from a particular centration, one must recognize the existence of 'perceptual activity' commencing with changes in centration (or decentration) and consisting of comparisons, transpositions, anticipations, and the like. The need for this distinction is shown by the fact that whilst the effects of simple perceptions remain relatively constant at all ages (e.g., simple geometrical illusions diminish only very little in the course of development) the effects of perceptual activity are progressively augmented as the child develops. A good example of this will be seen in the phenomenon of 'haptic' perception, which becomes vastly more sensitive in the course of development of tactile-kinaesthetic perceptual activity.

Now 'perceptual activity' is probably nothing but a continuation of the 'sensori-motor intelligence' already active before the appearance of representation. If this is so one can understand why the perceptual constancies, the product of sensori-motor activity during the first year, continue their subsequent development with advancing age. As a matter of fact, constancy of size reaches adult level only towards 9–10 years, showing clearly that the construction of this schema, which is at a lower level in the behavioural hierarchy than representational activity, still continues after this latter has already appeared.

Furthermore, during the development of representational, and later of operational intelligence, these higher mechanisms continue to react on perceptual activity itself. In the course of this work we shall see several instances of this, especially in the way that systems of co-ordinates arising from processes of conceptual inter-connection react back on the organization of perceptions along horizontal and vertical axes. (See Chapter XIII.)

that element or relationship. Cf. Piaget, J., and Lambercier, M., 'La comparaison visuelle des hauteurs à distances variables dans le plan parallèle', *Arch. de Psychol.*, 1943.

[1] Cf. Piaget, J., 'Essai d'interprétation probabiliste du loi de Weber et de celle des centrations relatives', *Arch. de Psychol.*, Vol. XXX, p. 95. It is in relation to just such factors that geometrical illusions such as the Delboeuf, Muller-Lyer, etc., are to be explained.

Thus we can say that not only is movement active from the very beginning of perception, but that the importance of its role is enormously increased by perceptual activity. And in the transition from perception to representation we shall again see this factor at work.

SECTION II—THE RECOGNITION OF SHAPES ('HAPTIC PERCEPTION')

Perception is the knowledge of objects resulting from direct contact with them. As against this, representation or imagination involves the evocation of objects in their absence or, when it runs parallel to perception, in their presence. It completes perceptual knowledge by reference to objects not actually perceived. Thus as an example, one may recognize a 'triangle' and liken the given figure to the entire class of comparable shapes not present to perception.

Hence if representation can be said to extend perception, it can also be said to introduce a new element peculiar to itself. What is distinctive of representation is a system of meanings or *significations* embodying a distinction between that which signifies and that which is signified. Admittedly, perception itself contains significations (for example, forms seen in perspective are related back to the constant form) but in this case they are merely signs or pointers, part and parcel of the sensorimotor schema. In contrast to this, representational signification draws a clear distinction between the *significants* or signifiers which consist of signs (ordinary or mathematical language) and symbols (images, imitative gestures, sketches), and the things they signify (in the case of spatial representation; spatial transformations, spatial states, etc.). The transition from perception to representation is a twofold problem, embracing that which signifies and that which is signified; that is to say, both image and thought.

In this chapter it is the image we particularly want to discuss, although we cannot entirely dissociate it from the concepts it serves to indicate. But no sooner do we begin to study the spatial image than we are once again confronted with the problem of movement and its relation to the sensory or figural element, a problem we have just discussed in connection with perception. Now in all probability the image is an internalized imitation (as we have elsewhere tried to show[1]), and is consequently derived from motor activity, even though its final form is that of a figural pattern traced on the sensory data. Thus because of its very nature the mental image tends to oscillate between purely motor and figural characteristics, just as did sense perceptions at an earlier stage. The intellectual relationships which constitute the beginnings of representational space are at first linked to the image as a

[1] *Play, Dreams and Imitation in Childhood*, 1951.

C 17

means of support. But as they attain to spatial transformations, as opposed to static forms, these relationships separate the figural from the motor elements of the image, and at the same time free themselves from the figural elements to such an extent that the latter are henceforth used simply as auxiliary symbols.

We may outline the problem in this way. As a result of internalized imitation, the mental image benefits from the attainments of perceptual construction and is sooner or later (though much later than is generally thought) able to avail itself of ready-made forms, such as straight lines, curves, parallels, angles, squares, circles, and the like. Not that this stamps representational space as being euclidean or projective right from the start, for it is in truth more directly linked with symbolic imagery than with genuinely conceptual relationships. In the case of the latter, as opposed to the imitative images on which they depend, it may well be that spatial representation has to begin by once more establishing the topological relationships of which perception itself was part. Only later can it embrace both projective and metrical relationships, and last of all embark upon the construction of a comprehensive space of co-ordinates and co-ordinated perspectives.

§3. *The recognition of shapes by means of 'haptic' perception. Technique and general results*

We thought it worth while to repeat a well-known experiment on children aged 2–7 as a suitable introduction to the study of spatial intuition, since it deals with the borderline between perception and the image. We are referring here to what has been termed 'haptic' perception, although, as we have already mentioned, we consider the expression to be quite unsuitable since it refers as much to imaginal representation as it does to perception. That the originators of the term recognize this fact is evident from the distinction which they make between simple or primary perceptions, and representational interpretation.

A child is presented with a number of objects, familiar solids (ball, scissors, etc.) or flat geometrical shapes (square, circle, etc.), and touches or feels around each one without being allowed to see it. It must then be named, drawn or pointed out from a collection of visible objects or drawings of them. Clearly, the reaction involves translating tactile-kinaesthetic impressions from an invisible object into a spatial image of a visual kind. Thus the study of such data can be used to analyse the construction of the intuitive image as well as the mechanisms involved in tactile perception.

The method adopted by us is as follows. The child is placed before a screen behind which it feels the objects handed to it. By following this procedure rather than the conventional one of placing objects beneath

a table, the experimenter can see the methods of tactile exploration employed, knowledge of which is vital to the study of the results.

The following objects are offered in succession: 1. For very young children (older children find these too easy), a series of common objects: pencil, key, comb, spoon, etc., which they must identify among a corresponding series of objects which they can see. 2. A series of cardboard cut-outs in the shape of geometrical figures. (A) Simple and symmetrical: circle, ellipse, square, rectangle, rhombus, triangle, cross, etc.[1] (B) More complex but also symmetrical: star, Cross of Lorraine, swastika, simple semi-circle, semi-circle with notches along the chord (see Fig. 1.), etc. (C) Asymmetrical but with straight sides: trapezoids of various shapes, etc. (D) A number of purely topological forms: irregular surfaces pierced by one or two holes, open or closed rings, two intertwined rings, etc.

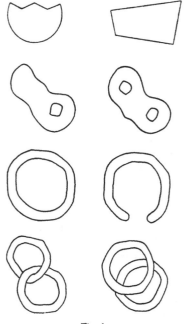

In order to eliminate the element of chance, when the child has named the objects it has felt it is asked to identify them among a collection of figures. Alternatively the child may be shown a collection of drawings, or simply asked to draw the objects it has felt. We also employed (though simply as auxiliaries) shapes made of matchsticks stuck on a flat surface in the form of squares, triangles, etc., and letters of the alphabet cut out of cardboard. Outlines chiselled in wood worked even better than the matchsticks. The child

Fig. 1.

Toothed semi-circle, trapezoid, irregular surfaces pierced by one or two holes, open and closed rings, intertwined and superimposed rings.

has only to follow the grooves instead of making a complete tactile exploration, and in this case one can study the correspondence between the image or drawing and the simple movements themselves.

The problems set before the children face them with two distinct tasks. First, the translation of tactile-kinaesthetic perceptions into visual ones. Second, the construction of a visual image incorporating the tactile data and the results of exploratory movements.

The subject is confronted with the first of these tasks when he has to

[1] Circle 11·5 cm. diameter, square 10 cm. side, etc.

recognize among several objects he can see, one he can feel but cannot see. In this connection it is worth mentioning that the translation from tactile-kinaesthetic into the visual mode is by no means a new task for the 2–4 year old child. A baby of 3–5 months (the age of co-ordination of touch and vision) is already becoming accustomed to making visual perceptions of its hand or objects it manipulates correspond to tactile or kinaesthetic perceptions of the same.[1] Apart from this, the general development of imitation, especially imitation of facial movements, leads to the achievement of such correspondence. For the parts of its own body which the baby cannot see correspond to the parts it can see of the bodies of other people, and which it can only come to know in its own case by tactile-kinaesthetic means.[2] Hence we may expect to find the ability to recognize objects simply by means of tactile exploration developed at a very early age. The only new feature in this task for the child at the level of representation lies in the fact that it is now presented differently; namely with the aid of speech.

As regards the second task, the construction of an image confronts the child with a new problem, and it is with this problem that the present study is exclusively concerned. What we find is that as soon as objects become too complex to be recognized (particularly the moment cardboard cut-outs of two-dimensional geometrical shapes are met with) the child can no longer identify the figure simply by touching it. Instead, he is forced to make a tactile exploration of it. In this case, to identify or draw the object the child has to construct for himself a visual image of it.[3] What we are seeing here, then, is not only the transition from a tactile-kinaesthetic to a visual percept, but in particular the transition from tactile-kinaesthetic perception to the visual image.

Because it demonstrates how perceptually known forms are more or less rapidly exploited by imagination, and at the same time how the spatial relationships arising in the latter lag behind those already known perceptually, the analysis of this transition seems to us particularly interesting as an introduction to the study of conceptual space. It shows how early the mental image appears, but at the same time reveals its superficial character as regards the understanding, even from the intuitive standpoint, of the relationships themselves.

The results of these experiments were as follows. During the first stage, extending on an average up to 3; 6–4 years, one finds familiar objects more or less easily recognized, but not geometrical euclidean figures. During the second stage (4; 6–6 or 7 years) euclidean figures are progressively differentiated. Only during the third stage (after 6; 6–7 years) is the synthesis of complex forms achieved.

[1] See *The Origin of Intelligence in the Child*, London, 1953.
[2] See *Play, Dreams and Imitation in Childhood*, 1951.
[3] It is interesting to note that drawing the object and identifying it were found to be of about equal difficulty.

Below the age of 2; 6 years (Stage 0) experimentation with hidden figures is not possible, although this by no means precludes the existence of spontaneous tactile recognition outside our experimental conditions, which are rather trying for the very young (bandaging the eyes was found even worse).

Stage I can be divided into two distinct substages. In substage IA one finds familiar objects recognized but not shapes—even visual correspondence between shapes, by simple superimposition, is only possible with practice (the children studied never having done any drawing nor having had experience of Montessori exercises). In Substage IB (3; 6–4 years) one finds, however, the beginnings of abstraction of shapes. But, curiously enough, the shapes first recognized are not euclidean but topological. Thus the circle and the square cannot be distinguished because both are closed forms, although they are distinguished from open forms, etc. Neither straight lines nor angles are as yet identified.

Throughout Stage I tactile exploration remains relatively passive. The child simply grasps the object, often with both hands, and responds to chance discoveries, such as when it pokes its finger through the hole in the key-handle, etc. In Substage IB, shapes are explored as if they were three-dimensional objects.

In Stage II one can distinguish three successive levels following one on the other. Between Substages IB and IIA (4–4; 6 years) there begins a crude differentiation of rectilinear from curvilinear shapes, whilst different rectilinear shapes (square, rectangle, etc.) or curvilinear shapes (circles, ellipses, etc.) are not differentiated among themselves. Representation by means of drawings is possible (beginning in Stage IB) but lags somewhat behind identification by choice. Tactile exploration remains global but use is made of chance indications as they are encountered. In the course of Substage IIA (4; 6–5 or 5; 6 years on average) one can observe a progressive differentiation of shapes according to their angles and even their dimensions (circle and ellipse or square and rectangle). There still remains a slight gap between recognition and drawing but the latter is becoming more precise. Tactile-kinaesthetic exploration shows signs of a search for significant clues to identity. Finally, during Substage IIB (5–5; 6 years) one sees the successive discoveries, attended by much hesitation, of the rhombus and trapezium. Crosses and stars begin to be differentiated but many errors still occur in the representation of complex forms. Exploration becomes more active but it is not always systematic.

Lastly, Stage III commencing at 6; 6–7 years is notable for methodical exploration, doubtless influenced by what may now properly be called operations, which by this stage exist in all fields. The child can now distinguish between complex forms, such as the swastika, and simultaneously take account of order and distance. From this stage, the

image (drawing, etc.) shows exact correlation with power of recognition, as if the fitting into place of relationships were directly expressed by a more flexible figural symbolism, under the steady control of thought.

§4. *Stage I. The recognition of familiar objects, then of topological, but not of euclidean shapes*

What is interesting about this stage is that the child, whilst recognizing with ease the things it touches, is at first unable to abstract shape for want of sufficient exploration. Later, when the child develops the ability to abstract shape he cannot get beyond topological relations and is unable to reconstruct euclidean shapes. This raises the first question as to why the exploratory movements are absent when one might have expected them to be guided by the shapes offered as models, since nothing would appear easier than to follow the contour of a square or a circle with one's finger. A second question is also raised by the reactions observed during this stage as to just what abstraction of shape consists of, and why it is that topological shapes appear psychologically more simple than euclidean ones.

Here are a few examples from Substage IA.

CRI (2; 10) recognizes a ball, a pencil, a key, a second pencil, scissors (but misses a spoon). But he cannot identify a cardboard circle from a collection of models, nor draw it. For the ellipse, semi-circle with or without notches, the reaction is the same.

DAN (3; 0) recognizes objects in the same way—takes hold of them, passing them from hand to hand. Takes hold of a triangle but makes no attempt to explore it. "Have you any idea which one it is?—*No*—Keep trying—(He seizes it in both hands and turns it over). Can you draw it?— *Yes*—(scribbles). (Given several models to choose from) Is this it? (square)—*Yes*—Or is it this one? (rhombus)—*No*—Look at them; which is it?—*This one* (square)".

Ellipse: Takes hold of it in his left hand and feels the surface, then thinks he can recognize the semi-circle with notches among the models. "Not this (ordinary semi-circle)?—*No, that one* (with notches)".

Square: "*I can't see anything*—Draw it—(scribbles)—(round, oval and square models shown) Which is it?—*That one* (oval)".

Circle: At first remains passive, not making the slightest movement. Then explores it with the palm of the hand without touching it with the fingers. Drawing (scribble). From three models (oval, circle, square) chooses the oval one.

Semi-circle with notched chord: Takes hold of it and places his fingers in the notches. From four models he chooses the triangle because of the point. "Take a good look—*That one* (oval)—Not that one? (rhombus)—*No*—Feel it again—(Moves his hand over the round part)—*That* (points to the ellipse).

Ordinary semi-circle: Chooses the triangle after taking hold of the semi-circle by one of its angles.

RUT (3; 3) recognizes key and comb after some hesitation, but like the two

previous subjects stumbles over the recognition of shapes. After placing the square, circle, notched semi-circle, and triangle on the table, we gave him another square, putting it in his hands and simply asking him to place it on the corresponding shape (his eyes were wide open, all considerations of haptic perception being left to one side). Rut does this correctly but then puts a triangle first on the circle, then on the square, a ring on the square, etc. However, after practice he succeeded in placing all the shapes (including the ellipse, rhombus, etc.) on the corresponding models and was not misled by suggestions as to where to place the ordinary semi-circle, for which there was no corresponding model. But once the conditions of haptic perception were reimposed he was again completely baffled.

AND (3; 5). Pencil: Takes it in both hands, turns it round and touches the point, and says: "*It's wood*—(shown the key, comb and pencil). Which one? —Points immediately to the pencil". A key: feels it, turns it over, holds it in his right hand and puts his finger through the hole in the handle, exclaims: "*A key!*" Comb: correct.

Circle: Turns it over, places the card horizontal between his palms and then takes hold of the thickness between two fingers: "*It's a box*—Look at them (circle, square, ellipse), which is it?—*That one* (ellipse)". For the square the reaction is exactly the same. Takes hold of it, puts his hands round it without exploring it: "*Also a box*—Which one?—(First points to the circle then feels it again when it is replaced in his hands)—*That one* (ellipse)—Not that one?— *No*".

The main features of these reactions are clear. The child understands the questions since he shows himself capable of recognizing most of the familiar objects set before him. But when geometrical shapes are involved he cannot reconstruct the complete figure and, according to whether he has felt a curved or straight side or a point, he likens the shape touched to a visual shape possessing the same characteristic, not bothering about the rest of the object or attempting to put together the total structure. Thus Dan identifies the triangle with the square because of one of its angles, the ellipse with the notched semi-circle on account of its curved outline, the square and the circle with an ellipse (not distinguishing straight from curved lines) and the notched semi-circle with the triangle because of its points, etc.

It is obvious that these errors are due to inadequate exploration of the objects. The exploration required to identify geometrical shapes is not the same as avails for the recognition of familiar objects. The latter are in the main no more than prehensile gestures, or movements barely distinct from such: seizing in both hands, rolling from one hand to the other, touching, pressing the hands against both ends, sticking the finger in the hole of the key-handle, etc.

But to recognize geometrical shapes the child has to explore the whole contour, whereas he is content merely to take hold of the cards, feel their surfaces and touch only part of the contour. As a result, the

geometrical shapes are not distinguished from familiar objects as recognized through prehensile or global exploration.

But this remains only a partial explanation, since we have still to find out why exploration is not taken far enough to permit recognition of detailed geometrical shape. It may be granted that ordinary prehensile movements are quite sufficient for the recognition of familiar objects, without their requiring further exploration.

The act of seizing a ball, pencil, key or a comb automatically involves some sort of tactile-kinaesthetic adaptation or accommodation which at the same time makes it possible to distinguish the object concerned. Then why is such a mechanism not brought into play in exploring the contours of geometrical shapes, discerning straight lines and angles, recognizing divergent or parallel lines or estimating the number or size of triangles, etc.? The usual answer is that the child cannot 'analyse' its perceptions and is incapable of 'abstraction'. But what do such notions really mean?

It is in connection with 'analysis' that the distinction made in §2, between perception and perceptual activity, becomes relevant. Perceptual activity begins with 'decentration'. Touching any one part of a square involves centration and results in an initial tactile perception. Touching another portion involves another centration, producing a second perception, and so on. But being incomplete, each centration must lead to the over-emphasis of the part contacted at the expense of parts peripheral to the area of centration.

The passage from one centration to another (or *decentration*) thus tends to the correction or regulation of centrations by each other, and the more numerous the decentrations, the more accurate becomes the resulting perception. But such a process correspondingly implies an activity to some extent motor in character (going beyond pure perception) and consequently underlying many other active movements such as the 'transfers' of perceptual data one to another, 'comparisons' (reciprocal transfers), 'transpositions' (temporal transfers), etc. It is this combination which constitutes perceptual activity and which is often referred to under the rather vague term 'analysis'.

The lack of exploration on the part of children at this stage may therefore be explained as the result of a general deficiency in perceptual activity itself. This means that the child's perceptions are still passive or static instead of being integrated in a system of sensori-motor co-ordinations tending to bind them together.

By working back one can thus understand what most probably takes place during the child's first few months, in the case of visually perceived shapes. Exploration by eye is much easier than exploration by touch, for the simple reason that a visual centration can embrace many more elements simultaneously than a tactile centration, and hence visual

shapes are more rapidly constructed than tactile ones. But the process of construction is doubtless much the same in both cases, despite the gap of a year or two between them. Therefore the process is exactly the same for tactile recognition of geometrical shapes as that described in the first of the three periods of §1 in the case of visual perception.

Also, we may note that this lack of exploration or perceptual activity similarly explains the children's difficulty in drawing. The children instanced above could only scribble and could not copy even the simplest shapes (circle, square). The reason is that perceptual activity, in contrast to perception pure and simple, is the source of imitation. Imitation tends to prolong the process of motor adaptation and is therefore the source of the image, which is itself only an internalized imitation. Failing to explore the edge of a surface the child can therefore no more draw the shape than recognize it among a collection of models.

We are now in a better position to see what the current term 'abstraction' of shape means. People often speak as if geometrical shape were a property of an object like its weight or its colour, and as if abstraction of shape meant extracting the shape of an object by some process similar to the abstraction of its physical properties. This way of looking at the question is not altogether wrong because there does exist a space, to some extent physical, and in fact inseparable from the mass, etc., of a body—in other words, from the sum total of its main properties. But this point of view is a limited one, for there is much more to the abstraction of shape than merely abstracting the inherent properties of the object studied. There is first of all an abstraction related to the actions, or co-ordination of actions, carried out by the subject, and it is essential to grasp this fact at the outset if one is to explain how the geometrical thought of older children so quickly outstrips their experience. The analysis of tactile-kinaesthetic exploration and perceptual activity of very young children has just shown us that the shape of familiar objects is recognized as a result of prehensile movements involving the global adaptations distinctive of this level. Thus shape is not just inherent in the object, since it also results from the subject's movements in handling the object. Only because these movements are co-ordinated from their inception is the shape grasped as a single whole, and not as a series of discrete elements put together as an afterthought.

The next question is whether 'abstraction' of geometrical shape takes place on the basis of the object alone or on the basis of the subject's movements relative to the object. Substage IB enables us to answer this question by revealing the nature of the first geometrical shapes recognized, as distinct from the grasping of familiar objects. For during this substage a very instructive reaction is observable. The first geometrical shapes recognized by the child are remarkable, not for the properties apparent to ordinary sense perception, such as straight lines,

curves, angles, etc., but rather for those properties which abstract mathematical analysis shows to be much more primitive, such as closed, open, intertwined, etc.:

ANI (3; 5) recognizes pencil, key and comb immediately. She is then given a circle which she takes in both hands and touches in a random fashion (rubbing it between her palms, etc.). Ani seems to recognize it but also points to a circle when she is touching a square. "You are quite sure that this one (square) is the same as that (circle)?—(First she holds it between her palms, fingers splayed out, then begins to turn it about). *Yes, quite sure*". She is then shown the circle and the square and is asked to draw them. She draws two closed figures, both elliptical and similar to each other except that the square is elongated slightly (she has both models in front of her).

Ellipse: she grasps the cardboard, rubs it like a cake of soap, and then makes a correct choice from the four models shown her. Then she chooses another ellipse when holding a triangle, part of the contour of which she explores by rubbing the points against her palm. She declares that the triangle is "*a planter* (garden tool)", then, having taken another ellipse in her hands, she rubs one end against one palm and says: "*It is also a planter*". The semi-circle with notches she first likens to a circle, but after putting her fingers between each of the notches she identifies it correctly.

Ring: Ani puts her finger through the hole and recognizes the figure immediately. The circle of the same size is distinguished from the ring as being filled-in. The open half-ring is also recognized, then the irregular surface with one hole, then that having two holes, and finally the two intertwined rings (these last are distinguished from the two separate rings).

DON (3; 6) recognized all the shapes by visual superimposition. After this we pass over to tactile perception. He recognizes the circle (holds it in both hands, turns it slightly, touching it across the diameter), but not the ellipse, etc., nor even the notched semi-circle (which he holds both by the points and the curved side). As against this he distinguishes the ring from the circle, likewise the open half-ring and the surfaces with one or two holes.

MAR (3; 10) recognizes the surface with one hole and also the closed ring without hesitation, and after some hesitation the open ring and the intertwined rings. In the case of the circle he sometimes makes the right choice but sometimes chooses the ellipse. Both the rectangle and the triangle are likened to an elongated ellipse.

SIM (4; 0) makes the correct choice for the circle, but is unable to draw it (scribbles). After his hand was guided once, he was able to draw a closed figure by himself. He easily recognizes the open ring, the two intertwined rings and the irregular surface with one hole. But he refuses to locate the triangle among three models comprising a circle, square and triangle, although touching the apex with both index fingers whilst holding the converging sides between his hands.

Thus we can say quite definitely that each of these children easily distinguishes an open from a closed figure, a surface with one or two holes from one without holes, a ring from a circle, intertwined rings

from separate rings, etc. In other words the topological relations of open and closed shapes, intertwined and separate shapes, give rise to correct identification. On the other hand, simple euclidean shapes remain undifferentiated, apart from the case of the circle where the beginnings of differentiation may be seen, although how far this extends has yet to be determined.

In most cases the circle is recognized from among several figures; it is, in particular, never likened to a square or rectilinear figure, but it is sometimes confused with an ellipse (Mar). Although the circle that is touched is likened to a visually perceived circle or ellipse, it is not the only figure that gives rise to this comparison. Ani likened the square to a circle, and while handling it said she was quite sure it was a circle. When she came to draw the square (now visually perceived) she produced a figure similar to a circle. Similarly the ellipse is sometimes recognized correctly and sometimes likened to a circle, whilst a visually perceived ellipse is likened to the triangle (Ani and Mar) or the rectangle (Mar) which were touched but not seen. In short, one can say that the balance of choice lay in favour of curved shapes, subject to the proviso that these are made to include all the other simple shapes (squares, rectangles, triangles). Or in other words, curved shapes are only partially differentiated at this level, and the main feature which strikes the children is their closed character. A square, rectangle or triangle are also closed but they exhibit complexities (straight lines, parallel lines, angles) still alien to the geometrical notions peculiar to this stage. On the other hand, a circle or an ellipse are at the same time closed and free from these added complications, and for this very reason they exercise a special fascination. Drawing seems to confirm such an interpretation (*vide* Ani) and we will return to this in Chapter II. For the moment it is enough to say that the relative preference shown for curved shapes confirms the topological nature of the relationships characteristic of spatial representation at this level.

We can now answer very simply the question of the 'abstraction' of shapes raised in connection with Substage IA. If abstraction meant no more than extracting from the object its most striking morphological features, what is the likelihood that topological relationships will be the ones singled out in the first place, and in particular, what is the likelihood of this choice being consistent? Does a rectilinear side or an angle present features so much more complex than the relationships of openness or closure, or interlacement, etc.?

But inasmuch as the shape is abstracted from the object by virtue of the actions which the subject performs on it, such as following its contour step by step, surrounding it, traversing it, separating it and so on, these relationships of proximity and separation (from which openness and closure derive) and interlacement take on a far greater

importance, from the point of view of perception, than even the simplest euclidean relationships.

It is similarly quite understandable how, being associated with the most rudimentary forms of action, especially one as crude as exploration at this passive and global level, these fundamental relationships have for a long time escaped the attention of geometry. For geometrical science began with the problem of measurement and only embarked on the study of these primitive notions comparatively late in its history.

§5. *Stage II. The progressive recognition of euclidean shapes*

We have just observed, apropos of Substage IB, that the first discriminations made by prehensile movement constitute the beginning of tactile-kinaesthetic activity. In spite of its global and undifferentiated character it nevertheless makes possible the abstraction of elementary topological shapes. During Stage II with the progress of this perceptual activity co-ordinating tactile centrations, which are retained as graphic and mental images, euclidean shapes come gradually to be recognized by haptic perception. Similarly, the ability to draw also shows signs of progress.

Though the child's exploration of the shapes remains basically global, at some point between Substages IB and IIA he comes to notice, more or less by chance, certain cues or pointers. By means of these he is able to discriminate between curved shapes and those with straight lines and angles, although he fails to distinguish the different sizes of the various shapes through not exploring them systematically. Drawing presents similar general features, but still lags slightly behind tactile recognition. This transitional phase can be placed somewhere between the ages of 4 and 4; 6 years:

Lou (4; 1) recognizes immediately the pencil, key and comb. He also recognizes without hesitation the surfaces with one or two holes, open and closed rings, etc.

He recognizes the circle and is able to draw it, likewise the ellipse (which is drawn slightly elongated). In the drawing of the square, one corner is more or less a right-angle, the others being shown as curved, but it is only recognized among the models on one of two occasions. Triangles, rhombuses, etc., are all lumped together. His reaction to the notched semi-circle is interesting: Lou draws a complete circle with points adorning the circumference.

Zil (4; 11). At the beginning of the experiment Zil's response may be described as midway between Substage IB and the present level, inasmuch as he cannot immediately distinguish the circle from the square. Both are drawn looking like triangles with curved sides, whilst he describes both shapes as '*houses*'. Later he makes the same kind of drawing of the triangle itself, but after having explored the shape of the rectangle he distinguishes rectilinear from curvilinear shapes. He draws the rectangle fairly accurately, with four near-rectilinear sides and four more or less right-angles. Next, the

ellipse is represented as a sort of quadrilateral with curved sides, but at the point where he finishes the drawing and connects the two ends there is a large black dot. "Why did you draw a black dot?—*It's to close it* (!)". The trapezium is drawn most interestingly; it is shown either as composed of three elements in juxtaposition, or as some kind of ellipse bisected internally by two intersecting straight lines.

This is a complex case, for conscious discrimination between curvilinear and rectilinear shapes was only beginning to appear in the course of the actual experiment, though inside these two categories the only successful recognitions were the rectangle and, to a lesser degree, the ellipse.

LAM (4; 10). In this case the method of guided movements (wood-engravings of figures) was used. He immediately recognizes the square and the circle and draws them correctly. Of the triangle Lam says: "*It's a roof*" and then draws it as an open angle. All the rectilinear shapes (rectangle, rhombus, cross, etc.) are likened to square and drawn as such, whilst the ellipse is called "*a small square*" but drawn as a circle.

LEO (4; 9). In the case of the square he makes a movement with both hands, partly surrounding it; then holds it still and says: "*It's round*", but he recognizes it among four shapes (including the circle). Next he explores the rhombus and says: "*I saw what it was. It was round.*—Like this? (circle)—*No*—Like this? (three shapes are pointed to, one after the other)—*Yes* (he points in turn to the square, rhombus and triangle)".

The circle: "*It's round*" (points correctly). The triangle: "*It's round, it's a roof*—Point to it (among four)—(points correctly). *I saw, I felt what it is; it's something that pricks*".

He is then shown (visually) a square and a circle: "*They are both round*— Are they both the same?—*No, not the same thing*—What are they like then? —*They are round. This one is like this* (points to another circle) *and this one is not the same*". He draws the circle fairly accurately, whilst the square is a sort of ellipse but showing signs of an effort to make the sides parallel.

The features of this intermediate level are thus well marked. First of all exploration is more active than in Stage I, the child being no longer content to grasp or simply feel the surface of an object without making any further movement.

He probes and explores it, though still in a global and haphazard fashion with no attempt at following the complete contour. But in this way he does happen on a number of cues or pointers, whose significance he is able to keep in mind.

As a result of this increase of perceptual activity, not only are the one or two topological relationships present in these experiments completely mastered, but we also see the beginnings of discrimination between rectilinear and curved shapes, the former being recognized by their angles. Lou demonstrates this discrimination in an extremely simple form, distinguishing the circle and ellipse from the rectilinear shapes but remaining unable to discriminate between the latter, while his drawings represent them all by means of a single prototype, a closed shape with

29

one right-angle. Zil distinguishes circle from ellipse but gets mixed up with the other kinds of shapes. Lam recognizes the circle, square and triangle but cannot go much further than this. Leo distinguishes clearly between the triangle and 'round shapes' but at the same time draws a distinction between circular 'round shapes' and other 'round shapes' which 'are not the same', i.e., the squares. In short, a general distinction is drawn between two major classes of shape, curvilinear or without angles, and rectilinear or with angles, though sub-divisions within the two classes are hardly noticed.

Although less well developed than the process of translating tactile-kinaesthetic into visual perceptions, drawing remains an invaluable guide to the nature of these global recognitions and explorations. The drawings now made certainly show an advance on those of the previous level, for scribbling is no longer met with as it occasionally was in Substage IB. Instead, one now comes across drawings which are quite obviously those of shapes, though they tend to look all very much alike. Only Lou was able to draw a square, but this was due to the grooves of the wood-engraving guiding his exploratory movements. For the rest, the squares were drawn simply as round shapes, more or less flattened to suggest the straight lines (Leo) or showing some attempt to reproduce angles (Lou, Zil). Zil was able to draw the rectangle and made an effort to analyse the trapezium, but left the other shapes looking very much alike. Lam reproduced the triangle as an open acute angle, though for the most part the drawings stress the topological element of closure, like Zil's remarkable ellipse containing a black dot "to close it". In short, drawing expresses the child's exploratory movements rather than his visual perception, even when he afterwards has the models before his eyes (cf. Leo).

The information gained firstly from tactile recognition, and secondly from drawing, brings to light a new element which is involved in the abstraction of shape. There is no doubt that it is the analysis of the angle which marks the transition from topological relationships to the perception of euclidean ones. It is not the straight line itself which the child contrasts with round shapes, but rather that conjunction of straight lines which go to form an angle. Now is not the discovery of the angle a typical case of abstraction direct from the object? As Volkelt[1] has shown, drawing and modelling often exhibit a multi-sensory character at this level, at once tactile, kinaesthetic, and visual, quite apart from haptic perception. And Leo's remark 'It's something that pricks' is a definition of the angle which illustrates Volkelt's thesis at the same time as it reveals the importance of 'feeling out' the object in constructing the first representational euclidean shapes.

[1] Volkelt, H., and Rabe, J., Einleitung zu Rabe: 'Umgang mit Körpern von verschiederen Form und Farbe in frühester', *Kindheit*, VII/4, 1938, München.

But this by no means disposes of the matter. To consider the angle as two intersecting straight lines (Lam's drawing), and especially to incorporate it in a closed figure, the child has to be able to reconstruct it, and this necessarily implies that abstraction comes from the action rather than direct from the object itself. In this respect the angle is the outcome of a pair of movements (of eye and hand) which conjoin. Without bringing in notions such as these which include the idea of straight lines the child can never get beyond the simple impression of 'something that pricks'. Admittedly, the object with its spatial, physical properties must play some part in the appreciation of shape. But these properties, owing to the prior construction of topological relations, are made part and parcel of a system of co-ordinated movements, of which drawing is the visible manifestation. This being the case, euclidean shapes, like the previous ones, are at least as much abstracted from particular actions as they are from the object to which the actions relate. Thus it is the co-ordination of the child's own actions which from the outset confers on these structures a geometrical character and not simply a physical one.

In the course of Substage IIA progress is visible in two fields. Exploration becomes more active, particularly in probing for significant clues, although it is not yet exhaustive or systematic. As a result we see a progressive differentiation of angular shapes but no overwhelming success in their recognition. Similarly, drawing shows an advance on the previous level, but still lags somewhat behind recognition. On the average this substage begins about the age of 4 years 6 months.

AST (3; 2, very precocious) recognizes the circle: "*a ball*"; the notched semi-circle: "*a rake*"; the rhombus (by sliding her thumb and index finger along two sides, starting from the middle so that they meet): "*a church*"; the triangle, cross and a four-pointed star. She fails with the ellipse (likened to a circle) and more complex shapes. But she recognized much more easily the irregular shapes involving only topological relations, such as the surfaces with holes and the open or closed rings. Of an open ring Ast immediately says: "*No, it wasn't that*" (closed ring) *because it was open*".

Although Ast succeeds in making these comparisons, quite remarkable for her age, her drawing of euclidean shapes still belongs to the earlier stage. Her shapes are curved so that the square is represented by an ellipse which is elongated to denote the rectangular sides.

ARM (4; 6) turns the square over very quickly, feeling it with his hands and fingers. Given the triangle he immediately feels for the angles. "Can you draw it?—*Yes, and the other one too*" (he draws a square standing on one corner, then an angle like a hillock, and finally a rhombus. The last two figures correspond to the triangle, the first to the square).

The other shapes are quickly identified (circle, plain and notched semi-circles, ellipses, curved triangle). There is some hesitation over the rhombus but he gradually identifies it by a process of elimination. The second drawing

31

of the square results in a circular figure which is immediately replaced by one with four corners.

ERI (4; 4). Circle: "*It's like a wheel*" (correct drawing). Ellipse: "*It's a cardboard egg*" (correct drawing). Triangle: he says immediately "*It's like a little cheese*" (i.e. triangular portion of processed cheese). Afterwards he explores its surface and contour (correct drawing). He hesitates over the rhombus and his attempt to draw it is unsuccessful, being an oval figure with an angle at each end. He fails to differentiate the cross and the star, and his drawing of the cross contains only three arms, the fourth being replaced by two dotted squares put next to the arms. The trapezium: "*It's almost like a little cheese* (triangle)". But Eri notices that it does not correspond to the visual models he is shown (it was deliberately left out) and does not identify it when questioned further.

The open and closed rings and the figures with one or two holes are indeed recognized but the latter are drawn badly, being represented by the triangle seen previously with the simple addition of one or two holes. The intertwined rings are immediately recognized and drawn as intersecting circles.

DRE (4; 7) recognizes the square, circle, semi-circles, ellipse, etc., but has some difficulty with the rhombus. He turns the triangle over several times with his fingers and draws it as a rectangle with one of the shorter sides extended to represent the point: "*It's an animal, like a trolleybus*".

VEI (4; 11) distinguishes the triangle from the square at once: "*Because it has this, and this*" (he makes two intersecting movements, both in a straight line). Given the star, he touches the points in turn but not the recesses in between, and thus hesitates in choosing between the correct model and that of a pentagon. "*I don't know what it is. I think it's that*—It could be that (hexagon)?—*Yes*—And that (circle)?—*No, because it's pointed*—And that (star)? —*Yes*". But he does not make up his mind. The cross: "*It's the star*—Try again—(he feels the angles in the recesses) *It's the cross*".

JEA (5; 0) begins by holding the circle motionless between the palms of his hands and draws a square. Then he explores it and recognizes it immediately. The triangle, ellipse, semi-circles, and cross are recognized and drawn correctly, but the rhombus causes difficulties and is drawn first as an open rectangle, and then as a closed rectangle surmounted by a pointed hat.

CHAR (5; 2) is successful with the simple shapes and is able to recognize the rhombus after a series of explorations: "*It's two roofs*". He then draws two opposed triangles on a common base. He confuses a curved triangle with the semi-circles.

HAS (5; 8 up to 5; 11) was the subject of repeated observations aimed at comparing the results of various techniques. From among the cardboard figures he recognizes the circle, ellipse, square and rectangle, and all the irregular shapes involving topological relationships, and is able to draw them all correctly. But he does not at first recognize the triangle and draws it as an incomplete cross with only three arms! Then he has another try and this time draws it with three angles and curved sides. The rhombus he first draws as a square, then as a rectangle with two little figures in the middle of the long side intermediate between a square and a triangle. He draws the Cross of Lorraine just like an ordinary cross but identifies it correctly.

After this, while still at the age of 5; 8, he is given the same shapes formed in relief by means of strips of plasticine stuck on a wooden board. This brings about a simplification of the child's movements which are then expressed exactly by the drawings. The square is drawn first as a right-angled triangle, then correctly. Conversely, the triangle is drawn first as a square, then correctly. The rectangle is drawn as an elliptical shape bisected by a straight line. The rhombus is shown first as a square with a triangle on top, to which is then added another triangle. The final drawing shows two triangles base to base. The cross produces drawings of unco-ordinated right-angles. A further rhombus is represented by a square bisected diagonally, and then by a square standing on one corner.

At the age of 5; 11 Has is given the same models, this time engraved on wood, his movements thus being guided by the grooves. The square and the triangle are now drawn correctly straightaway. The cross is drawn first as a right-angle and subsequently as a double right-angle, thus giving it three arms. The rectangle is drawn correctly whilst the rhombus once more appears as a square.

For a proper understanding of these results one really needs to appreciate in advance the remarkable similarity between these drawings obtained by means of tactile exploration, and those based on ordinary visual perception which we shall analyse in Chapter II. This said, it may be observed that although drawing still trails in the rear of visual recognition, i.e. behind tactile-kinaesthetic perceptions expressed in visual terms, it nevertheless follows it pretty closely (apart from the exceptional case of Ast who is very advanced for her age, both as regards recognition and drawing) and progresses through exactly the same stages. This phenomenon of parallelism accompanied by a slight time lag would seem to throw light both on the problem of the formation of the image through perceptual activity, and on that of the 'abstraction' of shape.

In the case of the representational image (to which we shall return at Chapter II in connection with drawing proper), it is clear that the drawings described above express not so much the model visually or tactilely perceived, as perceptual activity itself. In other words the drawing, like the mental image, is not simply an extension of ordinary perception, but is rather the combination of the movements, anticipations, reconstructions, comparisons, and so on, that accompany perception and which we have called perceptual activity. This is already well known in connection with the spontaneous drawings studied by Luquet[1] at the stage of 'unsuccessful realism' and 'intellectual realism'. Like a mental image, a drawing is an internal or external imitation of the object and not just a perceptual 'photograph', whilst by its very nature imitation has the effect of prolonging the muscular accommodation or adaptation involved in perceptual activity. This explains the affinity between the

[1] Luquet, *Le Dessin Enfantin*, Paris, 1927.

adaptive movements involved in the children's tactile-kinaesthetic exploration and their drawings (the time lag between the two may be explained by the technique required). In this connection the case of Has is particularly striking. Every one of his drawings is in some respect a direct continuation of his exploratory movements, modified by the different techniques employed.

In the case of 'abstraction' it is worth noticing how the child, even at this relatively advanced level of shape discrimination, extracts from the object only that which he is able, not merely to reconstruct in imagination, but actually to construct through his own actions. The object is acted upon, and it is from this action that its shape is extracted. In the case of simple shapes, such as squares, rectangles, circles, etc., the actions consist in the grouping together of identities (such as equality of sides of the square, of the opposite sides of the rectangle, of the radii of the circles, right-angles, etc.). In these simple cases, however, the reconstruction results in the object being imitated to such a degree that it produces the illusion of a representation abstracted directly from the object. On the other hand, in the more complex figures the element of construction is directly visible.

The most suggestive example is that of the rhombus, because of the dual difficulties in recognition and drawing which it occasions. From the perceptual point of view the rhombus would seem a relatively 'good' shape, because it is doubly symmetrical. But it is not its symmetry along the two axes which strikes the child. In this respect the rhombus is a good example of the kind of difficulty symmetry sometimes causes, due to its reversal of the relationship of order. The child first draws it as either a square or a rectangle, but adorned with a point or triangle (or with a wire, as in Dre's "trolleybus"), or flanked by two appendages halfway up the sides to represent the obtuse angles (Has), or else as a square bisected diagonally, or a rectangle left open (probably to indicate the slope of the sides), and finally as two triangles facing in opposite directions but having a common base (which is in fact correct).

Now these extraordinary constructions are by no means results peculiar to tactile-kinaesthetic exploration alone. For, as we shall see in Chapter II, exactly the same results are obtained when the rhombus is drawn from the visual model. The example of the rhombus (or Has's triangle and the like) shows to what extent the abstraction of shapes really implies their assimilation to the child's constructional schemata, before the adaptation of these schemata becomes flexible enough to allow for the correct imitation of the external model.

In the course of Substage IIB analysis becomes well-nigh complete. Thus, for example, the child is no longer content merely to locate the extremities of the arms of a cross or a star, but goes on to explore the recesses, and notices whether they are right-angled or acute. Neverthe-

less although capable of being carried to completion, this analysis remains empirical, so that in the case of complex shapes it fails to achieve a synthesis based on reasoning with which to co-ordinate the perceptual data. Only towards the age of 7 does the development of the operation proper enable deductive reasoning to direct exploration. Here are a few examples from Substage IIB:

MAR (5; 2) explores the rhombus and says of each side in turn: "*It's leaning, it's leaning, it's leaning, and this is leaning too*". He refuses to try drawing it but identifies it correctly among the visual models, and later draws it successfully.

MAY (5; 6) recognizes the simple shapes and draws them correctly, including the cross (after exploring the two arms). In the case of the Cross of Lorraine he follows the angles and draws it correctly except that the two parallel arms are made equal in length. With the rhombus he explores the two obtuse angles and one of the points. His drawing has three obtuse angles and one acute angle, and is thus asymmetrical along one axis. The swastika, however, after he has explored its right-angles, finishes up as a drawing consisting of a long vertical axis with three transverse lines all ending in a short line joined on at right-angles.

MYR (5; 6) recognizes the crosses and a four-pointed and six-pointed star. But she is unable to draw the latter figures correctly as she fails to return to the base of each point. The result is that she draws the stars like emblems of the sun, i.e. circles surrounded by an indefinite number of points.

WAG (5; 6) is successful with the rhombus (correct drawing), the ordinary cross and the Cross of Lorraine, but draws the trapezium with one corner surmounted by a point.

NAT (6; 1) recognizes and is able to draw simple shapes such as the rhombus, the ordinary cross, the trapezium and a four-pointed star: "*It's a star because its pointed; a cross is square.*" But the swastika is drawn as a staircase, with four steps arranged symmetrically on each side.

ULR (6; 11) turns the cardboard figures round in a clockwise direction: "*I've got the hang of it; I turn them like this and feel them*". The rhombus: "*It's almost like an egg, but it's pointed*". He draws it with four angles, each pair symmetrical, but makes the sides slightly convex. He is successful with the trapezium. Given a half-swastika he can neither draw nor identify it among a few models.

These few examples should be sufficient to show what a complete exploration amounts to so long as it lacks operational guidance. The child explores everything but keeps moving ahead all the time (*vide* Ulr's explanation of his method), never returning systematically to obtain a stable point of reference. In this way he succeeds in reconstructing the rhombus by a sort of 'closure' of the four "leaning" sides of which Mar speaks. The trapezium presents greater difficulties because its sloping sides are farther apart (cf. Wag, who runs two sides together). But attempts at the swastika end in complete failure because the child is

unable to relate the arms bent at right-angles, either with one another or with a common centre. Some subjects (Myr) are not even able to cope with the star, and for the same reason. The responses obtained in Stage III, to which we now come, show how this process of development is completed through the reversible co-ordination of the exploratory procedures.

§6. *Stage III. Operational co-ordination*

An operation may be defined as an action which can return to its starting point, and which can be integrated with other actions also possessing this feature of reversibility.

Now even within the limited sphere of simple actions typified by tactile-kinaesthetic exploration, it is interesting to notice that as drawing or representation grows more exact so it begins to react upon the process of perceptual activity from which it first arose. As a result, perceptual activity becomes increasingly complex until by the age of seven or eight reversible co-ordination is achieved, though naturally, only in a very rudimentary form. Nevertheless, our experiments show that prior to this, reversible co-ordination cannot be achieved at all. At this level it takes the form of a systematic return to the point of departure in such a way as to group all the parts of a figure around one or more stable points of reference. The swastika (of whose notorious symbolic associations the children seemed quite unaware) constituted a particularly good demonstration of this point, because with such a figure it is essential to return to the starting point of exploration in order to co-ordinate the parts correctly.

JAN (7; 4) recognizes and draws all the simple shapes right away. Swastika; he touches each arm in turn, exploring the right-angles in between the straight sections, returning each time to the centre where the four arms meet. "*I don't know what it is. A starfish?*" He then draws it from memory with each arm bent the right way, but does not manage to line up the four arms correctly.

Tus (7; 9) draws crosses, half-crosses, etc., correctly. Six-pointed star; explores the six arms, returning systematically to the centre to co-ordinate them. He draws it correctly, checking each arm in turn by going back to the central reference point.

Swastika; "*I don't know what it is.* (same method of exploration). *It has bends but I've already forgotten what they're like.* (First draws a horizontal line with pieces at each end placed at right-angles, then makes another exploration.) *No, that's wrong. I felt it; it's the same all the time.* (He begins a fresh drawing which bit by bit approaches an accurate copy, except that one of the end pieces faces the wrong way.)" He is then shown a collection of models and recognizes all the figures. He points to the swastika and laughs: "*So that was it!*"

RAST (8; 2) is successful with all the simple shapes. Right-angled trapezoid; first draws it as symmetrical and then draws it accurately. Swastika; draws

first an ordinary cross, which he noticed as a feature of the shape, before bothering about the bent sections. He then adds these at right-angles and all facing the same way.

JAC (8; 2) used models made from match-sticks stuck on cardboard. He succeeds in drawing a swastika with arms pointed clockwise after exploring each arm and returning to the centre. Is then shown one with the arms pointing anti-clockwise: "*Same as before but it's the opposite*". The drawing is reversed correctly. Is finally given a half-swastika: "*I can't say what it is but I can draw it*" (drawing accurate). A similar but more complex shape is also drawn by means of returning systematically to the points of reference.

The difference between these reactions and those of the previous level is obvious. The exploration is of course carried out by means of the same type of perceptual activity as at earlier stages. But this activity, instead of depending solely upon its own initial resources, is from now on directed by an operational method which consists of grouping the elements perceived in terms of a general plan, and starting from a fixed point of reference to which the child can always return. Now this reversible co-ordination is nothing more nor less than the form of equilibrium reached by the movements of exploration and imitative adaptation once they are related in such a way that every element explored is at the same time distinct, yet connected with all the rest in a single coherent whole. In the preceding stage these movements merely succeeded one another, earlier members of the series being obliterated by subsequent ones. At its present level therefore, the construction of shape is clearly quite separate from its perception and from its imitative or pictorial representation. It may be regarded as preceding both of these functions by a prior assembly of their data according to an anticipatory schema, which embodies the various possibilities of grouping afforded by different features, such as straight or curved lines, angles, parallels, order, and equal or unequal lengths. In other words, every perceived shape is assimilated to the schema of the actions required to construct it. This is why the pictorial image so accurately reflects the constructional process, in the same way as perceptual activity is governed by the operations.

§7. Conclusions

The main outcome of this brief enquiry is the demonstration of the contradiction, and at the same time, the continuity between perceived and imagined shapes. It is one thing to perceive a circle or a square and quite another to reconstruct a visual image of it to the point where it can be picked out from a group of models, or draw it after a purely tactile exploration. In the case of visual perception, shapes are recognized through an almost instantaneous structurization. This process may not coincide with the very earliest visual perception but almost certainly

takes place during the second of the three stages distinguished in §1., that is, at an age of about 3–5 months. As against this, the visual image of such shapes presupposes a mental representation, conjured up while the object is out of sight. This necessitates the intervention of more complex functions of a kind which hardly come into play before the latter half of the second year. Thus the image is not a direct outcome of perception.

The construction of space begins on the perceptual level and continues on the representational one. A study of the transition from one level to the other is therefore an essential preliminary to the examination of spatial intuition on the representational level. Detailed analysis of the process termed haptic perception has so far enabled us (1) to verify the way perception actually works, by using tactile perceptions as pointers to the origins of processes involved in recognition, (2) to observe how the child sets about translating these tactile perceptions into drawings or mental images, and (3) to introduce the study of how shape is abstracted.

1. As regards the first point, the study of the child's method of exploring the object was extremely relevant to the distinction which was drawn between perception, and perceptual or sensori-motor activity. Being unable to take in the whole shape with a single tactile 'centration' the child is compelled to move its hands or the object itself, producing a series of centrations. The perceptual recognition of the shape is consequently a result of the co-ordination of these centrations. Thus it becomes apparent that two separate processes are involved. (a) Perception itself, which is purely receptive (which does not mean entirely passive) and results from each individual centration of the child's hand on the object, or at least some part of it. And (b) sensori-motor or perceptual activity which consists at one and the same time of decentration, or changing the centrations, and of 'transporting' the results of one centration to another. (Or it may consist of 'comparisons'—reciprocal transportation, 'transpositions'—transportation of relationships, and so on). Perceptual activity therefore amounts to the inter-co-ordination of centrations of actual perceptions.

Let us first of all note that this constant conjunction of perception and perceptual or sensori-motor activity enables us to corroborate what was stated in §2. as regards the reciprocal relations existing between perception and movement. When the hand is centred on some part of an object, such as one of the angles of the cardboard triangle, it is obvious that the perception of this part of the surface, closed towards the point and open in the other direction, will automatically bring about a movement in the open direction, towards other parts of the triangle. This is an example of the kind of process so well described by the Gestalt school. Perception in a state of disequilibrium (since the angle

is open only in one direction) occasions a movement corresponding to the neural flow arising from the difference in potential between the stimulated region and that not yet stimulated. But this same movement which will culminate in the exploration of the remaining angles of the triangle, itself reacts on the subsequent perception, since it 'transports' the data of the previous perception and on discovering a second angle will 'transpose' the earlier relationship on to the later ones. Thus the movement co-ordinates successive perceptions and constitutes the sum total of transformations ensuring the transition from one perception to another.

From this standpoint there can be no perception which is not incorporated in a complex of sensori-motor activity. A perception linked to a particular centration is only a kind of snapshot or 'still', cut off from the dynamic flow of perceptual activity which reacts constantly upon the perceptions on which it is based and which it links together.

We may also note that this interpretation, which appears self-evident in the case of tactile perception and the exploratory movements which constitute the corresponding perceptual activity, is also valid for the same reason in the case of visual perception. The only difference between the two cases is that a visual centration can take in more elements simultaneously than a tactile centration. Thus with simple shapes like the triangle and the circle, vision can apprehend all the elements and their relationships with its first centration. But when the shapes are more complex, the eye, like the hand, is forced to explore[1] with the result that perceptual or sensori-motor activity occurs, co-ordinating the centrations in exactly the same way as for the tactile mode, and with the same reciprocal influences between perceptual and motor elements. Indeed, it is very probable that a neonate's reactions to extremely simple shapes is similar to an older child's reactions to more complex shapes. Due to the lack of sufficient perceptual activity the child will probably fail to perceive immediately that a square has equal sides and equal angles. For at first these equalities are most likely only perceived as a result of the interplay of 'transpositions within the shape'. At a later stage these may become instantaneous and merely virtual, but at the outset they are more difficult to take into account.

In addition we have found that, unlike the perceptual mechanisms, which are probably fairly constant, perceptual or sensori-motor activity develops noticeably with age. During Stage I (up to 4 years) the child remains almost passive when confronted with the objects he has to identify. He grasps them, usually in both hands, feels them, turns them round and contents himself with the first haphazard centrations. There is no decentration so that he does not really explore them at all. During

[1] Cf. P. A. Osterrieth, 'Le test de copie d'une figure complexe', *Arch. de Psychol.*, Vol. XXX, 205.

Stage II (4–7 years) perceptual activity becomes apparent, as was noted in connection with the tactile-kinaesthetic experiments. At first the child confines himself to global exploration, especially to taking hold of an object by two extremities and thereby establishing some general relationship between them. At a later stage analysis of specific features (angles, etc.), though as yet incomplete, could be observed. Later on analyses appeared complete with transpositions, anticipations, etc., though still without any methodical kind of synthesis. Similarly, during Stage II exploration remains unmethodical, starting without any preconceived hypothesis and concluding with a review, complete though hesitant and only in one direction, of all the most striking features of the object. An example of this type of exploration is the action of turning the object over and over in one direction. At this stage also occurs the transition from movements made against the palm of the hand to the exploration of the whole contour with one finger. Finally, at the level of genuine operations Stage III (7–8 years) one finds systematic exploration and a constant return to the point of departure, which is now used as a point of reference.

This does not, of course, prove that the same age levels apply to the evolution of other types of perceptual activity, especially visual activity (with the probable exception of Stage III). However, in the course of this work we shall find evidence of a similar course of development, though over varying periods of time, in the realm of visual activity.

2. We now come to the question of the image, or the transition from perception to mental representation. In the present experiments this process is accompanied by the translation of tactile into visual data. It occurs when the child attempts to derive either a mental image or a drawing involving vision and movement, from tactile perceptions governed by perceptual activity of a tactile-kinaesthetic order.

Although the image cannot be considered as deriving from the purely receptive aspect of perception, for the simple reason that it is a representational symbol evolved along with the thought relationships which perception points to as the 'meaning', one can certainly discover in the make-up of the image a motor element which is an extension of perceptual activity as distinct from perception itself.

As we have tried to show elsewhere,[1] considered from the point of view of its origin, the image is a product of imitation. It is in fact, an internalized imitation, one that can be made without resort to external gestures, though it is at first associated with such gestures, as in the ludic image or deferred imitation. But imitation is basically a continuation of the adaptive movements characteristic of actions, and this begins at the neonate level of sensori-motor activity. Imitation (and consequently the image as well) is, to use a metaphor, the 'positive'

[1] *The Origin of Intelligence in the Child*, 1953. (See p. 74ff.)

corresponding to the 'negative' of adaptation, i.e., to the modifications which the schemata of an action undergo through the influence of the object on which the action is directed. This is why, after having been involved in the origin of imitation during the first two years of life, sensori-motor activity remains the actual source of the image in co-ordinating simple perceptions, even when imitation becomes internalized.

As far as the processes analysed in this chapter are concerned, the connections between image and movement seem quite clear. On the one hand there is the remarkably close correlation between the way the child explores the models he is given and his ability to draw them. On the other hand, the skill he shows in the drawings roughly corresponds with his ability to recognize a shape by selecting it from a collection of visible models, though with simple recognition running ahead of drawing.

Thus the whole trend of events appears to suggest that the power to imagine the shapes visually when they are perceived through the sense of touch alone, is an expression of the sensori-motor schema involved in their perception. It is, to repeat the metaphor, as if the drawing constituted a 'positive' corresponding to the 'negative' produced by the accommodation or adaptation concerned in perceptual exploration.

If the recognition of the visual models had been greatly in advance of the capacity to draw them one might well have entertained the alternative hypothesis, namely, that images derived from perceptual activity were copious enough to direct tactile exploration. It is true that this does happen, though only to a limited extent, for as a rule it is the movements occurring in tactile exploration which control the visual image itself, as is the case with drawing.

Naturally, these findings must not be taken to imply that any and every visual image must invariably be influenced by movements associated with tactile or other than purely visual perception. One can easily conceive of purely visual images whose construction is governed solely by movements belonging to visual sensori-motor activity (eye movements, etc.). But as we shall see time and again in these experiments, it is not these kinds of image—if they exist in this pure form at all—which constitute the essence of spatial notions.

The visual image of a plane figure, a tri-dimensional shape seen in perspective, a projection, a section, a plane rotation, etc., or even the image of an elementary topological shape (a knot, etc.), involves, when it is at all accurate, many more movements on the part of the subject than is generally realized. It is really an image of a potential action relative to these shapes rather than a purely visual intuition, and the recognition of this fact is, as we shall see, vital to our interpretation of the process involved in abstraction of shape.

Even in the case of everyday images, is it at all possible to imagine a

landscape, a house, or other familiar object without the aid, as essential components, of the schema of the various roads traversed, the actions performed, or the changes of position commanding different perspectives? And this assistance is made even more necessary by the fact that such images are nearly always multi-sensorial and refer to complex actions.

In short, the motor activity already employed in perceptual activity, and consequently involved in the construction of perceptual space, is again found as an essential component in the creation of representational images, and consequently in the representation of spatial notions. In this way one can understand why there should be both continuity of perceptual and representational space, and at the same time, a gap separating the two types of structure. This gap is of such a nature that although representational space benefits from and has its imagery enriched by forms already developed by perception, it has nevertheless to reconstruct on its own plane, and in the same order of succession, the elementary spatial relationships, first topological then euclidean and projective.

This brings us to the problem of shape abstraction. Before being able to discuss it intelligently we must draw a further conclusion from what has been seen of the part played by motor activity in the construction of images, and its relation to sense data.

With the image, as with perception, it is the sense data which 'signifies', while the movements and their organization (in the form of comparative sensori-motor schemata) constitute the basis of the 'signified' relationships themselves. In the case of perception the static sense-contents are momentary pointers to various relationships, some real and others virtual. But at this level, signifying and signified are not clearly differentiated, for the former are no more than pointers, or aspects of the total situation.

On the other hand, at the representational level, signifying and signified are clearly distinguished, and it is precisely this distinction which marks off representational thought from perception. Beyond this point, sense data influenced by movement become symbolic and acquire the properties of a 'free' pointer. It is now the image itself, to the extent that it exists as a fact of consciousness, as against the motor activity which helped bring it into being. As for the motor activity whose innervation has thus been translated into images, its comparative or assimilatory function remains the actual source of the representational relationships which the image symbolizes, and it is to this aspect of the matter we now turn.

3. Are the geometrical 'shapes' involved in these experiments 'abstracted' from the object by perception and imagination, or are they 'abstracted' from the actions or movements made in the course of

perception? In other words, from the co-ordinated movements required to construct a representational image. Our findings with regard to the part played by movement helps to clarify what we have already learnt from the study of our experimental data. We may now go so far as to say that in each of the three stages yet covered, the children are able to recognize, and especially to represent, only those shapes which they can actually reconstruct through their own actions. Hence, the 'abstraction' of shape is achieved on the basis of co-ordination of the child's actions and not, or at least not entirely, from the object direct.

Thus during Stage I the only shapes which are recognized and drawn are closed, rounded shapes and those based on simple topological relations such as open-ness or closure, proximity and separation, surrounding, etc. We have already seen that these relations express in essence the simplest possible co-ordinations of actions, like following a contour step by step, surrounding, separating, and so on.

With Stage II we encounter the beginning of recognition of euclidean shapes, based on the distinction between straight and curved lines, angles of different sizes, parallels, and especially on relations between equal or unequal sides of a figure. Now it is obvious that representation, even more than perception, can only 'abstract' the idea of such a relation as equality on the basis of an action of equalization, the idea of a straight line from the action of following by hand or eye without changing direction, and the idea of an angle from two intersecting movements.

This is why the simple euclidean shapes correspond to concepts easily brought to mind, because they result from the most elementary types of co-ordination (except for the topological relations which precede them in simplicity), as against what a purely perceptual interpretation of shape, like the Gestalt theory, would have us believe. Lastly, at Stage III the connection between shapes and co-ordinated actions becomes clearly apparent in that the return to a fixed point of reference which is necessary to their conceptualization is equally necessary to their recognition and representation. This topic of shape abstraction, however, is far from being exhausted by these few introductory remarks and we shall encounter it over and over again, beginning with the abstraction of visual structures in the drawing itself.

Chapter Two

THE TREATMENT OF ELEMENTARY
SPATIAL RELATIONSHIPS IN DRAWING.
'PICTORIAL SPACE'[1]

IN the first part of the preceding chapter we tried to show that perceptual space is organized in three successive stages. The first of these is based on topological, the second on metric and projective, the third on overall relationships bearing upon displacement of objects relative to one another.

We next endeavoured to show that the transition from perception to mental representation—in other words, to notions which are no longer perceptual but imaginal—implied reconstruction of the relationships already grasped at the perceptual level, with functional continuity preserved between the new construction and the earlier perceptual one. For both constructions employ sense-data by way of signs (perceptual pointers, or symbolic images of a pictorial nature) and both make use of movement and sensori-motor assimilation in the actual construction of the relationships to which they refer, i.e. to the 'shapes' themselves.

Indeed, we have gone further in showing that at both levels the constructional process follows the same order of succession. It begins with topological relationships and only later arrives at euclidean ones, with an interval of months or years between visual perception and mental representation based on haptic perception.

Now this sequence of events is in no way inevitable. In fact, so little does it correspond with generally accepted views with regard to representation of space that, so far as we know, it has never before been recognized. For this sequence could just as easily have been reversed. Perception having by degrees arrived at the level of ·projective and metric relationships (constancy of size and shape) and overall relationships (dimensions co-ordinated in terms of objective displacements), representational space might then have begun with general euclidean co-ordination, passing to the development of projective relationships (perspective) and arriving at the abstraction of simple topological relationships last of all. There would be no inherent absurdity in imagining representational space developing in the reverse order to perceptual space, for this is the course followed by the historical development of formal geometry. The elements of Euclid dealt only with metric geometry

[1] In collaboration with M. A. Morf and Mlle. B. Demetriades.

44

and similarities, projective geometry did not arise until the seventeenth-century (Desargues), eighteenth-century (Monge) and nineteenth-century (Poncelet), while Analysis Situs or Topology is an entirely modern development.

It could thus have been the case that mental representation develops in the reverse order from actual perception, following instead the path traced out by formal analysis. This is the sequence usually accepted; at least, when the intellectual is distinguished from the genetic order, and not confused after the manner of elementary text-book authors who start out by treating distances and simple euclidean figures as if they constituted real 'elements' in the construction of space.

It is therefore essential to find out whether, after some years interval, the reconstruction of conceptual space really does pass through the same phases as does construction of perceptual space. In particular, we must verify whether it is actually the case that the reconstruction of topological relations at the level of mental imagery comes first, followed by the refashioning of metric and projective concepts, with construction of overall systems of co-ordinates and co-ordinated perspectives coming last of all.

Now such a verification is extremely difficult to carry through, and for a reason which, incidentally, explains why this alternative explanation has been so neglected. It is obvious that once the child can picture things to himself, he has at his disposal the achievements of perceptual activity and sensori-motor intelligence. In terms of perception he knows what distance is, what constitutes a straight line or a perspective or a metric figure such as a square. Nevertheless, he is unable as yet to translate these entities into thought or imagination the moment his efforts to do so are no longer supplemented by direct perception. Consequently, if in drawing or visualizing objects he can only avail himself of topological notions, then he will use them to supplement his existing projective or euclidean perceptions, and it is this circumstance which tends to lead the untrained observer astray. In order to reconstruct the true formative order of conceptual space, it is essential not only to separate perception from representation, but within the realm of the latter to separate the element of imagery from the relationships actually grasped and applied.

For this reason it has seemed advantageous to continue with the problem begun in Chapter I, and to investigate the elementary relationships operative in representational space through the study of children's drawings, or more accurately, the study of their 'pictorial space'. With haptic perception we have already seen that children's drawings confirmed the view that topological relations are grasped prior to euclidean shapes. But in the first place, projective relations played no part in those experiments; and in the second place, the drawings were

based on a tactile rather than visual perception. The problem we now have to investigate poses this question afresh in the case of ordinary drawing, whether spontaneously produced by the aid of visual memory, or by copying visible models.

We are well aware of the objections which have been levelled at the use of drawing as an index to the development of spatial representation. Stern,[1] Decroly,[2] and many others have shown that the structure of a drawing, as regards the third dimension for example, is not entirely a translation of image representation.[3] As a matter of fact it is quite clear that on the basis of a given technique the drawing will be found to lag behind image representation to an even greater extent when it deals with complex wholes that are more difficult to organize. Admittedly, to study the development of the child's idea of space on the basis of drawing alone would be an extremely hazardous venture. But assuming that this type of analysis is checked by other methods, and especially if one restricts oneself to the general features of drawings based on simple everyday shapes, there can be no doubt that drawing does constitute a certain type of representation. 'Pictorial space' is one of the types of representational space and Brunschvicg[4] went so far as to account for the origin of geometry on the basis of the technique of drawing. It is from this standpoint that we intend to summarize briefly what can be said as regards space in spontaneous drawing, and in the copying of simple shapes by children.

SECTION I—SPACE IN SPONTANEOUS DRAWINGS

The three principal stages characteristic of children's drawing once the level of mere scribbling is left behind are quite well known, and have been termed by Luquet,[5] (1) synthetic incapacity, (2) intellectual realism, and (3) visual realism. It is these three stages of development that we shall endeavour to examine from the point of view of spatial representation.

§1. *Stage I. 'Synthetic Incapacity'*

In his work, Luquet (op. cit., p. 154, Fig. 85) cites the example of a boy aged 3; 6 who draws a man in the shape of a large head to which are appended four strokes, two representing the arms and two the legs, as well as a small trunk separate from the limbs. The head contains two

[1] Stern, W., Troisième Congrès Allemand de Psychologie Expèrimentale, Frankfurt, 1908. In *Arch. de Psychol.*, 7, 1907–8.

[2] Decroly, O., *La Psychologie du Dessin. Société belge de neurol.*, 1912.
Decroly, O., 'l'Étude du petit Enfant par l'Observation et l'Expérimentation', *Documents Pédotechniques*, No. 2, p. 127, Brussels, 1929.

[3] Cf. Pouillard, G., 'Essai Psychogénétique sur la perception de la troisième dimension dans l'espace', *Journal de Psychologie*, 31, 88–151, 1934.

[4] L. Brunschvicg, *Les Etapes de la Philosophie Mathématique*, 2nd ed., 1922, pp. 500–3.

[5] Luquet, *Le Dessin Enfantin*, p. 154, 1927.

eyes, a nose and a mouth, but the latter is placed above the former. What is the meaning of such a drawing, which is quite typical of 'synthetic incapacity', when one tries to interpret it in terms of the spatial representation of a 3–4 year old child?

Obviously it cannot teach us anything about the child's perception as such, for when looking at the object the child sees the arms and legs attached to the trunk and not to the head, the mouth below the nose rather than above it. Why then does the drawing fail to correspond with the perception? In answering this question Luquet seizes on those factors which naturally spring first to mind, such as the clumsiness of the movements which are unable to carry out the child's intentions, and the limited and sporadic nature of his attention. But is this really all? Does not a lack of attention often betray an absence of some function (representation, etc.), whose momentary centration is betokened by the specific type of attention in question?

A drawing is a representation, which means that it implies the construction of an image, which is something altogether different from perception itself, and there is no evidence that the spatial relationships of which this image is composed are on the same plane as those revealed by the corresponding perception. A child may see the nose above the mouth, but when he tries to conjure up these elements and is no longer really perceiving them, he is liable to reverse their order, not simply from want of skill in drawing or lack of attention, but also and more precisely, from the inadequacy of the instruments of spatial representation which are required to reconstruct the order along the vertical axis. Possibly the drawing is sometimes more complex than the purely internal visual image, but it may well be that this is not always the case. Luquet himself mentions a little girl, also 3; 6, who represents a house by a kind of triangle, but who explains that she was trying after another shape and describes four movements representing the sides of the rectangle which she was attempting to draw. In this case we do indeed have a gap between image and drawing, though one may well ask oneself whether the internal image really took in the parallelism between the sides, the right-angles and so on, or whether it also was merely a vague sketch. It is well known that small children have the greatest difficulty in achieving parallelity when placing a number of straight sticks in alignment,[1] and if one also recalls to mind the children of 3; 6 mentioned in Chapter I, who could not distinguish circles from triangles and squares by tactile perception, it seems very likely that drawings such as these exhibit more than mere clumsiness in technique.

In order to decide this question one has only to compare the main features of the drawing with the results of experiments dealing with

[1] See Wursten, H., 'L'évolution des comparaisons de longueurs de l'enfant à l'adulte', *Arch. de Psychol.*, Vol. XXXII (See V, A, §1–4).

the same relationships which will be discussed in subsequent chapters. From this last remark one might conclude that from the drawings by themselves we can learn nothing. On the contrary, they enable us to establish the spontaneous character of the structures inherent to representation, which can only later be submitted to detailed analysis by means of more or less artificial experiments. It is entirely from this point of view therefore that we intend to study the problem, and the development of drawing will provide a framework which we can fill in afterward by means of more detailed analysis.

In this context, and confining ourselves to formulations which can be checked by techniques other than the study of drawing, the stage of synthetic incapacity is of special interest since it is a representation of space which neglects euclidean relationships (proportions and distances) and projective relationships (perspectives with projections and sections) and which has hardly begun constructing topological relationships, and even these only where the simplest shapes are involved. Let us therefore examine these latter relationships in order.

1. As regards 'proximity', which is undoubtedly the most elementary spatial relationship, it obviously plays a part in every drawing that goes beyond mere scribbling. For example, in the construction of a face the various parts are drawn near to each other and not dispersed to the four corners of the sheet of paper. But in a complex figure, such as the representation of a man, whilst proximity is taken into account in a general way it is not adhered to in detail. Attaching the arms and the legs to the head whilst drawing the trunk separately is a good example of this. Luquet mentions several other cases: fingers attached to arms, the tail of a dog joined to the front of its head, and so on.

2. The relationship of 'separation' must obviously be brought in, to the extent that the elements which are drawn are distinguished from each other. But already with the simple geometrical shapes, which we shall study in Section III, we shall notice the difficulty the children have in 'separating' those elements they represent in a global fashion. And this is all the more true for complex shapes.

3. It is therefore natural that the relationship of order (which, as we shall see, constitutes the synthesis of proximity and separation) should only begin at this level, and at the most only for pairs of terms whose relative position has to be determined. So soon as combinations of several terms are involved they cease to be co-ordinated, a fact which is expressed by the 'synthetic incapacity' of the drawing. As instances, one may cite the reversal of left to right relationships (the tail on the side of the head in a profile picture of a dog), or reversal of upper and lower (mouth, eyes and nose inverted), or reversal of back and front. This shortcoming in preserving the order between different elements corresponds to a phenomenon we shall have occasion to check specifically

in Chapter III; namely, that before the age of four a series of multi-coloured beads is reproduced, not in its original order, but simply as isolated elements.

4. The relationships of surrounding or enclosure are the ones most clearly indicated in the case of simple shapes (we shall see an example in Section II, in the case of small circles put inside, outside or on the contour of closed curved figures), but errors frequently arise when complex shapes are involved. Thus eyes are put outside the face, buttons to one side of the head or the body (at 3; 6 and 4; 6: cf. Luquet, op. cit., p. 158, Fig. 91), the roof projecting into a house instead of outside it (*ibid.*, p. 162, Fig. 95), etc. We shall also notice the difficulties caused, at the same age, by enclosure in connection with knots (Chapter IV).

5. Lastly, although the elements of continuity and discontinuity are visible in broad outline, in complex shapes they remain at this stage very different from what they ultimately become. In fact, one of the principal features of synthetic incapacity is that parts of figures are simply juxtaposed instead of being continuously linked together. Thus a rider remains suspended above his horse, a hat above a head, etc.

Briefly, if each of the most primitive topological relationships begin to be defined as soon as drawing of shapes really begins to appear, they nevertheless fail to be generalized when applied to complex structures. And these are just the structures children are most likely to produce in their spontaneous drawings; little men, animals, houses, etc. It can therefore be understood that at this stage pictorial space is necessarily lacking in euclidean relationships of distance, proportions, and particularly in general axes in terms of three dimensions, as well as perspective relations, etc. But this predominance of topological features over all others, together with the failure to master these relationships themselves, is it really evidence of a law of pictorial space, similar to what we thought ourselves able to perceive (Chapter I, Section I) in the development of perception? Or is it to be ascribed merely to technical ineptitude of a motor character? We shall find, during the study of the next stage of development, that it is the first of these two hypotheses which is confirmed, though of course without altogether excluding the part played by the latter factors.

§2. *Stage II. 'Intellectual Realism'*

We saw in Chapter I, through the experiments on haptic perception of shapes, that progress in exploration is followed very closely by pictorial synthesis. Here once again, as soon as the child becomes capable of such a synthesis he concentrates for a considerable period on one particular type of drawing, which has been described by all authorities and which Luquet analysed extremely accurately. We refer of course to 'intellectual realism' which consists in drawing not what the child

E 49

actually sees of the object (this would be visual realism based on perspective) but "everything 'that is there' " (Luquet, op. cit., p. 224). Consequently, there can be no question of ascribing the features of pictorial spatial representation apparent at this level to want of technical skill or lack of attention. On the contrary, we have here a schema that is in part deliberate and undoubtedly systematic and lasting. What then is its geometrical or spatial significance?

Without exaggerating their powers in any way, or crediting the children at this second level with any real geometry which they could formulate or develop, it is nevertheless possible to see that 'intellectual realism' constitutes a type of spatial representation in which euclidean and projective relationships are just beginning to emerge, though as yet in an inchoate form as regards their interconnections. But the topological relationships only sketched in at the previous stage are now universally applied to all shapes, and in the case of conflict prove stronger than more recently acquired ones.

Elementary topological relations are in fact adhered to in all situations. Thus, (1) Proximities are correct, or at least aimed at; arms and legs are attached to the trunk, the eyes placed in the head and the two eyes are always shown side by side, even in profiles where proximity runs counter to perspective and euclidean co-ordination itself. (2) Separations are made more clearly, and there is some progress in analysing the separate elements. (3) In complex drawings (landscapes, houses, etc.) an order of succession is found which may not be in accordance with each dimension of a system of co-ordinates, but which does follow a direction corresponding with a practically possible order. For instance, in the plan of a house or a garden the elements succeed one another as if the whole were expanded or contracted in various directions, but nevertheless in an objective order. (4) The relationship of surrounding or enclosure assumes very great importance, since in many situations the interior of things is represented by means of transparency. Thus, food in the stomach, a duck in its egg (Luquet, loc. cit., p. 162, Fig. 96), potatoes in the ground (*ibid.*, p. 167, Fig. 98), etc. (5) Lastly, continuity is well defined, as contrasted to the purely external juxtapositions which were seen in Stage I.

Although projective and euclidean relationships begin to be developed during this stage (as we shall see with reference to euclidean figures in Section II) their as yet incoherent character goes hand in hand with a representational space not yet structurized in terms of perspective and distance. That is, there are neither co-ordinated points of view nor any general co-ordinates. This is further evidence that representation is still essentially topological, consonant with flexible and deformable objects, so long as the relationships listed above are complied with. As a result one finds in one and the same drawing evidence of a jumble of irrecon-

cilable points of view. In one example given by Luquet (p. 179, Fig. 111) is shown a horse in profile, and a carriage head-on but lying on its side with its wheels rotated. In addition the different sides of this combination are simply drawn together so as to be seen all at once. As regards the so-called "rotation" that is frequently seen at this stage, it bears so little relation to a real projective operation of this kind that, as we shall find in Chapter X, the latter is quite incomprehensible to a child still producing drawings containing pseudo-rotations. Real projection begins to be grasped (after 7–8 years) precisely at the point where these pseudo-rotations characteristic of the period of intellectual realism begin to disappear. On the other hand, in the case of euclidean relationships, it is obvious that intellectual realism marks the appearance of straight lines, angles, circles, squares and other simple geometrical figures, though naturally without any exact measurements or proportions. But at this stage, their construction cannot in any way result in a comprehensive, euclidean organization of space. On the contrary, the distinctive features of intellectual realism are as remote from such a structure as they are from the co-ordination of perspective viewpoints. For instance, when a child draws a profile head with two eyes, or a horseman in profile with two legs, or a group of houses seen from various points of view concurrently, his drawings are equally at odds with euclidean as with projective structures. The object is distorted just as if it were plastic; distances and, consequently, co-ordinates play no more part in it than do perspectives.

Thus intellectual realism in children's drawings may be defined in geometrical terms by saying that while this particular structure derives its elements from concepts which are just becoming projective and euclidean, nevertheless its relationships are expressive of a representational space belonging to a level of understanding which is mainly topological and consists primarily of relationships of proximity, separation, order, surrounding and continuity. For in the first instance, as regards projection; jumbling up different points of view necessarily implies the prior development of a certain number of projective relationships—though not necessarily co-ordinated with one another. And this point applies equally to the euclidean properties of these constructions—they too are dealt with separately and are not yet integrated into a single whole. Thus with this kind of drawing, resemblance to the model amounts to no more than a crude sort of 'homeomorphism'; that is to say, a point—point, term for term correspondence, remaining purely intuitive and qualitative without any co-ordination of projective or metrical relationships, although these begin to be separated out within the topological complex. This is why, at the level of intellectual realism, we find the tentative beginnings of the accurate copying of euclidean shapes (Section II of the present chapter) and a start made

in the construction of projective relationships (see Chapter VI, on the straight line in projection), but as yet no co-ordination of perspective in the drawing as a whole (Chapter VIII), no understanding of proportions (Chapter XII), and especially a lack of co-ordinate systems (Chapter XIII) capable of application to a complex layout (Chapter XIV).

§3. *Stage III. 'Visual Realism'*

Towards the age of 8 or 9, on the average, there finally appears a type of drawing which endeavours to take perspective, proportions and distance into account all at once.

This 'visual realism' has a three-fold interest. First is its late appearance relative to 'intellectual realism'. In this respect, after due allowance has been made for perseveration and 'conservation of type', rightly suggested by Luquet as explanatory of the sometimes surprising duration of intellectual realism, the fact remains that such an order of succession in pictorial structures seems to indicate that projective and euclidean notions are slow to appear in the realm of representation, in contrast to their development in perception. This interpretation is in fact borne out by the remainder of our investigations.

The second point of interest is that an examination of visual realism seems to show neither projective relationships of perspective preceding euclidean relationships (measurements, co-ordinates and proportions), nor the reverse, but the two systems developing in unison and, indeed, interdependently. This conclusion is also one we shall be able to verify by direct experiment.

But the third point, which is of paramount importance, is that visual realism shows by its very contrast to intellectual realism the real nature of projective and euclidean relationships as compared with topological ones. The latter proceed step by step, remaining tied to each shape considered as a single entity and not related to other shapes. On the other hand, projective relationships determine and preserve the true relative positions of figures, as distinct from the medley of viewpoints, pseudo-rotations, etc., found in the preceding stage. Finally, euclidean relationships determine and preserve the relative or co-ordinate distances between figures. Hence in both cases, comprehensive systems replace empirical constructions, a development which is confirmed throughout the rest of this work.

SECTION II—THE DRAWING OF GEOMETRICAL FIGURES

Having broadly summarized the way pictorial space develops we must now try to analyse the construction of a few simple geometrical

figures, such as the circle, the square, the triangle, the rhombus, etc. For this purpose it is necessary to study the way these figures are drawn, both as regards their topological and euclidean properties. The drawing of perspectives will be dealt with later in Chapter XII and XIV.

The actual drawing of figures as such raises a series of interesting questions, though the problems of perception and the spatial image we shall leave aside, since they have already been discussed in the course of Chapter I. In dealing with the particular type of image which drawing constitutes we shall encounter reactions similar to those obtained in the study of haptic perception. Nevertheless, what we wish to submit to detailed examination in the present section are the geometrical relationships themselves, together with the 'abstraction of shape'.

From this standpoint, the copying of geometrical figures by children between 2–7 years yields results which are extremely important for the psychological theory of representational space. Although familiar with euclidean figures such as circles, squares, triangles, rhombuses, etc., these children do not primarily express in their drawings the perceptual features of 'good gestalt' which such figures present, but rather the topological characteristics of proximity, closure, surrounding, etc., as already seen in the case of haptic perception.

§4. *Technique and general results*

We begin by asking each child to draw a man from memory, both to put the child at his ease and to give ourselves some idea of his natural drawing ability. Next we ask him to copy, either wholly or partly, the following series of models. It will be noticed that some of the models emphasize topological relationships while others are simple euclidean shapes. A third group combine both types of relationship (total or partial interlacing of euclidean figures, etc.).

(1) A large irregular shape 4–5 cm. long with a small circle 2–3 mm. in diameter outside but close to the boundary (Fig. 2, No. 1). (2) The same with small circle inside and close to the boundary. (3) The same, with the circle astride the boundary. (4) A large circle. (5) A square. (6) An equilateral triangle. (7) An ellipse. (8) A rectangle twice as long as wide. (9) Two circles 1 cm. apart. (10) Two identical circles in contact. (11) Two intersecting circles. (12) A circle circumscribing an equilateral triangle whose points touch the circumference. (13) A circle containing an equilateral triangle, apex at the centre and base resting on the circumference. (14) A circle 4 cm. in diameter with a small equilateral triangle of 1·5 cm. side placed at the centre. (15) An equilateral triangle of 4·5 cm. side containing a circle tangential to the three sides. (16) An identical triangle with a circle 4 cm. in diameter intersecting its sides to form three equal segmented arcs. (17) A square having a single diagonal. (18) A rhombus of 4 cm. side. (19) A similar rhombus bisected

53

by a horizontal diagonal forming two equilateral triangles. (20) A vertical-horizontal cross. (21) An oblique cross.

In order to eliminate the element of skill and motor habits from spatial representation proper, we supplemented the task of drawing with another. The children were given a number of matchsticks with the heads removed with which to reconstruct the straight-sided models. Thus to form a square, twelve match-sticks are dealt out and if the task proves too difficult the number is reduced. This method often facilitates

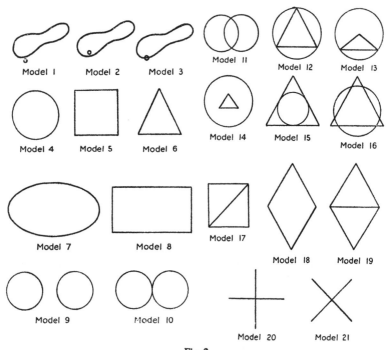

Fig. 2.

Figures to be copied by drawing (21 shapes).

a better estimate of the child's intentions, though it is not without its disadvantages, for when the number of matches corresponds to the number of sides there is an element of suggestion, and when it is greater than the number of sides the construction is usually more difficult to execute than a drawing.

Finally, it should be noted that with very young children, who for the most part produce pure or only very slightly varied scribbles, it is necessary to scrutinize the drawings extremely closely to discover in them any possible influence of the visual model. It is also possible to

introduce a motor stimulus by guiding the child's movements and then study a further copy made unassisted.

Allowing for the special features deriving from the nature of the experimental set-up, the results obtained are remarkably similar to those of experiments in haptic perception.

During Stage 0 (at which no experiments in haptic perception were possible) no purpose or aim can be discerned in the drawings. They are simply scribbles (Fig. 3) which show no variation whatever the model (up to the age of 2; 6–2; 11).

Stage I can be divided into two distinct sub-stages. In the first, Substage IA (up to 3; 6–3; 10), the scribbles appear to vary according to the model being copied, open shapes being distinguished from closed ones. Thus without being able to copy a cross or a circle, the child produces different types of scribble according to whether he is looking at one or the other shape (see Fig. 4). At the level of Substage IB

Fig. 3.
Pure Scribble.

(average 3; 6 – 4 years) however, one can begin to speak of real drawings, though curiously enough it is only topological relationships which are indicated with any degree of accuracy, euclidean relationships being completely ignored (see Fig. 5). Thus the circle is drawn as an irregular closed curve, while squares and triangles are not distinguished from circles. That is to say, they are all shown as closed curves

Copy of the cross
Model 21

Copy of the circle
Model 4

Fig. 4.
Varied Scribbles (Substage IA).

with perhaps an occasional symbolic suggestion, such as wavy lines jutting out to indicate angles, and so on. Only the open shapes are distin-

55

guished from these, like the cross (as two more or less intersecting lines, though not necessarily drawn straight). While there is no distinction as yet between straight-sided and curved figures, there is however, a correct rendering of the topological properties of models 1–3, the closed figures with attendant small circles, and the enclosed figures are represented by means of enclosed circles also.

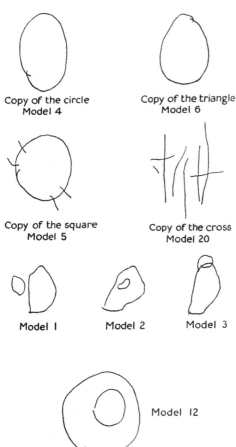

Copy of the circle
Model 4

Copy of the triangle
Model 6

Copy of the square
Model 5

Copy of the cross
Model 20

Model 1 Model 2 Model 3

Model 12

Fig. 5.
Sample Drawings from Substage IB.

Stage II (starting about the age of 4) is marked by progressive differentiation of euclidean shapes. At a level midway between Substages IB and IIA curved shapes begin to be distinguished from straight-sided ones, though the latter still remain undifferentiated from each other (notably the square and the triangle), so that these figures are given straight sides but no regard is paid to how many. It is most frequently the rectangle which is reproduced correctly (for this intermediate stage, see Fig. 6).

During Substage IIA (Fig. 7) shapes are gradually distinguished according to their angles, and even their dimensions. The square is separated from the triangle, as is the circle from the ellipse. Squares and rhombuses with diagonals (17 and 19) are reproduced with success, though not the ordinary rhombus (18). The two crosses are distinguished, marking the discovery of oblique lines. The circumscribed figures are drawn correctly enough as regards their actual shapes but the points of contact are not properly represented (as contrasted with the contiguous circles (10) which are

56

successfully reproduced). Lastly, during Substage IIB the rhombus is drawn correct and the circumscribed figures are gradually mastered, except for No. 16 (see Fig. 8).

At Stage III (from 6; 6–7 years) all the problems are overcome, including the composite figures such as No. 16 (circle emerging from a triangle at three places).

It is thus apparent that the process of development is very similar to that which occurs with spontaneous drawing, with a constant bias in favour of geometrical shapes which are easier to draw than natural figures.

§5. *Stage 0, simple rhythmic movements. Stage I, beginnings of discrimination (IA), then appearance of closed curved shapes (IB)*

Stage 0 is marked by pure scribbling, complete inability to close a line in order to form a shape, even with help from the experimenter.

Copy of circle	Copy of ellipse	Copy of triangle	Copy of square
Model 4	Model 7	Model 6	Model 5

Fig. 6.

Drawings midway between Substages IB and IIA.

THER (1; 9) and MAR (2; 8) when asked to copy circles produced only shapeless scribbles. Their hands were then guided and made to describe four or five circles of 2–3 cm. They were then asked to repeat this unaided. The result was a mixture of vaguely straight lines with rhythmic in and out swerves, together with curved though never closed lines. Comparison of these drawings with those produced spontaneously fails to disclose any influence of the visual models whatsoever.

LUC (2; 5) is asked to draw something of her own choice, a little man, etc. The result is a scribble having as many vaguely straight as curved lines. The 'straight' lines are produced by in and out movements with a continuous rhythm, or become curved when the rhythmic movement tends inward instead of keeping to a more or less similar in and out path. After this we tried to get her to copy a circle, at first alone, then assisted. When asked to continue on her own she begins by scribbling wavy lines in a roughly circular shape, but only from simple perseveration. After a while she lapses into her original semi-straight, semi-circular mixture of lines. She was asked to copy the square (we tried the same method again; free-guided-free drawing) but the result was the same as the preceding trial; a few straight lines through perseveration, then a mixture of straight and curved.

It is thus apparent that these children are not influenced by the geometrical models, even after having their hands guided several times over the drawing. We do not wish to harp on this rather trite observation, but rather to note that although the child cannot copy any figure at this stage, his scribbles, whether spontaneous or resulting from a fruitless attempt to copy a shape, present features of particular interest for the psychology of more advanced spatial representation.

Copy of square
Model 5

Copy of rectangle
Model 8

Copy of triangle
Model 6

Copy of circle
Model 4

Copy of ellipse
Model 7

Model 19

Model 20

Model 21

Model 12

Model 13

Model 15

Model 16

Model 9

Model 10

Model 11

Fig. 7.
Sample Drawings from Substage IIA.

The first of these has nothing whatever to do with space as such, even in the form of pictorial space. What it does relate to is the mode of operation of ideo-motor behaviour, from whose subsequent stages will arise increasingly accurate drawings, and which will finally result in true operational construction of geometrical shapes. This is particularly the case if, as was suggested in Chapter I, shape is abstracted from the subject's own movements rather than from the object which occasions them. The primary feature of the children's drawings or scribbles is their simple rhythm. This

Model 18

Model 16

Fig. 8.
Sample drawings from Substage IIB.

very primitive expression of ability to draw is the product of a continual hither and thither movement of the hand across the paper, and it is from such a rhythmic pattern of movement that the first shapes come to be distinguished at Stage I.

This point requires to be stressed because every mental mechanism passes from rhythm to 'grouping' by means of regulatory processes which begin by co-ordinating the component parts of the initial rhythms and culminate, as an outcome of their increasing reversibility, in various types of groupings.[1] This is absolutely clear in the construction of geometrical shapes. It is on the basis of the rhythmic movement which the scribble constitutes that the rectilinear and curved shapes will later be gradually differentiated, through a series of perceptual-motor and intuitive regulatory processes. We shall be able to follow the development of these processes in the course of the later stages and see how the products of these morphogenetic regulations will ultimately "group" themselves into spatial operations built up according to well-defined models.

There is another important feature of these rhythmic movements which should be noted in this connection. This is, that they already contain in an undifferentiated state all those elements which will later go to make up the drawing of straight lines, curves and angles, even though the child cannot yet extract or "abstract" these from the rhythmic complex. When the rhythmic action consists of a simple outward and return movement it results in a roughly straight line. As soon as the return fails to follow the outward path exactly or, after moving from left to right, the child's hand moves down the page and back again, acute, obtuse or right-angles result where these lines intersect. At the opposite extreme, when the child tries to cover the greatest possible area with his rhythmic movements, he ends up with a quasi-circular pattern like the threads of a ball of wool.[2]

Hence from these various drawings one could extract pieces of real straight lines, different angles, ellipses and very near circles. The child Luc is in fact so near to possible differentiation at this point that for some moments after her hand has been guided in drawing a circle or a square she carries on with the curved or rectilinear shape, though she soon relapses into mere scribbling. But from the next stage on we shall encounter the beginning of real differentiations of shape. In fact, one of the main features of Stage I is that after beginning with scribbles which, like those of Stage 0, remain similar irrespective of different visual models, the child can with very little practice, and especially after guidance by the experimenter, begin to vary the primary rhythmic

[1] *The Psychology of Intelligence*, 1950, Conclusions.
[2] These rhythms, among others, have been studied by Krotzsch, *Rythmus und Form in der freien Kinderzeichnungen*, Leipzig, 1917.

movements in a way which tends toward a fairly clear reproduction, not of the model itself, but at least some aspect of it.

Rol (3; 0) in his spontaneous scribbling at first produces the up and down and left to right lines at various angles, likewise the circular movements present in Stage 0. His hand is then guided in making discontinuous parallel lines, first horizontal and then vertical (the rhythmic movement is clearly interrupted at frequent intervals as against the original interlacing of the lines). The horizontal lines are nearly level, though not quite straight, whilst the verticals are not entirely parallel and slant at various angles though approximating to the vertical. As for the circles, after a little practice they result in purely circular movements which are kept up indefinitely according to a continuous rhythm without ever reaching a point of closure.

The topological shapes (1) and (2) (large closed curves with a small circle inside or outside) are clearly distinguished. The first is represented by a curved-in line, and at the spot where the small circle is located (clearly outside the boundary) Rol makes a small scribble which is accurately placed although shapeless. As for shape (2) (circle inside), the whole of the figure is represented by a tangle of circular sweeps without any distinction between the exterior curve and the enclosed circle, but clearly distinct from shape (1).

Jac (3; 6) likewise varies his scribbling in the following way. The circle results in a long thread wound round itself three or four times and open at both ends but presenting only circular contours. The square is represented by a structure which at first sight appears similar, but in which may be distinguished one or two breaks and a few lines that are a little straighter. The same is true of the triangle. On the other hand, the cross results in a broken line rather like a flash of lightning, through an extension of the rhythmic movements whose variation produces a zig-zag.

Mon (3; 8) represents a man by a shapeless scribble and the circle, square and triangle by a collection of curved and disconnected threadlike lines. Figures 9–11 (separate, touching or intersected circles) resulted in a tracery of interwoven lines. But the upright cross is again represented in the form of zig-zags beginning like those of Jac and ending in intertwined lines. The oblique cross results in a few discontinuous lines, some separate but others intersecting.

The significance of these early discriminations will be readily appreciated. To analyse them one must draw a distinction between the way in which the child appears to divide the perceived figures into open or closed shapes, and the manner in which he tries to interrupt the rhythm of his own continuous movements in attempting to express the different features of each model. Now these two processes do not necessarily coincide, because in drawing a closed shape the child has first of all to interrupt his own motor rhythm and is thereby forced to recognize discontinuity of an objective, involuntary character.

The problem with which the child is faced actually amounts to producing a given shape through rhythmic movements which tend to oscillate between vague zig-zags and curved paths. Consequently, the

child has to break this continuous rhythm even to draw a simple circle, while at the same time taking advantage of its bends and natural closures. This is what Rol and Jac are doing. They form their circles from a number of spirals more or less intertwined, begun and ended so that the extremities cannot possibly meet, yet interrupted more sharply than in the case of a haphazard scribble. The circle is produced by interrupting the rotary movement and the failure to close it is entirely due to want of skill in drawing. This is shown by the enormous difference between the drawings of the circle and those of discontinuous lines (Rol) or crosses (Jac and Mon) where an open appearance is aimed at. But before passing on to the latter shapes it should also be noted that the squares, triangles, etc. are drawn, very similar to the circle, though there is some attempt at differentiation by way of inward and outward as against circular movements, and with more frequent breaks in the line (foreshadowing the appearance of straight lines and angles).

As regards copying lengths of parallel straight lines (Rol) and crosses (Jac and Mon), there is an undoubted attempt to render the open character of these figures, distinct from failure to close the pattern as mentioned above. For the former, Rol succeeds in producing a collection of thread-like lines, some discontinuous, and for the crosses Jac and Mon end up with variations of the outward-inward movement in the form of wide zig-zags.

In all these cases it is possible to see a distinct effort on the part of the child looking at the model to reproduce either the closed (circle, square, triangle, etc.) or open shape (parallels and crosses), by a species of extraction, on the basis of his own initial rhythmic movements. The features which tend thus to be extracted from these initial shapes are primarily topological. The feature which strikes the children first and foremost is whether a shape is open or closed, and also, as in the case of Rol (Figs. 1 and 2), whether there is anything inside or outside the closed contour.

In conclusion it may be said that abstraction of the circle on the basis of rhythmic scribbles corresponds to what is most probably the normal path of development in spontaneous drawing. Thus Luquet[1] reports that Simone Luquet began by making round shapes and was only able to draw a man at her second attempt (op. cit., p. 3). However, as these 'men' are simply heads with lines adjoining, they are no more than particular examples of possible meanings given to these round shapes, which are thereby distinguished from the original scribbles as the first recognizable figures. It is this transition from scribbling by varying the scribble according to particular features of the earliest definite shapes which indicates the appearance of Substage IB.

[1] Luquet, *Les Dessins d'un Enfant*, Paris, 1913.

At this level are found the first properly closed circles, the first crosses with true intersection of lines, together with some appreciation of the relationships of inside and outside (Figs. 1–3). These begin to be clearly distinguished for the first time a little before the age of 4 on average, and this corresponds fairly closely to the developmental stages of spontaneous drawing. In this connection, Hetzer's[1] statistical research has shown that at the age of 3, children can only produce scribbles when making spontaneous drawings and that only 10% (on average) of such children attribute any representational meaning to their scribbles when these are completed. By the age of 4, attribution of meaning after the event is found in a third of all cases, another third discovering some meaning while actually producing the drawing, only the remaining third fixing on the meaning in advance. But by the age of 5, 80% of children decide on the intended meaning of the drawing beforehand.

Here are some examples of Substage IB, beginning with three cases intermediate between Substages IA and IB.

BER (3; 9) draws the circle and achieves a shape about 4–5 cm. across, consisting of only two lines, one semi-circular, the other undulating somewhat but fitting closely to the first at each extremity so as to close it except for a space of 1–2 mm. at each end. The square is shown by two irregular closed shapes stuck up against each other. The triangle results first in a properly closed shape, though elliptical and lacking angles, then at a second attempt in a series of intersecting but unco-ordinated lines which are subsequently transformed into a closed figure.

By contrast, the cross gives rise to a very curious effort. It begins as a closed circular shape (a perseveration from previous types) but finishes up as a number of ellipse-like figures each having long threadlike lines on opposite sides to represent the arms of the cross.

A man is drawn as a large closed shape completed by dividing it up irregularly by means of a number of intersecting lines.

JEA (3; 9) is an interesting example from the point of view of studying the match-stick technique. For despite his age he had never done any drawing and should therefore reach a more advanced level when reconstructing shapes with match-sticks than he can in his drawings. But this does not turn out to be the case. The drawing of the square, triangle, and circle produces the same final result, namely, shapeless scribbles at the commencement gradually becoming differentiated into closed shapes (though with rather uncertain outlines for want of acquired skill). As for the match-sticks, Jea does not succeed in producing any rectilinear shapes by his own efforts even though he is given a number of match-sticks equal to the number of sides. For example, in the case of the square he starts by putting four match-sticks fanwise $\diagdown\diagup$, then puts three at right angles to each other, failing however to close the figure with the remaining stick which he puts outside the collection. Next he

[1] Hetzer, H. Kind und Schaffen. 'Experimente über Konstruktive Betätigung des Kindes'. Qu. u. Stud. 3. JugdK. 7. Wien, 1931.

takes three match-sticks, places them in line and then puts the fourth at right-angles on the end. For the triangle he places two sticks at right-angles but does not know what to do with the third. After this he makes a straight line of the three, then constructs a three-sided open figure with two right-angles (similar to his attempt at the square), and finally returns to the two sticks making a right-angle. For the rhombus he constructs an open figure using five match-sticks, then makes a cross, and then a shape having one right-angle but consisting of four elements. The attempt at copying the cross (which he stumbled upon in attempting the rhombus) is likewise a failure. It is represented in turn by a straight line, a zig-zag in three parts and a half square. The rectangle gives rise to various combinations, none of them closed and all lacking right-angles (though consisting of five or six elements), etc.

Nevertheless, when, after a demonstration, Jea can imitate the details of the experimenter's movements, he is successful with the upright cross, the square and the triangle, though he fails with the rectangle and, not surprisingly, with the rhombus.

Yvo (3; 10) represents a circular shape by means of a single line, making it a spiral at first, and then closing it correctly at a second attempt. The square, triangle, ellipse, rectangle, etc., all result in the same figure. The separate and adjoining circles (9 and 10) produce two closed shapes which do not touch, but for the intersecting circles (11) Yvo draws twice in succession a clearly defined intersection. The figures with other shapes inscribed within them all result in an identical closed shape with a scribble inside each one, thus recognizing the relationship of containment but not of contiguity. The square with a diagonal results in a sort of circle crossed from side to side by a line.

Finally, the crosses are represented by separate lines cutting one another in various ways. Thus the oblique cross gives rise to a long wavy line cut in three places by almost straight lines.

Fra (3; 6) is ahead of the previous children and is the first real example of level IB. The men he draws may be described as of the 'newt' type. That is, a head containing two very large eyes with everything else represented by long wavy lines. In response to the square he draws a well-formed ellipse (at one stroke and properly closed); the circles, triangles, rectangles, etc., produce the same result. The shapes circumscribing a figure (12, etc.) produce ellipsoids enclosing smaller ones. The contiguous circles are not made to touch, but the intersecting circles result in a chain of 10–12 circles with clearly defined links. The irregular closed figures with a small circle inside or outside them (1 and 2) are reproduced successfully, whilst the one with a small circle on the boundary (3) gives rise to an attempt correct in principle but technically a failure. Lastly, both crosses have four distinct arms but a complete cross (Red Cross on a white ground) is represented by a circle.

Gen (4; 0). Under the heading of spontaneous drawing Gen produces an enormous scribble representing "*pancakes being tossed*", then a closed curve with seven or eight hairs sticking out of it to represent a cat, an ordinary circle for "*a little baby*". Finally he draws a pine tree with a long straight line for the trunk and perpendicular lines for the branches, whilst the needles and cones are shown by means of general scribbles. Thus he is able to draw straight lines and angles.

But when it comes to drawing a square Gen is a complete failure. He represents this by a wavy line (a curved zig-zag). The circle, rectangle and ellipse are all shown as closed curves. Only the cross is distinguished as two intersecting straight lines. The pairs of contiguous, separate and intersecting circles are not differentiated, but the topological shapes (1–3) are reproduced correctly, especially the small circle astride the boundary of the shape.

Moc (3; 11) produces a man with a clearly defined stomach and four lines representing limbs. He is successful with the circle. The square is at first made circular but is later provided with the beginnings of an obtuse, curved angle. The figures 1–3 are reproduced quite successfully (including the circle on the boundary) and he is also successful with the intersecting and separate circles. The contiguous circles are at first drawn as separate but are subsequently linked together with a few strokes. A circle inscribed within another results first, in a closed shape with another supposed to enclose it but actually closed outside and separate from it; second, in the same thing on a smaller scale; and third, in a successful attempt by analogy with shape 2 (closed shape with small circle inside boundary).

Mal (4; 4) is successful with shapes 1–3 and consequently with the circle, which is represented by a closed curve. But the square is shown in exactly the same way. The triangle is very similar but contains one almost straight side and two curved angles. The ellipse is not distinguished from the rectangle, except that the latter is drawn as an oval with a thin line at each end to mark the angles. The rhombus is drawn in the same fashion as the rectangle except that the thin lines are placed laterally to show the obtuse angles.

The separate, intersecting and contiguous circles are performed successfully, the last being separate, technically speaking, but joined together by means of a line to show their contiguity. The diagonalized square is represented by an elliptical figure having vague angles and bisected by a median. The upright cross, however, is reproduced quite successfully.

Fran (5; 3, backward) can draw a man but with arms and legs coming out of his head, though the feet are represented. The topological shapes are produced successfully at first attempt. The square and circle are drawn as similar, but the former is later represented by a circular shape with first two then four strokes emerging from it to indicate angles. The triangle is a circle from which issues a single thin line. The ellipse and the rectangle are both similar in appearance. The separate circles are drawn correctly, but the contiguous ones are shown as intersecting, as is the truly intersecting pair. All the figures with inscribed shapes, and likewise the diagonalized square, are shown as circular closed shapes with an identical shape inside them.

Til (5; 2) responds similarly, also drawing the square as a circular shape. But he is successful with the topological figures 1–3.

These reactions are extremely illuminating in three respects. Firstly, as regards the link which connects topological relationships with euclidean ones; secondly, with respect to topological shapes considered in terms of perceptually 'good' forms; and lastly, as regards the 'abstraction' of shape in general.

To arrive at a correct understanding of these three questions, however,

it is necessary to begin by considering the technique itself, as it is applied in these drawings. For this naturally conditions the approach to abstraction of shape, and also governs the preference shown for one shape rather than another. The question of technique presents itself in quite simple terms. It is a matter of arresting or interrupting the primitive rhythms of scribbling. This means breaking it down into discrete elements, arranging these elements in relation to one another, and then reassembling these elements with the aid of a series of perceptual-motor and intuitive regulations.

Ber and Yvo, children who are passing from Substage IA to IB, illustrate how the break-down of the rhythmic movements, begun at Substage IA, is continued and reinforced by the first attempts at reassembly. Thus Ber adjusts two curved lines to make a circle and joins two curved lines to form a square. Yvo gradually closes up a single line to make a circle and links up several roughly straight lines to represent a cross.

In each instance the movements are interrupted and the rhythm of the whole is superseded by a series of individual movements. The co-ordination of these individual movements is determined by a complex of successive adjustments resulting from the action of one perception upon another, of one movement upon the next, or the interaction of the representational images themselves. Since these children are as yet quite incapable of performing reversible operations of thought, it is obvious that the task of controlling the actual drawing of the shapes must, at this stage, devolve upon perceptual-motor and intuitive regulatory mechanisms (i.e., relating directly to the images which sustain this perceptual and motor activity).

What types of figure are the main outcome of such mechanisms? The clear and unambiguous reactions of all the subjects indicate that structures such as the large closed shape with a small circle inside, outside or upon the boundary are far more easily rendered than are squares, triangles, rectangles, etc. Their responses also show that open shapes like the cross are distinguished from closed shapes much more clearly than straight-sided angular shapes are distinguished from curved ones.

In short, in every case it is the topological relationships which appear to be grasped initially, while the euclidean figures still remain undifferentiated.

For from what other cause can the success achieved with Figs. 1–3 derive? These figures are structures which merely combine the relationships of proximity, separation and enclosure without involving straight lines or angles. In Figs. 1 and 2 the small circle lies close to the boundary of the shape but is separated from it by a small gap and is therefore either inside or outside the figure. In Fig. 3 the circle is both close to

and not separated from the boundary and therefore is at once inside and outside the larger figure. And it is these three features of proximity, separation and enclosure which the children immediately notice and indicate correctly in their drawings, despite the technical difficulty of putting the circle astride the larger figure (Fra still cannot manage to depict this relationship, though visibly striving to do so, but all the children who follow are successful).

Now why are the same children who can reproduce Figs. 1–3 unable to distinguish rectangles, squares, and triangles from circles and ellipses, and among the rectilinear shapes are only successful with the cross? Can this be explained by attributing it to a simple motor difficulty? For the circle does correspond to a single natural movement since it is curved, whereas squares and triangles are made up of straight lines which are harder to draw. Squares and triangles also require the deliberate location of these lines in a particular direction, according to a given angle, and their closure must be brought about by joining up a number of separate elements instead of merely following an unbroken line. But firstly, we have seen that on occasion the circle is constructed by means of composition, as with Ber who adjusts the ends of two separate curves. Secondly, one finds just as many straight or nearly straight lines as curved ones ; mong the children's spontaneous scribbles, and Gen can even manage to draw a pine with a trunk and branches at right-angles and thus disposes of all he needs to construct a square which he is nevertheless unable to copy. Finally, as regards deliberate combination of lines, the reproduction of Figs. 1–3 shows that this can be done. For to put a small circle astride the boundary of a closed shape seems just as complicated as adjusting four straight lines, although the children master the first of these tasks and fail with the second.

We may therefore take it that the problem is not one which depends upon mere motor ability, but rather on the method of composition itself, in other words, on the type of regulatory mechanism which will result in the construction of a shape on the basis of elements isolated from the original pattern. In this respect it is precisely the elementary topological relationships which demand only such compositions as are already implicit in the more complex ones, even after projective and euclidean relationships have been differentiated.

Thus it comes about that as soon as the rhythmic movement has been broken down into discrete elements, the very fact of connecting or not connecting them together results in relationships of proximity and separation, enclosure and open-ness, ordered succession and continuity. At this level drawing expresses in the simplest terms the relationships inherent to the actual organization of the earliest compositions, as distinct from the more complex types of organization which involve directions, such as parallels, angles, straight as against curved lines. In

short, topological relationships are first in order of appearance because they are inherent to the simplest possible ordering or organization of the actions from which shape is abstracted.

In line with this, it is interesting to observe the success with which the upright cross is drawn, as compared with the failure to distinguish the squares, rectangles, and triangles from circles and ellipses. The explanation lies clearly in the fact that the cross is an open shape, no more than a couple of intersecting lines, whereas all the other shapes (including the tri-dimensional cross likened to a circle by Fra) are closed. As regards the closed shapes it would be incorrect to say that the circle and ellipse are copied accurately earlier that the square, or that the square is likened to the circle. It would be nearer the truth to say that at this stage children are not influenced in any way by the metrical and projective peculiarities of the circle. Although their perception of these figures naturally registers an accurate distinction between them, their representation retains only the topological characteristics; that is, the fact of their both being closed shapes. It is a 'Jordan's curve'; that is to say, the topological equivalent of a circle, and not a circle which these children are really drawing. For the same reason the triangle, square, etc., are also depicted by means of closed curves, since from this primitive point of view they have the same shapes as the circle. They become differentiated from the circle only very gradually, as in the case of Mal who represents the rectangle by a closed curved shape adorned with two wavy lines (see also his rhombus). Fran also shows the triangle by means of a similar rounded shape with a single wavy line added, while Mon inserts straight lines and points into his closed round figure to mark the sides and angles. Even the ordinary upright cross is started off in this way by Ber (ellipsoid with long wavy lines) before being drawn correctly as an open figure with lines that cross.

The representation of figures containing inscribed shapes is similarly based on topological relationships. They are all drawn as closed curved figures containing other curved figures with no regard to accurate rendering of shape or size. As for the two large circles, separate, contiguous and intersecting, whilst the last of these is shown correctly contiguity is most often indicated by one or two strokes connecting separate closed shapes. But oddly enough, these models present somewhat more difficulty than Figs. 1–3 although they are in fact their analogues, because while these last make up a single whole in each case, the large circles give the impression of two separate wholes as the thing to be reproduced.

In sum, topological relations universally take priority over euclidean relations, which are not as yet differentiated from them. We are thus enabled to answer the remaining two of the three questions posed at the outset of this discussion. To deal with the first point, it is

obvious that in Substage IB, as throughout Stage I, pictorial representation does not in any sense correspond to the perceptual data at this level, for this data has long since acquired a projective and euclidean character. In particular, far from being something determined by perceptual 'good Gestalt', pictorial representation expresses in essence the basic requirements for the composition of figures; the active rather than the perceptual aspect of their construction. Similarly, as regards the second point, the 'abstraction of shapes' is not carried out solely on the basis of objects perceived as such, but is based to a far greater extent on the actions which enable objects to be built up in terms of their spatial structure. This is why the first shapes to be abstracted are topological rather than euclidean in character, since topological relationships express the simplest possible co-ordination of the dissociated elements of the basic motor rhythms, as against the more complex regulatory processes required for co-ordination of euclidean figures.

§6. *Stage II. Differentiation of euclidean shapes*

As a criterion for the appearance of Stage II one may take the successful reproduction of the square, or at least the rectangle, which is usually achieved slightly earlier. Binet and Simon long ago showed that copying a square constituted a test for an M.A. of 4 years, and their conclusions have been confirmed by Terman for the U.S.A. Once the rectangle and square are mastered they are soon followed by the triangle (the order of succession is frequently reversed), but the rhombus is not mastered until much later (not until 6 years according to Binet, and 7 years for the U.S.A. according to Terman) for reasons which it will be interesting to investigate.

In its general outlines one finds, as in Stage I, a course of development running remarkably parallel to that of the successive levels laid down in Stage II for haptic perception. The transitional level from Substage IB to Substage IIA is marked by the simple discrimination between curved and straight lines within more or less curved structures, whilst there is at the same time no clear discrimination between squares and triangles. Here are a few examples, beginning with a child still almost in Stage IB.

DEN (3; 4) starts with a 'newt' type of man. He is successful with figures 1–3 and with the circle. (He then draws the square like a circle, but with some attempt to reproduce an angle similar to Moc, IB.) His triangle has a well-formed angle shaped like a 'beak', but is closed by means of a distinctly curved line; it is then drawn with two straight parallel lines and these are likewise closed with arcs. By way of contrast, the rectangle is spontaneously much enlarged and is made of two nearly straight lines each bent at right-

angles. The ends of these are adjusted to fit by means of further straight lines and a proper rectangle is thus obtained.

REN (3; 10) is successful with figures 1–3 and with the circle (a long ill-closed line with a short length added "*to close it*"). The square is formed of three adjusted straight lines with one acute and one obtuse angle while the fourth side is curved, or rather, wavy. On a second try it is given three sides, one of them curved. As a result he very nearly succeeds in forming a triangle, except for making one side curved. The rhombus is a kind of ellipse crossed in haphazard fashion by four straight lines at various angles of inclination. The remaining shapes are drawn similar to the efforts seen in Substage IB.

MON (3; 11) very nearly succeeds with the square except for one side which is slightly curved, but his rectangle has only two straight sides with a well-formed 'beak' for one of the angles (resembling the angles found in spontaneous scribbling) and has a small strip tacked on to the apex to indicate the second angle, whilst the third angle is rounded. The rhombus is an open square elongated in a way which resembles the triangle.

LOU (4; 6) achieves by degrees a good drawing of the square, starting from a circle. It is first a curved line closed by means of a parabolic curve. Then a curved angle joined to another identical to it (and thus a figure with four curved sides), next an attempt consisting of a single straight line ending in an arc, and finally four large rectilinear sides almost at right-angles. The triangle is first made to resemble a long artillery shell, then a rectangle closed on one side by an arc.

AMB (4; 9) was studied both by means of drawings and the match-stick technique. The square results at first in drawings which show the same sorts of differentiations as those of the previous children. First an irregular ellipsoid, then an acute angle drawn at a single stroke and closed rather badly by means of an arc, and finally an almost right-angle (drawn in two strokes) closed with an irregular curve tending to represent two sides symmetrical to the first pair. Amb is no more successful with match-sticks. He makes four-sided open figures, some with re-entrant, acute angles, others with two obtuse angles and therefore having large gaps at two angles out of the four (a sort of trapezium with an unfinished long side). When he uses strips of plasticine the result is a figure even less closed. As for the triangles there is a remarkable similarity between the drawings and the match-stick constructions. These are all four- or five- sided figures (sometimes even more sides), badly closed but with one or two acute angles. At times they are open figures with three sides and two right-angles. On the other hand, the drawing of the rhombus is more similar to a triangle. It is first just an angle with two sides, then a triangle nearly closed; next follows an irregular quadrilateral and finally, an irregular pentagon. Not altogether surprisingly, we find that the technique of using match-sticks produces exactly the same result. A triangle of three sticks is followed by a figure using seven sticks, intermediate between a triangle and a pentagon.

JAC (4; 10) is successful with the square but the triangle, in spite of several attempts, is also given four sides, some of which are curved. He succeeds with the rectangle. The inscribed figures begin to assume shapes which are not just

circular. The inscribed triangle is either a square with a thin line to denote the apex or a three-sided curved shape beginning to resemble a triangle.

ROG (5; 2) is very nearly successful with the square, though one corner is still rounded. The triangle is first rectangular and then a species of square with a domed top. The rhombus is a closed ellipse, then an open quadrilateral and finally a kind of elongated artillery shell. *"It's hard to draw the point"* says Rog.

ZEZ (5; 4) draws a little man complete with hair, torso (complete with heart), arms coming out of the neck, hands, etc. ('intellectual realism'). His squares and rectangles are similar but have straight sides and right-angles. The triangle is first a rectangle given a rounded angle, then a shape formed by three rectangles opening on a common centre (like a clover with rectangular leaves), finally becoming a kind of dome. (He actually mastered the triangle some fifteen days later.)

HEL (5; 8) succeeds with the square, but begins the triangle as a square, the two opposite sides being extended by two additional lines. He later draws it as a dome.

Thus at the transitional level which indicates the approach to Stage II angles and straight lines are gradually differentiated, and the triangle, the rectangle, and to some extent the square are represented successfully. However, there is as yet no distinction drawn between square and triangle. In the case of Jac, Rog and Hel the triangle sometimes resembles a square, while with Ren, and partly also with Den, it is the square which resembles a triangle, or at least the child's drawing of one. Our first problem is therefore to obtain an understanding of the development of angles and rectilinear shapes on the basis of the closed curved shapes from which they are derived. Our second problem is to explain the relative lack of differentiation between the different rectilinear shapes.

As regards the first of these problems, the present results strongly confirm what has already been seen in the case of haptic perception; it is the analysis of angles which leads to the discovery of straight lines rather than the other way about. The earliest squares or triangles are simply circles distinguished by the addition of one or two angles. Now before being obtained by adjusting discontinuous lines (as in the case of Ren), this angle is formed in one of two ways. Either by means of transforming an arc into a kind of blunted point, or by a rapid out and return movement with a space between the two paths, resulting in the sorts of 'beaks' (cf. Mon) found in spontaneous scribbling. The angle is thus extracted from the incipient rhythmical movements, as are indeed the circular shapes themselves, and it is only through this process of extraction that the straight line is differentiated as such. However, at a later stage the angle can be reconstructed in turn by the intersection of two straight lines.

It is just because this adjustment of straight lines drawn alone is so

much more difficult to bring about than the abstraction of a complete angle, that the first rectilinear shapes are so little differentiated from each other. In order to connect a given straight line with others at certain angles one has to take into account their inclinations, parallelity, number of lines, points of conjuction and their distances. It can therefore be easily understood that the organization of this whole complex is vastly more complicated than simple topological relationships such as are found at Stage I, or the angles taken as a whole, as in the processes of differentiation just described. This is why Ren forms his rectangle simply of two lines which each contain an angle of 90°. But it is also the reason why so many shapes are incomplete, for the angles which the child first draws are merely closed by curved lines and cannot be co-ordinated with other lines.

These co-ordinations begin to take place during Substage IIA as a result of various detail adjustments concerned mainly with sizes and inclinations of lines giving rise to differentiation of the square, the triangle, and the rectangle from each other, and the circle from the ellipse, etc.

ALB (4; 1, advanced) produces accurate squares right away, but shows a process of gradual differentiation in the case of the triangle. He draws first a rectangle but with one of the short sides extended by an open acute angle outside the rectangle. This is followed by a trapezoid with two right, one obtuse and one acute angle extended by a line at an angle to one side as in the previous figure. Then a similar figure is drawn, and finally a true triangle by closing the external angle and eliminating all the rest. The ellipse and rectangle are drawn correctly. The figures inscribed in circles begin to be more precisely defined. The points of contact with the circle are not shown but Alb points out his mistake accurately.

The rhombus is an open quadrilateral. The diagonal is not yet distinguished from the upright cross and the diagonalized square is fumbled. The diagonalized rhombus is shown as an ellipse with a median.

BERT (4; 6) is successful with the circle, square and rectangle. The triangle is also formed correctly straight away, from an angle made with one stroke and closed with a straight line. The triangle inscribed in a circle (Fig. 12) is drawn after two attempts and so is the triangle inscribed but not touching the circle (Fig. 14), but Fig. 13, the triangle touching the circle at the base with the apex at the centre, is a failure. Fig. 16, a triangle which protrudes from the circle at its extremities, is almost correct at first try and the diagonalized square is also a success. The rhombus results in many attempts, all unsuccessful. For instance, a three-sided square with a re-entrant angle in place of a fourth side (something like a bishop's mitre), then a rectangle drawn obliquely, then a pentagon, then a square extended by a line at one corner, then a triangle, and so on. On the other hand, the diagonalized rhombus results in a square surmounted by a triangle, then two opposing triangles on a common base. The two types of cross are distinguished.

Bert was given a trial of the rhombus using match-sticks, but he was no

71

more successful than he was with his drawings. He finishes up with the same open quadrilateral and is reduced to closing it with a fifth match, thus producing a pentagon. But the rhombus with a diagonal gives rise to two correct triangles.

DAV (5; 2) is successful with the square, the triangle (through three separate lines later joined together), the ellipse, as distinct from the circle, and the rectangle. But he fails to indicate any points of contact in the case of the inscribed triangles (Fig. 12 and 13) and similarly so for the circles inscribed in triangles, though he renders their shapes correctly. He succeeds with the diagonalized square and distinguishes the two kinds of cross. But the rhombus results at the first attempt in a rectangle opening on a trapezoid, then by two opposed acute angles whose extremities are joined by a pair of parallel straight lines (without which it would have been correct!). After this he draws an acute angle and tries to locate its twin counterpart. *"It ought to be like the top half but I can't get it!"* The diagonalized rhombus becomes a pentagon, also with an attempt to construct its counterpart. *"It ought to be like this!"*, then follows a triangle mounted on a square; but with an awareness of having failed, he says *"Here it ought to be pointed as well"*.

PAG (5; 3). Circle, square and triangle are drawn correct, but the rhombus is a square with thin lines added to indicate the corners. There follows a square left open, then a right-angle poorly closed by means of an acute angle, yet approximating to the right shape. With four match-sticks Pag builds a square standing on one corner, with eight he does the same, but given twelve he leaves the quadrilateral open and it no longer bears any resemblance to a rhombus.

CIL (5; 3). After successfully producing triangles and squares Cil likewise draws the rhombus as an irregular quadrilateral. Using match-sticks he succeeds with four but fails with eight or twelve. He turns out squares with a rounded angle, rectangles leaning over, an acute angle with no symmetrical counterpart and closed in haphazard fashion. He is successful with a circle protruding from a concentric triangle and says it is *"inside and outside"*.

TEA (5; 5) draws the rhombus as a square. He does just the same using match-sticks and the same again when using six match-sticks. But after building a triangle with ten matches he makes a rhombus like a square standing on one corner.

MIC (5; 6) draws the rhombus as a square surmounted by a triangle. With the aid of twelve matches he builds a large angle closed by an arc.

GENT (5; 8) succeeds with the triangle, square and ellipse. The triangle inscribed in a circle with corners touching the periphery is a failure. He replaces this by drawing a square which does touch the periphery. The diagonalized square is drawn successfully after a trial in which it is bisected by a median. The rhombus is first an acute angle closed by a parabola and subsequently, two opposite but not contiguous acute angles. He is successful with the diagonalized rhombus.

Gent has great difficulty in distinguishing the upright from the oblique cross and only succeeds in reproducing a slight degree of inclination.

GEO (6; 1) is successful with triangles, squares, rectangles, etc. His rhombus remains a square standing on one corner. With matches he builds a triangle

without difficulty but when he comes to the rhombus he cannot close the acute angle with which he began: "*I can't do it*".

PAU (6; 7) shows the same reactions. The construction of the rhombus is very remarkable; an acute angle extended by one and then two parallel sides, then a pentagon with two right-angles, next a regular pentagon. With twelve matches Pau constructs a quadrilateral surmounted by a point, similar to the usual drawings.

These are the typical reactions of Substage IIA. In the preceding stage the global discrimination of angles and rectilinear sides was achieved on the basis of curved shapes and elementary rhythmic movements. Subsequent to this there can be seen an effort at composition based on the differentiated elements themselves. But as yet this process of composition, which is the real mainspring in the "abstraction" of shape, is not carried out by means of reversible operations, as it is from Stage III onward, but only by a series of tentative adjustments governed by regulatory mechanisms simultaneously perceptual-motor and inherent to imaginal intuition. Of these regulatory mechanisms three in particular are worthy of mention.

The first is concerned with length and distance. The successful drawing of the square and its discrimination from the rectangle, likewise the drawing and discrimination of the circle and ellipse, marks the beginning of an attempt to take account of equalities and irregularities of length. Thus the square is given four equal sides, the circle tends to have equal radii, the ellipse is slightly more elongated, and so on. The belated appearance of these relationships in drawing is worth noting. Although long since known in the realm of perception they are only applied to graphic representation after a distinction has been drawn between curved and rectilinear figures (level intermediate between IB and IIA). However, it would be a mistake to imagine that this is due to the technical difficulty of drawing, for as the study of haptic perception showed in the case of tactile exploration and recognition of shapes, it is only at the identical stage of IIA that the relationships of length and distance begin to be taken into account. It is hardly necessary to point out that the dimensional relationships involved in graphic construction so far are governed merely by simple perceptual and intuitive mechanisms and not at all as yet by operational measurement.

Secondly, one should note the effort, not always successful, to apply to the euclidean shapes themselves the relationships of contiguity and separation which determine the position of figures inscribed within others. So long as only indefinite closed shapes were involved we saw, in relation to boundaries and enclosures, how precocious were these topological relationships. But it goes without saying, that no sooner is an attempt made to relate them to definite metrical shapes than they have to be reconstructed on the euclidean level. This is what we have already

seen in the case of the two circles (Models 9–11) noted above and what we meet with again in all the various combinations of inscribed figures.

The third and most interesting process of regulation to examine at this level is that of inclinations, previously unknown, but essential for the discrimination of the triangle from the square, the two types of cross, and especially for the construction of diagonals and the rhombus. Indeed, up to Substage IIA the child can neither represent the different inclinations of the two crosses nor draw diagonals successfully. Because of his inability to master inclinations he cannot even distinguish the triangle from the square and vice versa. At this stage however, about the age of 4; 6 to 5; 6 years, one sees a systematic effort to master the drawing of inclinations in spite of considerable difficulties. (See Gent at 5; 8 in the case of crosses, etc.) In fact this problem of inclinations will recur frequently in our studies, particularly in connection with the horizontal and vertical axes themselves, and with systems of co-ordinates (Chapters XIII and XIV), notions which are not worked out until much later (not until 8–9 years). At this point, therefore, we must make an important distinction. When it is a question of two completely separate figures, ability to judge their inclination (e.g. to estimate horizontals by finding some point of reference outside the figures themselves) is never in the least acquired prior to the appearance of operations, and such problems are only mastered after the age of 7. On the other hand, the kind of inclination we are dealing with at present and which begins to be constructed at this stage is purely internal to a single figure, for example, the inclination of one side of a triangle to the other two, the diagonal of a square to the sides, or the oblique as compared with the vertical cross (though here we have two separate but closely connected figures).

Although a few simple problems of inclination, such as angular co-ordination of sides belonging to the same figure or a pair of figures, are solved, the construction of the rhombus is by no means mastered at this stage. This is extremely interesting from the point of view of the abstraction of shape. The fact that *at least* 2 years work is required (as much as 3 according to Terman) in order to pass from copying the square to copying the rhombus (although all that is needed is to shorten the diagonal of an oblique square) shows pretty clearly that to construct an euclidean shape something more than a correct visual impression is required. Such a task really involves an extremely complex interplay of actions on the part of the subject.

Furthermore, the actions involved in drawing a rhombus are the same as are needed for its haptic exploration and recognition, as was shown in Chapter I §5, and they recur in the technique of match-stick construction (Bert, Mag, Cil, Tea, and Mic). This demonstrates that it is not mere skill in drawing, but abstraction of shape in general which

74

is involved. What is the nature of the difficulty presented by the rhombus? It is a problem, besides that of closing the figure and drawing the straight sides, of adjusting their tilt to certain acute and obtuse angles. But over and above this, what is most difficult to achieve is the symmetry between the two triangles from which the rhombus is formed. For this involves reversing the relative order of the parts lying each side of the central axis.

Now these are precisely the relationships whose construction could be followed step by step through the successive levels which we have so far examined. At Substage IB the rhombus is little more than a closed curve, after having been confused with the wandering open lines by which the children of Substage IA distinguish shapes from spontaneously produced scribbles. But occasionally in Substage IB the rough oval representing the rhombus is provided with a thread-like appendage denoting an acute angle. At the level midway between Substages IB and IIA the rhombus acquires angles and straight sides though the slope of these cannot be controlled. Thus it is confused either with the square and rectangles or else with the triangle. Nevertheless, the acute angles together with the inclinations they govern are suggested in various ways, such as by lengths of straight line running from one corner of the square at an angle of 45°, or a triangle (beaks, hats, etc.) placed over the square. Alternatively, the obtuse angles may be indicated by means of little triangles or even curves (ears, etc.) on two sides of the square or rectangle. (For all these stages, see Fig. 9.)

Finally, at Substage IIA the child begins to attempt to represent the inclination itself, from which result the various trapezoids, pentagons and the like, as the fruits of this activity. Similarly, figures are left open, not intentionally of course, but for lack of being able to close them in a way consistent with the desired inclination. Now what is missing at this stage? What would enable the rhombus to be mastered, after allowing for the fact that the problem of slopes has already been overcome in other figures? The answer is symmetry, which necessitates the inversion of order. "It must be like the top", says Dav speaking of the lower half of the rhombus, "but I can't manage it!" That is the reason why

Fig. 9.
Development of drawings of the rhombus from Stage IB to Stage IIB.

[1] For all these stages, see Fig. 9.

most of the children succeed with the rhombus on a horizontal axis, for this axis enables them to grasp the reversed order more easily whereas the ordinary rhombus is as yet beyond their powers.

During Substage IIB the rhombus is at last conquered and the problems of contact and separation, external and internal in circumscribed figures, are also resolved, though still by adjustments rather than by instantaneous organization.

URS (4; 10, very advanced) succeeds with all the figures either immediately or, in the case of inscribed shapes, by trial and error. The rhombus is constructed right away by means of two strokes each including an acute angle and correctly related to one another. Her spontaneous drawings (little men, well formed; boats, flowers, etc.) are quite typical of 'intellectual realism'.

MAY (5; 3, also advanced) is also successful with all the figures. The rhombus is formed by means of three strokes; an acute angle, then two straight lines from each extremity uniting in a point symmetrically opposite the apex.

PUC (6; 7) draws the rhombus at once with four separate, well-placed strokes. The inscribed figures engender a variety of attempts accompanied by correct verbal formulations of the problem: "*It isn't right because it's not touching*". "*They ought to be stuck together*", but by means of successive approximations they are all drawn successfully in the end.

The analogy with exploration described in Chapter I §5 is clearly evident, especially with Mar's remark when successively discovering the four sides of the rhombus: "It's leaning, it's leaning, it's leaning, and this one's leaning too!" (p. 35). Adjustment of the inclination according to the reverse order of the symmetries, such is the principle underlying these achievements. But with the more difficult figures it is still a matter of trial and error adjustments rather than operational anticipation.

§7. *Stage III and Conclusions*

It will be recalled that our study of exploration in conditions of haptic perception indicated Stage III as starting at the point where the movements through which the shape is abstracted could be defined as operational. That is, as being flexible and reversible enough to return constantly to the point of reference on which the subsequent construction is based.

The drawing of simple figures does not bring out this distinction very clearly, except for those models which are oriented wholly about a centre (such as the swastika, the drawing of which was described in Chapter I §6). However that may be, with our present figures it is distinctly noticeable that from the age of 7, many children can draw them correctly right away, their construction being anticipated by a

mental image drawn up in advance (mainly in terms of potential measurements, co-ordinations, etc.).[1] Here are a couple of examples.

Mul (6; 4) All the models are drawn correctly right away, though Mul's little man is still rather primitive, his hat being on the very top of his head, his trunk shown as a triangle, and so on.

Ric (7; 6) All the models are reproduced correctly right away. The man is shown by combining full face and profile.

In sum, it is apparent that the analysis of geometrical figures is far more developed than is that of the freely drawn figures like that of the mannikin. The development of geometrical drawing has enabled us to study in detail the actual problems posed by the abstraction of shape, in terms of the interesting theory proposed by Brunschvicg; namely, that the origin of the idea of spatial form was to be found in the effort to follow the contour made by a person drawing an object. But it must be stated categorically that in drawing, even more than with tactile-kinaesthetic exploration in haptic perception, the mental abstraction of spatial form is not just a matter of extracting the morphological features of an object through the activity of the subject, even though such a process does in fact take place—and acts as a constant stimulus to the corresponding physical construction.

In so many words, geometrical space is not simply a 'tracing' made over a simultaneously developed physical space, temporarily corresponding with it point for point. The abstraction of shape actually involves a complete reconstruction of physical space, made on the basis of the subject's own actions and to that extent, based originally upon a sensori-motor, and ultimately on a mental, representational space determined by the co-ordination of these actions. This is the main conclusion to be drawn from the study of drawing, whether it is a question of topological relationships or euclidean relationships. From beginning to end of the process just recapitulated, all these structures are invariably derived from the general co-ordination of physical actions.

In this connection it is important to give special attention to the analogies which our present findings indicate as holding between graphic construction, or imitation of shapes by drawing, and between the reproduction of such shapes with the aid of match-sticks. Although the second method might be expected to turn out the easier of the two, since the question of technical skill in execution does not arise as with drawing, nevertheless it is drawing which gives the impression of a more direct abstraction of shape from the object, as compared with the arrangements of match-sticks in which the part played by the constructional or reconstructional element is self-evident. Comparison of the two tech-

[1] As regards the drawing of complex wholes, where these factors are explicitly involved, see Chapter XIV.

niques is therefore useful, not only from the geometrical point of view, but especially in relation to the question of whether shape is abstracted direct from the object, or by means of the subject's actions.

The systematic study of thirty children with the aid of both techniques (starting sometimes with one and sometimes with the other, and also spreading out the observations to avoid any effect of 'carry-over') yielded the following results. Although the same types of errors are not necessarily found in the same children when using either technique, there is nevertheless a fairly close correspondence between the stages reached in figure construction, irrespective of whether match-sticks or drawing are employed. In only one case, that of a child of four who had never previously drawn, were match-stick constructions superior to drawings (though even in cases of this type it is normal for development to run parallel, as is shown by the case of Jea noted in Substage IB). Admittedly, drawing often has a slight lead over match-stick constructions as regards the easier closure of shapes, though when it comes to working out the structure as a whole, successive corrections are made more easily with the aid of match-sticks. Thus in the case of the square, drawings of closed shapes which lack angles and straight sides can be regarded as equivalent to match-stick constructions which remain unclosed, since the four straight sticks making up the sides cannot be bent or adjusted bit by bit. Likewise, the earliest squares achieved in drawing correspond to successful construction of squares from four match-sticks.

The case of the triangle provides an effective illustration of the difficulties the child encounters in trying to show the inclination of the three sides and co-ordinate the three angles with a suitable closure. With both drawings and match-sticks the children cannot at first manage to distinguish triangle from square, but begin with open shapes (or sometimes with closed ones) having right-angles and no oblique sides. At the level of drawing where triangles consist of a straight-sided angle completed by a curve instead of a third straight line, the corresponding match-stick constructions fail either to close the figure or to coincide at the extremities so that one of the three sides is left extended beyond the other two. The task of adjusting three matches to form a triangle is therefore just as difficult as the problem of drawing it, and in fact the two problems are solved at exactly the same time. As for the rhombus, all the various figures discovered in the drawings can be paralleled by the match-stick constructions and all reveal the same difficulty of co-ordinating the inclinations and the symmetries.

In short, the match-stick techniques provide conclusive confirmation of what could already be discerned from the study of drawing. And this conclusion is that the reconstruction of shapes is not just a matter of isolating various perceptual qualities, nor is it a question of extracting

shapes from the objects without more ado. The reconstruction of shapes rests upon an active process of *putting in relation*, and it therefore implies that the abstraction is based on the child's own actions and comes about through their gradual co-ordination.

Furthermore, the process of construction does not exclude, but to the contrary, directly implies that the actions, and the geometrical shapes they give rise to, are adapted to the object and even make possible the abstraction of its physical shape. But in the case of geometrical figures the process goes beyond these adaptations or extractions, for the object is assimilated to the co-ordination of the child's own actions, and it is this alone which enables the physical shape to be reconstructed by analogy with the geometrical shape which these actions first brought into being.

Chapter Three

LINEAR AND CIRCULAR ORDER[1]

OUR study of drawing and haptic perception showed that the simplest topological relationships such as proximity and separation are also the first to emerge in the course of psychological development. This order of appearance is also maintained when space is treated axiomatically by geometricians. In the realm of psychology it would be true to say that the relation of proximity expresses the most fundamental characteristic of the actions by which the subject generates the notion of space.

The relationships of difference and similarity exemplified by the acts of seriation and conjunction give rise to logical relations and classes, independent of the spatio-temporal location of the things ordered or classed. They can therefore arise from purely mental comparisons. As against this, a spatial structure must necessarily be composed of adjoining elements, since the action which generates space must bear upon the object as such, and not merely on separate congeries or intermittent series of objects. And this it does in the course of constructing or reconstructing it from its parts, one by one, and thereby in terms of proximity. But sometimes a pair of neighbouring elements cannot be separated because they interpenetrate to such a degree that a distinction cannot be drawn between them. In such a case the relationship of separation confers on them that 'externality' which has often been considered an essential feature of space.

In the case of a linear series (and as was seen, spontaneous drawing begins with lines), the relationship of proximity subsisting between separate elements A . B . C . . . etc. is sufficient to provide a basis for the relation of order. And this may be perceived intuitively at an equally early stage of development. The notion of *order* or *sequence* is thus a third basic topological relationship, and it is perhaps best to study its psychological development before that of *enclosure*, since the relation of *between* linking an enclosure with a dimension is itself a relationship of order. For example, in the series ABC, B is 'between' A and C. Admittedly, one could begin with enclosure and revert to linear order under the heading of boundary lines, but a series of boxed-in enclosures also constitutes a series.

We shall study in the chapter which follows the simple linear order (ABC . . .) and the circular order (ABC . . . XYZABC . . .), even com-

[1] In collaboration with Mlle. E. de Planta.

80

plicating the latter with the model of a 'pseudo-knot' (see Fig. 10) so as to be able to compare the findings with those resulting from the study of knots carried out in the next chapter. We have already published the results of some studies on the notion of order in an earlier work.[1] However, in that case we were concerned with order in relation to movement of balls through a tube which was rotated about its centre, a series of colours in a rotating cylinder, etc. As distinct from this, what is at present required is a study of order as such, separate from movement, which is thus reduced to the relative displacements of the subject who follows with his steps, his eyes, or even his thoughts, the direct or reverse order of an array of objects. Thus the experiments discussed below are completely different from those performed in the studies just referred to.

§1. *Technique and general results*

The study which follows is concerned with five main points, viz.: 1. Reproduction of a simple linear order. The child is shown a model consisting of seven or maybe nine vari-coloured beads on a rod and has to slip a simi-lar set on the same or another rod. Care is taken to ensure that the child can recognize

Fig. 10.
Pseudo-knot.

the different colours by getting him to sort out the beads according to colour. Large, easily handled wooden beads are used in preference and more are offered than are found in the model, so that reproduction of the last element is not determined merely by absence of choice.

Following this, two 'washing lines' (two strings) are presented, one strung out a few centimetres above the other. Small pieces of washing (seven or nine paper imitations) are arranged to hang on the first string. After the child has named them (they are directly associated by collect-ing them together before hanging them up; "Give me another red dress", etc.) he must place the corresponding objects in the same order (again there are more to choose from than are in the model). This correspondence has to be made either opposite the model, each article being hung beneath its opposite number, or with a gap of a few items so that the correspondence is not simply based on a perceptual configura-tion. Similarly, one can have the children imitate a circular order by arranging coloured beads on a piece of flexible wire or stout cord, to correspond with a string of beads lying on the table in the form of a circle.

[1] *Les Notions de Mouvement et de Vitesse chez l'Enfant*, Chapters I and II.

2. Transposition of circular into simple linear order. Making various coloured beads passed along a rod correspond with the seven or nine beads arranged in a circular loop.

3. Establishment of reverse order. Reproducing the beads arranged on a rod but in reverse order. This is done immediately below and facing the model. An odd number of elements is used, e.g. ABCDE, so that the bead placed in the middle of the reversed set EDCBA, i.e. C, is found opposite the same element in the model. Similarly, the child is made to construct a string of beads in a reverse order. Finally, the pieces of washing have to be arranged beneath the model, also in reverse order.

4. Direct or reverse order of stacking. To stack pieces of washing in two baskets, taking them from either left or right following a fixed sequence.

5. Reproducing the string of beads arranged in a figure of eight (Fig. 10), either on a string which can be arranged in that form, or else on a rigid stick (occasionally with beads closer together than on the model). In this last experiment we shall encounter certain problems which will recur in connection with the study of knots, though with separate discontinuous items whereas the studies of Chapter IV deal with continuous series.

On the basis of the reactions to the above tasks, three stages were discerned, disregarding the initial state of affairs (Stage 0) where there is no correspondence, even by resemblance of items irrespective of order. The first stage is that of simple, intuitive correspondence of items irrespective of order. The second is that of simple linear but not circular order. This leads to articulated ideas enabling reverse order to be established and linear order to be brought into correspondence with circular order, though only by means of trial and error. The third stage is that of operational correspondence with easily made, systematic reversals of order.

Stage I can be split into two substages. At Substage IA, when the child is asked to reproduce the string of beads in a given order or to "hang up the washing" in the same order as on the model, he can only make a correspondence of similar items. Thus he places the same objects (beads of the same colour, similar pieces of clothing) on his copy as are on the model, paying no attention to the order in which they occur. This period covers from about 3 to 4 years of age. Prior to this (Stage 0), children of 2 to 3 years will place any objects in any order with not the slightest attempt to copy the model. At Substage IB the child can pair off elements by the principle of proximity but he cannot co-ordinate such pairs with one another.

During Stage II (4–6 years) the child becomes capable of making ordered correspondences. During Substage IIA this is confined to objects which are face to face, and various perceptual features acting as

controls are noticeable, bringing out clearly the reason for this limiting condition. For as soon as the situation no longer permits of visual correspondence the child can no longer reproduce the order. Apart from this, at this level there is absolutely no comprehension of the relationship 'between'. However, with the arrival of Substage IIB a greater degree of mobility in the correspondence of order becomes apparent, for it can now be brought about even when there is no longer an identical perceptual configuration in the model and in its copy. As a result, the circular order can be transposed into a linear one, though a reversed order cannot yet be made. Lastly, at a level midway between IIB and III the construction of the reversed order is gradually achieved through a process of trial and error, though in rather uncertain fashion. At the same time, more complex patterns like the figure of eight do not give rise to an exact correspondence.

From the age of 6 or 7 it becomes possible to speak of a Stage III, of an operational character. The reverse order is now made immediately, no longer by a semi-motor, semi-intellectual process of trial and error, but by a reversible operation of thought. The transposition of a figure of eight into a linear order still presents further slight difficulties but these are too rapidly overcome for it to be worth while distinguishing two separate substages at this level.

All in all, the development of ordered correspondences shows a smooth and continuous process of evolution, beginning with purely perceptual resemblances and culminating in the operation of ordering elements either in a forward or reverse direction and this is brought about by motor co-ordination at various levels, and either simple or articulated mental imagery.

§2. *Stage I. Simple intuitive correspondence without order through resemblance between objects*

When 2 to 3 year old children were asked to reproduce a series of objects in a particular order they were found unable to understand such a request. They selected objects at random and arranged them in completely haphazard fashion without the slightest attempt to choose those corresponding to elements present in the model. This is a type of purely negative behaviour comparable to that of scribbling whilst making no attempt to copy an object by drawing. There is little purpose in quoting such examples from Stage 0, but here is a case intermediate between this level and Substage IA.

TEA (3; 0) With the string of beads he reproduces only about one in every two similar to those in the model. As regards the washing, he is first made to cover each article with its twin before it is hung up. After all the pieces have been hung Tea manages to hang the corresponding pieces on the lower line but not in any kind of order. A second attempt is made with the string of

beads. The result is slightly better as regards similarity of colours chosen but there is still no trace of order.

Thus, Tea is still at Stage 0 with the beads, though he reaches IA in the case of the clothes line and washing. He can select the articles which correspond but cannot take account of proximity, even of pairs like AB or BA.

Here is a second example from this Substage:

ELI (3; 7) knows the names of all the pieces of laundry and himself hangs up seven adjoining one another. Asked to repeat his own arrangement on the lower line and facing his model he puts up the identical elements (7 out of a possible 12) but not in the same order. "Is it absolutely right?—*Yes*—There is nothing to change?—*No*—Is the dress next to the shirt on this line (model)? —*Yes*—And here?—*No*—etc.... —Then try to do the same as you did here". Eli tries again but still without any order. Only one proximity is respected but this is by pure chance because he is unable to trace any others.

Beads: exactly the same elements but again not in order. "Is it right?— *Yes*—Why?—*The blue one is here and the blue one is there, etc*". He makes a second attempt but there is not one correct proximity in it.

In contrast to this, from 3; 6–4 years behaviour characteristic of Stage IB is seen, which is the starting point of correspondences leading to order. The child places exactly the same objects in his copy as are to be found in the model, still without any general, but with some attempt at a partial, order. In other words, the child arranges the objects so as to conform to the general pattern of the model, but only succeeds in contriving proximities between pairs of elements and without bothering about how the adjacent elements are arranged (AB or BA) nor retaining it when adding one pair to another (ABCD or CDAB, etc).

SYL (3; 6) herself hangs up the washing on the line, one piece next to another in an order we shall call ABCDEFG. Asked to repeat this performance on the other line she takes the identical articles (7 out of the 12), hangs them up without any definite order and declares herself satisfied. When pressed as to whether the copy is correct in all respects she discovers that the green dress (D) and the red stocking (E) which are adjacent on the model are not so on the copy. She is asked to correct her copy on a third string, but in doing so places them in the order ED instead of DE. Then, noticing that B and C are adjacent, she puts BC after DE. She is asked whether the stocking (E) is next to the shirt (C) on the model, whereupon she puts C next to D, thus producing the order DCEB, etc.

Arrangement of beads: Syl chooses the right beads but in haphazard order: "Is it the same now?—*Yes*—Why?—*Because*—But explain it to me a little more—*There, there is one like that* (pink) *and these as well. There, there is that one and there the same again* ... (corresponding by similarity in colour but ignoring order)—It's absolutely right?—*Yes*—and the pink one is next to which one?—*The green one*—And on your rod?—*No*". She is made to begin all over again. The resulting copy is still without order but some proximities are shown correctly; EF for EF but CB for BC, etc., in pairs but with no co-ordination between the pairs.

Jac (4; 0) shows some slight advance in that his first attempt produces a correct pair and he improves his copy bit by bit, though without arriving at the right answer. The washing hung up in the order ABC . . G results first in the copy AEDBFG, (one element missing): "It's exactly the same thing?—*Yes*—What is next to the trousers?—*The sock* (adds C)—And next to the sock?—*A yellow dress*—Well then, arrange it all in the same way—(Arranges them in ABDECFG, i.e. with the end pairs and the pair DE correct)—And the blue jacket (D), is it in the right place? (rearranges them to give ABCEDFG)—Now there's a wind blowing and the lady wants to hang the washing around her (A G are arranged in the shape of a circle so that G and A are adjacent)—Would you like to do the same thing?—(Produces the order ACFBDEG)". The circular order is no more successfully reproduced using beads, nor is the transposition of circular into linear order a success.

Reverse order: "You see, the last is put first (G) and it carries on like this (demonstration by gesture)". Jac places GFBCDEA, then puts F between E and A.

Hen (4; 0) copies the model of the washing hanging in the order A G as ABC+EFG+D, then alters it to ABCD+GFE, then to AEBGCDF and ABGECDF, the growing confusion being caused by his desire to make a term for term correction of his basic series of three or four elements (the inversion GFE can be seen in his second attempt). The circular order A GA produces AH (which is not in the model) FGECDB, and then AHFEDGCB. The reverse order produces CDGEFA. The translation of circular to linear order is equally unsuccessful.

These elementary reactions give us some idea of the psychological conditions necessary for the construction of a sequence. If it is desired to reproduce exactly a series of adjoining elements then first of all the proximities of elements must be preserved. In fact, correspondence of two orders assumes that two elements A_1B_1 which are adjacent in the model shall likewise be adjacent in the copy giving A_2B_2 or B_2A_2. With a third element C_1 the model has the proximity C_1D_1 so that the copy must have either C_2D_2 or D_2C_2. In the model $A_1B_1C_1$ however, C is next to B but not to A so that the copies $B_2A_2C_2$ or $A_2C_2B_2$ are ruled out and only $A_2B_2C_2$ or $C_2B_2A_2$ are eligible. In short, co-ordination of proximities is enough in itself to determine the fixity of the order in which the elements can be arranged, whether direct or reverse, thus introducing the notion of only two possible directions of travel in such a series. In addition to this, the idea of order presupposes that proximity is regarded as entirely relative in the sense of being independent of the size of intervals; and especially, as independent of perceptual proximity. For example, in the linear series A . . B . . C, B must always be nearer A than C can be, whatever the size of the intervals between them, so that only the order of succession is taken into account irrespective of the shape it might assume in euclidean space.

As for the direction of the order, ignoring projective notions (such

as being to the right or left of the subject) and euclidean co-ordinates, this is governed solely by the way the subject chooses to enumerate the series, either A–B or B–A. Since this enumeration must follow in one or other direction, the elements must be separated before they can be arranged in order. Expressed succinctly, order implies proximity, separation and a constant direction of travel.

Now with the children described above one notices immediately a preliminary requirement which was still missing at the age of 2 to 3. This is the ability to copy a model by arranging identical elements on the basis of similar properties (colours, etc). In contrast to this, what is missing, at least in the beginning (IA), is the copying of proximities, the preservation of the proximity relations present in the model. As a result, Eli, who has collected together all the elements visible in the model, arranges them in complete disorder and then, when his attention is drawn to the fact that the dress is not 'next' to the shirt, etc., has a second try at reproducing the proximities with no better results. At Stage IB, Syl begins in a similar fashion but discovers for herself that she has failed to place D and E next to each other. This leads to her constructing the pairs ED and BC but these she is unable to co-ordinate. Jac can construct a correct pair of elements for himself right away, but he too is unable to co-ordinate successive pairs. Finally, Hen is able to build a series of three (ABC and EFG) and even four elements, but gets confused when he endeavours to co-ordinate these series with each other and finishes up by destroying their internal order as well.

What is the cause of these difficulties? The problem is the same as that which operates in the drawing of complex patterns like the mannikin, and so on. We saw in Chapter II that when the child can abstract a closed shape but cannot as yet portray the difference between a square, a triangle, or a circle, he can all the same draw a small circle near the boundary of some figure (inside, outside or astride the border itself). He can thus be said to possess, at this stage, a true mental representation of proximity for simple shapes or pairs of things, but when he tries to draw a mannikin he will attach the arms to the head, and so on, and continue doing so for several years without paying any attention to accurate proximities (synthetic incapacity). In the case of both drawing and making ordered series this can be explained as follows.

Proximity is the most primitive of all relationships. Nevertheless, separating nearby elements in the course of reproducing them in a drawing or copying them in a series is enough to alter the proximities themselves. This means that the original relationships must be recreated after having been broken down in course of reproducing them. Now this synthesis of the separated elements, or rather, the proximities, presupposes the choice of a fixed order of succession for the original analysis or enumeration. But this fixed direction of order can only be

maintained by co-ordinating the proximities between the separated elements. The child can therefore get nowhere, because he is in fact going round in a circle.

The really interesting thing about these reactions is that they show us how the child can only succeed in keeping to one direction while making his correspondences by basing himself on the co-ordination of the proximities themselves, for he has no other criteria. In the first place, it is impossible for him to locate the elements according to a system of co-ordinates because he has as yet no understanding of linear order and cannot relate distances or lengths to one another. In the second place, as regards projective notions such as right or left, it is noticeable that when reproducing an isolated pair of elements, these children are just as likely to arrange them in the order BA as in the order AB because they are unable to judge of their orientation. Mlle. Descoeudres has shown,[1] using Decroly's Lotto test, that pictures of sabots (clogs) are not properly oriented to left or right until the age of 5 or 6 on average, and that flags to be pointed in four directions, left, right, up or down, are not correctly turned until about 6, etc. Hence irrespective of verbal judgements as to left or right, these relationships will be of no assistance in maintaining a fixed direction of travel.

Thus to construct the sequence the child is reduced to starting with pairs and connecting them by the method outlined at the beginning of this discussion. But to succeed in this venture must nevertheless keep to a single order of succession, either left to right or right to left. We actually find Hen, the most advanced of these children, trying to co-ordinate ABCD with EFG and getting first ABCD+GFE through unwittingly reversing the order of succession and then confusing everything in the attempt to alter the position of the last term E.

In order to arrange the corresponding pairs in the right order, the child must achieve a degree of motor co-ordination sufficient to enable him to keep his own sense of direction. But to arrive at such a co-ordination he has to advance step by step and is hence compelled to rely on external co-ordination of proximities and pairs. At the present stage this remains a vicious circle which impedes the child's discovery of a general sequence within a given series. But at the next stage the difficulty is overcome through a general link-up of proximity, separation and sense of direction, each one of these relationships being supported by the other two.

§3. *Stage II. Intuitive representation of order when correspondence is visible*

The 4–5 year old child can understand the notion of order when he can check it constantly, through having the items of the model directly

[1] A. Descoeudres, *La Developpement de l'Enfant de 2 à 7 ans* (1922), p. 231.

opposite those of the copy he is making beneath it, but is no longer able to do so the moment a reverse or circular order is introduced. He cannot construct the order even with a direct linear series as soon as it is placed to one side of the model.

MON (4; 9) copies a set of beads by placing them on a rod in the same order as the model. He begins, just as at Stage I, by looking for similar beads but ignoring the order. He then draws his rod near the model and sees that the beads of the same colour are not opposite one another. He starts again, checking each bead in turn by putting his copy next the model.

A circular string of beads to be copied on a straight rod gives rise to a reproduction which contains all the correct items but not in the correct sequence. Mon tries to check his copy by superimposing it against the model, but he cannot manage it. The string is then opened out to a straight line and he sees his mistakes, after which the string is made into a circle once more. Again he cannot reproduce the order, except for two pairs BC and FE, the second pair being reversed. When the model is again stretched out in a line, but with a slight gap between it and the copy (the model being placed a little higher and to the left), Mon places the initial terms ABC correctly but the remainder are wrong except for one reversed pair.

A new attempt is made with the circular order and with the same colour recurring at every other element (ABACAD): "Where do you look on this necklace to see where you're up to?—*A blue one* (B), *then a yellow one* (A) *after that. It's a bit hard! Another yellow one* (A), *then a green one* (C)". The three elements BAC are successfully reproduced, but after this Mon comes out with AAD. The model and the copy are lined up. The copy is corrected at once.

Once more returned to the shape of a necklace, the same difficulties arise. We try to get him to point out the correspondences by hand, one finger on the rod and one on the necklace: "Which one is between the green and the blue?" —(without understanding the question he enumerates the whole lot). He cannot follow the order on the circle (although he follows it on the straight rod), for lack of tactile-motor and visual co-ordination.

He is asked to pick out two necklaces both in the same direct order from among three, one of which is in reversed order (each has the same elements and the same proximities, of course), but he fails in the comparison for want of visual-motor co-ordination, finding all three the same.

PEL (4; 7) is given beads to fit on a straight rod. On the first attempt the colours are right but not the order, except for a few pairs matched in both directions and not co-ordinated. By bringing his copy near the model Pel sees his mistakes, then begins again and succeeds by means of superimposition. The translation of the circular order to a straight rod results in total failure.

The correspondence of articles of washing in direct order on two lines is successful at first go when the second line is placed near the first, but failure ensues when it is offset a little to one side. The reverse order is likewise a failure.

Pel is asked to point out on a bead necklace (direct order): "between which

and which colours is the red (B)?" He points to all the colours in turn, showing that he has not understood the question.

LIL (5; 4) is asked to hang up washing. A trial is first made with the model offset to the right. Lil manages AB but cannot continue. When her line is moved directly under the model she is able to form the order correctly, though at first omitting the sixth element (out of the seven) and then correcting her mistake by checking each item in turn with one finger. Fresh attempts are made with the model offset to the right. At first she produces ADCE, then moves E to the right and forms ADCFE. Then remarks: "*Oh no, that goes next to it*" and alters it to EF. A new attempt gives ABCFEG, then ADBCEFG. "What is next to (A)?—*Oh yes, the shirt* (finally produces ABCDEFG)".

"Good. Now the lady hangs up her washing in a circle. You must do the same". Lil manages to copy the circle but not by reproducing the order. She starts by putting A at one pole, then puts DE at the other. Then she puts C in front of D and G in front of A, finally inserting F between E and G and B between A and C, thus ending up with a correct reproduction. Lil is then asked to copy the same circle in the same direction with the two poles reversed, to see if she can reproduce it following the order alone rather than by flitting about from one pole to the other as she previously did. She first puts up BAE, then starts again in the opposite direction ABGCE (thus moving from one side of the model to the other). She starts again in a circle but leaves this at a tangent, ABGFCED. "But you must hang your washing in a ring". Lil hangs up (again following the reverse order) ABFCEDG and after making many corrections at the experimenter's suggestion she achieves a correct but reversed order, thereby re-establishing the original state of affairs.

Given a necklace to copy in a straight line, she produces a series of unco-ordinated pairs BADCFE. She cannot transpose from the circular to the linear order at all.

FRAN (5; 6) is successful right away in lining up pieces of washing when the two cords are face to face. He is also able to reproduce the circular order, but as soon as the poles are reversed he proceeds by means of unco-ordinated pairs; ABGFEDC altered to ABCDEFG as a result of successive suggestions made by the experimenter. A fresh attempt (with different elements) gives GFCAD, then ABFCED and finally ABCDGFE.

UL (5; 8) constructs the direct order for seven beads right away. Reverse order: "Can you start from the other end this time? (He is shown G is to be put where he began with A before)—*I don't know how it's done. I can't do it* (he places GE, leaves out F, then comes D which is opposite D in the places GE, leaves out F, then comes D which is opposite D in the centre of the model)—*There's something that's bothering me there* (D! He then begins again with G and says)—*There's nothing bothering me there*" (GFE) but he stumbles once more over D. He also fails to transpose a circular into a linear order.

With the washing he succeeds with the direct order, then starts piling up the articles, unfastening them one by one. He is asked beforehand: "Could the trousers (median D) go on top?—*No, because it's next to that* (E)—And could this go on top (E)?—*No . . .yes, it might do*". Reverse order; he manages GFE then gets completely mixed up from D onward.

We observed at Stage I that once the proximities are broken up by analysis (in the course of separation of terms), the maintenance of a constant direction of travel was essential to re-establishing proximities between successive elements. Since each pair of elements AB can be arranged in two directions AB or BA, their co-ordination virtually presupposes a distinction having been made between the two directions of travel, and also the possibility of maintaining each one separately. This is precisely what the children at the level of IIA enable us to corroborate in the most unequivocal fashion, since in some cases they succeed in reproducing the order whilst in others they fail, thus making it possible to isolate the factors involved and study them separately.

First of all, it is abundantly clear that the discovery unique to this stage, the reconstruction of the direct order with the copy directly below the model, is entirely the outcome of the newly acquired ability to maintain a constant order of progression. For example, Mon begins (just as at Stage I) by collecting together the same beads as he sees in the model, without concern for any particular order. Then he has the idea of bringing his rod up to the model and he notices as a result that the order is not the same as that in his copy. At his second attempt he tries a method which consists of checking each item in turn by setting it against its opposite number on the model. In this way the constant order of progression is guaranteed automatically, with the result that he can locate the proximities correctly as long as the orientation remains unchanged. Pel uses the same method with the necklace and also succeeds in reproducing the order of the clothes hung on the washing line, when those on his copy are no more than a few centimetres below the model and directly in line with it. Thus the sense of direction is once more guaranteed as a result of the child organizing his movements according to a simple perceptual pattern.

But this pattern need only be complicated very slightly—as when the model is moved to one side so that the child's movements between the items of the model and those of his copy are a little handicapped—for the pattern of unco-ordinated proximities immediately to reappear, just as at Substage IB. Under these conditions Lil produces a series ADBCFEG in which the pairs BC and FE may be discerned, but facing in opposite directions. Thus by and large, the proximities are maintained but neighbouring pairs of elements are not related for lack of those movements which, in the first type of situation, guaranteed the maintenance of a constant direction of travel through the simple perceptual pattern.

In addition to separating the items—an essential step in the process of reproducing the sequence—there are, in the present case, two factors obviously concerned in the construction of order. The first of these is

the re-establishment of proximities destroyed in the process of separation; the second, the choice of a sequential order running either from A–B or from B–A, together with the maintenance of this sequence without oscillating from one direction to the other. At this stage, however, so soon as a spatial gap occurs between model and copy it is just this sense of direction that the child finds difficult to maintain for lack of motor co-ordination.

The point becomes even clearer when it is a matter of copying a circular order (a circle formed of pieces of washing laid on the table), either direct or reverse, or even transposing the order of a necklace into a linear series. In the latter case Mon arranged the beads regardless of their order. He was subsequently able to rake together a few sets of two or three items but was never able to co-ordinate the whole series. Lil managed to copy the circle of laundry—but only when permitted to ignore the correct sequence and locate the items in relation to the two poles. As soon as she is compelled to progress in the correct order—as a result of the initial item being changed—she proceeds just as did the children of Stage IB in the case of linear order, producing the series ABGFCED in which the pairs AB and GF are adjacent and reversed, and are followed by an isolated item, then the reversed pair ED. Fran responded in exactly the same fashion.

Now it is easy to see the kinds of difficulties which circular order introduces. They are difficulties associated both with separation and direction of travel, and therefore of the kind which tend to cause a regression to behaviour similar in principle to that exhibited by younger children when they try to solve problems involving linear order. Unlike the straight line, which has two opposite ends, the circle has no points of reference[1] since it is a closed figure shape, so that the child finds it more difficult to separate the items mentally without overlooking any. Having broken up the series he has next to reconstruct the proximities, and here the circle presents additional difficulties since both directions of travel lead back to the same item. Moreover, in following the series round both sides of the circle, from top to bottom or the reverse, the child reverses the order without realizing it. This is the reason why the pairs of neighbouring elements which he brings together are oriented now one way, now the other, just as at Substage IB.

In this connection, it is particularly interesting to notice that at the present level the less advanced children cannot even follow the corret spondence between the beads on the necklace and those on the straighrod with one finger, nor can they establish whether the order is identical in two circular necklaces by eye (Mon). Thus in making a comparison between a necklace and a straight line of beads or between a pair of

[1] Except when given two perceptual poles. This is what enables Lil to succeed in making her copy.

necklaces, neither finger nor eye movements are adequate to maintain a constant sense of direction.

In these circumstances it is not altogether surprising that the reversed order cannot be achieved, even with lines of washing superimposed directly above one another. For even when the direct operation, such as putting objects in a particular order, has been mastered, the reverse operation entails, from the motor standpoint, a degree of mobility far beyond the powers of a child who already finds it difficult to co-ordinate his hand or eye movements in the case of objects which are in an identical order but not superimposed. Here it is obvious that the reason the thinking of these young children is non-reversible in character is because it is still sensori-motor, and this feature is a product of a deeper-lying non-reversibility inherent to their very perceptual and motor activity. In the case of the most advanced child Ul, who, after considerable trial and error, can manage to reverse three terms GFE, a further difficulty arises. When he reaches the midpoint D, corresponding to the same mid term in the direct sequence ABCD . . . , he loses his sense of direction because of the alternative possibilities of continuing either DCBA or DEFG. The identity of the two midpoints 'bothers' him and he loses his direction of travel, like an inexperienced oarsman who in trying to turn back moves forward again at every few strokes.

Lastly, it is interesting to observe the difficulties which the children of Substage IIA experience in trying to understand the meaning of the expression 'between'. When asked to show 'between' which beads (e.g. A and C) a given bead (B) is situated, Mon and Pel, in the case of direct circular order, are unable to give any better answer than enumerate all the other members of the series.[1] As for Ul, he is of the opinion that if the series A–G arranged before him is made into a pile, then the term E will somehow be found at the top of the pile. Yet he had already begun to stack the items and it was during the actual course of this that he foresaw this possibility.

§4. *Stage II. Intuitive correspondence of order substage IIB. Transposition from circular to linear order. Failure to reverse the order*

The intuitive correspondence achieved at Substage IIA is of a rigid nature, only applicable to cases in which the model can be directly superimposed upon the model. At the present substage there appears a freer and more flexible type of mental process capable of extending beyond the confines of perceptually adjacent patterns. At the outset this new development only affects linear correspondence when there is a slight offset between model and copy, or the transposition of circular

[1] They are, of course, quite correct in the sense that in the circular order DEFG are also between A and C just as much as B is, but they make no distinction between the sections ABC and CDEFGA.

into linear order. Neither linear nor circular reverse order is as yet achieved, nor can the figure of eight be transposed into a linear series.

Joc (4; 11) copies a straight row of eight beads accurately, following each bead by eye and not touching them. He does not make one mistake. But for the reverse order he could only manage HABC... (and this after several attempts). But he has no difficulty in copying a necklace by means of a linear series.

Figure of eight: Joc follows the course of the upper loop from left to right, then turns from right to left at the crossover, ignoring the intersection.

Laundry: (Here he has to predict the order in which the clothes will stack in the basket when taken from the line). At first he cannot even state the order, enumerating them out of turn. He then piles them in the order A (bottom) BC... G (top) and is asked to transfer them to another basket by putting G at the bottom and continuing with FE... A. This confuses him completely and he imagines that the mid term D will be at the top of the pile, that the upper articles will remain on top (under the middle one, D) and lower articles will stay at the bottom.

DEL (4; 10). Transposition of the necklace into the linear order is correct immediately, and also correct with gaps between the elements. Confronted with three necklaces, one in reversed order, Del thinks they are all similar and is unaware of the reversal. "You see this silvery bead; where is it?— *Next to the green*" (he points to the green bead, to the right of the one and the left of the other).

Laundry: Direct order is given correctly but the reverse order is a failure. He does not manage to predict the order of stacking either direct or reverse.

GET (5; 4). Given the direct linear order with large intervals between the beads he constructs first ACB, then ABCE, etc. With small intervals he has no difficulty.

Two necklaces, one in reverse order. Get sees no difference. "Next to the pink?—*The blue* (points to the right)—And on the other?—*It's the same* (points to the left)" One of the necklaces is turned round but Get does not see the difference (as in the case of mirror writing).

Laundry: He is successful with direct order with the model offset to the left, while the reverse order is correct as far as the Mid-point GFED, but having reached D, Get is unable to go further.

AND (5; 4) also fails with the reverse order (laundry) after reaching the mid-point D, but transposes correctly the order of beads on the necklaces into a straight line. "Is it the same?—*Yes* (points out each correspondence with his finger)—But (A) is next to (G) on the necklace?—*Oh yes* (he removes A and puts it at the end, giving BCDEFGA)—But (B) is next to (A)?—*Oh yes* (produces CDEFGAB)—But (C) is next to (B)?—*Oh yes* (produces DEFGABC)—*Oh, it's always the same!*" (The penny has dropped!)

The necklaces are reversed: "*It's the same, but this one is this way and this one is that way*" (he makes a gesture in a reverse direction).

MOR (5; 9) is at once successful in transposing the circular into a straight row (necklace) but finds it difficult to come to a stop. He places A FGAB ... FGA. The linear order with large intervals is performed correctly.

Reverse order (laundry): GF followed by DE corrected to EC, then BC, etc., constantly following back into direct order.

Stacking: After piling the first three articles ABC he manages to foresee that since A is at the bottom G will finish up on top. But he is unable to anticipate the reversal when the articles are put into another basket. We put G at the bottom of the second basket and he adds F and E but cannot see that A will be the last to go in.

LOT (5; 10) manages to transpose circular order of the necklace into a straight line at first attempt: *"There we are, it's exactly the same* (he checks spontaneously by opening out the necklace and putting it next to his own).

Reverse order (necklace): He begins with ABC . . . then makes a few attempts to correct his error—GAB, etc., and falls back to direct order again. But when he is assisted by having GFE arranged for him he continues with DCB. Nevertheless, he fails to see the difference between two necklaces, one in direct and the other in reverse order. We place GF, and Lot carries on with ED, not knowing how to go on after the mid-point D which is common to the direct and reverse orders alike. On the other hand, he can copy the circular order no matter at which pole the starting-off point A is placed.

These observations are of particular interest for the psychology of intuitive representation, especially in connection with the role of motor activity in linking up ideas and developing reversibility. Broadly speaking, one can say that the reactions obtained at this level, in fact, mark the beginnings of mobility in motor co-ordination. Furthermore, that it is this increasing mobility which explains the progress made in abstracting shape, and the one or two signs of anticipatory thinking which it was possible to glimpse in a few of the children.

This increased mobility is first of all apparent in copying a direct linear order, which is now performed at first attempt, even without superimposition and without checking the correspondences by hand (Joc, etc.). An interesting obstacle is still present in the case of Get, though Del, Mor, etc., solve the problem immediately. This is in connection with perceptual proximity of the elements. When large intervals are introduced between them the child finds it more difficult to preserve the right order in his copy. Thus it is clear that in the beginning order depends upon absolute proximity (which means perceptual proximity) and only at the present level does the child begin to rid himself of this handicap and only observe relative proximities, placing B after C or C after B irrespective of the distance between them.

As for circular order, this is now reproduced correctly no matter whether the starting point is at the same pole as on the model or on the opposite one (Lot). Moreover, all the children can transpose the circular into the linear order without difficulty.[1] Some of them can immediately

[1] It would be wrong, however, to draw a parallel between these results and those derived from cylinders in motion (*Les Notions de Mouvement et de Vitesse chez l'Enfant*, Chapter II) where it is a question of predicting order in terms of displacements which take place unseen.

grasp the fact that an open necklace is only a line needing to be drawn taut for it to become straight (Lot). But it is apparent that although this transformation is understood, the children sometimes seem rather reluctant to accept the idea that in a linear order the last element cannot be next to the first, as it can in the case of the circular order. Hence, Mor does not know how to complete his construction and forms the sequence ABCDEFGABCDEFGA. Others such as And—whose difficulties are particularly clear—move the first term to bring it next to the last, then the second, then the third, and so on, up to the point where they realize that they could go on doing this for ever.

As for stacking in order, the majority of these children are still unable to solve this problem (except those at the end of this substage, like Mor) because it entails a 90° rotation so that the left-right relationship becomes one of upper and lower. Not only do the children fail to grasp this change but one even finds them imagining that a term in the middle of the horizontal series, such as D, will come out on top of the pile. This is a further proof that, prior to reverse operations of thought, relationships are not maintained invariant. It follows automatically that the reverse order of stacking is not understood either. The children cannot see that when the pieces of washing are transferred from one basket to the other, one by one, the top will become the bottom and vice versa (see Mor and Joc who, after piling items in the order ABC . . . G, think the middle one D will be last when the operation is reversed).

Although circular is transposed into linear order correctly, the figure of eight is not mastered with any accuracy. The children merely follow the path of each loop in succession without considering the intersection (see Joc). We shall again encounter this kind of difficulty when dealing with semi-intertwinements and knots in Chapter IV.

Thus although the increasing mobility of thought which is characteristic of this stage can give rise to the articulation needed to reproduce the linear order with the model separated from the copy, or for transposing direct circular into direct linear order, nevertheless, the problems of rotation or semi-intertwinement cannot yet be solved. In this connection, the outstanding problem is that of reproducing a linear or circular order in reverse direction. Joc produces the series HABC . . . G, Del and And begin with GH but then continue with unco-ordinated pairs, each of which is first arranged in direct order. Many children can manage to follow the reverse order as far as the midpoint, but as the middle element is the same for both directions (when the series consists of an odd number of elements) they are embarassed by this coincidence and no longer know how to carry on (cf. Lil's being 'bothered' at the previous level).

Now although failure to complete the reverse operation is common to all intuitional levels, it is even more striking in the case of actions such

as arranging objects in order, in that most of the children fall victim to the same quasi-perceptual illusion as at Stage IIA. When confronted with two or three necklaces, one of which is in reverse order, they fail to see any difference in the arrangement of the beads. Del considers the three necklaces similar because the silvery bead is 'next' to the green, unaware that in pointing to the green bead he indicates now the right and now the left of the silver one. Get cannot understand the reversal, even when the necklace is turned round and replaced in the direct order. Only And recognizes the two opposing directions, all the other children remaining just as incapable of grasping the distinction as those in Chapter IV are shown to be of recognizing the difference between what topologists term a righthand and lefthand 'overhand' knot.

It would seem that this illusion is only explicable in terms of insufficiently developed motor co-ordination, in that the child cannot yet describe two circular movements in opposite directions in rapid enough succession to be able to compare them. It is significant that the illusion does not occur in a linear series, for with the straight line, direct and reverse paths lead to two exactly opposed poles. In the case of circles, however, the opposite is true and movement in either direction covers the same elements and leads back to the same starting point. The result is a phenomenon, similar to that which continued to impede the transposition of circular into linear order at Substage IIA, and which now reappears when two circular series have to be compared in reverse order. In making such a comparison the child has first of all to 'separate' pairs or miniature series and then rearrange them in the opposite direction. But even with a single circle the two alternative directions lead eventually to the same point. In comparing two reverse circular orders this element of confusion is obviously doubled so that the child cannot maintain a constant direction of travel. Instead, he darts from one pair of elements to another in the two circles, follows now one direction now the other, and sees indifferently series such as AB or CB, and so on, with the result that comparison is made impossible and nothing but a single order is discernible.

It is therefore not difficult to see what hinders these children from constructing the reverse order when they are given the direct order model. Without realizing it, they continually relapse into the more familiar direct order, in the same way as they tend to confuse the two opposite directions when looking at two circular orders. But as we shall see throughout the course of this work, it is basically the inadequacy of motor co-ordination which is the cause of all these difficulties, which are identical to those which arise in co-ordinating perspective viewpoints (left-right relations, general perspective) and constructing co-ordinate systems in euclidean space (vertical, horizontal and tilted in the three dimensions). In this respect, the complexities encountered in the develop-

ment of the relationship of order tend to suggest motor and intellectual complexities of a more general character, of which mirror writing is a particularly well-known instance.[1]

From this we may conclude that motor activity in the form of skilled movements is vital to the development of intuitive thought and the mental representation of space. It will be recalled that the initial construction of order (transition from Substage IA to IB and IIA) already entailed the co-ordination of eye movements. Without such a perceptual activity, simultaneously sensory and motor, order cannot even be perceived. This is followed by co-ordination of hand and eye movements (fingers touching the items in turn) so that perceptual activity is reinforced by motor manipulation. In this way, proximities picked out by perception are made to tally with the separations produced by the process of analysis, and their continued correspondence is guaranteed by choice of a fixed direction of travel, maintained throughout the course of the action by motor activity.

At Substage IIA, however, this process is insufficient to maintain correspondence between circular and linear order, since in this case two different perceptual patterns are involved. The problem is solved at Substage IIB by linking up or articulating these existing notions, again by means of an action, that of opening out the necklace and drawing it into a straight line. It is this kind of movement, internalized as a pictorial image (cf. Lot), which signalizes the appearance of mental processes, reconstructive and anticipatory, able to transcend the limits of direct perception.

But this is as far as the advance covered by Substage IIB goes. When it is a matter of distinguishing the alternative directions of travel in three necklaces, the child is unable to make the distinction, due to inadequate visual or tactile co-ordination, as we have just noted. And in particular, when he has to reverse a linear or circular order, motor activity, which is essentially irreversible, is unable to solve the problem. Such a reversal, and reversibility in general, is not possible of attainment until the increasing mobility of motor and perceptual activity are extended in the course of their own development and able to provide more comprehensive imitative anticipations and reconstructions. This is what we find taking place at the subsequent transitional level, the point at which the growing conceptual reversibility begins to take over, by means of a species of retroaction or 'reflection', the self-same motor activity that has culminated in operational thought. And so soon as motor activity comes under operational control it is able to function in the two successive directions.

[1] On this topic, see the interesting article of I. Meyerson and P. Quercy, 'L'orientation des signes graphiques chez l'enfant', *Journal de Psychol.* (1920), p. 462.

§5. *Stage II. Intuitive representation of order. Examples of transition from Substage IIB to Stage III. Construction of reverse order by trial and error*

The problem of reverse order is not solved fully and immediately until Stage III. Between Substage IIB and Stage III it is only solved in trial and error fashion through intuitive corrections and adjustments. Other problems of a similar nature, such as the direct circular order arranged as a figure of eight (homeomorphic with the circle but with the appearance of semi-intertwinement), are not solved at all, at least as a general rule.

Here are a few such transitional cases, beginning with a child who still belongs almost entirely to Substage IIB.

MAR (4; 10, advanced) is successful with the simple linear order, first with gaps between some elements, then with all elements spaced wide apart. She has no difficulty either in transposing it to a circular order. Next, with one or two reversals which are subsequently corrected, she succeeds in reversing the circular order, in addition to a linear series of seven elements. But the transposition of circular into linear order still gives rise to a reversed pair at one end (GF). This is the only instance in which this problem appears more difficult to solve than that of reversed order.

DUP (5; 1, advanced) arranges articles of washing on a first line. "Now the lady wants to hang them starting from the other end. You see here (under the A of the model) she wants to put the green dress (G). What comes next?—He places F then CDFG—Try again"—He succeeds no better, placing GFCDEAB.

But his reactions with the necklace are more advanced. First he is shown three similar necklaces, one reversed. "Are they the same?—*Yes* (shows the correct proximities on the necklaces in direct order)—And that one— . . . —Next to the silvery bead, what is that?—*The blue*—And here?—*It's not on the same side*". After which Dup correctly copies the necklace in a linear order. "Now you are going to do the same thing, but turning it round the other way"—(Picks out each element in turn with one finger and thus succeeds).

A figure of eight made up of nine elements to be transposed into linear order. He follows the outline without taking account of the crossover. "Now we're going to make it round again, like you saw it before. Will it be the same as on your bit of wire?—*Yes*—(He is asked to compare and is astonished at the partial inversion). Now we're going to make it an eight again. How would you do it?—*I'll make it the same*" (he fails).

SYL (5; 4) makes a correct copy of one necklace at first attempt. He is shown three of which one is reversed and immediately notices the difference of order, pointing it out with one finger whilst laying the reversed necklace side by side with the other. "Can you make me a copy of the necklace on this straight needle?—(Manages to do it without one error, but reverses the order without noticing it)—And now like this the other way round?—(He again copies it in direct order without realizing it, but then turns the whole thing

round of his own accord to obtain the reverse direction!). Laundry of six articles to be reversed. He produces FECDB, then corrects it to FCDEB and finally to FECDBA.

Hof (5; 6). Laundry of seven articles to be reversed. He places GFEDBCA, and then by following it with his finger discovers his mistake BC, but is unable to reverse this pair without starting all over again.

"We're going to put the washing in the basket starting with (G). What is going to be in the middle?— . . . —And on top?—(A)—Good, and in the middle?—(Points to each with his finger) *The sock* (D)—That's right. Now if we empty this basket into the other one, what will there be on top?—(G) —And at the bottom?—(A)—And in the middle?—(D)" Thus the inversion is correct.

Three necklaces, one reversed. For a moment he thinks they are similar, then he spots the inversion by following with his finger. He thereupon turns the reversed necklace around of his own accord, in order to obtain the direct order.

Glo (5; 10). Laundry to be reversed. She begins correctly with GFED but when she reaches the mid-point D she wants to carry on with the direct order EF, then noticing FEDEF, corrects it to DCBA. For the stacking Glo foresees that if A is at the bottom G will be on top and vice versa. "If the basket is emptied out?—(A) *right underneath and* (G) *on top*—Why?— *Because you've turned them round!*—And this (D)?—*In the middle*—And if it's turned round?—*In the middle again. It stays the same*".

Cha (6; 4) transposes the circular order of the necklace into a linear series quite correctly and without too much difficulty produces the reverse of a simple linear series. However, he fails to solve the problem, usually mastered at Substage IIB, of copying a circular order whilst altering the position (pole) of the starting point. After reproducing, in accordance with their perceptual pattern, articles of washing arranged in a circle, he is asked to begin again, placing A at the lower pole (nearest himself) of the circle instead of the upper pole. Cha thereupon places ABCD correctly but cannot go on. He starts again producing ABEDCFG and after a series of trials and errors is forced to rearrange the whole lot according to the pattern of the model.

Fin (6; 4). Laundry. Produces the direct order correctly, but for the reverse order places AGFEDEG, stumbling over the middle term D, then he corrects it and ends up with the whole series. He distinguishes the reversed necklace from the other two: "*That one's upside down*". When he comes to the necklace arranged as a figure of eight he neglects the crossover. When it is rearranged into a circle he notices the difference between his copy and the model and then tries to make his into an eight like the model. "*There you are, that's right. Oh no, there's that which isn't right* (points to a section)". But he still does not succeed at the next attempt.

Kos (6; 5) reverses a necklace on a rod: GFEDCB, then he places A before G. "Is that it?—*Oh, no* (puts it after B without realizing that it will come to the same thing when the necklace is closed)—How can you see whether it's right?"—(He at once reverses his rod, correctly).

The figure of eight. He misses the crossover, but after the model has been rearranged in a circle he corrects his error.

It will thus be seen that these children, who have reached the most mobile articulations of Stage II, and are consequently on the verge of the operations of Stage III, succeed in reversing the models only with great difficulty and after many trial approximations or intuitive adjustments. A curious fact is that the reverse order sometimes appears easier to achieve with the circular than with the linear series (e.g. Dup), despite the greater difficulties previously encountered in copying a circular order. This is not a universal phenomenon since Cha, for example, is still unable to produce a circular order when the poles are changed (the position of the initial term of the series). But when it does occur, the explanation again lies in motor activity. For the movements which correspond to the two directions of travel around a circle resemble one another more than do those describing straight lines, for while the former tend to approach one another, the latter get further and further apart. It is thus understandable that so soon as they can be distinguished, the two opposed movements tend to elicit one another more easily in the case of the circle than with straight lines.

The child Syl responds in a remarkable way, at least in one particular, for he transposes the direct order into the reverse order without realizing it. When he is now asked to produce the reverse order he does just the opposite and finishes this display by turning round the complete series to obtain the reverse order, thus behaving in an almost operational way. Here one is actually witnessing the spontaneous transition from gradual, piecemeal differentiation between two movements to a true conception of reversal. It will also be noted that practically all children at this level can distinguish between the necklaces in direct or reverse order, as contrasted with the reactions seen at Substage IIB (see Dup, Syl, and Hof).

As for reverse order, the children of this stage only manage this after considerable trial and error, or prompting by questions. One cannot speak of reversible operations as yet, unlike the subsequent stage where the solution is immediate and part of a complex operational system. In this connection, it is interesting to watch the children actually at work trying to construct a reverse order. They pass from the last term of the model to the first term of the copy, back and forth, touching each item in turn with contrary hand movements. Yet despite this active motor guidance they stumble over many obstacles, even though they understand quite well the general sense of what they are doing.[1] In particular, the middle term, the meeting point of the direct and reverse paths, still occasions involuntary reversals, later corrected with considerable difficulty. At other times, a pair in direct order is suddenly introduced into a reversed series, and so on.

[1] This grasp of the general nature of the problem is illustrated very clearly by the expression which the children use. The term 'the contrary' takes on a serial meaning it did not possess at earlier levels.

On the other hand, the stacking of items is nearly always achieved correctly. Not only does the child realize that the top will become the bottom and vice versa, according to whether the pile is made by taking items from one end of the line or the other, but he also discovers the invariance of the middle term which always remains 'between' the two extremes.[1]

§6. Stage III. Operational correspondence. Conclusions

Towards the age of about 6 or 7, children arrive at what may be considered a stable and rational conception of direct and reverse order. They eventually come to see the order between members of a series as part of a unified whole and are consequently able to reconstruct a series just as easily in one direction as in another. Already at the previous stage one occasionally found a child turning round a rod, on which he had more or less painfully constructed his reverse order, in course of trying to find the direct order once more. But in such a case it was merely a global, intuitive notion, which ignored errors of detail.

From now on, each movement is linked with the rest and this general reversibility transforms what was merely a mental action into a true operation of thought. Here are a few children who have reached this level as regards reverse order, but still experience difficulty over circular order with semi-intertwinement (the figure of eight) before reaching the correct solution.

Rys (6; 6) arranges the articles on the washing line. "Would you like to do the opposite of what you did on there, starting with this one (G)?—(He does this right away). *It's just the same thing, they're all the same*—Why?—*I didn't start the same way, but like this* (movement of fingers in two directions), *it's just like playing games in break*—And if you did the opposite of this (reverse of reverse)?—*It will come out like this*" (he indicates the direct order)[2].

In the case of stacked laundry, Rys predicts the positions of the top, middle and bottom articles correctly for both directions.

Transposing the necklace into linear order is performed correctly. "Why isn't the yellow (last) next to this one (first)?—*If it curved round in a circle it would be, but not like this.*" He notes the reverse order in one of the necklaces and turns it round immediately to show that it has the same order as the others. Construction of reverse order along a straight line: he has no difficulty. But when his reversed copy is rotated to direct order and then put in the figure of eight shape he is misled at first by the intertwining: "*Oh no! It's*

[1] Cf. *Les Notions de Mouvement et de Vitesse chez l'Enfant,* Chapter I.

[2] To illustrate how variable the likening of direct to reverse order can be, compare this example with a new one from the level midway between IIB and III. PHI (5; 10) constructed the reverse order correctly. "Now make it again, the other way round—(He does so) *Oh, it's the same thing!*" Thus Phi discovers that the order is identical only after he has produced it and is filled with astonishment at the fact, whereas Rys grasps the point in advance.

wrong! (he unwinds and compares it, then makes it into a figure of eight once more) *No, it's the same after all*". Thus after a little hesitation he finally understands.

LONZ (6; 6) reverses linear and circular order immediately, but for the figure of eight he first constructs two separate circular orders before grasping the semi-intertwined relationship through manipulation.

PIS (6; 10) produces identical reactions for the reversals. Begins the figure of eight by following the contour, but then cries out: "*Oh, I made a mistake, because it crosses over and I went straight on!*"

And now here are a couple of examples of children who succeed immediately with the figure of eight as well as with reversal of linear and circular order.

LEP (6; 10) reverses without difficulty the order of a necklace, a line of washing and the pile of laundry. With the figure of eight necklace he follows the correct order taking the crossover into account "*because it passes over the top*".

GRA (7; 5). Three necklaces, one in reverse order. "*The beads are the same but they're not strung the same way. There it's the white then the pink. Here I have to go backwards for the pink*—And if you copied it going this way? (we indicate the order)—*It would be like the other one*".

The figure of eight necklace is copied along a straight line, taking account of the crossover, then joined together to make a circle and finally twisted into a figure of eight spontaneously.

Such are the reactions obtained at about 6 or 7 years of age (though we did come across one little girl, a few days under 5, who could reverse necklace and the line of washing at first try, and copy the figure of eight after following the order with one finger). They differ from the reactions of the previous stage in one important respect. Although the children are capable of constructing the reverse order at both levels, they now solve the problem right away, whereas formerly they could only do so after trial and error. At the earlier stage, conceptual thought was not able to control motor activity completely but could only anticipate it slightly, after having shared in its misadventures. At the present stage, however, the simple reversibility which has now been achieved at the conceptual level reacts upon and guides motor activity.

The main conclusion to be drawn from this study, which we are ending at this point, relates to the fundamental difference between the perception and the representation of order. By this latter is meant the reproduction of order, either in the form of a mental image or in the form of a material copy identical with an actually perceived model. The perception of order entails no more than the perception of proximities, the separation of neighbouring elements, and a constant direction[1] of

[1] In the case of discontinuous elements separated by appreciable intervals, the sense of direction in particular must be kept constant to avoid reversals. The relationship of proximity will therefore be concerned with the intervals themselves.

travel in successive centrations upon these elements. Now the process involved in imagining or copying a sequence takes place in an essentially similar way, except that both the mental image on which the notion of order is based, and its reproduction by corresponding elements, can be compared to an imitation or a drawing. And this implies (as we saw in Chapter II) analysing the model with the aim of re-establishing the correspondences and rearranging the elements at a further remove. Perceptual proximities are totally inadequate for this purpose, however, since the separation of the elements is required, both for effecting the mental transfer between model and copy, and for the preliminary analysis which must precede it (since it affected one element or pair of elements at a time).

The proximities having now been broken up, the next problem is that of reassembling them. As we have repeatedly seen, it is in this process of reassembly that the role of orientation or direction of travel is so important, because the elements must be transposed with their order unchanged. This process must therefore be controlled in such a way as to preserve and re-establish the proximities which have been broken up, and this raises the question of how the constant direction of travel is to be maintained.

The answer to this has already been given. From the end of Stage I, up to and including Stage III, it is action or movement in its most highly developed and mobile form which carries out this task, thereby ensuring the further elaboration of these ideas, and indeed of the operations themselves. At Substage IIA it is the action of running the length of the model, by eye or with the fingers, and mentally transferring the separated elements one by one until a simple linear order has been re-established. At Substage IIB it is the action of changing the perceptual order (such as a circular order) and transforming it to a linear one. In the transitional stage between Substage IIB and Stage III the same actions are performed in reverse. Finally, at Stage III, when the anticipations and reconstructions are sufficiently linked together, these actions are grouped in the form of a rapid and mobile co-ordination, their reversible combination transforming them into an operation.

The concept of order is therefore no more the product of abstraction direct from the object than are the elementary topological relationships of proximity, separation, etc., which were studied through haptic perception and drawing. Order is abstracted through increasing co-ordination of actions such as transferring (transporting elements mentally) and replacing, step by step and piece by piece. It is the result of reconstructing the object through ordered actions, and not a directly abstracted quality. The physical order found in the object is reproduced through the adaptation of these actions, which in consequence lie at the root of the geometrical concept of order.

103

Chapter Four

THE STUDY OF KNOTS
AND THE RELATIONSHIP OF 'SURROUNDING'[1]

THE relation of order exemplified by three elements arranged in a series ABC also entails a specific relationship expressed by the word 'between'. Thus B is 'between' A and C, and at the same time 'between' C and A. In Chapter III we saw how this relationship, whose invariance remains a mystery to children who have not yet learned to reverse a series, evolves concurrently with the notion of order itself.[2] Now the relation 'between' is one particular instance of the more general relationships of 'surrounding'. These are, of course, elementary spatial relationships, just as much as proximity, separation or order. Indeed, as regards the construction of space, they are even more important, since it is most probably these relationships which lead the child by the most direct route, to differentiate and build up the three initial topological dimensions.

If the location of a point 'between' two others designates a one-dimensional surrounding (defining a line), and the location of a point inside or outside a closed figure (see Figs. 1–3, §5. Chapter II, drawn correctly at Stage IB) designates a two-dimensional surrounding (defining a surface); then the relationship of a point, whether inside or outside a closed box, designates a three-dimensional surrounding (defining a space).

It is therefore our next task to examine these relationships of surrounding (or intertwining), the mental analogues of the action of surrounding, in the same way that we have analysed the relationship of order; namely, in terms of the action of following or assembling one element after another. For the purpose of such a study one might utilize the action or notion of surrounding in connection with the relation of container to contained exhibited by rigid solids such as boxes, etc. But since solids have definite shapes with euclidean features, the disadvantages outlined in Chapters I and II would be encountered once more. That is to say, there would be an interaction between the elementary representational relations and the more highly developed perceptual ones.

Moreover, certain types of behaviour, such as surrounding a stick

[1] In collaboration with Mlle. G. Ascoli, Mme. J. Halperin-Goetschel, and M. A. Morf.
[2] On this topic, see above all, *Les notions mouvement et de vitesse chez l'Enfant*, Chapter I.

with a ring, have already evolved at the sensori-motor level,[1] which would tend to make such tasks too easy by the age of 4 or 5.

It so happens that in the case of 'surrounding', there is one area in which perceptual relationships have not yet been developed and hence ideally suited for studying the main features of representation. This is the province of knots, which possess the added advantage of having been the subject of extremely detailed geometrical analysis. It will be recalled that the most elementary branch of geometry, topology or analysis situs, does not deal with straight lines, distances, angles and the like, but only with forms which are elastic and capable of deformation, though without breaks or overlapping. The basis of topology as a branch of geometry is formed by the operation of "homeomorphisms" or point-point, bi-continuous correspondences (i.e. correspondences which retain unchanged the proximities, separations, and in the case of lines, the relative order). One of the types of correspondence studied by topologists in this connection is precisely that covered by the theory of knots.[2] From the standpoint of mental development, the knot is something which the child learns to form at an early age and it is therefore eminently suited to psychogenetic investigation. The value of such an approach is considerably enhanced by the fact that, in addition to their not originating perceptual metric relationships, knots do not form visual or sensori-motor gestalten, and in consequence their transformations only come to be understood by degrees.

In this chapter we therefore propose to study children's responses to the very simplest kinds of knot, the 'overhand' knot (an ordinary single-looped knot),[3] laying particular stress on the idea of surrounding (the relationship of enclosure or intertwinement) and homeomorphic correspondence or non-correspondence between simple shapes such as may be formed with an ordinary piece of string. For example, a circle, a figure of eight, a pseudo-knot, left and right overhand knots, taut or slack according to circumstances.

§1. *Technique and general results*

The technique employed is simple in the extreme. To start with, the child is shown an ordinary simple knot (see Fig. 11) tied tightly and asked to state what it is, solely to ensure that he understands the meaning of the word. He is then asked to make a similar knot. 1. (B) If the child cannot tie a knot he is asked to form one round a thick stick or bobbin and his method of learning studied. If he cannot succeed in this after

[1] Not without difficulties however. The children begin by simply pushing the ring against the stick, as if it would encircle the stick merely by contact. See *The Origins of Intelligence in the Child*, p. 320 (obs. 174), 1953.

[2] A knot is a closed curve lacking multiple points; that is to say, with no intermediate breaks. See L. Godeaux, *Les Géometries*, Paris, p. 188.

[3] See Glossary.

a few attempts a knot is formed slowly whilst he watches and he is then asked to imitate the actions he sees. If this also fails, he is shown a piece of string in two colours (half blue, half red) and the process is explained as a story ("the red goes underneath, then on top, then inside," etc.) as the action gradually unfolds, after which he is invited to do the same.

2. Once the knot has been formed, the child is shown one which is similar in pattern but more loosely tied so that it is enlarged or expanded (Fig. 11) and is asked if it is the same knot as the first. He is asked to copy this second knot and is again asked if it is like the first, "if it was made the same as the earlier one, etc." We next ascertain whether the child knows what will happen if the two ends of the slack knot are pulled.

3. The same knot is expanded still further in such a way that the two wings or half-loops become clearly visible in the pattern used conventionally to represent the 'clover' in geometry textbooks (Fig. 12). The same questions are then put once again. In other words, we have so far been trying to establish mainly whether the child understands the perceptual continuity between shapes (1), (2) and (3).

4. The child is shown a 'left-hand clover' (Fig. 12) and a 'right-hand clover' (Fig. 13) and asked if the knots are identical. He can either judge this by eye or by running his finger over the string from one end to the other. The problem may be rendered a little clearer by threading a bead on the string and asking what course it will follow, or by pretending that the string is a pipe inside which there is an ant crawling from one end to the other. If the child still fails to appreciate the difference between the two knots, he is asked to push the bead from one end of the string to the other, or to copy the knots. 4. (B) It is useful to have the children draw these knots, and each of the earlier ones, despite their being unable to show in their drawings whether one part of the string runs under or over the other.

5. Using similar methods the children are asked to compare a true and a false 'overhand' (the false 'overhand' is a pseudo-knot, homeomorphic with the circle when the ends of the string are joined, see Fig. 14).

6. In the same way, the children are shown what we will term, for the sake of brevity, a false and a true figure of eight. The false figure of eight is a simple 'overhand' knot whose ends are joined together and arranged in such a way that the knot separates two loops which appear identical (Fig. 16). The true figure of eight is, of course, homeomorphic with the circle (Fig. 15).

7. The children are shown two pairs of circles made of string, the first pair being merely superimposed, the second pair intertwined (Fig. 17), and are asked what would happen if the two opposite sides of the two loops were pulled in different directions (obviously, the first pair will separate and the second pair will remain linked together).

The reactions to these questions can be divided into the same three stages as were found to hold in previous chapters. The first stage, below the age of 4, is taken up by the learning of simple knots. Among the social strata from which our subjects are drawn, children learn to tie knots around the age of 4, on average. It is obviously interesting, however, to investigate how younger children approach the task of copying the model knots which they are shown, for in this respect a knot is directly comparable to the drawings of Chapter II or the ordered series of Chapter III. It was found that during Substage IA the children could not copy knots, despite being able to watch a visible model or listen to a verbal explanation, because they cannot grasp the principle of intertwinement. Thus they either wind one end of the string round the other, but without managing to insert either end in the loop; or else they insert one end in a half-loop without superimposing it. In neither case is there the necessary 'surrounding' and, consequently, no knot.

During Substage IB the children learn how to copy the knots but are unable to follow the various sections of

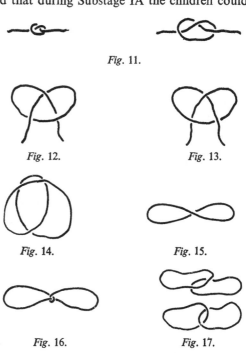

Fig. 11.

Fig. 12.

Fig. 13.

Fig. 14.

Fig. 15.

Fig. 16.

Fig. 17.

a slack knot with one finger, nor are they able to distinguish true from false knots. At Stage II they can reproduce the simple taut knot (1) because they now understand intertwinement and are able to distinguish between complete loops and half loops[1] when these are not superimposed. But at Substage IIA they cannot yet perceive the identity of two similar knots when one is taut and the other left slack and hence expanded (2), nor when it is arranged in the shape of the clover (3). Neither can they distinguish false from true knots at sight.

At this stage, therefore, we find a simple mental correspondence

[1] We term 'half-loops' the circles made by the string when the ends are not twisted one over the other.

between a pair of taut knots, or between a pair of loose knots. But this is lost as soon as the situation alters through the tightening or slackening of one of the knots, even though each of the pair is homeomorphic.

During the subsequent period (Substage IIB), the children recognize the homeomorphism between the taut (1) and the slack (2) knots, but not between these and the knot arranged as a clover (3), nor can they distinguish false from true knots at sight. As soon as they have discovered the identity of taut and slack knots, however, they are able to follow the path of the string continuously, whereas at the previous substage they simply jumped from one loop to the next.

After a transitional level, midway between Substage IIB and Stage III, in which the right answers are only forthcoming after trial and error, Stage III proper appears (between 7–7; 6 years). At this point the correspondence between knots (1), (2) and (3) is generally recognized with the result that these become reversible, and thereby operational. It necessarily follows that all these knots, whether taut or slack, are distinguished correctly from the false overhand knot, just as the false figure of eight is distinguished from the true one. Moreover, these children are able to distinguish left from right overhand knots and to understand that when pulled tight they do not produce the same knot.

§2. *Stage I. Learning to tie knots*

The first stage lasts up to the age of 4 on average but includes a number of children aged 4–5. None of these children yet understands how a knot is formed. At Substage IA, of which a few examples are given below, the child cannot even tie a knot after he has watched it formed before his eyes.

Col (3; 10). "Can you tie a knot? (a piece of string is placed in front of him) —*Yes*" (He merely brings the two ends together). No further explanation enables him to improve on this, so a knot is tied while he watches. This is left slack. "What is that there? Now pass this bead through there—(He passes the bead through the loop)—Now move the bead along the string—(He moves the threaded bead all the way along the string)". Despite this lesson he cannot copy the knot but can only bring the ends of the string together.

Mer (3; 11) does not stop when he has brought the ends of the string together but goes on to remark, "*You can go into the little hole like this*", and thereupon passes one end through the half-loop formed by the curved part of the string. The ends are then pulled and Mer is amazed to see the 'knot' disappear and the string come untied. He is then shown that the string "must be crossed". This is demonstrated for him but he cannot repeat it for himself.

Gab (2; 3) seems to be more advanced than the last two children despite his tender years, inasmuch as he makes a distinct effort to copy the loop and shows by his facial expressions that he is aware of his repeated failures, registering visible satisfaction when he succeeds by pure chance. He begins by

passing the string around the experimenter's arm and bringing the ends together, putting the first on top of the second, then carries on to form a true figure of eight. Following this he passes the string round his own arm several times in succession, but without bringing the ends together. Finally he makes a trial on the table by imitating a loop, placing one end on top of the other and pulling. After this setback, he succeeds once by chance but is unable to repeat the operation he has thus discovered fortuitously. Gab is then shown a rather slack knot, but though the experimenter follows the complete outline with his finger, he fails to do the same, skipping from one section to the other at the nodal points without regard for continuity. Neither does he succeed in distinguishing between two entwined circles of string and two loops one on top of the other, despite a few trial attempts.

Jac (3; 10) makes real experiments with the string, exhibiting great patience, after he has been shown how to tie a knot. He begins with a loop, simply putting the one end over the other and then pulling it. After this he starts all over again but twists the two ends round one another before pulling, etc. Despite a chance success he does not succeed in solving the problem. He is then shown two intertwined circles of string together with two partly superimposed but independent circles. He cannot distinguish between them by eye, even after handling them several times. Neither is he able to follow a partly untied knot in such a manner as to take account of the continuity.

Amb (4; 6), unlike Mer, does not try to pass the end of the string through an apparent loop, but tries to wind the string round several times. The loop thus becomes rather thick but Amb does not insert the end of the string through it. He is shown how to do this but without any resultant success. A rubber pipe, a little less flexible than the string, is put on the table in front of him. "Look at the snake. He puts his head on his tail (a gesture), then slips it under his tail (another gesture) and that makes a knot (tightened slightly). You do the same thing." (Amb makes a loop but cannot continue.)

Han (5; 3) fares no better than the previous children, despite her age. She forms a loop by putting one part of the string over the other (some way from each end) and then rightly remarks, "*You make a loop and then slip inside it*". But this is just what she cannot do, for she merely winds the string round a number of times, beginning a fresh loop on each occasion, but never "slipping inside it".

Although commonplace enough, these few reactions are very important in the study of elementary topological notions used by children. Firstly, it is evident that the children can bring the ends of the string together (Col) or place one part over another (Han) or even twist the ends round one another to produce a closed shape (Jac). The study of haptic perception and drawing have already indicated that the relationships of opening and closing appear quite early, so that we need feel no surprise in finding the children of Substage IA forming a loop right away. Secondly, we find Mer trying to slip one end of the string through the loop, and Han describing the action. This is another relationship which is grasped at an early stage, since children who can draw a closed

109

curve can also draw a small circle inside, outside, or even astride the boundary of the curve, as was seen in Chapter II.

Thus these children are acquainted with the notion of 'surrounding' (being inside or outside) and closure is intimately linked with this idea. The question is therefore, what is it they lack to enable them to tie a knot?

If their actions are considered from the purely phenomenological aspect, the answer is clear. They cannot manage to form the loop and "slip through it" (despite Han's perfectly lucid plan of action), while Col is content to form the loop without even attempting to do this. Mer tries to do so but is unable to close the loop, so that the string remains untied. Amb produces a number of loops by winding the string around several times, but cannot manage to pass the end of the string through the coil. Han proceeds methodically, forming a loop and then trying to "slip through", like Mer, but at each attempt she merely ends up with one more loop, like Amb, whose level of achievement she is unable to surpass.

What is the meaning of this failure in motor activity, from the geometrical point of view? Simply this; a string, considered as a linear series, is composed of consecutive portions or one-dimensional 'surroundings' (such that if B is 'between' A and C, it is actually surrounded by A and C along one dimension only). But the knot which has to be tied with this same piece of string is a three-dimensional 'surrounding', a complex of intertwinements. Although children have a clear idea of three dimensions at this age, nevertheless the transition from a single to a three-dimensional surrounding presents an obvious difficulty when it occurs through the agency of one and the same object. As proof of this we have the inability of Gab and Jac to follow slack knots with their fingers while at the same time following a continuous path when they get to the point where one part of the knot passes over another, likewise their failure to distinguish visually between intertwined and super-imposed circles.

It must of course be borne in mind, that in dealing with representational space (as contrasted with perceptual space, though the same process was also quite likely involved on the perceptual level at the beginning of mental activity), the 2–4 year old child is unable to construct dimensions by any other method than these self-same topological 'surroundings'. For he does not possess any system of reference or co-ordinates, even for horizontal—vertical axes (see Chapters XIII and XIV), or any projective co-ordinates (see Chapters VI–X). Consequently, the first dimension is afforded by a simple linear series, through his grasping immediately the fact that the midpoint of a line lies 'between' its extremities (that is, 'surrounded' by them along one dimension).

Granted, the experiments of Chapter III showed that the relationship of 'between' only becomes truly operational at a relatively late age (at least, in the case of the invariance of this relation for two directions of travel), and even makes it more difficult for the child to understand circular order. Nevertheless, with direct linear order it is apparent that the 'between' relation, the 'surrounding' along one dimension is grasped right away.

The child begins to construct the second dimension, not with euclidean surfaces or projective planes, but with the aid of simple topological surfaces, such as are enclosed 'within' a closed curve, and this is a case of 'surrounding' in two dimensions. Thus the closed curves with circles placed inside, outside or astride the boundary, drawn so accurately by the children reported in Chapter II, are examples of two-dimensional surrounding. In the case of a linear series having an element B located 'between' A and C, the segment connecting B to a point D, external to AC, does not cut the line itself. But a segment connecting some point within a closed curve with a point outside its boundary must of necessity cut the boundary, which is itself a line. This type of surrounding is therefore two-dimensional.

Lastly, the third dimension is produced by the notion of something enclosed within a box in such a way that in order to grasp the object it is necessary to open the box or pierce the sides. This dimension is therefore characterized by a type of surrounding, such, that an internal point cannot be connected with an external point save by a line cutting a surface.

Hence each of these three kinds of surrounding gives rise to ideas which appear at a very early stage in the child's development, and it is precisely these relationships which engender the construction of three spatial dimensions in advance of the topological structure being replaced by a projective and euclidean one.

It is therefore not the three dimensions as such which constitute the main obstacle to the child's tying a knot, but the transition from one dimension to another, within one and the same object. The problem is one of passing from the unwound string (a simple linear series with a 'surrounding' in only one dimension) to the string in the form of a loop (the loop and its interior constituting a 'surrounding' in two dimensions), and from this to finally passing one end of the same length of string through the inside of this loop (the loop and the end of string crossing its interior plane constituting a 'surrounding' in three dimensions). It is not any inability to comprehend the 'surroundings' constituting these dimensions which hinders the child from tying the knot. Rather is it the necessity of passing from a one-dimensional to a three-dimensional system, via increasingly complex surroundings, in the context of one and the same object. In a word, the difficulty is an outcome of failure to

111

link together the notions relating to each dimension, in so far as these depend upon the idea of 'surrounding'. This linking together or articulation of notions begins to take place during Substage IIB, for it is at this level that children start learning how to tie a knot during the actual course of the experiment.

FRA (2; 11) succeeds in tying a simple knot, several times in succession, despite his tender years. He learns to tie the knot in this way. Seeing his sister (3; 11) learning how to tie a knot, he starts by winding the ends of the string round each other. Finding that this simply comes unwound, he passes the string around the experimenter's arm, then round the leg of the table, crossing the opposite ends of the string and twisting them together. A simple knot is then tied as a demonstration, though without explaining it verbally. He copies it accurately enough, starting with the crossed loop and passing one end inside the loop. He follows this up by tying several knots successively without any help. After a short interval, however, he is unable to repeat these earlier feats.

BAR (3; 6). Whilst we actually watch, he discovers how to tie a knot through his own unaided efforts. For his own amusement he tries to 'tether' an adult by tying a string round his arm. He makes ten attempts to do this, which at first consist of merely winding the string round the arm. He is surprised to find this does not hold but simply pulls undone. Then by a lucky stroke he manages to tie it properly, though without realizing how he has done it. He tries to repeat the performance, but without success until he suddenly happens on the answer: "*The string must be put inside*". From then on he is able to turn out several knots in succession by crossing two ends of string and passing one through the loop to make the knot, though he is unable to apply this discovery to other situations like tying shoe laces, and so on.

NEL (3; 11). Fra's sister. After being shown an example she brings the two ends of the string together but fails to cross one over the other, simply passing one end through the half-loop thus formed. Seeing that it unwinds itself when pulled, she says, "*You've got to go right round it*" and follows up with several successful efforts. Nevertheless, Nel is unable to distinguish between an uncrossed loop and a true knot at sight.

ZEE (4; 1). After having seen an example, he at first says: "*You've got to make the hole*" and forms an open loop like Nel's, then passes the end of the string through it. He starts again, this time crossing the ends and produces two real knots, but cannot predict by sight whether his attempts will succeed or not. He next winds the string a number of times around a stick and says: "*It doesn't hold, the string isn't inside*". After this he succeeds.

TEA (4; 1). Like the children at Substage IA, he begins by winding the string round the experimenter's arm. But after a demonstration (completed too quickly for him to see just how the knot is tied) he succeeds in slipping the end of the string through the loop. Moreover, he is successful five times out of seven in distinguishing at sight intertwined circles from superimposed ones. On the other hand, he cannot manage to follow the outline of a partly untied knot with his finger, even when he is asked to do it by imagining an ant crawling through the rubber pipe from end to end.

It was thus established that the children of this level are able, by

112

means of a series of approximations, to bring the opposite ends of the string together, cross them, and then pass one end through the loop so formed. In other words, they at last succeed in passing from an initial linear series to a two- and then three-dimensional surrounding. Once having made this discovery however, they are unable to apply it generally. In addition, it was noted that although the transformation was success-fully achieved by the child's own actions as such, i.e. on the ideo-motor plane, it fails to result in an accurate visual perception. Admittedly, in five cases out of seven, Tea is able to distinguish at sight between intertwined and superimposed rings. But he still cannot follow the sections of a slack knot by passing his finger over or under the string at the point where it crosses, even when he thinks of an ant crawling inside it (he even tries to extricate himself from his dilemma by asserting that the ant "dies" when it reaches the crossover because he does not know which way he should make it turn).

Furthermore, it was discovered that the children who did manage to tie knots successfully after a few attempts were unable to recognize whether they were being shown knots or open loops solely by visual inspection. This invariable backwardness of imagination, as compared with action, which we shall again encounter in Stage II, will throw considerable light on the true relations between intuitive images and motor activity, the source of the subsequent operations.

§3. *Stage II. Partial intuitive correspondence between knots which can be reproduced in practice*

From the very beginning of this stage the child can copy a knot which he can see, and without receiving any help from the experimenter. But at the start, in Substage IIA, the knot needs only to be tightened or loosened a little for it to become unrecognizable. In addition, the child is frequently unable to tell a false from a true knot.

Rot (4; 6) ties a knot without any model. "How did you manage it?—*I pass it through a hole, then after that I make a knot*". He is shown an over-hand knot very loose and all parts clearly visible. "*No, it isn't a knot*—Pull it —*Oh, it is*—And this (a half loop without a knot)?—*No it's not a knot because it doesn't pass through the hole*—And this (loose knot)?—*No, neither is that*—Run your finger along the string. Let's suppose it's a pipe and an ant starts crawling along it. He can't get out until he reaches the other end. Which way will he go? (on reaching the crossover point he blunders and slips from one section to the other)—And by slipping this bead along the string (it is moved a few centimetres and he has to continue on his own)?—(He fails again)—And this (a taut knot), is it a knot?—*Yes, that's on top and that's underneath*".

Vag (5; 4) is confronted with a taut knot and asked to draw it. To represent the string he draws a straight line and for the knot, a circular shape filled in.

He then copies the knot correctly (without having seen it made previously)—"And this (loose knot), what is it?—*A loop*—Draw it—(he draws a straight line ending in a curve with a semi-circle rising from the middle)—Can you copy it?"—He does so, but maintains that it is different from the first knot without being able to explain how.

DEG (5; 6) reproduces the taut knot correctly, then draws it in the shape of a circle with two straight lines branching off at right-angles. "And this (slack knot)?—*It's a knot also*—Could you copy it?—(He does so successfully)—Did you make them both the same?—*No, this one's different*—Why . . . ? Do it again just to see—(He still comes to the conclusion that it is different)—And this (open loops in the form of the clover)?—*It's a knot*—Can you copy it?—(He places the string on the table and folds each end back in the shape of a loop, but without passing them round the central section)—Is that right?—*Not quite*—What is missing?—(He points to the 'wings' at each side of the model)—Try again—(He does not succeed and cannot see the correspondence with the earlier knots)". An attempt to draw the overhand knot results in an ellipse with an inscribed angle whose apex touches the curve and whose sides extend beyond it.

Deg fails to distinguish right from left overhands and cannot follow the string in a continuous path.

BOR (5; 6) copies the taut knot straight away and draws it in a curious fashion. A circle crossed from one side to another by a straight line, with a half-loop inside the circle resting on one of the points where the straight line cuts the periphery. "Is your drawing the same?—*The knot isn't tied, I don't know why*—And this (loose knot), is it the same as before?—*No* (he draws an angle with a half-loop resting on one of the sides)—And this (open loops shaped like a clover)?—*It's a knot, but not the same one*—Do it again". He puts it on his paper and tries to draw it in one stroke but fails. Neither can he copy it with a piece of string. He does not succeed in tracing the course of the knot with his finger.

GEN (5; 7) has before him two intertwined circles of string and two merely superimposed, which look the same but are not linked together. "Suppose we pull that one (the second)?—*It will come apart*—And the other?—*It won't come apart*". After he has tied a knot he is shown a loose one. At his first two attempts he is unable to trace it out with his finger (though with the aid of suggestions he succeeds the third time) and draws it as an ordinary half-loop not passed under. He is shown a string forming a loop folded back on itself but with no knot—"*It makes a single thread because it's not like a knot*—And this (slack knot), if we pull it?—*It makes a knot; no, it won't*—And this (another one, even slacker)?—*No*—And if we pull them?—*No*".

CHAL (5; 8) copies the taut knot. "And this one (slack knot)?—*It's a bracelet*—Are they alike?—*No*—Can you copy it?—(Two unsuccessful attempts, then he does it)—Did you make it in the same way as the other one?—*No, another way*—And this one (the clover)?—*Spectacles*—Is it like the others?—*No*—And if we pull it?—*No*". A bead is threaded on it and Chal is asked to show the route it will take through the knot. He misses the continuities. His drawing shows an ordinary half-loop without any knot.

LYD (5; 11). Like Gen she solves the problem of the two circles intertwined or superimposed, but despite several trials is unable to follow the route of a bead along the string in the form of a slack knot.

LUC (6; 1) says: "*It's a reef knot*", speaking of a taut knot and copies it. Then he draws it as a straight line crossing a circle. "And this one (slack)?— *That's a reef knot as well* (he copies it correctly)—Is it the same as the other? —*No*—Why?—(He points to the spot where the string is crossed)—Do the first one again—(he does it)—Is it like the other one?—*No*—You didn't make it the same way?—*No*—And this one (clover)?—*It's an 'iris' knot* (a boy-scout term understood by Luc)—Can you copy it?—(He makes it differently, then succeeds but tightens it like the earlier ones.) *It's not the same* (as the model of the clover)—Try again—*There it's on top, there it's underneath; it's difficult to make* (thus he has no suspicion that it is absolutely identical to his previous ones!)". He is unable to trace its course with his finger.

FRA (6; 2) reproduces the taut and slack knots. "*It's not the same as before* (copies it again)—But you made it the same?—*No, I didn't make it the same as before*—And this one (clover)?—*I don't know what it is*—Is it a knot?— *Yes, but not tightened*—The same as before?—*No*. (He tries to tie it once more, but placing the string on the table, folds the two ends back into half-loops without winding either round the central portion)—Is that right?— *Yes*—Look, (we pull) it all comes apart". Fra tries again but succeeds no better and has no suspicion that this knot is the same as the earlier ones. He cannot trace its course with his finger.

Such are the main types of reaction seen at Substage IIA. The way in which they both resemble and differ from the reactions of Stage I are immediately apparent. The present children are ahead of their colleagues in the previous stage in being able to tie a knot without a model; that is, without seeing a demonstration beforehand. But they cannot carry out in imagination what they can already perform in actual fact. It is true that as opposed to the previous subjects they can detect at sight the difference between a half-loop with no appearance of surrounding and a real knot (cf. Gen), likewise the difference between intertwined and superimposed pairs of circles (Gen and Lyd). But when they come to deal with the three homeomorphs, the tight knot (1), the slack knot with expanded loops (2), and the knot with very large wings (3) (which we term a 'clover' for the sake of clarity, though geometrically all the knots are overhands, of course), the children of this stage fail to see that the three knots correspond. On the other hand, children belonging to the next stage (IIB) will be found to perceive the similarity of (1) to (2) but not of (1) or (2) to (3).

The reason for these difficulties is easy to see. To start with, let us remind ourselves that at any age knots are troublesome things to deal with mentally, for they do not give rise to strong visual patterns or tend to produce metrical perceptions. Consequently there is always some difficulty in trying to visualize the changes which would ensue from

115

tightening or slackening a knot. However, something more than just this is involved for children at the level of Substage IIA. It is their failures which invite particular attention, since after the transitional reactions found at Substage IIB these purely negative responses are replaced, toward the age of 7 or 8, by the genuine understanding of the problem indicative of the attainment of Stage III.

The outstanding thing about the various shortcomings most typical of Substage IIA is their identical character. In the first place, although these children are able to reproduce the taut (1) and slightly loose (2) knots (the last sometimes only after hesitation, though all children succeed ultimately) they nevertheless fail to recognize their identity. In the second place, and this is most likely part and parcel with the first shortcoming, they cannot trace the course of the string whilst respecting its continuity. Even in the case of a partly slackened clover knot (3), they leave the section of string passing underneath as soon as they arrive at the intersection, and go straight on to the upper part without considering the true order of succession.

These two reactions obviously derive from the selfsame cause; namely, that though these children have been able to achieve a three-dimensional surrounding on the plane of action (after overcoming the difficulties we encountered in Stage I), they cannot achieve it on the representational plane, nor even in that semi-active, semi-representational form of behaviour consisting of tracing the course of an already formed, visible knot with one's finger.

Dealing first with the child's refusal to admit of a correspondence between taut and slack knots (1), (2) and (3), his reaction is quite comprehensible. He considers the knots placed on the table or attached to a piece of cardboard just as if they were two-dimensional figures and does not extend the correspondence to include the actual three-dimensional surroundings. Furthermore (and this second type of behaviour goes along with the first), he looks at the taut and slack knots in a purely static fashion, taking no account of the change which would lead from the one to the other, consisting of simply pulling the string and tightening the knot, or slackening it. Obviously, if he does not apply the correspondence to three-dimensional surroundings, it must be because although he can achieve them in his actions (by reproducing the knots), he can neither imagine nor discriminate between them when viewing them as ordinary two-dimensional patterns. From this derives the second sort of error, of failing to imagine the knot as it would appear when modified through being tightened or slackened, but considering it only in its present perceptual configuration. On this latter point, the attitudes which these children adopt are directly comparable (allowing for differences in the nature of the problem) with those exhibited by children of the same age when faced with the problem of one–one correspondence

in a numerical series.[1] This point is worth emphasizing, since more recent work on geometrical theory has shown that there is a closer parallel between the concept of number and the concept of space than has been hitherto suspected.

Thus we find that at about 5 or 6 years of age, a child can establish intuitively the correspondence between a number of objects and a separate but equal number of other objects, but only when they are arranged in a similar visual pattern, such as two straight rows, and even then, only when the rows are facing each other. It is enough to alter the intervals between consecutive items in one of the rows for their equivalence no longer to be recognized, because from the perceptual standpoint, the correspondence has ceased to exist. Thus the correspondence disappears the moment the perceptual pattern varies. Similarly in the present experiment, the child can recognize either tight or slack knots when they are compared with visually identical models, but he is unwilling to grant that they are equivalent as soon as the comparison knot is tighter or slacker than the model; in other words, as soon as one of them takes on a different appearance. Thus despite being able to copy the shapes (1) and (2), he nevertheless regards them as non-corresponding, solely because of a purely apparent difference. As for the clover knot, we found some children so certain of its being absolutely unlike the earlier ones, that they were quite unable to copy it (cf. particularly, Luc and Fra). The only point of difference between the present experiments with knots and those involving whole numbers, is that with the latter, it is a question of discontinuous correspondences on which depends the numerical value of the whole series, whereas with knots we are concerned with bi-continuous correspondence; that is to say, a correspondence affecting both sequential order and surrounding of sections continuously linked together. Apart from this, it is extremely interesting to note the points of analogy in the development of these separate but cognate operations.

As regards non-correspondence between the surroundings themselves, this is a direct consequence of the difficulty which these children repeatedly encounter in trying to trace the course of even loosely tied knots with one finger. In this case, if the child fails to perceive the correspondence between the surroundings in identical knots it is because he cannot recognize them perceptually. For despite being able to tie such knots he cannot imagine them.

This brings us to the core of the problem of homeomorphism. In studying how the child actually formed knots (§2) we saw that his difficulties arose when he tried to pass from a one-dimensional surrounding (one part of the string passing through the loop formed by the other two parts) via the agency of one and the same linear object. But

[1] See *The Child's Conception of Number*, Chapters III and IV, 1952.

no sooner has this particular problem been overcome in practice and the child has learned to tie a knot, than the paradoxical situation arises, in which the knot being placed on the table and loosened slightly, the child no longer recognizes it, is no longer able to distinguish the surroundings in terms of the three dimensions (above-below, left-right, before-behind). And when he endeavours to trace them through with one finger, he even loses track of the sequential order of the different sections (i.e. the one-dimensional surrounding). In other words, he overlooks the relationship of 'between' linking up each section of the knot according to its relative proximity. We find that where one part of the string passes beneath another, the child loses track of the real order of succession, the true proximity of neighbouring parts, and passes over into another part of the knot which is not actually adjacent to the first. Thus although he can reproduce the knot in practice, the child not only fails to note the three-dimensional surrounding, replacing it with a two-dimensional one (a point well brought out by the drawings showing the knot as no more than a circle crossed by a line), but even loses sight of the order of succession. For the true proximities he substitutes apparent ones, so that instead of a particular section of the knot being located 'between' adjoining ones (surrounding along one dimension) it is perceived as the neighbour of the section lying nearest to it, with the result that the continuity of the knot is broken.

We do not have to look very far to see the reason for this short-coming of perception and imagination. It is entirely because the child is unable to anticipate the result of tightening or slackening the knot he is studying that these momentary, static perceptual proximities tend to outweigh the real, permanent proximities which remain unaffected by such actions. Similarly, it is because he cannot anticipate the corres-pondences between the surroundings that he cannot copy or draw them. And in turn, the lack of a mental picture results in his being unable to trace the course of the intertwined string with one finger.

At bottom, it is because the underlying ideas are still far too per-ceptual in character and have not yet achieved a sufficient degree of flexibility. More precisely, the child's ideas are still tied to static configurations and are unable to grasp dynamic transformations, remaining centred on a particular shape rather than being decentrated, in the sense of being linked together in an imaginary reconstruction.

A slight advance in this direction is perceptible at Substage IIB, resulting in correspondence being established between the knot in forms (1) and (2), though not between forms (2) and (3) as yet. Here are a few examples, beginning with a child midway between Substages IIA and IIB:

KNU (5; 10) draws the taut knot in the form of a circle traversed by a pair of wavy lines. "Is it like your drawing?—*Yes*—(Shown a looser knot)—Is it

the same as the one before?—*No*—Try to copy it—(He makes a few trials then arrives at the answer)—Look, I'm tightening it a little. Is it the same as before?—*No . . . Oh, yes!*—And this (clover)?—*No*—Can you follow the string with your finger?—(Follows it correctly without a break).

JUI (5; 10) copies first the taut knot, then the slack one. "Is it (the loose knot) the same as the other?—*Not quite, but if I tighten it, I'll get the one before*—And that one (the clover)?—*It's a heart*" (He tries to copy it but is unsuccessful, forming loops and pulling them apart again). He can follow the knot accurately enough with one finger, but still fails to see that it corresponds with the previous ones. He cannot distinguish the left from the right overhand knot, nor the false from the true figure of eight.

MOT (6; 3) copies the taut knot. "And this one (enlarged knot), what is it? —*It's a knot that isn't closed* (i.e. not drawn tight). *To close it you have to pull* —And this (clover)?—*It's a flower*—Is it a knot like the other one—*No*— Could you copy it?—(He arranges half loops adjacent to each other, but without entwining the ends)—Look (He is helped and succeeds)—Is it like the one before?—*No*". Nevertheless, he traces it through correctly with one finger. "And this one (a false knot looking like a true one), could you make it into a knot by pulling it?—*Yes*".

RAY (6; 6) copies both the taut and slack knots. "Are they alike?— *Not quite, but if I pull it will come the same*—(clover)?—*It's a circle crossed in a different way*—Copy it—(succeeds right away)—Did you make it the same as the others?—*No*". He follows it through correctly with his finger, but does not distinguish the false from the true knot and thinks he will get a knot by pulling the string wound in a half-loop.

MOR (6; 8) copies the taut knot and looks at the slack one. He says: "*It's different because it's open, it's not pulled tight*" but apart from this he thinks "*it's the same*". "And this (clover)?—*It's a heart, it's not like the ones before* —Copy it—*It's difficult* (he puts the string on the table, twists it round several times, producing something very complicated but homeomorphic with the circle, saying): *I must pull here, but it shouldn't be crossed*—Look!—(the model is pulled, producing a tight knot)—Now, give it a good pull—(his 'knot' comes apart so he starts all over again but is unsuccessful. Then by a stroke of luck he hits on the slack (2) knot)—*Oh look! It's just like the earlier one!*—Is it like this (clover)?—*No, it's not like that*". He fails to distinguish the left from the right-hand clover, and a false knot from a true one.

DAN (6; 9) at once remarks of the enlarged knot: "*It's the same because if I pull it, it will make the same knot as before*—And this (clover)?—*No, that's not the same as before. Nearly, but not quite the same*—Where is the difference? — . . . —Can you copy it?—(He twists the string about without succeeding and does not understand that it is the same knot)—And this (a false knot like the clover in appearance)?—*It's the same knot as this one* (the clover)". He follows the course of the true and false clovers with his finger, but without comprehending the difference.

STU (7; 0) makes a tight knot and expands it. "Is it the same?—*Yes, when you pull it*—And this (clover)?—*No, not the same; it's got two loops*—Follow it with your finger—(He does this correctly)—Copy it—(He makes a false knot, homeomorphic with the circle)."

119

A cursory inspection of these reactions shows right away that the correspondence established between the taut knot (1) and the slack knot (2) is the result of motor anticipation. The child Knu, seeing the knot (2) becoming a little tighter through the experimenter's action, immediately foresees the result of continuing this alteration, and thus sees the correspondence between (2) and (1). The rest of the children behave similarly at this stage. "If I pull, I'll get the one before" says Jui. "If I pull, it will come the same" say Mor, Dan, Stu, etc. It is because they envisage the knot in this way, in terms of motor activity and no longer perceptually (and therefore imagine actual transformations rather than mere static patterns), that they are able to follow the path of the 'clover' (3), no longer considering the apparent proximities but taking account of the real proximities and surroundings. These proximities (between successive regions of the knot, marked off by passing the finger over the string) and intertwinings are both the outcome of 'articulated' ideas, ideas that extend beyond perceptual patterns to embrace imaginary anticipations and reconstructions, potential actions depicted in imagination.

But though this type of notion is 'articulated' or 'connected', in the sense of maintaining a flow of changing ideas, it is nevertheless still tied to the image and hence confined to brief and limited transformations. It is incapable of being generalized and applied to correspondences between all the diverse forms which a simple knot can assume. The child can link the perceptual pattern (2) with the pattern (1), but without perceiving the analogy between them and the 'clover' (3) which is not yet regarded as equivalent to the preceding shapes. And this is because these 'articulated' ideas are insufficiently mobile and flexible. In consequence, true and false knots are confused completely, so soon as the latter go beyond the appearance of a simple half-loop (which was already occasionally distinguished from a knot at Stage I), and similarly so with true and false figures of eight.

To sum up, at Stage II mental processes are still intuitive; that is to say, they can produce only partially correct correspondences, even though this stage marks a transition from perceptual (IIA) to articulated notions (IIB). At the subsequent stage these articulated notions attain a dynamic equilibrium in the form of reversible operations of thought.

§4. *Stage III. Operational correspondence between simple knots. Right and left hand 'clover' knots distinguished*

The articulated idea, still limited in application at Substage IIB, begins to be applied generally toward the age of 7. At this age, children have no difficulty in establishing a correspondence between the taut knot (1), the slack knot (2) and the spread out 'clover' (3). They can also distinguish between true and false overhand knots. Hence they can

predict the result of tightening or slackening the knot for all cases, and in both directions, by working out the correspondences in terms of the surroundings in an active and reversible way. Some children, though able to do all this, are not yet able to tell a right from a left overhand knot right away (though they do so after a little trial and error), whereas the two most advanced examples of this stage are able to do so at once. Here are a few examples of children belonging to the first category, starting with a child who reacts in a manner transitional between Substage IIB and Stage III:

DALC (6; 10) at once says of the enlarged knot: "*It's a less tight knot*— And this (clover)?—*I don't know*—Is it the same?—*Not quite*—Why?—*I don't know*—Look at it (it is tightened a little)—*Oh! the knot!*—What is a knot?— *It's these two strings* (the two ends) *which are crossed. This one goes on top and passes back underneath. It's the same string, it has two ends . . . this end is crossed with the other and it comes up again"* (through the hole).

BER (6; 10) says of the knots (1) and (2): "*One is small and the other is big but not tight*—And if we tighten it?—*It's still the same*—And this (clover)?— *It's a heart*—Is it the same?—*Yes, you must put it like this* (he turns back the ends) *and then you get a knot like this"*. He then shows that the second knot is obtained by slackening the first and that by widening the second the third is reached. "And this (left and right hand clovers)?—*They're the same*—Can you follow them with your finger?—(He follows them in continuous fashion) —Now, are they the same or not?—*Yes, the same: at least they're not quite the same. This is on top of this and this is underneath, and this side it's the opposite*—You didn't notice that?—*I didn't look properly*—Copy them— *There we are* (at once and accurately done)—And this (true and false clovers)? —*They're different*—Why?—*There everything is underneath* (therefore it is not a knot) *and there it's on top here and underneath there*—If we pull, what will happen?—*There, there will be a knot, and there nothing at all*—Are you sure?—(He hesitates and then makes a false knot.) *Yes, if you pull here, nothing will be left*—And this (false and true figure of eight)?—*There it's a knot and there it isn't"*.

DEV (7; 5) immediately recognizes the likeness between (1), (2), and (3). "Is this one different from the others? *No* (he makes it). *I put the loops in this way* (outspread wings)". Left and righthand clovers: "*They're alike*—Look carefully—*Oh, yes; there it's on top and there it's underneath*—And this (true and false knots)?—*There the two branches are both underneath, and there on top and underneath*—And if we pull?—*There it will make a tight loop, a knot, and there, there won't be a knot, it's simply twisted round"*. Dev then produces exact drawings of each besides drawings of the three sorts of clover knot.

Now here are three examples of children who distinguish right-hand from left-hand clover knots at first sight:

FONT (6; 0, ahead in his school form) says of knot (2) and the clover (3): "*If I pull it will be like I had before*—And this (true and false figure of eight)? Are they alike?—*No, that's not a knot*—And this (left and right-hand

clovers)?—*It's not alike; there it's going up and there it's coming down. There it passes on top and there underneath*—And this (true and false knots)?—*That's not a knot, they both* (the two ends) *go underneath*".

AND (7; 2). "*That one* (2) *isn't tight. It will be the same and smaller, or like that one* (1) *if it's pulled*—And if the first one is loosened?—*Then we'll get that one* (2)—And this (clover, 3)?—*That's a loop knot as well* (pulls it slightly to demonstrate)—And these (left- and right-hand clovers), are they similar?—*No there it's on top, and there it's underneath*—And if you pull it?—*There will be two knots*—Similar?—*No, because they're made the opposite way*—And this (true and false knots)?—*There you won't have anything at all, because both strings are underneath*—And this one (true knot)?—*It's a knot, because one is on top and the other is underneath*—How do you make a knot?—*You have to take a string, cross it over and pass it through the hole* (gesture of intertwining) —And these (true and false figures of eight)?—*There* (true) *it's a knot, and there* (false) *it's nothing at all because it's only crossed, but there* (true), *it's crossed in the hole*".

GEL (7; 10). Clover knot (3): "*It's the same as the earlier ones but it's not pulled tight yet*—(Shown left- and right-hand 'clovers'.) Are they alike?—*No, different; there it goes on top and there underneath*—How can you make them alike?—(Without saying a word, Gel turns one of them upside down, then passes the string on top and beneath)—If they're pulled will the knots be the same?—*No, one will be on top and the other will be underneath*—And these (true and false figures of eight)?—*There it'll come undone; there, you can't undo it, it'll stay put*".

This is the ultimate form of equilibrium then, which the correspondences first tentatively established at Substage IIB eventually assume at the end of Stage III. It is apparent that each of these children (starting from the age of 6; 6–7; 6 on average) can immediately recognize that the 'clover' with outspread leaves is the equivalent of the ordinary taut knot, and can also distinguish the true from the false clover (the homeomorph of the circle). With the right-and left-hand clovers, some children fail to note the difference at first glance (like many adults for that matter), though when asked to look at the knots more carefully they distinguish them perfectly clearly and reproduce them correctly. The children who definitely belong to this stage are not only able to distinguish between them, but even realize that two different knots will be produced by pulling them taut "because they're made the opposite way" (And) or "because one will still be on top and the other underneath" (Gel).

It is therefore clear that the child now begins to exploit simple perceptual notions as a basis for logical thought. The shape he perceives is sustained in thought by anticipation of the future outcome of tightening or slackening the knot, of spreading out the loops or bringing closer together parts that are widely separated, and so on. In a word, the perceived figure is located within a framework constituted by all its

potential transformations, in terms of motor activity or its mental representation.

But how is one to explain the course of development by which these operations have arrived at a state of dynamic equilibrium within a fluid yet stable system, as compared with the fragmentary notions of Stage II, which were both static and unstable? The answer is that the actions, of which they are an internalization, have arrived at a state of completion, a state defined by its property of reversibility, and by the specific form of conservation entailed by this attribute.

At Stage IIA the child was not even able to anticipate what would result from tightening knot (2) to form knot (1), despite the fact that he had already learnt to tie knots for himself during Stage I. By Stage IIB he has begun to master this kind of anticipation and mental reconstruction, though still unable to extend them to embrace the 'clover' (3) or distinguish between the different kinds of knot. In addition, he has learnt to trace the course of a knot with one finger, something which the children of Substage IIA, though able to reproduce the 'surroundings', could not do.

In short, in the course of Stage II, the actions originated at Stage I become internalized as mental images and little by little are linked together as 'articulated' ideas. Following this, as the action becomes entirely mental, a kind of picture of the three-dimensional surrounding which constitutes a knot appears in the form of the operation proper. Then and only then do the partial and incomplete notions which result from imagining the movements of contraction or expansion of the knotted string begin to play their full part in the attempt to establish correspondences between the various shapes. Whatever these imaginary contractions or expansions may be, from now on the child comprehends the fact that they leave the basic operation of 'surrounding' unchanged. No matter what happens to the perceptual pattern, this fundamental relationship is preserved intact through all the seeming modifications which the knot undergoes, and it can be obliterated only by the reverse action of untying the knot.

From the operational invariance of this relationship of 'surrounding' there results the establishment of a certain type of correspondence. This is a type of correspondence taking no account as yet of distances, or of euclidean and projective figures (straight lines, circles, ellipses, angles, parallels, etc.), but merely conserving elementary topological relations such as proximity, separation, order, and surrounding.

The adjacent parts of two knotted strings remain adjacent and the separated parts remain separated, the relative proximities of near and distant parts remain unaltered, the surroundings reappear unchanged in corresponding knots. Such is the principle which underlies the establishment of correspondences enabling children of this stage to judge

two knots equivalent. A correspondence of this nature which embraces only topological relationships and does not involve metric relations, nor proportions (similarities), affinities or projections, is a purely qualitative homeomorphism based on operations which are concrete and not yet formal or abstract.

At this point a problem arises which will engage our attention in the next chapter. The correspondence involved in homeomorphism is bi-continuous in character, and similarly, the preservation of 'surroundings'—the principle underlying the comparisons made by the children of Stage III—necessarily implies that the curve envisaged as defining the surrounding is continuous and unbroken.

The question which must be answered is, what kind of continuity operates at this level, and how does the child pass from simple, perceptual or intuitive continuity to conceptual or operational continuity of a type which can draw together the notions of proximity, separation, order, and surrounding into an organized whole? To answer such a question it is necessary to vary our approach and in place of actual knots and strings, substitute imaginary lines or curves on which can be brought to bear, not only conscious actions, but during the period between 7–8 and 11–12 years, the process of abstract thought which begins to evolve at this stage.

Chapter Five

THE IDEA OF POINTS AND THE IDEA OF CONTINUITY[1]

WE saw in Chapter III how toward the age of 7, both linear and circular order become reversible and give rise to true operational correspondence. And in Chapter IV we have just seen how this notion enables knots to be understood as simple homeomorphs. Now at this point it is legitimate to ask whether such correspondences as are established between shapes by the age of 7 or 8 entail more than a crude, intuitive idea of continuity itself. For this reason, and also to conclude this brief survey of the psychology of elementary topological relations, we intend to examine the development of the notion of continuity, from the form in which it first appears to that which it exhibits when formal thought emerges at the age of 11 or 12.

Considering the subtlety with which mathematicians have demonstrated the complexity of this notion, and recalling that the names of Weierstrass, Cantor and Dedekind have become identified with the postulates that have enabled its deceptive outward appearance to be penetrated by means of logical analysis, it may seem somewhat absurd to embark on a problem of this kind by studying children, and particularly in the course of a work purporting to deal with their conceptions of space. However, since it is part of our aim to show that in its mathematical connotation the idea of continuity is far from being a simple fact of experience, but actually develops from perception to concrete operations of thought, it seems relevant to test our theories by applying them to this particular concept. Now the mind does not pass direct from perceptual notions of continuity to abstract schemata evolved for the purpose of formulating such a notion. On the contrary, to arrive at reciprocal schemata of the sort required in order to reduce a line or a surface to points and then reassemble the points to form a line or surface once more, necessitates the development of a complete mental structure.

Thus it will at once be seen that an examination of the ideas of point and continuity is an essential counterpart to the earlier studies, and one which can on no account be omitted from a study of infantile topological conceptions. The relationships of proximity and separation really involve no more than extremely general notions of a type pre-requisite to any operational concept of space, including topological relations themselves. In contrast to this, the relationships of order and surrounding

[1] In collaboration with Mlle. U. Galusser.

result in true operations, such as those of 'positioning' producing ordered series (logical addition) and the operations of establishing correspondences giving rise to simple qualitative homeomorphisms (logical multiplication).

Both these types of operation however, only involve relationships which are extensions of proximity and are therefore merely the analogues of seriation in the field of logical relations. It still remains to discuss both how the operation of subdivision which supersedes the original perceptual 'separations', and the operation of reuniting the separated elements. In other words, the sub-logical counterparts of the logical operations concerned with separating and reuniting classes.

Now the process of reducing what is regarded as continuous to a series of adjoining points and re-creating an operational continuity on the basis of these points, a process thereby identified as one of reversible combination, is the most advanced type of the operations involved in separating and reuniting enclosed parts. Hence the development of the notion of continuity is the necessary accompaniment to the development of operations concerned with order and surrounding, and it is therefore essential to the completion of a qualitative concept of topological space.

Now the growth of the idea of continuity does not depend upon what the child learns at school to anything like the degree that might be imagined. This is shown by the fact that it is possible to trace out, step by step, a more or less parallel process of development for the ideas of point and continuity, and those dealing with atoms and physical objects in the child's conception of the external world. Thus in watching a lump of sugar dissolve in a glass of water, he passes from the perception of visible though gradually diminishing particles to the idea of invisible grains, and finally to that of ultimately indivisible particles.[1] Similarly, with a line or a figure, the child proceeds from the notion of parts that are separable but still perceptible, to that of invisible parts, smaller than but similar in principle to the former, and finally to the idea of its being reduced to ultimate and indivisible points. The only difference between these two processes is that to the child's way of thinking, physical points or atoms still possess surface and volume, whereas mathematical points tend to lose all extension (though during the stages of development which concern us here, this remains only a tendency).

This analogy together with remarks made earlier indicate clearly from what standpoint the study of children's ideas about points and continuity should be approached. Obviously, from the standpoint of operations of 'subdivision', which are akin to those concerned with order and correspondence, just as in the field of logic, operations dealing with classes are akin to those dealing with asymmetric relations.

[1] See *Le Développement des Quantités chez l'enfant*, J. Piaget and B. Inhelder, Geneva. Chapters IV–VI.

§1. *Technique and general results*

The children were questioned on four main topics.

1. To introduce the main problem of finding out how the child envisages the subdivision of a line or figure into its ultimate constituents, we began by asking a question which has already been used by Rey.[1] In his study of intelligence, Rey wished to employ an operational mechanism, seriation of sizes, already investigated by the present authors in connection with the development of the idea of number. In his investigation, Rey had the idea of combining seriation with the limiting factors imposed in drawing. Thus a square is drawn on a sheet of paper and the child is asked, "here, right next to it, draw the smallest square that can possibly be drawn, one so small that nobody could make one smaller" (these instructions may be amplified, but all gestures indicative of size are avoided). The child is then asked to draw, "the biggest square that can be drawn on this sheet of paper" (a separate sheet).

These preliminary questions, while not yet touching directly on points or continuity, enable us to gauge the child's initial ability to seriate or enclose different sizes. For drawing the smallest square that can be seen, or made with a pencil, presumes (as will be seen in due course) that the child runs over, in his mind, the entire series of possible squares that could be inserted between the original square and one of two or three millimetres side, which is the limit we set in practice. And this is effected by a process of anticipation based on an operational schema of seriation. The same holds true of drawing the largest possible square, and if this square surrounds the original drawing, then the series amounts to an enclosure of the intervening figures. These operations of seriating or enclosing, based on order of size (and comparable to operations of order), are in fact the exact parallels of those involved in subdividing figures or lines into their ultimate elements. This is the reason why we chose to begin the interview with this question, the answers to which vary widely according to the child's age.

2. The second problem examined is that of subdividing some figure (square, circle, triangle, etc.) or a straight line and seeing how far this process is carried. In this case, the method of bisection can be utilized. Shown a straight line, the child is asked to draw another half its length, then a half of the half, and so on. When he arrives at lines so short that he cannot draw them any shorter, the child is asked whether he cannot "continue in his mind": "You can do a lot of things in your mind, can't you? If one of your schoolmates is better than you at a game you can still beat him in your mind, even though you can't really? Well then, try and imagine you are going to go on cutting up this little bit without stopping. What is going to be left in the end?" If the child answers "A

[1] Andre. Rey. "Le problème des 'quantités limites' chez l'enfant", *Rev. suisse de Psychol.*, Vol. II, 238–49.

short line" he is told, "Very good. But go on cutting up this short line in your mind. What are you left with right at the end?"

To help the child understand the idea of indefinite subdivision one can ask him to cut a rubber band in half, following which, one of the cut halves is stretched and cut again. In this way one can show that however small the residual portion, it can always be thought of as expanded and therefore capable of being subdivided still further. This technique is often useful in finding out whether the child can form any conception of the infinite number of possible subdivisions, and also to encourage him to continue in imagination the operations begun in actual practice.

3. The third question concerns the shape of the end product of the subdivision. Basically it is a question of ascertaining whether or not this final term is a point, and whether or not this point will have a shape. Hence, if the child uses the word "point", one must ask him whether the point has a shape, and if so, what the shape is (for the younger children the residual point of a square remains a square, that of a triangle is triangular, and so on). In the case of a straight line he is asked whether it is still a length or whether it has no real shape at all. Here we may note that the child often asserts that at the end of the process of subdivision there will be "nothing left at all". In this event he is asked what is left "just before nothing at all" which forces him to consider the shape of the point once more.

4. The fourth question is concerned with the re-creation of the line or figure out of its ultimate elements. Can a line or a surface be conceived of as a collection of points? In dealing with this problem it is necessary to supplement the verbal questions by having the child draw a series of points and then insert extra points between them, or to insert as many points as possible in between two limiting points with the aim of finding out whether he thinks they will eventually form a line. In practice we tend to find the child admitting that the dots appear to form a line, though refusing to accept the idea that a line consists of a series of points.

These four questions enable us to distinguish three distinct stages of development running from Stage II, as already defined, up to Stage IV where thought becomes operational in character (there is no difference between Stages I and II in the questions being dealt with at present). It is pointless to try and subdivide these three basic periods in view of the slow rate at which development proceeds, at any rate, up to the age of 11 or 12.

The first period (Stages I and II combined) lasts until about 7 or 8 years. With respect to the first question it is marked by the child's being unable to draw either the smallest or the largest possible square, since he lacks an operational schema of seriation. When trying to break up a line or a surface (question 2) he can only make a very limited number of

subdivisions (many children cannot understand the meaning of "the half of a half"), and in question 3 they end up with so-called ultimate elements of a distinctly perceptible size which, curiously enough, are of the same shape as the original, the final terms of the square being square, those of the line being lines, and so on. Finally, (question 4) subdivision and reassembly are both irreversible. The line is not regarded as a collection of points and if one has been rash enough to break up the short sections into points, these are fated to remain for ever discontinuous.

Stage III covers the period from 7 or 8, up to 11–12 years. The first question, that of largest and smallest squares, is now solved as a result of the anticipatory schema formed by grouping the operations concerned with seriating items, so that one finds a greater flexibility in the treatment of subdivision (question 2). But though the child is now prepared to admit the possibility of a large number of subdivisions he does not regard them as being infinite. Moreover (question 3), these procedures never rise above the level of concrete operations, they are never generalized beyond the finite, beyond visible or tangible size. While the ultimate elements are no longer thought of as isomorphic with the original whole, as they were in Stage II, their shape is regarded as dependent upon the particular mode of subdivision and they are never envisaged as an infinite number of points without surface area. Lastly (question 4), construction of the whole out of its constituent elements is now seen as the reverse counterpart to subdivision, but this goes no further than a purely intuitive continuity, so that the child finds himself in a dilemma, since he cannot reconcile the discontinuous nature of the points which are to be reunited, with the continuity possessed by the structure which results from this reunion.

Last of all, at Stage IV (beginning around 11–12 years) thought is liberated from the quasi-perceptual notions of the earlier stages, where the concrete operations were caged in under the restrictive conditions of actual drawing and handling. The operation of arranging items in series (question 1) no longer presents any difficulty and subdivision (question 2) is conceived of as unlimited. As for the structure of the ultimate elements (question 3), from now on this is seen to be entirely independent of the shape of the original figure or the mode of subdivision. The points or 'spatial atoms' no longer possess either shape or surface and, most important of all, they are all homogeneous, whether they belong to a line or any sort of figure. The synthesis of the whole is now the reverse product of unlimited subdivision (question 4), although the children still seem to find a contradiction between the discontinuous points and the continuous whole formed from them. A number of children arrive independently at the idea of a term for term correspondence between the series of points forming a line and the series of numbers considered as

infinite (though naturally, without having the least inkling of the concept of irrational numbers to fill intervening spaces).

§2. *Stage II. Pre-operational notions*

The distinctive feature of the first reactions, up to and including Stage II, lies in the fact that the child grants real existence only to what is directly perceptible, as against elements so minute that they cannot be seen. Even so, there is a complete lack of operational mobility which could, within these limits, facilitate the mental representation of these processes of subdividing and reassembling, thus relating them to one another in a general way.

ZUR (4; 6), (question 1) draws three squares in slightly decreasing sizes and a fourth a little larger than the third. Thus he can neither anticipate a very small square nor even arrive at one by a decreasing series. The same reaction in the opposite direction, that of the largest square; the third is smaller than the second. Question 2: he fares no better in the bisection of lines. Composition (question 3): "If you put some points right up next to one another, will they make a line? (Drawing)—*No, it's wrong*—Why?— . . ."

FRAN (5; 6). Starting with a square of 4 cm. size, he produces first a reduction to a quarter the size, then a second reduced by a half, a third a little smaller still and a fourth the same size as the second. For the largest square he doubles the size of the model in the form of a rectangle, then lengthens it still more but using only the free space along one axis, not succeeding in drawing a square around the border of the whole sheet so as to enclose all the drawings made so far.

In dividing a line Fran cannot draw the half, nor is he able to go on to the half of the half when it is bisected for him—"And if you cut it with scissors, what would it become?—*Like this* (he draws smaller but irregular sections)—And if you cut that?—(Draws them smaller still)—And that?—(Same thing again)—And if you went on cutting all the time without stopping, what would be left in the end?—*A little tiny line* (draws a length of 2 mm.)—And if you went on cutting?— *You couldn't*—But just suppose you could. It's like in a game; when you are playing you can say and think anything you like. You can pretend you're Mummy when you're playing. Well, now we're going to pretend we keep cutting it smaller all the time. What shall we find in the end? —*A tiny little line*—What will it be like?—*Like this* (points to the 2 mm. line)".

CLAU (5; 6). The smallest square: decrease of size following several trials but without anticipating the outcome. The largest square: first an enlargement twice size, then a gradual lengthening. "Can't you draw a larger one?— *There's no more room*—But around the others?—(He fails to understand)".

The line: he draws the half. "And now the half of the half—(he draws the opposite half)—But half of that?—(Draws a third line also the same length)— And smaller and smaller?—(He manages to diminish them bit by bit)—And what is it like in the end?—*Dunno*—Draw it—*All little* (He shows 2-3 mm. with his fingers)—And if we cut that?—*Smaller still*—What is it called when it's quite, quite small?—*A point*—Draw this point—(He draws it as a line of

2 mm.)—But if we still go on cutting—(He draws the same thing again)—
At the end will it be like a little line or like a little point?—*Like a little
line*".

Next he is given a square to divide up. "Can you make it smaller and
smaller? (As a demonstration it is cut into four)—(Clau divides the quarter
into four again, and so on)—And if you go on like that to the end, what will
be left?—*Nothing*—Very good. But just before we get to nothing at all?—
A little square—And if you cut it again, will there be a little square, a point or
a line?—*Still a little square*". A triangle divided by a line to make similar but
ever smaller triangles—"In the end?—*A very little church-steeple*—And right
at the end?—*A little wedge* (He points to its apex)".

NEU (6; 1) can draw a series of smaller and smaller and a series of larger
and larger squares, but only after several tries. Subdivision: "Divide this
line—(He draws a half)—And again—(Draws a quarter, then an eighth)—
Can you go on dividing it?—*It's too small, you can't make it any smaller*—
And if you go on doing it in your mind. Like when you're playing, etc . . .
What will you find?— . . . —(Contiguous points are drawn for him) Like
this?—*Yes*—If you have points touching each other, do they make a line?
—*No. They're not points any more. You see almost nothing but a line*".

BRU (6; 2). "I want you to put some points between here and here (two
points 5 cm. apart)—(He makes a few equally spaced points)—Can you make
them closer together?—(He doubles the number)—And if the points touch
each other, is that all right?—*No, that makes little lines*".

JUB (6; 8). Points forming a line: "Can you put some more between them?
—*No, there's no more room*—But between two of them?—*No, they would touch*
—And what then?—*You'd see a line*—But is it wrong to draw a point for
a tiny little line?—*Yes, because it's a point. If you draw a very small line you
can only put one point on top, not several*". The point is therefore not the limit
of the line, neither is the line an assemblage of points.

CHAR (6; 10) gradually arrives by stages at the smallest possible square,
but with the largest he leaves a marginal space round the edge of the sheet.
"How many points can you put between these two?—*Fifteen* (he inserts
them)—Why so far apart?—(He adds a few more)—What about some more?
—*No, there's no space left*—And here?—*Yes, but they'd be too close together*
—And what then?—*They wouldn't be points any longer. You couldn't count
them any more*".

"Can you divide this square into pieces?—(He makes four squares)—Can
you go on?—(He continues)—Can you divide it a different way?—*Yes, like
this* (diagonally)—And if you go on dividing it for a long time what's left in
the end?—*Nothing at all*—But just before?—*A little square bit*—Why square?
—*Because it was a square*—And with this circle?—(He cuts it)—And in the
end?—*There's nothing left*—And just before nothing is left?—*There'll be
small pieces of a circle*—Show me—(He draws them rounded)*".

RAP (7; 0). Smallest square. Rap finishes up with a square considerably
smaller than the model but only by diminishing the size very gradually.
Largest square. At first hardly any bigger than the model. The one enclosing
it, another larger still, finally a still larger one enclosing the first but without
reaching one of maximum possible size.

The line: "If you cut it smaller and smaller, what do you find in the end? —*Nought*—Very good, but before nought?—*One*—One what?— . . . —One stroke or one point?—*A stroke*—If you go on cutting, can it be cut any smaller?—*Yes*—And if you go on cutting?—*A nought*—But just before nought?—*A little stroke*". The square: "In the end?—*Nought*—But just before?—*A small square*—And if you cut it some more?—*Nought*—But just before nought, the last thing you will find, is it a square, a stroke or a point? —(Long pause) *A little square*".

Triangle: same reaction: "Just before nought?—*A little triangle*".

BUC (7; 3) arrives gradually at the smallest and the largest squares on the sheet of paper. "And now I want you to draw the smallest possible line— (2 mm.)—Can you make it smaller still?—*No, it would make a point*—And in the line (the 2 mm. one) are there any points?—*No*—Let's try to divide this (another) line—(He does so)—Can you carry on for very long?—*No*—Why not?—*It would make a little point*—And wouldn't that be the right thing for a divided line?—*No, a point isn't a line!*—How many little lines do you need to make a big one like this (1 cm.)?—(He counts up mentally whilst looking at the line) *Ten*—And how many points are there between these two points?— *A hundred* (he draws twenty-three)—Could you get a hundred in?—*No, the points would be too close together*—And wouldn't it be right then?—*No, when you're making points it isn't a line!*"

Division of the square: "And at the end?—*There's nothing left*—But just before, what is the last thing left?—*A little tilted square* (because it has now been cut and Buc is no longer certain about its regularity!)".

Such are the reactions seen at Stage II, which we must now examine question by question.

The problem of drawing the largest and the smallest possible squares on a sheet of paper produces some very interesting responses. The most backward children (such as Zur and Fran, and children from 4 to 5 in general) not only hardly increase or diminish the square at all, but after two or three moves either way lose the sense of direction and start doing the opposite without realizing it. Somewhat more advanced children succeed in producing a descending or ascending series but only very slowly and by means of successive trials (nine or ten attempts before reaching the 2–3 mm. square or the one covering the whole sheet). Lastly, the most advanced children arrive at the smallest or largest squares more rapidly, but still in every case by means of successive approximations instead of anticipating the ultimate result direct, as we find them doing in Stage III (after 7–8 years of age).

This particular experiment calls for some comment, even though it deals with euclidean figures and consequently falls outside the scope of the topological notions at present under discussion. However, metrical relations really play no part in it at all, for the size of the figure remains purely 'intensive', so that if the square were to be replaced with any kind of closed figure capable of being simply stretched or squeezed, the

operations required on the part of the children would be of exactly the same, purely qualitative character.

This remark suggests an immediate analogy between the negative reactions obtained in response to the first question, and the reactions observed at the corresponding stage (IIA) in the study of order and the problems of knots. There we found the 4–5 year old children unable to transpose the circular order seen in a necklace into linear order, and likewise unable to recognize the taut, slack and open overhand knots as homeomorphic. So here we find them unable to break away from the perceptual pattern of the given square and imagine it contracted to a couple of millimetres or expanded to the edges of the paper. In all three cases, perception tends to obstruct or suppress in advance any idea of transformation. Motor activity is subordinate to perception instead of sustaining it in anticipation of future, potential perceptions, so that the mental image is centred on a particular perception and is not yet directed toward the changes which action would bring about.

However, in all three cases, the originally static behaviour eventually becomes more flexible through the gradual linking up of consecutive ideas as they begin to anticipate future actions, thus initiating a swing away from immediate perception toward motor activity. Once more comparing the present experiments with those dealing with order, we find that at Substage IIB and the level midway between IIB and III, order remains invariant in spite of alterations to the line on which the beads are arranged, likewise the knot remains the same whether the string is tautened or slackened, and in just the same way the square can be successively expanded or contracted. In all three cases there is a roughly equal rate of progress toward a gradual linking up of these ideas right up until the end of Stage II, with a slight lead in favour of order, knots, and squares lagging behind somewhat, as will be seen.

What then, do the children of Stage II require to be able to draw the largest and smallest possible squares right away? What they require and do not possess, is an anticipatory schema of the type indicated by Bergson and Selz.[1] A schema that suggests an answer before the details are 'filled in' by the action during the actual process of arriving at it. But the notion of an anticipatory schema as presented by these authors, though a shrewd suggestion, does not go beyond an accurate description. What is really needed is some understanding of how such a schema is constructed and an idea of the way in which it might function. And this can only be obtained by examining the operational mechanisms of intelligence.

The linking up or articulation of ideas is originally due to motor

[1] Bergson, B. *Essai sur les Données Immédiates de la Conscience*. Paris, 1926, 24th edn. Selz, O., 'Essai d'une nouvelle théorie psychologique de l'espace, du temps et de la forme', *Journal de Psychol.* (1927), Nos. 5 and 6.

activity which enables actions, once begun, to anticipate their goal and to form a schema through repetition of past successes. Furthermore, motor adaptation is continued and extended through external and internal imitation, the latter constituting the images which serve as symbolic expressions of action. By this means, processes of anticipation and reconstruction which were originally purely motor in character are given imaginal or conceptual dimensions.[1] But these processes do not themselves reach a stable equilibrium until the moment when action, now internalized in the form of symbolic or representational images, becomes reversible and thereby constitutes operations of thought. Hence an anticipatory schema is simply a 'grouping' of operations, the arrangement of a number of potential operations in direct or reverse order.

Thus the child cannot draw the largest or smallest possible square until he arrives at the stage when he can also arrange in a qualitative series a collection of squares ABCD ... such that $A<B<C$... $K<L<M$... $S<T$..., the model L being at one and the same time $L>K$; ..., C;B;A and $L<M$; ..., S;T And in fact, from previous studies we know that at Stage II, children cannot arrange sizes in rank order when it is a matter of comparing them by pairs, and when arranging heights in series they only succeed toward the age of 7. Now this seriation of sizes, which is the actual source of the anticipatory schema involved in the present experiment, is itself derived (on the logical plane) from operations of order, and no doubt from those of surrounding also. Arranging sizes in rank order when this does not involve measurements but only qualitative relations of the type $A<B$, amounts merely to arranging a series of 'enclosed' or 'included' differences. That is, constructing a series of inclusions such that size A is included in size B, B in C, and so on, independent of whatever may be the metric (or numerical) intervals between A and B or B and C (in this connection we may recall the difficulties experienced by Fran, Rap, etc., in trying to enclose the model square within their largest one).

It is therefore quite definitely the absence of operations which precludes the seriation of sizes, and the absence of 'grouping' (which is what seriation of qualitative relations such as $A<B$ amounts to) which prevents this process being conceived in advance as a single whole; that is to say, precludes its existence as an anticipatory schema.[2]

These brief observations assist in interpreting the reactions obtained in response to questions 2–4. These reactions indicate that at this level the children have absolutely no idea of operational continuity (in

[1] On this subject, see *Play, Dreams and Imitation in Childhood*, 1951.

[2] As regards the question of limits, in the present context it is simply a matter of qualitative seriation limited by material circumstances and has nothing to do with mathematical 'limits'. By the latter is meant, ever smaller intervals, and consequently, extensive quantities.

contrast to intuitive continuity based on perception of adjacent elements which cannot be discriminated) and are therefore unable to reduce lines or surfaces to points, "pushed together" to use the expression employed by one child (though refusing to entertain the idea he expresses so admirably).

The most remarkable feature of these reactions is in fact the difficulty which the children experience in subdividing lines and surfaces (question 2). Thus Fran cannot draw half of a line and when it is drawn for him does not understand what is meant by the half of the half, but points to the other half instead. Then, when he accepts this as his starting point his subsequent subdivisions decrease less and less in size. Lastly, when the children begin to make more or less regular subdivisions (Neu, etc.) they soon arrive at a point which they regard as final and ultimate. In the case of a line this appears to be a length of 2 mm., and 2 sq. mm. for the squares. And though this so-called ultimate element is still clearly visible, the child considers it impossible to subdivide it any further, and this is the most important point. It is also a rather complex point which needs to be more closely examined.

In the first place, we are again confronted by the tie-up, at first unbreakable, between thought and perception itself. The end elements must be perceptible or they cease to be real; as Char puts it, "they can't be counted any more" (he uses 'counted' in the sense of recognized). There is of course an element of doubt about this. When it is a question of what can actually be drawn with a pencil, as in the case of the smallest square (question 1), the child is partly right . . . but only partly, because he could after all end up with a point, and it is just this which he consistently refuses to do. However, if there is an element of doubt we soon remove it. It is made perfectly clear to him that he could continue "in imagination" just as in playing a game. Why then is the child—who can conjure up anything he fancies in symbolic play—unable to cut up "in imagination" a 2–3 mm. line or square, which is in any case quite clearly visible? The answer is that a hypothesis is something very different from a figment of imagination, and that hypothetico-deductive reasoning is a system of formal operations altogether unattainable before the various 'groupings' of concrete operations have been carried out. That is to say, until around 11 or 12 years of age.

But this is not the whole answer. If the children do not select the point as the ultimate element at this stage, their answers to question 3 show that there is a particular reason for this. In the child's eyes, the ultimate element must in general preserve a clearly defined shape because it must remain similar to the original whole from which it derives. Thus for Fran, the ultimate element of a line is "a very small line" which is itself indivisible. For Clau, it is a "point", but one elongated in shape "like a little line", whilst the ultimate element of a square is "a little

square" and that of a triangle "a little church steeple" or a needle-point. For Char, the end element of a square is "a little square piece", even if the square is cut diagonally, and that of a circle consists of "little pieces of circles" which are round in shape. For Rap, one only ends up with "nought" by subdividing a line, though just before "nought" there is still a line, etc. Finally there is Buc, who starts out with similar ideas but is no longer altogether certain that the last element of a square before "nothing at all" is really a square, and therefore compromises with a "little tilted square".

There is no need to look very far for the explanation of this isomorphism between the ultimate element and the whole from which it was derived. The inability of these children to subdivide a continuous whole indefinitely and their acceptance of this isomorphism between part and whole is accounted for by one and the self-same reason. In both cases it is due to the perceptual nature of early thought. For in truth, to the degree that one cannot think of looking for elements beyond the limits of visual perception, it is obvious that the initial whole cannot be resolved into perceptual 'points' that are round and discontinuous, because a continuous and non-circular whole cannot be built out of parts having characteristics so different from its own. The whole must therefore be created, at least in principle, from elements which resemble it if its distinctive qualities are to be preserved.

This is the ultimate explanation of the manner in which question 4, the re-creation of the whole from its parts, is answered at this stage. It is in this field undoubtedly, that one has to look for the underlying factors which govern the child's attitude, and this irreversibility or lack of reciprocity between analysis and synthesis of the whole is the best possible illustration of the difficulties which beset incipient thought.

For the child belonging to Stage II there are not two but three things to be reconciled: (1) The *complete figure* which is continuous, but whose continuity is of a perceptual nature and therefore unanalysable; since it cannot be subdivided without losing its distinctive qualities in the process. (2) The *parts* of the whole which the child is asked to subdivide. He is willing enough to do this, except that having subdivided the whole he considers the continuity broken and therefore relegates it to the interior of the parts. Thus in order to preserve the continuity as much as possible, he refuses to carry out too radical a subdivision and gives each element a shape isomorphic with the whole. (3) Points, which are regarded as discontinuous and related neither to the whole nor to its isomorphic parts. Points are regarded as the outcome of too radical a subdivision, or rather, the result of an illegitimate and badly made one.

What will happen if the child is asked to reconstruct the figure (1) from the parts (2)? He will see no obstacle to doing this so long as he can piece together the fragments, though it should be clearly understood

that such a response does not imply that he is using a set of reversible operations, for it is as yet no more than a simple empirical movement of return. As a matter of fact, the child intentionally limits his subdivision for the reasons we have just outlined, and he understands quite well that by going on he might eventually arrive at points. Buc, for instance, says "it would make a little point" and foresees such a possibility. But he will have nothing to do with it for the very good reason that "a point isn't a line" (in other words, it is not a constituent element of a line). This being the case, a synthesis beginning with the isomorphic parts, deliberately preserved with a view to their ultimate reassembly, cannot be regarded as a general and reversible action but remains a simple action of return; that is to say, an intuitive return to the original state of affairs.

Therefore the real problem is the relation between either the whole (1), or its isomorphic parts (2), and the points themselves (3), which the child stubbornly refuses to regard as elements, even though he is forced to recognize that further subdivision of his "little lines", "little squares" or "little steeples" would inevitably disclose a punctiform reality. There can be no doubt whatever that the children are convinced of this eventuality, whether they admit it or not. They all know and often say (cf. Clau, Dub and Buc) that if a line or a square, etc., becomes too small it turns into a point. But to their way of thinking, this is a result of imperfect subdivision which fails to achieve the true ultimate state because it vitiates or alters it in some way by going beyond it.

To regard these 'sub-elements' as elements or parts of parts would seem to be a relatively easy thing to do (and would in fact constitute a general reversible operation). But instead of this they are considered unsuitable material for reconstructing the original whole, or even for re-creating the parts isomorphic to the whole—and this at the price of the most glaring contradictions.

In this connection we confined ourselves to asking the children whether a line might not be envisaged as a series of points. The answer given to this question was categorical. If the points are discontinuous and can be seen as points, then it is not a line. If they appear to touch continuously throughout then they are no longer points. Thus, we find Neu saying, "No, they aren't points. You can see hardly anything but a line", and Bru, expresses himself in similar vein. Dub lays it down that a short section of line can only include "one point and not several", while Buc considers that when the points are touching "they are too close together" to remain points, and when they are not touching "they are points and it isn't a line".

Such is the outcome of this incipient reasoning based on images and merely copying perception. An absolute dichotomy between continuity and points; continuity analysed into elements isomorphic with the

original whole, but with an ever-present danger of these elements being changed in the process of subdivision. And should this happen they will split up into points and it will be impossible to reassemble them or rebuild the whole.

§3. Stage III. Operational synthesis within finite limits. Transitional reactions with respect to continuity

Toward the age of 7 or 8 the child is able to begin carrying out concrete operations. That is to say, the realm of the visible and tangible —until now the exclusive preserve of pre-operational ideas—becomes organized through general operations which are reversible in character and able to be combined. Beyond the realm of perception, however, thought remains impotent and can only function through analogies borrowed from the tangible and material. This explains the nature of the reactions reported below, which are completely operational within the realm of the finite but midway between intuitive and operational when they pass beyond it.

RAC (7; 3) arrives directly at the smallest and largest squares. Then (question 2) he divides a line into 2, 4, 8, etc., without hesitation: "What will be left in the end?—*Nothing at all*—But just before that?—*A little line, or a point*—How many points are there in a line like this (2 cm.)?— ... —A thousand, a hundred or less?—*Less than a hundred ... fifty*—Is a point the last thing before there is nothing left at all?—*Yes*—And here there are only fifty?—*Yes*".

The square: immediate subdivision. "And in the end?—*A point*—What shape?—*No shape*—The same shape as the point of the line?—*It will have a little shape after all; it will be a little bit square*". The triangle: he subdivides it into ever smaller similar triangles. "In the end?—*A point*—Will it have a shape?—*The shape of nothing at all*—Like the point of the line or the square? —*Of the line, because the corner of the square is still a little bit square* (he shows the way in which he subdivided it), *but the triangle would still have two things on top* (the sides) *like a sharp point*".[1]

AND (7; 3) succeeds in two approximations with the smallest square and with the largest right away. He cuts up the line by successive bisections: "*I can't go on, it's too small*—But if you just do it in your mind, what does it get like?—*Smaller and smaller*—And in the end?—*It comes to a point*—How many points are there in a line like this (1 cm.)?—*Ten*". He then proceeds to cut up the square: "And in the end?—*A point*—Like the point of the line?—*No, because it's a square*—What will it look like then?—*Like a little line*—And the point of the line?—*Like a point* (i.e., one dimension less each time)—But if you go on cutting the square right to the end won't you find a point?—*No, a short line*—How many points are there in the square?— *Forty*—Why?—*I counted the number of lines* (hence, 4×10 since there are 10 points in the line!) The triangle: "Right at the end, what will be left?—

[1] 'Comme une pointe' in the original text, as distinct from 'un point', meaning like a steeple or an arrowhead. Tr.

A line; nothing except a little line—Is a triangle made of points like a line or not?—*You find short lines*—Why?—*Because you make strokes like this* (he points to his reduction into similar triangles)—And right at the end?—*A little triangle*".

ZOI (7; 11) achieves a 2 mm. and then a 1 mm. square (question 1). Is successful with the largest square right away: "And if you make a square even smaller than this (1 mm.) what do you find?—*Nothing*—And just before that? —*A wedge, a point*—Has it any shape?—*Round*". To the square of 1 mm. he attributes two or three such points, not with a pencil but "*in his mind*" and to the model of 3 cm. square "*at least twenty*"—"And if you make them even smaller?—*A hundred I should think, or very likely less*".

The line: "At the end?—*A point*—Has it any shape?—*Slightly round*—The same shape as the point of the square?—*No, because it's lengthwise*—And if you cut it?—*It will make a smaller point*—Like that of the square?—*No, a little long*—But if you keep on cutting it in your mind, what will you find in the end?—*A little stroke*—And if you cut it?—*A point*—With a shape?—*Long*".

In the case of the triangle the point is itself "*a little bit pointed*".

LEP (7; 11). "You see these two points; how many can you put in between them?—*Maybe twenty, no, fifteen* (he draws them). Must they be touching?—*Just as you like*—(He makes them separate)—Not any more?—*No, otherwise they would come out of line*—But if they were quite small?—*Perhaps a hundred or a hundred and fifteen*—If you cut up a line like that, what would be the result?—(He proceeds to bisect it) *A very small line*—And if you go on?—*A dash, like this* (an elongated point)—And if it was elastic (if a piece of elastic were cut and stretched out)?—*You could do it as many as thirty times, perhaps even a hundred. I don't know, perhaps you could*". But they will always remain "*little lines*". Nevertheless he thinks that circles cut up by means of straight lines will culminate in very small rectangles.

PIE (7; 11) draws the smallest square at his first attempt. "And if it was made smaller still, what would be the result?—*A point*". Subdivision of a line results in spontaneous bisection: "And in the end?—*Also a point*—Like that of the square?—*No, the other one is a square point, this is a little dash*—But if you cut it?—*It will still have the shape of a dash*".

BLI (8; 6). "Can you put any points between these two?—*About a hundred* —And closer together?—*Two hundred*—And closer still?—*Four hundred, there might even be five hundred*—If you put them right next to each other, will it be all right?—*Yes*—Will you still be able to count them?—*Perhaps not any more*—And then?—*There will be little points next to each other* (he draws them), *when there's a space you can add some more. You could add more between the points, but that makes a line*—Many points make a line?—(Hesitation)—A line is many points?—(No answer)—Halve this line (and so on), can you go on for long?—*Yes*—And in the end?—*It becomes like a drawn out point*".

A triangle will eventually produce "*a point drawn out at the end like an angle*", and the line "*a drawn out point lying flat*".

PAT (8; 11) at once asserts that the smallest possible square "*is a point*". "Has a point got a shape?—*It can have many shapes, round, square*—But

just imagine a square point. Can you imagine in your head that it is cut?—
Yes, it makes a very, very small point—Has it a shape?—*You can't see*—
Then it has no shape?—*It still has a shape*". The line: "*In the end there will
be a point*—Will it have a shape?—*It will be rectangular*—And if you cut it
again?—*A square*—And again?—*Rectangular*—And in the end?—*There'll be
nothing at all*—All of a sudden, nothing at all?—*There will be a very, very
small rectangle*".

"How many points are there in a line like this?—*Very many*—Are they
touching?—*Yes, because otherwise it wouldn't make a line*—But will there
be any empty space between two of them?—*No, you can put plenty of them
in because you can put them in the middle*".

FRED (9; 9). Subdivision of a line: "And in the end?—*Nothing at all*—But
just before?—*A tiny little bit of a line*—Then you can cut it?—*No*—You can't
cut it when it's a bit of a line?—*Oh, yes*—What does it make?—*Nothing at
all*—How many of these bits are there in a line like this (1 cm.)?—*Just under
a hundred*—But can you go on cutting this line until it's nothing but points,
or will it always be lines?—*One could . . . Yes . . . No, it will always be bits
of lines*".

BRO (10; 3). The smallest possible square is "*like a point*". "A real point?—
No, a point is smaller—What is it then?—*It would be filled in in the middle,
it wouldn't be a square any more*". Subdivision of the line: "Can you go on
cutting it up for a long time?—*No, it wouldn't be anything except a point any
more*—How many points can you put between these two?—*Thirty*—No more?
—*Yes*—Many more?—*No, it would be a line*—But aren't a line and many
points the same thing?—*No . . . (hesitates)*—If you put them all in?—*It would
make a line*".

GIN (10; 4). The smallest possible square "*is a point*". "Has it any shape or
not?—*Round*—If you cut this line without stopping?—*It would end up in
nothing at all*—And just before?—*A stroke*—And if you cut it?—*A half, then
half of the half*—And in the end?—*The last stroke*—Can you cut it?—*Yes*—
What have you got then?—*Points*—How many are there in this line?—*About
two hundred*—And between two of them?—*There's the line*—But if you cut it,
will there be points?—*Yes, so small that you can't do anything more*—But
is there nothing but points in the line, or is there something else besides?—
It's a big line—But if you went on cutting it in your mind?—*It might come to
nine thousand points, maybe even more*—And the square?—*Hundreds*—Have
they any shape?—*Round*—Are they touching?—*Yes*".

We have given a fair selection of the answers obtained at Stage III
because of their obvious importance, despite the only too evident
difficulty of pursuing such an enquiry while neither suggesting answers
to the child nor inhibiting and confusing him.

What has been achieved since Stage II is a mastery of the operations
of seriation and subdivision, which by the age of 7 or 8 have become
functionally reversible. This explains why the questions dealing with
largest and smallest possible squares (question 1) are now answered
without difficulty. Furthermore, and for the very same reason, the child
is now ready to embark on a series of bisections of a line or surface,

knowing full well that he can go on doing this without meeting any obstacle so long as he can see or feel the material. Similarly, having reached the limit of perception he knows he can just as easily return from the part to the original whole. In short, so long as it remains a series of concrete operations involving physically possible action within the realms of the finite there is a definite advance over the previous stage.

But what happens when we venture beyond these limits? What happens when we move outside the realms of the visible and touchable? In other words, outside the realm of possible actions which, internalized as images, constitute the concrete operations through the interplay of reversible analysis and synthesis. As soon as this is done, the earlier difficulties reappear, for the simple reason that concrete operations are not hypothetico-deductive in character. Only formal, abstract thought can operate in the direction of infinity and so carry through a real analysis of continuity. In fact, throughout the entire course of Stage III it is apparent that an attempt is being made to reconcile the operations developed on the material plane with their pre-operational counterparts, which model the invisible on the pattern of the visible and fail to resolve the ensuing contradictions for lack of an operational mechanism.

In this connection, the first point to note is the very small number of subdivisions considered possible (question 2). For instance, Rac thinks that the result of subdividing a line of 2 mm. will be some fifty points. And, suggests ten such elements for a 1 cm. line and forty for a 1 cm. square. These very modest estimates, which would greatly simplify the mathematical theory of point sets and topology, increase in rather an amusing way as the child grows older. Bli, at the age of 8, reaches four or five hundred points. Pat, who is nearly 9, gets as far as "very many" and Gin, at the age of 10, suggests "nine thousand points, maybe even more", which puts him well on the way to infinity. But none of the children have the slightest conception of infinity at this level, and this explains the difficulties which ensue.

So far as the shape of the ultimate element is concerned (question 3), one can certainly observe considerable clarification of the highly confused ideas prevalent at Stage II. However, the solutions now proposed still fail to go beyond the bounds of the finite, for lack of any formal mechanism. At Stage II the child was aware of three separate items, the continuous whole, the elements isomorphic to the whole, and finally, the points which though alien to the character of the completed whole are nevertheless always liable to appear from too radical a subdivision.

By Stage III however, the child recognizes only two items. The whole and its constituent parts, which he envisages as capable of producing each other through the reverse operations of taking apart and putting together. But what do these parts actually consist of? In most cases the ultimate element is a point, but a point which takes over the properties

considered in the previous stage, distinctive of visible parts isomorphic with the whole. That is to say, having surface area and a definite shape depending on the shape of the whole and the way in which it was subdivided.

Thus for Rac, the point derived from the square has "no shape", but in spite of this, still has "a little shape" notwithstanding. And, uses one of the dimensions of the original figure to bring the corresponding element to mind. Thus the shape of the line is a point, while that of the square is "a dash". Zoi, thinks the point belonging to a square is round, that of a line "drawn out". Pie, puts forward the idea of a "square point" and Bli, that of "a drawn out point lying flat". Pat, declares spontaneously that a point "can have many shapes" and even has a shape "when you can't see" (when it has become too small to see). Only Gin, aged 10, after having recognized that points "are round", like Bli, who is the same age ("filled in in the centre" says Bli), begins to think of them as "so small that you can't do anything more", thus taking a step toward Stage IV. But all these children are actually still a long way from the idea of infinite subdivision. For all of them the elements are points. But while these points were regarded at Stage II as distinct from elements isomorphic to the whole, they now possess definite shape and exist in finite numbers.

The main achievement of the present stage is the synthesis of the whole from its constituent elements (question 4) and it occurs between the ages of 7–8 and 10–11, along with a gradual increase in the number of points. From the beginning of this stage, the synthesis of the whole no longer presents any real difficulty and the operation itself seems more clearly understood, since there is no longer confusion between actual elements and points as there was in Stage II. Since an element is really a point with a shape of its own, synthesis is simply the exact opposite of analysis, so that reversibility can easily be conceived of for a score or two of points possessing surfaces.

Thus Lep, who is 7, thinks that if there are too many points they will "stick out of the line", and to avoid the danger of any overcrowding he makes them separate, though freely admitting that they could in fact touch each other, and even being prepared to grant that if they were very small there might possibly be a hundred or hundred and fifteen of them in the line. But as the number of points increases, the child begins to find it more difficult to reconstruct the continuous whole from these separate, discrete elements and grows more and more aware of a contradiction between the two things. This contradiction recalls the parallel difficulty met with at Stage II, though now appearing on another plane, because it is only as points cease to be perceptible and tend towards infinite smallness that they raise the problem of how to reconcile them with the continuity of the whole.

Thus Bli, at the age of 8, already envisages some four or five hundred points "next to each other" between dots two or three centimetres apart, adding "when there is a space you can add some more . . . but it becomes a line". These simple words reveal a great deal. On the one hand they indicate the child's tendency to pass beyond the visible by multiplying the number of points. On the other hand, Bli uses the word 'but' rather than 'and' to express the transition from points to line. And when he is asked whether a line is the same as a series of points he refuses to answer because the idea of the continuous whole seems after all distinct from the discontinuity of the finite elements (a surmise which is absolutely correct, except that for want of abstract operations it does not occur to him that the answer lies in infinity). Pat goes even further than Bli. For him there are "very many" points and they must be touching "because otherwise it wouldn't make a line". Where there are gaps one can insert more points "in the middle" which is very nearly the theoretical solution . . . but the point, though "very, very small", nevertheless has "a shape all the same" (the point of the line is a "very, very small rectangle"). Finally, Bro and Gin illustrate the last few hesitations of this stage. Too many points, says Bro, "would make it a line". Furthermore, according to Gin, "there's a line" between two points, since together with the sum-total of points there is something else because "it's a big line". All the same, a line and a surface are made up of thousands of points which touch each other and are "so small that you can't do anything more", i.e. they cannot be represented.

In sum, we have here a reversible synthesis of the whole out of the parts and analysis of the parts from the whole. But because this operation is 'concrete' and not 'abstract', because it remains finite and perceptible (or analogous to perceptible) instead of becoming infinite and purely theoretical, there persists a latent and temporarily insoluble contradiction between the continuous whole and its discontinuous parts.

However, there are two differences between the attitudes shown at the present stage and those exhibited at Stage II as regards the relations between points and lines. The previous attitude amounted simply to contrasting the visibly discontinuous points, which ceased to exist as soon as they came into contact (because they are then merged in the line), with the visibly continuous line, not formed of points. On the other hand, the contradiction sensed by the children of Stage III relates to the multiplication of points beyond the limits of visibility and is therefore intellectual rather than intuitive, thought rather than felt. The second, and main difference is that from the conflict between points and line, the child of Stage II draws the conclusion that the former is not an element of the latter, whereas in Stage III his chief discovery is precisely the recognition (and even the postulation) of reversible com-

position of the line from elements which are points. This makes it necessary for the child to resolve the contradiction by reconciling the opposing terms rather than by denying one of them, which was the course taken at Stage II where the point was regarded as an irreversible end product of subdivision.

The main feature of this conflict is self-evident. What is brought to the fore by the natural development of operations is the problem of continuity itself, and it is posed in terms closely analogous to the treatment of the question found in the historical development of mathematics.

The perceptual continuity which sufficed for the children of Stage II is in practice the absence of separation between neighbouring elements. According to Poincaré's celebrated analysis, the impression of continuity depends upon the following contradiction: among three adjacent elements ABC, A is not distinguished from B nor B from C. Perceptually, A=B and B=C, but A is distinguished from C and thus appears as A\neqC. It will be realized immediately that Köhler explains differential perceptual thresholds (formulated in Weber's Law) in identical fashion, which is clear enough evidence of the psychological significance of these relationships as regards failure to discriminate A from B or B from C, and differentiate A from C.

Using the terminology of Chapters I to IV, we can say that perceptual or intuitive continuity is a synthesis of proximity (developed from perceptual 'proximity') and separation (of spatial elements separated by analysis, whether adjacent or not),[1] but an incomplete synthesis because A and B are perceived as adjacent to a greater degree than is really the case. Having established this point, we can go on to say that conceptual continuity begins at the stage where separation is generalized in terms of operational subdivision and is therefore no longer confined to perceptual discrimination.

A new synthesis must now be found between proximity and separation, and this synthesis will not be complete until all adjacent elements are separated (or separable) by analysis. This is a necessary condition for the concept of continuity but it is by no means a sufficient one, because apart from this it is also necessary that in the immediate environment of every point, however small, there should always be at least one other point belonging to the whole. Continuity therefore appears as the synthesis of the relationships of proximity, separation, enclosure (the surrounding of points) and order (surroundings being regarded as smaller and smaller and hence organized in a series of enclosures).

[1] Two elements may be adjacent and not separate or adjacent and separate, separation being something distinct from non-adjacency since it depends purely on the circumstance of being differentiated through some type of analysis (perceptual or logical).

As regards the reactions at present being discussed, however, it is first and foremost the development of separation which is most evident, and it is this activity which causes the rest of the process to follow. The child begins by separating from each other, points which are perceptually indiscernible (though he visualizes them as analogous to visible points). Only secondarily does he invoke order and enclosure (see Bli and Pat, who insert points "in the space" lying "in between" two other points, or "in the middle" of other points, etc.). The contradiction which these children experience is due entirely to the fact that the approach to increasingly remote separations in the course of subdivision appears, to them, to entail the breakup of proximities, and even a permanent discontinuity. For they have only an imperfect grasp of the second condition of continuity, that while multiplying the separated points it is also necessary to guarantee the presence of at least one adjacent point in the environment, however small, of every point envisaged.

Why then are the relationships of proximity and separation not combined through this process of forming ordered enclosures or surroundings? The answer is again that the child does not yet dispose of abstract operations of thought which would enable him to carry on the subdivision indefinitely, and because he cannot imagine a sufficient number, that is, an infinite number of points. Without an infinite number of points the gaps which are created cannot actually be filled. The child is perfectly well aware of this at this stage, but is unable to do anything about it since he is not yet capable of generalizing operational subdivision without limit. It is the task of the fourth and last stage to achieve this synthesis through hypothetico-deductive or abstract operations.

§4. Stage IV. Abstract operations of thought and the synthesis of continuity

By Stage III, the child has mastered the notions of proximity, separation, order and enclosure on the plane of concrete operations, but is unable to combine them in the way essential to the understanding of continuity because he cannot perform abstract operations of thought enabling the subdivision (separation) of a whole to be extended indefinitely. And this applies equally to the converse operation of bringing the separated elements together in surroundings (enclosures) which are likewise unlimited in number.

As we have shown in a number of studies, it is at about 11 or 12 years of age that the child begins to employ abstract or hypothetico-deductive thought. That is to say, the system of second order operations, envisaged simply as possible or hypothetical and functioning in abstract propositions referring to concrete operations. Not until he reaches this level does the child envisage the ultimate elements of continuity in this way. That is, as purely hypothetical points which can be neither seen nor touched but can be mentally separated and combined to the limits of infinity.

However, from the age of 10, children already exhibit reactions midway between Stages III and IV, as these few examples will show.

ALF (10; 2). The smallest square (question 1). He makes a tiny point. "When you cut a line, what is left in the end?—*A point*—Can you cut it in your mind?—*Yes, it will get smaller and smaller and in the end there won't be any left*—Between these points (close together) can you put in any more?—*Oh yes, if you make a short line straight away . A short line is lots of little points all put together*—Can you count them?—*No, because they're all touching*—How many?—*Hundreds*—And in between two of them?—*There's nothing at all between them* (i.e., they touch)—Are there points in the square?—*Yes*—Have they any shape?—*Round*—And in the line?—*Round as well*—How many points are there in the square (3 cm. side)?—*Thousands*—And in this table?—*Billions*—How far could you go on counting them?—*I think I could go on for ever*—And would a grown-up come to the end of the number?—*No, never, because no-one has ever come to the end*".

MAG (10; 3). Subdivision: "*You can go on cutting two hundred, five hundred, a thousand times. In the end you won't know what the number is*—How many points are there between these two dots?—*A hundred or five hundred at most, but I can't count them because the points would be touching, it would make a line*".

DIS (10; 3) believes there are "*millions of points*" in a line of two to three centimetres and that "*they are touching, perhaps not quite*" but if one were to add any more "*there wouldn't be any space left between them*—Are there as many points as there are numbers?—*Perhaps; no, I don't think so, because this line is small*".

MUH (10; 10). "How many points?—*You can't know how many because they can't be counted by eye*". Subdivision: "*The last bit would be a point because the line is made up of points*".

STEI (10; 7) believes that one finds points at the end of every subdivision because "*you can't cut without leaving something*" and that "*a point is smaller than a circle*" (a visible circular point).

PAU (10; 2) at first thinks "*there are two thousand round points*" in a one centimetre square, just as in a line. "*They are all touching because they're so small*—But will there be any empty spaces?—*Yes, but you can always add some more points*—How many?—*You can go on adding them until you come to the end of numbers*—Do numbers ever finish?—*No, you could go on counting all your life without coming to the end*—And if you count the points in this square will you come to the end?—*Yes, because it has a border*—And the points in this table, do they have an end?—*Yes. Numbers don't come to an end, but a thing* (something real) *does come to an end*".

And here are a few clear examples of Stage IV.

BET (11; 7). "How many points could be drawn along this line?—*You can't say. You can't count them. You could make points that get smaller and smaller* (cf. the decreasing enclosures)—How many are there in this circle?—*It's impossible to tell*—But roughly; 10,000, 100,000, 1,000,000?—*It's impossible*

to tell, there are so many you just can't say—Make a drawing showing what the smallest possible line looks like—*But it can't be done because it could always be made smaller still*".

Zum (11; 7). Subdivision of a line: "How long can you go on?—*For ever*— Why?—*Because there'll always be a bit left*—And how many points will there be in the little bit that's left?—*So many that they can't be counted*".

Duc (12; 9). "Can you add any more points between these two?—*As many as you like*—And how long can you go on cutting up this line?—*Indefinitely* —But what will you find in the end?—*Various kinds of points. In the end they're all mixed up*".

Dan (11; 7). "And if you go on cutting?—*There are still points*—What do they look like?—*Like dust floating in the air* (cf. atomism)—How many are there in a short line?—*You can't count them, there's no end to them*".

It is thus apparent that at the level where thought becomes hypothetico-deductive, where operations free themselves from their material content and begin to function solely in terms of their formal structure, the child can transcend the idea of visible subdivisions and perceptible points, extending the mechanism of analysis and synthesis beyond any physical limit. It is this alone which facilitates the operational synthesis of continuity.

We may appear to be using a somewhat far-reaching expression to describe these partly (but probably only partly) spontaneous and not very consistent ideas which these 10–12 year old children formulate. For it is hardly necessary to question them at all closely before they begin to hesitate or embroil themselves in contradictions and retractions. And we certainly have no intention of crediting them with the theory of point condensation or any presage of Weierstrassian axioms.

However, one thing seems certain enough to justify employing the term operational continuity. At a certain point, the child suddenly becomes aware of the dynamics of the operation itself as a process of indefinite, abstract combination, subsequent to which subdivision and reassembly are no longer simple additive operations applied to finite, physical objects but become operations dealing with an infinite series of "encasings" or "uncasings". Furthermore, the merit of abstract operations lies precisely in the circumstance that, being "operations based on operations" they mark a decisive turning point in the freeing of the full power of thought.

To take a series of examples, when Bet refuses to draw the smallest possible line because "you could always make it smaller still", when Zum considers that the subdivisions could go on "for ever" because "there will always be a bit left", when they both refuse to estimate the number of points because they are "uncountable", when Dan says, "you can always go on adding more points" and Duc specifies "as many as you like" and "indefinitely", all these children have caught a glimpse of

147

the fundamental truth that the infinitely small is not a static residual but the expression of a process of infinite subdivision.

As for reassembly, no longer do we find as we did with Gin, at Stage III, "points" on the one hand and "the line" considered as a continuous whole on the other. Instead, the reassembled points and the line as such are one and the same thing, because "a short line is lots of little points all put together" (Alf) and because fresh points can always be inserted to fill in the gaps (Pau). So that when Duc declares that "in the end they are all mixed up" he no longer has in mind the perceptually indiscriminative (A=B; B=C and A≠C), because the "mixture" contains "as many points as you like". Rather is it a homogeneous and continuous entity composed of the sum total of adjacent points.

What is the basis of this synthesis, which remained undiscovered at Stage III, despite its components being known? In essence, it is the ability to continue the operations indefinitely as against the material limitations still accepted at Stage III. But this dynamic process now unfolds itself along two cognate paths of development, whose eventual conjunction results in true continuity. The notions of proximity and separation are no longer counterposed as they were while thought remained bound up with perception. In other words, when the process of subdivision becomes operational, intuitive separation is replaced by logical, conceptual separation based on the notion of proximity itself. At the same time, the immediate environment of every point is now completely occupied with other points until, as Duc remarks, "There won't be any more empty spaces between them". And this can go on "until you come to the end of numbers". Bet expresses the same idea, not by filling in the spaces between points, but by internally subdividing the "smaller and smaller points" or the bits of the line "which you could make smaller and smaller", a system of 'enclosures' one within another, as contrasted with the insertion of further points suggested by Dis and Pau.

In short, the series of neighbourhoods or 'surroundings' (one-dimensional for lines, in the form of spaces 'between' points; two-dimensional for surfaces, in the form of spaces 'around' points) are themselves filled with points, close to, yet separable from them in thought. The fusion of subdivision and enclosure thus makes possible the synthesis or combining of the four relationships of proximity, separation, order and enclosure which were already mastered at Stage III, but could not be brought together in a single whole in the absence of the idea of unlimited subdivision and enclosure.

Although the logical framework of continuity has been created by means of these abstract operations, it hardly needs pointing out that it is no more than a qualitative, rough outline. What is still lacking is the concept of irrational numbers serving as a basis for the idea of

continuity. For these children, points correspond with the series of whole numbers, even though they make some interesting reservations apropos of this, such as Pau's "numbers don't come to an end" whereas something real or occupying physical space "does come to an end". But they have no idea of the special kind of numbers destined to fill the gaps between the points already enumerated. Furthermore, they seem to have no hint of the theory of limits or points of condensation which would enable the series of enclosures to be quantified extensively as opposed to their present logical, intensive treatment. At the same time, one might very well query whether they really have no idea of extensive quantities, or whether they are merely unable to formulate it. For it is only a short step from the relationship of "smaller and smaller" envisaged by Bet, to that of extensive quantities.

To conclude, the development of the idea of continuity, which the children of Stage IV enable us to watch taking place, leads to a synthesis of the topological relationships worked out during Stages I to III. In so far as operational subdivision involves a conceptual separation of neighbouring points in place of a perceptual or intuitive process, it reconciles the opposing notions of proximity and separation within a global, unified concept of continuity. And in so far as it fills in the immediate surroundings of every point, continuity enables the operations of order and enclosure to find a general form equally applicable to lines, surfaces and three-dimensional spaces. In this way, the previously intuitive ideas, whose relatively early appearance in connection with relationships involving boundaries, openings and closures has already been noted, are thus given a rational basis.

As a result, continuity, though completing its development somewhat later than the other relationships—which is inevitable since it constitutes their synthesis—rounds off the development of the topological concepts on which rest the child's idea of space, thus bringing us to the end of our present study.

PART TWO

PROJECTIVE SPACE

SUMMARY

THE most important difference between topological relations, whose main features we have just examined, and the projective and euclidean relations we are about to study in Parts II and III, occurs over the way in which different figures or objects are related one to another.

The relations of proximity, separation, order, enclosure and continuity are built up empirically between the various parts of figures or patterns which they organize. They are independent of any contraction or expansion of these figures and are therefore unable to conserve features such as distances, straight lines, angles, etc., during changes of shape. Hence, it is impossible for relationships of this type to lead to comprehensive systems linking different figures together by means of perspective or axial co-ordinates, and for this reason they are bound to remain psychologically primitive.

This primitive, topological space is purely internal to the particular figure whose intrinsic properties it expresses, as opposed to spatial relationships of the kind which enable it to be related to other figures. Thus it has none of the features possessed by a space capable of embracing all possible figures, and the only relation between two or more figures comprehended by topological operations is that of simple one-one and bi-continuous correspondence, the basis of 'homeomorphism' or structural equivalence between figures. In other words, it only furnishes the basis for that type of analysis which operates from the standpoint of each figural object considered in isolation, rather than that of a comprehensive system, one able to co-ordinate all figures within a whole, organized in terms of a common spatial structure throughout.

With projective and euclidean space we encounter a new and different problem, that of locating objects and their configurations relative to one another, in accordance with general perspective or projective systems, or according to co-ordinate axes. Projective or euclidean structures are therefore more complex in organization and are only evolved at a later stage in the child's development.

Since they entail the conservation of straight lines, angles, curves, distances—relationships which persist throughout the course of transformations—these structures invariably refer, either explicitly or implicitly, to a general system of organization. And this is still the case, even when it is only a matter of analysing a single figure isolated by a process of abstraction.

Projective space, whose development we are about to trace, begins psychologically at the point when the object or pattern is no longer viewed in isolation, but begins to be considered in relation to a 'point

of view'. This is either the viewpoint of the subject, in which case a perspective relationship is involved, or else that of other objects on which the first is projected. Thus from the outset, projective relationships presume the inter-co-ordination of objects separated in space, as opposed to the internal analysis of isolated objects by means of topological relationships.

This is what we shall find in studying projective lines and simple perspectives (Chapter VI), shadow projections (Chapter VII), general co-ordination of perspective (Chapter VIII), sections (Chapter IX) and development of solids (Chapter X).

Chapter Six

PROJECTIVE LINES AND PERSPECTIVE[1]

THE concept of the straight line results from the child's first attempts to relate objects spatially in a system of projective viewpoints or co-ordinates. Strictly speaking, the topological idea of 'a line' does not include the 'straight line' at all. To transform an ordinary line, the only kind of line recognized by topology, into a straight line requires the introduction, either of a system of viewpoints such as the elements of a line masking each other to form a perspective, or else a system of displacements, distances and measurements. Drawing or imagining a straight line therefore presupposes a projective or euclidean space, so that in actual practice such a notion is far from elementary, whatever may be the opinions expressed in textbooks of geometry. However, this is not very important since their authors are as ignorant of psychogenetics as they are of the logical foundations of their own subject.

The child begins to perceive straight lines as such very early in life, though at precisely what age a baby is first able to follow a rectilinear shape by eye or hand is a question which still awaits a definite answer. However, as we saw in Chapter I (Section I), it is one thing to be able to perceive a straight line and something else to be able to picture it in imagination. In other words, there is a vast difference between the construction and the reconstruction of a figure. In particular, the study of drawing carried out in Chapter II showed that ability to copy squares, rectangles and the like, or to reproduce a straight line, is only acquired after the child has already learnt to copy figures which, though apparently more complex, actually involve only topological relations such as closure, two-dimensional surrounding, or overlapping of boundaries. The construction of a straight line may be defined as the linking of distant points by the interpolation of a series of points along a direct path, and in the course of the present chapter we shall see at just what age this is first carried out.

The purpose of this chapter is therefore to outline the development of the concept of the straight line through the act of 'taking aim' or 'sighting', and to investigate how simple perspectives come to be constructed. Now the latter are entirely concerned with preserving the shape of straight lines despite modifications in length, inclination, parallelity, etc. Hence, it is mainly the projective straight line we must now deal with, both in its own right and in relation to elementary

[1] In collaboration with Mlles G. Ascoli, J. Nicolas, and Ch. Renard.

perspective, since the straight line is the sole aspect of shape which remains unaffected by perspective changes.

SECTION I—CONSTRUCTION OF THE PROJECTIVE STRAIGHT LINE

Under this heading we shall deal only with straight lines constructed through the action of 'taking aim'. Limited in scope though this may seem, it is a problem which merits a section to itself since nothing is more suited to illustrating the vast difference between perceptual and representational space than to see how backward in imagining or constructing a straight line are children who have long been able to recognize straight lines perceptually.

§1. *Technique and general results*

For these experiments a square or oblong table and a round table are used, on which stand a number of match-sticks stuck into bases made of plasticine. The child is told that each match represents a telegraph pole and that these must be arranged to form a perfectly straight line running along a straight road. To start with, the first and last posts are placed in position (20, 30, or 40 cm. apart, varying in different cases), and both equidistant from the edge of the table. Thus the child can make a straight line parallel with the edge of the table simply by inserting the remainder of the posts between these two. Although nothing is said about their being parallel with the edge, the results of the experiment show that, without so much as mentioning it, the child does in fact constantly refer to the straight line formed by the table edge, and it is also evident that this helps him considerably. When he has completed this task, the two end posts are moved so that a straight line constructed between them will run at an oblique angle, neither parallel nor diagonal to the edges of the table. The required straight line will thus be at some angle to the two adjacent sides of the square.

With the round table, the end posts are placed so that the line between them is either a diameter or a chord of the circle. In this form of the experiment the edge of the table offers little or no perceptual guidance.

In addition to these set-ups, the child is shown, preferably on a round table, a series of posts arranged in a curved or zigzag line and he is asked to correct it and make it straight. If the child fails to discover the method of 'taking aim' of his own accord, if he does not, on his own initiative, place himself in line with the posts in order to align them by eye, he is brought to different positions around the table (to one side or

along the path of the line, etc.) and questioned as to the particular advantages and disadvantages of each position.

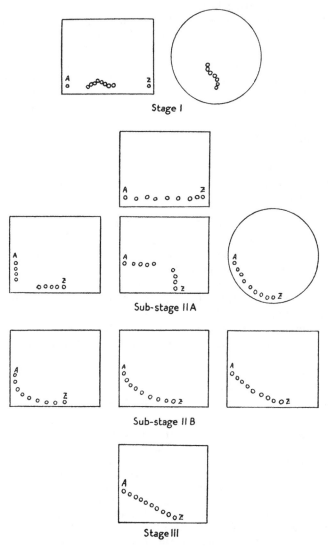

Fig. 18.
Stages in the construction of the Projective Line.

On the basis of these few questions it was possible to identify the following stages of development (see Fig. 18). At Stage I (up to 4 years),

the child is equally incapable of forming a straight line—even when it runs parallel with the edge of the table—as of drawing the straight sides making a square or triangle when given a model to copy.

At Stage II (roughly, from 4 to 7 years) he can form the straight line more or less correctly when it runs parallel to the edge of the table, but is unable to do so when it lies at an angle to the sides. Within this stage may be distinguished two substages. In the first, Substage IIA (up to about 6 years), the child finds it quite impossible to break away from the perceptual influence of the table edge. In Substage IIB, he gradually overcomes this obstacle through successive trial and error, gestures playing an important part in the process.

From Stage III (starting about 7 years, or a little earlier in some cases), the straight line is constructed no matter where it lies on the table and this is done by the child spontaneously 'aiming' or sighting along the trajectory, putting himself in line with the two posts to be linked by the straight line.

§2. *Stage I and Substage IIA. Inability to form straight lines parallel with the table edge (I), or independently of it (IIA)*

Although the reactions seen at Stage I are closely analogous to those obtained at the same level in Chapter II, it is extremely useful to examine them in some detail, because they demonstrate, even more clearly than did the graphic or haptic reactions, the great difference between imagining and perceiving a straight line. It is also apparent that the topological line predominates over the projective or euclidean line during the early stages of mental representation. The children of Stage I can recognize a straight line and distinguish it from a curve, but they are totally unable to construct such a line, even parallel to a straight edge, such as the edge of the table. They can only succeed in doing this when allowed to form a line immediately by the side of an existing model.

ALB (2; 6) is asked to arrange the 'trees' (matches stuck into slabs of plasticine, also referred to as 'children holding hands', etc.) in a 'perfectly straight line' along the edge of the table (not merely parallel with the edge, but right on it). He can do this without difficulty. Similarly, a straight line is drawn for him and he places eight matches along it with no trouble. But when asked to copy the same line parallel with the edge of the table (10–15 cm. distant from it) he fails completely and contents himself with simply placing matches next to each other as close as possible. The result is not a straight line but a meandering one. We then place two matches 20 cm. apart, 2–3 cm. from the edge of the table, and ask Alb to make a line using the rest of the matches, between the end pair and parallel with the edge of the table. He puts two matches next the first and two more next the last but fails to put the remaining pair in line with the rest, thus ending up with a wavy line not parallel with the edge of the table.

As for drawing, Alb is still at the level of scribbling and cannot copy either

158

a circle or a square (as closed figures). Nevertheless, he can arrange the matches along the circumference of a ready drawn circle, as he did with the straight line.

MIC (2; 9) also succeeds in placing matches around a ready-made circle, along a straight line or the edge of the table, but is unable to construct a straight line as soon as it is a few centimetres away from the edge. The same happens when they are arranged on the floor where he is without either help or hindrance from the perceptual surround. He places the matches as close together as possible and ends up with wavy lines.

His drawings of circle and square are vaguely closed scribbles.

PAU (3; 9) draws a circle as a roughly closed shape and a square in similar fashion, though with some angles and a few scraps of line. He also fails in attempting to draw a simple straight line. He is no more capable of grasping the meaning of the word 'straight' in phrases such as 'a straight road' than were the previous children; but he does understand what is being asked of him when the matches are likened to children standing in 'a ring' or placing themselves 'in line'. For 'the ring' he can manage to arrange seven matches in a closed figure (at intervals of 4–5 cm.). For the line (also constructed on the floor) he places the matches as close together as he can and ends up with a circular arc. We try to persuade him to space the matches out a little ("they are holding hands like this, they are not so close together"), but with widely separated elements he is unable to arrive at any sort of line at all.

"Now make a wall from here to here (the extremities are placed for him)— (Pau bunches the elements at each end so that there are two lines, but he cannot manage to join the two sections together)—Try it along the edge of the table then (the end elements are placed 2–3 cm. from the edge to start him off)—(he produces a circular arc)". Several successive attempts on the edge of the table produce the same results as with Alb and Mic; namely, a straight line along the very edge but failure when there is a separation of 2–3 cm., parallelism being an inadequate guide to representation. Also, the greater the intervals between matches, the more irregular becomes the line.

An attempt to form a straight line across one corner of the table is also a failure. Curiously enough, Pau showed by his approach to the problem that although he cannot make a straight line parallel with the edge of the table, he is equally unable to break away from it entirely. Thus the perceptual cues offered by the line of the edge, though insufficient to help him form a straight line, are strong enough to inhibit the attempt at forming one across the corner of the table.

DAN (4; 0) illustrates the transition from the present level (as demonstrated by the previous children) to that of IIA. He is already able to draw circles and squares and is able to form a nearly straight line almost parallel with the table edge. But he is quite unable to form such a line against a neutral background (such as the floor), and in this respect he falls short of the performance characteristic of Substage IIA.

The significance of these results is immediately apparent. On the one hand, these children can easily recognize a straight line, for they distinguish circles from squares at sight, and can easily follow a straight

line by arranging matches either on an existing line or along the edge of the table. On the other hand, they have no clear idea of what constitutes a straight line, in the sense of a symbolic image going outside the field of perception, or as regards organizing a new construction within the framework provided by perception. Verbally, they do not know what the word 'straight' means, only understanding the word 'line', while being unable to draw a straight line in actual practice. But above all, when it is a matter of forming straight lines with matches, even parallel with the edge of the table (and as close as 2 or 3 cm.), they fail utterly and completely. Their performance is confined simply to the formation of a topological line with successive elements very close together and curved in various ways (the notions of proximity between separate elements, order, etc., all being very well deployed). Finally, it would seem that proximity is indispensable to achieving a linear order, for as soon as the elements become widely separated the line grows more and more irregular until it is hardly possible to speak of a line at all.

In short, Stage I is aptly described by means of the two features referred to earlier. Absence of representation of the straight line (despite its being known perceptually), and pre-eminence of the topological line, which can be formed so long as the elements remain sufficiently 'near' each other.

The reactions encountered in Substage IIA are no less interesting. By now the child can arrange his matches parallel with the edge of the table, and can even arrange them against a neutral ground (though with more difficulty at first), but he is still unable to throw off the influence exerted by the edge of the table when the required line no longer runs parallel to it.

BER (4; 4) draws a circle as a closed curved shape, but fails to distinguish between a square and a rectangle, both being shown as a straight line plus a parabola giving a more or less closed shape. When he comes to form a straight line on a neutral background, Ber is successful unaided—though only when the end elements are not fixed in advance so that he can place the matches close enough together. If the end posts are set up beforehand he can still manage to form a straight line but cannot incorporate the end units into it. A box is then placed on the floor about one metre from the child who is told to walk towards it. He moves in a straight line and at our request places a stick on the floor to mark his course. He is now asked to arrange the posts along the same line, the stick having been removed in the meantime, which he does correctly. However, he is unable to space the posts far enough apart so that the line only extends for a quarter of the full distance. Next, he manages to arrange the posts on the table, first along the edge and then parallel to it (30 cm. away), though here again he puts the posts too close together. But he cannot form a line across one corner of the table and can only produce two lines following adjacent sides.

TEA (4; 6) is asked to "put the children in a straight line" on the floor.

He cannot space out the matches but arranges them close together. As soon as he tries to space them out his line meanders. At the same time he succeeds in forming a 'ring'. In addition, he can construct a straight line parallel with the edge of the table, though only when the posts are brought close together. When he tries to form the line across one corner of the table he cannot break away from the edges but forms first a right-angled line and then a curved arc. On being asked to indicate a straight line with his finger he does so correctly enough but continues to arrange his matches in a curve just as before. The experiment is repeated in a corner of the room and the influence of the two adjoining walls produces the same result.

Mar (4; 8). "Do you know what an absolutely straight road is? Show me what it looks like—(He indicates a straight line with a movement of his hand) —And a road with bends?—(He makes a zigzag gesture)—Do these three posts (placed along the length of the table and a few centimetres from the edge but not quite straight) make a straight line?—*No*—Put them right then— (He arranges them in a straight line)—Is that quite straight?—*Yes*—Where do you have to look from to be sure it's quite straight?—(He does not move) —If you stand there (opposite the row)?—*It's straight*—And if you stand there (In line with it)?—*It isn't straight* (He puts them straight)—Now arrange them here quite straight (parallel to another side of the table. He arranges four almost in line)—Are you sure they're in line?—*Not quite*—Which is the best place to look from?—(He again moves to one 'end')".

Mar is now asked to arrange "along an absolutely straight road", three posts, B, C and D, between two others A and E, of which A is located midway along one side of the table and E midway along the adjacent side, so that AE cuts one corner of the square. He places B, C and D parallel to the side containing E and in line with it, so that A is excluded from the line. "But this road is supposed to be straight. Haven't you got a bend here (AB)?— *Oh yes!* (he places B in a straight line between A and C, but the section of line ABC now makes an angle with the section CDE)—But now it bends here (C) —*Oh, yes* (He replaces B at the edge of the table)". Mar never succeeds in forming a straight line between A and E. At one moment he puts B in line with CDE, while at the next he reverts to two separate straight lines ABC and CDE but cannot include C and D since he cannot free himself from the perceptual influence of the edges of the table, although this has not been referred to explicitly.

Fran (5; 4) can also arrange three posts parallel with the edge of the table without difficulty. He contents himself with an approximately straight line and does not think it worth while changing position in order to check up on it because, like Mar, he is ignorant of the method of 'taking aim'. Nevertheless, by making use of the perceptual parallelism he is able to turn out a fairly straight line. "Now the man wants to go from here (A=one corner of the table) to there (E=a point midway along the opposite side, 20 cm. from the edge) along an absolutely straight road—(Fran places BCD after A in a straight line running parallel with the edge of the table, D lying close to E although the latter is not actually part of the line) *There!*—Is your road really straight? Hasn't it got bends in it?—*Only one, here* (CDE)—Well then, get rid of it, so that it's quite straight all the way from here (A) to there (E)—

(Fran wants to move E)—No, leave that one where it is—*Well then, I can't do it*—Go on, try—(He puts BDC close to A, then spaces them out, arranging them parallel to the side of the square and in line with E, so that the section EDCB is straight but excludes A)—Are there any bends now?—*Yes, one there* (ABC)—Well, get rid of it then—(He replaces BCD in line with A but now excludes E)—See how I do it (before his eyes the posts are placed in a straight line between A and E). Now is that a straight road or isn't it?—*It's quite straight*—Why didn't you do it like that?—*Because . . . I don't know why*—Now if I place them where you did (ABCD parallel with the edge and E lying outside the line), is there a bend or not?—*Yes, there's a bend*—Then arrange them properly, quite straight—(He places them in an arc between A and E as if the line were somehow attracted by the edge of the table)—Is that right?—*No*—Then put them in a straight line—(Once again he produces a straight line ABCD parallel with the edge of the table but excluding E)''.

LIL (5; 3) makes a line of posts parallel to the edge of the table and adjusts the zigzags in it well enough to make it roughly straight, but without 'sighting' along it. He is shown an absolutely straight line cutting a corner of the table: "Is it quite straight?—*Yes*—Where is the best place to stand to find out whether it's straight, here or there (in line or in the middle)?—*There* (the middle)—Now let's move to this table (round). I want you to make a straight line between these two posts (A and E, 30 cm. apart)—(Lil fits in B, C and D, but following the round outline of the table)—Is it straight or round?—*It's round*—But you're supposed to make a straight line—(Lil begins again) *It's the same thing! I can't do it. It ought to be put there* (on a diameter of the table: Lil places one post at the centre and constructs a straight line passing through it)—But there (between A and E on a chord of the circle)?—(He produces another arc) *Oh no, it's round again* (rather annoyed). *It was so easy before, but now I can't do it at all!*—And on this one here (square table)? —*It's all right* (forms a straight line parallel to one side). *Now it's straight*— Why?—*Because that table over there was round and this one's straight*—Try it on the round one again—*No, I can't!*''

ROG (6; 0) places three matches 30 cm. apart in a straight line, parallel to one side of the table. "And like this (we move the middle post a little to one side)?—*No, it isn't straight*—How can you tell?— . . . —Move over to where you can see best—(He stays in the same place, correcting the error by guess-work)—How do you know whether it's right?—*I made a line with my finger* (he did in fact sight the extremities with the aid of his forefinger, but quite haphazardly)—And when it's like this (two end posts each midway along adjacent sides)?—(Rog places the remainder of the posts along the sides producing a right-angle)—Is it straight?—*No*—Well, put them right—(He makes several successive attempts and ends up with a curve)''.

NOE (6; 6), when asked to make a straight line parallel to the edge of the table, makes a straight line, not by 'taking a sight' along it but by following with one finger. When A and E are placed, one in a corner, the other midway along the opposite side and 20 cm. from the edge, Noe makes first of all a section ABCD near the parallel side, then another section BCDE again parallel to the same edge but 20 cm. from it, so that he is unable to connect A and E by a line which is not parallel to some side. After repeated assistance

and encouragement he does succeed in joining the two points, but only by means of a convex curve attracted toward this same edge of the table.

These results speak for themselves. Obviously, at the perceptual level, each of these children can recognize a straight line and distinguish it from a curved or broken one. Even when the row of posts cuts one corner of the table—precisely the position in which he will be least able to construct a straight line—the child is perfectly clear as to whether or not the row is straight (cf. Lil). But so soon as he has to imagine it, so soon as he is asked to construct, either mentally or in practice, a line joining two posts A and E, then difficulties intervene. And the variety of these difficulties is in itself extremely interesting.

One situation presents no difficulty at all. When the child can base his idea on a perception, when he can obtain the right orientation for his line by following the existing model step by step. This is what happens when the line to be formed runs parallel with the edge of a straight-sided table. In this situation all the children belonging to this substage can construct the straight line. At the same time, it would be improper to speak of true mental representation in these circumstances, since this process is only a species of imitation guided by perception.

Another instance in which the difficulties, though somewhat more serious, can still be overcome occurs when the line is to be formed against a neutral background or equidistant from opposite sides of the table. Thus Lil, for example, can construct a straight line along the diameter of the round table. In this case the process of imagination is not influenced by the curved edge, and the same is true for a line constructed on a surface so large that no peripheral obstacle can get in the way (e.g. in the centre of the floor). But in this case also the representation can be regarded as a kind of imitation, not direct of course, but a delayed and internalized imitation. Thus the straight line which the child imagines is simply a copy of previously perceived straight lines and in this respect is no different from any straight line or square drawn from memory.

There is a third case, however, where the difficulty proves insurmountable. This is when the line which the child has to imagine and construct conflicts with perceived straight or curved lines lying adjacent, such as on the 'ground' offered by the table top (in the perceptual sense of 'ground' as opposed to 'figure'). In this case, imagining the line no longer consists of merely imitating a past or present perception, but entails creating new relationships within an existing pattern distinct from those sought after. Such an achievement requires either a projective operation based on the action of 'taking aim', or else a euclidean operation based on changes of position.

The reactions described above are important and interesting precisely

because they demonstrate that such operations are not yet acquired, and we must now find out why this is so. When the straight line has to be formed parallel with the edge of the table, the child rests content with a rough approximation without sighting or 'taking aim'. Mar is placed, first in the middle and then at one end of the row, and he does in fact control the position of the matches more easily in the second position—as might be expected—but he fails to derive any consistent method for future use from this experience. When they are asked to find the best vantage point from which to check whether the row of posts is straight, not one of these children thinks of standing along the line of sight on his own initiative.

As for movements, Rog says "I made a line with my finger" but this is merely an example of imitative movement, not a system for finding the most direct route or keeping the direction constant during the displacement. Thus when they come to form a straight line not parallel with the edge of the table, not one of these children can solve the problem since, lacking ability to 'aim' or carry out a controlled, metric displacement, they attempt to substitute an appeal to perceptual configuration for a projective or euclidean operation.

For example, Mar begins with the straight line BCDE parallel to the edge when trying to join A and E obliquely. Noting the angle ABC, he moves B to correct the section AC but does not dare touch C and D, with the result that two straight lines ABC and CDE are left forming an angle. Even more striking is the way Fran oscillates between two straight lines ABCD and BCDE, both parallel with the edges of the table, the one including A lying near the edge and that including E being toward the centre. In the case of the first line his solution contains the angle CDE and in the second case, the angle ABC. Nevertheless, he is quite unable to break loose from his obsession with the edge of the table and join A to E by an oblique straight line: Fran is typical of the children of this stage (see also Noe) and his conduct is particularly remarkable in that he was unable to form a straight line, even after he had watched it being made before his very eyes, but finished up with a convex curve directed toward the edge of the table. Confronted with the same problem on a round table, Lil cannot break free of the influence exerted by the curved edge and for the required straight line substitutes circular arcs. Similarly Rog, faced with the problem of forming a line across the corner of the square table, tries to keep parallel with two sides at once and produces first a right-angle and then a curve.

It might perhaps be objected that these results are merely the product of perceptual influences and are unconnected with the operations involved in forming a straight line. Being unable to separate the 'figure' to be constructed with match-sticks from the 'ground' constituted by the table, the child replaces the straight lines he is asked to produce by

others running parallel to the edge of the table. It should be obvious, however, that to speak of a perceptual 'illusion' in the present circumstances would be entirely incorrect. The child sees clearly enough that he has not succeeded in making the straight line asked for and endeavours to correct this mistake. Thus the ground configuration acts simply as an intellectual obstacle and does not distort his perception in any way.

The special interest of these responses thus lies in their intellectual mechanism. The child can envisage a straight line when the background contains examples ready to hand, running parallel with the line he has to construct, but he cannot conjure up the image of a straight line when it has to be independent of lines present in the background. This is what our observations show and it must therefore be regarded as bound up with construction of the intuitive image and not with perception itself.

This conclusion is extremely significant and makes it quite evident that there are two types of spatial representation. The first, which is simply intuitive, is no more than an internalized imitation (a mental image) of previously perceived events and is consequently either favoured or discouraged by current perceptual configurations. The second, not evolved as yet, is based on operations and can therefore free itself from the influence of such configurations. It should, of course, be pointed out that between these two extremes numerous transitional stages arise, resulting from the internalization of actions which modify perception and whose growing organization leads precisely to the development of operations.

§3. *Substage IIB, intermediate reactions. Stage III, operational construction of straight lines by the method of 'sighting' or 'aiming'.*

The various failures and shortcomings which the child experiences in trying to form a straight line and which were discussed in the previous section, impel us to ask why the technique of 'aiming' or 'sighting', by which the child could link two points merely by putting the distant point in line with the near, is not discovered earlier. The answer to this question is undoubtedly to be found along the following lines, as will be seen time and again in connection with the various problems of projective space. The discovery that he has a particular viewpoint, even the child's becoming aware that he occupies one momentarily, is far more difficult to come by than might at first be supposed. For such a discovery or awareness really presupposes the co-ordination of all possible viewpoints. The operation of 'sighting' is therefore not just a simple action but the result of discriminating between, and hence co-ordinating, all the several points of view that may be involved. And this will become apparent when we examine first the intermediate reactions of Substage IIB and then the correct responses in Stage III.

During Substage IIB it is already possible to observe a progressive

165

discrimination of viewpoints by checking lines made parallel with the edge of the table. Then, together with this, a gradual liberation from the influence of the surrounding perceptual configuration and eventually, lines formed independent of the edges of the table.

CLAU (5; 6). "I want you to make a really straight road with these three posts—(Clau positions them straight in front of himself, unintentionally taking up a sighting position, and makes his straight line obliquely in relation to the table whose edge, however, he does not notice)—Very good. Now watch carefully (the three posts are put parallel with the edge but not quite straight). Is that properly straight?—*Yes*—Quite sure?—*Yes*—Is there a place from which you could tell better whether it's straight than where you're standing now?—. . . (no answer)—When you come over here next to me, is the road quite straight?—*Yes*—And what about another place?—(He moves around the three posts and seeing them 'end on' cries) *Oh, no!* (he puts them straight) —Put them in a straight line somewhere else—(He moves them and lines them up in front of himself without bothering about the edge of the table)—Very good. Now I'm going to put these two posts here (A in the corner, F facing an adjacent side and 30 cm. from the edge). I want you to put these four posts between them to make a straight line—(Clau then proceeds to place BC in line with A parallel to the side of the table, then D and E in line with F parallel with the adjacent side so that DEF is not continuous with ABC). *No, that's wrong* (he forms BCDEF into a single line, neglecting A)—Is it straight?— *Oh, no* (he then places ABCDE parallel with the side and neglects F)—Is it straight now?—*Oh, no, this time the bend is there* (DEF). (He now forms BCDEF at some distance from the edge but parallel to it, ignoring A)—And this (ABC)?—*Oh yes* (produces ABCDE again, once more ignoring F) *Oh no!* (at last he tries to connect A and F direct, but ends up with a meandering line)—Is it straight?—*Almost*—Where ought you to stand to see whether it's straight or not?—*There* (he stations himself in line with the posts but does not take a proper sight along it)—Now arrange them properly—(He produces another line ABCDE parallel to the side of the table, but puts E between D and F, thus obtaining an angle with sides ABCDE : DEF)—Is that straight? —*No* (he stations himself along the axis once more and produces another meandering line between A and F)—(All the posts except A and E are removed). Now show me the road between the two posts with your finger— (He does this correctly and arranges the posts in a more or less straight line, though he does not correct their position by means of taking a deliberate sight along them)".

LUC (5; 11) begins by constructing his straight line by a euclidean method, whereas Clau began using a projective method right away.[1] Thus, where Clau immediately lined up the posts by eye, Luc starts off by endeavouring to move them in a constant direction. We arrange A and G parallel with the edge of the table. Luc then puts BCDEF close together next to A, holding them between

[1] It should be noted that there is nothing in the basic design of this experiment to encourage the child to choose a projective method (such as 'sighting') any more than to choose a euclidean one (such as keeping to the shortest route or maintaining direction unchanged). The two modes of constructing a straight line appear at the same time, as we have shown, and are simply the natural reactions of children at this level of development.

the palms of his hands, which he keeps turned in the direction of F (Luc spaces them out and keeps repeating this action step by step thus maintaining a constant direction of travel)—"Suppose you only had three matches?—*That's easy* (he makes a movement with his hand from A to F and puts a match halfway between them)—Very good. But are you sure it's straight? Where is the best place to stand to see if it's straight?—(Luc walks round the table without deciding in favour of any one position). *You can tell from anywhere*—Now I'm going to put the first post here and the last post there (midway along two adjacent sides). I want you to make an absolutely straight road between them—(He follows along the two sides, making an angle of 90°)—Is it straight?—*No, there's a bend*—Well then?—(He flattens the angle a little, forming an arc)—Is that straight?—(He flattens the angle still more) —How would a bird fly from here to there?—(He indicates a straight path with his hand)—Well then, arrange the posts like that—(He disposes them along a slight curve)—Is it straight?— *Yes*—Look at it from somewhere else— (He walks around the table and notices it head on). *No, from here you can see this one sticks out a bit* (he corrects it)—Now we're going to try on this table (round)—(Two posts are placed on a chord of the circle. Luc follows the arc described by the edge, but spontaneously exclaims) *It isn't straight. How should I do it?*—(The two posts are put on a diameter of the circle) And what about like this?—*It's difficult* (Luc traces a line with his finger and succeeds in making a straight line)".

ING (6; 1) arranges three posts in a straight line: "Space them further apart from each other (He does so but loses the effect of straightness). Is that straight?—*Yes*—Can you see if it's straight any better if you stand anywhere else?—(He walks round the table and about 45° from the axis says) *No, it's not straight*—Where can you tell most easily, there (45°) or there (in line with the axis)?—*From here* (45°)—Now I'm going to put one here (A in one corner) and another here (G, 20 cm. from the edge midway along an adjacent side) and you must put the other posts in between to make a really straight road". He first arranges BCDEF in line with A parallel to one side of the table, resulting in an angle EFG, then puts EFG in a straight line, also parallel with its side, leaving ABCD nearer the edge. Next, he moves D and adds it to EFG producing two separate lengths ABC and DEFG. He now places B and C obliquely between A and D, resulting in two lines ABCD and DEFG forming an obtuse angle at D, then puts E and F in line with ABCD, thereby leaving out G. At last he manages to construct a line ABCDEFG with some posts rather poorly aligned. "Is that straight?—*No* (on his own initiative he moves to a position along the axis to check the line and corrects the alignment of the posts, though without sighting along it in a proper way)".

MIR (6; 2) lines up three posts. "Are you sure they're straight? Look at them any way you like and get up from your seat if you want to—(Mir walks round the table. When in line with the row he says) *This is the best place* (adjusts them)—(They are now lined up in another direction) Are they straight now?—(Mir walks across, looks along the axis and puts them straight)— Why do you stand there?—*Because here you can see straight* (makes a gesture along the row of posts)—Now make a really straight row between these two (One post near the centre of one side, 30 cm. from the edge, the other in

the nearby corner)—(Mir makes an evenly curved arc, running toward the side of the table, then looks and exclaims) *Oh! Look, the road makes a curve!* (He corrects it slightly, then goes and stands at the end to check it) *It's still curved* (corrects it again and returns to check it) *Now I can see it's straight"*.

As the reader will note, these transitional reactions enable us to watch the representational straight line developing in place of the perceptual straight line, which was all that the children belonging to Substage IIA could manage to achieve. In fact, after showing the same hesitation as the children of Substage IIA when the required line runs counter to the side of the table, every one of these present children eventually succeeds in mastering the problem and forming a straight line. How does this come about?

First of all we must note that projective methods are by no means the only ones by which the child can imagine or construct a straight line, since there are at least three ways of defining a straight line in terms of euclidean space, all of which correspond with simple actions which can be immediately understood. These are first, the shortest distance between two points (a tautology from the theoretical standpoint, but which in the present circumstances states in precise fashion the very inter-dependence between measurements and actions or operations of recti-linear motion). Second, the displacement which conserves its direction, otherwise expressed as the only line which maintains its shape when rotated about its own axis. This latter notion, formulated originally by Leibnitz, we shall meet with again in a later work,[1] though the methods used here preclude its application to the present experiment. Last, the idea of the straight line as the intersection of two euclidean or projective planes, which is likewise excluded for the present but will be dealt with in Chapter IX.

We are therefore left with two alternatives. Either the projective straight line obtained by 'sighting' (alignment along the line of regard); that is to say, conservation of shape independent of viewpoint, or else the euclidean straight line determined by the shortest path of movement or maintenance of a constant direction of travel. Our experiments have already shown that as soon as the child goes beyond the perceptual straight line (toward Substage IIA) projective and euclidean concepts appear simultaneously and operate to reinforce each other.

Hence, we find that although Clau, Ing and Mir do not yet employ any precise method of taking aim (as seen at Stage III), they nevertheless arrange objects along their line of sight and discover the projective straight line for themselves by means of the 'point of view'. Luc, on the other hand, makes use of the euclidean method and so do a number of the children described above. However, it is evident that the two pro-cedures are psychologically interdependent. The technique of visual

[1] *La Géométrie Spontanée de l'Enfant*, Chapter X.

alignment employed by Clau is frequently accompanied by gestures which can take the place of the visual perspective, while the euclidean method used by Luc is checked by being viewed projectively. Thus we have here an early example of the interdependence of projective and euclidean concepts, and we shall encounter numerous instances of this general tendency to correlate one with the other.

It is the eventual perfecting of visual alignment as a method which leads in Stage III to the emergence of 'sighting' or 'taking aim' as a specific form of behaviour. For the present however, let us confine our attention to the problem of how the children at this substage first discover this particular technique. As was stated at the outset of this discussion, the ability to deal with the problem in this way results from the beginning of discrimination and co-ordination of viewpoints. At Substage IIA the children are not in the least concerned about which aspect they view the row of posts from. All that matters to them is the perceptual pattern itself, or more precisely, the manner in which it expresses the essential features of the object as such. This initial realism explains why perceptual space takes priority over representational space, and why topological notions, concerned solely with the object in itself, precede projective and representational ideas which deal with objects co-ordinated one with another and with the subject.

At the present level, however, we find that although the child starts out with a similarly realist attitude he soon discovers that what he sees alters according to his point of view. "You can tell from anywhere" says Luc at first, but he soon finds that for the purpose of correcting an imperfect alignment certain points of view are better than others. And hence Mir's formulation: in line with the row, "this is the best place ... because here you can see straight". In other words, the discovery of the projective straight line is made when the child grasps the fact that two points X and Y can be related to the observer O through the agency of his line of regard OXY. The representational straight line thus differs from the perceptual straight line (and from the undefined topological line) by virtue of the child's becoming aware of the part played by different points of view.

This is the reason why the children, after much hesitation and repetition of all the mistaken ideas of the previous level, finally manage to solve the problem of making a straight line when it is not parallel with the edge of the table, precisely because of this gradual differentiation between points of view. After getting bogged down in the details of the perceptual configuration, the child at last tries to join the first and last (X and Y) posts together in a direct line. Now to do this he must, at the same time as he separates them from the perceptual ground, join X and Y either by means of a movement (a euclidean procedure which presumes the functioning of a potential reference system) or else by visual

inspection. The second procedure can only be carried out by discriminating between different points of view, and it is the choice of the point of view OXY that enables the child to correct his alignment.

By Stage III (around 7 years on the average) the discrimination between points of view is developed sufficiently to enable the children to carry out spontaneous operations of 'sighting'. This ensures the correct alignment of the posts through their projection one on the other, the first post masking the rest from the viewpoint of the observer.

WIL (5; 10). "Make an absolutely straight road with a row of posts—(He lines them up between the palms of his hands, thus maintaining a fixed direction, then bends down and takes a sight along the top of the posts to check his alignment)—And between these two (two posts on two adjoining sides of the table)?—*I must do it this way* (he indicates the line between them with his finger, then puts his posts in between)—Can you see if it's straight? —(He bends down and sights along it) *Yes*".

BUR (6; 4) lines up a row of posts and takes aim by bringing his eye in line with the tops. "*I'm looking to see whether it's straight or if there's a bulge*— And from here to here (cutting the corner of the table)?—(He lines them up curving slightly towards the edge of the table, then takes aim and says): *It's a bit curved this way* (corrects it)".

TON (6; 4). "Make a straight road with these three matches—(He puts them in position and takes aim bending to table level)—And with these seven?— (Same procedure) *There you are. It's straight*—Were you taught to do it that way?—*No*". The line running obliquely across the table is constructed straight from the outset.

CHEL (7; 7) makes a roughly straight line of six posts and adjusts them by guesswork: "Which is the best spot to look from?—*I prefer to be there* (in the line of sight, but he does not really take aim along it)—And what about like this (crosswise to the table)?—(He straight away makes a straight line and adjusts it but without bending down)—And from where can you see best if it's straight?—*I can see better from the side* (where he stands)—Is it straight this way (we point to a slight bulge)?—*No, because you put those over there a little to one side*—Make another one yourself—(He does so)—Is it straight? —(He leans first to one side, then the other, and ends by putting himself along the line of sight) *Yes* (After adjusting it)".

BON (7; 9) at once makes a straight line between two posts cutting one corner of the table, then adjusts it by sighting along it with one eye closed: "How can you tell if it's straight?—*Because I'm taking aim, I'm looking through one eye* (gesture indicating the direction of the line)".

Some of these children actually 'take aim' (Wil, Bur, Ton and Bon) whilst Chel, though not sighting along the row, nevertheless carries out his alignment from a particular viewpoint. But all of them show clearly just what a projective straight line is; a topological line with the well-known features of serial order, etc., but also having its elements ordered relative to a particular 'viewpoint' in such a way that they succeed one

another in terms of the relationship 'before: behind', the first element obscuring the rest.

But a projective straight line is something more than just this. As against a curve, it is the only line whose shape remains unaltered from whatever point it is seen, only its length being changed, with the point as the limiting case. In the course of Section II we shall see that it is at just this same level IIIA that the straight line is differentiated from the curve; that is, when a change of perspective takes place. In Stages I and II perspective is not involved at all and both straight lines and curves naturally maintain their shape, though only for want of projective transformations. During Substage IIA, however, circles and curves are modified when represented in perspective, whereas straight lines remain unaltered, apart from changes in length. This is what we are about to see in the section which follows.

SECTION II—PERSPECTIVE

As we have just seen, the precondition for forming a projective straight line is a progressive discrimination and co-ordination of different viewpoints, or in other words, perspectives. Conversely, the power to imagine, as against merely perceiving, straight lines facing in any direction constitutes the essential requirement for forming perspectives, because the straight line is in fact the only shape which remains unaltered during perspective changes. But as this problem is absolutely fundamental to the psychology of space we shall treat it as two separate problems. In the present section therefore we shall confine our investigation to finding out how the child sets about representing isolated objects seen in perspective, in terms of their displacement relative to the observer. The next chapter will deal with projections of the same object by means of shadows, a problem whose solution turns out to be exactly analogous to that of ordinary perspectives. Not until Chapter VIII shall we be in a position to tackle the problem of the overall co-ordination of perspectives such as arises when the observer moves around and about a number of interrelated objects.

§4. *Technique and general results*

We present the children with the following problem. We ask them to imagine what apparent shape an object such as a needle, a disc, etc., will present when placed in a number of different positions. Here, two difficulties arise. The first is to get the child to understand that the question bears not on the actual shape, but the apparent shape, and hence the perspective of the object. The second is to obtain a rendering of the shape without being led astray by shortcomings in the child's ability to draw.

To overcome the first difficulty we employ the two following methods in turn. The first consists of placing at the side of the child a doll (at right angles to him) representing a man who is looking at the same object as the child. The child is asked how this object looks to the man, so that a needle seen full length by the child would appear end-on to the man, and vice-versa. It follows that if the child draws the needle lengthwise when it is end-on to him, one may be sure that he is drawing the needle as it appears to the 'man' and not as it appears to him. This simplifies considerably the problem of grasping perspective, and especially the treatment of borderline cases such as the point, drawn as a picture of the needle seen endwise, which the child rarely perceives from his own viewpoint in such a precise way.

At the same time, the introduction of a second observer in the person of the doll has the effect of producing complications. It is therefore necessary to supplement this method with an alternative. This is to alter the position of the object in front of the child and ask him to predict the shapes to be expected from further similar changes. For instance, the object is turned through 90° or 180° and the child is asked to imagine what would be the shape in the intermediate positions. On the other hand, the object may be turned very gradually and the child asked to forecast what the shape will be when it reaches some ultimate position.

As for the method of depicting the object, here again it is very useful to apply two techniques concurrently, each having its particular advantages and disadvantages. The first method is to have the child make a drawing. This brings out various ideas or beliefs which the child is unable to express verbally, though the younger the child the more such a method is hampered by deficiencies in motor skills. The second method is to show the child a number of drawings, some correct, some incorrect, and ask him to select the one corresponding to the apparent shape of the object. The incorrect drawings contain errors of the types found in children's spontaneous drawings, circles of decreasing diameter to indicate rotation, or arcs of circles that are not closed, and so on.

The principal objects employed were a needle (or a stick) for the straight line and a thin metal disc for circles, ellipses, semicircles, etc. But besides questions on perspective in connection with the various possible shapes of near objects, we posed others dealing with distance. One of the commonest perspective distortions noticed by children is that of parallel lines meeting in the distance, such as railway lines or the sides of a road, and so on (convergent lines). One can therefore have them draw such perspectives or select them from among a series of ready-made drawings some of which show parallel, others converging lines. It is then a simple matter to ask them questions about their drawings or the drawings they select.

Lastly, it should be mentioned that in addition to studying alterations in shape, it is necessary to examine the problem of quantification. When the stick or needle is rotated, its shape remains unaltered but its length diminishes. In the case of a railway line or a fence receding into the distance, the child is asked to draw the sleepers lying across the rails or a series of vertical posts running to meet the horizon. Will he make the distances between sleepers or fence posts regular or haphazard? Such a technique enables us to investigate the problem of intensive or extensive quantity independent of any metrical system.

The answers obtained to the different questions (see Figs. 19 and 20) make it possible to isolate four distinct levels of development, corresponding stage for stage with those of Section I for the projective straight

Fig. 19.

Successive presentations of the needle and the disc, seen in perspective.

line, of Chapter VII for shadow projections, and of Chapter VIII for multiple perspectives.

Stage I (below 4 years) does not afford any drawings of geometrical figures worth the name and can be ignored altogether. The type of perspective drawing seen at this level (along with a complete lack of understanding of any sort of pictorial perspective) continues right up to the beginning of Stage II. This second stage, lasting on average from 4 to 7 years, is notable for total or partial failure to distinguish between the different viewpoints from which the object might be seen. The object is in fact imagined and shown by and for itself, independent of the angle at which the observer actually views it.

Within this stage, Substage IIA lasts from about 4–5; 6 years, during which period the object is shown with shape and size unvaried whatever its position relative to the observer. At the very most, different positions

are indicated by different orientation, the figure otherwise remaining the same. In addition to this, there is a general confusion of the respec-

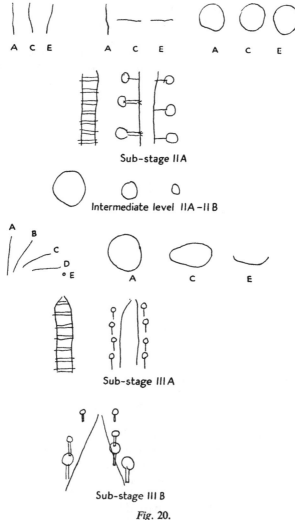

Fig. 20.
Development of Perspective Drawing.

tive viewpoints of the doll and the child himself, though different spatial positions are occasionally suggested.

Toward the end of this period transitional reactions appear, betraying some awareness of the inadequacy of the present types of drawing and

the manner in which they portray depth. For the 'end-on' position in particular, the child is quite incapable of making a satisfactory drawing but tries to imitate reality by turning his sheet of paper to a similar angle. Occasionally he attempts to render the circle in perspective by means of smaller circular shapes.

During Substage IIB, however, the child begins to distinguish between different viewpoints, mainly when the method of choosing comparison drawings is employed, which at this stage elicit more advanced types of reaction than the task of actually making a drawing. Thus, although the rails receding into distance are still drawn parallel, the drawings chosen from the sample display show converging lines. The circle drawn in oblique perspective is often drawn as smaller than the frontal-parallel figure but among the comparison drawings is recognized as having the shape of an ellipse. The stick drawn endwise is sometimes drawn the same size or even larger than when in profile, but is identified among the samples as a dot or very small circle.

At Stage III (from about 7–7; 6 years) a clear distinction is drawn between different points of view, though this actually comes about in two substages. The first of these (IIIA) affects only the general shape and does not entail extensive quantities, while the second (IIIB, about 8; 6– 9 years) includes quantification and thus deals with all changes of shape.

During Substage IIIA the comparison drawings chosen tally with the drawings made by the child himself. The railway lines are drawn as converging, likewise the fence posts (though decrease in spacing or length of sleepers and posts is still irregular), the stick seen end-on is drawn as a dot (though its rotation produces forecasts suggesting that the changes appear in sudden instalments rather than gradual diminution in length). The child is sometimes unwilling to accept the straight lines as a rendering of the circle seen in perspective, though changes of shape are understood well enough in a general way.

Finally, about the age of 8½–9, we arrive at Substage IIIB, the stage of 'visual realism' or perspective applied systematically to drawing. Changes of shape are now understood properly with the result that the children can portray quantitative alterations in shape.

§5. *Stage II. Inability to discriminate (first total then partial) between different viewpoints. Representation without perspective.*

We will start with a few examples from Substage IIA, showing complete lack of differentiation as regards shape and size of the object. Changes in its appearance which result from a change of position are shown simply by means of changes in orientation.

AN (5; 0). A stick is placed upright before the doll. An draws it vertical. Placed horizontal before the doll it is again drawn vertical because from where

he sits An himself sees it as slanting and says: "*He* (the doll) *also sees it slanting like this* (he points to his vertical drawing), *you can't see it any other way*". When the stick is put end-on before the doll (lengthwise to the child) he draws it full length and horizontal. The same experiment is repeated except that the child is now asked to draw the stick as it appears to him. When he sees it horizontal he draws it as such, vertical when he sees it vertical, and again vertical when it is end-on.

For the full circle as seen by the doll An draws a circle, though he does the same for a circle seen edgewise and says: "*This one is both standing up and lying down*"—which probably means that a circle lying face down is still a circle, constancy of shape taking precedence over perspective. The circle tilted at an oblique angle he again draws as a full circle and says: "*it is turned to one side and that makes it slope a bit on one side*". For similar positions of the circle relative to his own point of view, he continues to produce drawings all showing full circles. The same reactions are obtained with a semi-circle.

Both the fence and the railway lines which recede in depth are shown without any perspective.

ZUM (5; 2) draws the stick vertical when it is vertical for the doll and horizontal when it is horizontal. But he also draws the stick seen head-on as horizontal. "Take a careful look to see whether the man will really see the stick like that when it's in this position—*Oh no!* (this time he draws it vertical)". He is then asked to choose from the prepared drawings, still from the viewpoint of the doll. Horizontal and vertical positions (without perspective change) are correctly identified, but for the head-on position Zum hesitates between horizontal and slanting views (all drawn full length).

For the disc seen frontal-parallel he draws a circle but for the edge (turned vertically) he also draws a full circle. "Careful!—(He draws a circle again)—Do you see the same thing this way (full view) and that way (edge)?—*No*—Why not?—*I don't know*—Try to draw it—(Another circle)—Look at these drawings and try to find the circle you see like this (full view)—(He selects the full circle)—And like this (edge)?—(He chooses the half circumference). *Because it's like this* (indicates the outline of the disc)".

Rails and fences seen in depth are drawn parallel and not convergent, and from the prepared drawings Zum chooses those showing parallel lines (except for one chance selection of converging lines, for which he can give no explanation).

UL (5; 2). Vertical and horizontal stick drawn correct. Endwise stick drawn horizontal and full length. Oblique (foreshortened by perspective) is drawn as oblique but full length. Presentation of prepared drawings yields the same results.

Front and sideways views of the disc both result in a full circle—"Look at it carefully (edge)—*I see a circle*—Do you see it the same as before?—*Yes, just the same*—And like this (oblique)?—*Still the same* (draws a circle once more)". From the comparison drawings he chooses first a semi-circle, then a circle to show the sideways view of the disc. Rails in depth (drawing): parallel. Choice of drawing: same result.

GER (5; 5) gives the same reactions as Ul for the stick (head-on view drawn as vertical). From the prepared drawings Ger chooses a full-length oblique

176

to represent the head-on view. Circles give rise to similar reactions. Rails and fences are drawn as parallel. When given drawings of these to choose from, his reaction is particularly clear: *"This one is right* (parallel). *That one* (converging) *isn't right because it's not straight"*.

NIC (6; 7). A red pencil (vertical): *"I see a pencil* (draws it vertical)—And this way (looking at the point)?—*He* (the doll) *sees it differently* (he again draws it full length but horizontal)—How does he see it?—*He sees the red point at the end*—And the rest of it?—*As well*—And like this (oblique and foreshortened)?—*He sees it a bit crooked* (drawn oblique but still full-length) —Does he see it the same length?—*Yes*—He doesn't see it longer or shorter? —*No, the same"*.

"And this watch (full view)?—*He sees it as round*—And this way (side view)?—*He doesn't see the whole watch* (he draws another circle but does not close it)—How do you see it yourself?—*I see two lines* (nevertheless he draws a semi-circle)".

MER (6; 0) draws the rails as parallel: "Are they as big over there as they are here, when you see them a long way away?—*They're both the same*—And a fence like this (the beginning is drawn for him), continue it to the end of this long road—(He carries it on at the same height all the way)—And at the end of the road, do you see it the same height or shorter?—*The same*—Carry it on further still—(He does so but makes it slightly shorter, a difference he promptly corrects to make it the same height again) *I drew it smaller*—But if you look at something a long way away, does it seem bigger or smaller?— *Smaller*—Well then, draw this fence the way it looks when it's a very long way away—(He still makes it a constant height)—At the end, over there, does it seem smaller or not?—*It's no smaller"*.

It is not easy to determine right away the real nature of the difficulties which prevent these children understanding how a variety of possible perspectives may result from displacement of an object. On the perceptual plane they clearly realize, and are able to say so, that the appearance of the object changes with its orientation. Thus, Nic immediately declares that the doll, when confronted with the pencil point first, will "see it differently" and when presented with the watch in profile "doesn't see the whole watch". In a similar way Mer knows perfectly well that something seen from a distance seems 'smaller', and so on. Why then are they unable to represent perspective in imagination when they are so familiar with it perceptually? The results seen cannot be put down to technical difficulties in drawing, for at this stage selection from prepared drawings produces the same results as does having the children make their own. For example, the half-circumference chosen by Zum for a disc seen in profile (which seems in his case peculiar to the selection technique, since he draws this disc as a full circle) is found once again in Nic's drawing (the method of comparison drawings was not used in his case).

We must therefore look for something other than difficulties in drawing to explain the inability to understand perspective. Such explana-

tion must be comprehensive enough to account, not only for the failure to comprehend perspective, but also for the frequent occurrence of drawings from which it is absent, since in many cases nothing could be easier than for the child to draw 'what he sees' as opposed to 'what he knows' of the object. It is no more difficult for him to draw a round dot for a needle or a pencil than to represent them by a straight line, and the 'two lines' by which Nic describes a watch are just as easy to draw as a full circle.

The explanation for these difficulties must therefore be sought in the basic difference between perception and representation of perspective. To see an object with a given perspective is to view it from a particular viewpoint, but it is not necessary to be consciously aware of this viewpoint in order to perceive the object accurately. On the other hand, to represent this object in perspective by means of a mental image or a drawing necessitates a conscious awareness of the percipient's viewpoint, together with the transformations induced in the perceptual object by this viewpoint. Thus, in contrast to perception, representation of perspective implies operational, or at least conscious, co-ordination between object and subject; or in other words, a recognition of the fact that they both occupy the same projective space extending beyond the object and including the observer himself (since this space envelops what geometricians term the 'picture plane' on which the object is projected). However, the study of 'sighting' or 'aiming' carried out in Section I has shown clearly that at the present level no such co-ordination is possible.

In short, due to the lack of any conscious awareness or mental discrimination between different viewpoints, these children are unable to represent perspective and cling to the 'object in itself'. To this object they attribute a kind of 'pseudo-constancy', a mechanistic approach in terms of which their ignorance of the fact that viewpoints are subjective (an ignorance typical of ego-centrism) results in the creation of spurious absolutes.

This interpretation is confirmed by examining the conflicts, apparent with some of the children, between their perceptual awareness of perspective and their representational ignorance of it, which at this level go hand in hand. To render a disc seen in profile by means of a half finished circle (like Zum, Ul occasionally, Nic, etc.), is clear proof that such children perceive the difference between a disc foreshortened and one seen full face. But aware that only part of the object can be perceived they represent what they see in terms of their own current perspective. Thus they draw, or choose from the model drawings, not the projective figure (a horizontal line) but a structure that expresses part of the outline without embodying perspective. In other words, some aspect of its properties considered in isolation. Thus, the viewpoint does

178

not enter into the representation directly, but only by way of breaking up or mutilating the object so that the child draws what he can see—but not exactly in the shape he sees it.

This reaction, not encountered among the less advanced children (such as An), gives some idea in advance of what may be expected in Substage IIB, where discrimination between viewpoints begins to take shape. There are some children, however, more advanced than those so far mentioned, who represent a transition between the two substages. To enable the gradual emergence of this awareness of viewpoint to be followed more closely it is worth while giving a few examples of the way they react.

LIL (5; 2, advanced), "draw the stick (vertical) the way the little man sees it—*That's easy, it's just a line*—And like this (horizontal)?—*There you are, like this*—And this way (point first)?—*Oh, but this way you ought to do this* (pass through the paper) *but I can't do that* (makes a full-length horizontal drawing and says) *It's like this*—And how do you see it (point first) yourself?—(Vertical drawing)—And if you show it to the little man like this (sloping backwards)?—*You can't draw that. It's like this* (she draws it oblique and full-length)—And this way (sloping forward)?—*You can't draw that at all, you'd have to do it this way* (gesture of passing through the paper with the pencil)—And what about this (circle, full-view)?—*He sees this* (draws a circle)—And if it's put like this (horizontally in profile)?—*It's just the same as I've already drawn* (draws another circle)—And like this (vertical profile)?—*Well, you have to do it like this* (gesture indicating contour)—Draw what he sees—*No, it's impossible*—(She is asked to choose from the prepared drawings.) Which of these is the right one?—(Chooses a full circle)—And this one (showing the profile of the disc as a line)?—*It's not right*—Look at it yourself (Lil is shown the horizontal disc in profile)—*It's that one* (full circle)—And this way (vertical profile)?—*There isn't one*—And like this (oblique)?—*There isn't one* (although there are a number of ellipses to choose from)".

MUS (5; 10). The stick, vertical and horizontal: correct drawings. "And this way (endwise)?—*Like this* (gesture of piercing the paper) *but you can't draw it*—And how do you see it yourself (shown the stick end-on)?—*I put the paper this way* (he takes the drawing of the horizontal stick and turns the sheet perpendicular to frontal-parallel so that it is edge on). *I saw it like this*—Choose the right one from these drawings—(He chooses the full length view of the stick)—And this (disc, full view)?—(He draws a large circle)—And if you turn it this way (horizontal profile)?—(He takes his drawing and turns it horizontal, raising it to eye level; he can then see nothing at all, and says), *But you can't do it. You'd need a sheet of paper like this*—And like this (vertical profile)?—*That's not difficult, it's like this* (draws a full circle)—And if I put it right in front of you?—(Draws the same again) *That's it*".

CYR (5; 8). Same reactions in the case of the stick. For the oblique circle sloping backwards he draws a half-circumference: "*When it slopes like that, it's this* (indicates the rear half)—And how does the little man see it (same position so that it is oblique left to right from the doll's point of view)?—

Like this (complete circle)—Look (he is shown the disc sloping edge on from left to right)—*Yes, it's like that* (draws it smaller)—Why?—*Because it's lower down, it's smaller*—It's smaller when it's sloping?—*Yes*". Cyr therefore expresses the elliptical shape as a circle, only somewhat smaller! He shows the rails receding as entirely parallel.

ZBI (5; 8) draws a beautiful circle for the disc seen full face. He is then shown it in profile and told explicitly, "Now, draw it like this, lying flat—*Lying flat? O.K.* (Takes his sheet of paper and holds it horizontal) *Now it's lying flat* (He then draws another circle the same as the first)—Is that the same one?—*No, because that one* (the second) *is lying flat and the other one is standing up*—But how can you tell that from your drawing?—*I don't know how*—Draw it the way the little man sees it when it's lying flat—(He draws a third large circle)—And like this (sloping backwards)?—(Like Cyr, he draws it smaller)—Is it the same one?—*No, the other one's upright, this one is sloping*—Why did you make it smaller? Did you do that on purpose?—*Because . . . otherwise you couldn't tell it was sloping*".

Rails are drawn parallel. "Don't they grow smaller when you see them over there in the distance?—*Yes . . . No, bigger rather than smaller, because at the far end* (horizon) *the train turns round*".

MAST (6; 0) shows the same reactions. In every case he draws a straight line or a full circle. Though he recognises the difference, he is unable to express it either verbally or pictorially. "Does he (the doll) see the same thing as before?—*No, he doesn't, he sees it differently*". He also draws the rails and fences as parallel.

BUR (6; 4) says of the stick seen end on, "*I can't do it like this, I see a line which stretches a long way*". He thereupon draws it vertical and full length.

NIG (6; 7) in the same way says of the disc seen lying down (appearing like a short line), "*It must be drawn flat; that's very difficult* (he then draws a full circle, remarking): *You can't do it on paper. It comes out the same as this* (full view)". He draws the rails as parallel and chooses a similar rendering from the sample drawings.

These examples of transitional reactions reveal an unsuccessful attempt to discriminate between different aspects of the object, and thus demonstrate the continuous gradation between non-discrimination in Substage IIA and emergence of discrimination at IIB. However unsuccessful the present efforts may be, they mark a considerable advance over Substage IIA, and in this respect they form a definite starting point to Substage IIB.

Whereas the children at the earlier, more primitive level showed only the object in itself, or some fragmentary portion of it regardless of viewpoint, the present children, although they still do not depict perspective changes, nevertheless express some awareness that their drawings are inadequate and also attempt to show why. Thus, there is at least an awareness of the problem as a novel one, though without any attempt to solve it, except on the part of a few children who draw the oblique disc as a full circle but make it smaller than that which illustrates

the disc seen full face. This reaction is continued right throughout Substage IIB.

As for being aware of the problem of perspective itself, the typical attitude is that of the children who feel that to show the stick seen endwise it would be necessary to draw it normal length and view it at eye level in the horizontal plane, just like the thing itself. Thus Lil would like to pass her pencil through the paper, "You ought to do this, but I can't do that". Mus answers in almost the same words and then draws the stick full length, bringing his drawing to eye level. He does exactly the same for the circle seen in profile. In short, the children see the object as it actually is, and in this respect they still belong to Substage IIA. On the other hand, they are already aware of the problem raised by the observer's view of the object, and to this extent they are the advance guard of Substage IIB. But being unable to modify their drawings in such a way as will portray the transformations induced by this point of view, they fall back on the device of putting the drawing in a similar position to the thing itself. Only in one case so far is the drawing modified in any way; in that of the oblique disc shown as a circle diminished in size, a reaction already characteristic of Substage IIB (this also applies to Cyr and Zbi, who first show the stick seen endwise in the same way as the earlier children). As for the rest of the reactions, these are no more than verbal expressions of the inadequacy of the drawings (Mast, Bur and Nig).

Turning now to cases belonging definitely to Substage IIB, we shall see, in contrast to the previous examples, the first signs of discrimination between viewpoints appearing in the drawings themselves, or at least in the way the child selects the comparison drawing which appears to him closest to a particular perspective.

Rol (5; 5, advanced) draws the horizontal and vertical stick correctly. The stick seen endwise he draws horizontal for the doll and vertical for his own viewpoint, both drawings showing the stick full length. However, when shown the sample drawings he picks out the small circle for the stick viewed end on. "Why this one?—*Because it's a small point, and there* (the stick) *it's also a small point*—Put it the way it is in the drawing—(He does so correctly)".

For the disc seen full face from the doll's position, Rol draws a vertical ellipse. This is an advance on the previous level since this is how it looks from his own position, though it represents an error as regards viewpoint because he is likening the doll's position to his own. The disc seen in profile is likewise shown as an ellipse, horizontal this time, and the tilted disc as an oblique ellipse. When these three settings are repeated and Rol is asked to draw the shapes from his own position he renders the full face disc and the oblique disc correctly, but for the profile he says: "*That's more difficult*" and draws it as a horizontal ellipse. At the same time, he immediately selects the horizontal line from the sample drawings.

The road with receding posts is shown without perspective, the posts being laid flat (or 'rotated' in the sense used by Luquet[1]) on each side of the road and all made the same size. The rails are drawn parallel and Rol selects the comparison drawing of parallel rails as the correct one: "*It's right because it's perfectly straight*" whereas the converging lines "*are not right*".

MON (6; 10). Vertical pencil; correct. "And this way (oblique)?—(Draws it the same length but slanting)—Does the man see it as long as before or shorter?—*Shorter; no, a bit longer* (lengthens his own line)—Why?—*Dunno* —And this way (more slanting still)?—*He sees it longer*—Why?—*Because he sees it like this* (indicates the oblique position)—And this way (head on)? *He only sees the pointed part* (he draws a cone, the point of the pencil side elevation)—And this way (oblique once more)?—*Longer*—Longer than this (vertical)?—*Yes*".

GAL (6; 10). The stick seen from the doll's point of view. Horizontal and vertical positions shown correctly; head-on position drawn horizontal and full length. For his own point of view he produces similar drawings. "You drew them the same way (lengthwise and head on); do you see them the same way?—*No*". Makes the correct choices from the sample drawings. The disc, from both points of view: full face; correct. Horizontal (profile) drawn as an "*oval lying flat*". Oblique; drawn as a smaller circle.

Rails and posts. He draws them parallel but selects converging lines from the samples "*because the rails are bigger, then smaller and smaller*".

VAL (7; 0). The vertical stick (his own viewpoint) is drawn correct. Sloping backwards; he draws it the same length and says "*You can't show it slanting backwards*". Horizontal (side elevation) shown correct. Head-on; he draws it vertical and full length. From the sample drawings he chooses (after suggestion) a small circle for this last object, but in the case of the stick slanting backwards he remarks "*There's nothing here*" (=no satisfactory equivalent among the drawings)—Does it always stay the same length?—*No . . . yes, because it's still the same thing when it's lying flat*".

Disc seen full face is drawn correct. Slanting backwards, it is drawn as an ellipse; "*It goes this way. It looks as if it wasn't round all the same*". Seen in profile: same drawing of an ellipse. "*You can't draw it on a piece of paper*— How has it become so thin?—*I don't know. But anyway it gets like this* (the ellipse) *you couldn't see it otherwise*". From the sample drawings he makes a correct choice.

With the rails he draws parallels, but chooses converging lines (after some hesitancy). "*Because it keeps on getting smaller*".

UL (7; 3). Vertical stick is drawn correct. But end-on he draws it smaller. "*Yes, smaller because you can't see it very well*", though he refuses to draw it as a simple circle (or even to select it from the samples) because "*when it's like this* (lying flat) *you can still see the line*".

Disc, full face drawn correct. Leaning backward also drawn circular but much smaller. "And if I put it quite flat—*You'll see it flat* (draws a circle again)". But he recognizes the horizontal line as corresponding to the disc in profile when shown the sample drawings. "Isn't it that one, perhaps (ellipse)? —*No, because it's got to be lower*".

[1] See Translators' Notes (The Developable Surfaces).

LEY (7; 4). Vertical stick: correct. "And like this (end-on), what do you see?
—*Nothing at all. Yes a very small thin line* (draws a full-length horizontal
line, but makes it very faint)". But from the sample drawings he accepts the
small circle, after checking it in practice. Disc in full view: correct. Inclined:
an ellipse. Rails: drawn first as parallel, then in perspective.

MIC (7; 7). Stick, horizontal and vertical: correct. Head-on: full length and
horizontal. "Is it the same thing?—*No*—Is there any difference?—*Yes*—
Well, try and draw them both again—(He draws two parallel, horizontal
lines, the second to represent the stick head-on)". Following this he is asked
to choose from among the sample drawings, but instead of choosing the
small circle Mic picks out the horizontal line, puts it in front of the doll and
hides nine-tenths of the line with his hand so that only one end can be seen.
He does the same thing in the case of the stick leaning backwards, except that
he leaves more of the line uncovered.

The disc, full face, oblique, tilted backward, etc. In each case he draws the
same full circle, "*It's the same thing each time, because you can't draw it like
that*". But shown the sample drawings Mic points to the ellipse, or a full circle,
and then covers more than half of them with his hand.

With the rails he draws parallel lines and chooses the same from the
samples, but the posts he draws parallel and selects the drawing of a perspec-
tive.

Cases of this type are still encountered at 8, 9 and sometimes even at
10 years of age. Here is an example of one such backward child.

GOL (10; 9) invariably represents the stick by a vertical or horizontal
line of the same length, whatever its position. But shown the sample drawings
he accepts both the foreshortening and the small circle. The disc is likewise
drawn as a full circle, except for the profile which is depicted by means of a
rather sharply curved arc "*because the front is round*". From the sample
drawings he selects an ellipse but refuses to go as far as the horizontal line.
On the other hand, the rails are immediately drawn as perspectives.

These reactions do not merely express a conscious awareness of the
problem of perspective, as do the transitional cases quoted earlier, but
denote the beginning of real discrimination between different viewpoints.
What is interesting is that this new development is much more to the
fore in the selection made from the samples than it is in the children's
own drawings. It is as if whilst already feeling that the drawings ought
to express the changes produced by different viewpoints, the children
do not know how to render these alterations themselves.

Thus, with the stick seen end-on or tilted back they are content to
draw full-length vertical or horizontal lines. But when they make a
choice of ready-made drawings they accept a point or a small circle as
satisfactory (for example, Rol, Gal, Val, although refusing the correct
drawing of the inclined stick). Ul still holds out against the small circle
because when the stick is endwise "you can still see the line", while Mic

hides all but the tip of the line. In general however, the extreme perspective of this shape is accepted in ready-made drawings.

As regards the disc, when it is drawn from imagination in the horizontal position it is nearly always shown as an ellipse. But when lying flat so that only the edge can be seen it results in a drawing similar to that produced for the stick viewed end-on, an ellipse lying flat (Rol, Gal, and Val) or else a full circle (Ul), though among the sample drawings it is immediately recognized as a straight line.

As a general rule the rails and posts are drawn without perspective, as if the lines remained parallel regardless of distance (a straight carry-over from Substage IIA or the transitional level), but presented with the ready-made drawing most of the children (except for a few such as Rol, for example) realize that the perspective drawing are the right ones.

In short, the outstanding feature of all these cases is that the children are aware of making a distinction between successive views of the object, but except for the circle which becomes an ellipse they cannot themselves draw or imagine the outcome of these changes in viewpoint. Val gives us a clear insight into their inability to perform this feat. While on his own initiative drawing an ellipse to represent the disc tilted backward, he explains "It goes this way, it looks as if it isn't round, but it is round all the same". In other words, the child is still torn between a realism which tends to represent the object *per se*, and the beginning of differentiation between different perspectives. It is only when he sees perspective incorporated in an existing drawing, dissociated from his own activity as an observer and thereby acquiring some degree of objectivity as a ready-made representation, that the child is prepared to accept it as an adequate rendering of the object from a particular viewpoint.

§6. *Stage III. Operational discrimination between viewpoints of subject and object: Substage IIIA (partial). Substage IIIB (complete). Spontaneous rendering of perspective*

When we finally come to Stage III, beginning about the age of 7 or 8 as a rule, we find that children start distinguishing between viewpoints in their own drawings and no longer only in choosing from ready-made ones. But this development raises a thorny problem in separating Substages IIB, IIIA, and IIIB. For in actual fact, the problems of perspective covered in this chapter are not entirely solved at the commencement of concrete operations but only by about halfway through Stage III, or after the age of 9 (Substage IIIB). As we saw in the previous subsection (§5), discrimination between viewpoints may be considered as starting at the level of connected or 'articulated' notions (IIB), but in forms that are not yet fully co-ordinated, which is not unusual when problems are solved by intuitive methods rather than by means of

grouped, reversible operations. Now in the realm of perspective, the solutions characteristic of Substage IIIA are ones which result from 'articulated' notions, intuitive ideas linked together, although they are produced by children who in other fields are capable of carrying out well-grouped concrete operations. This being the case, how is one to establish the upper and lower limits of this substage? The answer we have given to this problem is to use as a criterion the child's ability to discover certain laws of transformation, which whilst enabling him to correlate his own drawings with the ready-made drawings he chooses, do not enable him to solve all the problems raised for lack of systematic quantification. Here are some examples of Substage IIIA, beginning with one midway between this level and Substage IIB.

THER (7; 4) first draws the vertical stick. It is then tilted backwards. She represents it in the same manner and says, "*No, now you see it smaller*", then draws a line no more than half the length of the first. "And when it's lying down flat?—*Very tiny* (line of 2–3 mm. length)". The tilted disc gives rise to a smaller circle (typical of Substage IIB) and when the disc is tilted at a greater angle the circle is drawn quite small though still perfectly round. By way of contrast, the profile is represented by a straight line. The method of choosing from samples leads to the correct choice of an ellipse for the tilted disc (the small circle drawn by the child being due in all probability to the influence of the minor axis).

The rails and posts are represented by parallels, but perspective lines are chosen from the sample drawings (another characteristic survival from Substage IIB).

JEA (7; 6) draws the horizontal and vertical stick normal length and the inclined stick as a rather shorter, oblique line. The stick end-on is represented by an even shorter oblique line.

The disc seen full face is drawn correctly. "And now draw it as it looks when I tilt it backward— *You have to make a line like this* (a horizontal line anticipating the profile view) *or else a very little one like this* (he draws a shorter line but is then tempted into extending it by a curve at one end to represent the contour; he immediately checks himself and says): *No, because it would get like a circle*—Now draw it when it's leaning back so far that it's flat—(Having already represented this view in the previous drawing, Jea says): *I don't know how to* (he draws a little circle, and like most children of IIB he adds): *The paper really ought to be like this* (raised to eye level)".

He draws the rails correct from the start. "*Yes, when they're a long way away things get smaller*". But the diminution of the gap between the rails is not shown in terms of a regular quantification, i.e., the size of the sleepers does not decrease in a regular fashion.

THO (7; 6) first draws the stick vertical and horizontal, and is then shown it end-on. On his own initiative he follows this up by representing five positions from vertical to horizontal, including three oblique. They are all drawn the same length while the first one is slightly curved. "Is the stick curved here?— *A bit*—What do you see when it's like this (end-on)?—*Only a tiny bit*—What

ought you to draw?—*A small circle*—And between the two positions?—*A sloping drawing* (he now produces a series of obliques, the first few lines being equal in length and those most inclined growing shorter and shorter until they arrive at the small circle representing the end-on position).

Tho draws the rails parallel for some distance, then begins to bring them together (in perspective). He points to where his lines change and says: "*You make it very small* (extremity); *after that it gets bigger* (up to the spot he is indicating) *and then it becomes straight* (parallel)". Thus, there is no regular quantification but in its place, sudden transformation of parallel lines into perspectives.

MUR (8; 3) draws the stick seen vertical, horizontal and head-on correctly, but then between vertical and head-on positions he draws a series of oblique lines progressively inclined but all of equal length; "Does it suddenly change from that into a little circle?—(Draws a shorter line but then changes his mind). *No, he* (the doll) *sees it just as big* (making it longer)". From the sample drawings he also chooses obliques of a similar length.

For the backward tilted and profile discs he draws various ellipses, but without any accurate proportions.

Rails. First he draws parallel and then converging lines: "*Because he sees them far away. Because he sees them less and less clearly, they become smaller*". But trees bordering a road are not drawn smaller in like fashion.

WAG (8; 6) also draws the stick seen vertical and head-on correctly. For a position that is "almost head-on" he draws "half" the length, but for all other angles of tilt he draws full-length oblique lines. "So all of a sudden it becomes a little circle? First he sees it lying flat, then round?—*No, I don't think so*". Among the sample drawings he takes the quantitative decreases into account.

The disc. He draws a number of arcs decreasing in size for the inclined positions, and an almost straight line for the profile view. From the sample drawings he makes a correct choice of ellipses. For the rails he makes the lines at first parallel and then convergent.

ROS (8; 7) first of all draws the vertical stick correctly. Then, when it is tilted backward, draws it "*smaller*". "Are you making it smaller on purpose? —*Yes* (not being altogether sure of himself, he makes it longer)—And this way (head-on)?—*It's round* (draws a small circle, then checks it against the end of his pencil). *Yes, because when it's facing you like that you can't see anything more*". From the sample drawings he chooses shorter lines for the tilted positions "*because you see them smaller*".

The disc: for the tilted positions he draws ellipses, and for the profile view, a very thin ellipse. He makes correct choices from the comparison drawings.

Rails: he draws them parallel at the beginning, then suddenly converging. The sleepers are drawn of equal length but at one point they begin a sudden regular decrease in size.

As with the previous stage, it should be noted that although the average age of the children belonging to Substage IIA is as given above, one does come across backward cases who are still at this stage at 9 or even 10 years.

These reactions are clearly different from those obtained at the previous stage. In the first place, the children's own drawings now illustrate the perspective changes which result from alterations in viewpoint. It is no longer a question of their only accepting these modifications when choosing sample drawings, which means that the perspective can not only be recognized but can be drawn in anticipation.

In the second place, now that the child has reached an operational level in other realms of activity (as was seen in Section I of this chapter as regards the straight line, solved at the level of IIIA), he is now beginning to imagine perspective in the form of a continuous process of transformation and not just a static isolated case. Consequently, we find Ther representing the increasingly tilted stick by means of shorter and shorter oblique lines, until she ends up with a line of 2 or 3 mm. to represent the end-on position. Similarly, Jea foreshortens the tilted stick; Tho fails to show the foreshortening right away but soon grasps the meaning of the series of tilted positions. The same may be said of Mur who also foreshortens his oblique lines, though he later reverts to his original rendering. In short, there is obviously a quest for a law governing the alterations and we are no longer confronted with a mere linking together of fragmentary intuitive ideas.

However, the quest for a solution to this problem is not yet wholly successful, and it is in this respect that Stage IIIA differs from the one that follows. The children of the present level show signs of being able to perform operations but the actual solutions they give to these elementary perspective problems remain purely intuitive. The reason for this is extremely interesting, and in fact, the existence of Substage IIIA enables us to follow the process of development more clearly than if these problems had been solved right away. Although the child is growing aware of perspective changes, nevertheless they do not yet give rise to an organized system of correspondences. This is due to the absence of continuity and any genuinely extensive quantification, the child's thought being confined to noting certain qualitative changes (any quantification being merely intensive) without understanding them properly or linking them up in a continuous fashion.

In this connection, the example of parallel lines made to appear convergent through the effect of distance is a particularly illuminating one, though the same phenomenon will again be encountered in the case of change in shape of the circle and straight line with change in orientation. The children know perfectly well that the rails do not continue parallel in perspective and they try to depict this convergence in their drawings, as is the case with Jea. The remarkable thing is that they do not think of this convergence as something occurring gradually and almost imperceptibly. Either they rest content with a drawing showing irregular changes (Jea, etc.), or else they maintain that the rails

187

stay parallel up to a certain point (such as half the distance in depth) after which perspective suddenly comes into play and the lines converge. We find Tho indicating this point explicitly in his drawing, as if the transition from parallel to convergent lines was something that happened suddenly and not a continuous process. In the case of Ros the drawing resembles a kind of pencil with its two parallel sides suddenly converging to meet in a point. Absence of regular convergence is, of course, found once more in the drawings of the sleepers, fence posts, and telegraph poles, examples which were devised for the express purpose of studying how children think of the quantitative relationships occurring in perspective.

In addition to these examples, the same shortcoming is present in reducing the length of a line or the width of an ellipse in the case of an increasingly tilted stick or disc. Here we find that the foreshortening is either jerky and irregular, or as with Ther, it is regular but never attains the final state of becoming a dot. Quantitative rendering of the apparent width of the tilted circle seems even more difficult (transition from circle to ellipse and ellipse to straight line). While the majority of the children can form the ellipse (occasionally drawn even at Substage IIB), they are quite unable to vary its width, nor can they imagine the straight line as the culmination of the process (disc seen in profile). For instance, Jea gives the impression of anticipating this line as the final outcome of tilting the disc, but fails to arrive at the correct solution when actually confronted with the profile view. For this position Mur produces an extremely thin ellipse, but he cannot draw it as a straight line, nor draw his other ellipses in their correct proportions.

Now it is relatively easy to understand the cause of these difficulties. As we are already aware, the discovery of perspective is an outcome of discriminating and co-ordinating different points of view. In other words, it comes about through the object no longer being regarded as a thing in itself, and through the child's becoming increasingly aware of the relations which link it with the viewpoint of the subject. The actual achievement of such a perspective construction obviously presupposes an operational system of 'putting in relation' (simple additive relations and correspondences between relations through logical multiplication). Before they can be quantified these operations must first be established qualitatively. This done, they are immediately applied to the key positions, upright, tilted and horizontal. Thus the tilted stick (B) is regarded as appearing shorter than the upright stick (A), whilst the stick seen end-on (C) is thought of as reduced to a small circle, etc. But these key perspectives involve no more than the intensive relations $A>B>C$. Once these relations have been arrived at however, it will sooner or later be possible for the children to think, not only of an increasingly numerous series of intermediate terms $A>B_1>B_2>B_3>$

...$>$C, but also of regularity between the differences A–B$_1$; B$_1$–B$_2$; B$_2$–B$_3$, etc., and this is precisely what extensive quantification amounts to.

The process is particularly clear in the case of fence posts or railway sleepers (assumed to be equidistant). If A, B, C, D ... are successive elements and A', B', C' are the differences separating them (A–A'=B; B–B'=C, etc.), then extensive quantification is reduced simply to regular decrease in size, such that the differences A', B', C', remain constant, or at least maintain a constant relationship. This is just what the children at this stage do not realize, since they proceed by jerks from large sleepers to small. For instance, there are some children who draw the sleepers in three sizes, first the nearest ones which are all made equally large (A=B=C...), then those in the middle distance which are made smaller but also equal in size (F=G=H...), and finally the most distant which are made equally small (X=Y=Z...) thus producing a false series (A=B=C...)$>$(F=G=H...)$>$(X=Y=Z) in which the differences A', B', C', or F', G', H' remain nil and the only differences recognized are the gross ones separating the three sets.

In the reactions of Substage IIIB are to be seen both operational generalization of the relationships already discovered at Substage IIIA, and extensive quantification whose deficiency we have just noted at the present level. The first of these enables the child to conceive of the transformations as being continuous, by comparison with the intensive notions of Substage IIIA which offered him only particular examples, whilst the second enables him to deal quantitatively with the qualitative transformations which have thus been generalized.

Here are some examples, beginning with the case of a child who reached Substage IIIB during the actual course of the experiment.

HAN (8; 0) begins by drawing the vertical stick. "And if it's tilted back a little, how ought you to draw it?—(Prolonged reflection). *You must make it smaller* (draws it a little smaller)—And if I tilt it back a bit further?—*You must draw it smaller still*—And laid down flat?—*In the end you'll see nothing but the little round bit*".

The disc is drawn full face—"And if I tilt it back a little?—*Like this* (ellipse) *because before you could see the whole width. Now you can't see so much*— And if I tilt it back further still?—*It will be smaller than there* (the previous ellipse)—And in the end?—*It will be like this* (a line)". The selection of sample drawings produces similar observations. Among the shapes he is shown an ordinary circular arc: "*That isn't right. To make this drawing you'd have to flatten it or bend it again* (the circle itself)".

The road is drawn as growing ever narrower, with trees of regularly diminishing size. Likewise the railway lines have sleepers "*thinner and thinner*".

WAG (9; 4) draws a series of lines shorter and shorter, culminating in a point, to represent the series of positions of the stick between vertical and end-on. Likewise, he constructs a series of ellipses becoming thinner and thinner

189

until they are simply a line, to show the successive inclinations of the disc. The rails are drawn correctly right away, with sleepers of regularly diminishing size: "*He* (the little man) *sees them always getting thinner and thinner* (shorter) *because they're further away*". He continues his drawing like this with constantly diminishing size until it contains over thirty "sleepers".

Moc (9; 10). A straight line: "*I see it shorter . . . shorter . . . smaller still*" etc.; end-on, it is now only a point: "*It's the beginning, you can't see the rest*". Rails are drawn with sleepers decreasing regularly in size.

Lam (9; 11). The tilted stick is drawn as a line becoming shorter and shorter. "*It's shorter because one end is hidden. You see it shorter*" then, "*It is even a bit less long than the other because the more you bend it back, the more you hide some part. Each time you see it it's a bit shorter*".

Tor (10; 7) on the other hand relates the foreshortening of the stick not to the fact that the front hides the rear, but to the distance of the other end. "*The bar becomes smaller because it's further away. It's like when I move away, or like a stone you throw down into a valley*—And what will it look like in the end?—*A point* (he draws a series of vertical lines decreasing in length until they reach a point)". The rails are drawn not only with sleepers decreasing in length but with regularly decreasing intervals between them.

Wil (11; 10). Same reactions. The tilted circle results in thinner and thinner ellipses. "And in the end?—*You'd see nothing but a line, if the circle was properly made*". The rails and sleepers resemble those drawn by Tor, "*They get closer and closer together, but actually the distance is always the same*".

Such is the form ultimately attained by the child's thought. It will be seen that continuous operational transformation and extensive quantity are closely allied to one another.

The first thing to be noticed in these reactions is actually the way the child himself accounts for the operations which, by relating the object to the subject's viewpoint, result in the perspective. By Substage IIIA the child has already discovered the connection between perspective changes and changes in orientation, and even tries to work out the law governing these transformations. But he is unable to conceive of them in operational fashion and can only imagine the principal perspective shapes. In contrast to this, we find the children of the present stage spontaneously seizing upon the two main relationships which link the object with the subject's point of view. These are, projection in depth, and the section produced by near parts of the object masking the more distant parts of it. In short, once the projective straight line has been discovered through the method of 'taking aim' (Substage IIIA), the operations thereby introduced are subsequently extended in the course of Substage IIIB to cover perspective in general.

As a matter of fact, it will be remembered that unlike the topological line, which forms part of an object considered in isolation, the projective straight line appears only when the parts of this line are linked with an

observer viewing them from one end, so that the near elements are seen to mask the distant ones. Now by the level of Substage IIIA, this practice of 'taking aim' not only enables a straight line to be formed independent of perceptual ground (cf. Section I), but it also enables straight lines to be distinguished from curves since only the former retain their shape during perspective changes. The reason for this is that 'taking aim' itself presupposes rudimentary sectioning operations (resulting from masking of distant by near objects) and also projective operations (the straight line remaining straight while changing length with change of orientation, the point being the limiting case). The children of Substage IIIB apply and generalize these operations explicitly up to the point where they can derive a comprehensive operational treatment of perceptual changes from them.

Why does the stick grow shorter and the circle narrower when they are tilted? The reason, says Lam, is that "the more you bend it back, the more you hide some part. Each time you see it, it's a bit shorter". And as Tor says, the furthest part of the tilted stick "gets smaller because it's further away", adding "it's like when I move away" (and you see me from a distance) or "like a stone you throw down into a valley". Having formulated the twin processes of section and projection, and in consequence understanding the laws governing perspective changes, it naturally follows that these children can now go ahead and produce the shape which corresponds to each position of the object. Hence, as a result of introducing continuity by means of a law of transformation, the merely intuitive ideas covering the key perspective shapes are replaced by qualitative operations.

It is likewise comprehensible that so soon as qualitative operations such as putting in relation and putting in correspondence are developed, extensive quantification is made possible by direct recognition of the regularity in perspective changes. That is to say, by perceiving an invariant relation between differences, and moreover, one independent of a metric relationship requiring a particular difference to be selected as a reference unit. For example, when Han and Wag speak of the sleepers between the rails as being "always a little thinner (shorter)" and when Wil says "they are closer and closer together", while noting that "actually the distance is always the same", it is evident that they have established a fixed relation between each sleeper and the next, or between adjoining intervals. Thus they do not remain content with mere qualitative seriation, but quantify the successive differences. How, one may ask, does such an invariant relation come to be recognized? It is recognized, not through a metric process but (like the method which has been developed theoretically in projective geometry) by a process of pictorial construction. It is the construction of receding convergent perspectives which brings in its wake the relationship of invariance

exemplified by the sleepers connecting the rails, or the intervals between the sleepers diminishing in size at a constant rate.

In fine, it is apparent how simply and rapidly simple projective relations develop from topological relations as soon as they are organized according to co-ordinate points of view. The projective straight line is originally no more than a continuous, ordered series of points, such that seen from one end the first point obscures the rest. Once this idea has been worked out in concrete form (as at Substage IIIA) the child can conceive of the perspective changes as linked with the varying appearance of the object in different positions. Yet this is no more than a grouping of previously enumerated topological relations, though now in terms of a complex of interconnected viewpoints. Nevertheless, once the three topological dimensions arising from the relationships of order ('between') and enclosure are connected with a specific viewpoint they acquire a new significance.

As an example, let us take an object viewed from a given position. There are other objects to the left and right of it, and from the viewpoint of a subject it lies 'between' them (whereas from the standpoint of topology, left and right are meaningless save as directions of travel along an isolated line). Likewise, there may be other objects above and below it, representing a second dimension, that of height. Lastly, there may be objects before or behind it, linking it with the viewpoint of the subject, and these are new relations introducing a third dimension, that of depth. Thus the 'between' relation (unidimensional) and the two and three dimensional relationships all acquire a heightened significance by virtue of their being co-ordinated with a single viewpoint (this idea of a single viewpoint is an essential requirement for the definition of every-day notions of left and right, as has been recognized since Kant). Finally, if an isolated straight line constitutes a single dimension, then a sheaf or bundle of lines constitutes, in terms of the relations just enumerated, a projective plane or a three-dimensional space, between them capable of giving rise to various new relationships such as projections or sections.

The child is thus able to envisage perspective alterations of a line or a circle as projections or sections and reduce them to operations which express precisely this co-ordination of viewpoints. And he is able to do so entirely as a result of these new relationships of left and right, above and below, before and behind. Hence a vertical straight line is shown as decreasing in length when tilted backward because the child realizes that relative to his own viewpoint, what it loses in height it gains in depth. What is more, he realizes that the process leads continuously and imperceptibly to the limiting case where the line becomes a point because, in the final analysis, the whole of the original height is, from his own point of view, now disposed in depth.

In short, as the straight line leads to an understanding of projection, and the three dimensions of projective space lead to the idea of a bundle of lines intersected by a plane, so both these fundamental operations of projection and section become familiar enough to enable the child to give the kind of explanation seen in the examples quoted. But the concept of the straight line itself, together with the various relationships resulting from its synthesis with the original topological relations, ultimately presumes the discovery of the part played by points of view, that is, their combined co-ordination and differentiation.

How is this discovery to be accounted for? To ascribe the origin and development of projective geometry to the influence of visual perception, as does Enriques,[1] is to overlook the fact that the purely perceptual point of view is always completely egocentric. This means that it is both unaware of itself and incomplete, distorting reality to the extent that it remains so. As against this, to discover one's own viewpoint is to relate it to other viewpoints, to distinguish it from and co-ordinate it with them. Now perception is quite unsuited to this task, for to become conscious of one's own viewpoint is really to liberate oneself from it. To do this requires a system of true mental operations, that is, operations which are reversible and capable of being linked together.

It is therefore hardly surprising that perspectives do not become organized in this sense until the middle of Stage III, whereas they are acquired perceptually together with the visual constancies during the first year of the child's existence. This fact alone should enable us to realize that the investigation so far carried out, only dealing with the perspective of a single object seen in successive positions by one observer, cannot possibly provide a satisfactory solution to the general problem of perspective.

If it is the case that the discovery of the role of points of view does in fact presuppose their being co-ordinated, then it becomes essential to study this process, examining perspectives in relation to a number of observers and a group of interrelated objects, and this we shall endeavour to do in Chapter VIII. But before embarking on this project we must first of all look into the question of projections as such in order to verify the correctness of our assumptions about the part which the straight line plays in the development of this group of ideas.

[1] Enriques, F., *Problemi della Scienza*, Bologna, 1926.

Chapter Seven

THE PROJECTION OF SHADOWS[1]

IN the last chapter we showed how the object comes to be envisaged in terms of a particular viewpoint, and how the introduction of this viewpoint serves to transform the simple topological relationships into projective relations. We also saw that the reason perspective is slow to appear on the conceptual level, so long as perception remains dominated by egocentrism, is that the conscious awareness of the relativity of viewpoints presumes that they are distinguished one from another, and this demands an attitude just the reverse of egocentric.

Far from helping the subject to distinguish between his own and other viewpoints, the egocentric attitude tends to encourage him to accept it without question as the only one possible. The result is that the child imagines he is placing himself wholly at the point of view of the object itself, consequently he turns it into a kind of 'false-absolute'. In actual fact, discrimination between viewpoints requires not only a breaking away from this initial egocentrism, but also a co-ordination of perspectives through grouping the relationships which constitute three-dimensional space. This is an operational concept not achieved until the level of concrete operations is reached about the age of 7 or 8.

Now there is no better way of testing this hypothesis than to study how children draw and visualize shadow projections. The projection of shadows obviously follows the same laws as the projection of objects on a plane perpendicular to the line of regard and is therefore governed by the same laws as perspective. But since perspective depends upon the relative positions of object and subject, and since the projection of shadows involves the relative positions of at least two objects (that casting the shadow and the material plane on which it falls, not counting the light source which governs the entire projection), from the psychological point of view one might very well expect the child to find the projections of shadows more difficult to understand than perspectives.

This greater difficulty in understanding would not be altogether unexpected on the assumption that perspective is discovered solely through perception, since the child would be capable of discovering perspective directly (imagination being regarded simply as a continuation and extension of perception) whereas an understanding of shadows would still require a good deal of preliminary interpretation.

On the other hand, in order to confirm our own hypothesis, according

[1] In Collaboration with Mlle G. Ascoli.

to which the imagining of perspective entails the co-ordination and differentiation of various possible viewpoints, and hence an operational grouping of projective relationships, it ought to be the case that projection of shadows becomes understood at roughly the same level of development as perspective transformations relating to the same object; and this is, in fact, what the present chapter demonstrates.

In dealing with shadows, however, we must distinguish between two questions which may perhaps be interconnected but may be independent. The first relates to the understanding of the physical causes of shadows, and the second to the ability to foresee the shapes they may assume according to what shaped object they correspond to. We have already carried out a study of physical explanations of shadows given by children[1] in which we were able to describe four distinct levels of development. These are: (1) the shadow of an object placed on the table is regarded as emanating from some outside source (such as the night or the shade of trees, etc.); (2) the shadow is not related to the light source but belongs to the object; (3) the shadow belongs to the object but runs away from it (is somehow 'put to flight' by the light); (4) the shadow is simply absence of light and is due to the object forming a screen between the light source and the projection plane.

It would therefore seem that for the purposes of experiments on the geometrical shape of the shadow, only children belonging to Stages (3) and (4) would prove suitable as subjects. However, in the experiments which follow, the shadow is cast on a nearby vertical screen by a lamp which the child can see. He thus has ample opportunity of clarifying his ideas about the nature of shadows and can learn from experience that they depend on the shape of the object as well as on its position relative to the source of light. At the same time, given this set-up there is no reason why children belonging to Stages (1) and (2) may not also attribute changes in the appearance of the shadow to variations in the position of the object. At least there is nothing which stands in the way of their doing so. Thus it would seem quite in order to study the geometrical problem of shadows independently of the causal problem, if only on the strength of its demonstrating how the child reacts to the situation confronting him.

§1. *Technique and general results*

Various objects are mounted on a thin rigid support and placed between a lamp and a vertical white screen, the three elements being separated by only a few centimetres. The child is simply asked to draw the shape he expects the shadow to assume, or choose a shape from a set of sample drawings. The following objects are presented in turn: (1) A cone, upright or inverted, producing a shadow identical to its shape as

[1] *The Child's Conception of Physical Causality*, Chapter VIII, London, 1930.

perceived by the child. (2) A bobbin or spool made by putting two cones point to point, presented vertically and also giving an identical shadow. (3) The simple cone lying end-on to the light source, the point or the base to the screen and giving a circular shadow. (4) A cone in the same position but with a hole through the vertical axis producing a ring as a shadow. (5) The bobbin (2) placed endwise to give a circular shadow. (6) A cardboard disc placed vertical or horizontal giving a circle or a straight line as a shadow. (7) A cardboard rectangle in the same positions. (8) A pencil placed vertical to give an identical shadow, then turned endwise so that it declines to a small circle. In addition, the same objects, especially the cone, disc, rectangle and pencil, may be presented variously inclined to give either elliptical shadows or foreshortened straight lines.

It will be apparent that objects (6) and (8) reproduce the shapes already studied in Chapter VI with regard to perspective. Only the rectangle is a new feature. On the other hand, shapes (1) to (5), consisting of single or double cones with or without holes, are distinguished by having variable cross-sections. The forecasting of their projective shapes is therefore more difficult, since the shadows will vary according to which end faces the screen.

With thes imple shapes (those having constant cross-sections) we find exactly the same four stages as with perspective, except that the pencil seen end-on is more easily imagined in the form of a small circle with shadow projection than with ordinary perspective. During Substage IIA (up to 6–6½ years) the child draws the shadow as similar to the shape of the object as it appears from where he stands (no perspective). At Substage IIB he begins to distinguish between different projections. The vertical and horizontal positions begin to be differentiated for simple shapes (pencil, disc and rectangle) though not yet the oblique positions, whilst the horizontal position is not as yet invariably drawn correct. During Stage III, however, the correct solution is discovered for simple shapes. The discovery is made in two phases. In the first, Substage IIIA, the shapes are distinguished but lack quantification; whilst in the second, Substage IIIB, quantification is applied both to the oblique and extreme positions. Not until Stage IV are these solutions applied to the conical shapes. This is to be explained by the additional operations needed to anticipate in imagination the various possible cross-sections arranged in series.

§2. *The projection of straight lines*

We will first of all deal with shadows cast by a pencil. This will make possible a preliminary comparison with the results of Chapter VI on the projection of straight lines and the straight line as seen in perspective.

Now in this connection we not only find the same stages of develop-

ment with shadows as with perspective, but as the result of questioning fifteen children (other than those participating in experiments on shadows) on both subjects simultaneously we discovered that for both shadows and perspectives the stages of development were identical. The sole exception to this was that several children were found able to draw a small circle for the "end-on" pencil when they thought of it as a shadow whilst still showing it as a full-length line when asked to draw it in perspective. Apart from this minor discrepancy (a discrepancy operating in favour of shadow projection) the stages are absolutely the same for both activities.

Here to begin with are a few examples from Substage IIA. At this level the child can only represent the shadow in the same way as the object appears to him from where he is placed.

BUI (5; 10). "If I stand the pencil like this (vertical)?—*It makes something pointed* (draws an upright pencil)—Now look and see if that's right (the lamp is switched on)—*Yes*—And if I tilt the pencil (toward the screen)?—(He draws it as he sees it, leaning from left to right)—Look at the shadow— *You can hardly see anything at all now*—And suppose I make it flat?—(He again draws what he sees, a horizontal pencil)—Now just watch the shadow— *I don't know what that makes; it seems to make a tiny circle*". Thus, he does not understand the shape of the shadow itself.

PAU (6; 9) similar reactions: "And if I tilt it like this (point toward the screen)?—(He draws a horizontal line)—Look—*A circle! Then my drawing is wrong*—Are you surprised?—*Yes, I am*—Why does it make a circle?— . . . —And what about this (tilted toward the screen)?—(He draws a full-length line tilted from left to right)".

Thus at this level there is a complete lack of understanding as regards the projective shape of the shadow. In this respect, Substage IIA is simply a continuation of Stage I, though the earlier stage cannot be studied for the child does not possess the necessary skill in drawing at this level. Whatever may be the child's explanation of how the shadow is actually formed, he thinks of it as nothing more than a simple copy of the object, regardless of the object's position. Just as he will draw this object as an isolated thing in itself, regardless of perspective and indicating only its general direction, so he depicts the shadow without regard for perspective and similar to the object in shape.

Coming to Substage IIB, we see the child beginning to distinguish different projections. The inclined pencil is drawn tilted as before, but it is occasionally made longer than when drawn vertical. The shadow of the 'end-on' position is sometimes drawn as a point, or even as a small circle.

FRAN (6; 8). Vertical: correct. "And suppose I made it lean over, what will the shadow look like then? Will it be bigger or smaller?—*Bigger, because it's leaning*—Why should that make it bigger?—*Because it isn't straight*—And

like this (end-on)?—(Drawn horizontal, full length)—Is that right (without as yet switching on the light)?—*No, it will make a little circle*".

LEP (7; 2). "If I stand this pencil up straight?—*It'll be just like a pencil* (draws it vertical)—And if we lay it flat?—*Maybe a circle, or pointed* (he draws the point in profile)—Look—*It's a circle*—Why—*Because there's a circle there* (he points to one end) *and a point there* (the other end)—Then why can't you see a point?— . . . —And if I raise it up halfway?—*It will make this* (same length as the vertical)—The same as before?—*No, it's a little bit sideways*—And if I make it lean the other way (always tilting towards the screen or the light)?—*It'll lean the other way* (he draws it leaning towards the right instead of the left, but still full length)".

SCHAL (7; 8). "Supposing we stand the pencil like this (vertical)?—*It'll make a line*—And lying down flat (point towards the screen)?—*It'll make a little point* (he draws the point as such and not as a circle the thickness of the pencil)—And if we stand it up again but tilt it just a little (toward the screen)? —*It will be leaning a bit* (drawn the same length and tilted from left to right) —Look—*Oh, it gets smaller and smaller!*—Why?— . . . "

These children, just like those studied at the corresponding substage in the case of perspective, show definite signs of a rudimentary discrimination between different viewpoints, except that here it is a problem of relating the position of the object with its shadow projected on a screen. In this connection we again come across the view, expressed by certain children, that an inclined object becomes lengthened as a result of its inclination, which certainly amounts to distinguishing the vertical from the inclined position despite the error in estimation. Furthermore, the fact that this type of error should recur again here suggests that neither perspective nor projection are involved as yet. It is most probably the result of a feeling that a tilted object must be longer than a vertical one if absolute height is maintained unaltered; that is to say, like a diagonal relative to the sides of a square. The fact that a point or circle is drawn to indicate the pencil lying end-on is doubtless explained as follows. Whilst in direct vision one can almost always see a little more than the mere extremity of an object (the cross-sectional view thus being largely an abstraction), so soon as the child regards a shadow as capable of changing according to the position of the pencil, he comes to consider it as deriving solely from the extremity, and particularly from the extremity pointing towards the screen. As a result, he draws either the circular base of the pencil or its point, not projected in accordance with laws analogous to those of perspective, but separated from the pencil itself in some way. It sometimes happens that the point is drawn in profile instead of head-on, but even if the head-on view is drawn it expresses the extension of the pencil pointing toward the screen rather than its actual projection.

Finally, it should be noted that the error seen in Substage IIA still persists at Substage IIB; namely, that an object tilted toward the screen

is drawn leaning from left to right (or the reverse), due to the child identifying the light-object-screen axis with his own line of sight, thus substituting his own viewpoint for the projection.

From the commencement of Stage III, however, it becomes possible to speak of projection proper. This corresponds exactly with the beginnings of differentiation seen at the analogous stage in development of perspective. At the same time, in Substage IIIA the child has only just begun to discriminate, for he still persists in confusing points of view (making them left to right instead of front to rear, for instance) and is also in continual trouble with regard to quantification (the amount of foreshortening allowed for tilted uprights).

Here are three examples, beginning with a child midway between Substage IIB and Substage IIIA.

GFE (8; 9). Vertical pencil: "*It makes a pencil*—And if we lay it flat?—*It will make a little circle*—If we stand it up again and then tilt it a bit (toward the screen)?—*It will be a bit slanted* (draws it tilted left to right and full length)—And if we make it tilt more still?—*It will be even more slanted* (still drawn full length)—And even more (it is now horizontal)?—*It will be a little circle*—What, all of a sudden?—*Yes*—What, you see it coming down lower and lower, and then as a circle?—*Yes, when it's all the way down*—Look (the light is switched on)—*It's getting smaller*—And if we raise it again?—*It gets bigger and bigger*—Why?—*When it's lowered a bit the shadow gets smaller*—Could it have become a circle all of a sudden?—*No*".

DUM (7; 8) draws an upright pencil. "And if we lay it flat?—*It will make a little black point*—If we stand it up again and then tilt it a bit?—*It will make a pencil that's leaning a bit* (draws it tilted left to right, but a little shorter)—And if we tilt it lower still?—*It will be tilted even more* (draws it the same length as previously)—Will it be the same length?—*No*—And further still?—*There will be a little point*".

TRAN (8; 1) shows the same reactions, the shadow is drawn reduced in length but foreshortened in an irregular fashion and is still inclined from left to right. "What is it like when it's tilted; is it the same size, bigger or smaller? —*Smaller*—Why—*Because it's leaning*—Well, what of it?—*You see it shorter* (as a shadow, not directly!)".

There is thus a beginning of quantification, though this process can only reach a state of equilibrium when it is linked with a general understanding of projection; in other words, an understanding of the relation between the screen and the illuminated object independent of the child's point of view. Here are some examples of reactions typical of Substage IIIB.

JAC (7; 10). "If I tilt the pencil, what will the shadow be like?—*A little shorter* (he draws it upright and foreshortened)—And if I tilt it still more?—*In the end there won't be any shadow left at all* (he draws a series of shorter and shorter lines, then a small circle; thus 'no more shadow', which is to say, straight)".

HAN (8; 6). "If I stand this pencil up straight?—*It will make a bar* (draws it straight)—And like this (horizontal)?—*You won't see the long part, only the tip* (he draws a circle)—And tilted halfway?—*You'll see half the pencil* (draws it upright and foreshortened by half)—Can you explain why?—*You can't see the lower half any more* (hidden by the upper half which is tilted towards the light)—And between here and the circle?—*You'll see a little bit of pencil getting smaller and smaller*".

MAX (8; 9). "And when it's lying flat?—*A circle*—And half-way down?—*The pencil will be smaller* (draws it upright)—Why?—*The pencil's leaning over so you can't see all of it*—Why not?—*Because on the screen it's not so long* (he shows the distance between top and bottom)".

In these children then, we see a striking parallel between this succession of stages and the corresponding levels in development of perspectives, made all the more convincing in view of the fact that none of these children took part in the perspective experiments. Not only do we find the actual law of the foreshortened series understood, but also the distortion due to truncation is explained correctly, just as at Substage IIIB in Chapter VI. This is even more remarkable seeing that in the present circumstances one part of the object obscures another, not from the viewpoint of the observer but relative to the axis of the lamp and the screen.

§3. *The shadow of the disc*

As was stated in the section dealing with perspective, we cannot assume that the child understands that straight lines alone retain their shape unchanged during perspective changes until he begins to adjust the curves in his drawings while leaving the straight lines unchanged (for in the beginning he leaves everything unchanged because he cannot understand the changes at all). This means that the results obtained with the shadows of straight lines must now be compared with the reactions to shadows produced by a circular disc. However, it will be seen that here also the drawing of shadows follows exactly the same path of development as did the drawing of perspectives.

During Substage IIA the shadow of the disc is always imagined as round (as it is throughout Stage I) regardless of the object's position relative to the lamp or the screen.

LIS (5; 6). Disc upright and parallel to the screen: "*It will be round* (drawn circular)—And if I lay it flat?—(He draws another circle)—Watch (the lamp is switched on)—*Oh, a plate!*—Why is it like that?—*I don't know*—And if it's halfway (tilted toward the screen)?— . . . —Will it be like a wheel or like an egg?—*Like a wheel*".

LEV (6; 6). Disc upright: "*It will be a circle*—And if I lay it flat?—*Still a circle*—The same as before?—*Yes*—Watch— . . . —What do you see?—*A circle* (actually nothing but a very distinct straight line can be seen)—Does

it look like a circle?—*No*—And if we make it lean halfway?—*It will make a tilted circle* (he draws a full circle!)".

But the child very soon foresees that when tilted or horizontal the disc will not produce the same shadow as when upright. Hence at Substage IIB we find some attempt to discriminate similar to the behaviour shown at the corresponding level, or between IIA and IIB, discussed in Chapter VI. At this level the oblique disc is either represented in the same way or else shown as a broken circular arc.

WEB (6; 6). "If I stand the circle up straight?—*It will make a circle* (he draws it)—And if I lay it flat?—*Like this* (he draws a sort of cup)—Look (the light is switched on)—*No, it's just a stroke*—And if I tilt it halfway between the other two?—(He draws an oblique line, from the end of which another runs off, somewhat shorter, like a fishing hook)—Look (shadow)—*An egg!*".

SOL (6; 8). "*It will make a circle* (upright)—And lying flat?—*It will make a circle. No, you'll only see the edge* (draws a circular arc)—Watch—*That's right* (only a line can be seen)—And tilted halfway?—*The same again* (He once more draws an arc, but turned the other way)".

MAR (7; 4) also draws a circle for the upright disc, but a cup for the horizontal position and an arc for the tilted one.

LEP (7; 2). Although remaining confined to the reactions already described, Lep presages the appearance of Substage IIIA. "*A circle* (upright)—And lying flat?—*It will make a short straight line* (though he draws a circular arc) —And like this (tilted)?—*A tilted circle* (draws it irregular and vaguely elliptical)".

In contrast to this, at Substage IIIA one finds vertical and horizontal positions clearly distinguished, though no consistent quantification of the tilted positions.

BRU (6; 11). "*It will be perfectly round* (upright)—But lying flat?—(He draws a horizontal line (*Very, very thin*—Why can't you see the circle in this shadow?—*Because it's completely flat*—And like this (tilted)?—(He draws an oblique line)—Watch (shadow)—*It's like an egg!*".

DON (7; 2) and WAG (7; 6) likewise draw a horizontal stroke for the shadow of the horizontal disc but say, "*it makes half a circle*" and draw a semicircle for the tilted disc.

SHAL (7; 8). "*It will make a circle*—And lying flat?—*It will be a very thin line* (horizontal)—And tilted?—*It will make a tilted circle* (he draws it roughly elliptical)—And like this (less tilted)?—*A circle*".

At last, about the age of 8–9 years (Substage IIIB) the problem is solved and the tilted positions are shown correctly.

DUM (7; 8). "*You'll see a large circle*—And laid flat?—*Just a line*—And in between?—(Draws an ellipse)—And tilted a bit more?—(He flattens the lower half of the ellipse)—*Rounder on top and not so round underneath, because as you lower it, it keeps on getting smaller and flatter*".

MAI (8; 2). "*A circle*—Lying flat?—*A line*—And in between?—*It will be on the slant* (ovals, with oblique axis at first, then vertical)."

CHAP (8; 7). "*You'll see a circle*—And lying flat?—*A flattened circle. No, a stroke*—And in between?—*It will be a bit slanted* (he draws five figures intermediate between a circle and a straight line, by gradually flattening the ellipse)".

MAR (8; 9). "*You'll see first a circle, then a line, and in between the two, an oval*".

There is no need to dwell upon the exact analogy between these replies and the corresponding ones given in connection with perspective problems. The only differences are that the ellipse appears slightly later for the tilted circle in the case of the shadow, and that there is still a momentary confusion between the viewpoint of the child and the projective axis (see Mai). Apart from these minor details the path of development, from initial lack of differentiation to the final differentiation, is exactly the same.

§4. *The shadow of the rectangle*

We will now make a very rapid survey of the children's ability to predict the shape of the shadow cast by a rectangle. Instead of placing the object in front of the lamp as previously, this time we put a piece of cardboard directly below it, so that the shadow is cast vertically downwards upon a horizontal screen. In this way the plane of projection is completely dissociated from the viewpoint of the observer. Consequently, the questions concern the horizontal position (similar rectangle), vertical position (straight line) and intermediate angles (rectangles of decreasing width).

This change in method, useful as a cross-check, nevertheless left the four previously established stages unchanged. Thus during Substage IIA the rectangle remains invariant.

ELI (6; 0). "If I put this card under the light (horizontal), what will the shadow be like?—(He draws a rectangle)—And now if I tilt it like this, what will the shadow be like?—*Just the same*—And if I turn it like this (edge-on), will there still be a shadow?—*Yes, I think so*—Draw it—(He again draws the same rectangle)—Watch (the lamp is switched on)—*Oh! It's become ever so small!*".

As before, there is a beginning of discrimination during Substage IIB, though the edge-on position is still not rendered correctly.

LAL (5; 11). Horizontal: reproduces the shape correctly. "And like this (oblique)? Will that make a shadow too?—*Yes*—Bigger, smaller or the same size?—*Smaller* (he draws a similar shaped, but smaller rectangle)—And like this (edge-on)?—*Smaller* (he draws a much narrower rectangle but makes it too short by half, so that it is a combination of reduced width and reduced size)—Why will it look like that?— . . . "

NAD (6; 3). Oblique position: "*Maybe it'll be a bit shorter*—Why?—*Because it's higher* (he mistakes the shortened side, takes the cardboard and brings it near his drawing, then makes his side the right length)". Edge-on: keeps the length constant and contents himself with reducing the width, though without succeeding in making a simple line.

At Substage IIIA the children master the extreme position.

FAD (6; 10). Edge-on: "*It will make a square. No, a line, because it's like this* (points to the edge)". Tilted: length and reduced width shown correctly.

MOG (7; 8). Tilted: he draws it at first the same size but on an oblique axis "*It will be slanting*", then he makes it narrower. Edge-on: "*It's smaller* (he draws a simple line)".

And finally, the reactions of Substage IIIB showing correct quantification and explanation of the projection.

MIR (7; 10). "If the card is tilted?—*The shadow will get smaller and smaller* (draws the length correct and shows the width decreasing)—Why?—*Because when the cardboard is tilted it gets thinner* (narrower) *so that the light has more room to pass*".

RAY (8; 2). Same kind of answer for the tilted position; "*the shadow gets shorter when you raise the card because it doesn't block the light so much*".

Thus the answers to questions about shadows of rectangles are exactly similar to those obtained in §2 and 3, even though these are in positions more remote from the child's own viewpoint than were the former objects. Hence for all simple objects, the straight stick, the disc and the rectangle, it would seem that the projection can be drawn and imagined by about 8 or 9 years of age, and this corresponds fairly closely with the construction of perspectives.

Having fixed the boundaries of these stages, however, we are not in a position to go right ahead and assume that projection of more complex shapes will be mastered at the same age levels. As will be seen in the case of the single and double cones, the facts speak otherwise.

§5. *The projection of cones*

There is a distinct time lag between the child's being able to imagine the kinds of shadows cast by the simple shapes just described, and his being able to deal with those of more complex objects such as single or double cones, solid or pierced along the axis, and it is not difficult to see why this is so.

In the first place, sections of a cone cut parallel with the base are circles of varying diameter, and for some appreciable time the child tries to distinguish between shadows according to whether the base or the apex of the cone is toward the lamp. In the second place, when tilted, the cone sometimes casts an irregular shadow making it difficult

to construct mentally. As a result, the projection of these shadows is not mastered until Stage IV.

Here are some examples of Stage II (covering Substages IIA and IIB).

LIS (5; 6). "If I hold my finger near this little white wall, what will it make? —*A picture*—And if I hold this little thing (a cone) there instead of my finger? —*It will make a picture like this* (draws a triangle)—And if I put it like this (point towards the light)?—(He draws a kind of square representing the cone lying flat, considered from his own viewpoint)—Look (the light is switched on)—*A circle*—And like this (point again towards the light)?—(He draws an acute triangle)—Look (again the light is switched on)—*It makes a circle again*".

And what about this (double cone, base common)?—(He draws two points) —And lying flat?—(Same drawing, but horizontal)—Look—*A circle!*—Why? —*Don't know*—And this (pierced cone, point toward the light). Now watch what it makes (shadow produced)—*It makes a little circle and there you see a hole*—And if I turn it round this way (base toward the light)?—*It will make a big circle and a little one* (he draws them side by side)—But will the big circle be on one side, and the little circle on the other?—*Yes!*"

CHAN (6; 8). Vertical cone: draws a triangle. Lying flat (base toward the light): he draws a cone consisting of a complete circle at the base and a point placed vertically above. "Look and see whether that's right (shadow)—*No, it's a circle!*—Why?—*Don't know*—And if I turn it this way round (point toward the light)—*It will make a point* (drawn vertical)—Why?—*Because it's pointed*—Look (shadow), is it right?—*No, it's a circle!*—Like before?—*Yes* —Why?—*Don't know*—And this thing (double cone, common base)?— (Draws a rhombus)—And lying down flat?—*It would be pointed*—When I put this cone with its point toward the light, what did it make?—*A circle*— And with this one (the double cone)?—*It will make something pointed*— Watch (shadow)—*A circle!*—Why?—*I don't know*—And now, if I put this thing (double cone, point to point) there, quite straight like that, what will it make (vertical)?—*A circle*—(So he has understood nothing at all and predicts the circle simply by perseveration)—Look (shadow)—*No* (he draws it)—And if I put this thing with a hole in it (pierced cone) flat like this (point toward the light)?—*It will make a point*—Look—*Oh, no! It makes a circle with a little hole*".

FIN (7; 0). Cone lying flat: draws the shadow as a horizontal triangle. "Look—*Oh! A circle*—And with the point toward the light?—(Draws an acute angle pointing downwards)—Look—*Another circle*—And this (double cone, common base, placed horizontal)?—*It will be pointed because the thing itself is pointed*—Look—*Oh, another circle!*—And this (horizontal double cone, point to point)?—*It will make a little circle because of this* (he points to the narrow waist)—Look—*Oh no, it isn't little!*—And this thing with a hole (pierced cone, horizontal and point toward the light)?—*It might make a little circle at the back* (draws a circle topped by a point)—And if I tilt it?—*The little hole will be more that way* (higher)".

The essential nature of these reactions is obvious. First, the shadow is thought of simply as a copy of the object as it looks from the child's standpoint. Second, although asked to look at the shadow each time it

204

appears, in order to compare it with his prediction, the child is nevertheless unable to take advantage of this information. He sees quite clearly that the horizontal cone with its base toward the lamp makes a circle, but fails to draw the obvious conclusion that it will still make a circle when turned to face the other way. Even when he has actually seen this take place he does not deduce that the double cone will give the same result. Having seen this also he still fails to draw any conclusions as to what will happen with the later double cones, and so on.

Could it be maintained that all this is simply the result of his not understanding the mechanism of shadows? Such a position would not be untenable in the case of children at Substage IIA, who react in just the same way for the pencil and the disc. But the children of Substage IIB (Fin and Chan) predict a change of shape for the shadows of the pencil and disc when horizontal, although they cannot predict the shadows of conical objects. Thus it is in fact the geometrical shape which confuses them, apart from any uncertainty as to how shadows are actually produced. They simply cannot imagine the object from the point of view of the relations between light and screen. In this connection, the replies obtained at Stage III are extremely illuminating.

Here are a few examples beginning with children at Substage IIIA.

AUL (6; 8). Just like the previous children, Aul draws the shadow of the cone with base toward the light as a triangle lying on its side. "Now watch— *It isn't that, it's a circle*—Why?— . . . —And like this (point toward light)? —*It will make a circle*—Bigger or smaller?—*The same*—Why?—*Because it's always the same size*—And this (double cone, base common, horizontal)?— *Also a circle because the middle is round*—And this (pierced cone horizontal)? —(He draws a cone lying flat, with a second cone in the middle of the base) —And if it's tilted (45°)?—(He draws a horizontal acute angle having a small circle pierced by a point at the end of the upper side)—And this (double cone, point to point, horizontal)?—*It will make a circle*".

ROS (7; 6). Immediately after seeing the circular shadow of the ordinary cone lying flat he correctly predicts the shadow of the double cone with bases common. "*It will also make a circle*—Why?—*You'll see this* (the middle)— Only a circle?—(He hesitates) *A point as well, the one nearest the light*— Look—*A circle*—And this (cones, point to point, flat)?—*A circle because the part nearest the wall* (screen) *is round*".

DUM (7; 8). Horizontal cone (base toward light). "*You'll see a circle* (before any experimenting)—And like this (point nearest the light)?—*You'll see a point*—Look—*It's round, because it's round at the back* (the base)— And this (cones point to point, flat)?—*A circle*—Sure?—*Yes*—And this (cones base to base, vertical)—*It makes the same shape* (he draws the object) —And lying flat?—(Draws the same object lying flat)—Look—*It's a circle* —And the pierced cone (flat)?—*A little circle inside a big circle* (correct)— And tilted?—*You'll see nothing but a line* (a circular arc)".

MAI (8; 2). Ordinary cone, flat. "*You'll see a circle*—And like this (point towards the light)?—*You'll see a point*—Look—*It's a circle, because this*

(base) *is behind the lamp*—And this (cones, point to point, flat)?—*It's a circle, because there's a circle at the front* (nearest the light)—And this (cones, base to base, flat)?—*You'll see a circle because there's a circle there* (in the middle)—And this (pierced cone, flat)?—(Drawn correctly)—And tilted?—*There won't be a hole any more*".

BAR (9; 3). Ordinary cone, point toward the light: "*You'll see a point*—Look (shadow)—*No, it's a circle, because the edge* (the base) *is in front of the light* (i.e., it intercepts the light)—And like this (base towards the light)?—*—Also a point. Oh no! I mean a circle*—And this (cones, base to base, flat)?—*A circle, because the light goes here* (indicates direction of the rays) *and because the point is smaller than the circle* (the widest part obscures the part at the apex)".

REY (10; 2). Ordinary cone, point toward the light: "*A circle, because there's a circle there* (the base) *and there it's smaller* (the apex) *so you can only see a circle* (part obscured by the whole in projection)". The same line of reasoning is forthcoming when the base is nearest the light. For the pierced cone lying flat, Rey first draws the point with a small circle at the very tip, followed by a small circle placed inside a larger one.

FEL (10; 7) still thinks the ordinary cone lying flat "*will be pointed because it's lying down*". Later he draws it as a circle. Pierced cone lying flat: correct. Tilted: "*You can't see the hole any more because the thing is raised and it hides the circle*".

Thus throughout the entire course of Stage III there is a gradual advance towards connecting together the light—likened to a sort of observer or potential viewpoint—the object and the screen, so that the shadow comes to be regarded as the product of something which obscures the light. At the beginning of this stage we still find children expecting the shadow to resemble the object as seen from the position of the lamp (Ros, for example, thinks the cone with its apex to the light will produce a pointed shadow, and so do Dum, Mai and Bar). Besides this there still remain traces of confusion between the child's own viewpoint and one corresponding to the position occupied by the light (Aul, etc.). Later the child begins to realize that shadow is simply negation of light and that it represents a viewpoint complementary to that of the light source. From then on, his answers grow more or less correct.

Influenced by what he sees take place in the experiment he begins to realize that the endwise cone will produce a circular shadow, "because the part toward the wall is round" (Ros). Finally he starts to perform the operation which foreshadows the emergence of Stage IV. This consists of enclosing the smaller parts of the object within the larger and understanding that it is the larger parts that block the light, thus explaining the shape of the shadow. "It's a circle" says Rey "because there's a circle there, and here it's smaller, so you can only see a circle". Bar goes so far as to introduce the idea of the light rays forming a bundle of

straight lines obstructed by the largest cross-section of the object: "the light goes here, and the point is smaller than the circle".

The children described above only arrive at the correct answers through trial and error, and by the aid of the experiment itself. The children of Stage IV, however, understand right away the projective construction on which the drawing of shadows rests.

HEN (11; 0). Single and double cones: "*You'll see a circle all the time because it goes like this* (points to the tapered sides) *up to here* (largest diameter)". Pierced cone, horizontal: correct. Oblique: "*The circle will be flat* (drawn correct) *and you can't see the little hole any longer because when it's raised it gets flatter and flatter*".

MON (12; 0). Single cone, horizontal: "*It's a circle because it gets bigger and bigger, and the point is hidden by the big circle* (i.e., enclosure by increasing cross-sections)—*And this* (cones, base to base, horizontal)?—*A circle, because the points are hidden*—And this (double cones point to point)?—*It's a circle as well, because the two circles are alike and the one in front hides the one behind*". Pierced cone: draws the same figure regardless of whether the point is near or distant from the lamp.

These correct answers are arrived at somewhat later than those quoted in §2–§4 since the cone involves the enclosure of diminishing cross-sections. Consequently, they show even more clearly the type of mechanism employed in visualizing the shape of shadows.

The whole trend of this chapter has been to demonstrate that this mechanism is exactly the same as that required to imagine perspectives. In order to imagine perspectives the child must distinguish his own viewpoint from those of others and co-ordinate it with theirs. In the case of shadows, the light corresponds to the observer's viewpoint while the shadow is, in a sense, the 'negative' of this. That is, the shadow is what cannot be seen from the place where the light is, what remains dark on the screen because it is hidden by the object itself. This being so, it is hardly surprising that the stages of development for projection of shadows correspond term for term with those of direct perspective.

The simple shapes, those having the same cross-section throughout, give rise to the same process of development as perspective representation of the identical objects. The beam of straight lines connecting lamp and screen, cut by the object obstructing the light, is directly comparable to the lines connecting the eye with the object seen in perspective. In both situations the child constructs identical systems of projection and cross-section. The sole difference is that the shadow constitutes a 'negative' (to use a metaphor) in relation to the light. But, and this is the essential point, once the stage of operational co-ordination between viewpoints is reached and thought becomes reversible, the 'negative' no longer presents any greater difficulty than the 'positive'.

On the other hand, objects with varying cross-sections, such as cones,

present a further difficulty in that parts of the projection are enclosed within the area of the greatest cross-section. With the cone, the point is obscured by the base, so far as the light source is concerned, whether the cone is pointing toward or away from the light. And it is more difficult for the child to conceive of an 'enclosure' of this kind in the realm of projective shapes than in that of topological shapes for the simple reason that to do so he must carry out, at one and the same time, a series of "enclosing" operations and also consider a system of co-ordinated viewpoints distinct from the object itself. This is most probably why we have to wait until Stage IV to see this accomplished.

Chapter Eight

THE CO-ORDINATION OF PERSPECTIVES[1]

WE saw in Chapter VI that perspective appears at a relatively late stage in the child's psychological development. In this respect our experiments merely confirm what had already been demonstrated through direct observation of children's drawing. According to Luquet (op. cit.) 'intellectual realism' is not superseded by 'visual realism' until about the age of 8 or 9. Not until then does the child draw things 'as he really sees them', according to his perspective as an actual observer. Well known though this may be, it is nevertheless surprising, and for two good reasons.

First, assuming that projective relations are geometrically more complex than topological relations, and assuming that their construction requires a set of axioms equivalent to those of euclidean geometry, then in terms of psychological development one might expect the operations leading to their elaboration to appear somewhat in advance, and to be promoted by experience of perspective in visual perception. But on the contrary, what we actually find is that the order of psychological development runs concurrent with that of axiomatic, theoretical construction, perspective appearing relatively late in the child's approach to geometrical problems. It does not appear, and this is the interesting point, until he reaches the stage where he begins to form co-ordinate systems or systems of reference. Hence perspective would appear to depend upon operational concepts rather than upon familiarity born of intuition and experience.

Second, and this is even more puzzling, since the relationships inherent to perspective are already operative in the realm of direct perception they might be taken to express the child's own viewpoint in the simplest and most immediate fashion. Yet we know very well that the child's outlook is at first completely egocentric and tends to change appearances which are in fact purely relative to his own perception and activity, into false or spurious absolutes.

The question therefore arises as to why the child is so slow to master simple perspective relations and only does so when he is able to co-ordinate a number of possible points of view. The answer is that a perspective system entails his relating the object to his own viewpoint, as one of which he is fully conscious. Here as elsewhere, to become conscious of one's own viewpoint involves distinguishing it from other

[1] In collaboration with Mlle Edith Mayer.

viewpoints, and by the same token, co-ordinating it with them. Thus it is evident that the development of perspectives requires a comprehensive, global construct, one which enables objects to be linked together in a co-ordinate system, and viewpoints to be linked by projective relations corresponding to various potential observers.

The experiments performed thus far have dealt only with perspective or projection for successive positions of a single object, whether seen by the child or by an imaginary observer. We must now proceed to examine the perspective of a group of objects as envisaged by an observer from different positions, or alternatively by a number of observers. The experiments which follow have two aims. Firstly, to study the construction of a global system linking together a number of perspectives. Secondly, to examine the relationships which the child establishes between his own viewpoint and those of other observers. These experiments involve multiple perspectives of the sort which it is possible to imagine when standing before a mountain massif, or group of mountains which can be seen from various different positions.

The problem is therefore no longer one concerned simply with changes in apparent shape and size of objects, but mainly with the positions of objects relative to one another and to various observers (or the same observer in different positions). Hence we shall be concerned chiefly with the relations of before-behind, left-right, relations of within two of the three dimensions operative in imaginary perspectives.

Now although these are based on the topological relations studied in Chapter III, it is obvious that the introduction of the observer's own viewpoint serves to differentiate them from the latter. In a system of topological relations, the expressions 'to the left' or 'to the right' can only refer to alternative directions of travel along a linear series. They remain purely arbitrary so far as the viewpoint of an observer is concerned (this is well illustrated by the way in which some of the younger children reverse a series as if it were seen in a mirror). In a projective system, however, 'left' and 'right' are relative to the viewpoint of the observer, and the type of problem posed by the perspectives of a group of mountains involves several objects and several observers at the same time. It will be seen to depend, therefore, on a global projective system directly comparable to the type of co-ordinate system required in constructing maps or plans in the realm of euclidean geometry and which are dealt with in Chapters XIII and XIV.

§1. *Technique and general results*

A pasteboard model, one metre square and from twelve to thirty centimetres high, was made to represent three mountains (see Fig. 21). From his initial position in front of the model (A) the child sees a

green mountain occupying the foreground a little to his right. The summit of this mountain is topped by a little house. To his left he sees a brown mountain, higher than the green one and slightly to its rear. This mountain is distinguished not only by its colour but also by having a red cross at the summit. In the background stands the highest of the three mountains, a grey pyramid whose peak is covered in snow. From position C (opposite position A) a zigzag path can be seen running down the side of the green mountain, while from position B (to the right of the model, relative to position A) a little rivulet is seen to descend the brown mountain. Each moun-

tain is painted in a single col-
our, except for the snow cap
of the grey mountain, and the
only reference points are those
described.

The children are also shown
a collection of ten pictures,
measuring 20×28 cm. These
represent the mountains seen
from different viewpoints and
are painted in the same col-
ours as the model. They are
clearly distinguishable and are
large enough for particular
features such as the cross, the
house and the snow-capped
peak to be easily visible. The
children are also given three
pieces of cardboard, shaped
and coloured the same as each
of the mountains, and these
may be arranged to represent
the mountains as seen in a
given perspective.

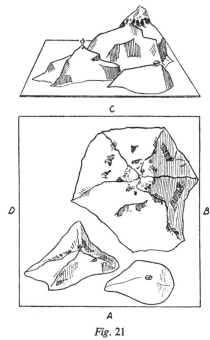

Fig. 21
The Three Mountains.

Finally, the apparatus in-
cludes a wooden doll 2 or 3 cm. in height. The head of the doll is a plain wooden ball with no face painted on it so that the child can ignore the doll's line of sight and need only consider its position. This doll is put in a number of different places and the child's task is to discover what perspective the doll will 'see' in each of the different positions. It is not the child who moves around the group of mountains —except to check his answers—but the doll which is supposed to be doing the travelling. The child has the problem of trying to imagine, and to reconstruct by a process of inference, the changes in perspective that

211

will accompany the doll's movements, or the different positions which the doll must occupy to suit the various perspectives.

For this purpose we employed three separate but complementary methods of questioning the child. Firstly, the child is given the three pieces of shaped cardboard and asked to reconstruct the kind of 'snapshot' which could be taken of the group of mountains from position A, laying the pieces in appropriate positions on the table. Next, the doll is put at position C and the child asked to make the kind of picture which the doll, or he himself, could take from that position. This procedure is repeated for positions B and D. After this the child is told to sit at B (or C or D) and asked to show with the pieces of cardboard, the picture he could take from there. He is also asked to reconstruct the picture he has already made from A or other positions he has occupied previously. With older children it is of course possible to arrange the doll in more complicated positions in order to differentiate the perspectives more clearly. Conversely, with the younger children, the emphasis is laid more on the child's own changes of position and on the co-ordination of his own changing perspectives.

In the second type of experiment we no longer ask the child to construct imaginary snapshots of the mountains, but show him the set of pictures, asking him to pick out the one which is most suited to the view seen by the doll. As a rule, all the ten pictures are shown at the same time, though naturally the questions only deal with four or five positions to avoid boredom and routine answers.

The third experiment is the converse of the second. Instead of trying to find the picture which corresponds to the position of the doll, the child selects one of the pictures and then decides what position the doll would have to occupy to take a snapshot similar to it.

These experiments were carried out on a hundred children, 21 between 4 and 6; 6 years, 30 between 6; 7 and 8 years, 33 between 8 and 9; 6 years, and 16 between 9; 6 and 12 years. The results may be classified as follows, stages of development being the same as those of previous chapters.[1]

Throughout Stage II the child distinguishes hardly or not at all between his own viewpoint and that of other observers (represented by the doll in different positions). At Substage IIA Method (1) for instance, each time the doll is moved the child makes a new picture with his bits of cardboard as if to reproduce the observer's point of view. Nevertheless, when examined, each of these pictures turns out to be the same. They all show the mountains from a single point of view, that of the child himself. During Substage IIB the child shows some attempt at

[1] Children of Stage I do not understand the meaning of such questions, so that it is pointless to attempt any consistent studies with them or report the sort of answers they give.

discrimination but usually relapses into the egocentric constructions of Substage IIA.

Throughout Substage IIA Method (2) also results in the choice of a picture corresponding to the child's own viewpoint, or else in a random choice indicating that, so far as the child is concerned, all the pictures are equally suitable for all points of view, so long as they show Three mountains. Conversely, Method (3) shows a complete lack of discrimination between different positions of the doll in relation to the different pictures. The doll is placed anywhere at random or simply left in the same place all the time, because the child thinks the doll can see the three mountains from any position, regardless of perspective. During Substage IIB, Methods (2) and (3) reveal the child engaged in an attempt to separate the various points of view. But, as he fails to relate the relevant factors in the correct way his efforts are doomed to failure.

Stage III, on the other hand (7–8 to 11–12 years), shows a progressive discrimination and co-ordination of perspectives. At Substage IIIA (averaging 7–8 to 9 years) certain relationships are varied with changes in the position of the observer, but there is still no comprehensive co-ordination of viewpoints. This is not achieved until Substage IIIB (about 9–10 years), at which point the mastery of simple perspective is complete (as has already been seen) and perspective has begun to appear in drawing.

§2. *Substage IIA. The child confined to reproducing his own point of view*

It will be recalled from Chapter VI, that when trying to forecast the appearance of objects at different orientations, the children of Substage IIA were quite unable to anticipate changes of apparent shape and seemed to accept the object as a permanent and immutable thing in itself, ignoring their own point of view. But when a number of objects are involved, as in the case of the group of mountains, it is found that the child fails to realize that different observers will enjoy different perspectives and seems to regard his own point of view as the only one possible.

Admittedly, this contradiction is no more than apparent and one can immediately detect the kinship between the 'false-absolute' object of the earlier experiment, which failed to respond to any change of apparent shape, and the predominance of the child's own viewpoint as evidenced here with the group of mountains. However, it is worth examining closely the child's reactions to this new problem, since they throw light on the overall co-ordination of the projective relationships which have so far had to be studied in isolation.

Method 1. Asked to make a picture of what the observer (the doll)

can see from a particular position, the child confines himself to reproducing with his pieces of card, what he sees from his own position.

Luc (6; 3) is seated at A and constructs an exact reproduction of what he can see, placing the green card on the right, the brown on the left and the grey in the centre, its lower edges being hidden by the green and brown mountains as in the original. The doll is now placed opposite the child at C and he is asked to reproduce what the doll will see (the existing reproduction being moved far enough away for him not to keep looking at it). Luc takes the brown card and brings it close to the brown mountain as if to help himself think, then puts it down in front of it. He next takes the grey card and moves it about slowly, looking at the mountains the while. Then he puts it down under the brown card so that part is hidden, with its apex to the right of the brown card. Finally he places the green card partly in front of the grey one but somewhat to the right of it, thus reproducing exactly the previous construction (Position A, his own).

"Tell me what you've done. Which is that photo there (his first construction)?—*That's when you're here* (position A)—And that one (the second)?—*That's when the little man is over there* (at C). *When he is here* (at A) *we have the green, then the brown and then the grey, and that's when he's over there* (C) *and we have the brown and the green and the grey*—Are the mountains really arranged as he sees them from there?—*Yes, it's right*".

The doll is put at B, to the right of the table; Luc dismantles his previous productions and replaces the green mountain on the right, the brown on the left and the grey in the middle, set back a little, thus reproducing not B but perspective A once more. He is then asked to seat himself at B to check his model. In the correct fashion he puts the grey mountain on the right, the green on the left and the brown in the centre and in the background. "Can you remember what you saw from here (position A)?—*Yes*—Was it the same?—*No*—Try to copy it—(He thinks, looking up at the ceiling, and produces the original model without looking at the mountains. He is thus working purely from memory)—Very good. Now show me the kind of photo the little man could take from there (position C)". Luc now proceeds to place the grey card on the right, the green on the left, the brown in the centre, partly hidden by the other two. He has thus produced the perspective corresponding precisely with the position he actually occupies (B) and not with perspective C at all! Repeated with the doll at D (opposite B) the resulting construction again corresponds with B while Luc firmly believes he is reproducing a picture taken from D!

Zan (6; 6) is seated at A and arranges the cards correctly, the green on the right, brown on the left and grey in between, partly screened to show that it is in the background. The doll is put at B (to the right of A). Zan hesitates and considers; then he puts the green card in front of him, thinks again and puts the brown on the left and the grey behind the others and in between them, amounting in all to a reproduction of perspective A. "Is that right?—*Yes*—Completely right?—*Yes*—Would your photo look like that if you were sitting here yourself (at B)?—*I don't know, I don't think so. It's the first time I've done this*—Well then, go over there and take a good look". Once

seated at B, Zan arranges the cards correctly, the green on the left, the grey on the right and the brown between and behind them. He is also able to reconstruct the view from A by memory. But to construct the perspective from D (opposite B) Zan places the grey on the right, the green on the left and the brown in the middle, as if D were the same as B where he himself is sitting. Similarly, for perspective C (to the right of B) he also produces the same view as from B. "Is it really quite right like that (suggestion)?—*No, I don't think so. I'll try to arrange them properly*". Zan takes his picture to pieces and starts again, looking very attentively at the model each time he puts one of his pieces in place, even getting up to check the doll's position. In this fashion he places the grey card on the right, the green on the left and the brown in the middle and exclaims (without realizing that the result is just the same as before), "*Now it's right!*" Zan is now told to stand at C and check his model. He pulls it to pieces and starts to remake it from memory which brings him once again to view B! Following this he succeeds in making the necessary corrections. But when asked to reconstruct the view from B (which he has just left), then from D, etc., Zan confines himself simply to what he can see directly and thus ends up with the view from C! When asked: "Is that right or should anything be altered?" he takes it all apart, starts again and relapses into his newly acquired schema (i.e., that of view C, although he has been through all the other positions). "Is what you see from there (B) different, or is it the same as what you see from where you are now (C)?—*It's the same* —Can you take the same picture from anywhere, there, there or there, etc? —*No*—(He takes it apart, then rebuilds the view from C)—Where was this picture taken from?—*From the other side* (He points to A)".

We particularly wanted to present these two examples in detail since they are good illustrations of the kind of reaction obtained at this stage by means of Method (1). Instead of constructing the perspective corresponding to the different positions, the child considers his present point of view the only possible one and is unable to deduce from it the transformations produced by a change of position. It is true that one can ask oneself whether or not he has understood the nature of the problem or whether he is not concentrating his efforts on making an exact copy of the complete group of mountains, in which case all his copies are likely to be the same. But after seeing the care with which he works, gets up to check the doll's position (Zan), hesitates at each new position before making up his mind, and in particular, how he continues with the same methods after having himself changed positions, one cannot but be convinced that he has understood the meaning of the question. On the other hand, it is necessary to discover how satisfied he is with his reproductions, since it is evident that Zan, for example, has momentary doubts about their correctness, even though he afterwards begins again in exactly the same fashion.

In trying to account for any illusion which occurs consistently in the child's conception of space it is very natural to hesitate over assigning it a definite status among the numerous levels which range right

from simple perception to abstract thought. For instance, when a 7–8 month baby is given his feeding bottle back to front and starts sucking the wrong end without being able to turn the bottle round, it is certainly an error of perception or 'perceptual activity' (see Chapter I §2.). In the absence of shape constancy the baby cannot fit his momentary perception into any organized schema of rotatory movements (or vice-versa, since the schemata of constant shape and rotatory movement are mutually supporting[1]). In contrast to this we can instance the children taking part in the present experiment. At Substage IIB we find them trying to reverse the appearance of the whole group of mountains by rotating each mountain individually, taking no account of background and foreground. Here, of course, we are much closer to an error of reasoning.

Now in the present case there are a number of indications which suggest that at Substage IIA the child is already perfectly well aware that the appearance of the group of mountains changes together with the observer's point of view. This is what might be expected considering that from their second year babies are perfectly capable of turning things round to co-ordinate the different perspectives, or if the object cannot be moved, turning their heads or their entire persons. Admittedly, this is only a matter of successive perceptions and not yet a series of visual images as in reconstructing or anticipating a situation.

Indeed, no sooner is imagination involved—as in the case of real mountains seen too close to be viewed by different perspectives in a short space of time—than the former difficulties arising from shape constancy and co-ordination of viewpoints immediately reappear.

To give an example. A boy of 4½ years is taken to see the Great Salève[2] from a spot only an hour's journey from his home. He seemed to have the impression that the mountain had undergone a change in real shape rather than a change of perspective (disappearance of the Little Salève, etc.), similar to the change of shape in the case of the feeding bottle given to the 7-month baby (disappearance of the rubber teat, etc.). In the case of the boy looking at the Salève, he was not expecting to see a change of apparent shape as a result of changing his viewpoint. Nevertheless, his discovery of such a change, though interpreted as a change in real shape, must have forced him to realize that mountains look different from different places.

Thus, when the child looks at the group of mountains in our experiment, which are far nearer the size of objects that can be handled than that of real mountains, he has even less reason for doubting that what he sees will change as he changes his position. In consequence, he is not

[1] See *The Child's Conception of Reality*, obs. 78, 1955.

[2] Fr. Text, 278. See op. cit., *Play, Dreams and Imitation in Childhood*, 1952.

NOTE.—The Great and Little Salève are two mountains close outside Geneva (Tr.).

in the least surprised to find that in moving from position A to position C opposite, he has to make a new picture quite different from the previous one. Zan even goes so far as to state explicitly that one cannot make a single picture suited to every position, especially, he says, for one side and "the opposite side". What is more, once the child has changed positions he can usually reconstruct his previous perspective from memory, even while he makes the new arrangement with his cards. He is therefore quite capable of imagining how the mountains look from two different viewpoints seen successively in the actual course of the experiment. Why then does he remain unable to imagine possible alternative viewpoints and stubbornly continue to copy his present perspective? This is really the question, and the answer to it must obviously be sought for in some sort of 'non-constancy' of shape for the group of mountains, though naturally, of an imaginal or representational character, a phenomenon intermediate between perception and thought.

When the child moves from position A to position B and, by means of his pieces of card, reproduces his present view together with his previous one, he is simply co-ordinating a perceptual notion (the view from B) with an imaginal one (the memory of the view from A). But if asked while sitting at A, to predict what he would see from B, C, or D, he has to deduce or imagine in anticipation some virtual perception not actually experienced but referred to another observer. Although reasoning plays some part in this process, whereas it is involved to a lesser degree in reconstructing a previously perceived scene and not at all in a baby's perception, what really occurs is a phenomenon comparable to the non-constancy of shapes during the child's first year.

In the case of the baby who could not find the teat of his feeding bottle, perception is not 'decentrated' towards virtual rotations of the object but remains centred on it as it appears just at that moment. In a similar way, the 4–7 year old child who gazes at the group of mountains, unable to conceive of any perspective but his own, reveals a type of spatial imagination which is likewise not yet decentrated as regards changes of position, but remains centred on a position (or previously experienced positions) corresponding with his present viewpoint.

This egocentrism in drawing or imagination is a carry-over from the egocentrism characteristic of early perception. The transition between the two is illustrated perfectly by the child of nearly 4 (Stage I) who grants constancy of shape to a small, easily handled object but cannot yet extend it to cover a real, full-size mountain like the Salève, simply because such perspectives cannot be co-ordinated through a rapid succession of images but only by way of being represented in thought.

Let us now turn to our experimental model of the mountains. By

the end of his first year the child has already arrived at constancy of shape for small objects. By the end of his third year (during Stage I) he has achieved some sort of representational constancy for large objects such as buildings, mountains, and so on. But he is still unable as yet to apply it to a number of objects linked together in a single whole such as a group of mountains. Unlike the younger children, he knows full well that a mountain does not change its real shape when he walks round it and he rightly ascribes its apparent changes of shape to his changed point of view. At the same time, he cannot form a comprehensive mental picture detailed enough to enable him to think out the transformations in terms of virtual perspectives; in other words, by means of deductive centration, or grouping the relationships arrived at in the course of the experiment. Unable to develop such a dynamic, mobile concept, the child merely substitutes his immediate perceptual data for the shape constancy of the group, thus elevating it to the status of an absolute. This is quite understandable, since shape constancy for a group of objects is neither more nor less than a system of invariant correspondences holding between a number of changing relationships and requires a higher degree of decentration than constancy of a single object, whilst the false-absolute produced by the child's spatial ego-centrism is simply the result of his being centred exclusively on his own viewpoint, both in perception and imagination.

To sum up, it is the egocentric illusion which prevents these children from reversing the left-right, before-behind relations and thereby rotating the perspectives along with their changing viewpoints, a continuation of the illusion which is responsible for absence of shape constancy in the young baby's perception. The same phenomenon is again apparent with the 4–5 year old children of Stage I who as a result of centration, both in perception and imagination, are unable to extend shape constancy to larger objects.

Method 2. The use of ready-made pictures representing the various possible perspectives enables us to check and clarify the previous results, because with this method the child has merely to choose from existing models instead of having to make them for himself. In the event, children of this level are found either to choose the picture identical with their own point of view, or to choose one that shows everything that can be seen from this position.

Here are some examples of the first type of response.

ZAN (6; 6), whose answers to the previous questions are given above, is now seated again at A and asked to select from among ten pictures, one corresponding to a position near D (grey mountain on the left, brown on the right, green in the centre background). He searches for the right one, eventually choosing pictures I (position A: green right, brown left, grey centre) and VIII (somewhat to the left of A but very similar in appearance). "Why do you

choose these two?—*I saw they were both the same because the grey one is at the back and the other two in front*". The doll is then placed at B (from left to right: green, brown, grey). Again Zan picks out the picture corresponding to his own position and says, "*It's this one because the green one is here* (points to his right) *and so is the little man* (points to the doll, also on his right)".

GIL (7; 4) is seated at A (brown, grey, green) and the doll placed at B (green, brown, grey). He chooses picture I (=A) and says, "*It's because there he is taking* (photographing) *the mountains*". He then lays aside picture IV (grey left, brown right, green not visible) saying, "*This way he can't see the green one; he'll have to turn round* (he is thus assuming that in this picture the man must have his back to the green mountain and does not realize that it may be hidden by the brown one)". He then picks up picture I again and remarks, "*This one will do; here you've got the three mountains, he can see them all*". The doll is then moved to correspond with picture IV. Gil (still at A) says immediately, "*From there he can get the grey one, the green one and the brown, all three of them*". He thereupon chooses pictures I (=A; brown, grey, green), VII (=D; grey, brown, green) and IX (grey, green, brown) and discards the rest, observing, "*He must have all three*—But which of the ones you've chosen would suit him best?—*That one* (I—his own point of view), *it's the best all right, because it's got all three mountains*—And how many are there in the others (VII and IX)?—*Three as well, but that one is the best of all because he is in between there* (points to the doll between the grey and the brown)—But from where he is, can he really take that picture?—*Yes, he can, though he can't see much of the green one. That one's* (IX) *probably better; there is a bit of the green one in it*".

FER (8; 2). The doll is placed to see the grey mountain to the left, the brown to the right and the peak of the green centre background. Fer, seated at A, chooses three pictures each showing three mountains. "Which of these three pictures is the right one?—*That* (I=A) *is the right one; he sees the three mountains just as they are* (!)".

SEL (7; 7). For the same position of the doll, he too chooses two pictures including I (= his own position). "Which is the right one?—*That one* (I) *because the little man is opposite* (actually he is near D!). *It's the nearest one because the mountains are more like they are from here*".

Now for a couple of examples of the second type.

REN (7; 6) is at A and the doll at B (to the right of the model). Of each picture in turn he says, "*It's right; he takes the grey one and the green one*", then (picture I) "*He can take that one as well, he gets the green one and the brown one; it's got all the three, the brown, the green and the grey*", etc., etc. In the end he expresses a preference for those pictures which include all three mountains.

TEA (8; 1) also chooses a series of pictures for each position, one after another while saying, "*He can take all three*". Finally he is asked which picture is most correct. Running over the ones he has picked out (he has already eliminated those showing only two mountains) he once again says, "*This one will do just as well because it's got all three*".

The egocentric illusion, or the child's centring his perception on his

219

own viewpoint, is therefore just as much in evidence when he is confronted with ready-made pictures as when he makes the perspective with his three pieces of cardboard. The children belonging to both groups from which we drew our examples all really imagine that the doll's perspective is the same as their own, they all think the little man sees the mountains in the way they appear from where they themselves sit. In the first type of reaction this confusion has a restricting influence and the doll is presumed to see the mountains only as they look from the child's position. The second type of reaction exhibits the same confusion in a more diffuse form, one that encourages the child to believe the doll can enjoy any and every view of the group whatever its position, so long as this view includes all the items the child can himself see.

Now although the disparity between the two types of reaction must be regarded as more apparent than real, if one accepts the argument which has gone before, it nevertheless provides a useful adjunct to our remarks on Method 1, as regards the pseudo-constancy or false-absolute that results from the child centring exclusively on his own point of view.

It will be remembered that at the level where he tends to make every perspective a facsimile of his own momentary viewpoint, the child also shows himself unable to draw things according to the laws of perspective ('visual realism') but gives them an invariant shape, topological rather than euclidean ('intellectual realism'). Thus it is not until he begins to be able to distinguish between other perspectives and his own that he becomes conscious of his own viewpoint as a particular one and is able to indicate it by means of relationships which are specifically projective (an explicit rendering of perspective).

In the experiments using Method 1, it was precisely this unconscious egocentrism, this failure to distinguish between different viewpoints which seemed to explain why the child endows the group of mountains with a spurious type of shape constancy rather than a constancy of projective correspondences between changing relationships, and in this respect the answers just quoted from the experiments using Method 2 are extremely apposite. In the first place, the children who invariably choose Picture I fail to realize that what they are expressing is actually their own viewpoint. "That's the best one," says Fer, "he sees all three just as they really are!". To see the mountains just as they really are—meaning, to see them as one sees them oneself. The phrase illustrates perfectly both the unconscious character of the child's intellectual egocentrism (an expression we must apologize for having dwelt on for the last twenty-five years!), and the nature of that spurious type of shape constancy presented by the general layout of the mountains when their perspectives have not yet been 'grouped' and are consequently

reduced to no more than the child's own perspective. In the same way, Sel chooses Picture I also, since "it has all three and he is right opposite" and "because the mountains are more like they are from here". Further-more, Gil, like the children who gave the second type of answer, lays down the proviso that "all three must be there" without realizing that this entails seeing the mountains as he sees them himself.

Although they may appear to comprehend a variety of perspectives, the children giving the second answer are in fact confusing their own perspectives with those of other observers just as much as the children giving the first type answer. Except that instead of noting the left-right, before-behind relationships but regarding them as fixed, as did the former children, they merely insist on all the items being present, as in the 'intellectual realist' stage of drawing. Hence their indifference to which picture is chosen does not imply any understanding of the changes which occur in these relations (left-right, before-behind) according to the laws of perspective, it only means that these children do not think about them at all.

In fine, whether the children regard these relations as fixed and reduce them to the pattern of their own perspective, or whether they ignore them entirely, the answers obtained by means of the comparison pictures fully corroborate the results obtained from the study of the children's own constructions (Method 1). Unconsciously, they liken every perspective to their own, though even this perspective is not differentiated in terms of projective relationships, either stated explicitly or implicitly sought after.

Method 3. What will be the child's response to the question which is the converse of the previous one; namely, given a picture, find the relevant position of the doll? The results of such a study are in complete conformity with those already obtained. The child rests content with bringing the doll close to the main elements shown in the picture, but instead of putting it where it could see them from the outside and cor-responding to some perspective, he simply puts it down among the mountains shown in the picture, in the perspective as he, not the doll, sees it.

Luc (6; 3). His reactions to Method 1 were described above. He is now asked to locate the doll in such a position as to enable it to "take the picture" (IX: brown right, grey left and green centre). Luc at first moves the doll over the green mountain, then the brown and finally the grey one, as if he were trying to put it successively on each of the elements shown in the picture. "But where should we put the little man so that he can take a photo looking like this? *There* (just the foot of the brown and green mountains, a spot from which the grey one cannot be seen) *so that he can see all the mountains*". Several pictures displayed in succession all produce the same response expressed in similar terms, and then for Picture 1, which corresponds to

Luc's own position, the doll is put in the centre of the group between all three mountains!

ORG (7; 6). For Picture IX (cf. Luc) Org puts the doll, "*in the middle—And to take this photo* (I=his own point of view)?—*Also in the middle—Will the picture he takes from there be the same as this one?—No, he'll have to turn around* (he turns the doll round as if to show it each of the mountains). *Now his picture will be right*".

VON (8; 0) puts the doll at the foot of the brown mountain and to the left of the green one in order to produce the same picture (IX). "Why?—*Because that's facing all three*—And for this Picture (I)?—*The same again*—You have to stand at the same place to take both pictures?—*Yes, it's the same*—If you take a photo or make a drawing from two different places will you see the same thing?—*Yes*", etc. "And to take a photo as nearly like that one (Picture IX) as possible, where ought you to stand?—*Here* (position A=his own)—Why?—*To get all three*".

MAR (8; 9, backward) responds in similar fashion and ends up by putting the little man in his own position "*because he will be able to see the three mountains best from here*".

There is no need to embark upon a lengthy disquisition in order to demonstrate the manifest analogy between these answers and those already reported. The child is in no doubt whatsoever about what he has to do and clearly endeavours to make the doll "see" the mountains as they appear in the picture. Unfortunately, he completely fails to grasp the fact that a particular position imposes a limitation on what will actually be seen, that it corresponds to a given perspective.

Instead, he imagines that he sees the entire group of mountains "as it really is", in some way which is common to any and every perspective. As a consequence, no matter what picture he is shown he reacts in only two ways, which can in fact be reduced to one.

The first is similar to the one with which we are already familiar, and consists of putting the doll in a position adjacent to his own. "He can see them best from here", says Mar; or as Luc remarks, "He sees the whole of the mountains, all the three"; or in the words of Von "Because that's facing all three". The second reaction is to put the doll plumb in the middle of all that is to be shown in the picture, either at the foot of a mountain or in between two or three. In this case the child locates the doll actually within the perspective in which he himself sees the items shown in the picture. Of course, there are some cases, similar to the second type reaction seen with Method 2, where the doll is set down at random as if the observer's position had no bearing on the perspective of what he sees. However, there is no need to revert to this point.

The present results are in evident agreement with those obtained by the other two methods. They contain, however, one fresh piece of evidence which will help to round off our description of the pseudo-

shape constancy that is characteristic of this non-perspective system. When Luc moves the doll about among the mountains, or when Von puts it at the foot of one of them; in general, when the children set the doll in the midst of the group or as close to the mountains as possible, they behave as if they did not consider the different positions mutually exclusive and representing distinct perspectives. Rather do they appear to consider them as separate parts of one and the same whole, like sectional photographs that fit together to form a panorama. Built up in this manner, the whole is imagined as presenting a more or less unchanging appearance and this does not clash with what is seen from one or another viewpoint because any such differences are regarded simply as the outcome of laying stress on particular aspects rather than different perspectives involving a reversal of relations of order. This interpretation is rendered all the more probable by the fact that it applies equally well to the drawings which children at this level produce of their own accord. Thus, what Luquet has termed a "medley of viewpoints" consists precisely of a juxtaposition of items belonging to different points of view, all shown in one and the same picture.

§3. *Substage IIB. Transitional reactions. Attempts to distinguish between different viewpoints*

In order to understand the mechanism by which perspectives are co-ordinated and projective relationships transformed so that one perspective may be made to correspond with another, nothing is more instructive than to follow the child's progress step by step as he attempts to distinguish between different points of view. In this connection, Substage IIB is especially interesting. The child senses that some of the relations are relative to others, that they vary according to the particular point of view, but he immediately stabilizes these nascent relations in the form of 'false-absolutes' or 'pre-concepts' midway between the pseudo-constancy of Substage IIA and the reciprocal constancy of Stage III.

Method 1. Instead of reproducing their own viewpoint with their pieces of cardboard, like the children of Substage IIA, the subjects belonging to this level attempt to break free of it. But their efforts remain unsuccessful and result only in the construction of one single pattern, though this occasionally comes near the doll's point of view. Sometimes the positions of individual mountains are reversed, though never that of the structure as a whole. Lastly, the child occasionally produces a picture which is an exact copy of what he himself sees, as at Substage IIA, though turning each piece of card toward the doll before deciding on its eventual position.

OL (6; 10) is seated at A (from left to right: brown; grey, green and the doll is placed at B (green, brown, grey). Ol takes the grey card and at the same time

looks at the doll which is at the foot of the grey mountain. He then partly obscures the grey card with the green by placing the latter to the right of the former (corresponding to his own and not the doll's point of view). This done, he covers the left side of the grey card with the brown. The result is a picture corresponding exactly to the viewpoint A, though Ol has been careful to arrange things so that the right-hand edge of his picture is at the right-hand edge of the board on which it lies. That is, in the direction of the doll, as if moving the structure A towards B was sufficient to alter it to the pattern which corresponds to that point of view.

Similarly, when the doll is put at the foot of the brown mountain (toward D), but so arranged that only the brown to the right and the green to the left are visible, the grey mountain being hidden by the brown, Ol puts the brown and green cards on the corner of his work-board nearest the doll and keeps the grey card in his hand. But instead of leaving them like this he eventually decides to put his grey in between the brown and green, which once more results in the arrangement corresponding to A, only rotated through 90°. With the doll near C (green, grey, brown) Ol unhesitatingly places the three cards to suit his own viewpoint A (brown, grey, green). Then, keeping the cards in the same order he slides them over the board to the corner nearest the doll. Finally, for D (grey, green, brown) he once more constructs the pattern for A and then rotates it through 90° so as to bring it alongside the left-hand side of the board, the one nearest side D of the model.

RAC (6; 7) is seated at A and asked to make the view seen from B (on the right of A). He takes the grey card, places it on the board and turns it toward B, then he adds the brown card, placing it to the left of the grey (though not behind it as he should have done) also turned toward B. Finally he takes the green card and puts it on the right of the others (as seen from A) but turns it through 90°. Thus, the cards appear to be arranged so that an observer at B could see the perspective of A!

AN (7; 0) constructs perspective A sitting at A and C sitting at C. He is also able to make A from memory when sitting at C. Still seated at C he is asked to construct the picture that would be seen from B and answers, "*It will be the same* (as A)" and then starts to arrange the cards in order of brown, grey, green. The child is now seated at B to correct his picture and the experimenter sits down at D (opposite): "Guess what it looks like to me". An, stationed at B, arranges the cards as if he were copying perspective B. But instead of leaving them on the board with the bases nearest to him, he inverts the lot so that their bases are facing D, though without changing the order. In this way he imagines that the experimenter at D can see the group turned round. In actuality, the order seen from B is green, brown, grey; and from D, grey, green and brown.

WAN (8; 3) is seated at A and tries to build the picture seen from C. He puts the grey card on the right, the green in the middle and the brown on the left. After this he hesitates, picks up the green one again and puts it on the right of the grey, thus forming his own perspective A. He next tries to make perspective D (grey, green, brown) and remarks, "*the brown one will go first*" showing a clear grasp of the foreground of D. After this promising opening, however, he once more proceeds to build perspective A, but with all three

cards pushed to the side of the board nearest D. Following this he is seated at D and asked to build the view seen from C. He turns the bases of the cards towards C, their apexes pointing towards D, but the actual arrangement of left-right, before-behind is that corresponding to position D where he himself is seated! The same thing happens when, still seated at D, Wan tries to construct the perspective of A. He again puts the grey on the left, the green to the right and higher up, the brown on the right and at the bottom (thus reproducing the view from D), but turning the cards to make the bases face A and the apexes face C.

This initial attempt to vary the relative positions of items is extremely interesting since it is transitional between the spatial egocentrism of Substage IIA and the first signs of true relativity which appear at Substage IIIA. Of course, the child does not alter the relations between the mountains in terms of the observer's point of view, but only the relations between the observer and the group of mountains as a whole, regarded as a fixed arrangement. Thus the observer is imagined as seeing always the same picture so far as concerns the internal relations of left-right, before-behind, and the picture is merely turned to face another way to suit the changed viewpoint or new orientation. In other words, the picture somehow or other turns itself round in the direction of the observer without changing its pattern or internal arrangement!

The fact that all the children without exception tend simply to reproduce their own point of view, no matter what the perspective, is a clear sign that they remain tied to a single "false-absolute" viewpoint. And, it should be noted, not only at the beginning of the experiment but right to the end, they are quite satisfied with their performance and fully believe they have reproduced the viewpoint of the observer. Obviously, if the brown mountain appears on the left and the green on the right when seen from A, then they will appear in reverse order from C. But at the present stage the child understands this fact no better than he did at the previous one. And he is equally at a loss to grasp the fact that if the grey mountain appears in the background from A, then it will occupy the foreground when viewed from C.

The relationships of left-right, before-behind are therefore not yet real to the child. That is to say, they are not yet subject to changes of sequence and reversals dependent upon the observer's position. They are still immutable, intrinsic properties of the group of mountains which define once and for all the pattern of the group as a whole.

The child has not yet begun to think in terms of 'groupings' of projective relations and correspondences, to discern the invariance of the correspondences amid the endless transformations of the projective relationships. Instead, he fixes upon some kind of rigid, ideal picture. It is this picture alone, treated as a solid, immutable bloc, which he envisages as capable of being turned in various directions.

225

The resulting phenomenon is therefore similar to the one met with in connection with what were termed 'rigid series' when investigating the relationships of order.[1] There, children at the same stage of development were unable to split up a series and reproduce it starting with an intermediate term, but could only copy it en bloc. In the present experiment they likewise regard the relationships belonging to a perspective viewpoint as inseparable from one another, despite changes in this viewpoint, though at the same time making some attempt to distinguish them.

At this point may be seen the first tentative efforts to discriminate between different perspectives. These isolated signs of an approach to relativity presage the appearance of Stage III. Although he still regards the appearance of the group of mountains as fixed and unalterable, as something to be assimilated to a specific, concrete image, the child is already aware that other observers will experience an image different from his own, though resembling it. But to indicate this distinction he is content to move or turn the picture in their direction to enable them to see it head on, though not varying its content in any way. Thus, all observers are assumed to see the mountains looking the same as they do to the child, but from their own viewpoints. This is indeed a start to relative discrimination of viewpoints, but one which in no way impairs the immutability of the egocentric viewpoint!

Hence it comes about that Ol, trying to make the perspective of B while sitting at A, makes a picture that corresponds to A but arranges the cards pointing toward the doll and then repeats the process for all positions. The same thing may be seen with Wan, etc. Rac, An and Wan arrange the cards to suit first their own perspective and then turn each card separately toward the observer so that the base of each card is nearest him, irrespective of whether he is on the left, the right, or directly opposite, and consequently regardless of whether or not his position is symmetrical with the child's. In this way the relationships between the mountains are preserved unaltered instead of being reversed (or are only reversed by accident) although the direction of each piece of card is altered.

Thus at this stage, relativity is only partially attained, it remains global in character and is not analysed in detail. It covers only the relations between the entire group of objects and the subject and does not deal with relations between each of the single objects and the subject. Since the relationships are not 'grouped' we have here only a 'preconcept', for a perceptual or mental relationship can only be regarded as a concept from the point when it can be co-ordinated with others in an overall grouping or group which combines the invariance of certain

[1] See op. cit:, *Les Notions de Mouvement et de Vitesse chez l'Enfant*, Chapter II, and in the present work, Chapter III.

relations (in this case, the correspondence between viewpoints) with the variability of others (the relations of left-right, before-behind, and also distance and apparent shape).

Method 2. Method 2 enables us to examine more closely the details of these problems and the difficulties of 'grouping' since it offers more opportunity to compare a large number of relationships with the ready-made pictures.

FUL (6; 10) is at A (left to right: brown, grey, green) and the doll near D (grey, green, brown). Seen from A the most striking feature of the doll's position is that it is close to the grey mountain. Ful, therefore, chooses a picture with the grey mountain in the foreground but to the right, with the green to the left and the brown hidden by the green. "Why that one?—*It will do; the grey one's in front. He's right near the grey one. He sees it first and here it's first as well*". He rejects a picture showing the grey mountain on the left and the brown on the right (as at D) saying, "*the brown one is first; that won't do*". ("To be first" must therefore mean "to be on the right"). Ful chooses next a picture showing (from left to right) green, brown, grey, on the grounds that "*it's all right, the grey one is first* (= on the right)" and eventually rejects the picture which really suits because "*it won't do, the grey one isn't first; it's the other way round*". In other words, the picture is rejected because the grey one is on the left whereas from Ful's position it is on the right of the doll.

JOS (6; 9) is seated at A (brown, grey, green) and the doll is to his right at B (green, brown, grey). Jos chooses the picture corresponding to D (opposite B; grey, green behind, brown) and says "*That's the same thing . . . the little man is behind the green one*", which corresponds to the doll's position as seen from A and not to the actual position of the doll. Jos also accepts the picture corresponding to A ("*that's all right too*") but rejects the rest. When asked to decide between the two pictures he has chosen he eventually settles on the first "*because the green one is behind*".

GIS (7; 7) is at A and the doll in front of him but in the centre of the mountains between the brown and green ones. He then selects the picture corresponding to D (grey, green, brown) and to justify his choice makes a circular movement with his hand all around the mountains, saying, "*It's like this one*". He chose this picture, in fact, because the brown mountain is in the foreground and the doll seems closer to the foot of this one than the other two (when seen from A).

ELI (7; 11) is at A and the doll at B (green, brown, grey): he chooses the picture corresponding to D (grey, green, brown) and says "*I think that's the right one because he is in front of the brown one*". However, on the picture the brown mountain is in the foreground, whereas in reality the doll would see it in the background; apart from this he takes no account of the other relationships.

CEL (8; 1) is at A and the doll again at B. Cel looks at the doll for a long time and also at the picture corresponding to his own position A. But he chooses, as did Eli, the picture suitable to D (opposite B) "*because the little man is behind the green one and here* (in the picture) *the green one is at the*

back". Thus, Cel reverses the foreground and the background because he assimilates the doll's viewpoint (B) to what he sees from his own position (at A). After this he also selects the correct picture (corresponding to B) and picks up again the picture fitting his own position. Finally, he says of the latter, "*Yes, it's better, because you can see the grey one better* (like from the point of view A!)".

These quite typical examples are noteworthy for two consistent, complementary illusions. In the first place, even while making an effort to grasp the doll's point of view, the child remains so convinced that the relationship holding between the mountains is rigid and immutable that he restricts himself to taking account only of one particularly striking feature, as it would appear from the position of the doll, as if it were unnecessary to consider all of the relationships involved; or rather, as if this one relationship implied the rest.

Thus, seeing the doll opposite the brown mountain, Eli chooses a picture showing the brown mountain in the foreground and does not bother about the relationship of the brown to the grey and green mountains nor about those between the mountains and the doll. This choice of a 'dominant feature' is obviously bound up with all that we have demonstrated so far. It is because the mountains, in the child's eyes, form one rigid mass, independent of perspective, that he imagines that depicting one elementary relationship correctly will automatically elicit the remainder.

Even this 'dominant feature' is by no means always correctly rendered, however, because the child usually judges the issue from his own viewpoint, not that of the doll. Thus arises the second of these illusions; despite attempts to discriminate between different viewpoints and to see things as relative to the position of the observer, the child is at this stage still dominated by the illusion of egocentrism. The examples of Jos and Cel illustrate this particularly clearly as regards the relations of before-behind. When Jos, for instance, says "it's the same thing because the little man is behind the green one" he is placing himself purely and simply at his own point of view. As for the relations of left and right, also illustrated by the same two children, Ful's response is even more instructive; "that won't do, the grey one . . . is the wrong way round". He makes this statement from his own point of view, as if the doll's point of view were reversed in some improper fashion. Whether or not they are fastened upon as dominant features, the relationships signified by the terms "before and behind", "left and right" are not yet truly relative as far as the child is concerned, since they cannot be reversed with the reversal of perspective. On the other hand, they are no longer purely absolute since the child is manifestly trying to put himself at the doll's viewpoint and to establish the relations of front to back, left to right, relative to it, though remaining under the dominant

influence of his own perspective without being aware of it. Consequently, there appear these "pre-concepts", intermediate between the false-absolute of egocentrism and the complete relativity of grouped projective relationships.

These two illusions may at first sight appear rather unlike the responses elicited by Method 1, where the child arranged the perspective himself and then turned it toward the doll. But in fact the children using this method are similarly influenced by a single dominant feature; in that being unable to determine the relations holding between the various different features, they are led ineluctably to reproduce step by step their own perspective without realizing it. With the second method the child is confronted with the pictures ready made and so soon as he comes across the dominant feature no longer concerns himself with the others but simply chooses any picture which seems in conformity with it. It is only when he tries to analyse the relationships in any detail that he assimilates them to the ones involved in his own perspective. Thus, despite apparent divergences, these various reactions are really homogeneous and all express in one form or another this transitional level we have designated IIB.

Method 3. When faced by the task of finding a position corresponding to a given picture, the child of this substage proceeds on the assumption that there is a definite, identifiable position for each separate point of view. This is without doubt a considerable step toward the discrimination of different viewpoints. But the relationship between position and perspective is not yet envisaged in a way that can be described as genuinely perspective, for it rests on the same "pre-concepts" as described in connection with Method 2. This is hardly surprising since the question is merely the same one reversed.

Jos (6; 9). "Could you take the same photo from anywhere?—*No, it's not the same thing from anywhere*—Well then, find the spot from which the little man was able to take this picture (position D, left to right; grey, green, brown)—(Jos puts the doll on the summit of each mountain in turn)—Why are you doing that?—*Because you can see a mountain better if you're standing on top of it*—But where did the little man take the picture from?—(He puts the doll at the foot of the brown mountain on the side nearest A)—Will his picture be right?—*No, because the grey one is not on this side* (Jos looks at the grey mountain for a long time, both on the model and in the picture, then places the doll between the brown mountain and the green, opposite the grey)—Will that be it?—*No, it's better like this* (in between the three mountains)—Why?—*Because he's behind the green one. Here* (picture) *the green one is at the back and he* (on the model) *is behind the green one. It's all correct*".

AN (7; 0), whose reactions with Method 1 have already been described, looks for the position which fits a picture showing the brown mountain in the foreground, the green on the right and the grey on the left (hence a point

somewhere between D and A). He puts the doll at the foot of the brown mountain but on his side of it. "*It's there. The little man will take the brown one first and then the other* (circular movement of the hand)". Brown on the right, grey on the left, green hidden by the brown: An places the doll in front of the brown mountain, relative to his own position, i.e., next the green; "*Here he'll take the brown one with one eye and the grey one with the other*".

CIE (7; 4) puts the doll at the foot of the brown mountain for picture D (almost correct), opposite the green for picture B (correct) "*because he can only see half the grey one and the whole of the green*", but later moves it nearer the foot of the green mountain "*because here he's near the green mountain, he can see it better. When you're nearer you get a better view of the whole of it*".

GIL (7; 6) also puts the doll at the foot of the green mountain for the same picture, "*because he's near the green mountain. He can take the photo with the green one best, he'll see it more completely*".

BER (7; 7) for a picture corresponding to D, puts the doll at the foot of the brown mountain but nearest his own side, "*because he is just opposite the brown*—Could you put him anywhere else?—*Yes, here; it's opposite as well, it's right opposite the green one*".

VAN (8; 2) for a picture taken at B puts the doll at the foot of the brown mountain, towards A. "Why?—*The green one ought to be on the left* (it is so in the picture) *so I put the little man on the left* (but on his own left, and thus on the left of the green mountain as well)".

These results need only to be compared with those obtained using the same method at Substage IIA to see the progress that has been made. No matter what picture they were shown, the children of Substage IIA always put the doll in their own position, or in the midst of the mountains—two ways of confusing the doll's viewpoint with their own—whereas the children of the present level try to find a definite point of view suited to each picture. In other words, from now on they admit that one cannot see the same thing from everywhere. But in trying to distinguish between different viewpoints they can only reason on the basis of 'pre-concepts' incapable of being 'grouped' within a system of reciprocal transformations. For each one of these 'pre-concepts' still remains centred on the child's own viewpoint instead of leading to a decentration, the only means by which the invariance of the correspondences could be reconciled with the variations in the relationships themselves.

The simplest of these pre-concepts (or 'pre-relations') is topological proximity, though employed without concern for projective differences. This consists of putting the doll in the immediate vicinity of the main item shown in the picture, taking no account of perspective or distance. This response is a repetition of that seen at Substage IIA where the children put the doll in the midst of the mountains or on their peaks, that it might see the whole more clearly (this is again seen in the interview with Jos). But now, instead of placing the doll on top or in the

midst of the mountains, they begin to put it at the foot of the mountain which appears in the picture foreground, and as close to it as possible; for as Cie says, "when you're nearer you get a better view of the whole of it" (or as Gil explains, "he'll see it more completely"). This idea that the closer one gets to a mountain the better it can be seen is very typical of this substage. On the one hand, it is a distinct improvement on confusing the doll's point of view with that of the subject, since it shows an attempt to locate the observer opposite what he is supposed to be viewing instead of putting him in the 'absolute' position of egocentric perspective. On the other hand, the notion of topological proximity is of little value in solving a projective problem, for it fails to take into account either the choice of a perspective corresponding with everything seen in the picture, or the distance the observer must be from the mountain if he is to perceive it in its entirety. It is obvious that these children do not react in this way for lack of experience, since they have seen for themselves that the whole of the Salève or the Jura cannot be seen from close range, and when this is put to them they readily agree. Putting the doll in the immediate vicinity of the most prominent object must therefore be regarded as a vestige of egocentrism, because to see the mountains as the child himself sees them the doll must be close to the mountain which occupies the foreground of the picture being presented. More accurately speaking, such a reaction is evidence of a residual inability to distinguish between his own viewpoint and that of the doll, and in this respect it is completely typical of this transitional stage.

In addition to these errors over depth or viewing distance—and which are peculiar to this technique—the mistakes over left and right revealed by the first two methods are again present here.

For example, Van, finding that the green mountain is "on the left" in one of the pictures (i.e., to the left of the brown and grey), puts the doll on the left, both in relation to the green mountain and to his own viewpoint! "The green one ought to be on the left" he explains, though the truth of the matter is that "on the left" is not yet a real relationship as far as the child is concerned (as in the relationship "on the left of the grey one"), but a more or less stable attribute or quasi-absolute property. Hence the necessity of putting the doll as far to the left as possible without stopping to ask "to the left of what?" (in reality, to one's own left, of course!). Exactly the same applies to the before-behind relationships. Jos, for example, in trying to locate the position which corresponds to the picture showing the green mountain "behind", places the doll "behind" the green one! That this interpretation of the meaning of before-behind and left-right is due to unconscious egocentrism and not merely a product of verbal habit, is shown by the examples of Ber, An, etc., in which it remains implicit and consequently non-verbal. Thus,

with the picture in which the doll should be behind the green mountain, we find Ber putting it in front. That is to say, "straight in front" but on his own side. Similarly, An puts the doll in front of the brown mountain, relative to himself, whereas from his own point of view it should really be behind it. In short, all before-behind, left-right relations remain at a pre-conceptual level, at the level of qualities rendered absolute through being evaluated solely from the child's own viewpoint and not from that of an outside observer.

Now assuming that the relationship between the child and any one of the three mountains is still largely egocentric in character, how will he set about representing the relation between this key mountain and the other two, according to the doll's point of view? The answer is that for children at this stage of development, such a question does not even arise, because to them the relationship between the three mountains does not appear to vary with change of position, but forms an immutable whole, identical with what they see from their own position. Consequently, as soon as the doll is stationed relative to one of the three mountains it must see the other two as they appear from the place where the subject is seated. As An says when he puts the doll in front of the brown mountain, "It's there. The little man will take the brown one first and then he'll take the others". In other words, if one relationship is determined, the others will follow as a matter of course. As pointed out in connection with the making of pictures from cut-out cards, the three mountains still form a kind of fixed array (regarded as a plane) which may be rotated in one direction or another relative to the observer, but which always maintains the same set of internal relationships. This is why the children find a single reference point sufficient to determine the observer's position, since within this static and immutable whole the remaining relationships appear to be only a function of this dominant or key relation.

After due allowance has been made for those aspects of the findings which derive from the method adopted, such as placing the doll close to the mountain because it can see it better as a whole, it is evident that these results largely coincide with those yielded by the other two methods. This is true, not only as regards the pre-concepts of left-right and before-behind, but also with regard to the immutable character of the group of mountains considered as a total picture.

The general features of this substage can therefore be grouped around one basic phenomenon; namely, the inadequacy of the idea of relativity which is just emerging. This notion is inadequate because it only takes account of relationships linking the observer's position with a single one of the mountains belonging to the group, or with the picture regarded as a static whole, which amounts to the same thing. The relations between this item and the rest are at present ignored, whereas under

conditions of true relativity they vary in precise conformity with changes in the position of the observer.

Compared with Substage IIA, the present level is a definite step toward true relativity, to the extent that there is some awareness that things will look different to an observer stationed elsewhere. But this idea is not yet by any means sufficiently developed to warrant an understanding of perspectives or their fundamental relativity.

The baby at the sensori-motor level is at first unable to turn things round. Before he can turn them to particular positions or arrange them relative to other things (including parts of his own body) he must learn to turn them in relation to himself. In the same way we find the child at the present stage content, as it were, with relativity applied only to the subject and not to other objects. True, he makes some attempt to relate the group of mountains to each position of the observer, but without realizing that all the relationships between the three mountains will vary with each position. This is why, when given the cardboard cut-outs, he always ends up by reproducing his own perspective and then turning the picture in the direction of the observer. For the same reason, when employing the other two methods, he is content to isolate some key feature as a reference point and having decided on it, does not bother about the other relationships which he accepts as bound up in one immutable whole. Hence the dominant relationship is conceived of as something which can only be described as a 'pre-concept', since left and right, before and behind retain a kind of 'absolute' character, absolute because they are related solely to the point of view of the child himself.

§4. Substage IIIA. Genuine but incomplete relativity

The event which marks the appearance of the third stage of development is the child's discovery that the left-right, before-behind relations (ignoring above-below) between the mountains vary according to the position of the observer. However, as the three mountains are at different distances these relations are manifold and complex, so that the child is unable to master them right away, nor co-ordinate them as an integrated whole. Consequently, we encounter a transitional stage lying midway between the egocentric behaviour displayed thus far (Substages IIA and IIB) and a completely objective grouping, and this period constitutes Substage IIIA.

Method 1. The technique of cardboard cut-outs clearly reveals the transitional nature of this phase, in that some of the children's pictures are based on actual transformations, while others are the outcome of illusions which are residual traces of spatial egocentrism.

ILB (7; 4) is at A (left to right; brown, grey in the background, green) and is asked to reproduce the view that would be seen from position C opposite.

233

He gets up to look on top of the model, then takes the grey card, puts it on his workboard and partially covers it with the green one which he puts to the right of it. He then puts the brown card behind the grey one. "*He sees the whole of the grey mountain, none of the green and a little bit of the brown one*". Thus in words perspective C is described accurately enough but in practice an error still occurs, for the green mountain is located as from the child's own viewpoint. He is asked to make the picture for position B (to the right of A; green, brown and grey). Ilb first puts the grey cardboard on the right, which is correct, but then moves it to the middle, putting the green one on the right as in his own perspective. The brown one is finally put on the left and the result is perspective A, but Ilb corrects himself, "*Oh no! The brown one is in the middle*". He dismantles the whole thing, puts the grey first on the left and then in the middle, the green on the right and the brown between the green and the grey but beneath it, and says, "*I see the whole of the grey one and the whole of the green one, but only a little of the brown one*". It will be seen that on this occasion the relation between the grey mountain and the green is derived from his own perspective, whereas the brown mountain corresponds to perspective B (except that the brown should be partly behind the green and not in front of the grey, this last relationship also being derived from his own perspective).

On the other hand, perspective D (opposite B) is made quite correctly (after trial and error). The child is then brought from A and seated at D and he notices that his construction was correct. He is thereupon asked to reproduce the picture corresponding to B whilst still seated at D. Ilb puts the brown card behind the green one; "*If I'm sitting there the grey mountain is whole and the green one is whole but the brown one is like this* (in the background)". Ilb has thus succeeded in inverting the before-behind relationship but continues to leave the left-right relations unchanged, so that in this respect he remains the victim of his own perspective.

The child is next asked for the perspective from A (seated at D) or in other words, the perspective corresponding to his initial position. He puts the grey card on the left, the brown in the middle (a little above it) and the green on the right and above the brown one. "Why?—*Because if I'm there, I see the green one and all of the brown one but only a bit of the grey one*". Thus, as previously, Ilb bit by bit reproduces the before-behind relations but still leaves the grey mountain on the right and the brown one on the left, just as he sees them from D. Likewise, when he is later at B and is asked to reproduce the view from C, he puts the grey card on the right and the brown on the left as they appear, not from C, but from B. At the same time he correctly locates the green card in the background as it appears, not from B, but from C!

RES (8; 1) is at A and is attempting to reproduce the perspective of D. He puts the grey card on the right, the brown on the left and sets the green one aside. "Is that all?—*Yes, because you can't see the green one, it's too far away*". Thus, like Ilb, Res constructs the depth relationship correctly but mixes up the left and the right on account of his own perspective.

ECK (9; 0) is seated at C and reconstructs B. He puts the brown one in the middle, the green on the right and the grey in the left foreground. Thus, the before-behind relationships are correct for the brown and grey mountains

234

but not for the brown and green ones (which from C are at equal distances). Furthermore, the brown one is rightly put in the middle, but the grey one is put on the left as it appears from C and not on the right as it would appear from B. In a similar fashion, for perspective A, the child who is seated at C puts the grey in the middle, the green on the left and the brown on the right and behind the grey. Thus, the depth relationship for the grey mountain and the green are correct, but those between the grey and the brown are not and the left-right relationships between the green and the brown are reversed, these errors being produced by the child's own perspective. As against this, perspectives B and C are later correctly reproduced from position A.

AR (9; 2) in contrast to these last two children, takes account of the alterations in the left to right relationships but not those of before and behind. Seated at A he tries to construct the scene from D. He puts the grey card on the left, the green on the right and the brown in between, which is correct. But he fails to take account of their positions in depth. Similarly for position C he puts the grey card behind the green one instead of in front of it, etc., though reproducing the relations of left to right correctly.

These responses are therefore exactly midway between true relativity and the reactions of the previous levels. At last the child realizes that changes in the observer's position bring about transformations of the internal relationships connecting the different parts of the group of mountains, and he is no longer restricted to dealing only with the relations that link the group, as a static display, with an observer who sees it from different points of view. IIb understands that if the grey mountain is in the background when seen from A, it will appear in the foreground when viewed from C, its relative position having changed. Ar can grasp the fact that if the brown mountain is on the left of the grey one when seen from A, it will be on its right when seen from D. This understanding of changes in internal relations indicates a decisive step forward as compared with Stage II and marks the commencement of Stage III, which agrees fully with our earlier findings in connection with perspective of isolated objects and shadow projections in Chapters VI and VII.

Along with these correct solutions, however, past errors are repeated through the lingering influence of the child's own perspective. In most cases they occur in connection with relations of left and right, before and behind being reversed with less difficulty. Though this is true in general it is not invariably so, Ar providing an evident exception. The reason for such a tendency is fairly clear inasmuch as it is easier to form an abstraction of one's own viewpoint (i.e., to become aware of it) in the case of depth than with left and right. For intuitively—which is to say, egocentrically—there is a bigger difference between a background beyond the reach of immediate action and a foreground directly subject to it, than there is between a left and right which are equally near or distant. Hence the before-behind relationships become reversible, and

consequently more responsive to changes of perspective, sooner than those of left and right.

Method 2. The results obtained with comparison pictures are identical at this stage with those above in some repects but different in others.

STIE (8; 1). When the doll is at D (brown in foreground, green on the right and grey on the left in the background) he chooses a picture corresponding to A "*because not all of the grey one is there*". He also chooses another picture showing the brown on the left, the green on the right and the grey in the middle, "*it's right like this, he can't see all the grey one, it's further back—*Which one is most correct?*—They're both correct because you can't see much of the grey one and you shouldn't*". Stie is thus taking account only of the fact that at D the grey mountain is in the background and does not concern himself with the left to right relations which he leaves unchanged and hence corresponding with his own position.

LEI (8; 3). When the doll is at B (grey on the right, green left, brown centre background) he hesitates and is unable to decide between the correct picture and the one belonging to the side opposite (D). The former appears right to him "*because the brown one is in the middle*", but the second appears correct also "*because the brown one is in the middle as well*". After this he decides on the basis of the before-behind relation but ignores that of left to right.

DEL (9; 2) is at A and the doll at D (grey on the left, brown right, green hidden by the brown). Del picks out the correct picture and explains: "*Seen from here* (so far as one is able to) *the green is behind*". However, he regards as equally correct a picture taken from somewhere between A and D "*because the green is behind in this one as well*", oblivious of the fact that in this picture the brown is to the left of the grey, whereas the other one shows the reverse. With the doll at B, Del first chooses a picture also taken from somewhere between A and D, "*because there he can't see the grey so well*", and finally the correct one because it shows the brown mountain in the background.

As with the method of cardboard models, the child achieves no more than a limited transformation, a partial relativity, for he takes account of only one relationship and ignores the remainder. At the same time, within the field of the relationships he disregards, the connection between his own perspective and the picture he selects is not quite the same as with the first method.

We may state at the outset, that the relationship which is determined correctly, though at the expense of the others, is altogether unlike what were termed 'dominant features' at Substage IIB. These 'dominant features' are either false and erroneous ones, or they apply solely to the relationship between the observer and a single mountain and not between this mountain and the other two. As distinct from this, the isolated relationship which the child selects at the present level, as when Stie puts the grey mountain in the background, etc., is evidence of true relativity, and as such is the outstanding characteristic of this stage.

On the other hand, the fact that some relationships are neglected is not entirely due to residual traces of the primacy of the child's own viewpoint, as was the case throughout the examples of cardboard constructions where the method involves an active construction by the child. It is better described as a relic of the belief in a rigid bloc, but surviving in a new and subtler form. We are no longer confronted with the idea that the relations between the mountains remain unchanged irrespective of viewpoint, but with an implicit assumption that to change one of these relationships automatically changes the others as well, so that there is no need to allow for each change separately.

Method 3. It will be recalled that children in Substage IIB react to this third method by fixing upon one mountain to serve as a point of reference, and by placing the doll as close to it as possible, taking no account of either angles or distances. The children of Substage IIIA likewise concentrate on a single relationship, use it as a reference point and disregard all others. But as we have just seen from Method 2, the converse of the present one, this relationship implies at one and the same time a relation between the selected mountain and the other two, and a precise relation between the perspective of the mountain and the position of the doll in terms of angles and distances. It is only the first of these relations, that between the chosen mountain and the other two, which there is no attempt to check or verify, as if it were self-evident. Here are some examples, beginning with a case midway between Substages IIB and IIIA.

ARC (8; 0). For the picture corresponding to A (his own position) he puts the doll halfway up the green mountain, then between the brown and green, facing the grey. "*It's better like this*". He is shown a picture corresponding to D (grey, brown, green from left to right, brown in the foreground). Arc puts the doll at the foot of the brown mountain: "Why?—*Because the brown one is in the middle*—Can he see the grey one from there?—(He studies the model for some moments then moves the doll back some distance from the brown mountain)". Up until his last answer Arc's reactions were identical with those seen at Substage IIB but his withdrawal of the observer is more characteristic of Stage III as are the following reactions. Shown a picture with the brown mountain on the left, the green on the right, the grey in the middle and in the background, Arc places the doll so that it can see the green one in the distance and to the right of the brown, the grey mountain remaining entirely hidden. For a picture with the grey on the left, brown on the right and the green hidden by the brown, he places the doll between the grey and the green, but facing both the grey and the brown, showing that he understands that although the doll is at the foot of the green mountain it is not necessarily looking at it. Unfortunately, in this position the grey mountain is on the right and the brown on the left.

Again, when the green one is on the right, the brown on the left and the grey one hidden, the child puts the doll between the grey, green and brown

with its back to the grey, so that it can only see the other two. In this position however, the green is on the left and the brown on the right. Finally, Arc is shown a picture with an impossible perspective. This shows the grey in the background between the green on the left and the brown on the right. Arc then places the doll correctly in such a position that the grey will be in the background *"because he would see less of the grey one and he would see the other two"*. But he pays no attention to the relations of left to right between the brown and green mountains.

GRA (8; 0) succeeds in finding the positions which correspond to the pictures taken from B, *"because the little man must be able to see all of the green one"*, and also from A, *"because these two* (green and brown) *are in front here and the grey is behind and can hardly be seen"*. But for a picture having the grey on the right and in the foreground, the green on the left and half hidden, he tries to find on the model the path which can be seen on the green mountain (visible in the picture) and puts the doll opposite the green mountain and some distance away. Next he moves it to a position between the three mountains with its back to the brown but with the green on the left instead of on the right and the reverse in the case of the grey. "Is it all right there?—*Yes, because he can get these two there* (green and grey, regardless of left and right)".

ROB (8; 1). For the picture corresponding to D he places the doll correctly, facing the brown mountain *"because the brown is in the middle"*, but in such a position that the relationship of left to right is reversed. He does the same with a second picture.

RIE (9; 0). Is ahead of the preceding children in that he endeavours to take account of each set of relationships in turn, thus anticipating Substage IIIB, though he fails to synthesize them. For the picture corresponding to B, he starts by putting the doll behind the green mountain, then changes his mind; *"That's not right because like that you can't see the green"*. He then puts it in front of the green; "Why did you put it behind the green one before?—*Because there was the grey in front*—And would here be all right (pointing to another spot)?—*Oh no, you haven't got the grey one in front.* (He puts the doll between all three mountains). *No, he can't take the green one from there. There* (a new spot) *we'll have the grey in front of the green, but he mustn't take the brown one* (he tries to turn the doll round so that it cannot see the brown mountain). *No. He can see it. I can't find the answer"*. He is given a picture taken from a position close by; *"There he'll only see a little bit of the grey one . . . Oh no, the brown has got to be behind* (he then puts the doll at A), *there we are . . . Oh no, he can't see the end of the grey one* (he pushes the doll nearer B); *there he can see a bit of the grey* (hesitates). *If it were bigger* (the grey mountain in the picture) *it would be all right here"*. It will therefore be seen that Rie very nearly reaches the correct solution, though with a complete lack of conviction.

These results are analogous to those yielded by Methods 1 and 2. The child begins by selecting any set of relations as long as they entail a relationship between the three mountains themselves and also between the reference mountain and the doll, which is now put some distance

away from the display and no longer as close to it as possible, the usual procedure at Substage IIB. The way in which this relationship is selected as a starting point is therefore evidence of the commencement of true relativity and of a real understanding of perspective. But the start is not followed up, the understanding remains incomplete, for at this stage the child fails to determine the relationship between the doll and the other two mountains, either from the standpoint of left to right (Gra) or of before to behind. When, like Rie, the child does make an attempt to co-ordinate all the relationships he meets with only an indifferent success.

§5. Substage IIIB. Complete relativity of perspectives

There is obviously a complete continuity of development between the partial determining of relationships typical of Substage IIIA and their complete determination, of which we will now give a few examples.

Method 1. It was found a much easier task to reconstruct a scene by means of three pieces of cut-out cardboard than to choose from a number of pictures that corresponding to the three mountains, for this latter involves a purely mental process. So that we find the correct solutions arrived at somewhat earlier with this first method than is the case with the other two.

STA (8; 1) seated at A, is asked to make the view seen from C (opposite him). He takes the grey card, puts it in the foreground, putting the brown and green cards in the background (but with the left to right relationship reversed). He is then asked to make perspective B (grey right, green left, brown centre background). He puts the grey in the centre background, the green on the right and the brown on the left (which is his own perspective) and looks at it. "*Oh no, I've made a mistake. The grey one is in front for him* (he puts it in front but leaves the brown on the left). *Oh! the brown is nearer the middle*—From your position?—*No, from there* (he makes the picture correctly)".

YVO (9; 2) is seated at A and like Sta tries to reconstruct C. He takes the green card which corresponds to the foreground of A and the background of C and says, "*he won't see the green one*". He covers the green card almost entirely with the grey one (on the left) and inserts the brown card between the green and the grey, on the right. His picture is therefore correct.

For perspective B he first puts the brown in the middle, then the grey on the right and in front, the green on the left, also in the foreground. For perspective D, he begins by putting the green on the right, then the brown in front of it in the centre, and finally the grey underneath and on the left, which is completely correct.

JUL (9; 5) for perspective B, puts the brown in the middle, then the green on the right and the grey on the left. After this he corrects himself by switching round the green and the grey.

In contrast to Sta, who seems to progress by immediate or gradual co-ordination of all the various relationships which are involved, Jul

and Yvo appear to start out from a single relationship. But unlike the children of Substage IIIA, Yvo performs a logical multiplication between this initial relationship and all the rest in turn, thus arriving at a correct arrangement. In a similar fashion, Jul begins with the relationship 'brown in the middle' and then proceeds to arrange the remainder relative to this initial relation. Whatever route is taken to arrive at the answer, the reasoning which takes place involves the co-ordination or 'multiplication' of relationships. Thus, the child can go forward either by direct conversion of the relationships, like Sta; or, like Yvo and Jul, by multiplying a single relationship with each of the others in turn.

Method 2. The same procedure is followed with the second method:

MAR (9; 0). The doll is at D with the grey on the left, the brown on the right and the green barely visible. Mar chooses a picture showing a similar relation for the grey and the brown and leaves the green just visible in the background. "*It's because the green is at the back from over there*". He then hesitates before choosing a picture also having the green in the background but on the right of the brown, "*perhaps this one is all right too, because the green is also at the back*". But he decides in favour of the first "*because the green is between the two*". For position B, Mar remaining at A, he chooses first an inaccurate picture "*because he can't see the grey very well*" and then the right one "*because the green and the grey are in front on the left and right and the brown is behind*".

These reactions are thus the same in essence as those yielded by Method 1, the only difference being a slight time lag as regards the age at which complete success is achieved.

Method 3. Here are a few examples of correct answers given more or less immediately.

LUC (8; 4) is shown a picture representing the brown mountain on the left, the green on the right and the grey out of sight. He puts the doll between the brown and the green "*because the green must be on this side* (right) *and the brown there—And the grey?—When the man is over there he can't see it because of this* (a spur of the green mountain)". For the next picture in which the green hides the brown a little, he puts the doll in the same place but changes his mind directly and moves it, "*there, because from there the green is in front of the brown*".

DAR (9; 6) given a picture corresponding to B, unhesitatingly puts the doll at the correct place "*because the green is the nearest, the brown behind and on that side* (points to the left)—Can't you find another place?—*No, there isn't any other*". He is then shown an incorrect picture containing impossible orientations, green on the right, brown on the left and grey in the centre, partly hiding the green. Dar hesitates for a moment and then declares in a determined fashion, "*That's no good!—Why?—The green is behind the grey, and then the brown can't be in front!*"

These reactions are an advance on those of Substage IIIA, not only because the projective relations are now completely co-ordinated or

'logically multiplied' but on account of the method used to bring this about.

At Substage IIIA grouping of relationships remains incomplete and is only achieved in piecemeal fashion. At this level the various relationships are brought into correspondence (logically multiplied) one after the other. Consequently, each of these acts more or less obliterates the ones preceding it in the series and brings the process to a premature conclusion by obstructing the acts due to follow. In contrast to this, the children of Substage IIIB start out with some kind of anticipatory schema, which is nothing less than the actual framework of the grouping itself in the form of possible, or as they have now become, virtual operations. This may be seen from the fact, that as far as the child is concerned there is from now on only one picture for a given position. This is the most significant new feature of the development which has taken place between these two levels. For example, Dar declines to "look for another place" for a picture taken from B and asserts flatly that "there isn't any other". In short, the correspondence between the observer's position and the projective relationships has become point to point. It is this point to point quality which indicates the existence of an operational anticipatory schema, completed and no longer in process of construction as at Substage IIIA.

Another significant indication which, in the last analysis, points in the same direction, is the child's response to false pictures showing impossible perspectives. The child of Substage IIIA cannot yet avoid this trap (see Arc) simply because he fails to take all the relationships into account simultaneously. The child of Substage IIIB, however, clearly perceives the contradictions (see Dar again) precisely because his certainty of the point to point character of the correspondence enables him to tell whether or not the relationships postulated by a given picture are mutually compatible. For their mutual compatibility indicates correspondence with a specific position and their incompatibility, the absence of such correspondence.

In sum, at Substage IIIB the operations required to co-ordinate perspectives are complete, and in the following quite independent forms. First, to each position of the observer there corresponds a particular set of left-right, before-behind relations between the objects constituting the group of mountains. These are governed by the projections and sections appropriate to the visual plane of the observer (perspective). During this final substage the point to point nature of the correspondence between position and perspective is discovered.

Second, between each perspective viewpoint valid for a given position of the observer and each of the others, there is also a correspondence expressed by specific changes of left-right, before-behind relations, and consequently by changes of the appropriate projections and sections.

It is this correspondence between all possible points of view which constitutes co-ordination of perspectives. That is to say, it provides the essential unity and homogeneity of projective space, completed at this level, though as yet only in a rudimentary form.

A question now arises in connection with the findings of Chapters VI and VII. Does the development of projections or perspectives for single, isolated objects make possible the overall co-ordination we have just been discussing? Or is it the overall co-ordination which enables isolated projections or perspectives to be developed? Before concluding this chapter we must endeavour to answer this question.

§6. *Conclusions. Co-ordination of viewpoints and elaboration of isolated perspective relationships*

In the course of Chapter VI we studied how the child envisages the perspective changes produced when an isolated object, such as a stick, is turned at various angles. We found that with simple objects like the stick or the disc these changes, still beyond his comprehension at Substage IIA, are completely mastered by Substage IIIB. And moreover, not merely in terms of simple perceptual notions, but through the gradual development of operations covering projections and sections, and the establishment of correspondences between them.

The child is at first unable to imagine the object as he sees it (e.g., in oblique perspective, endwise, etc.) and leaves it unchanged as a kind of fixed 'false-absolute'. Only by constructing a system of intellectual operations is he able to form a mental image corresponding to his perception. Chapter VII confirmed this hypothesis by demonstrating that perspectives and true projections (in the form of shadow projections) develop concurrently, despite the fact that the former correspond to a viewpoint of which the child is subjectively aware, while the latter correspond to objective data which can only be perceived externally. Lastly, the chapter now being concluded has yielded a number of findings which at first glance appear directly, sometimes flagrantly, contradictory to the earlier results. However, as we shall try to show, this is far from being the true state of affairs, and in fact the last results actually help to explain the earlier ones even more satisfactorily.

The apparent contradiction may be stated in this way. At Substage IIA, the child confronted with a single isolated object is unable to take account of the perspective in which he perceives this object when he wishes to imagine or draw it. On the other hand, if confronted with a group of objects like the group of mountains (whilst at the same stage of development), he appears to be rooted to his own viewpoint in the narrowest and most restricted fashion so that he cannot imagine any perspective but his own. Indeed, he cannot imagine any perspective but that of the passing moment, since with a change of position he

repeats his performance in terms of the new position! As against this—and here, not only is this apparent contradiction resolved, but the earlier studies tend to throw light upon one another—at the stage where the child completes his construction of perspectives and projections as applied to movements of single objects (Substage IIIB), he is likewise able to construct the perspectives of other observers in the case of the group of mountains.

This dual situation, seemingly contradictory in its earlier stages, approaching consistency by Substage IIIA, and completely consistent by Substage IIIB, is in fact a demonstration of the hypothesis maintained over the last three chapters.

The child's own point of view, which is the source of simple perspective, can give rise to a genuine representation, one that anticipates and reconstructs as well as records, only in so far as it is distinguished from other viewpoints; and this process can only occur within the framework of a global co-ordination. The child can only discover his own viewpoint as he becomes able to envisage those of other observers. This is why discovery of perspective is equally difficult when he deals with objects as they appear to him and when he deals with the same objects as perceived by other observers.

Hence there is no real contradiction in the earlier stages, between the child's inability to understand perspective (as described in Chapter VI), and the fact (described in the present chapter) that at the same stage he can only imagine a group of mountains, no matter from what aspect, by constantly reproducing his own viewpoint. For in truth, not only is he quite unaware that he possesses a viewpoint distinct from those of other observers but, and this is the essential point, his own viewpoint—which he elevates to a kind of false-absolute—is really nothing like a perspective representation; it is simply a wrongly centred or egocentric notion. As we have seen in numerous examples, this preponderance of the subjective viewpoint, which prevails throughout Stage II, leads to an inflexible rigidity of the relations between the three mountains. Instead of conducing toward any kind of perceptual correspondence, it results in making the object 'real' in just the same way as the spurious realism or pseudo-shape constancy found in children's drawing prior to the advent of perspective, and it reflects a complete lack of understanding of the perspective relations studied in Chapter VI.

Consequently, to the extent that the child can co-ordinate his own viewpoint with others, he succeeds both in constructing these alternative viewpoints and in distinguishing his own from them (Substage IIIA, and especially IIIB). In so doing, he masters simple perspective relations and solves the problems of global co-ordination (Chapter VIII) along with perspectives of isolated objects (Chapter VI) and shadow projections (Chapter VII).

The main conclusion to be drawn from this discussion is therefore, that global or comprehensive co-ordination of viewpoints is the basic pre-requisite in constructing simple projective relations. For although it may be granted that such relations are invariably dependent upon a given viewpoint, nevertheless the last three chapters have made it abundantly clear that a single 'point of view' cannot exist in an isolated fashion, but necessarily entails the construction of a complete system linking together all points of view, just as distances and metric relations are linked together within a co-ordinate system in euclidean space. This is the prime and fundamental difference between projective space and the topological relationships dealt with in Part One.

The second important difference derives from the way mental operations superimpose themselves on perceptions, or if one prefers to put it otherwise, the way they integrate the perceptual data. Topological space is wholly inherent to the object and consists of operations worked out step by step. It therefore corresponds to no more than a series of possible perceptions capable of being juxtaposed, and the main task of such operations is to assemble the data of this space into one coherent whole. The groupings involved in this process consist of additions and subdivisions of proximities and separations, the formation of ordered series, and enclosure by means of surrounding; the entire process raised to the level of operational continuity and of point-point and bi-continuous (homeomorphic) correspondence.

In contrast to this, a system of projective relations or perspective viewpoints consists essentially of operations which do not merely assemble perceptual data, but co-ordinate it in terms of reciprocal relationships. Hence the function of projective space is not to link up the various parts of the object, but to link together all the innumerable projections of it. Consequently, the perceptions to which these different projections or perspectives correspond are not like fragmentary pictures that have to be assembled, but each one of them complete views taken from different angles that have to be reconciled.

The problem raised by the experiment with three mountains is not one of topological proximities or enclosures, nor is it a euclidean problem of measuring things by comparing adjoining elements or moving units from one part of the structure to another. It is a projective problem and for this very reason, no single perspective, no one visual picture corresponding to a particular point of view, can render the spatial character of the group of mountains as a whole. This can only be done by means of operations enabling one perspective to be linked with the rest. That is to say, by operations that link a particular perspective with the universe of possible perspectives.

To put it another way, the reason why no single perception can embrace every aspect of the entire group of mountains is not because it

refers only to one small section of the whole (like one square of a chessboard in relation to the rest), but because it only relates to a single perspective. The sum total of all these various aspects can only be grasped through an act of intelligence which links together all the possible perceptions by means of operations. Such operations deviate from the perceptual viewpoints themselves to a far greater extent than those by which we distinguish operational from perceptual proximity, it being understood that the operations tend to react upon the actual transformations leading from one potential viewpoint to the next.

Thus the perspective system which the child builds up in the course of the four substages we have identified is not perceptual but conceptual in character. It is the psychological counterpart of a projective space which, unlike topological space, is based primarily on the group of transformations itself, a grouping initially qualitative, but becoming quantitative in course of development, and partaking of the nature of the mathematical group.

However, we must now go further and ask whether the perception of perspective, and especially perception of shape constancy, does not in fact already presume the functioning of sensori-motor co-ordination (in the case of 'perceptual activity' as described in Chapter I, §2) on the purely active level, as a precursor of these mental operations. As a matter of fact, the four stages outlined in this discussion (Chapters VI-VIII) recall very vividly, though with a considerable time lag, the stages described in an earlier work.[1] There we were concerned with the sensori-motor construction of empirical relationships such as depth and shape constancy, a developmental process which, contrary to Gestalt hypotheses, has been confirmed by more recent perceptual studies. During the earliest period of the child's life, corresponding to the first two stages outlined in Chapters I and II of C.R., space seems to lack the quality of depth and appears much as does the sky to an unsophisticated adult. Furthermore, since a baby does not handle anything very much, searching for objects which vanish from sight is altogether out of the question. In addition, as rotatory movements of things are not understood, their rear sides remain undiscovered and the child fails to realize that objects possess a constant three-dimensional shape. This primary stage with its lack of perspective and predominance of phenomenal appearance may be compared directly with the first of the three stages mentioned here in Chapters VI-VIII.

During the second period, corresponding to the third stage described in C.R., the child learns through handling objects to distinguish different planes of depth, and thereby, different aspects of an object. At the same time, he is still unable to search for an object temporarily hidden by a screen or turn an object round in relation to himself (his feeding bottle,

[1] Op. cit., *The Child's Construction of Reality*. Here referred to as C.R.

for example), so that he does not yet grant objects constant perceptual shapes. This transitional level is comparable with the second of the conceptual levels (Substage IIB) described in the present work.

In the third period (the fourth stage in C.R.) the child learns to perform certain reversible actions implying some understanding of depth, such as hiding and finding objects, though as yet these are not co-ordinated with the complete set of relations now brought into play (such as subsequent movements of the hidden object, so that he still tends to look for it at the place where it disappeared rather than where he has seen it reappear). The child can now turn things relative to himself, though not relative to other things (by placing it upon them, for instance), and he now moves his head from side to side to observe the resultant changes in the shape of objects (C.R. Obs. 88-91), which means that he is becoming aware of perceptual perspective. Here, the functional analogy with the present Substage IIIA (Chapter VI-VIII) is self-evident.

Last of all comes the fourth period (Stages V and VI in C.R.) where the various relationships are linked together in global fashion, resulting in an ordered arrangement of planes in depth and the placing of objects one behind the other. This, of course, corresponds to the operational co-ordination seen here at Substage IIIB.

In short, the sensori-motor co-ordination responsible for perception of perspective appears to develop, from the very outset, in a way that is functionally analogous to the operational co-ordination of viewpoints culminating in the concept of projective space. Operational co-ordination may thus be said to recapitulate in large measure all that has previously been achieved on the plane of perceptual activity, while completely surpassing it as regards the power of its deductive mechanisms.

The feature common to both processes of development is precisely the transition from egocentric realism to relational co-ordination. The fact that this process recurs in identical fashion after the lapse of several years demonstrates what a vital role it plays in forming the idea of projective space. Though there is, of course, the difference that at the perceptual or sensori-motor level it is only a matter of linking momentary perceptions or actions with earlier or later ones. At the conceptual level, however, the passage from actual centration to virtual decentration is brought about by the subject co-ordinating his own viewpoint with all possible viewpoints, replacing egocentrism by grouping.

Such is the meaning of the four stages revealed by investigating the co-ordination of complex wholes. These findings make clear that their development runs parallel with the four stages described in Chapters VI and VII dealing with isolated projective relations; and by comparing the two courses of development we are driven to conclude that projective space entails the sensori-motor, and ultimately, operational co-ordination of viewpoints.

Chapter Nine

GEOMETRICAL SECTIONS[1]

SINCE the operations involved in making geometrical sections are concerned with specific shapes rather than primitive plastic structures of a topological character, they apply equally to euclidean and projective geometry. Hence one could just as easily imagine a conic section made by interrupting a cone of light with a screen (projective section) as one made by cutting a solid cone with a knife (euclidean section).

In psychological terms, operations of sectioning could be described as applying equally to the 'geometry of objects' as to the 'geometry of viewpoints'. The first treats of objects as if the observer were co-extensive with them and could, in a manner of speaking, touch and see every point at one and the same time. This is, of course, the standpoint of topology which disregards the question of movement. As against this, the geometry of objects or euclidean geometry introduces the factor of measurement by passing from one object to another or around the periphery of an object. It thus brings movement or displacement to bear on the object as such, passing beyond the confines of topology in which only movements of the observer are taken into account.

Nevertheless, such measurements are still carried out as if the observer adhered directly to the surface, or were inside the object, regarded as a rigid solid, analogous to the way in which a human being might explore the globe by travelling about it, or explore the inside of a building by moving from floor to floor in a lift. Thus, in so far as the geometry of objects quantifies or 'measures' solids, it does so by virtue of measurement and object being regarded as co-extensive. For example, a line is considered as being measured through constant repetition of a length unit in the process of traversing it from one end to the other, either in practice or in thought. In particular, the development of a co-ordinate system as a basis for 'object geometry' implies the orientation of objects relative to each other, and to a system of reference points arranged along different dimensions.

In addition to the 'geometry of objects', however, it is possible to conceive of a 'geometry of viewpoints'. Here, the object is envisaged, not from the surface or from the interior, but from a more remote vantage point, so that the observer now occupies a position from which he perceives the object as it looks from that particular point of view. Now the projection of objects on a given plane, or the

[1] In collaboration with Mlle. E. Bussmann, M. T. Kiss, and Mlle. G. Ascoli.

247

visual plane of the observer (perspective), entails a geometry of view-points, and it was the earliest manifestations of this which were examined in Chapters VI-VIII.

Hence sections are involved equally with geometry of viewpoints as with geometry of objects though in the form we have given it, the problem with which 4–12 year old children are confronted derives directly from the latter type of geometry. The experiment consists simply of looking at objects made of plasticine, such as a cylinder, a prism, a parallelepiped or a cone, and predicting the shape of the surface produced when the solid is cut along various planes with a large knife. For instance, a cylinder cut parallel with the base will give a circle, and cut lengthwise, a rectangle. The same problem could obviously be posed in terms of projective geometry by making sections, not of solids or surfaces occupying euclidean space, but of beams of light or shadow radiating from these same objects and having the same shape. In this way, sectioning operations could be studied using either euclidean or pro-jective methods according to whether the questions concerned solids considered as things in themselves or projections in three dimensions.

However, there is little point in choosing the more artificial of the two methods, since in any case the euclidean method implies perspective or projection, for the actual cutting is rendered by a drawing on a plane surface. So although the experiment is kept within the bounds of everyday experience, like seeing something cut with a knife, it is still the case that any pictorial, or even imaginary, representation of it nevertheless involves projecting the solid on a two-dimensional surface.

It is therefore quite adequate to have the child draw the cut surface for his drawing to represent one of a number of possible perspectives, and consequently, to be related to all of them. For instance, the per-spective of a solid seen from the cut side as compared with the appear-ance presented from the sides left intact. Now the child has to predict the shape of the section before the cut is made and not merely to draw it subsequently. It is therefore a question of causing an imaginary plane (the knifeblade, in imagination) to pass through the object which is so far intact. To put it another way, to cut through a sheaf of straight lines as imagined in projection, without actually traversing any distance in physical space.

It should always be borne in mind that a solid can only be shown by means of a projection, as is demonstrated by the fact that pictures of cubes, spheres, parallelepipeds, etc., in textbooks of euclidean geometry are only perspective diagrams (except for the use of developed and rotated figures to express surfaces in descriptive geometry). We may therefore assume that since the act of cutting a solid entails a euclidean operation, a drawing of it implies a system of projections to which the section must be related.

Now these prior considerations are not merely theoretical but pose a genuine psychological problem. This is the extremely intimate connection between the development of euclidean and projective operations; the first dealing with movements or displacements, and the second with their representation. From the psychological standpoint, to construct perspectives, whether of single objects (Chapter VI), shadows (Chapter VII) or groups of mountains (Chapter VII), assumes some knowledge of the outcome of relative movements of such things, or movements of the subject relative to them. But this in turn presupposes that these objects are represented or envisaged projectively, since movements can only be oriented in space in so far as it is possible to conceive of points remote from the position occupied in the actual course of movement.

In sectioning solids, the closest possible interaction is apparent at all levels of psychological development, between euclidean operations which traverse a solid by an actual movement (like cutting the plasticine), and projective operations which represent the solid according to a given perspective cutting the three-dimensional figure along a plane. At the earlier levels of development such an interaction is apparent through the children's drawings being neither purely euclidean nor purely projective. Instead of showing the section as a euclidean surface the child draws a shape which combines the appearance of both the section and the intact solid. Alternatively, when the section and the intact solid are shown separately, his drawing is conspicuous for what Luquet (op. cit.) termed a "medley of viewpoints", indicating the simultaneous existence of a number of perspectives with neither coherence or system. At later levels, operations of sectioning are represented projectively, and at the same time, perspectives and movements are seen to interact with one another.

To ensure that the child's responses are a genuine product of his spatial or geometrical concepts, and not merely artifacts of the experimental technique, we invariably asked him to (a), draw the expected surface before the section is cut, and (b), pick it out from a selection of comparison drawings, both questions being put in the course of conversation aimed at following his train of thought. In this way a series of increasingly complex solids were investigated, ranging from the cylinder, prism, parallelepiped, hollow sphere and the cone, to irregular shapes such as twists, snailshells, paper cornets, and so on. By using this varied collection the child's reaction to different types of solid could be studied without putting too much emphasis on the description of general stages of development.

As with the projective relationships previously investigated, there are general levels in the development of sections, and in fact, these correspond term for term with the overall development of projections and perspectives. At Stage I, where different surfaces are not yet distinguished

from one another, it is of little avail to ask questions about sections. At Stage IIA (see Fig. 22), about 4–5½ or 6 years, however, the results are very interesting. Before the solid is actually cut, the child is unable to show the section as he cannot distinguish the internal viewpoint

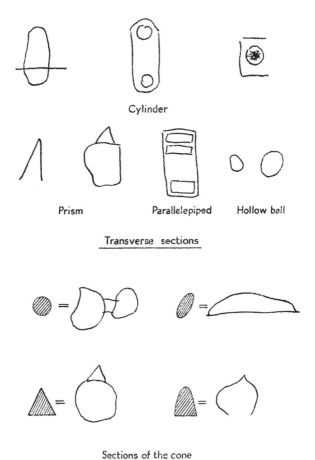

Cylinder

Prism Parallelepiped Hollow ball

Transverse sections

Sections of the cone

Fig. 22.
Sections of various solids (Stage IIA).

which represents the section of the object. This is so even when the section is identical with the exterior, as in transverse section of the cylinder. Consequently, the drawing shows a curious jumble between views of the intact exterior and the surface of the imaginary section, though the latter always remains rather vague and sketchy in shape. The

child also fails to select the appropriate drawing from the sample collection.

During Substage IIB (5½ or 6–7 or 8 years) the sectional surface is gradually distinguished from the intact shape, usually in the form of a rough suggestion of the interior view of the solid. This is mainly achieved by imagining, more or less correctly, the path of the movement described in making the section. By Stage III this achievement is consolidated in operational form, the success in rendering the section varying according to the type of object, extending through Substages IIIA, IIIB, and even to Stage IV.

§1. *Transverse and longitudinal section of the cylinder, the prism, the parallelepiped, and the hollow ball*

In front of the child are placed a cylinder or prism made of plasticine and a large flat knife. Before cutting a transverse section he is asked to guess what shape the surface will be where it is cut. To assist him in this we hold the knife over the plasticine without actually cutting into it, but indicating clearly the place and direction of the intended cut. The hints and suggestions are of course varied in accordance with the child's ability, and range from beginning to make the cut to cutting a section as a control. The same procedure is carried out for the longitudinal section, not directly following the transverse, but after various questions have been asked about other solids.

Here are a few examples from Substage IIA which show the child's inability to distinguish the sectional surface from the shape of the intact solid.

BRA (4; 6). "I'm going to cut this roller in the middle, like this (transverse). Can you draw the side you'll see where it's been cut (gesture of cutting)?— *No, I can't*—Try—(He draws an elongated oval indicating the rounded ends of the cylinder and its straight sides)—Watch (it is cut)—*Oh, it's round!*— Did you think it would look like that?—*No*".

ROS (4; 6) thinks that the transverse section will be "*square*—Why?—(He points to the edge of the cylinder between base and side, thinking of the planes formed by the base and the surface of the side)—(It is cut) Is it like you expected it to be?—*No, it's round*". Prism (transverse section). He draws an acute angle without a base, then a long oblique line. Longitudinal section: he draws a right-angle, then a right-angled triangle. From the sample drawings he selects the square but rejects the rectangle.

EBE (4; 11). For the transverse cut he draws an oval like Bra's but not quite so elongated. For the longitudinal cut he starts to draw a shaded oblong with no definite outline, saying "*That's the inside . . . it's all filled in*—But what shape will it have?—(He adds a pair of circles, one at each end of the elongated shape, put underneath like the wheels of a cart, saying) *That* (the elongated part) *is the inside, and that* (the circles) *is the outside*—Show me how you'd cut it—*You cut it here where it's long and half will be here and the*

other half will be there (he points to the right half of the circle on the left and the left half of the circle on the right, thus showing that he is fully aware that the section will bisect the base)—But draw just the part you'll see when you cut it—(He repeats the same drawing and says), *That will be long*—Which? (He is shown the set of drawings and selects both the rectangle and ellipse)— *It will be like that because it's long; and that, that will be the same as well*— Now watch (it is cut). Draw it yourself—(He draws a shape with sides parallel toward the middle but rounded at the ends, each one of which contains a circular figure. He points to the left hand one and says), *You wouldn't see that, but that* (the right-hand one)". Thus, with the section actually made there is some beginning of perspective differentiation though not of the section as such, or any representation in advance.

PER (5; 0) draws the transverse cylindrical section as a short rectangle representing one half. "Have you drawn the inside?—*Yes*—Then it's the same as that (complete cylinder)?—*Yes*—(It is cut)—*Ah, it's all round!*" As for longitudinal section (some time later) he draws a long rectangle but rounds both ends. "But will it be rounded here?—*Yes*—And there?—*Yes*—But inside?—*That will be round as well*—(It is partly sectioned to let him see the start)—*Ah! It will be flat!*—Now look at these drawings. Which is the right one?—(He rejects them all one after another). *It's not the same thing*—Then what will it be like?—(He points to his own drawing). *Like that*".

PIE (5; 1). Cylinder (transverse section): an oval. For the hollow ball[1] he draws a small circle, saying "*a little round*—Is that the ball?—*There* (he draws a large circle to one side)". The prism: "*It will be like a roof* (draws a kind of vaulted arch)—Show where this point is (the ridge)—*It isn't a point because the ridge* (the top edge of the prism) *is long*—But if you were to cut it, would you see it like that?—*Dunno* (he draws a square with a triangle on top, then a vague shapeless surface, shaded to indicate the plane of the section)".

PEL (5; 2). For the transverse section of the prism Pel can produce only rectangles, because it will be "*flat inside*". However, his final attempt has a triangular point on one side.

MAR (5; 9). Cylinder (cut transverse and lengthwise). He draws ovals with rounded ends to represent the complete cylinder. Hollow ball: a closed circle, then a round shape, open towards the top to indicate the hole inside.

SUL (5; 11) cannot foresee that a circle will be the result of cutting the cylinder transversely, but draws an elongated oval which takes in the complete shape including the base, the latter hardly differentiated from the rest. Thinking that we had failed to make him understand the question we actually cut the cylinder and straightway asked, "What is it like?—*It's round*—Is that what you expected it to be?—*Yes, you can think now because it's been cut!*" In other words, Sul is of the opinion that a section cannot be imagined beforehand. . . .

FIN (6; 0) draws a rectangle (to represent the complete cylinder) then a short stroke across the middle (to indicate the transverse cut). "But if you look at it endwise, like this (showing him the base), what will the cut part look

[1] It should be remembered that when we asked for the section of the hollow ball to be forecast we always told the child in advance that the ball was hollow.

like?"—He proceeds to draw half a rectangle, then a rectangle with rounded ends each of which contains a circle (just like Ebe's final effort), and finally a single circle placed within a rectangle which is left open at one end. Shown the sample drawings he rejects the circle as a picture of the section.

ARL (6; 3). For the transverse sectioned prism he cannot confine himself to showing the triangular face but draws a rectangle (i.e., one side of the prism) with a triangle at each end. For the longitudinal section he draws a long trapezium, saying *"There's one line that's tilted and one that's straight"*, and proceeds to select a parabola from the sample drawings. Once the section has been cut he draws the rectangle without any difficulty.

Parallelepiped (longitudinal section). He draws a large rectangle but places within it three small rectangles, two at one end, a third at the other. "What's that?—*You'll see three sides*".

BRU (6; 5). Cylinder (transverse section). *"It will be all red*—But what shape will it be?—*Flat* (draws a large square and shades it in)—And if you were to cut it like this (longitudinally)?—(He draws a long rectangle but with a line outside it indicating half of the cylinder opened up)—And this hollow ball, if you were to cut it through?—(He draws an oval, the upper half containing a well-formed circle, half of whose circumference is run together with the boundary of the oval).

These results merit close examination. It would be altogether too naïve to suggest that the child does not understand the questions and feels compelled to draw the entire half of the object to be sectioned, merely through having failed to grasp that he was only required to draw the sectional surface. For there are two immediate answers to this objection. Firstly, the children of Substage IIB who gradually arrive at the correct solution, still make the same kinds of errors as those of IIA, in spite of the fact that they understand the nature of the problem (as is evidenced by their partial success in solving it). Secondly, the children reported above do not draw the entire object in order to represent the sectional surface more effectively, this last not being neglected but merely remaining undifferentiated from the drawing as a whole, which is the most the child is capable of in the way of abstraction.

To understand these results properly it is perhaps best to relate them to the general pattern of the child's approach to projection. To begin with, let us suppose that instead of asking the children to draw the sectional surface in advance we had confined ourselves to having him draw it after the cut had been made. This would have reduced the problem to that of Chapter VI, namely, imagining an object according to a particular perspective, or reconstructing the visible portion from a given viewpoint as opposed to showing the whole object. Now we know that at Substage IIA the child cannot yet clearly distinguish a particular viewpoint, for his attention still rests centred on the shape of the thing as a whole, just as he habitually perceives it and draws it according to

his "medley of viewpoints". Similarly, we know that with shadow projections (Chapter VII) or imagining a group of objects (Chapter VIII), he reacts in just the same way since the pattern of the global whole still frustrates any attempt at analysis of the parts.

With sections, two new factors intervene, one tending to make the task of imagining the cut surface easier, the other to make it more difficult, though less so than at first appears. However, neither of these factors cause any noticeable deviation from the average level of projective notions at this substage.

The first of these new factors derives from the fact that what the child has to imagine is the outcome of cutting the solid. As this is a euclidean operation which actually changes the shape of the object and not merely its perspective, imagination tends to dwell upon the final result of this change. As against this, the second factor complicates matters considerably because instead of making the section we ask the child to imagine the result of a potential, future cut, and hence to envisage projectively the interior of the object cut by an imaginary plane. However, it is common knowledge that at the stage where neither projective nor euclidean relations are distinguished from simple topological notions such as enclosure, etc. (see Chapter II §2), the inside as well as the outside of the object will of course appear in the child's drawing. For example, the inside of a house is shown as if the building were made of glass, potatoes are shown below the ground or in a person's stomach, and so on. The second factor is therefore less of an obstacle than might have been supposed, except that this 'interior' cannot be imagined projectively any more than the section sketched can be envisaged in a truly euclidean fashion. Moreover, the child continues to produce drawings containing a medley of viewpoints in which diagrams of the cut solid seen from inside and outside simultaneously, the section along the path of the knife, the surface of the section, etc., are jumbled together in random fashion with no attempt to distinguish between any of the different 'points of view'.

Thus, the results show two main types of reaction. Firstly, the interior 'point of view' presented by the cut surface is neither better nor worse differentiated than is any other perspective or projective viewpoint relating to the same solid. Secondly, the drawing which purports to show the sectional surface is actually an inextricable mélange of every possible viewpoint, even including (though lacking precise differentiation) that of the interior itself.

We see that Bra, for instance, illustrates the transverse section of the cylinder by an ellipse having a pair of long sides and circular ends, all together in the same plane. Ros draws a square to indicate the right-angle made by the transverse cut on the cylinder and an acute angle to represent the gash made by the knife on the edge of the prism, though he

closes both the square and the angle to form a boundary for the cut surfaces. Ebe's first concern is with the solid interior of the object as its outstanding feature ("it's the inside, it's all filled in"). To invest this content with some sort of form he then expresses the surface of the lengthwise section by an ellipse and the ends of the cylinder by a pair of circles, all of these figures being part of the same drawing. Fin first bisects the rectangular outline of the cylinder by a line which marks the actual path of the cut, then draws half a rectangle for the portion cut off and finally puts one circle inside the closed end and another inside the end which he has deliberately left open. In this way all the different viewpoints are either successively or simultaneously jumbled together.

The shape most favoured in the case of cylindrical section is therefore one that tends to link the image of the object's general structure to that of some sectional surface, often with the addition of a line or an angle to indicate the commencement of the cut. The proof that the child fails to recognize the actual shape of the section, despite the inclusion of some sectional plane or other in his drawing, is firstly that he fails to recognize circles or rectangles as sections of the solid when he is shown the sample drawings. And secondly, that he is always completely dumbfounded by the shape he sees when the section is cut. "Oh, it's round!" says Bra and Per, while Sul, the brightest of them all, remarks, "You can think now because it's been cut!"

The outcome is exactly the same with section of the prism, the parallelepiped and, despite its apparent simplicity, the hollow ball. Again the different viewpoints are confused and unco-ordinated, the child being unable to distinguish the sectional surface from the contour of the intact solid. Thus, Per draws the transverse section of the prism as a vaguely rectangular shape (because it will be "flat inside") tacked on to a little peak representing the edge cut by the knife.

Substage IIA as seen here corresponds to the same failure to distinguish different points of view as was seen with perspectives of single objects or projections of their shadows in Chapters VI and VII. Substage IIB continues this parallel development for it marks the beginning of discrimination between planes, inasmuch as the sectional surface is in certain instances now separated from the general outline of the object.

Ans (6; 2) begins, like the children of Substage IIA, by drawing a long rectangle for the transverse section of the cylinder. He then bisects it with a transverse line and draws a second rectangle less than half the length of the first. "But can't you draw just the cut side?—*It isn't easy if it's not cut. No, I don't know how to* (he looks at the knife poised over the cylinder and rounds the ends of his rectangle). *Ah, it'll be round* (he draws a circle)". With the prism however, he misses the triangular shape completely and makes do with a kind of rectangle.

REN (6; 3) begins in a similar way with a bisected rectangle indicating transverse section of the cylinder, adding a pair of circles below each end (just like Ebe in Substage IIA). When we begin to cut the object he draws a new rectangle and rounds the ends, finishing up with an ellipse. For the lengthwise section he again starts with a rectangle with a circle under each end, then joins them by a line to indicate the face of the section, concluding his performance by drawing an irregular figure somewhat like a trapezium.

RAU (6; 4) realizes immediately that the transverse section of the cylinder *"will be round"*. For the longitudinal section he draws, by way of contrast, a circular arc with a chord. *"There* (the arc) *is that* (the curved surface), *there* (the chord) *is the line that's cut* (the sectional plane)" Only after the cut has been made does he draw a rectangle. For an oblique section (ellipse), however, he very nearly brings it off: *"I can't draw it*—Then pick it out from these drawings—(he points to the parabola) *That's it*—Why?— . . . —Could it be any other?—*That's it as well* (ellipse)—And that (triangle)?—*No*—And that (circle)?—*It could be like that one as well*—Then choose one (circle, parabola, ellipse)—(He looks at the cylinder). *If you cut it straight across, it's round. But if you cut it like that* (oblique) *it'll be like that* (ellipse)".

MAY (6; 4). For longitudinal section of the parallelepiped he starts to draw a short horizontal line, then a rectangle bisected by a line and finally a simple rectangle. But for longitudinal section of the cylinder he draws two parallel lines and leaves them unconnected. The drawing of the sectioned hollow ball ends up as a circle lacking part of the periphery (like a cake with a slice cut out).

LET (7; 2). For transverse section of the cylinder Let starts by drawing a rectangle with ends rounded, then puts a circle inside one end and remarks, *"There at the end it's round, so if you cut it in the middle it will be round there as well"*.

MAG (7; 4). Longitudinal section of the cylinder: *"It will be oval* (draws an ellipse). *No, it will be the same as the outside* (draws rectangle)". For the hollow ball he draws a hemisphere resting on a straight line and containing a semi-circle to indicate the hole. Thus, we have a direct lateral view of the section itself, plus a view of the act of cutting it indicated by the straight line.

VAR (7; 7) begins by drawing a triangle with curved sides for the oblique cylindrical section. He then says, *"I can't do it. I'd feel happier if you cut it"*. We refrain from doing so and ask him to guess the shape instead. He draws the cylinder seen from one side in the form of a rectangle, tracing a diagonal across it to mark the section. This done, he rounds each end of the oblique line, ending up with an open ellipse. For the transverse section he draws a circle without the least hesitation.

Starting from the confused jumble of viewpoints seen at the previous level, a visible increase in discrimination takes place as this substage proceeds. The reactions described above illustrate very clearly the mechanism of this process, which mainly takes the form of an interaction between euclidean and projective concepts. That is to say, between the idea of movement and the changes of viewpoint which result from it. It should be borne in mind from the outset, that mutual

interdependence between euclidean and projective concepts is the general rule, not only for geometrical sections but within the entire field of perspective and projection.

At the level of topological notions no distinction is drawn between movements and points of view. As soon as this level is left behind it is euclidean ideas of displacement or change of position which lead to the earliest conceptions of perspective and projection. Conversely, it is the perspectives and projections which enable the child to distinguish different positions and consequently to visualize movements for himself. This is precisely what takes place with sections. The actual movement involved in cutting a section constitutes a euclidean operation whilst the changes of viewpoint which result from it constitute a projective operation. That is to say, visualizing a section implies cutting through various different solids, imagined in projection, along some imaginary plane.

We will try to follow the main drift of the child's thought, setting it in some sort of order, but in such a way as to bring out what is more or less common to all the subjects described above. The point of departure is a drawing of the object itself, but one which contains, just as at Substage IIA, all the various different viewpoints jumbled together. For instance, the cylinder is a long rectangle with two circles near or inside the ends to indicate top and bottom (see Ren and Let). This preliminary sketch is therefore neither truly euclidean nor projective, but simply undifferentiated and still dominated mainly by topological proximities and enclosures. Next to appear is the representation of the act of cutting itself, and thereby the movement or idea of euclidean displacement. Thus, Ans draws a line cutting his rectangle transversely (and shows in turn, the rectangle cut in half as a result of the section). Ren draws a similar transverse line and also an oblique line for the longitudinal section which joins together the circles at each end of the figure. Rau represents the section by means of a chorded arc, May by the midline of a rectangle, Mag by a stroke closing a hollow hemisphere, and Van by a diagonal.

The third phase consists of curving these various lines to adapt them to the shape of the cut solid. This is extremely important for it marks the transition from the euclidean idea of an actual cutting movement (shown by a simple straight line) to the projective rendering of the sectional surface. Nevertheless, having got as far as imagining the surface of the section, the child is unable to go further and visualize its periphery, the line along which the knife cuts into the solid. This is why Ans looks at the knife poised over the curved edge of the cylinder and then proceeds to round the ends of his rectangle. Ren does exactly the same, whilst Var curves the ends of his diagonal to form an open ellipse, and so on. Having at last produced this semi-euclidean, semi-projective

drawing (a kind of 'development'[1] of the path of the knife), the child can now imagine the cut surface projectively. "It will be round", says Ans after rounding the corners of his rectangle. Ren concludes his performance with an ellipse for the cylindrical cross-section, while Let passes directly from the first to the last of these phases by making use of the analogy between the base and the section of the cylinder.

Finally, at the level of Stage III, projective representation of the sectional plane, i.e. the sectional surface proper, is achieved instantly and directly. This result is obtained by Substage IIIA in the case of the cylinder, prism, parallelepiped and hollow bowl.

ALO (5; 8, advanced). Longitudinal section of the cylinder: "*It will be perfectly flat* (draws a rectangle)—And like this (transverse section)?—*It will be round*". Hollow bowl: he draws a small circle inside a large one.

DAN (6; 8). Same reactions with the cylinder. For the bowl he draws a circle saying, "*It will be hollow inside*", then puts a small circle inside the first.

DOLS (7; 2). Transverse section of cylinder. "*It's like that* (draws a circle)—And if it were cut here (longwise)?—*It would be like that*" (rectangle)—And this (transverse section of prism)?—(a triangle).

GER (7; 11). Cylinder, transverse section: "*A round*—And if it were cut across the diagonal (ellipse)?—*It would be like a tree trunk, like that* (an oval)". Asked to pick out the oblique section from the sample drawings he rejects the parabola on the grounds that "*it must be round at the bottom as well*".

Two questions arise from the reactions described above. Firstly, does the fact that the child represents the sections immediately, prove that he conceives them projectively? Secondly, why should sections be imagined and drawn more easily than general perspectives or projections of the same or similar types of object?

As regards the first question, there can be no doubt whatever that these really are projective sections, if for no other reason than their being drawn almost instantaneously—as compared with the way they are arrived at in Substage IIB—and moreover, in advance of the solid having been cut (i.e., before euclidean section).

Even we ourselves as adults can only visualize a solid such as a cylinder or a prism in perspective, because although we can consider a surface as if it could be checked through some real or virtual congruence (measurement) we cannot do the same with a solid. True enough, for the purpose of measurement we can imagine a series of little cubic blocks filling the whole of space, all equal however distant, but we can only establish their equivalence with any degree of accuracy through the congruence of their boundaries and interfaces, never by the direct congruence of their volumes. This is why a solid can never be visualized in the same way as a line or a surface, by a simple juxtaposition of successive viewpoints, each resulting from the direct application of an

[1] See Translator's Notes.

object to some part of the line or surface (congruence). Consequently, to imagine a solid it is necessary to co-ordinate a number of different points of view; in short, to create an imaginary projection. This being the case, when the child belonging to Stage III attempts to visualize the sectional surface before it has been cut, and therefore prior to any movement, he has to imagine the solid projectively, just as if it were a bundle of straight lines, and then cut this bundle along some equally imaginary projective plane. In this sense we are perfectly justified in saying that representing a euclidean section necessarily implies its being conceived of projectively.

This brings us to the second question. Why is this task easier for the child than that of representing perspectives or projections (such as those cast by shadows) of the selfsame objects? For instance, the cylinder used in the present experiments is directly comparable with the stick or the pencil used in the experiments of Chapter VI. But the circular shape of the cylindrical section is often discovered as early as Substage IIB whereas the circular perspective of the stick seen endwise is not achieved until Stage III. This is undoubtedly due to the fact that the connection between euclidean displacements and projective viewpoints is less direct with perspectives than it is with sections where the actual movement of cutting follows the contour of the solid itself. In particular, section of the solid brings about a specific new shape, whereas rotation of the object or movement of the observer only modifies, in terms of viewpoints, the balance of the relationships which characterize the object. However, it is with the conic sections that this as yet slight distinction becomes well marked.

§2. *The conic sections*

We now intend to apply the same method of investigation to conic sections, setting the children four problems which deal with: (1) section parallel with the base, giving a circle: (2) vertical bisection, yielding a triangle: (3) oblique section, giving an ellipse: and (4), oblique section, through the side and base resulting in a parabola.

Again we find the same three stages of development and we give below a few examples from Substage IIIA.

Ros (4; 6). "What is this one (a cone)?—*A steeple*—Very good. Now if I cut it like this (triangle) what will it look like from the side where it has been cut (he has already performed the cylinder experiment correctly)?—(Ros draws a circle then a triangle with a curved base, thus representing the complete half cone)". Horizontal section: "*It will be flat* (he draws a vaguely circular closed shape)". Parabola: he draws a large circle, "Show me where I must cut it—(With one finger Ros indicates the correct outline of the section and then draws a cone cut by a vertical line)—And this (his drawing of the circle), where is this?—(He points to the base of the cone)—But is that all

you'll see if you cut it like that?—*No* (he puts a point in the centre of the circle to indicate the apex)—But just draw the part where it's cut, as if you were hiding the rest with your fingers—(He draws the entire cone)—But if I take this part away (showing the intended section on the cone) what will you see?—(He draws a square and points to the upper side as representing the summit of the parabola and the laterals as its two sides)—Look at these drawings; which is the right one?—(He chooses the square and the rectangle) —Why these?—*Because it's been cut*—And those (ellipse and parabola)— *Perhaps*—But which one is the nearest?—(The rectangle)".

PIE (4; 11). Horizontal section: "(He draws two circles one above the other) —Is that right?—*Yes, because it's round inside* (he proceeds to connect the circles by two lines to show that the upper is the section and the lower the base of the cone). *No, it will be long, because that* (the cone) *is long* (draws an oval). *No, that isn't right* (draws a horizontal line to show the cut, surmounted by an arc to indicate the periphery of the cone)".

The ellipse: he draws a cone cut by an oblique line thus correctly indicating the plane of the section, then draws a kind of triangle with rounded apex and base. When offered the sample drawings he rejects all but the triangle. We then draw for him a shaded ellipse, a shaded rectangle and a pair of long, irregularly parallel lines. From this assortment he chooses the last named *"because it will be long through the middle"*.

Vertical section: he draws a circle topped by a triangle (together representing the cone entire) and then cuts the circle by a stroke indicating the section.

PER (5; 10). Horizontal section: he draws a kind of fan, then rubs out the apex leaving only a semi-circle. Vertical: he starts by drawing a shaded area without a boundary, vaguely rectangular in shape, saying, *"It's flat*—And the shape?—*It will be round* (indicating the base) *and all straight* (vertical section)—Like this (a drawing of a triangle)?—*It's like that now, but when it's cut it will be round"*. From the sample drawings he chooses the rectangle as one of its angles show the peak of the cone and its surface the sectional plane.

JOR (6; 2). For both elliptical and parabolic surfaces Jor predicts circular shapes because *"If you look at it from the top* (of the cone) *you'll see that it's round*[1]—But if it were to be cut like this (parabola)?—*It would be very like, but only here* (upper portion of the parabolic curve is roughly sketched). *It must be round. You can put it on top of the drawing"* (he places the cone on the circle as if this proved his point. (N.B. Note[1].) Oblique section: he begins by remarking, *"If you cut it through it would make that* (draws a cone intersected by an oblique stroke)—But if you looked at the inside?—(He draws an irregular quadrilateral)—choose the nearest one from these drawings— (he selects the rectangle)—How is it cut?—(He points out the correct outline on the cone). *You cut it from here to here*—And will this drawing (ellipse) be all right?—*Maybe, because it will be like this all the way round* (indicating the edge of the section)—So which drawing will be the best?—*That one* (pointing to the rectangle) *and not that one, because that's too wide. It'll be that one*

[1] Note that the way in which he expresses himself does not mean 'relative to this point of view, the cone is round' but rather 'this point of view enables one to discern in the cone the inherent property of being round'.

(rectangle) *because it's flat"*. Even so, returning later to the same problem he draws a kind of trapezium and chooses a rectangle from the samples *"because it won't be round, it will be square"* (he has in mind the angle between the base and the side of the cone).

The extent to which these results bear out those of Substage IIA for the cylinder, prism, etc., is obvious enough. In each of these cases the child cannot yet manage to abstract the actual surface of the section for the simple reason that, wanting to see the whole thing all at once, he fails to consider it according to one particular perspective. As a result he cannot separate mentally the side which is to be cut, nor imagine it co-ordinated with the remaining sides.

For the sections parallel with the base (circular) or centrally perpendicular (triangular) to it the problem is closely analogous to transverse or longitudinal section of the cylinder. Although the child feels quite sure that the cut surface will be roughly circular for the horizontal and similar to the outline for the vertical section, nevertheless he cannot manage to abstract this in the form of a simple circle or triangle. Thus, although he states quite clearly that "it's round inside", Pie still feels compelled to show the base and sides of the cone in addition to the circular section, thereby indicating that the circle represents not so much the sectional surface as the line of incision. Again, when he wants to abstract the surface of the section itself he starts by drawing an ellipse to indicate the height and the base of the cone at one and the same time and eventually returns to a drawing combining all points of view. In a similar way, Per deals with the triangular section by trying to indicate simultaneously the cut surface ("it's flat"), the rounded base, and the height ("it's round and all straight") despite the manifest impossibility of showing all this on one and the same plane!

As for the ellipse and parabola (which have been discovered by Stage III and are thus not beyond the comprehension of a 7–8 year old), the attempt to represent these sections naturally accentuates even more sharply the tendency to combine different viewpoints in the same drawing. Hence Ros, trying to imagine the kind of surface that will result from the cut between base and side (parabola), looks at the cone from above and begins drawing a circle with a central point to show the apex. Jor starts in the same way and concludes that the circle is an essential attribute of the cone ("it must be round") so that the parabola is degraded to a circle. For the ellipse which he can perfectly well trace with his finger around the periphery of the cone, Jor has to draw a rectangular surface simply "because it's flat".

In the course of the next substage, that of IIB, the jumble of different viewpoints is gradually replaced by discrimination between them.

CHA (5;]10) discovers that section parallel with the base results in a circle

through directly comparing the latter with the base of the cone. For the vertical section he begins with a circle but rejects it *"because it won't be round inside"* and thinks it will be a rectangle *"because it's flat"*. On the other hand, for the section through the side and base, after remarking that *"it will be a little round"*, he studies the intended section carefully and observes *"it'll have to be made flat like this* (an ellipse); *that will be nearer to it"*. Finally, when we start to cut the section he decides on the parabola, having noticed that the descending sides will never meet. For the oblique section (ellipse) he draws a circle but after tracing the actual path of the section round the cone he eventually selects the ellipse from the sample drawings.

Clav (6; 2) draws a round shape for the circular section and then adds a triangular peak. However, he immediately rubs this out. For the ellipse he starts with a rectangle and then says, *"If it were cut through . . ."* and chooses an ellipse from the samples without finishing the sentence. On the other hand, he is unsuccessful with the parabola.

Ans (6; 2. Reported in §1. for transverse section of the cylinder). Horizontal conic section. He says, *"It won't have a top"* and draws the peak, only to erase it again, then adding, *"afterwards it will be like that* (pointing to the base). *After it's been cut, it's round; because it's pointed one end and round the other. If you cut the cylinder it's round just the same"*. Vertical section: *"It'll always make this shape* (the triangular outline of the cone which he had just begun to draw). *Oh yes, it's a triangle!* But he is evidently still in some doubt for he proceeds to make the base of the triangle curved. Parabola: *"It's rather difficult. If you cut off a little piece it'll look like that* (he draws a cone with a portion missing, seen in profile)—But what will the part you've cut look like? —(He draws a triangle, one side convexly curved, the other concave, then places a small circle within the concavity. Next he starts to draw an ellipse but realizes almost immediately that the two sides will never meet)".

Mag (7; 4. Reported above in §1.). For the horizontal section he draws a truncated cone seen side elevation, then a circle. Parabola: first of all he indicates the section with a vertical line down the centre of the cone, then draws a rectangle, studies the actual line of the cut and rounds the corners of the rectangle. He finally replaces this with a triangle inside which he draws a parabola. For the elliptical section he starts with an oblique line; *"here it's on a slope"*, then says, *"it's round"* and goes on to produce first a kind of circular arc, then an elliptical arc chorded by a straight line and finally a tilted ellipse. From the assortment of drawings he chooses an ellipse but remarks, *"Yes, but you've got to see it sloping"*. That is, the axis must be kept inclined.

At the start of all these reactions there appears the same medley of different viewpoints as was found at the previous level. Right throughout Substage IIA, however, the sectional surface remained undifferentiated from the rest of the solid, since there was no attempt to relate it to other aspects. Instead it was simply put alongside other planes. Its 'flat' character was affirmed although the periphery could not be separated from the outline of the whole in advance of the section being cut. As against this, in the reactions seen here, the joint development of

co-ordination and differentiation enables the section to be separated from the shape as a whole by mentally comparing the piece cut off with the remainder of the solid and imagining it placed against the line of cut to determine the shape of the surface enclosed. It is somewhat difficult to follow the actual steps by which this advance is achieved, but it is possible to see the gradual emergence of euclidean concepts (as in the case of the cylinder, etc. §1.), and correspondingly, the interrelation of successive viewpoints which accompanies these movements.

While in Substage IIA the line of section is simply placed alongside other aspects of the figure, it now becomes the symbol of a new point of view, distinct from the previous ones and co-ordinated with them rather than merely juxtaposed. At the same time, this process is still purely intuitive and fails to attain an operational form.

In contrast to this, during the course of Stage III the child becomes capable of imagining sections directly and immediately, and of co-ordinating them with the whole family of projective solids. In this way the concept of the section becomes fully operational.

PAU (6; 4). Horizontal section: *"It's round because it's the same shape"*. Vertical section: he straightway draws a triangle. Elliptical section: he studies the roughly marked edge of the future cut and says, *"it will be shaped like this"* and draws an ellipse. Parabola: he looks at the line of cut carefully, then immediately draws a parabola with a straight line as the base.

MORT (7; 11). Circle: *"It will be round because the bottom* (base) *is round"*. The vertical section is drawn correct right away. Parabola: *"It'll be square because you cut it here. No, it'll be round at the top* (apex of section)*"*. He then draws a parabola. Ellipse: *"It'll be the same only without corners* (the angle at the base) *but not perfectly round because it slopes downward"*. He draws an ellipse.

BAL (8; 0). Parabola: *"It'll be round. No, because it goes down to the bottom it'll have corners"*. He immediately draws a parabola. Circle: *"It'll be round like the bottom"*. Ellipse: *"Round; no, stretched out a bit"*. He draws an ellipse.

It may come as something of a surprise to find the child able to predict the shape of conic sections as circles and ellipses by the beginning of Stage III while we have to wait until Stage IV for him to be able to forecast the identical shapes cast by shadows (see Chapter VII §5.). And it is even more surprising to find children of a mental age of 7–8 discovering the shape produced by cutting a solid by imagining the action as it occurs before it has actually taken place. In the case of sections produced by projecting shadows, however, the various sectional planes surround or enclose one another in such a way that the child has to imagine the largest cross-sectional area of a cone as obstructing the rest of it. With the present experiment he has only to envisage the shape of the cut made by a knife. As for the parabola, this is derived from nothing more than a rectangle with its upper end rounded, or

a circle with its lower half opened out, as may be seen from the examples of Mort and Bal. Once the child has overcome the problem of relating the idea of movements producing a sectional line, to the idea of viewpoints forming a projection of this line and an image of its surface, it is no more difficult for him to construct parabolas than to draw circles, ellipses, or triangles.

§3. *The sections of complex objects*

The shapes so far discussed were chosen with a view to comparing their sections with their perspective projections as studied in Chapters VI and VII. Considered solely from the standpoint of objects employed to study sections they suffer from the disadvantage that their sectional shapes tend to resemble their intact shapes rather too closely, or at any rate, some particular aspect of them. Indeed, it might well be wondered whether or not the medley of viewpoints regarded as typical of Substage IIA was to some extent a product of this very circumstance. For this reason we have tried to check the earlier findings by examining the transverse sections of more complex solids.

With this aim in view we made use of the following objects: (1) A closed annular ring of plasticine having a circular cross-section. (2) A similar ring of square cross-section. (3) A pair of circular discs connected by a parallelepiped. Transverse section gives a short rectangle and longitudinal section a longer one. (4) A four-pointed star whose section across the points gives a long rectangle and section across the root a short rectangle or a square. (5) A cornet formed by rolling up two different coloured sheets of plasticine in front of the child. (6) A flex or twist made of two intertwined strips of differently coloured plasticine. (7) A helix made from a strip of plasticine wound round like a long snail shell or a corkscrew.[1]

These shapes cover a far wider range of complexity than the previous more simple ones. Nevertheless, they show, even more clearly than the past experiments, that at Substage IIA the child remains absolutely incapable of abstracting the sectional surface from the general structure of the object. Here are a few examples illustrating this substage.

PIE (5; 1) shown the ring (1) draws a semi-circular line broken by a gap of a few millimetres. "Why have you left a gap there?—*Because it's cut*— But I only want you to draw what you'd see inside, where the knife goes through—(He draws a short vertical line)". Similarly with the second ring, he draws only a vertical line. For the snailshell he starts to draw a spiral, but when we ask to be shown the sectional surface he produces only a pair of lines symbolizing the act of cutting the two sides. Shown the sample drawings he rejects them all, for they do not correspond to the external shape of the

[1] With all the above shapes we naturally do not ask for absolutely perfect drawings. In any case, sample drawings can be shown for the children to choose from.

objects. In the case of the cornet sectioned transversely, he cannot envisage the enclosure of one sheet by another and simply draws a pair of horizontal differently coloured lines, one above another (and not a spiral of interleaved sheets).

MAR (5; 9) also draws the ring (1) as a broken circle. "But what will you see inside where the knife goes through?—(He repeats his original drawing) —Look (the ring is cut)—*It's round!* (he draws the circular section)—And with this one (square ring (2))?—(He draws a pair of lines to show the cut)". The pair of discs (3): he draws the entire object with strokes indicating the cut. "But the inside?—(He draws a new, vertical line). *The knife goes through like that*—But it won't be just a line, what will you see inside?—(He slowly alters a line to suggest the plane)". For the snailshell he is content to show the external appearance. For the cornet he puts a red circle inside a green one, ignoring the spiral effect he has just seen produced as he watched the sheets being rolled up.

SOL (6; 6). The pair of discs: he reproduces the general shape cut by a line. The star (long section): he draws two arms seen from above, ignoring the other two. The flex (6): "*It will be perfectly flat*" (draws a rectangle). The cornet (5): he draws a small red square inside a green rectangle and touching one of its sides. Snailshell: he simply draws a line indicating the cut.

DAN (6; 8). Ring (1): a circle cut by a line: "But draw what it looks like inside—*I think that's what I've done*—Watch (it is cut)—*Oh, a circle!*—And with that one (ring (2))?—*That'll be round as well*—Why?—(He points out the circular shape of the ring as a whole)". Pair of discs: he draws the entire object, then a plane surface with no definite outline. The star: he draws an acute triangle representing one of the arms.

RY (6; 10). Pair of discs, sectioned longitudinally. He draws the whole object cut transversely by a line. He is then asked to fashion the half of the object in plasticine, using his own drawing as a model. "*I dunno, I've never done that*—But could you have a shot at it?—*Yes* (he makes it correctly)— Good, now try and make it cut in half like your drawing—(He entirely remodels it, making it slimmer, as if the bisection were lengthwise and not transverse as his own drawing indicates!)—(The original object is now sectioned). Is it like that?—*No, I can't do it. I can do the whole thing, but the half of it I just can't manage!*"

Before pausing to discuss these results we will continue with some examples from Substage IIB, where, as might have been expected, the children begin to differentiate between the sectional surface and the various elevations of the complete object.

MET (6; 6) draws the ring (1) as half a ring seen from above, "No, just the end where the knife has cut it—(He then draws a small circle, but puts another circle inside, confusing the shape of the section with that of the complete ring.) *Ah, no* (he draws an ordinary circle)—And what about this ring (2)? —(He immediately draws a square)". Similarly with the snailshell, Met draws the whole spiral though he understands perfectly well that it is a question of showing the sectional surface. Following this he replaces the spiral by a sort

of S-shaped hook, and then by a rectangle inside which he draws a series of circular arcs (nearly correct except for the slope of the spiral turns).

PAR (6; 8) draws the ring (1) immediately as a small circle, but he also draws a circle for ring (2). "You really think so?—(He looks first at one side then at the other.) *Oh no, it'll be square!*" For the pair of discs (3) cut lengthwise he starts by drawing a line similar to a bracket (⌐⌐) and showing only one half of the external outline of the object, then tries to correct it but without succeeding in producing a rectangle. For the transverse section he draws a semi-circle (same principle, half of the external outline) and eventually achieves some sort of square. For the star (4) he begins with a circular arc, then proceeds to draw the rectangle required. On the other hand, the flex results in a drawing of a long ellipse surrounded by a series of little arches all joined together but not inclined at an angle. For the cornet (5) he starts with a red circle surrounded by a green one, then begins to make them into a spiral, while the snailshell (7) is drawn as a simple wavy line.

In the course of Stage III (7–8 to 10–11 years) the shapes 1–4, which present no greater difficulty than the solids used in §1. and §2., are dealt with satisfactorily (except for a slight delay in mastering the discs and the star). As against this, shapes 5–7, which introduce the spiral principle, are not yet mastered despite the children's persistent efforts.

GIL (7; 4) starts his snailshell (7) as a closed figure in the shape of a kidney bean, then as a knot with numerous intertwinements though without any spiral appearing. The cornet (5) results in a circular arc with the outer portions red and the inner ones green. The flex (6) appears as a wavy line.

JEA (7; 9). The snailshell (7) is drawn as a series of circular arcs inside a boundary line. The cornet (5) is a series of circular arcs superimposed one on top of another. The flex (6) is drawn similarly to the snailshell. Not one of these figures contains the least suggestion of a spiral.

DID (8; 2). The flex (6): Two series of symmetrical rings like the section of a curled-up worm but not twisted or spiralled in any way. The snailshell (7): The same idea but this time in a globular form, rather like the section of a head of cauliflower, though with a suggestion of a spiral.

MIC (8; 6) Snailshell (7). He begins with a circle and then draws arcs superimposed one on another. The cornet (5) gives rise to a drawing of concentric circles but without any spiral. The flex (6): "*It's a hole running from top to bottom with circles all round it*". He produces two parallel lines which also indicate a hollow portion in between them together with a series of arches rather like those drawn by Did.

GRIS (8; 6) draws the cornet and the flex similarly to the previous children. But she draws the snailshell in the form of hollow bowls piled one on the other, each being joined to the next by a circular arc. These arcs are not placed in line, however, but spaced further and further apart, suggesting the rudiments of a spiral.

EPL (9; 3). For the cornet he draws a simplified spiral and for the snailshell, a series of bowls one on top of another.

DEP (10; 2) with the snailshell, demonstrates very nicely the advance towards the spiral. He begins with bowls piled one on the other, then sub-

stitutes semicircles for the bowls, then enclosed circular arcs, next a gradual curving inwards and finally, an exact drawing of the section of a spiral or a screw. The cornet at first results in concentric coloured circles and then the beginnings of a spiral.

ROU (10; 4). Snailshell: He starts by drawing a coil seen from the outside and then cuts it with two parallel lines. Now he begins a new drawing representing a half of one turn of this coil seen from above, but ignoring the sectional surface. At the same time he succeeds in drawing a simplified section of the cornet (having only a single turn).

VUA (10; 8). The snailshell: He draws a vertical line cut by a series of horizontal strokes, then in a second drawing makes them oblique and lastly, a much simplified section of corkscrew. The cornet results first in a series of concentric circles, alternately red and green. He then begins joining one to another in a way which anticipates the spiral. However, he fails to master the flex (6).

Last of all comes Stage IV, towards 11–12 years, where we find the child able to solve immediately the problem of sectioning the Cornet and the Snailshell, though the Flex is not yet completely mastered.

VENT (11; 2). Snailshell: A series of tilted ellipses is superimposed one on the other to give a spiral section. The Cornet: First, a spiral in green crayon, then one in red, following the same path. He cannot manage the Flex.

BURG (11; 6). Snailshell: Right away he draws a series of tilted ellipses, one upon another thus, giving a correct section. He draws the cornet similarly to that of Vent. The Flex he reduces to the section of a screw resembling the snailshell.

These interesting results illustrate each stage in the development of sections. The process starts from a jumble of viewpoints where there is absolutely no differentiation between the section and the external shape of the object as a whole (Substage IIA). Next comes a gradual differentiation of the sectional surface, though it is combined with other aspects of the figure (Substage IIB for simple shapes, Stage III for spirals), while last of all the surface of the section is rendered exactly (Stage III for simple shapes, Stage IV for spirals and twists).

The data from these further experiments enable us to resume the discussion, broken off at the beginning of this chapter, on the relations between projective and euclidean operations. If it is taken as agreed and understood that a euclidean solid can only be conceived of projectively (in geometry of viewpoints), and conversely, that the viewpoints inherent to projective space are always relative to positions or movements carried out in euclidean space (geometry of objects), how then do we explain the initial inability to represent sectional surfaces, on the one hand, and their eventual representation on the other?

The main conclusion to be drawn from the initial reactions seen in Stage II (and throughout Stage III for spiral shapes) is that the difficulty

of representing a sectional surface is due, in the last analysis, to the child's persistent inability to distinguish between geometry of viewpoints and geometry of objects. This shortcoming is equally the real reason for failure to solve similar types of problem in the realm of perspective and projection (Chapters VI-VIII), but it stands out most sharply in the case of the section, which is precisely why we have chosen to discuss it here.

At the outset, simple topological notions enable the child to think solely of the object in itself, unrelated to other objects save by way of relations such as serial enclosure or homeomorphic correspondence (Chapters I-V). But he soon finds himself compelled to venture further and link things together, either through an entire conceptual system of grouped displacements (measurement, distance, length, co-ordinates, etc.), or else by linking them with different points of view co-ordinated globally (perspective, projection and section).

Further, since these two global concepts have to be linked together in order to be applied, it is hardly surprising that the child, so long as he is still dominated by primitive topological ideas, is unable to distinguish euclidean from projective relations, for both are yet hardly by way of being formed. To predict the shape of a section he must imagine the euclidean operation of making a cut (object geometry), and at the same time envisage a projection of the solid in order to separate the 'interior viewpoint' of the sectional plane (viewpoint geometry). Consequently, when a 4–6 year old child (who is just learning to draw circles and squares) is asked to guess the shape of a section, it is only to be expected that he will leave all the different relationships jumbled together.

Thus these drawings all show, as part of a single context, the outline of the intact object along with a jumble of various different planes, the direction taken by the knife, or even the act of cutting itself (a stroke) and occasionally, what the children themselves call 'the flat', meaning the sectional plane, though entirely devoid of either shape or outline. The "medley of viewpoints" found in all the drawings produced by children of this age impedes them from drawing the sectional surface correctly. This is not because it prevents them from thinking of the internal aspect of the object, for on the contrary, 'intellectual realism' always includes some indication of the interior view of a solid, but because it implies a fundamental inability to distinguish between object geometry and viewpoint geometry with the result that it inhibits abstraction of a particular viewpoint such as that belonging to the sectional surface. Consequently, when the child looks at the solid along the line where it is to be cut and tries to imagine what sort of surface it will produce, he is unable to rid himself of distracting ideas about different planes and the general features of the solid as a whole.

However, the progressive discovery of the sectional surface is not

simply a matter of separating viewpoint and object geometry. It also involves a process of interaction, or rather, of ever closer collaboration between the perspective and projective operations belonging to viewpoint geometry, and those of displacement and positioning belonging to object geometry. Hence, to predict the shape of the section produced by cutting a cylinder, a cone, a spiral or a twist, the child has to imagine the exact movement of the knife and the external path it will trace (the line of intersection between the knife and the periphery of the solid). To be able to do this, not only for the side directly facing him but for the solid considered as a whole, requires in turn that the child be able to imagine the solid in projection. In other words, can imagine it from a number of possible viewpoints.

Hence, we find that at each stage of development, the euclidean concept of movement through the solid presupposes a projective concept of this solid with its different planes distinguished from each other, and vice versa. This is true, not only for surfaces, but even for the lines themselves. An example of this, particularly apposite in the present context, is the line formed by the intersection of two planes—in the present case, the line formed by the section of the solid along one plane, and the blade of the knife along the other. Two instances of this are the transverse section of the square ring (Question (2) above) and longitudinal section of the cylinder (§1.). Both of these result in straight lines, either along the sides of the square (section of the square ring), or along the short sides of the rectangle (section of the cylinder, ignoring the tangential planes on the long sides).

Now it is by no means as easy as it might seem for the child to imagine these lines. For at Substage IIB we still find him predicting a circular arc as the result of cutting the cylinder lengthwise (for example, see Rau in §1.), while transverse section of the square ring frequently leads him to expect a circle (see Par in §3.). The line, not simply perceived, but envisaged as the intersection of two planes, does not appear until Substage IIIA, which means that it is just as difficult to imagine as the projective line produced by the method of 'taking aim' (Chapter VI, Section I). This is just what might have been expected, since if the foregoing argument is correct, the intersection of two planes presupposes neither more nor less than operations of projective section performed concurrently with euclidean operations linking one object with another.

In general, the problem of imagining sectional surfaces (or as we have just termed them, intersections of planes) constitutes a clear case of 'shape abstraction', since it is a matter of isolating a particular surface in relation to the general shape of the object. But an 'abstraction' of this nature assumes a far greater degree of activity on the part of the subject than do the elementary shapes discussed in Chapter I and II (haptic perception and drawing). Far from being a simple process of

269

extracting the essential features of the object, this abstraction is one based wholly on the actions of the subject, for it entails not only the coming into play of two types of operation—one related to objects and the other to points of view—but also the establishment of correspondences between these two types of action or operation. The way in which these actions are preserved or recorded in the form of pictorial images still remains to be discussed. But we shall be able to return to this problem, which is one that presents itself afresh at each stage of the process of development under investigation, more effectively when we come to examine the last remaining aspect of the child's growing projective concepts. This is the 'development' of solids and the 'rotation' of their plane surfaces.

Chapter Ten

THE ROTATION AND DEVELOPMENT OF SURFACES[1]

THE study of children's own ideas about projective problems, of which this chapter provides the final example, brings to light a paradoxical situation which demonstrates very clearly how geometrical concepts are formed. On the one hand, projective concepts would seem to depend on visual perception and to do no more than record perceptual data in permanent form. Consequently, objects cannot be perceived otherwise than in perspective, according to complex systems of projection and section. Even when objects retain a relatively constant euclidean size as a result of depth perception, vision still remains euclidean and projective at one and the same time. In other words, even while we perceive an object at its real size it nevertheless appears distorted by perspective.

On the other hand, although such notions may appear to be directly given in perception, they do not emerge on the plane of thought and imagination until an age of between 7 and 10 years. A direct proof of this is furnished by children's spontaneous drawings in which 'visual realism' or perspective is not visible until about the age of 9. That is, about Substage IIIB, the point at which perspective and projection begin to be comprehended, as was shown in Chapters VI to VIII. Thus, the question arises as to why there should be this long interval of several years between the perception of projective relationships and their emergence on the conceptual level.

It is enough to examine with some care the findings of various studies bearing on perception itself to see that the problem is a complex one. In §1. of Chapter I we drew attention to the fact that estimates of perceived size tend to vary with age, and that euclidean "size constancy" is the product of a continuous process of development which goes on, as Beyrl[2] and Brunswik[3] have shown, up to the age of 9 or 10, in other words, right up to our Stage IIIB.

Now, far from being independent of the projective aspect of perception, this development goes hand in hand with a very peculiar series of changes in estimation of apparent (as distinct from real) size. In trying to study how children estimate projective size, not an altogether easy

[1] In collaboration with Mlles Ch. Renard and E. Sontag.
[2] F. Beyrl, 'Untersuchungen über Sehgrössenkonstanz bei Kindern', *Psych. Forsch.*, Vol. VII, 1926, p. 137.
[3] Brunswik, E., and Cruikshank, R. M., *Psychol. Bull.*, 34, 713, 1937.

task with very young children, though one capable of yielding more or less consistent results, we were struck by the fact that at 7 or 8 children tend to judge size more accurately than at 9 or 10. Only after the age of 10 or 11 is progress toward an adult level of accuracy resumed.

Hence it would seem relatively easy for the younger children to judge size in perspective in so far as their space is not yet structured to any considerable extent. As conceptual space becomes progressively more organized, size estimation becomes more difficult and accuracy is only regained when this structure is eventually able to react upon perception.[1] Thus, the original paradox has become even greater, for when at last the 9 or 10 year old child begins to master the problems involved in imagining things in perspective his perception is relatively poor, while that of the infant who has not yet embarked on this task is relatively more efficient!

It is therefore evident—and this is the main conclusion to be drawn from the past four chapters—that a projective representation is by no means a mere copy of the corresponding perception. On the contrary, it is the outcome of actions performed by the subject, internalized in the form of images which, as soon as they attain the level of reversible combination, culminate in mental operations. Thus, between perception and imagination there lies a whole series of increasingly systematized actions, internalized in the form of images.

The problem of multiple perspectives as studied in Chapter VIII has already given us some inkling of this, for it showed that in order to visualize a number of different points of view the subject must distinguish between them. In other words, it involves co-ordinating the actions performed in the course of viewing an object from different positions, as well as relating change of scene to change of position. For although perception is invariably related to some point of view, this is not a fact of consciousness, whereas imagining a point of view necessarily implies its being consciously distinguished from other points of view and co-ordinated with them. That is to say, it implies a schema of real actions (changes of position, etc.). The point is brought out even more clearly with sections, for here the image of the surface must be linked directly with the action of making a cut, and the actions involved in co-ordinating the different viewpoints according to changes of position.

But at this point a new problem arises. If actions and their internalized imitation (in the form of images) are interposed between perception and imagination at the operational level, then drawing might be expected to provide the natural intermediary between these two extremes. For drawing is an imitative representation which remains external and material in character, whilst at the same time laying a basis for inter-

[1] Piaget, J., and Lambercier, M., 'La comparaison des grandeurs projectives chez l'enfant et chez l'adulte', *Arch. de Psychol.*, 33, No. 130, 81–130, 1951.

nalized images. This was, in fact, the function performed by the drawings of geometrical shapes described in Chapter II; namely, material representations whose development ran parallel with that of spatial ideas. Now when we come to the problem of sections, we find that at the age where the child, in drawing objects from imagination, shows the insides as if the objects were transparent, he is totally unable to imagine them sectioned by an operational plane. Not until the age of about 7–9, when he gives up producing these 'transparencies', does the child begin to draw cross-sections correctly. However, this apparent contradiction is far less difficult to explain than that between perception and representation of perspective. For transparent drawing does not really imply that the child has the least idea of a section or of visualizing an object projectively. It is as yet no more than a topological notion of three-dimensional surrounding, and the most convincing evidence that such drawings are completely alien to projective space is the fact that they invariably contain a confused medley of the most diverse viewpoints.

Now the situation is basically the same, though even more striking in appearance, when we turn to investigate the sole remaining aspect of projection, the realm of what might almost be called children's unconscious descriptive geometry. In the drawings just mentioned, with their confused jumble of viewpoints, it often happens that the child will draw something, such as a cart seen from above, but with its wheels "rotated" into the horizontal plane (see Fig. 23 Substage IIA). Luquet, in the course of the work already cited, has termed this trick 'rotation', thereby referring to the concept which passes under that name in descriptive geometry proper.[1]

It is therefore legitimate to ask whether children who are at an age where they tend to carry out these 'rotations' spontaneously in their ordinary drawings can develop the lateral plane surfaces of simple solids in an intelligent fashion. Put simply, whether they can, in fact, rotate the sides of a solid into the frontal plane, and unfold or 'develop' the regular curved surfaces, such as the cylinder and the cone.

As might have been expected, we shall find that, just as with sections, the technique of rotating and unfolding surfaces is acquired in the course of a spontaneous and regular process of development, but one which begins only when the involuntary "pseudo-rotations" disappear from the children's ordinary drawings! We may therefore be pardoned for having lingered somewhat over this curious problem, since the study of rotation and development of surfaces throws considerable light on the origin of geometrical ideas.

§1. *Technique and general results*

To help the child understand the nature of the problem we start by

[1] See Translators' Notes.

placing before him an ordinary paper rectangle, folded down the middle like a ridge roof, and asking him "what will it look like if we open it out flat on the table?" He is asked to draw the shape it will assume,

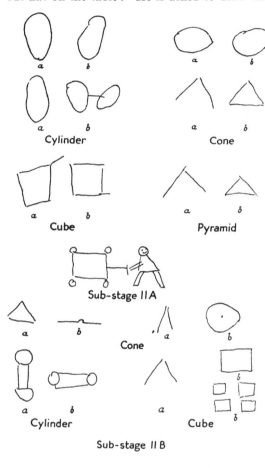

after which it is opened out and the child checks his prediction. Sometimes he is also given a rectangular sheet of paper bent up like a tunnel to introduce the unfolding of cylinders and cones.

He is now shown in random order a succession of solids, comprising a cylinder, a cube, a pyramid and a cone, and asked to draw them opened out flat. If he finds this too difficult he is asked to describe how he imagines them laid out. Apart from this he can always be given an assortment of drawings containing correct and incorrect solutions, asked to choose the right one and give the reason for his choice. However, we soon found by experience that this last method cannot be used alone, for the children tend to pick out the right drawing much too easily, not through genuine understanding but by guessing on the basis of certain details. Their choices also tend to be rather unstable, fluctuating with each fresh suggestion, whereas when they show the process of unfolding with

a = side elevation
b = developed surface

Fig. 23.
Stages in 'rotation' and 'development'.

drawings their intentions are much more clearly and intelligently motivated.

Lastly, before the beginning of each session it is usually worth placing a few of the solids in front of the child, folded and at eye level. In this way any tendency to confuse a particular viewpoint with all the possible viewpoints may be detected, giving some idea of the kinds of spontaneous rotation the child may be expected to introduce in his drawing. In addition, basing our approach on Luquet's work, we asked the younger children to draw a man with a horse and cart to find out whether they would 'rotate' the wheels, etc., or whether they could confine themselves to a single viewpoint. The solids used in the experiments are, of course, always handed to the child at the beginning so that he can turn them about and view them from all sides.

The findings of this experiment

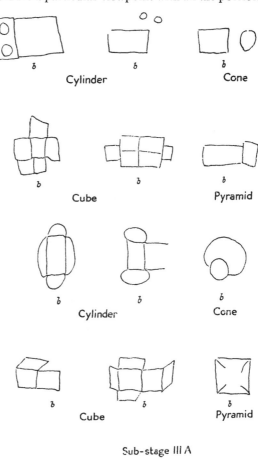

Sub-stage III A

Fig. 23.

Stages in 'rotation' and 'development'.

present two main aspects which are equally important for the study of geometrical thought. The first of these aspects concerns the difficulties which the children encounter in trying to imagine the development of lateral surfaces. It would seem that below the age of 8 or 9 they perform in a controlled way the rotations which are such a constant feature in

275

the spontaneous drawings they produce before the age of 6 or 7! The second aspect shows that imagining the rotation and development of surfaces depends largely on the actual prócess of unfolding solids, and the motor skills involved in such actions. In particular, the child who is familiar with folding and unfolding paper shapes through his work at school is two or three years in advance of children who lack this experience.

The general stages of development noted with all four solids were as follows (see Fig. 23). Stage I (below 4 years) cannot be studied since questions about solids are not understood. Stage II is defined by either total or partial inability to discriminate between different viewpoints, analogously with other projective problems. In the first period (Substage IIA), drawings of the solid folded cannot be distinguished from drawings of it opened out. The cylinder is shown as a rectangle or a pair of interlinked circles (sometimes merely by a circle or an ellipse) while the cone is degraded to a circle or a triangle. The cube is always shown as a square and the pyramid as a peak, a triangle, or a square. Hence, the object is represented by one particular feature, almost symbolically, whether it is supposed to be shown intact or unfolded. The same children invariably draw the cart with its wheels 'rotated'. This period lasts until the age of about 5 or 6.

In contrast to this, Substage IIB reveals the beginning of a discrimination between the intact and the developed solid. In its most rudimentary form this consists of suggesting the intention of developing the solid simply by means of a line to indicate the direction in which this process is supposed to take place. In this case, when the intact solid is shown only as a surface its development is indicated solely by a line. Alternatively, when the solid is represented by an angle, then the development is shown by means of a poorly defined surface, or by a repetition of the original figure placed either horizontally or in a position other than that of the model.

It sometimes happens that the development is shown by means of specifically defined surfaces, though these may be separated from the first figure, or if in contact with, arranged without any overall design. In short, when trying to visualize the rotations and developments of the solid, the child cannot rid himself of his current perceptions and is compelled to express his intentions by means of a gesture, with a line symbolizing a potential movement, by altering the orientation of the solid or by occasionally dismantling it.

Stage III is marked by the discovery of true rotation and development, at least for some solids. This process occurs in two phases. At Substage IIIA the child only shows one step in the development and not the ultimate outcome of the process. In general, two types of solution appear much about the same time. Either the parts of the solid are analysed

without being recombined in orderly fashion, or some attempt is made to keep or arrange the parts adjacent to each other, with the rotation remaining incomplete (for instance, partial rotation of lateral faces so that they appear half-open).

In Substage IIIB the correct solutions are arrived at, at least for the cylinder and cone. The cube and pyramid appear to offer rather more difficulty and a completely correct development of the latter is sometimes not achieved until Stage IV. In other words, until the level of true conic projections is reached (Chapter VII).

§2. *The cylinder and the cone*

As is well known, the cylinder and the cone are the only regular curved surfaces. They may be defined as surfaces capable of being produced by a straight line and developed on a plane surface without either breaks or overlappings, as contrasted with irregular curved surfaces. It is precisely these regular curved shapes which the child is soonest able to master.

At Substage IIA the drawing purporting to show the developed surface is very similar to that of the intact solid, whilst at the same time this latter often contains spontaneous 'rotations'.

FAES (5; 4) draws the intact cylinder as a rectangle. "Now we are going to unfold this one, just like the roof, and lay it flat on the table. Can you draw what it will look like?—*I don't know*—Try—*It'll be flat*—Will it be the same as before?—(he draws a rectangle, somewhat smaller than the original). *It's smaller but I wanted to make it the same size*—But if you opened it out and a little man were to look down on it, what would he see?—*He'd see the paper* (draws another rectangle)—Is that big enough?—(He puts the intact cylinder on top of his drawing). *Yes, it's the same thing*".

CHEV (5; 11) draws both intact and developed cylinders as circles and does the same with the cone. When he draws the cart from imagination he makes it a rectangle (seen from above) flanked by four circles (the wheels in side elevation) so that he has but to eliminate two circles to produce a complete development of the cylinder. Nevertheless, after he has himself opened out both the 'roof' and the 'tunnel', he is still unable to predict what will be the layout of the cylinder!

HUI (6; 1) draws the cart as did Chev (both children make this drawing at the end of the experiment, of course, to avoid influencing the results), but adds a horse shown in profile. This means that a third viewpoint must be added to that of the cart seen in plan and the wheels seen in side elevation. The intact cylinder is drawn according to similar principles. Two circles represent the ends and are joined by a pair of parallel lines representing the curved sides. These last however, are closer together than the edges of the circles. The developed cylinder is drawn exactly similar. "This is when it's opened out completely, like the roof?—*Yes*—Will it really look like this? —*Yes*—Watch (It is unfolded)—*Oh no!*" (He draws what he sees but fails

to profit by experience, for he deals with the other figures, such as the cone, just as he did with the cylinder).

Bu (6; 2) draws the intact cone as a triangle, adding "*You ought to draw a circle, but I can't do it*—And if you opened it out like you did the roof?—*I'd have to make it flattened, but it would still be like this* (he draws the triangle again though smaller)—Why?—*Because it's unfolded*". The change from solid to surface is thus expressed as a diminution in size to indicate the elimination of one dimension.

Geh (7; 1) draws the intact cylinder as a pair of parallel lines joined by arcs at each end. "Draw it opened out—(the resultant drawing is almost identical save that the arcs are replaced by circles)—If we cut out your drawing with a pair of scissors, could we make this (the cylinder) from it?—*Yes, you'd make it round* (rolling up the middle part represented by the parallel lines) *and put the circles at each end* (he again draws parallel lines joined together by arcs to show the restored solid)—Try and do it (we cut out his drawing and he attempts to make a cylinder from it!)—And with this (a correctly developed cylinder)?—(After a few trials he succeeds)—Now draw it without looking at it (he draws it easily from memory)".

Sche (7; 6) produces the same type of drawing as Geh, a long oval with straight sides, for the intact cylinder. For the developed cylinder he merely repeats the same drawing and thinks it could be folded to make a cylinder if cut out. This we proceed to do and he forms his cylinder simply by folding the paper double.

These results are extremely interesting, both as regards the way spatial notions are embodied in the child's spontaneous drawings, and for the light they shed on his ideas on rotation and development of projective solids. In his spontaneous drawings the child represents the cart according to Luquet's principle of a 'medley of viewpoints' and the pseudo-rotation which stems from it. Thus, the body is shown in plan, the horse in profile and the wheels are turned to the same plane as occupied by the body (cf. Chev and Hui). The identical principle is followed in drawing the cylinder. Hui, Geh, and Sche all show it as a pair of lines joined by circles or arcs, so that the ends are in the same plane as the side. Whether the ends are drawn as circles or arcs is immaterial.

Hence, it would seem that the child has all the necessary prerequisites for drawing developed and rotated surfaces, for he appears able to conjure up in imagination a group of virtual perceptions corresponding to a number of different viewpoints. Yet when it is a question of imagining the surfaces developed, all these children are limited to reproducing their original drawings of the intact solid, whatever their shape. What is more, they even expect to be able to cut them out (e.g. Geh and Sche), and fold them to reproduce the object complete with all its sides!

There is therefore no connection whatever, as yet, between the technique of 'mixed viewpoints', 'pseudo-rotations', and a geometrically

correct projective (or descriptive) rendering, nor is this sought after. It is still nothing more than a topological representation, aimed at the object in itself and expressing only simple proximities between its different parts, without any sort of euclidean or projective co-ordination. At the same time, the child is unable to transcend this level and imagine true development and rotation of the surfaces because they are based on something quite different from simple perceptual impressions. They imply a set of actions, originally physical but eventually internalized, linked together by means of a dual mechanism, at once motor (euclidean) and perceptual (viewpoints grouped, not by contiguity, but by projective operations).

In short, what these children lack is experience of actual folding and unfolding, in the same way as they lacked experience of cutting sections when they tried to imagine cross-sectional surfaces. Likewise, the 'medley of viewpoints' which appears in the spontaneous drawings is topologically akin to the method of showing objects from within (surroundings, etc.) also used with sections—and equally remote from any idea of true plane rotation.

At Substage IIB we see the first attempts to distinguish between intact and developed solids. This takes the form, either of lines indicating an intention of rotating the surface through a plane, or else of turning part of the object in another direction.

ARB (5; 5) draws the cylinder as a vertical rectangle, but adds, *"It's all round though you see it straight*—Now we're going to open it out like we did the roof—(He draws a horizontal rectangle). *It's flat on the table*—And can you make the cylinder again from this drawing?—*I just fold it the right way*—What about the circles? (pointing to the two ends)—(He draws two circles separate from the rectangle)". For the cone he draws an acute angle without a base. *"I can't do it any better*—And if we open it out on the table?"—(He draws a simple outline shaped vaguely like a square.)

PEL (5; 8) draws a circle to represent the cylinder, then having already unfolded the 'roof' and the 'tunnel', he remarks spontaneously, *"When you make it flat* (i.e., develop it) *it will become absolutely flat* (he draws simply a line)—Will that be enough to make another pipe (cylinder)?—*Yes, with this as well* (adding a circle). *You'd have to roll this up* (the line) *and put this circle underneath"*. The cone: he again draws a circle. *"There it's round* (pointing to the base) *and there it's pointed. You can't copy the pointed part* (he draws an acute angle separate from the circle)—And when it's unfolded?—*It will be like this"* (gesture of unfolding and laying flat).

UL (6; 0) draws the cylinder as a rectangle *"because it's straight*—Isn't it round as well?—*Yes, it's round, but it's straight*—And if you unfold it like we did before?—(He draws a long horizontal line). *There*—What's that?—*It's the whole paper*—But suppose we only unfold it a little bit?—(He draws an oblique line.) *Like this*—(He is now shown three drawings of possible developments, one correct, one also with a large rectangle but with the two circles

joined to the same side, and one with a small rectangle the same width as the diameter of the cylinder, having a small circle at each end) From which one of these three could you make the cylinder by folding?—*With this one* (third) *because it's round"*. For the cone Ul draws a circle. "*I'm doing the bottom—* And this (the point)?—(He draws a triangle)—What about this then (the circle)?—*You can't put it down; No, I can't manage it* (beneath his triangle he draws a circular arc)—And if it's unfolded?—(He draws an ordinary acute angle and makes some sort of gesture)—And then the circle underneath? —*You see inside"*. (Thus he achieves a better arrangement with the drawing of the development than he does with that of the intact cone, especially in representing the unfolding of the cone by means of an angle.)

NIG (7; 1) draws the cone in the shape of a circle and then makes the gesture of pricking the centre to indicate the presence of a point, "*because you can't draw that"*. He is asked to draw the cone opened out in the same way as he has just drawn the unfolded 'roof'. He opens the end of the cone and looks inside (at the interior, not the surface!). He draws another circle and makes his gesture of pricking the centre, after which he is asked to fold the circle to form a cone. At this, he surrounds the circle with a large rectangle crossed by a line representing the intended fold. The cone is now unfolded as he watches and he is asked to reconstruct the surface he has seen from memory. He draws a rectangle and next to it, a circle surrounded by a number of rays (like a sun), with a gesture of raising them up all the way round.

One can see how differentiation between the intact and unfolded solid begins. The child either contents himself with indicating the process of unfolding by making his drawing lie horizontal (Arb). Or else he represents the developed surface by means of a horizontal line (Pel and Ul), or a roughly rectangular surface (Nig, etc.). At the same time, the whole thing is an expression of motor activity (gestures of unfolding, spreading out, etc.) rather than an attempt at a genuine developed surface. Thus, the way Nig reconstructs the developed surface in the shape of a sun with rays is highly characteristic. He is indicating the global movement of unfolding rather than the surface he has been shown.

On the other hand, at Stage III cylindrical and conic surfaces are developed by means of true rotations. This comes about in two phases however. During Substage IIIA (from 7 to 9 years) an interesting series of trial and error attempts is to be seen. These are no longer sketches of intended actions as at Substage IIB, but the beginnings of co-ordination of between actual viewpoints.

The first type of response found at this level consists of representing one or more separate phases of unfolding the solid whilst being unable to predict the final outcome of the process suggested.

NID (6; 6) draws a cart as seen from a single viewpoint, in profile with the wheels beneath the body. The cylinder he draws as a circle; "Is that right?— *Yes, it's a pipe, it's completely round*—And now suppose we open it out—

THE ROTATION AND DEVELOPMENT OF SURFACES

(He draws a long rectangle)—Can you make another cylinder with that?—
Yes, it has to be rolled up (gesture)—And the circles (ends)?—*They have to
be made like this* (draws them separately). *They have to be stuck on*". For the
cone Nid draws a triangle, then completes it with the addition of a semicircle.
Unfolded it would become a large rectangle, which he draws. "Can you make
the cone with that?—*It's not really big enough. It would make a very small
one* (he draws another figure, this time like a trapezium, recalling the slope
of the cone seen in profile)—Could you make the cone again?—*The circle will
go right the way round. You must arrange the paper properly, with the point at
the top*—But have you done anything yet about the circle at the bottom?—
No. Wait a minute, you've got to measure it (he lays the intact cone on its
side, on top of his drawing of the trapezium. On seeing that the surface of
the latter projects on each side of the edge of the cone he declares himself
satisfied)".

MEY (6; 6) draws a two-wheeled cart in profile, only one wheel being
actually visible. "*You can't see the other one because it goes like that straight
through, left to right*". The cylinder is drawn like a Roman arch "because I
can see a bit of the top (like an arc) *and I can't see the bottom* (the circular
base)". Developed, he draws it as a large rectangle to be rolled up, later adding
two circles. These however, do not touch the rectangle. He draws the cone
as a triangle and its development as a large rectangle.

BOR (7; 2) also draws the cylinder as a rectangle with arcs at each end. He
sketches its development as a large rectangle flanked by two separate circles.
"Can you draw it with the two circles joined on?—(He now draws a pair
of circles joined by parallel tangents)—Would that make a cylinder if you cut
it out?—(He then notices that the width is the same as the diameter of the
complete cylinder.) *No, because it's already folded*—Then make a big drawing"
—(He draws a large rectangle with circles touching the border, but inside
instead of outside the figure. He is shown the correct drawing but prefers
his own). For the cone (drawn as a triangle) he shows the unfolding by
means of a rectangle and a separate circle.

AGU (8; 0) is an interesting example of an attempt to distinguish between
perspective and development. The intact cylinder is shown as a pair of parallel
straight lines, though Agu adds, "*I don't know how to do it. There* (the end)
it's flat and I've made it round—Just draw what you see—*On top and underneath
it's flat because there's a circle*". Unfolded, it is shown as a large rectangle;
"*You roll it up like this, stick it together and put the little round discs on the
ends*—You haven't drawn any discs—*I don't know how to. I don't know where
to put them* (he puts them at each end of the rectangle, but not in contact
with it)—*I made them round, though they ought to be square*—Why?—*Because
the big square* (the rectangle showing the cylinder in perspective) *is square,
but I've made them round. When you make it round* (the body of the cylinder)
you must make them round (the base and the top) *and when its square you must
make them square*".

BUR (8; 8) draws the cylinder in perspective with a circular base, etc., all
practically correct. But for its development he produces, first, two concentric
circles, "*because it's flattened*", then two circles linked by parallel lines. "*No,
it's still rolled up a little bit*". Finally, there appears a large rectangle with circles

drawn separate from it. The unfolded cone is a large triangle with a curved base, *"So as to make it round"*, bisected by a line *"so that it can be turned"*.

This last case exhibited in part, features distinctive of the second type of reaction. This consists of indicating the development by means of a single figure, but with the planes only partly rotated, as if the action of unfolding were merely sketched out before being completed. Here are a few examples of this.

LUG (7; 7) represents the cylinder as a four-sided figure, three sides being straight, the fourth, uppermost side slightly arched to indicate the curvature seen in perspective. For the development he produces a drawing which leaves the width of the cylinder unaltered but rotates the circular ends to the shape of ellipses longer than the width of the cylinder. Thus, everything tends to suggest that Lug has omitted to develop the curved cylindrical surface and has not rotated the ends sufficiently.

DEG (8; 2) draws the intact cylinder as two ellipses joined by a pair of slightly convex lines, the whole thing coming to look like a barrel in the attempt to portray the curved cylindrical surface! Unfolded, the same cylinder is represented by two slightly more circular ellipses joined by two even more convex lines. Thus, there is a twofold, though incomplete, rotation.

RAV (8; 2) draws the cylinder, *"Like a tube*—Now you must open it out like you did the 'roof'—*It makes a cross* (he draws a large ellipse) *No, I've done it wrong, it's like this* (he draws the cross rather in the shape of a mushroom) *That's funny, this* (the left-hand side of the cap of the mushroom) *is on top* (he points to the circle forming the top of the cylinder), *this* (the right-hand side of the cap) *is underneath* (i.e., the circle at the base of the cylinder) *and this* (the mushroom stem) *is this* (the side of the cylinder)—Now watch carefully—*Oh no!"* (He finally draws a rectangle semicircular at each end).

GRA (8; 6) draws the intact cylinder similarly to Deg, like a kind of tunnel with both ends simultaneously visible as a pair of ellipses. Opened out, the cylinder becomes a long rectangle each of whose sides forms the chord of a circular arc. "How do you fold it?—*I turn them* (the arcs), *I get behind and turn*—Could you make another cylinder with your drawing?—*I don't know, it's not as easy as all that"*. He repeats his drawing, this time as an even larger rectangle, bisected by a line and having a small semicircle attached to each corner.

VUA (8; 9) draws the intact cylinder as a pair of ellipses joined by parallel straight lines (the sides of the cylinder). Unfolded, it appears in two forms, as follows. First, two parallel lines are added perpendicular to the sides of the cylinder (which is a sketch of the movement made in unfolding it). Then, on reflection, he joins together the ends of these new lines with a third, thus forming a rectangle to represent the curved cylindrical surface developed in one plane. The cone he draws as a circle topped by an arrow, whose shaft represents the junction of the rolled-up conic surface whilst the head indicates the peak. Thus, a suggestion of the movement made in forming the cone is embodied in the drawing.

UL (8; 10) asserts, apropos the development of the cylinder, *" You have*

to cut it". He thereupon divides the curved surface in two, likewise the circles at each end. Finally, he draws two circles connected by a rectangle the same width as the intact cylinder. His attempt thus falls midway between a sketch of movements made in unfolding the solid and a perspective drawing.

LUT (9; 1) draws the unfolded cylinder as a rectangle flanked by contiguous semicircles. The cone is unfolded as a trapezium, then as a triangle, and finally as a triangle with a circle attached to the base.

LAZ (9; 2) shows the developed cylinder, first as a rectangle containing two circles, one near each end, then with two semicircles touching it (as Lut). The cone he shows as a triangle with a circle attached to its base and this is the customary way of portraying its development prior to Stage IIIB.

These are the two characteristic types of response obtained at Substage IIIA. The first, in which surfaces are shown developed in a rather static and disjointed fashion, is probably at a slightly lower level than the second which expresses the development of the solid by means of a single, all-embracing figure, more dynamic in character, and depicting a phase in the actual process of rotating the surfaces.

The first type of response is transitional between Substage IIB and Substage IIIA. And although the second reaction is more long-lasting than the first, there is nevertheless a period between the age of 7 and $8\frac{1}{2}$ in which both reactions are forthcoming, sometimes even being interchangeable, as witness the case of Bur who reverts from the second to the first type of response in the course of the experiment.

This said, we may note that the two types of response are related to one another in the same way as were those of Substage IIB. These sometimes indicated a motor intention, such as unfolding the solid, expressed by means of vague lines, and sometimes the plane character of the rotated surfaces, shown as a flat surface without a sharp outline. These two aspects, the one motor, the other projective, which express the interrelations between euclidean movements and projective points of view. reappear in the two kinds of response noted here at Substage IIIA.

The first expresses, first and foremost, the idea of the rotated surfaces continuing to have a flat or plane character, though the child is unable to link them up in a coherent whole. This is well illustrated by the case of Agu, who tries to distinguish between the appearance of the rotated surfaces and that of the intact solid in perspective. On the other hand, the second reaction expresses mainly the action itself, an action which occurs without its ultimate result being entirely foreseen. This is brought out particularly clearly by the responses of Deg, Rav, Vua and Ul who show intended movements, and surfaces in course of being rotated. In other words, the first response indicates an action completed too rapidly to be followed and understood, with the result that the child cannot integrate the different points of view. This is demonstrated by

the drawings which show surfaces, fully developed but quite unrelated to one another. The second type of response is expressive of an action, which the child endeavours to follow and comprehend, but is unable to sustain in imagination right through to the end, so that the developments and rotations seen in the drawing remain incomplete.

The main conclusion to be drawn from the child's behaviour at the present stage is therefore the same as was suggested by that which marked the beginning of discrimination between intact and developed solids at Substage IIB. It is to emphasize once again the essential interdependence between euclidean ideas concerned with movements, and projective ideas concerned with the points of view which derive from particular positions, and are transformed by movements. In particular, what is just as clear with development of surfaces as with sections of solids (Chapter VI), is that to imagine a point of view not yet perceived (e.g. the image of a developed surface before a solid is unfolded, or a sectional plane prior to cutting it) the child must have some idea of the action which has to be performed. But this idea implies in turn, the concept of various different points of view, co-ordinated in terms of positions and movements.

The perception of the various sides of the solid which is to be unfolded is not, in fact, sufficient to enable the child to imagine the process taking place. And this is of even greater significance in the present case than with sections, since here all the data relevant to the problem are available to perception. To pass from perception of the intact solid to an image or a drawing of its development it is necessary to perform a mental action, and at the same time, to co-ordinate mentally the different points of view. Substage IIIA shows that neither of these ideas is adequate by itself, but that each requires the other as a complement.

Finally, at Substage IIIB correct answers appear; in other words, the two systems of operations are brought into correspondence. On the one hand, operational organization of rotatory movements made in unfolding the surfaces of the euclidean solid; and on the other, operational co-ordination of projective rotations involved in representing its development. Here are a few examples from this level, beginning with three children midway between Substages IIIA and IIIB.

CHAM (6; 9) looks at the cylinder and without hesitation draws a long, developed rectangle with two circles attached to the left and right hand sides. The developed cone is drawn right away as a large triangle with a circle attached to the base, though the base is still a straight line as it usually is in Substage IIIA (which is hardly surprising in view of his age).

Bos (7; 7) begins by drawing, for the cylinder, a pair of circles and a rectangle, all separate from each other. He subsequently joins the circles to the short sides of the rectangle. "How would you fold it?—(He shows the correct way to do it)—Did you put those circles in the middle on purpose?—*Yes*—

And if one of them was here and the other one there (one to the left, the other to the right) would it still be all right?—*No, they must be directly opposite one another*—Then you can't put them just anywhere (along the sides)?—*Oh yes, you can because they're round*—Both on the same side even?—*No, because one would be missing on top*".

BEN (8; 7) begins by drawing a rectangle in perspective, then divides it lengthwise by means of a pair of lines. The space between is supposed to represent a gap; "*It's like this when you only open it a little bit*". He is thus showing the action in progress, or even beginning, as at Substage IIIA. Then, suddenly he draws a large rectangle with a circle attached to each of the long sides and indicates the correct manner of unfolding the solid. The drawing of the developed cone is correct right away, a triangle with a curved base and a circle attached to it.

MAR (9; 2), shown the cylinder, says immediately, "*It's a rectangle and two circles*", and for the cone, draws the exact figure, a triangle with a curved base, without saying a word.

GIE (9; 8). Cylinder: correct drawing. "*You must close these two things* (circles), *then you wind this paper round* (rectangular band)". Cone drawn correct.

A study of the way in which the correct solution is discovered shows quite clearly that static perceptual attitudes do not provide an adequate basis for visualizing the rotation and development of surfaces. This can only be done by internalizing concrete actions in the form of symbolic images.

It is obvious that a child perceives a cylinder or a cone just as we ourselves do, quite independent of the action of developing its surfaces. He sees these objects in three dimensions as we do; like us he knows the base is round, the top round or pointed, like us he sees the sides are curved. What he fails to grasp, when asked to develop the solid, is not the shape of its surfaces as such, but their arrangement in a single plane. It is precisely the actions involved in bringing this about which he cannot visualize until Stage IIIB, and which he then internalizes in operational form.

At the same time, it is essential to realize that this achievement itself rests on, and is reciprocated by, the co-ordination of viewpoints. Without this it would be impossible for the child to imagine the action taking place, since the solid has to be visualized, not merely in one or two, but in three dimensions. To project the curved surfaces of the cylinder or the cone on to the same plane as the base involves passing from one point of view to another, whilst at the same time distinguishing between and co-ordinating them. This process, as the last four chapters have shown, is undoubtedly a good deal more complex than perception.

Consequently, the actions which have to be internalized in solving the problems of plane rotation include not only those relating to objects or displacements, but also those relating to the subject; actions which

consist of linking up the different viewpoints and putting them into correspondence with the particular viewpoint represented by the plane of development.

It is therefore a question of understanding the mechanism of the mental imagery or symbolic representation which enables the child to anticipate the development of the solid prior to its being carried out. In this respect, the evolution of the behaviour just described shows quite clearly that it is not enough for the child to perceive the external surfaces of the solid to be able to arrange them in an imaginary plane. Imagination is therefore a continuation, not of perception, but rather of the actions brought to bear upon the object and consists, as the results of experiment in Substages IIB and IIIA have shown, of an internalized imitation of movements, prior to becoming an imaginary projection of their consequences.

The fact that such symbolic representation appears so late is even more remarkable considering that when drawing the cart, and sometimes even the cylinder, the younger children use the technique of 'rotation' (in Luquet's sense) quite spontaneously although they are unable to imagine the necessary geometrical rotations. Thus, from the standpoint of skill in drawing alone, the younger children would appear to have been perfectly capable of producing true plane rotations. However, since their 'pseudo-rotations' are in no way derived from euclidean or projective ideas, but only express relations of proximity inherent to the object in itself, what is lacking is precisely the imitative schema evoked by properly controlled actions. In the absence of this a genuine rotation cannot be achieved.

The reason why the cone and cylinder are developed more easily than the cube and tetrahedron (which we are now about to investigate) is probably that the cylindrical and conic surfaces are not flat but curved, with the result that the curvature itself tends to suggest the action of unrolling them. Apart from this, these solids have only two or three sides as compared with the four or six sides of the pyramid and cube.[1]

§3. *Development of the cube and tetrahedron*

Since at Stage I children draw both the circle and the square as a vague closed figure there is little point in asking them to draw the development of cubes or pyramids. Even at Stage II, where they begin to distinguish between drawings of different solids, they draw (and imagine) these solids as just the same, whether they are supposed to be unfolded or intact. Here are a few examples from this level, starting with a child who is midway between Stages I and II.

[1] It is significant that the children cannot reconstruct the solids simply from a study of the drawings of their development, though they can do so *after* they have produced such drawings themselves.

Amb (5; 1) first draws the 'tube' used as an introduction (a rolled-up rectangle) in the form of a circle not quite closed; "Can you draw it completely unrolled (we spread it out)?"—He draws a circle opened out a little more, though containing the suggestion of a spiral, but fails to copy the rectangle. Thus, what he expresses is the movement as such. Had he not seen the 'tube' unrolled before making the drawing this response would have been appropriate to Substage IIB. As for the intact cube, it is shown as a closed circle (like the drawing of a square at Stage I) but with a short line added. This runs off at a tangent, about 45° from the top of the circle. The circle expresses the general closed character of the cube, and the tangent the paper flap by which two of its sides are stuck together. When asked to draw the cube opened out on the table he draws the circle once more, but this time somewhat smaller and without the tangent, thereby indicating that the cube is now unfolded.

Cheu (5; 11) draws both intact and developed pyramids as rectangles.

Ul (6; 1) draws both intact and developed pyramids as triangles, though reducing the size of the latter in accordance with the principle employed by Amb in the case of the cube. The cube he draws as a square, whether intact or developed, though in this case the dimensions remain unchanged.

There is no point in giving further examples from this level, for they are exactly similar in character to those described with the cylinder and cone at the same stage. Although the child knows full well that what he has to do is unfold the solid and draw the developed surface, as he has already seen performed in the demonstration models, he nevertheless makes the developed surface identical to that of the intact solid. At this point, however, it is necessary to draw attention to a feature possessed by all these drawings of the intact solid, which was passed over in §2. This is the frequency with which children of Substage IIA tend to draw the developed surface as smaller (though of the same shape) than that of the intact solid. Thus Bu (§2. p. 328) said "*It would still be like this* (the same shape) *though smaller . . . because it's unfolded*". We have now met with the same response from Amb in the case of the cube and tetrahedron. The reason for it is not difficult to fathom. When developed and projected on a single plane, the surfaces which formerly enclosed a volume have lost one of their dimensions and this transformation appears to the child as a reduction in size. The child's not altogether senseless reaction shows right away that he understands the meaning of the question put to him. He naturally expects that unfolding the solid will eventually result in a single plane surface but is unable to disengage himself from the point of view of the intact solid, for he reduces this surface to a contracted image of the original object! In contrast to this, we see in Substage IIB the familiar signs of approach to discrimination.

Cat (5; 3) draws the pyramid as a square capped by a triangle. Unfolded it appears as a square surmounted by a circle. This is explained as follows: "*That* (the circle) *is where you unroll it*".

LAZ (5; 11) draws the cube both as a square and an acute angle to indicate *"those points there"* (the corners). On the other hand, the developed cube is drawn as a rectangle larger than the original solid. The pyramid is represented as a triangle, and when developed, as a rectangle crossed by an oblique line, *"that's because you fold it there"*.

BUR (6; 2) draws the cube as *"A square*—We made this box out of a flat sheet of paper. Can you draw me the shape of the paper?—(draws a large square)—Can you make a box like this with it?—*Yes* (we cut out his square and he tries to fold it in the form of the box). *It won't work. You need a lot of them*—How many?—(He turns the cube about) *One here, one here . . . six* (he draws six separate squares)—(He is now shown that the sides are not stuck together but folded)—Now, could you draw the large piece of paper we folded up to make the box?—(Draws a large square)—And the folds?—(He surrounds the square with little margins representing the sides to be folded. These form long narrow rectangles)—Now try and fold it (we cut the drawing out and hand it to him)—*It doesn't make the same thing. It's too high* (the cube). *You need some lids for it*—Really? Well, start all over again with another sheet of paper—(He draws another square, this time dividing it into nine more or less equal parts)".

LUS (6; 2) draws the pyramid as a triangle and develops it as a large square. The cube is drawn as a square, its development being shown in the form of a slightly larger square divided into four smaller equal squares.

As with the cylinder and cone, Substage IIB marks no more than the beginning of an attempt to distinguish drawings of intact solids from those of their developed surfaces. The drawing of the developed solid usually shows it larger than the intact object, which suggests a considerable advance on Substage IIA, though the actual shape is still made the same. Where differences do occur, they centre mainly on some indeterminate increase in the number of sides, or else a vague suggestion of a fold or a movement, as in Cat's circle—"This is where you unroll it". One of Bur's drawings falls under this head, being an attempt to show the action of folding back the edges of the developed cube. It thus comes near the typical product of the subsequent stage whereas the other drawings merely express an increase in the number of sides by means of separate or contiguous squares.

As distinct from the present level, Stage III is noteworthy for a progressive growth in understanding of the true nature of development and rotation. At Substage IIIA the twin responses already encountered with the cylinder and cone are seen once again. To wit, the drawing shows, not the final outcome of development, but only one phase in the process; alternatively, the lateral planes are only partially rotated together with the merest suggestion of the actions involved. Here are some examples of the first type of response.

PIL (7; 2). "What do you call that (the cube)?—*A square*—Draw it opened out flat—(He draws a long rectangle)—Where do you fold it?—*You fold it*

like this, you raise these two edges (pointing to the short sides) *and fold them over. There* (the long sides), *I don't know what you do*".

AG (8; 0) draws the cube as a square. Developed, it is drawn as two large rectangles. "*I made two of them. One piece of paper goes right round like this* (indicating three consecutive sides of the cube) *and the other goes round like this* (indicating the other three sides at right angles)—Just draw where they're folded, would you?—*I can't*—You can make a new drawing if you like—(Ag then draws three squares stuck together in a horizontal line and three more stuck together vertically.) *These go underneath* (the last three)—Do you realize the two pieces can be put together?—(He joins them in the shape of a letter T)".

GUA (8; 8) draws the developed cube as a large square with a small square attached to each corner (about one-tenth as big as the large square). For the pyramid he draws a long rectangle inside which are oblique lines representing the folds, then a large triangle enclosing another smaller one in the centre of the lower half, the rest of the surface being subdivided by a pair of oblique lines. The result is four triangles inscribed within a larger triangle, three of them incomplete and one complete. In short, the merest hint of the four triangular faces.

BLAN (9; 5) starts drawing the pyramid as an ordinary triangle, then bisects it and ends up by adding an identical bisected triangle, producing a rhombus with its two diagonals. "*It's right like this* (we cut it out for him and he tries to fold it). *Oh dear, it doesn't fold very well*". He cuts it into two triangles but is no more successful. Finally, he draws a number of separate triangles; "*You need three or four of them*" he says.

The second type of response is also analogous to that obtained with simpler solids at Substage IIIA, though here it takes a more striking form. Instead of an uncompleted stage in the course of development, the child endeavours to show the action of unfolding itself. However, an abstract operation, a transition from one state to another, going beyond the limits of imaginal or symbolic thought, can hardly be expressed by means of a static figure. The child therefore resorts to a kind of symbolic representation or diagram and draws the sides but partially rotated, without having arrived at their ultimate destination.

SPU (7; 6) begins by drawing the cube as an ordinary square. He then adds three narrow trapezoidal sides, so that it appears as a cube in perspective. "If I cut this out for you, will you be able to make a box with it?—*Yes* (we cut out the drawing and he folds it, watching the cube meanwhile. He appears heart-broken when it fails to work)—Here you are (he is given the model to handle), try again—(He opens the cube a little and draws a square, then looking constantly at the model he adds four sides, but once more these are narrow and half open instead of being fully rotated)". From the sample drawings he selects first the cross with five squares and then the correct drawing.

DES (8; 6) first draws an ordinary square and remarks, "*There, I'll make another sheet* (i.e., another side) *besides. And there as well, etc.*". In this way he adds four sides to the original square, though only half opened and seen

U
289

in perspective. He finishes by adding a large square to one of these, forming the sixth side. Thus, the drawing is correct in showing the cube half opened with the top fully rotated. From the sample drawings he immediately chooses a cross containing seven squares. For the pyramid he starts by drawing a large rhombus divided into two triangles, as at Substage IIB, but goes on to add two narrow triangles seen in perspective to the lower sides of the rhombus. *"You can't see it very well because it's hidden"* he says. He is asked to draw the pyramid completely unfolded but merely produces a drawing similar to the first.

BLON (8; 10) starts by drawing an ordinary square, then a square divided into four. "What are you trying to do?—*I make a trial, then I have a look*—Is it right?—*No, because instead of lying flat they are all standing up* (thus, he sees the parts as sides in position). *This* (the first quarter) *is on top, this* (the second) *is underneath, this is in front and this is behind* (the two remaining quarters). *You have to have another square* (he draws a fifth square separately) —Would this make the complete box?—*No, I don't know how you're supposed to do it* (he then draws the cube in perspective, one side half open as if in process of being unfolded!)—And if we were to cut this out, would it make a box?—*No, because the squares are a bit wrong* (i.e., all faces are shown in perspective). *I'd like to try again* (he draws a true square on which he places a square seen in perspective, then adds rectangles for the bottom and sides, which are thus, midway between perspective and fully rotated squares!). *I'm going to fold it here. No, that's wrong, it's too narrow* (because it is in half perspective)".

SCHNEI (8; 6) draws the unfolded pyramid as a rhombus cut into four triangles. From the upper corner radiate a number of lines forming acute angles, suggesting the action of unfolding. He then tries to indicate the unfolding by a pair of bisected rhombuses representing the now rotated sides. Finally, he draws a large triangle with narrower triangles abutting each of its sides. These represent the sides of the pyramid seen in perspective during the course of unfolding.

VALO (9; 6) draws first a square, then a cube in perspective. "If we cut this out, will we be able to make a box with it?—*Oh yes* (he tries to do so, folding, unfolding and refolding it without realizing that the sides of a perspective figure can never make a cube!)—Do you think you'll do it?—*Yes, you just have to keep on trying* (he starts folding once more). *There's something missing!*". He finally draws something like an open box and then gives the problem up.

LAZ (9; 6) also tries to render the unfolded pyramid by means of a half-finished development. He draws a large square with diagonals broken at the centre. This produces four triangles lacking verticals as if the pyramid were partly unfolded.

At this intermediate level the two contrasting reactions are exhibited much more clearly than with the cylinder and cone. They deserve careful study, for they are a good illustration of the kind of mechanism involved in imagining the unfolding of a solid, and operative in symbolic thought generally.

As with the cylinder and cone, the children of this substage respond in one of two ways. Either they show some static, incomplete aspect of the action of unfolding, because they cannot imagine the whole process simultaneously. Or else they try to follow its dynamic, operational features but can only anticipate the start of the process, in which event they depict the solid opened only slightly and cannot foresee the rest of the action.

The first reaction resolves itself into a premature anticipation of the outcome of unfolding with the result that, unable to visualize the process in full detail, they can only show certain aspects of it. Thus, Pli sees the cube as a long rectangle while Ag sees it as two rectangles and Blan sees the pyramid as a rhombus. These are real images of the developed solid—unlike the mere suggestions offered at Substage IIB—but they remain incomplete because they only refer to certain limited aspects of the operations that need to be performed. On the other hand, the second type of response bears directly on the operation proper, emphasizing its continuity, and in such a way as to express most powerfully the link between this operation and physical actions.

In fact, the second type of drawing shows the entire solid in much the same way as it was shown throughout Stage II, except that it is now in perspective and opened out slightly as if to suggest that the unfolding is actually taking place. But although the child can portray the opening phases of this process quite explicitly, he is unable to envisage the stages immediately following, let alone the ultimate result. Having drawn the various faces that can be unfolded and shown one or two of them opened slightly, he imagines he can now cut his drawing out and fold it into a solid. Of course, he is rather taken aback to find this is not the case. For instance, Valo thinks that the sides of a cube drawn in perspective can be folded to form a real cube. In short, the child thinks that his rough sketch of the unfolding process will help him find out what comes next. This is a reasonable enough supposition, except that such a drawing shows nothing more than a symbolic unfolding, a picture of what is happening, while at the same time, the child is unable to go ahead and imagine the immediate consequences of the action he has thus symbolized.

What is the reason for this? Why does a correct representation of the first stage of the process fail to lead to a correct portrayal of its conclusion? Above all, how is this difficulty to be accounted for in the case of plane rotation, an action which the spontaneous drawings of the younger children appear, at first glance, to render in an exactly similar fashion?

It is at this point that we can appreciate to the full, the basic difference between an ordinary action such as simple unfolding, and an operation such as plane rotation or development. A simple action can be performed

291

without being co-ordinated with other actions, and once accomplished may be reproduced in imagination as an imitative or symbolic image. But it cannot be imagined until it has actually been performed, and this we have witnessed time and again in the reactions obtained at Stage II. As for the children of the present level, who in this field mark the transition from actions to operations—though in other fields able to employ operational schemata—they can as yet imagine only the beginning of the action (second type response) or some of its consequences (first type response), but not the complete and final result.

As opposed to this, the operation is a system of actions linked together in a reversible and transitive way. This means that a single rotation (e.g., one face of a cube) or a development of the surfaces of a three-dimensional solid in fact assumes the global co-ordination of a number of projective views of the object, plus a corresponding organization of euclidean space in terms of a system of reference. In other words, while operations presuppose the existence of an overall system, simple actions anticipate it. Nevertheless, they lead to such a system, and all that is required to pass from actions to operations is the progressive co-ordination of these actions.

Stage III marks the beginning of this process, but its limited character is evident from both types of response. The child can visualize either the unfolding of certain parts of the solid, or else the initial phase in development of the whole. But he cannot complete either of these processes, whether centripetal (starting from the result of the action) or centrifugal (starting from the action itself). In neither case can he foresee the full consequences of the action he has sketched out, because he cannot link up all the varying aspects of the process in a single, mutually-supporting system, but can only analyse them separately.

The correct solution is arrived at by Substage IIIB for the cube and Stage IV for the pyramid. In the case of the cube, however, one sometimes finds exceptional children able to give correct answers at the start of Substage IIIA as a result of possessing special aptitudes or having had experience in folding or making things at school. The same thing happens, though less frequently, with the pyramid at Substage IIIB. Here are some of these children giving the correct answers.

CHAM (6; 9). We have already watched Cham solving problems of the cylinder and cone. He is now working on the cube. "*It's difficult with this; you can't see how it's made!*—Well, have a try all the same, eh?—*Ah, that's it. I've got an idea* (draws a long rectangle and divides it into four squares). *This goes right round. Now we need this and this* (adds two more squares each side of the last but one in the row of four, making the correct figure)—How would you fold it up?—*You raise these up* (the four squares surrounding the square forming the base) *then you bend this down on top*".

TER (6; 10) also draws four squares in a line, observing, "*When it's flat

you've got four squares (the sides) *but you still want one for the top and one for the bottom* (which he proceeds to add)".

RUC (7; 7). Having unfolded and drawn the 'roof' he studies the cube for a moment, then without further examination or saying a word he produces a correct and complete development at first attempt.

EBER (8; 2) first gives the second type response of Substage IIIA, a square forming the base of the cube, surrounded by four slightly opened sides seen from above in perspective. He then adds a sixth side for the top, completely rotated. After this he is able to produce a drawing of the complete development.

BEN (8; 2), like Ter, draws four squares in line. "*These are the four sides and then these* (two squares flanking the penultimate one) *are the top and bottom*". He is next shown a four-sided pyramid. "*I'll have to think about that one. That thing, there, is the floor* (he draws a square) *and these are the sides* (he draws a triangle adjacent to the square, then three more attached fanwise to the first and getting narrower and narrower)—Is that one thinner on purpose (the last one)?—*Yes, because you see it further away* (he is confusing the perspective with rotation of the far side)".

REY (9; 2) succeeds at first attempt with the cube, but draws the pyramid the same way as Ben (a Stage IIIA response, confusing perspective with rotation). In addition, he deliberately makes the bases of the triangles 'curved' to indicate that they close round the intact shape.

BERS (10; 9) draws the developed cube correct immediately, but gives the pyramid four triangular sides (the base consists of three triangles arranged fanwise, the two outside triangles being narrower than the central one).

ALI (11; 0) succeeds with the cube right away, but draws the pyramid as four triangles arranged fanwise. He cuts out this drawing, tries to fold it and cannot understand why he is unsuccessful.

Finally, here are a few examples from Stage IV. These children can draw the developed pyramid either immediately or after trial and error.

MUN (12; 10) begins by drawing a diagonalized square, thus forming four triangles which he tries to fold. "*It doesn't work. I don't understand it properly*". Next he tries a rhombus divided in four, then turns the pyramid round and round, finally drawing four triangles, three surrounding the one which forms the base.

MUH (11; 5) begins by drawing a pair of contiguous triangles. He then draws a third triangle resting on the vertices of the first two and states that one has only to raise the three projecting triangles to obtain the pyramid—which is absolutely correct.

CHEV (12; 0), FREI (12; 5), etc., all produce correct drawings immediately.

With this slight time lag between the cube and the tetrahedron, the complex evolution is thus completed. But how are we to account for the tremendous difficulty with which these children, ranging from Stage III to Stage IV, finally arrive at such simple solutions? To do this it is necessary to review the whole of our findings and we shall therefore conclude by summarizing their main details.

§4. *Conclusions. The nature of the symbolic image and the connection between projective and euclidean operations*

The first important conclusion to be drawn from these experiments, brought out even more clearly with the cube and tetrahedron than with the cylinder and cone, is that to be able to envisage the rotation of the surfaces of a solid, it is not enough to perceive the solid clearly, or even to record this percept in the form of an image. In so many words, the notion of a developed solid is not a direct outcome of ordinary perception. Even the perception of all six sides of a solid such as a cube is not in itself sufficient to produce a mental image of the six sides rotated into one plane. What lies between the perception of a solid and the image of its plane rotation is an action, a motor response to perception. Thus, the image is a pictorial anticipation of an action not yet performed, a reaching forward from what is presently perceived to what may be, but is not yet perceived. It is precisely this potential perception, this mental picture which the children of Stages IIIB and IV are able to conjure up, and which is entirely absent until the end of Substage IIA.

Thus when the children of Substage IIA look at a cube they see only a folded piece of paper and have no idea how to unfold it mentally. Between this state of affairs and successful anticipation, lies a whole series of processes explanatory of the transition from the original simple perceptual notions, to imagining future potential perceptions. Such a transition entails a number of others, among them, that running from simple actions to co-ordinated operations, and it brings out the true character, not only of symbolic thought or thinking in images, but also of projective operations in general.

As regards the first of these, the findings of the present chapter confirm the view already expressed, that the image is an internalized act of imitation, a copy or transfer, not of the object as such, but of the motor response required to bring action to bear upon the object. Thus, what the image furnishes, to a far greater degree than perception, is a *schema* of action. This is why the image is at once less lively, but more mobile and sometimes richer in content than perception (particularly in the case of geometrical notions). In this connection, three distinct types of representational imagery can be identified among the preceding data. First of all comes the mental image of the object itself. When the children of Substage IIA are asked to draw the solid unfolded they merely reproduce the intact solid which lies before them. But it is obvious that they must possess an image of this object, as distinct from an image of its developed surfaces or the act of unfolding it. Now although such an image may be purely static, in the sense that it refers only to the object as such and ignores its possible transformations, nevertheless

294

this first type of image is already a schema of action. It is an imitative recording of the movements embodied in perceptual activity, as distinct from purely passive perception. The truth of this is sufficiently brought home by the reflection that even the perceptual and imaginal schema of a straight line presumes activity on the part of the subject, such as traversing the line, bringing its parts into relation with one another, etc., since there are no such things as straight lines (*per se*) in physical objects.

The second type of image is that which appears at Substage IIB and continues to develop up to Substage IIIA. In place of merely representing the object itself, independently of its transformations, this image expresses either a phase or an outcome of the action performed on the object. Whether it be a line or an unclosed surface suggestive of the act of unfolding, as at Substage IIB, or the slightly opened solid and partial rotation, as at Substage IIIA, the image henceforth transcends the perceptual data indicative of the static object, and anticipates the results of transformations. However, the most interesting feature of this type of image is its failure to anticipate the result of the transformation in a complete and accurate fashion. Whilst such images constitute an imitation of these very actions of unfolding and rotating, or rather because they do so, they are barely able to keep abreast of the actions. In other words, the action cannot be adequately visualized all the way to its ultimate conclusion before it has actually been performed.

Perhaps one of the most striking results of this chapter has been to show the inadequacy of thinking in images as long as this image is not incorporated in a complete system of operations (and this observation is, incidentally, completely consonant with everything we have seen in dealing with sections, projections and perspectives). To account for these limitations it is by no means sufficient to say that although originating in a motor imitation, the image is only able to represent states and never actions, and that actions can only be represented by a series of static images. On the contrary, once the operations have been constructed the image can symbolize their products flexibly enough to anticipate them, even though these operations are never carried out on the plane of action. The reason why this second type of image is unable to portray the results of an action in advance of its performance, is that it relates only to simple actions; that is, actions which are in process of being linked together but have not yet attained the level of operations grouped in completed systems.

And indeed, the imagery characteristic of Substage IIIA (which marks the transition from action to operation) reveals in the clearest possible way that until actions are embodied in operations they remain relatively unco-ordinated (it is, by the way, just this type of action which is internalized by images of the second type). Hence at this stage, children

can visualize a particular rotation, but as they cannot imagine a series of successive actions they cannot complete the process. Alternatively, they preserve the order and proximity between the parts of the solid they imagine as being unfolded, but cannot pursue the actions to their ultimate conclusion and content themselves with visualizing the whole solid with slightly opened sides. In neither case can the image keep pace with the actions because, unlike operations, such actions are not co-ordinated one with the other.

Finally, at Substage IIIB there appears a third type of image, one capable of anticipating the results of actions before they are carried out. This image is dynamic and mobile in character, free of the defects and inadequacies of its forerunners and entirely concerned with transformations of the object. It is this plastic type of imagery which geometricians term the 'concept of space' when it has become purely intellectual and transcends the bounds of sense perception, as opposed to the elementary spatial notions we have termed 'pre-operational'.

Moreover, this type of imagery only appears closely associated with fully developed operational systems. Unlike its predecessors it is no longer a necessary aid to thought, for the actions which it represents are henceforth independent of their physical realization and consist only of transformations grouped in free, transitive and reversible combination.

In short, the image is now no more than a symbol of an operation, an imitative symbol like its precursors, but one which is constantly outpaced by the dynamics of the transformations. Its sole function is now to express certain momentary states occurring in the course of such transformations by way of references or symbolic allusions.

This brings us to the second problem, a problem which has recurred time and again in the course of this research. How does the transition from actions to operations come about, and what are the relations between projective and euclidean operations?

As with the study of sections, projections and perspectives, the study of developments and rotations leads to two conclusions. Firstly, that an operation differs from an action in that it implies co-ordination of differentiated actions within the framework of a single whole. Secondly, that projective operations rest upon the correlation of co-ordinated points of view with co-ordinated movements. By co-ordinated movements we mean euclidean operations organized according to their own systems of co-ordinates.

Now in what way do the operations leading to correct solutions at Stages IIIB and IV differ from the mere suggestions of unfolding seen at Substage IIIA? At Substage IIIA the child is unable to develop the cube. None the less, he is aware of the six sides, though only as successive aspects of the solid. So he turns the thing about, looking at each face

in turn, or else views it from some angle taking it in as a whole, but in neither case can he co-ordinate the different points of view he has been able to distinguish. As against this, the development of the cube entails each of the six sides being thought of in relation to the six different points of view, and then co-ordinated in a single whole defined by the plane of the side to which all the other sides are rotated.

Such an operation demands that the topological relationships like proximity and separation, order and enclosure, be preserved, along with continuity, either in whole (for the so-called 'developable' surfaces) or in part (for the cube and tetrahedron).[1] But it also demands that they be subordinated to a system of viewpoints differentiated, and at the same time co-ordinated among themselves. Hence, it is obvious that isolated movements of unfolding and the particular viewpoints associated with each one (and symbolized by the image) are incapable of solving the problems posed by development of a solid. Conversely, it is likewise obvious that co-ordinating such actions within a system of reversible combinations will have the effect of turning them into operations.

Now it is clear that in the case of rotation and development, just as with sections, these operations will present two complementary aspects. On the one hand there are the movements imparted to the object, or described about it by the subject. These entail euclidean operations necessitating the construction of a co-ordinate system. But on the other hand, and so closely bound up with the first aspect that it cannot be considered as either preceding or following it, there are the 'viewpoints'. These depend upon the position of either subject or object, according to the particular plane being considered, and it is the co-ordination of these viewpoints which constitutes projective operations.

In sum, the study of rotations and developments of surfaces confirms and clarifies the results obtained from studying other projective concepts. It emphasizes the independence of the system, taken as a whole, which these ideas constitute in the growth of the child's conception of space, and simultaneously, the links between them and euclidean concepts. The investigation of this problem brings us to the end of our study of the principal projective concepts involved in children's everyday geometrical ideas. It now remains to examine the transition from concepts of projective space to those of euclidean space itself.

[1] See Translators' Notes.

THE TRANSITION
FROM PROJECTIVE TO
EUCLIDEAN SPACE

SYNOPSIS

FROM the point of view both of mathematical construction and psychological development, projective and euclidean space are doubly related. In the first place, they both derive, though independently, from topological space. Mathematically, a projective correspondence or *homology* may be regarded as a topological homeomorphism having the added property of conserving straight lines and certain quantitative relationships (anharmonic relationships). As for general metric relationships, these derive directly from topological relationships with euclidean metrics considered as a particular case.

From the psychological point of view we have seen that the concepts of the straight line and elementary projective relations are the outcome of topological ideas incorporated in a system of viewpoints. And in another work[1] we shall see that the child likewise derives the euclidean concepts of distance and measurement from these same topological notions. Thus, mathematically and psychologically, projective and euclidean space both derive in their two separate ways from topological space.

But in addition to this, projective and euclidean space are related in another way which we have now to consider.[2] It is possible to construct a series of transitional stages between projective and euclidean space, consisting of affinities and similarities. Affinities may be defined mathematically as projective correspondences (homologies) conserving parallelisms; similarities as affinities conserving angles; movements as similarities conserving distances. Thus mathematically there is a continuous series of gradations, a series of specifications leading from projectives homologies to euclidean displacements. Is the same true of psychological development also? This is the question we must endeavour to answer in the third and concluding section of this work.

To do this we must first of all investigate the conservation of parallels, not only in the purely perceptual field, but as it occurs during transformations of figures. This we do in Chapter XI by studying the child's reactions in a very simple case of "affinitive" transformations; namely, the increase and decrease in the width of the rhombuses in a set of "Lazy Tongs" (Nuremburg Scissors). Following this, Chapter XII deals with the discovery of proportions and the conservation of angles, whilst in Chapter XIII we examine the

[1] *La Géométrie Spontanée de l'Enfant*, Paris, 1948.

[2] One of the features of this first type of relationship is that the axioms required to construct a co-ordinate system are the same as those necessary to a projective geometry, a theorem first demonstrated by Hilbert.

simple co-ordinate systems required to construct horizontal and vertical axes. Finally, Chapter XIV, which deals with the construction of a topographical schema (such as the layout of a garden or a village), will enable us to again apply the concepts of perspective points of view, parallelism, proportions and co-ordinates to the solution of a similar general problem and thereby demonstrate the connections between projective and euclidean concepts.

Chapter Eleven

AFFINITIVE TRANSFORMATIONS OF THE RHOMBUS AND THE CONSERVATION OF PARALLELS[1]

IN Part One we investigated simple topological notions and showed that they were concerned only with the object in itself, and with its internal properties as established empirically. Following this, we saw in Part Two how these same notions, once linked with 'points of view', gave rise to specific shapes conserving straight lines and governed by projective relationships. Projective space thus appears as a co-ordination of objects—as opposed to analysis of the object in itself—but a co-ordination relative to specific points of view. In short, as a co-ordination of the actual points of view themselves.

The time has now come to investigate co-ordination as applied to objects as such, of which the development of co-ordinate systems is the most typical example. However, before discussing the general organization of euclidean space as constituted by such systems it will not come amiss to look first at less complex systems which lie between projective and metric concepts. Parallelism and proportions (and similarity) are both essential to the concept of space, and both are to be found in the spontaneous development of children's drawings.

Now the problem of parallelism, like that of similarity, is extremely difficult to formulate in precise terms. However, we may start by recalling a point made in Chapter VII (Section I). Because the child can perceive or even draw a straight line it by no means follows that he can imagine or construct a rectilinear series independent of the perceptual "ground". It is exactly the same with parallels. From the age of 6 months a child can distinguish perceptually between a square and a triangle, and by the age of 4 years he can even draw a square correctly. But we cannot conclude from this that he possesses any intuitive—let alone operational—ideas on the subject of parallel lines. To draw an upright square he has to make two vertical and two horizontal lines. But the fact that these lines are parallel does not mean that this relationship could be maintained if the square were to be tilted at an angle, and it is consequently far more difficult for the child to draw a tilted square or a rhombus. The rhombus is not drawn at all satisfactorily until about 6, and even then there is no great accuracy as regards the parallels. Not until the age of 7 are these drawn with any precision.

Therefore in investigating the conservation of parallels we should

[1] In collaboration with Mlle. G. Ascoli and Mme. M. Denis-Prinzhorn.

most certainly employ figures such as the rhombus rather than those containing only right-angles and vertical-horizontal lines, such as squares and rectangles in the upright position. But over and above this, what we must endeavour to concentrate on is not so much the static shapes, but rather their transformations.

Yet the correct reproduction of the rhombus is not in itself any real proof that the child has a clear idea of parallels. Such a reproduction may be no more than the product of perception and motor activity, whereas to imagine a figure or draw it from imagination definitely presumes some idea of its possible modifications. Hence, the representation of parallels implies a system of operations which will permit of certain transformations, whilst at the same time conserving the parallelity. This means that if we intend to study parallelism with the aid of a figure like the rhombus, which has parallel sides but no right-angles, it is the transformations we must seek to analyse rather than a particular rhombus.

Between projective concepts and similarities, geometricians recognize a special group of relationships defined by the concept of 'affinity'. These are relationships which conserve parallels and straight lines but not angles (similarities) or distances (movement and euclidean metrics). The best way to study the parallelism between opposite sides of the rhombus is therefore to submit the figure to a series of 'affinitive' transformations. The child's reactions to these changes can then be noted at each stage of the process which leads, by way of connected ideas and anticipatory motor responses—the form taken by the subject's activity—from perception and thinking in images, to operational thought as its ultimate goal.

There is in fact a well-known tool which obeys the law of affinitive figures and actually produces transformations of the rhombus. This is the "Lazy Tongs" (Fig. 24) whose mechanism is duplicated in a number of household tools (automatic corkscrews, wirecutters, etc.). As can be seen, it consists simply of crossed rods like scissor blades, but with the ends joined together in pairs so that they form a series of connected rhombuses. With the tongs closed the surface of the figures is nil, for the rods are all pressed together and make a row of vertical straight lines (with the tongs held horizontal). As the apparatus opens out the rods separate and form a series of rhombuses, narrow at first, then wider and wider, becoming at the same time narrower in the other direction. At the mid-point the figures have the shapes of squares placed diagonally, then the width begins to exceed the height. With the rods fully extended the width of the rhombuses is at a maximum and the height at a minimum which brings the appearance of the rods to that of parallel lines once more, but now perpendicular to the original position.

Thus, the problem we are about to investigate is that of forecasting the shapes of the rhombuses during the course of their transformations, and particularly the conservation of parallelism between opposite sides.[1] Dealt with in this way the problem of parallelism is, as may be seen, linked to a system of transformations, so that it is presented in operational rather than in perceptual terms.

Naturally, this does not mean that the perceptual aspect of the question can be ignored. But so far as this is concerned we are already in possession of the results obtained by our co-worker, H. Wursten, in experiments on perception of parallelism with vertically or obliquely placed rods.[2] For this reason it was unnecessary to return to the perceptual problem, since Wursten's findings are perfectly straightforward. At the same time, in discussing the present experiments it will be necessary to return to the relations between perception and representation of parallels (see §6.) because, contrary to what might be expected, the perception of oblique parallels does not appear to be ahead of their repre-

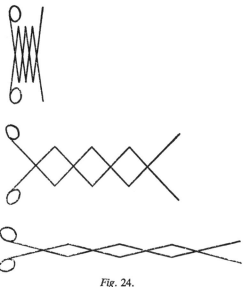

Fig. 24.

Affinitive transformations of the rhombus (Lazy Tongs or Nuremburg Scissors).

sentation, for the latter would seem to influence the former retroactively instead of merely depending upon it.

§1. *Technique and general results*

The child is first shown the apparatus in the closed position. He is asked to predict and draw what will happen when "the scissors are opened" by pressing the handles together (Fig. 24). After he has made his first forecast (which is usually valueless as a prediction, though useful

[1] Obviously these transformations only constitute a particular case of affine transformations which include not only the rhombus but all parallelograms. In the present case we have not only parallelity, but also invariance of the length of sides, which is not entailed by the concept of affinity.

[2] See Chapter II (§1).

in arousing his interest), we press lightly on the handles, opening the tongs slightly and causing a series of very narrow rhombuses to appear. We once more ask the child to guess at the final result, in other words to draw the rhombuses (we usually called them 'windows') as they will appear in the course of extending the apparatus. We carry on like this

Stage I

Sub-stage IIA

Sub-stage II B

Sub-stage III A

Fig. 25.

Affine transformations of the rhombus. (Stage I to Stage IIIA.)

right to the end, stopping at the more interesting phases of the transformation. The same procedure can then be carried out in the reverse direction, thus returning to the original position.

To help overcome the technical difficulties of drawing the rhombus, the younger children were given a selection of different-sized rods with

which to make a series of figures in imitation of the apparatus itself. Lastly, we occasionally gave the child a collection of rhombuses of varying ratio to arrange in series, corresponding with the increasing opening of the tongs; and alternatively, a collection of true and false rhombuses (i.e., with opposite sides parallel and non-parallel) to be sorted out. In the latter case the rhombuses were presented with the corners hidden so that the child is forced to identify the true rhombuses solely by the parallelism of the sides. To study these further points it was found useful to have, in addition to the cardboard figures, a large rhombus made of pivoted rods so that it could be adjusted according to the question being asked.

The following stages of development were identified (see Fig. 25). During Stage I (under the age of 4) the child is, firstly, unable to anticipate any kind of transformation of the 'windows'; and secondly, unable to draw a rhombus (any more than squares or triangles) save as a more or less circular closed shape. We will therefore pass direct to Stage II. In the opening phase (Stage IIA), the child is at first unable to anticipate any transformation with the apparatus stationary, even when it is open and the rhombuses are visible. On the other hand, when he sees the beginning of the change take place he can imagine the continuation of it, though only in the form of endless enlargement of the 'windows'. In this the child never bothers himself about the ultimate result, nor wonders whether the 'windows' will begin to get smaller again after reaching a maximum size. As for the shape of the 'windows', the children of this substage do not know how to draw a rhombus and curiously enough, fail to abstract this shape from the structure as a whole. Instead, they content themselves with drawing crosses to represent the intersections; only after following the outline with one finger do they attempt to isolate the closed figure which is then shown as an ellipse, a rectangle, a closed pointed figure, and so on.

The child of Substage IIB ($5\frac{1}{2}$-6 to 7), shown the apparatus opened some way, can foresee that the rhombuses will grow longer and he is also prepared to admit that they will eventually get smaller again. But this prediction remains global and inadequate in two important respects. Firstly, although there is a progressive structuring of the rhombus (a single rhombus is copied correctly about the age of 6: see Chapter III §6.), at this level the child still allows of changes in the length of the sides during the transformation, nor does he make the opposite sides parallel. Secondly, the expected transformations still do not imply a continuous series of figures with heights and widths in inverse proportion. For the length of the sides, and especially their parallelism, is not conserved, nor are the surfaces arranged in series.

In contrast to this, at Substage IIIA (beginnings of concrete operations, about 7-8 years) we find the rhombus drawn correctly, with sides

parallel and constant in length. Along with these innovations there is, from the beginning of this substage, an attempt to work out the connection between the lengthening of the tongs and the continuous transformations of the figures. In particular, one finds right at the outset, rhombuses drawn lengthwise, showing that the child has some idea of the connection between gain in width and loss in height. Nevertheless, there is as yet no clear understanding of these relationships nor any proper formulation of the procedure to be followed in actually making the drawing.

Finally, at Substages IIB and IV (9–10 years) the child is able to formulate all these relationships explicitly, through a conscious understanding of the transformations of the figure.

§2. *Substage IIA. Rhombus without definite shape. Figures produced by adjustment of the apparatus enlarged indefinitely*

Passing over the purely negative reactions of Stage I, we will confine ourselves, in describing those of Substage IIA, to emphasizing the mainly static character of the child's first geometrical ideas, a constant feature of this level in every one of our experiments so far. The child confines himself strictly to what he sees and does not attempt to visualize the transformations. When he has seen these take place he merely repeats and continues them, being unable to co-ordinate the different factors within an operational anticipatory schema. Left to his own devices, the child can neither draw the actual shape of the rhombus which he sees in the apparatus, nor imagine the transformations except as a process of constant enlargement.

ZUR (4: 10) We begin with the apparatus slightly open, "You see these two holes to put your fingers through. If I press on them like a pair of scissors, what will happen?— . . . —What do you see?—*Bars*—And if I press, what's going to happen to these bars?— . . . —Look (we open it a little more)— *There'll be still more bars* (he thinks the elements will be multiplied)—Can you draw them?—(He draws a series of crosses XXXX)[1]—And if we press it some more?—*It will get longer, the windows will get bigger* (he draws bigger crosses) —Make a drawing of a window—(He draws not a rhombus, but an X)—Show me a window with your finger—(He moves his finger around the outline of a rhombus but still draws a cross)—Try it with these (rods)—(He starts by arranging the rods in the shape of crosses but eventually succeeds in constructing a kind of square standing on one corner, but with double sides)— And if we go on pressing?—*If you pull the works the windows will get bigger and bigger*—Look (we have arrived at the point where the width of the rhombuses exceeds the height)—*No! Smaller*—And if we go on?—*Bigger and bigger*— Look (further pressing)—*Oh no, smaller still*".

AMB (5: 0) Similar reaction. To help him study the rhombus itself, Amb is shown a single rhombus made of four pivoted rods, changeable at will like

[1] Not parallel, of course.

those in the lazy tongs. "Can you make a drawing of them?—*Don't know how to draw it*—Try with these rods (he is offered a selection of rods 1.5, 3, 11 and 15 cm. long)—(He begins by placing rods around the model but not parallel with the sides, then constructs two separate angles < and >)—Now I am going to press here (the width of the rhombus is increased and its height decreased. Amb copies what he sees simply by pulling the identical angles apart) And if I go on?—*It will be like this* (spreads out his arms and pulls his angles further apart on the table)—Look (experiment), do exactly what you see—(Amb makes a pentagon, then a large triangle with his rods)—And if I continue?—*It will get bigger still* (takes the eight largest rods and forms a large trapezoid)—Look (experiment), is it the same?—*Yes, it's just like mine*".

Ro (5; 6) does not at first think there will be any change, then seeing the first movement says, "*It gets larger* (the whole affair)—And what will happen to the windows?—*They'll get bigger, bigger and bigger*—Can you draw them? —(He draws crosses XXX. We then try to make him follow the outline with his finger. He succeeds in isolating a rhombus after considerable difficulty and then draws it more or less correct, the drawing being modelled on the exploratory movement, though the sides are not made parallel)—What will the windows look like if we make the thing longer?—(He draws an appreciably longer rhombus, 7 centimetres high instead of 4) *Bigger*—And if we go on pulling?—*Bigger and bigger* (He draws a rhombus 12 cm. high, then 15 cm. and more or less proportional in width)—And right at the end?—*Bigger still* (a rhombus 25 by 15 cm. now covers the whole page)—Look (we stretch out the tongs and he then indicates which of his drawings the shapes he sees correspond to)—Does the window change shape?—*No, it's always the same* (he draws a series a rhombuses, decreasing in height but distorted more and more and more toward rectangles or trapezoids)—Try using these rods— (Same result)". The parallelism is not maintained any more than are the lengths, except now and again by accident.

Gab (5; 10) does not expect any change. After the first movement he says, "*It'll get bigger*—And after that?—*Bigger still*—And at the end?—*Three times bigger still*—Watch—*They're lower* (the windows)—And after this?— *Lower still*—And if I go on?—*Bigger*". His drawing consists of a series of crosses, then following tactile exploration he draws a sort of ellipse pointed at both ends.

These reactions are interesting in two ways. Firstly, even while they perceive 'windows' that grow larger during the first phase of the movement of the apparatus, these children do not succeed in abstracting the shape of the rhombus from the general pattern. They merely draw crosses and only discover the rhombus after tracing the shape of the 'windows' with their fingers. Even then they cannot reproduce the shape, or if they come close to it, never consciously reproduce the parallel opposite sides. As far as concerns reproducing parallels as such, the reactions of this stage are therefore clearly negative.

Secondly, and closely akin to the difficulty experienced in drawing the rhombus, the child cannot anticipate the changes that will occur

309

until he has actually seen them. It is remarkable to observe how strictly the child confines himself to what he actually sees. He does not yet possess imagery of the second type (see Chapter X: Conclusions) which results from anticipating the action to be performed on the object. On the contrary, once the initial transformation is perceived it is simply repeated in imagination, whence the idea of the indefinite enlargement of the 'windows', regardless of either the fixed length of their sides (despite their being seen as rigid bars!), or even their number (see Zur).

In sum, the reactions of Substage IIA are all of a piece, both with respect to each other and to what we have seen at this level in other experiments. Owing to the relatively immobile character of the child's imagery (as compared with the connected ideas of the next level, and especially the mobile and reversible operations of Stage III), he can neither anticipate the changes occurring in the apparatus, nor analyse the shapes produced at a particular phase of the process.

These reactions therefore indicate that it is not enough to perceive lines as parallel (as in the rhombus) in order to be able to imagine them so. To do this it is necessary to distinguish between lines running in all directions, picking out only those which form identical pairs. But so long as parallels cannot be visualized, can we be at all certain that such relationships are even perceived at this level? For the children's drawings and constructions with rods would seem to cast doubt on such a supposition. In addition, Wursten's investigations, to which we shall return, also show that at this level children are unable to lay sticks obliquely parallel, let alone attempt anything so ambitious as constructing rhombuses.

Such considerations immediately raise the whole question of the relations between percept and concept, a question we shall again encounter in the course of the stages which follow.

§3. *Substage IIB. Gradual construction of the rhombus: beginnings of anticipation, but without conservation of parallelity or length of sides*

At this level we see once again the type of reaction already found in previous experiments. It is marked by a growing articulation of the child's ideas and the sketching out of the operational construction which appears in the subsequent stage.

Here are some examples.

GER (5; 6). "If we press on the handles?—*It gets longer*—What will happen to the windows?—*They'll get bigger and bigger* (he starts by drawing a cross (X) just like those of Stage IIA, then after exploring the shape with his finger he draws a rhombus. He produces four rhombuses of increasing size)—And if we go on pressing what will happen to them?—*They'll get smaller*—How? —*Smaller but in a bigger line* (= in a more elongated series)—Draw what they'll look like—(He continues to draw the same shape, just as wide but constantly

decreasing in size)—Watch (experiment)—*That's the right one* (his smallest drawing)".

From the rods he picks out longer ones for the increase and smaller ones for the decrease in size. Only when he copies what he actually sees does he show the transformation by means of rods of the same length; "*It is squashed*". But he makes no attempt to keep the opposite sides parallel.

TIN (5; 11). "What will happen when I press?—*It will open out* (we press and he draws the slightly opened rhombuses as irregular squares)—And if I open it some more?—*A little bit bigger* (still draws squares, but larger)—And if I go on pressing?—(He draws larger squares. Given the rods, he produces first a rectangle, then a square standing on one corner)—And if I keep on pressing?—*Bigger still*—And now?—*Still bigger; no, smaller* (he draws smaller rhombuses which still have the same, almost square shape)—And after that?—*Smaller* (the same shape is drawn, smaller and smaller) —Watch (the experiment is performed and carried on until the tongs are fully closed)—*It's quite tight and there are no more holes*". Thus, Tin foresees the progression increasing and finally decreasing though without keeping the length of his sides constant or worrying about whether they are parallel.

MIC (6; 0). "*It will change, the windows will get smaller; no, bigger* (he draws first a kind of zigzag, growing in size, then a series of larger and larger curved rhombuses)—If we open it more?—*Bigger still* (it is placed half open) —If we go on?—*The windows will get smaller*—Why?—*Because you're pressing, you're tightening them*—And then?—*Smaller and smaller*". He draws curved rhombuses, growing smaller and smaller but all of the same shape.

BU (6; 0) shows the enlargement of the "windows" by means of a row of vertical rods, placed at first close together, then further and further apart. The adjustable rhombus is placed before him and he is shown the start of the widening of the figure. He is asked to draw what he has seen and what will come next. Bu draws four rhombuses, each one larger than the last, the fourth covering the whole sheet of paper. Thus although he has one actual rhombus as a model, he does not keep the length of the sides constant, nor pay any attention to the parallelism! "And if I go on pulling?—(He begins to draw smaller rhombuses, still of the same shape)—And more and more?—*It will become a line*". Hence he moves at one stroke from the rhombus of fixed shape to the completely flattened one! When the experiment with the collection of rods is resumed, Bu now tries (having seen the actual changes carried out) to construct rhombuses that gradually get wider and flatter, though he still varies the overall size. He chooses rods of different lengths, and in particular, builds asymmetrical rhombuses with opposite sides not parallel. We end the experiment by showing him sample figures, some symmetrical and others asymmetrical, with corners hidden so that he is forced to judge them solely by the degree of parallelity between the sides. Bu accepts all the shapes, true and false, except for two extremely asymmetrical ones.

JAC (6; 6) looks at the adjustable rhombus and draws it as a slightly open, asymmetrical figure with opposite sides not parallel. "And if I open it?—(Draws several increasing in width, but with sides made longer and not parallel)—And if I pull it more?—*It's bigger still* (wider and bigger rhombuses with unequal sides)—And still more?—(Draws it even larger, then suddenly pro-

duces a narrow vertical figure, also very irregular in shape)—And right at the end?—(Very narrow horizontal rhombus)". Thus, he senses the progression, first increasing then decreasing, but can only render it through abrupt transitions and without keeping the sides parallel or equal in length. To check this last point he was shown the sample rhombuses with corners hidden. Jac ignores whether they are parallel sided or not. When they are presented once more, this time completely visible, he bases his estimate on the shape as a whole and again leaves parallelity out of account.

ROL (6; 8) is ahead of Jac for he is better at predicting the increase and eventual decrease in surface area. He draws rhombuses higher than they are wide, then with axes more or less equal, and finally wider than they are high, though all these shapes are still asymmetrical and not parallel sided. When the rods are used he chooses ones of different lengths to represent the changing figure (still without parallelism) showing that it is not a matter of skill in drawing.

PHI (7; 4) also comes close to producing a correct rising-falling series of figures, though the narrower rhombuses are still very badly formed (asymmetrical) while the largest are represented by rectangles. To build his rhombus with the rods he either chooses rods of different sizes or adds together a number of rods to form one side. The figures thus have sides which are not parallel and of different lengths.

On balance, these reactions are a distinct advance on those of the previous level in two important respects. Firstly, the rhombus is beginning to acquire a definite structure. All the children can now draw it or build it with rods, and can even distinguish the shape from the apparatus as a whole. Secondly, the changes in its shape are now anticipated, at least in a global fashion, as an increase followed by a decrease in surface area as the tongs are extended. Thus so far as concerns these two related aspects, it is now possible to speak of a train of connected ideas as against the static and isolated notions apparent at the beginning.

But these twin achievements are limited in their scope by a number of similarly related omissions and shortcomings. Firstly, all the rhombuses, whether drawn or built with rods, are irregular and lack parallel sides. This latter defect is confirmed by the results of the trials made with cardboard comparison figures. When he studies these, the child cannot yet distinguish between true and false rhombuses. This is equally true of children at the beginning of this stage, whose rhombuses are curved and grossly misshapen, and the more advanced ones whose drawings are perfectly proportioned. In addition, their rhombuses grow larger as they change in shape and they cannot imagine a rhombus able to expand and contract without altering the lengths of its sides. What they have in mind is a series of increasingly large rhombuses, evolved one from another in some way not clearly understood, and without this process being governed by any definite operations.

It is this failure to comprehend the actual details of what takes place which accounts for the second weak point in these responses. The child can imagine the increase and decrease in the surfaces, but only in an overall, global fashion. They appear to him, not as a continuous series of transformations, but as abrupt, disjointed changes. In particular, he cannot anticipate the reversal which takes place when the midpoint is reached, and this is just because he is unable to realize that the transformations affect the dimensional relations of the figure, and not its absolute size. Curiously enough, not one of these children ever deliberately draws the midpoint rhombus as it is, a square standing on one corner, not even those who, like Tin, draw the rhombus very like a square.

In short, the child's reactions show that at this level he anticipates the course of the transformations through a more or less continuous chain of ideas, though not yet by means of operational thought. It is precisely this lack of operations which is responsible for the disjointed character of the changes which he anticipates, and for the fact that the sides of his rhombuses are still neither parallel nor of a constant length.

§4. *Stage III: Substage IIIA. Beginning of operational construction with conservation of parallelity and length of sides*

Stage III, beginning around the age of 7–8, is distinguished by the emergence of concrete operations. From its inception at Substage IIIA it marks an important advance on the previous level. The child no longer attempts to explain the expected changes in the shape of the rhombus as alterations in the length of its sides, but as a change (not explicitly formulated as yet) in the ratio of height to width, the length of the sides remaining constant. He also makes a visible attempt to keep the opposite sides parallel, and show the transformation as a continuous process.

WEI (6; 6) foresees that as the tongs are extended "*these windows will be spread out more* (he draws the rhombus with opposite sides parallel and constant in length, the surface being shown as continually expanding)—And if we go on?—(The same, repeated)—And then?—*They get like this* (draws a rhombus wider than it is high)—And then?—*It will make two lines, it will end up as two lines like this* (he draws the pairs of parallel rods)". He is given a collection of rods; "Can you pick out some rods and make the same thing?" He takes four rods the same length and builds a series of rhombuses of varying heights and widths until he reaches the final horizontal figure ("*a window lying flat*").

COI (6; 10) says, "*It will get bigger*—And then?—*Bigger still* (draws a series of rhombuses with parallel sides, the sides themselves being almost constant in length but the width of the figures increasing)—And if we go on?—*It will keep on opening more and more and then it will get lower* (he indicates the fall

in height whilst keeping the sides the same length and parallel)—And in the end?—*It will be completely closed*".

DAN (7; 4) begins by predicting an absolute increase of size (with no change in shape) just as at Stage II, followed by an absolute decrease. The same thing happens with the rods. He selects some larger and some shorter ones but then suddenly cries out, "*No, it can never be like that because the rods are always the same. They always stay the same size. This drawing is wrong*". He now shows the changes in shape by varying the proportions of width and height without varying the lengths of the sides and making sure that the opposing sides are parallel. He is now shown some sample models of rhombuses with non-parallel sides; "*No, it will never look like that. This* (the top) *is too flat. It must be the same as this* (the lower half)—(The angles are hidden from view) —*It still isn't right. It won't do like that* (he indicates the sides that are not parallel and not merely the general lack of symmetry)".

GRO (7; 6). "*They'll be spread out more*—In what way?—*The height gets less and the width becomes greater* (!)—Which drawing gets widest?—*This* (he draws five rhombuses increasing in width and decreasing in height, the sides being almost parallel and constant in length)—And then?—*The height is almost all taken up in the width* (correct drawings)—And in the end?— *You can't go any further, it gets completely flat*". He makes the construction with rods correctly, choosing ones of the same length and arranging them parallel.

WID (7; 6) behaves in the same way. He produces ten drawings showing rhombuses with the sides parallel and equal in length; "*the height gets smaller but the length* (the width) *gets bigger*—And in the end?—*There aren't any more* (he draws the rods parallel)".

MAR (7; 7) draws the rising and falling progression right through to the end. He is then shown some sample rhombuses; "*That one won't do because this side is too big* (he judges on the basis of asymmetry). *Nor will that one, because one side is bigger than the other*", etc. The angles are then hidden from view. "*That one's wrong because the whole of that side is sloping more than this one. That one is no good either because on this side it's straight and there it's sloping. That one is all right because both sides are sloping the same*". Here he is basing his estimate explicitly on the parallelism of the sides.

WEL (7; 8). Same reactions. The sample figures with corners hidden are judged on the parallelism of the sides; "*This one's no good because here it's too pointed and there it's too flat*".

BRU (8; 5) draws a rising and falling series with sides almost parallel and equal in length. He is shown the collection of rods. "How do you make it smaller?—*I bring them closer together* (increased width and decreased height) —And larger?—*I stretch them out more*" (thus he keeps the sides the same, changing only the relations between them).

PER (8; 6) "*It won't get any bigger, only narrower* (correct drawings)— And if we go on pressing?—*The windows will become square* (he anticipates the midpoint)—And after that?—*Nearly flat*". He draws the changes as far as the oblique square, then carries on with the width greater than the height, keeping the sides parallel and of the same length throughout.

The vast difference between these reactions and those of Stage II is

314

obvious. In the first place, the sequence of affinitive transformations occurring in a continuous progression is anticipated correctly, and we also find some children who realize that the half-open position will produce squares (cf. Per). In the second place, the details of these transformations are grasped operationally as a simple relation between varying height and width of the rhombus without any change in the length of the sides, so that the absolute size is seen to remain constant. Dan offers a striking example of this. He starts off by making a number of typical errors and then suddenly becomes aware of what is going on.

Furthermore, as soon as the child discovers how the alterations in the figure really come about, he automatically realizes that opposite sides of the rhombus must remain parallel or else it would cease to appear symmetrical and the sides would no longer be equal in length. Thus from this stage on, the parallelism of the sides is linked operationally with the transformation of the figure as a whole and is no longer simply perceived or imagined intuitively. The interdependence of these concepts is rendered even more significant by the fact that it is only at this level that oblique parallel lines begin to be perceived as such. For children in Substage IIB, who might have been expected to notice the parallelism of the opposite sides of the rhombus without understanding the reasons for it operationally, usually ignored it in practice.

§5. *Substage IIB and Stage IV. Explicit formulation of the relationships*

The only new feature introduced by the answers obtained at Stages IIIB and IV is an even more explicit formulation of the way in which the relationships function, and ultimately, the deduction of the whole process in advance.

PEZ (9; 10). With the apparatus almost completely closed he is asked, "What will it look like when it's wide open?—*The ends will touch, it will get longer* (he draws it almost fully extended, the rhombuses 1–2 mm. high and 10–11 mm. wide)—What will the rods be like?—*Swinging closer and closer to each other*—And their length?—*The sides are always the same length whether they're open or whether they're closed*—And the shape?—*When they are nearly open it's a square and when they're wide open it's a diamond*—At what point will it be a square?—*At the halfway point*—And does the surface change?—*No, it doesn't change. Or rather yes, it does. First it gets bigger and bigger, then smaller and smaller*".

KAU (10; 6). "What will change?—*The shape. The diamonds will get longer* (he points to the width)—What else is there in a diamond shape?—*Angles. They get bigger and smaller. They never stay the same*—What are the straight lines like?—*At an angle and always parallel*".

VAN (10; 8). "*They* (the rods) *stay parallel whether you're opening or closing it*".

RAD (11; 4). "*It works the same as a pair of scissors*—And when it's opened out?—*It will just open a bit wider* (correct drawings)—When will the width

become greater than the height?—*After the halfway mark, when it makes right-angles"*.

AZA (11; 6) draws all the transformations in advance: "When will we see the square?—*In the middle*—And the second time?—*No, we'll only see it once"*.

COT (12; 0). "*The diamonds turn into squares when you open them out*—How will the rods look?—*Oblique and parallel*—Do the sides change?—*No, the angles change but the sides don't"*.

The progress is self-evident, especially by Stage IV. The relations noted by the child are the same as those of Stage IIIB, but they are all formulated and deduced a priori, including the point at which the height becomes less than the width.

§6. *Conclusions. The conservation of parallelity*

To draw the correct conclusion from this rather brief study we must begin by comparing its findings with those gained from the study of the concepts, and above all the perception, of children attempting to estimate the degree to which ordinary lines are parallel. While following the experiments described above, the reader must doubtless have been constantly asking himself whether the actual structure of the rhombus does not in practice tend to complicate rather than encourage the perception of parallelity. For on the face of things, nothing could appear simpler to imagine, and especially to perceive, a pair of lines as always equidistant and never intersecting.

It is enough to question a young child about the parallelity of two oblique lines, however, to realize how complex this problem really is. First of all, how is one to pose the question in order to make the idea of parallelism comprehensible? Presumably by asking whether the lines "slant the same way", since any mention of ideas such as 'equi-distance' introduces far more complicated notions and measurements which themselves depend on assumptions about parallelism (i.e., the parallelism of lines at right angles to those under consideration, thus yielding a circular definition of parallelism in terms of equidistance). Alternatively, to speak of two straight lines "sloping the same way" means introducing the concepts of both straight line and spatial orientation. Now we have already seen in Chapter VI how late the straight line comes to be visualized; and as for the concept of orienta-tion, this is a matter either of measuring angles or else finding some other method of determining the inclination. But the idea of parallelism ap-pears at the same time as that of angles, and this is hardly surprising since a pair of straight lines intersect to form an angle whenever they are not parallel, and in the next chapter we shall see that these twin concepts are psychologically interdependent. If this is the case it necessarily follows that the concept of angle cannot precede that of

parallelism, nor can it serve as a measure of parallelity of a pair of oblique lines. This leaves us with the idea of identity in orientation, but this is soon ruled out when it is realized that the concept of spatial orientation is the foundation of the co-ordinate systems themselves. And as will be seen in Chapter XIII, their development is an extremely complex and protracted affair.

In short, it is no simpler to imagine the parallelism between two lines, than between the sides of a closed and well-organized figure like the rhombus. But, it may be asked, surely it would be simpler to perceive, even if not to imagine? Here the result of comparing perceptual and conceptual estimates is very much to the point, for actual study of perception of parallelism leads to the conclusion that the idea of parallel lines precedes their accurate perception, rather than being a consequence of it as might have been thought.

Wursten (op. cit.) carried out the following experiment: twenty adults and twenty children aged between 5–6 and 12–13 were asked to compare the lengths of oblique lines drawn on cards. Alternatively, they were invited to draw vertical, horizontal or oblique parallel lines, or else adjust pivoted metal rods to a parallel position. Wursten's findings were as follows; first, parallels are never perceived entirely without errors, even by the experienced adult. This is further confirmation of the intellectual, logical character of geometrical concepts which govern and influence perception rather than being wholly dependent upon it. Second, and most important, comparison of variations in thresholds and constant errors showed perception of tilt and spatial orientation to be extremely poor below the age of 7–8. The reason why young children are better than adults at comparing the lengths of lines pointing in different directions is precisely because they remain indifferent to their relative orientations.[1] The general findings of these experiments suggest that the perceptual space of the younger children is relatively unorganized as regards orientation, and consequently lacking in frames of reference. From 7–8 on, performance slowly improves and continues to do so until maturity.

Hence with the rhombus, the concept of parallelism—which as we have seen, is not acquired until Substage IIIA, which is about the age 7 or 8—is not a direct product of earlier perceptual development. On the contrary, it would seem part of a whole set of operational factors which interact with perception, gradually refining and sharpening it.

Now if the concept of parallelism is not to be explained as a mere product of perception, how is its development to be accounted for? Taking first the case of single lines, we showed in Chapter VI (Section I) that the idea of the straight line, associated with the practice of 'taking

[1] Less difficulty is experienced with vertical or horizontal parallels. Hence in these two cases it would seem that perception of parallelity precedes the idea of it.

aim' (i.e., co-ordinating a topological line with a perspective point of view), appears jointly with the idea of maintaining a fixed direction, and precisely about the age of 7 or 8. Now it is obvious that this latter concept brings in its train the idea of a common orientation for a number of lines. When the children of Substage IIIA begin to realize that railway lines appear to meet in the distance, they think of them as being parallel in reality although making them converge in perspective.[1] In short, once the child has grasped the operational concept of the straight line, he can also envisage a pair of straight lines as parallel. As for parallelity between opposite sides of the rhombus, in the present experiments it is bound up with understanding the series of affine transformations through which the figure passes. So long as the child regards these changes merely as absolute expansions and contractions of the rhombus he has little reason to think of the figure as four lines of equal length, parallel in pairs and disposed about two unequal axes. But the moment he grasps the fact that the angles and axes of this rhombus can vary without in any way affecting the lengths of the sides (as he does at Substage IIIA), he also realizes that parallelity of the sides is the invariant which enables these changes to be foreseen. Thus, in the system of affine transformations we have been investigating, the parallelity between opposite sides of the rhombus functions as an operational invariant, and this is precisely how the child works it out.

There still remains the problem of the relations between parallelism in isolated pairs of lines and parallelism in the rhombus. However, this is a comparatively simple matter. When discussing the question of drawing the rhombus (Chapter II §6.) we saw that it offered greater difficulty than did the square, the rectangle or the triangle. This is mainly because the child has to consider pairs of parallel lines which are not perpendicular, and because the sole criterion for judging the figure correct is the symmetry between the two halves. Hence, it is clear that the rhombus cannot be constructed in advance of parallel lines (if we include oblique as well as vertical and horizontal lines, and exclude any perceptual reference frame). At the same time, since the child can draw straight lines parallel to each other as soon as he has learnt to draw them singly and independent of the perceptual surround, it follows that conservation of parallels in the rhombus, construction of oblique lines, and the drawing of parallels in any direction whatsoever, are all very closely akin. For each of these activities is based on one operational mechanism which is common to all concepts dealing with spatial orientation.

[1] As regards this point, it should be noted that when children of Stage II draw the rails not converging, they are only shown very approximately parallel. Similarly, when they form a line parallel with the edge of the table, the parallelism only arises through the perceptual influence exerted by this edge as an existing straight line.

It may be asked what these ideas have in common. Let us ignore the projective method of forming a straight line (by 'taking aim') and consider only the idea of maintaining a fixed direction, which appears at exactly the same time. It should then be clear that what is common to the concepts of straight line and parallelity is that both form the starting point for co-ordinating directions in space, completed at the level of euclidean concepts by the construction of true co-ordinate systems or frames of reference.

Before going on to deal with this topic, however (Chapter XIII), we must first examine how the child, having acquired these preliminary notions, works out the cognate ideas of angles, proportions and similarities. As will be seen in the next chapter, in the development of the concept of space, the group of similarities (conserving angles) lies exactly between affine transformations (conserving parallels but not angles) and displacements (conserving distances in addition to angles, parallels and straight lines).

Lastly, it should be noted before broaching the problem of similarities and proportions, that though affine transformation of the rhombus does not entail the idea of proportions, it does imply some sort of extensive quantification akin to that involved in projective changes.[1] And it is apparent that the child does implicitly take account of the changes in the rhombus as forming a continuous series with a reversal at the mid-point (particularly evident at Stages IIIB and IV).

[1] See L. Godeaux, *Les Géométries*, p. 146.

Chapter Twelve

SIMILARITIES AND PROPORTIONS[1]

IN studying the evolution of child thought we frequently encounter the problem of how proportions come to be understood. In the case of speed and movement this idea is involved as soon as two successive movements have to be compared over different times and distances, say 5 cm. in 1 second and 10 cm. in 2 seconds.[2] Similarly, with children's judgements of probability, the idea of proportions is directly implied in granting the same degree of probability to two favourable cases out of four, as to three favourable out of six possible cases.[3] In both these very divergent fields, the idea of proportion does not appear to be fully developed until the level of formal operations is reached (Stage IV), although it is, of course, developing all through the earlier stages, especially as regards the simpler cases.

However, as far as purely geometrical proportions are concerned, the whole question has to be dealt with afresh and this we shall try to do from a number of aspects.

In the first place, the geometrical treatment of proportions based on Thales' theorem and current since Gassman, assumes as axiomatic the concepts of angle and similarity. In the previous chapter, however, we have observed that from the standpoint of psychological development also, parallel lines are constructed concurrently with angles. And at the same time, from the geometrical standpoint, the group of similarities which ensures the conservation of angles is an offshoot of the group of affinities which ensures the conservation of parallels.

From this we may infer that having seen how the child comes to keep the sides parallel during transformation of the rhombus, the next thing would be to examine how he perceives the similarity of inscribed triangles on the basis of the parallelity of their sides; and how he proceeds from this to perceive their angles as being equal. Treating this particular case as a transition from the study of parallels to the study of angles (from analysis of affinities to analysis of similarities), we may follow on by extending our study of similarities to cover comparison of angles in general, along with other figures such as the rectangle.

But there is another reason for devoting a certain amount of attention to proportionality in dealing with spatial problems; namely, that here

[1] In collaboration with Mme. Marianne Denis-Prinzhorn, Mlle. U. Galusser, and Mlle. M. Gantenbein.
[2] See *Les Notions du Mouvement et de Vitesse chez l'Enfant*. Paris, 1946.
[3] See *La Genèse de la Notion de Hasard*.

it is much easier to study than in non-geometrical forms. Long before he can think about 'similar' figures the child can directly perceive whether figures having different dimensions possess similar relationships. Hence the origin of the idea of proportions must be sought for in the actual perception of figures. So far as this goes, the problem has been narrowed down considerably by Gestalt theory, not only by showing the part played in every perception by patterns and 'good configuration', but also by demonstrating that one criterion of 'good configuration' is precisely the possibility of recognizing structures as identical despite variations in absolute size. The perceptual recognition of two shapes as similar, such as squares of different sizes, is termed 'transposition' and subsequent to the work of Von Ehrenfels and the various Gestalt ideas derived from it, the ability to transpose not only figures but other structures such as melodies has been accepted as one of the fundamental properties of perception, or perceptual activity as we termed it in Chapter I. Clearly, if this is the case, we must go right back to the details of elementary transposition to explain how the idea of proportions evolves.

However, it is one thing to perceive two figures as similar and quite another to be able to construct operationally a figure similar to an existing model but which does not yet itself exist. Thus, the perceptual problem by no means eliminates that of the psychology of intelligence but only indicates the need to study the two questions separately and relate them to one another.

Even within the realm of perception there exist variations in transposition. Thus, transposition from a small square to a large one involves the shape considered as a whole (the square as such), the size of the angles (which remain right-angles), and the relative lengths of sides or diagonals (which remain equal to each other). On the other hand, if two rectangles are presented for comparison, the overall shape and the angles can remain the same though one figure may be longer or wider than the other. In this case, transposition of the shape entails transposition of the angles but not the relative lengths of the sides. Finally, a pair of triangles or rhombuses may be perceived as of the same overall shape in that they are always triangles or rhombuses, but this does not entail the transposition of the angles or the relative lengths of the sides.

One must therefore be careful to avoid thinking that perceptual transposition leads automatically to perception of 'similarity' in the geometrical sense. Although it may do so in the case of some figures like the square (at a certain age), it is in fact no more universal than the perception of parallelism, which with young children, as we have already seen, only holds in the case of vertical or horizontal lines and not with oblique parallels. Hence, even within the realm of perception it is necessary to make a careful distinction between transposition

according to whether it concerns overall shape, dimensional relations or angles.

Thus, the problem is to discover how at each level of development the perception of proportions is extended and carried over into the realms of thought. More precisely, to see how at each stage intelligence exploits, or adapts itself to, the data accruing from the perception of proportions, a process which is itself in course of development. Assuming that the child can perceive two models as similar, will he be able to draw them in proportion, not only as regards the overall appearance, but preserving the angles and relative dimensions? Or does this require a new and further process of mental development? And if so, what will be the actual relations between perceptual and intellectual activity?

It is from this second standpoint of the relations between perception and intelligence, as much as from that of the relations between angles and parallelism (or similarities and affinities), that we must study the development of proportionality. Such a study clearly bears a double implication, for it concerns equally the development of the idea of space and the operations of geometrical thought.

SECTION I. SIMILAR TRIANGLES

To find out how children discover the similarity of triangles we set them two problems such as enabled us to isolate the relationships involved and to follow the transition from mere awareness of parallelism (studied in the preceding chapter) to the ideas of equality or inequality between angles, essential to the full conception of proportionality and similarity.

We began by asking the children to describe or draw pairs of similar or dissimilar inscribed triangles presented in such a way that the similarity may be recognized either through parallelism of the sides or through equality of the angles, and in particular, enabling the child to pass from one criterion to the other at will.

Next, the children were shown cardboard triangles which had to be sorted into groups (isosceles, scalene, etc.) after having been handled freely, temporarily covered, and so on. Here again the similarities may be inferred from comparison of either angles or sides. Hence, in both experiments the equality of the angles is experienced in association with a double or even triple parallelism (that of the sides of the figures compared in pairs), just as in Chapter VI (§6.) the concept of parallelism appeared in association with that of the straight line itself. This has the advantage of making it easier to trace the interconnections between the three concepts of straight line, parallels and angles.

§1. *Technique and general results*

The two problems were presented as described below. The first is

so arranged as to draw attention to the parallelism of the sides, while the second emphasizes the equality of the angles, though in each case the subject is at liberty to carry on in the way he thinks best.

Problem One. The method employed in presenting this problem has two aims. The first is to direct the experiment towards discovery of the parallelism of the sides as a criterion of similarity between triangles. The second, to facilitate study of the relations between this criterion and equality of angles on the one hand, and the relative lengths of the sides on the other. For this reason we simplified the procedure by using only inscribed figures, either drawn or compared by direct perception.

1. The child is given a triangular model and asked to draw: (*a*) A similar triangle which circumscribes the model.[1] The models consist of isosceles triangles, the first having sides of 3 cm. and a base of 3 cm., the second 1·7 cm. and a base of 3 cm. (or 3·4 cm. and base 6 cm.), and the third, sides of 6 cm. and a base of 3 cm. The base of each of these triangles coincides with a part of the base of the triangle in which it is to be inscribed and as a general rule we provide the base of the new triangle ready drawn. Thus, for the first two triangles we drew bases of 6, 9, or 12 cm., and for the third, bases of 6 or 9 cm. Given the model and the base of the new triangle to be formed around it, the child has only to draw the remaining two sides. It is therefore quite easy for him to maintain the parallelism between the sides of the existing and future triangles. Since the bases have the same midpoint it follows that a line bisecting the small triangle through this point will also bisect the larger one about to be constructed. To make things easier for the subject we sometimes even drew this bisecting line dotted in, taking it well beyond the limits of the triangle about to be drawn. On other occasions we avoided any such construction and left the child to carry on and produce the surrounding triangle entirely as he thought best.

(*b*) We applied the same technique to irregular triangles of 4 and 2·5 cm. side and 6·5 cm. base, to find out whether the method used to discover the parallelism of the sides was the same as for the isosceles triangle.

2. Using a small triangle as a model (equilateral with side 3 cm.; acute isosceles with side 6 cm. and base 3 cm.; obtuse isosceles with side 2·5 cm. and base 4 cm.; and irregular triangle, sides 6, 4·5 and 2·5 cm.), we produced two sides (the base and the left side) and asked the child to enclose it within the left-hand corner of a similar triangle, either double or triple the size (or sometimes enlarged indefinitely). The problem is then merely one of finding the third side which can be done simply by guessing the parallel line.

[1] The children are of course provided with a straight edge to help draw the lines but no other allusion is made to parallelism of the sides.

3. Having drawn triangles of equal sizes on one sheet of paper we asked the child to draw similar but larger triangles on the same sheet, not enclosing but either near or touching the originals. Except that the triangles he has to draw must not have their bases common with the models, the child is allowed to go ahead as he thinks fit (judging parallelism, measuring sides, angles, etc.).

4. An irregular triangle having sides of 2, 4 and 5 cm. is presented with base slanting. The sides are produced with dotted lines. Some point is chosen for the length of one of the new sides, for example, an increase of 4 cm. to the short side, making it 6 cm. in all, or 8 cm. to the long side making 12 cm. Having shown the child the figure and asked him to construct a similar triangle larger in size, starting from the new length marked along one of the produced sides, the base of the triangle is covered over and the child is left to make a new triangle as he thinks fit whilst being deprived of the use of the base with which to make his own base parallel. As the dimensions of the figures are not given, he cannot measure the increase as being double the original length of side. The object of this problem is to see whether the child will add an equal length to each side in the absence of parallelism, or whether he will make a drawing which shows some feeling for proportion, even without measuring.

5. Instead of having the child draw a circumscribing or adjacent triangle, we show him the triangles already completed in a selection of drawings, some correct and some incorrect. He is then asked to separate the similar and dissimilar pairs. For example, an equilateral triangle with 3 cm. sides circumscribed by a triangle having a base of 6 cm. common to the first, but with sides varying from 4 to 8 cm. or more. The pairs were presented in random order and the threshold of equality determined, based on the lengths of side of the triangles judged similar to the inscribed triangle.

6. By way of comparison and without dwelling overmuch on similar rectangles (which will be dealt with in Section II) we presented the subject with a cardboard rectangle $3 \times 1 \cdot 5$ cm. and a sheet of paper on which a base is already drawn, the latter varying between 6 and 12 cm., coinciding with the lower side of the model and beginning at one corner. The subject is then asked to draw a similar rectangle enclosing the first, using the existing base, or occasionally to draw the rectangle without the aid of the prepared base line.

7. Similarly, for the sake of comparison we had subjects compare pairs of rectangles, the enclosed figures being again $3 \times 1 \cdot 5$ cm. and the surrounding rectangles 4 cm. wide and of varying lengths.[1] The errors were treated as positive when the figure judged similar is over-estimated

[1] These dimensions were chosen to facilitate comparison with non-inscribed rectangles, studied in Section II.

and negative when it is underestimated, the threshold of equality being calculated in centimetres.

8. Since a rectangle is a double triangle we thought it might be useful, for the purpose of comparing similarities of triangles and rectangles, to present a small rectangle (again $3 \times 1 \cdot 5$ cm.) but with one diagonal drawn so that it is cut into two triangles, the diagonal being produced beyond the figure in one direction. The child is then asked to draw a rectangle circumscribing the first (as in 6.) to see whether he will avail himself of the produced diagonal in order to construct the new figure.

9. Lastly, we studied the perceptual comparisons which can be made between inscribed rectangles (as in 6.) when their diagonals are common or uncommon; continuous or broken (if the figures are dissimilar).

Problem Two. The second group of questions deals with triangles which have to be sorted into groups after being handled freely, superimposed, etc. To this end, children are presented with a series of cardboard triangles in such a way that they may compare them either in small groups or (with the older children) as a whole. Here the main thing is to study their manner of comparing the shapes. During the experiment new figures are introduced and others removed as the need arises. The complete set of triangles consisted of:

Series A. Five similar isosceles triangles with acute apex angles. A1=30 cm. side, 9 cm. base; A2=20 cm. side, 6 cm. base; A3=15 cm. side, 4·5 cm. base; A4=10 cm. side, 3 cm. base; A5=7 cm. side, 2 cm. base.

Series B. Three similar isosceles triangles with obtuse apex angles. B1=6·5 cm. side, 50 cm. base; B2=3·25 cm. side, 25 cm. base; B3=1·6 cm. side, 10 cm. base.

Series C. Three isosceles triangles, all 20 cm. inside but with different bases. C1=5 cm. base; C2=30 cm. base; C3=50 cm. base.

Series D. Three dissimilar isosceles triangles, all with base 15 cm., varying in height. D1=3 cm. height; D2=13 cm. height; D3=26 cm. height.

Series E. One scalene triangle E1=13·5 cm. base, height 4·5 cm.; 43°, 107°, 30° angles. One isosceles triangle E2=12 cm. base, height 6 cm.; 45°, 45°, 90° angles. One equilateral triangle E3=8 cm. base, height 7 cm., side 8 cm.; 60° angles. One right-angled triangle E4=16·5 cm. base, height 8·5 cm., and angles 28°, 62° and 90°.

Series F. Eight equilateral triangles (F1–F8) and a triangle (F9) with the same apex angle but with the base cut at a different angle.

The results accruing from both methods (I and II) enable us to identify certain general levels of development ranging from Substage IIA to Stage IV. It proved impossible to carry out useful experiments with children below the age of 4 or 5 (Stage I), even with Method II.

Although the stages we are about to describe relate to the findings of

both types of experiment, it should be realized that these results are complementary rather than identical. This, of course, renders them all the more interesting, since it is one thing to compare two ready-made figures, or even to draw one by enclosing the model with a copy, and something quite different to judge two figures as similar by moving them about and superimposing them. Thus, in the experiments of Method I the child cannot superimpose the angles directly and has to rely on the parallelism of the sides, whereas with Method II he makes the angles actually coincide by moving the two pieces and does not have to rely on the parallelism. What is most striking is the fact that with both methods the child discovers the parallelism of the sides (Method I) and the equality of the angles (Method II) at the very same age (7; 6 years on the average). In other words, in both cases he learns to ignore the actual lengths of the sides, a factor which constantly misleads the younger children. Again, with both methods the discovery of qualitative similarities appears to take place prior to any understanding of the relative proportions of the dimensions themselves, this latter being restricted to simple ratios at Substage IIIB and only being applied generally at Stage IV.

The actual stages observed are as follows: Substage IIA from 4–5 up to 6–6;6 years. Here the drawings obtained with Method I take account, neither of the parallelism of the sides nor the equality of the angles. Perceptual comparison of pairs of inscribed triangles leads to a constant error, usually in the direction of choosing too high a triangle as similar to the inscribed one. The rectangles chosen are too long, and the diagonal is not utilized as a guide to comparison. As for Method II, the comparisons are made without any direct matchings of the angles or any consistent effort to superimpose the figures.

During Substage IIB (6–7; 6 years) the enlargement of the inscribed triangle results in an intuitive idea of parallelism in a few special cases, such as obtuse-angled triangles with sides but slightly inclined. On the perceptual side there is marked progress in judging the slope of the sides of triangles. The errors described above are more pronounced with the rectangles while the diagonal is still not used to help judge their proportions. As for Method II, here also a beginning of discrimination is apparent though superimposition is not yet used spontaneously as a means of comparing the figures.

While Stage II is distinguished by the absence of any systematic operational comparisons, Stage III marks the appearance of operations facilitating general comparison of parallels, angles and simple dimensional relations. The parallelism between the inner and outer sides of the inscribed triangles is discovered at Stage IIIA (Method I), just as the notion of parallelism between opposite sides of the rhombus appeared at the same stage in Chapter XI. As for perceptual comparison, from

now on perception is governed by thought (remaining less accurate than operational comparison carried out with the aid of a ruler), though judging similarity of rectangles is still more difficult than judging similarity of triangles. Method II shows the children attempting to identify triangles as similar through the equality of their angles and we find them spontaneously superimposing the figures.

With Method I, we find the children of Substage IIIB (beginning 9–9; 6 years) making comparisons which take account of both parallelism and elementary dimensional relations (Questions 1 and 2), whilst Method II shows them attempting to relate parallel sides and equal angles at one and the same time.

Last of all we come to Stage IV, marked by the attainment of true proportionality for all dimensional relations jointly with those already mastered.[1]

To make the task of exposition simpler we will describe the results of the two methods in succession, first the inscribed figures to be drawn or compared by eye, then the movable cardboard figures to be handled and superimposed.

§2. *Inscribed triangles. Substage IIA: no parallelism between corresponding sides. Substage IIB: the beginnings of parallelism*

It will be recalled from Chapters I and II that below the age of 4 years (Stage I) the child cannot as yet draw either triangles or rectangles, or recognize their shapes in haptic perception. It is therefore a waste of time to attempt to ask questions about similarities at this stage unless one keeps within the boundaries of direct perception.

On the other hand, at Stage IIA, or at any rate towards the age of 5, the children have little difficulty in circumscribing one triangle by another supposedly representing its enlargement. But however much one tries to stress the fact that the larger triangle must "have the same shape" as the model, or "look just like it", be "just the same" and so on, the child nevertheless rests content with a rough, global analogy. That is to say, he draws a larger acute triangle for an acute model, or a larger obtuse triangle for an obtuse model, but he is still quite unconcerned for the angles or the parallelism between the sides. Here are some examples of this.

PER (5; 5) is given a model having a base of 6 cm. and side 3·4 cm. and a drawn base of 12 cm. for his construction. He draws a triangle which is much too high and not isosceles. Despite the fact that the common bisecting line is dotted in, he puts the apex over to the right. Its sides are 12 (given), 10 and 8 cm. For a model 3·6 and 6 cm. he draws an enlargement of 6 (given), 8 and

[1] The same order of development, from Stage II to Stage IV, applies to adjacent (Question 3) as to inscribed triangles, though there is a slight lag at the earlier stages because in this case the model cannot be placed inside the enlarged copy for comparison.

8·5 cm., thus barely higher than the model, with the sides not parallel and the apex moved over to the right.

A square with a side of 3 cm. has to be enlarged on a given base of 6 cm. produced 3 cm. beyond the model. He draws it correct. On the other hand, a rectangle 3 × 1·5 cm. with a given base of 6 cm. results in an enlargement of (=base 6 × 9·5 cm.), of which Per himself observes "*It doesn't look like it*". Nevertheless, he cannot do any better.

Visual comparisons produce a constant positive error in height for the triangle and length for the rectangle.

CYR (5; 8). Equilateral triangle 3 cm. side: "What is it?—*A Red Indian's tent*—Now you must make a big tent looking just like the little one, starting with this line (a common base is drawn, but right across the paper without indicating any particular length)—(Cyr draws a large triangle with a base of 15·5 cm. and sides 11 and 12 cm.)—Is it exactly the same (the sides are obviously not parallel)?—*Certainly*—Now you must make a tent like this (isosceles triangle with base 6 cm. and sides 3·4 cm.)—(He draws a triangle with a base of 20 cm. and sides 13 and 12 cm.)—And like this (base 3 cm., sides 6 cm.)?— *Oh, a very pointed one* (he first draws a triangle with base 16 cm. and sides 10 and 13 cm., then says), *It's not pointed enough.* (He draws one 16 cm. base, 13 cm. sides), *No, more pointed still* (draws a third triangle enclosing the previous ones, base 19·5 cm., sides 15 and 16 cm.)". Thus each attempt results in a shape quite different from the model and with a base larger than the sides.

As a comparison Cyr is asked to make some enlargements by the side of the model instead of around it, using a prepared base line. For the equilateral triangle, base 3 cm., he produces a copy with sides 6 and 6·5 cm., but for the triangle with base 3 cm. and sides 1·7 cm. he produces sides of 6 cm. on the 6 cm. base. For that of base 3 cm. and sides 6 cm., he draws the copy on a base of 6 cm. with sides 7 cm., subsequently altered to 8·5 cm.

Enlargement of rectangles results in figures that are either too high (like Per's) or too long. Visual comparison of the inscribed figures also leads to the same type of error; over-estimation of height for triangles and length of rectangles.

VOG (6; 9) is shown the isosceles triangle with base 6 cm. and sides 3·4 cm. He expands it into figures, each less parallel with the original than the one before, the series culminating in an irregular triangle of base 19 cm. and sides 11 and 15 cm. The same happens with the model base 3 cm., side 1·7 cm. As for the rectangles he simply lengthens them, taking no account of their width, nor bothering about the diagonal when this is shown.

As regards visual comparison, Vog seems a little more advanced than the previous children, though he continues to over-estimate the heights of the enclosing triangles judged similar to the inscribed ones.

SIL (5; 10). The child is shown the equilateral triangle with 3 cm. sides and offered a succession of six irregular triangles and one equilateral with 6 cm. side. "You see this little roof. It's for a little house. I'm going to draw a bigger house and I want you to pick a roof out from there that's exactly the same only bigger—(He rejects a certain number of triangles, saying each time) *It's too big.* (Then he selects two irregular triangles and the equilateral) *All these are all right*—Which fits the best?—(An irregular one)".

He is next shown an isosceles triangle and then a larger model together with six irregular triangles. He begins by choosing according to size, "*No, it's not the same size, it's not the same thing*". Then he puts one isosceles triangle on top of the other and lines up one of their sides; "*It's the same, only they're not the same size*". However, he also puts the model on an irregular triangle of a very different shape (an obtuse vertex instead of an acute one), and says "*It'll do, it's just the same, you can use this*" (the bases coincide and he does not bother about the shape).

He is then asked to draw "a big roof just the same as the little one", enclosing the triangle already drawn and using a common base. He fails completely, his copy having neither parallel lines nor equal angles. For an isosceles triangle with only slightly inclined sides he draws three lines one after the other, each being less parallel to the sides of the model than the one previous. Of the last he says, "*This one will do very well*".

After this he is asked to enclose triangles in the left-hand corner of a large similar triangle. Its base and left side are already drawn, leaving only the remaining side to be added. He is also asked to make a similar enclosure but without the two existing sides being extended. In the first case Sil fails to make the third side parallel and in the second he extends and completes all the sides without really knowing what to do and constructs an entirely different figure. The adjacent triangles which have to be copied enlarged fare no better, showing no sign of parallelism between the corresponding sides.

Enlargement of the rectangle results in one roughly similar and others which are too long.

Finally, he is given a set of triangles inscribed, some centrally, others in the corners of larger triangles, and asked to judge them by eye. He seems to notice the parallelism in one case; "*This one is the nicest*" (pointing to the parallel sides), but of two triangles not parallel he says, "*Yes, just as good as the last one*".

There is no need to multiply these examples to see the kind of reactions which are typical of this stage. Faced with the task of drawing a triangle larger than an existing one, the child contents himself with producing any sort of triangle, regarding all triangles as alike in contrast to non-triangular figures. When it is a question of enlarging the original by circumscribing it with another triangle on a common base, the situation no doubt leads the child to draw a figure which is roughly the same shape as the model. But even so, this is only true of equilateral and obtuse isosceles triangles. For the acute isosceles (base 3 cm., side 6 cm.) generally results in the copy being very different, for example, a base of 6 cm. and sides of 8 and 8·5 cm. with Per, and a base of 16 cm. and sides of 10 and 13 cm. with Cyr. It is quite clear that the task of enlarging the figure whilst preserving its similarity is rendered much easier by circumscribing it. This is shown by the results of a control experiment which consisted of having the subjects draw their enlargement next to the model and not around it. The report of Cyr's reactions to this test shows that all resemblance between the model and the copy disappeared

(save in the case of the equilateral triangle, though this exception is probably due to the perceptual influence of its strong configuration).

However, it is just because it is easier to maintain the similarity when the model is inscribed that we have restricted ourselves to this particular method, for it gives us a chance to establish definitely whether or not the child is taking account of the parallelism of the sides. This is the key question, and on this point the reactions of this stage give a perfectly clear answer. The children we have been studying are not in the least concerned with parallelism as such, even when the model is put between two sides of a larger triangle, leaving the third to be completed (cf. Sil, who cannot make even this one side parallel).

As to equating the angles, remarks such as those made by Cyr, "Ah, a very pointed one", "it's not pointed enough" or "more pointed still" might convey the impression that these really are the child's concern, did not the actual outcome of the experiment make it obvious that they are not. However, apart from this, the fact that there is no attempt to make parallel the sides which actually constitute the angles makes it clear that the child is not thinking about angles at all.

When we examine the results of visual comparison the reason for this indifference to parallels and angles becomes evident. A child looking at a pair of inscribed isosceles triangles and deciding whether or not they are similar gives the impression that he is only taking a single dimension into account, such as the width or the height, and not the relations between them. Usually it is the height which commands his attention as if he were saying to himself, "the higher it is the better match it will be". The constant error has a very wide dispersion; that is to say, the estimates fluctuate very widely.

As for the similarities of rectangles, so far only studied by direct comparison, the same difficulties are apparent but in a more accentuated form because it is harder to make the children understand the enclosing of rectangles than that of triangles. Drawing results in enlargements either too long or too high, and visual comparison of inscribed figures produces a constant error in the direction of the chosen figure being too long relative to the model, the error again having a wide indifference range. Producing the diagonal appears to have no influence whatever on the result.

In contrast to these early responses, Stage IIB appears as a transitional phase in which parallelism is acquired to some extent and for certain types of triangle but not at all for others. Here are a few examples.

Mus (6; 6) enlarges an equilateral triangle of 3 cm. side as a triangle of base 6 cm. (given) and 5·5 cm. sides. The obtuse isosceles having base 6 cm., sides 3·4 cm., results in a figure with base 12 cm. (given) and sides 5·6 and 6·5 cm., which is almost perfect, though Mus remarks self-critically, "*It's not quite as pointed as the first one*". On the other hand, the acute isosceles of

base 3 cm. and sides 6 cm. appears to him as difficult: *"That one's more difficult"*. And in the event he is only able to achieve a side of 6·5 cm. on a base of 6 cm. so that there is no parallelism at all. "Is it really quite all right?— *It is a little bit wider* (it is almost equilateral!) *but I don't know how to do it—* Have another try!—(He now produces a side of 7 cm.!)". Mus is therefore entirely unaware of the fact of parallelism between the sides even though he took account of it in the previous figures.

His visual comparisons do not result in a constant error but show a wide range of dispersion (2 cm. in 6 cm.). As against this, Mus does begin to base his estimates on the parallelism of the sides (*"not near enough"* or *"too far apart"*) though, as the dispersion suggests, this is rather crude.

The inscribed rectangles produce an elongated enlargement, the height being barely altered. Visual comparison yields a pronounced positive error whilst the produced diagonal has no effect at all. "Does this slanting line help you to see if the triangle has the same shape?—*No, it gets in the way* —What do you do then, to see if it's the same shape?—*I look at the length"*.

BAR (6; 8). Equilateral triangle (side 3 cm.). Given a base of 6 cm. he enlarges the sides to 5 cm., and on a base of 9 cm. to 6·5 cm. Obtuse isosceles triangle, base 6 cm., sides 3·4 cm.; he makes it nearly correct but hardly enlarges it at all (base 7·5 cm. and sides 3·75 cm.). "Make it a bit bigger— *There you are* (on one side he maintains the parallelism without moving his ruler while he draws the other side a little too short and too much inclined)." Acute isosceles, base 3 cm. and side 6 cm.: with a given base of 6 cm. Bar draws sides that are not parallel and hardly increases the height at all. He then alters the drawing and increases the height by 5 cm. though the sides are still not parallel.

The results of visual comparison are similar to those of Mus but Bar makes no direct reference to parallelism.

Inscribed rectangle. The drawing is too wide in proportion to the height. Visual comparison results in the same error (negative) and the diagonal is still not used.

MUL (7; 6) doubles the size of the equilateral triangle (side 3 cm.) and keeps the sides more or less parallel to those of the model. But the parallelism is lost in subsequent further enlargement (for example, on a free base of 17·5 cm. he produces sides of 13·7 and 13·2 cm.). With the obtuse isosceles triangle he maintains the parallelism in the course of two enlargements and then loses it again in the third, finishing up with a base of 20 cm. and sides of 13 and 16 cm. The acute isosceles is slightly increased in height, using first a given and then a free baseline, but like that drawn by Bar it contains no parallelism.

Visual comparison yields a negative error, the width being over-estimated in proportion to the height, but the dispersion is small (1 cm.).

The drawings of inscribed rectangles enlarge the figures, sometimes in width and sometimes in height, whilst the diagonal is completely ignored.

MIN (7; 10) is given the triangles partly enclosed by lines running parallel to two sides. His first attempts at producing the enlargement by drawing the third line completely miss the parallelism but his subsequent attempts are successful after closer and closer approximations. He reacts in the same way

when enclosing triangles concentrically, though the obtuse triangles are drawn better than the acute ones.

These reactions are in several respects an advance on those of Substage IIA. In the first place, the child's enlargements begin to take account of the parallelism between the pairs of sides, though only by means of successive approximations (Min) or under special circumstances. These arise firstly when the degree of enlargement is relatively slight and the parallelism is directly apparent; and secondly, when the triangles are of certain shapes. Thus, we find parallelism preserved better with equilateral and, in particular, obtuse isosceles triangles. The sides of this latter figure being but slightly inclined they are compared and estimated more easily than those of acute isosceles triangles which invariably yield poor and inaccurate enlargements. It is as if the child were hesitant to increase the height still more and felt himself constrained to increase the width alone. He seems to act as if there were some ideal perceptual prototype of the triangle in which the parallelism was most easily preserved and felt that the triangle with too acute an apex deviated too far from this "good gestalt", so that he is unconsciously driven to modify his enlargement in this direction.

In the second place, visual comparison of the inscribed triangles is on the whole more stable than in Stage IIA due to superior sensorimotor adaptation. The constant errors tend to be self-compensatory to a greater extent than hitherto, with an implicit, and occasionally explicit (Mus), reference to parallelism of the sides.

Errors are more pronounced with inscribed rectangles and usually take the form of excessive lengthening of the figure. It is worth noting the contrast between the improvement which occurs in judging similar triangles and the still primitive state of affairs so far as the rectangles are concerned. It reveals a considerable disparity between judgements based on parallelism of the sides, and thereby on equivalence of angles; and judgements, non-existent as yet, which depend on dimensional proportions.

Finally, as regards the produced diagonal shown on some models, the fact that these children completely ignore it (cf. Mus) not only confirms what has just been said, but also indicates how little the enlarging of a rectangle is connected with the enlarging of a triangle; for these children never perceive that the diagonalized rectangle is simply a double triangle.

§3. *Inscribed triangles. Substage IIIA: establishment of parallelism between sides. Substage IIIB: beginnings of dimensional relations*

In line with what was seen in Chapter XI as regards discovery of the parallelism between oblique lines, and particularly between opposite sides of the rhombus, as soon as the children of Substage IIIA are able

to conceive of and maintain such a parallelism they can apply it consistently and implicitly to the problem of enlarging triangles without altering their shape. Thus, this stage indicates the understanding of a specific form of similarity between triangles; two triangles are henceforward regarded as similar when their corresponding sides are parallel.

As for the angles, the children we are about to study do not usually refer to them explicitly. In this they are unlike the children studied with the aid of Method II in §5., but it is only fair to say that this is because they recognize the equivalence of the angles by means of the parallelism of the sides. To be precise, they do not refer to angles because so far as they are concerned these two ideas of parallelism and equivalence of angle are only one idea; whereas when confronted with the second method, which involves superimposing the figures, they are made conscious of the space separating adjacent sides of the figure.

Here are a few examples of this substage, starting with two children still midway between IIB and IIIA.

Mic (7; 6). Equilateral triangle, side 3 cm. "*Oh, it makes a kind of Red Indian's tent*—And I want you to make exactly the same sort of tent, only bigger (common base extending across the paper)". Without bothering about the bisecting line which is dotted in he draws an excellent triangle with sides 8·7, 8·7 and 8·8 cm., the left side close to the model and the right over 4 cm. away from it. He has clearly preserved the parallelism of the sides although we naturally make no explicit reference to it when setting him the problem. "How did you manage to keep the tent the same shape as the small one?— *I looked at it to see if it sloped the same. If I made it too flat it just wouldn't do* —And with this one (another equilateral)?—(Correct drawing) *You've only to move the ruler and then it will slope the same*—And that one (obtuse isosceles, base 6 cm., sides 3·4 cm.)?—*Oh, that one looks squashed* (he moves the ruler very carefully to maintain the parallelism)—And now (equilateral, 3 cm. side, on a given base of 9 cm.)?—(He starts with an irregular triangle) *Oh dear, that won't do, it's got a different shape* (he makes several attempts and not until the fourth does he produce a more or less satisfactory copy with a base of 9 cm. and sides of 9·5 cm.). *That's the only one that will do*—And that one (one with sides 10·5 cm. on the same base)?—*It's better than the others but not quite right*".

When enlarging the rectangles, Mic makes them too long and does not take advantage of the diagonal when it is given.

Met (7; 9) at first reacts after the fashion of Stage IIB though she ends up in the style of Stage IIIA. The equilateral with 3 cm. sides is enlarged on a given base of 6 cm. but the sides are no more than 5·5 cm. in length so that the copy is not absolutely accurate. "You think that's really correct?—*It ought to be just the tiniest bit higher*—And that one (acute isosceles, base 3 cm., sides 6 cm. enlarged on a base on base of 6 cm.)?—(She draws sides of 8·5 cm.) *I'm not very happy about that. I made it too pointed* (in fact it is the opposite). *The sides don't slant the same way*—And this one (base 3 cm., sides 1·7 cm.)?—*That one is resting on its long side* (this time she really tries to maintain

333

the parallelism and makes an enlargement on a base of 6 cm. with sides of 3·5 cm. She then places her pencil in line with the sides of the model to check the parallelism with that of her own figure and says,) *It's nearly right*—How do you know when it's right?—*When the lines go the same way* (= a definition of parallelism by identity of orientation!)".

Some of her enlarged rectangles are too long, others correct, particularly in the case of the rectangle constructed on the produced diagonal, though she is unable to explain why she has used the diagonal. "Does this line across the two rectangles help to get the right size?—*I don't see how it could help at all*".

MAT (7; 2) belongs entirely to Stage IIIA. He immediately succeeds in enlarging the three models (equilateral, side 3 cm., acute isosceles, 3 cm. base, 6 cm. side and obtuse isosceles base 6 cm., side 3·4 cm.). "*You've only got to follow the lines*" he says, bringing his ruler parallel with the sides of the model.

His visual comparisons are absolutely correct. When shown two dissimilar triangles he says, "*It's wrong, it ought to be like this*" and puts two pencils on the table to indicate the correct angle.

On the other hand, his enlargements of the rectangle still show constant errors in over-estimating the width. "*You must add to the width as you increase the height*" says Mat, "*but not too much*". All the same, he does "add too much", exaggerates the width and does not bother about using the diagonal.

In contrast to this, visual matching of inscribed rectangles is almost correct, though with a slight negative error (excessive width), but more accurate when the diagonal is drawn in. When this is present Mat suddenly becomes aware of its significance and says, "*The line runs across the big rectangle! Oh yes, I see now! It's right when the line goes up to the corner!*" But this is an empirical discovery made after the event and not a method of construction.

MEI (7; 10), given the first triangle to enlarge immediately says, "*I just follow the sides*", then moves his ruler parallel with the sides of the model. With the model of base 3 cm. and sides 6 cm. he says "*It's the same again, the lines must slope the same*". But he makes one unsuccessful attempt before managing to enlarge it correctly.

Visual comparisons yield a small negative error. He has some difficulty in perceiving the parallelism between the sides of the comparison figures even though he has explained, logically enough, that he is looking for it!

Both the enlarging and visual matching of rectangles lead to similar errors. He is then given rectangles with diagonals that are parallel to each other, though this has no effect on the degree of error until he makes a discovery, "*Oh, those lines must go up in the same direction, they must slant the same*".

BRU (8; 1) immediately moves his ruler about, keeping it parallel to the sides of the equilateral triangle in order to enlarge it. The triangle with a 3 cm. base and 6 cm. sides is only mastered after several efforts due to his having some difficulty in judging the correct degree of parallelism even though he declares, "*It must be just as thin* (the distance between the two sides of the apex) *and slant the same way*". He does the same thing with a triangle of base 3 cm. and sides 1·7 cm., the base enlarged fourfold. He succeeds in producing a correct drawing by moving his ruler parallel, though he himself pronounces it unsatisfactory.

Visual comparison. He checks his estimate each time by reference to the parallelism, "*It ought to be more steep . . . less steep*, etc.", but nevertheless makes some incorrect judgments.

With the rectangles his enlargements are drawn too high whereas in the visual matches he tends to over-estimate the length. He ignores the produced diagonals in both cases and even says "*He* (the person who made the drawings) *made a mistake; he thought it was right when the line goes straight up into the corner. He let himself be taken in*".

Lor (8; 2) is given an isosceles triangle with a base of 3 cm. and sides of 6 cm. She is asked to enlarge it on a base of 6 cm. (concentric enclosure). She cries out spontaneously, "*It has to be just as pointed. That's hard*" and then, moving the ruler with great care, draws two sides exactly parallel to those of the model. "How can you tell when it's right?—*The arms slant the same amount*". She is now asked to enlarge the same triangle, but adjacent to the model and on a common base line a few centimetres away. "*Oh, it's very hard! You can't do it with a ruler* (she tries to judge it by eye and fails). *It doesn't look as if it's sloping the same*". She then moves the ruler, exercising the greatest care, and succeeds in producing the figure. "Could you measure it to work it out exactly?—*What could you measure* (astonishment)?". She is then shown an irregular triangle with sides of 4 and 2 cm. placed at an angle to the paper with extensions of its sides dotted in. Lor at once finds a base parallel to the model simply by moving her ruler.

Finally, she is given another irregular triangle also with sides of 4 and 2 cm. extended so that the left side of the similar figure must be 8 cm. (no figures are given, the lines are simply drawn the right length). "I'm going to hide the bottom of the roof (the base). Can you find out where it is, just the same?—*Impossible! Bärbel, the things you ask for!* (She does not manage it)—And if I take away the paper (which hides it)?—*Oh yes, easy. It's just the same as before!* (Parallelism of the bases as in the previous test)—And if I hide the bottom but show you this line (the side of 8 cm.)?—*No, you can't tell*—But by measuring?—*But measuring what?*".

Nel (8; 3) is immediately successful with the three enlargements he is asked to make (enclosed either centrally or in one corner) saying, "*I make the lines slant just the same, it's easy. Then they look alike*" and "*you must be careful to keep the ruler in the right direction when you move it*", after which he askes for a second ruler to check the parallelism.

Visual comparison. He studies each of the various inclinations equally carefully but his visual comparison is inferior to his logical reasoning.

Inscribed rectangles yield a positive error (too long) both in drawing and in visual matches and he makes no use of the diagonal.

Ino (9; 0) starts by comparing an equilateral triangle with other similar triangles intermingled with various irregular triangles. The series is presented one at a time. He immediately directs his attention on the parallelism. "*No, that's too tilted . . . here it's a little straighter than there*" and for the enlarged similar triangle, "*It's the same thing only bigger*" (he points out the parallel sides). The same result is produced by comparing an isosceles triangle with a mixed series containing an enlarged similar triangle. He discards the dissimilar figures and retains the correct one. "*Absolutely the same, the two lines*

on the sides are sloping the same". However, with other samples he is unsuccessful until he discovers the trick of superimposing the bases and thus judging the parallelism of the sides. *"You've got to move it about, then it will go all right"*.

He is asked to enlarge an equilateral triangle with sides of 3 cm. by enclosing it. His first figure he tries to make similar but he fails to keep the ruler quite parallel, *"It isn't quite the same—*How can you tell?*—There it's nearer than here* (distance not the same at each end of the line)—Can you get it right?—*Yes*, (he draws a bigger enlargement and solves the problem of the parallels by putting the inside of the ruler against the edge of the model and drawing the line on the other side of the ruler)—And bigger still?—(He turns the ruler over on itself, once and then twice again so as to draw the parallels further away)". He does exactly the same for the remaining triangles (isosceles, etc.) and in particular, with the enlargements which have to be made to enclose the original triangle within one corner without any of its lines being produced in advance. He produces two sides of the model and finds the third by parallelism; *"It must tilt just the same"*. Using this technique he succeeds with an equilateral, an obtuse and an acute isosceles triangle. He is next given an irregular triangle (still to enclose in the same way). He produces the unequal sides and says, *"I made it shorter here and longer there"*, then finds the third side by parallelism. Finally, he enlarges five times an isosceles triangle adjacent to the model and without a common base, using the method of parallelism alone, saying, *"I saw to it that the sides should be just the same"*. With another, more acute, triangle he is unsuccessful and says, *"It ought to be steeper; it's not sloping as much"*.

On the other hand, the rectangle is made too high when enlarged and the diagonal is ignored, though in the visual comparison he grasps its significance, *"The line* (the diagonal) *of the larger one must run through the corner of the little one"*.

Lastly, he is presented with the acute irregular triangle having sides 2 and 4 cm., placed at an angle to the paper and the enlargement of 4 cm. being indicated in advance (without mentioning any numbers) as to be added to the short side (so that the triangle must be drawn with a short side of 6 cm.). *"Can I have the ruler?*—What for?—*To see if it's slanting the same—*No, we're going to hide the bottom of the model. I want to see if you can manage to copy it without seeing the bottom—*Then I can't—*Try—*Can I measure it?—* If you want to—*It makes four. I add four* (he adds 4 cm. to both sides, thus making the sides 6 and 8 cm., and then draws the line for the base. The base of the model is now uncovered and Ino sees his mistake). *Oh! that's a peculiar triangle. I see what you ought to do* (he draws a base parallel to that of the model)—But you could have guessed without seeing the base—*When you hide it I can't tell—*Measure how big they are—(He measures 8 and 4) *I just don't understand it at all! Oh yes! It must be larger on this side because the other one is larger on the same side.* (Ino is thus becoming aware of proportionality)—Now try it with that one (sides of 2 and 3 cm., same tilted position but the enlargement of one of the sides is not given in advance on this occasion). You are going to work it all out yourself. I am not going to give you the sizes and it's not much use measuring. Now we hide the base—(He first adds an equal length to both sides, about 2 cm., and then draws a line). *No, I don't*

think that will do (he then adds, without making any measurements, a considerably greater length on the side corresponding to the 3 cm. side on the model and draws a new base line. The base of the model is now uncovered). *Yes, that's better* (he checks the bases to see if they are parallel), *not quite right, but very nearly*". It is thus apparent that Ino not only applies the method of parallelism to all triangles but also that in the course of enlarging them he acquires a clear idea of proportions which indicates the approach of Stage IIIB.

In visual comparison he also bases his judgements constantly on the parallelism though he still makes errors.

These examples, though extremely diverse, are nevertheless completely typical of Stage IIIA. It is no exaggeration to say that they indicate a real discovery, the similarity of inscribed triangles through parallelity of their sides. At the previous level, this feature was only glimpsed now and again in a few exceptionally favourable situations. What is more to the point, at Stage IIB there was neither any implicit formulation of parallelism, nor even a conscious awareness of it, whereas in the present stage it is not only formulated in the most explicit fashion, but applied systematically to all situations. Naturally, this only applies to children genuinely belonging to this level and not to those who like Mic and Met are only just on the brink of it.

This rapid generalization and application of parallelism coincides entirely with the findings of Chapter XI as regards affinitive transformations of the rhombus and, as will be seen in the next chapter, with the formulation of vertical and horizontal co-ordinates. Such a process also gives rise to two interesting observations, one concerning the relations between perception and thought, the other in connection with the principle of similarity itself.

With regard to the first of these two points, it is very interesting to notice that nearly all the children seemed to have an intellectual grasp of the principle of parallelism distinctly superior to their ability to recognize it when they saw it. It might not appear altogether unreasonable to suggest that they come to see the connection between parallelity of the sides and similarity in the shape as a result of increasingly accurate perceptual 'transpositions' of triangles on other triangles of different sizes. If this were the case then the idea of parallelism might well derive from the perception of parallels as such. However, when we compare the way the child reacts when drawing inscribed triangles and when trying to match them perceptually, we find that this is not the case. He *knows* the two triangles will be similar when their sides are parallel; "I make the lines slant the same . . . then they look alike", says Nel, whereas in making a perceptual comparison he only *recognizes* the presence of parallelism in a rather hit and miss fashion. Of course, it could be objected that this only holds good for inscribed triangles

and that parallelism is directly suggested by the perception of two equidistant straight lines as a general rule. But this seems to be a very doubtful line of argument. The children rarely resort to equidistance as a means of denoting parallelism; and with good reason, since doing so itself presupposes parallelism in making such a measurement, and moreover, equidistance is a metric concept considerably more advanced than qualitative or "extensive" parallelism. At this stage it is much more usual for children to think of "identity of orientation" as a way of denoting parallelism; as Nel says, "to keep . . . the right direction", and especially as Met puts it, "when the lines go the same way". Now, maintaining the identity of direction involves not a perception, but a reversible action. This was apparent from our discussion on the construction of the straight line through the practice of taking aim (Chapter VI, Section I), and it is this operation, first discovered in connection with the straight line, that results in the construction of parallels.

Moreover, after having seen in Chapter XI the difficulty which children below 7 or 8 experience in perceiving or drawing oblique parallels, one has to admit that it is, in fact, the operational schema which at some point regulates the perception, and not perception alone which is responsible for the development of the idea of parallelism. Of course, it might well be found otherwise at earlier stages, if one were to go right back to the original relations between perceptual activity with its sensori-motor mechanisms and the initial, crude perception of parallels.

This said, it is even more interesting to note that with the present method of experiment we find that the children tend to envisage the similarity of triangles in terms of the parallelism of their sides (and of operational parallelism, as we have just shown), without referring explicitly to the equality of the angles. We must therefore assume that so far as they are concerned this equality is derived from the parallelism. Or rather, that these two sets of ideas are not regarded as separate, and it is that of parallelism which they first notice. Only two children speak of angles of their own accord. Lor and Bru say that to make two triangles similar "it (the distance between adjacent sides) has to be just as thin and slant the same way" or "the arms must spread out the same amount", though they make no attempt to measure this distance and content themselves with making sure that the sides are parallel to those of the model. Thus, we see the idea of equality of angles taking shape through operational construction, proceeding from the straight line to parallels and from thence to similar triangles. The results of experiments using the second method (superimposition) will enable us to resume this analysis later on.

As for the inscribed rectangles, these present a sorry contrast to the triangles, for hardly any progress over the previous stage is visible. This is because similarity of rectangles assumes some knowledge of

dimensional proportions, whereas similarity of triangles, recognized solely by the parallelism of the sides, is only dependent on a set of elementary qualitative operations.

In some of the model rectangles we drew a diagonal, thinking it would help the children to recognize the similarity of the figures. However, it is clear that at this stage the significance of the common diagonal remains completely incomprehensible. If any of the children do grasp its meaning they do so only after the event; that is, as an outcome of the comparison through which they select the figure as similar, and not as a means of guiding the process of selection (see the very clear examples of Mat and Mei, as contrasted with Met and Bru). The reason for this is clearly that they do not yet separate the rectangles into pairs of similar triangles, even though the common diagonal would appear to favour such a percept.

So far as concerns parallelism between the sides of triangles, there is no difference between the present stage and the next. Aside from this, however, there begins a transition from purely qualitative judgements of similarity toward an understanding of dimensional proportions. This takes the form of comparing the lengths of corresponding pairs of sides, the beginnings of a feeling for proportion and the discovery of certain simple metric relationships, like the ratio of 1 : 2. This last idea facilitates solution of the simpler problems involving the rectangle, while some children are now able to make use of the diagonal for their constructions.

Here are some examples of Stage IIIB:

MON (9; 5) successfully enlarges the equilateral triangle by moving his ruler parallel with the sides of the model, then exclaims, *"Oh! You could measure it as well"*. He sees that the base and sides of the model are 3 cm. in length and the given base line 6 cm. This done, he checks his copy to see if its sides are 6 cm. likewise. He does the same for the triangle of base 3 cm. and sides 1·7 cm., but with the model of base 3 cm. and sides 6 cm. he measures it straightaway and doubles all the measurements. *"It can't be, it goes too high"* he says, and proceeds to check whether the sides are parallel to those of the model, whereupon he declares himself satisfied.

Visual comparisons yield a small negative error with a threshold of 5 cm.

Enlargement of rectangles. Mon immediately starts to measure the 1·5 × 3 cm. model; "What are you measuring it for?—*Otherwise I shouldn't get it wide enough. If I keep it the width of the small one,* 1·5 cm., *it would become a different shape* (when the length is increased)". He succeeds in doubling the size of this model accurately but bigger enlargements he makes only roughly, by eye.

Visual comparisons: small negative error. When a pair of squares are introduced among the series of rectangles Mon spontaneously draws in the diagonal. *"I'm looking to see whether the corners go on top of one another* (= are in line with each other)". On the other hand, he does not at first pay

any attention to the diagonals drawn on the inscribed rectangles. "Does that line have any purpose?—*Yes, you could tell whether it makes a good or a bad cross*".

URS (9; 11) also starts enlarging the triangles simply by making the sides parallel. But with the model of base 3 cm., sides 6 cm., he says, "*It's more difficult to tell whether I've made the sides slope the right amount*" and after having noticed that the given base line is twice the base of the model he proceeds to measure the sides. For ratios other than 1 : 2 he contents himself with using the method of parallel lines.

He does not measure the rectangles and over-estimates the width in his enlargements. In the visual comparison, however, the opposite occurs. On the other hand, when he is shown the inscribed rectangle with the diagonal he makes a discovery; "*Oh! It just touches the line when it's right . . . now it's easy, I only need to see whether the line* (diagonal) *touches the corner*".

GUI (10; 4) is shown an irregular triangle with sides 3 and 4 cm, drawn at an angle and in one corner of the paper. The sides are produced dotted, the shorter stretching 9 cm. from the apex (an increase in length of 6 cm.). "Draw me a bigger one the same shape as the smaller—*I'll measure; the little one is 3 cm., the big one is 9 cm., then I'll need 9 cm. for the other side as well* (draws the line)—Is that right?—*No, it ought to be parallel* (he draws the base of the large triangle by eye)—Good. Now try this one (sides 3 and 4 cm. produced to 8 cm. on the larger side)—(He measures 8 cm. and does the same with the other side as before)—Is that right?—*No,* (he draws the base parallel) —Could you find the right answer by measuring?—(He measures the two original sides of 3 and 4 cm., and the enlarged 8 cm. side). *Yes, the short side is* 3 *cm. so you've got to double it like the other one*—Good. This time it's right. Now I'm going to give you another one (sides 3 and 4 cm., large side extended to 12 cm.)—*On the left you've added* 8 *cm. so I've got to add* 8 *cm. on the right as well* (he thus relapses into the same error for the third time)— Is that right?—*No, wrong again* (he measures). *If I add* 3 *cm. to the shorter one it will be too short. So I must add* 6 *cm. making it double*—Good. Now one more (sides of 3 and 4 cm., long side extended to 10 cm.)—(He measures). *On the left it's* 4 *plus* 6 *cm. so now I've got to add* 6 *cm. on the right* (error repeated for the fourth time!)—Is that right?—*No. The short side is* 3 *cm. so I should add* $2 \times 3 = 6$ *cm.* (he draws the base like this but notices it is not parallel). *No, not yet* (he tries several times and then adds $3 + 3 + 1 + \cdot 5$ cm. empirically, guiding himself by the parallelism in the absence of simple proportions)—And this one (3 and 4 cm., extended 9 cm. on the short side)? —*On the right you've added* 9 *cm. extra, and the left side is still larger* (4 cm.) *so I add one more* (he then adds 10 cm. so as not to repeat the error of adding the same amount!) Is that enough?—*No*—What must you do? (Once more he only finds the answer by the aid of parallels)." All in all he has grasped the idea of proportion as far as 1 : 2 after considerable trial and error, but always has to fall back on parallelism in the end.

NEUF (10; 4) also succeeds in enlarging a triangle of sides 6 and 4 cm. (long side extended to 12 cm.) into one of 12 and 8 cm., after having first added the same amount to each side. "*Good. Now I'm going to double it*". Having said this, however, he now proceeds to double the length whatever proportions are

involved, or else employs a trial and error method, making use of the parallelism between the sides.

RAY (10; 7) is shown the triangle of 3 and 4 cm. sides, the short side extended by 6 cm. He starts by adding 6 cm. to the other side as well but on looking at the figure he realizes it is not in proportion. *"You've got to add more to this side"* (4 cm. side), but he does not succeed in doing this by measurement except for twofold enlargement. In fact, when given sides of 3 and 4 cm. for the small triangle and an extension to 8 cm. in the copy he first makes both sides 8 cm., next adds 4 cm. to each side and only then finds the double proportion. *"It's two times on both sides"*.

Each of these examples is evidence of a distinct feeling for proportion based on comparing the unequal sides, both in the triangles and the rectangles. But this only lasts so long as there is no measuring or calculating to be done. As soon as measuring is involved the children cannot get beyond a twofold enlargement. With the larger ratios there exists a contradiction between the idea of adding an equal amount to each side (or as with Gui, adding a little more to the longer side by way of compensation) and maintaining the bases parallel, which is still the only stable criterion of similarity at this stage.

We now pass to some examples of rectangles constructed by means of the diagonals.

VOL (9; 5) constructs triangles as did the previous children. Shown the rectangle he starts off without measuring and continues to correct his copy by trial and error up to the point where we show him a model with a diagonal; *"Mine's wrong because the diagonal doesn't cut through the corner. It ought to pass through the corner of the little one"*.

NIC (9; 7) reacts similarly. *"The line* (the diagonal) *should be in the corner of the big one because it goes through the corner of the little one"*. He makes subsequent enlargements simply by producing the common diagonal.

LIO (9; 11) reacts the same with triangles and enlarges rectangles by rule of thumb. "Can this line be of any help?—*No, it only confuses you*". But after measuring the size of the rectangle enlarged two times he remarks, *"When it's right it must reach the corner when you double it. If it's the same* (if the two rectangles are similar) *the line has got to pass through there* (through the corner)".

JEA (9; 10). Same reactions to start with, then he draws the surrounding rectangle with the help of the diagonal. *"I wanted it to meet on the line* (the diagonal). *The line makes a triangle by passing through the middle!"*

The children of this stage and the one previous both use the same method to ensure similarity of the surrounding triangle, that of drawing its sides parallel with those of the model. The children of Stage IIIB, however, soon begin to guess that there is a proportional relationship between the lengths of the different sides. In such cases therefore we can say that the relationship of proportion results from the similarity arrived at through the qualitative relationship of parallelism. This fact

is particularly worth noting, for we shall encounter it in another form when dealing with the transition from the concept of the interval suggested by the sides of an angle, to the idea of proportionality associated with the lengthening of this interval.

As regards the rectangles, the findings of this substage are completely in line with what was said earlier about the relations between perception and thought. It is most remarkable that having progressed to the point where they can think of proportions, many children are still unable to make use of the diagonal. Like Jea, they fail to see that it turns the rectangle into a pair of triangles, thus reducing the similarity of inscribed rectangles to similarity of triangles which are not only inscribed but have one side in common. Only a few children perceive anything of this, the majority behaving exactly like the children belonging to Stage IIIA or even IIB.

What is the explanation of this? It must undoubtedly be due to the rôle of the perceptual pattern, the shape of the rectangle being too 'pregnant' for it to be broken down to a pair of triangles stuck together. Now as soon as the child is able to deduce by a process of inference that the pair of inscribed rectangles are similar, by simultaneously increasing the length and width of the outer rectangle (and thus preserving the shape unchanged), he often comes to realize, though only after the event, the significance of the diagonal, as a way of ensuring similarity without having to resort to measurement. Consequently it is the operational understanding which facilitates the perceptual analysis of the diagonal in this instance, just as with parallelism and the sides of triangles.

As for proportions between sides of similar rectangles, which these children can also discern in the simpler cases (the ratio of 1 : 2; cf. Lio), we shall return to this in Section II in dealing with the matching of adjacent as distinct from inscribed rectangles.

It remains to discuss Stage IV, where the child is no longer restricted to problems of simple proportions but can apply to all cases what he has only glimpsed fitfully in Substage IIIB. The fact that similarity of triangles is mastered through parallelism of their sides by the beginning of Stage III, whereas the idea of proportions is not worked out fully until Stage IV, renders the problem even more important and interesting. However, for the sake of brevity we must postpone consideration of this question until Section II where we shall encounter it in connection with rectangles. For the present we will limit ourselves to quoting a single example to illustrate the significant features.

ECH (12; 0) is shown the triangle with sides of 3 and 4 cm. We extend the short side to 9 cm.: "*So I must double this side as well which makes* 8 (he adds 8 cm. to the 4 cm. side, thus giving a similar triangle with 9 and 12 cm. sides, enclosing the model)—*And like this* (the same model with large side extended to 8 cm.)?—*I double it the same as the other one* (this time he simply doubles

the sides to 6 and 8 cm.)—And this way (the same with the long side extended to 12 cm.)?—(He adds 8 cm. to each side as at Stage IIIB). *Oh, it's not right!—* Well then?—*8 cm. is two times 4 cm. so I also add two times on the other side; 2 times 3 is 6, plus 3 is 9 cm.*—And that one (the same but with the long side extended to 10 cm.)?—*I'm going to add 7 because it comes to 10. Oh no! Gosh! 2 times 4 is 8 leaving 2* (up to 10); *so here* (the short side) *it's 2 times 3 and half again, that's 7·5".*

It is thus apparent the proportionality, already vaguely sensed at Stage IIIB, is henceforward expressed in numerical ratios and calculations. With Gui, towards the end of his interview, with Ray also in Stage IIIB, and even already with Ino at the upper level of Stage IIIA, comparing unequal sides of a triangle leads to the idea that more has to be added to the larger side to make the enlargement resemble the model. By Stage IV, however, this purely qualitative idea of proportions, derived from comparing different parts of the figure with one another, gives way to a system of paired numerical ratios increased at equal rates. It is this transition from extensive similarity, accompanied by pictorial diagrams, to genuine metric concepts of proportionality which will be seen occurring in §9. of this chapter.

§4. *Similarity of triangles based on equality of their angles. Substage IIA (slope of sides ignored). Substage IIB (first signs of analysis).*

It will no doubt be recalled that the second method involves presenting the child with a collection of different-shaped triangles to be sorted into various classes (see list, pp. 323–5). He is, of course, perfectly free to handle the cut-out cards and, in particular, to superimpose them in order to compare the angles, parallels, relative dimensions, etc. With the results from the inscribed triangles fresh in mind it is worth while giving a very brief résumé of the way the children respond to this rather freer type of situation.

Without going back to Stage I, for reasons already given, at Stage IIA we find the child still judging triangles in a purely global fashion. He does not examine the angles carefully, nor does he try superimposing or juxtaposing the figures of his own accord. Of course, the angle is considered implicitly among the various relationships which the child regards *syncretically*;[1] because, for example, if two triangles are equal in height but have different bases the angles will likewise be different. But in such a case the judgement really rests on the length of the base and not on angles as such. Here are a few examples of this level.

FUL (5; 6). Do A2 (20×6) and C1 (20×5) have the same shape?[2]—*No—* Why not?—(He puts them next to each other). *No, not quite the same shape—*

[1] See Translators' Notes.
[2] Letters and numbers, viz (A2), refer to the list given above. But to make it easier for the reader, the length of the base (6) and height (20) of the triangle are also given.

Why?— . . . —And A3 (15 × 4·5) and A2 (20 × 6)?—*No*—Why?—*That one is higher* (A2)—Now look here, just try looking at them like this (he is shown how to superimpose the cards, one on the other) and try to find two with the same shape—(He compares A3 and C1, then discards A3 in favour of A2). *These two* (A2 and C1)—Why?—(He points to the equal heights, ignoring the unequal bases)—And then?—(He takes F6, E3 both equilateral, and all the others but rejects F9, saying), *No, it's larger here*—You see, there is a way of finding whether they really go together, isn't there?—(He indicates the dimensions and the general outline but does not point to the angles).

Kis (6; 0) likewise recognizes the similarity of two equilateral triangles, but finds that F2 and E3 (7 × 8) "*go together better because they're fatter*" even though E3 is also equilateral. Similarly, he couples A2 (20 × 6) with C1 (20 × 5) pointing to their almost equal sides; "Why do they go together?—*Because of this* (the sides)—And F2 and F9?—*No* (points to the sides)".

Sue (6; 0) similarly, compares B1 (6·5 × 50) and B2 (3·25 × 25) but does not see that they are similar. "*No, that won't do*—Why?—(He indicates the unequal sides)". He is shown how to superimpose them but fails to grasp the point. Thus, he thinks that A1 (30 × 9·5) and C1 (20 × 5) go well together, simply because they are both very pointed, and completely ignores the angles of the sides.

Gra (6; 6) compiles the F series (equilaterals) but refuses to add E3 to it although it is also equilateral, "*because these two sides* (one of the F's and one of the E's) *are not the same length*".

It is obvious that all these comparisons are based solely on the overall shape, or where there is any search for detail, on the lengths of the sides. But as already remarked in §2. (example of Cyr), this type of comparison is sometimes sufficient for the recognition of similarity of certain figures such as the equilateral triangle. The reason for this is that with the equilateral triangle, as with the square, errors in over- or underestimating the size of the angles or lengths of sides tend to cancel out as a result of their objective equality; and it is precisely this automatic compensation that gives these figures their gestalt quality.[1] But with the exception of this rather special case of equilateral triangles, the global comparison with which these children rest content fails to bring about any accurate transposition of shape.

This is a point worth emphasizing, since it demonstrates quite clearly that, except for strong configurations, perceptual transposition is inadequate for the recognition of similar figures. In the case of angles as such, length of sides, ratio of height to base and, we may now add, estimate of inclination, perception is invariably subject to constant errors. The equilateral triangle is an exception because of the static neutralization of these errors, but in every other type of triangle they give rise to compound errors too complex to permit of direct transposi-

[1] See Piaget and Lambercier. 'Transpositions perceptives et transitivité opératoire' *Arch. de Psychol.*, XXXI, No. 124.

tions of the shape.[1] Moreover, once the confines of perception are left behind (whose effects remain unknown to the child himself) the children belonging to this stage are found quite incapable of making comparisons based on the details of relationships, and when they try to analyse their general impressions they are confined to comparing absolute dimensions such as height, length of side, etc.

In Substage IIB we observe reactions similar to those seen at the corresponding level when studying inscribed triangles. The child begins to notice different inclinations of the sides (when the triangles are both right way up) but without any degree of accuracy with respect to the angles themselves.

SAV (6; 9) places A1, A2, A4 and A5 all together, also D2 (13 × 15, hence not very acute) and C1, then compares them very closely. "What are you looking for?—*I'm looking to see whether the cards are all cut out the same*—And do A2 (20 × 6) and D3 (26 × 15) go together?—*No, because here it hasn't the same shape*—Why not?—*Here* (A3) *it's more sloping*—And this (A1, 30 × 9·5) and this (C1, 20 × 5)?—(He cannot make up his mind)".

YVE (6; 9) brings together F2 and D2, then separates them; "*No, they don't go together*—Why not?—*I couldn't say*—And (F5 and F4)?—*Yes*—And (F6, F7, E3, all equilateral)?—*No*—What do you do to see if they go together or not?—*I look there* (points to one side) *where it's slanting*". He is then shown how to superimpose them but does not achieve any consistent results.

GLAS (6; 10) collects together all the F triangles (equilateral) and refuses to group E1 (scalene) with them, "*because its two sides are not the same*". "And do A1 (30 × 9·5) and D3 (26 × 15) go together better than A1 and A2?—*No, it's* (A1 and A2) *because they're both equally narrow* (correct)—And C1 (20 × 5)?—*The same* (he does not study the exact inclination, nor the width of the bases)".

BAR (7; 11). "Can you collect together those that are the same shape?—*Those that are bigger or smaller?*—No, those of the same shape—(He takes A1, A2 and D3 (20 × 15). *Those there* (A1 and A2) *go better* (he tries D2 and D3 together, then separates them). *That one* (D2) *is smaller*". He is successful with the F series but rejects F9 "*because it is wider* (incorrect) *and does not rise so steeply* (correct)". He is shown how to superimpose them whereupon he checks the apex angles, though not very accurately. On the other hand he does eventually manage to discover the basic relationship: "Which has the bigger corners (apex angles), B1 (6·5 × 50) or C3 (20 × 50)?—*That one* (B1) *because it's thinner and seems longer*". He is thus judging the angle by means of the ratio between the height and the width, which foreshadows the approach to Stage III (despite the peculiar meaning attributed to the word "big").

[1] It might be argued, it is true, that such perceptual errors being invariably bound up with proportional relationships (law of relative centration) could equally well be transposed in the case of truly similar figures. However, like the many diverse errors which function according to statistical laws rather than those governing operational combination, their total effect is always of a more or less random nature.

These reactions contain estimates which are sometimes inaccurate, sometimes partially accurate. In one respect, the latter are reminiscent of the comparisons recorded at the same stage in connection with inscribed triangles (§2.), where the children simply wonder whether the sides "slope" more or less (Sav, Yve). However, a new criterion is emerging, distinct from parallelism of the sides. This is the greater or lesser "thin-ness" of the triangle (Glas and Bar) which no longer relates merely to the sides as such, but to the interval separating them. It leads directly to consideration of the angle itself, which becomes increasingly important in view of our present method, and will serve ultimately to distinguish its findings from those of the first method. But it remains as yet more or less undifferentiated from the first criterion and results in estimates that are only very approximate, until we come to the relationship noted by Bar, which introduces the third stage.

The appearance of this new criterion is therefore a very important event, for it marks the starting point for the development of a completely new concept of similarity between triangles based, not on the parallelity of the sides, but on the equality of the angles. In this lies its importance, for such a concept anticipates the development of new types of operations.

The concepts of parallelism and the tilted straight line will sooner or later lead to the development of orthogonal co-ordinates as systems of reference, necessary for estimating their inclination. But the same construction will also arise from unidirectional lines being judged parallel and from the fact of their being perpendicular to intersecting dimensional axes. Operations of this type, which we shall examine more closely when dealing with physical co-ordinate systems in Chapter XIII, are based on multi-dimensional correspondences. That is to say, they originate in logical multiplication by means of point-point (bi-univocal) correspondence.

On the other hand, consideration of the interval between two sides of an angle, starting from zero at the apex, leads to a completely different type of correspondence, one which is no longer bi-univocal, but co-univocal.[1] It is this type of operation which the children of the present stage intuitively suggest when they speak of the 'thin-ness' of a triangle, and which begins to evolve in the course of Stage III.

§5. *Similarity of triangles based on equality of angles. Substages IIIA and IIIB.* (*Progressive analysis of angles*).

The comparisons made at Stage II were intuitive and perceptual in character, remaining purely global or concerned with absolute length of the sides of the triangles. As a result of two simultaneous developments, Stage III marks a distinct advance on this state of affairs. The

[1] See Translators' Notes.

first of these developments is the spontaneous superimposing of the cardboard figures, a procedure involving reversible actions and wholly operational in character. The second development, springing directly from the first, is the discovery that angles may be equal independent of the length of the sides of the figures.[1]

Here are some examples of Substage IIIA during which this dual transformation takes place.

BEN (7; 7) is midway between Stages IIB and IIIA, in that he discovers the technique of superimposition for himself, and at times compares the angles as such (thus exhibiting features distinctive of Stage III), yet often contents himself with merely comparing the lengths of the sides. He is shown the whole collection of triangles and asked to "collect together all the triangles which are the same shape—(He immediately puts A2 (20×6) on D3 (26×15). *They don't fit*—Why?—*That one* (D3) *sticks out* (at the sides). (He tries A1 which is similar to A2). *It's too long*. (He takes D2 (13×15) and A3 $(15 \times 4 \cdot 5)$ and sees that the base of one equals the height of the other (15×15) but says): *They aren't the same shape*—And A2 (20×6) and A3 $(15 \times 4 \cdot 5)$?—(He superimposes them and tries to line up the edges). *They won't do, because they're a different length*". We query this and make him repeat it. "*Oh, yes* (with A2 and A3 he associated A4 and then A5, next adding D1, but says): *No, that one* (D1) *is not so slanted* (he compares D3 and B2). *No, that one* (B2) *is straighter than that one* (D3). (He studies the bases, then takes C3 and C2, saying), *they aren't the same shape*—Why?—*I'm comparing the corners at the top*—And D2?— *It won't do*—And C3 and E2?—*They go together*—And C2 and C3?—*That one* (C3) *is more slanted*—Do you always have to look at the top corner?— *You can look at the side*—And C3 and A1?—*They don't go together. This one is too pointed*—And C1 and A1?—*They go together* (he superimposes them and matches the lower right-hand corners). *No, this one overlaps*".

STAN (7; 6). On examining the complete collection he picks up D3 and C2. "*They don't go together* (he looks at the sides). *This one* (D3) *is not big enough and the other one's too big*—And (E3 and F2)?—*They're pretty much the same shape. This one's small but it's the same shape as the big one*—And (C2 and D2)?—*Yes, they're the same shape* (he superimposes them of his own accord) —And (F2 and D2), do they match better or worse than (D2 and C2)?— *They match better* (F2, D2)—And (F1 and F2)?—*Different size but the same shape*—And (C2 and B1)?—*No, that one* (B1) *is less pointed and wider than the other*—And (D1 and B1)?—*Yes, they're the same*—And F2 as well?— *No, it's too wide* (he groups together A1, A2, A3, A4, A5, and rejects D3)— How do you judge?—*I look to see how pointed the shape is*—What are you measuring?—*That* (he is measuring the angles by superimposition)—And these two (E1, E4), are they all right?—*No* (correct)—And (C2 and C3)?—*Not very good. That one* (C3) *is wider at the bottom* (correct)—And (B1 and B2)?— *That one* (B1) *is smaller, but it's the same shape*—Do (D2 and B2) match as well as (B1 and B2)?—*Not quite. That one* (D2) *is not so pointed*". He carries on in the same fashion, comparing F5 with F7. "*Yes, they're all right because*

[1] When the figures do not greatly differ in size, one also finds them occasionally superimposed on the midline of the base, the parallelity of the sides being noted.

the three corners are the same—And (F5, F9)?—*No, that one* (F9) *is too slanted. The corners must be the same*".

VUI (8; 0). "(A1 and B3)?—*The first one is very high and the second one small at the top* (= obtuse)—And what about (F6)? Is it the same shape as (F1)?—*It's smaller*—Yes, but is the shape the same?—*Yes. And that one* (F4) *as well*". He then takes A2, placing it between A1 and A3, and checks the similarity by superimposing them, then tries and rejects C1, "*because it's the same height but wider*".

GER (8; 9). "(E5 and F4)?—*Yes, they're the same shape*—Why?—*They're equally pointed*—And (B3 and A2)?—*No, the length* (the base) *and the height aren't the same*—Can you arrange these shapes in series or families?—*Yes*, (he groups the B's, then the A's, adding, then discarding, D3 from the latter, replacing it by C1 which he superimposes on A1 of his own accord)".

SCHE (9; 3) builds up the series of F's, then the B's. "*I can see they're all the same shape*—How?—*They're all pointed the same amount*—And does (D1) go with those?—*No, it's not slanted the same amount*—And (C2 and C3)?—*No, the distance must be the same*—What distance?—(He points to the interval between the sides)—What has to be the same to make the shape the same?—*The corners*—And why are (A1 and A2) alike?—*Because they're both triangles*—What does that mean?—*They both slant the same amount on each side* (= isosceles)".

It is apparent that all these children are perfectly capable of comparing the angles contained in the figures quite independently of the lengths of the sides. What we have now to find out is how they come to be able to do so, since the long and complex nature of the development leading to this achievement makes it obvious that within the confines of similarity, as distinct from measurement of angles, the concept of an angle is certainly not the product of ordinary perception.

In the case of Ben, it is the technique of superimposition, a trick he discovers right away, which guides his choice. Thus he finds that when he puts one triangle on another the corners of one protrude, or else the sides slope unequally. Although often tempted simply to measure the length of the sides he is eventually drawn to compare the 'corners' themselves. Stan starts by comparing the lengths of the sides, as at Stage II, but then discovers the similarity of the 'shapes'. His case is an interesting one, for he tries to relate the more or less 'pointed' appearance of the triangle with the length of the base. This amounts to an implicit recognition of the need for a co-univocal correspondence, because the lengthening intervals between the diverging sides are compared to one another right down to the base (which is the last of these parallel lines expressing the interval between the sides). He consequently arrives at a simultaneous comparison of the 'three corners' belonging to each of the two triangles and is thereby led to formulate the idea that one of the triangles "is smaller but has the same shape" as the other.

Vui follows a similar method. He starts out guided by comparing the

apex angles, then the relation between height and base, exemplified in his remark "it's the same height but it's wider" which expresses a co-univocal correspondence. Ger likewise begins with the idea of 'pointedness' and ends up with the ratio of the height to the base. Sche, after initially comparing the degree of inclination, goes as far as to say in so many words that "you have to keep the distance"; that is to say, the width of the triangle (or interval between the sides) at a given point along the height, which is the exact expression of co-univocal correspondence.

It can thus be seen that except for Ben, who is content to refer only to the corners themselves, all the children endeavour to formulate the similarity of the superimposed triangles in terms of co-univocal correspondence between successive widths of the angle, beginning from the apex. In other words, by the degree of 'pointedness' of this apex relative to the base, or else by the ratio of the height to the base of the triangle.

By Substage IIIB the child's reactions, which have so far been uncertain and tentative, attain a stable form. Comparing the results of Method II (superimposition) with those of Method I (inscribed triangles), it is possible to say that similarity of triangles on the basis of equality of angles is not completely mastered until Stage IIIB, whereas similarity on the basis of parallelity of sides is reached by Stage IIIA; that is to say, at a point where the equality between the angles is only in process of being discovered.

Here are some examples of Substage IIIB.

AUG (9; 3) compares A1 and A2 by superimposing the lower right-hand angles and checking the parallelism between the left-hand sides. "*It's smaller but it has the same shape*". He then groups all the A's by superimposing the vertices and one of the sides. He compares all the F's in the same way. "Must all the corners go together?—*Yes*—Do you have to measure all three of them? —*No, one or two is enough*—And (F5 and F8)?—*They match*—How many corners did you look at?—*You've got to measure two corners*—And the third? —*Not necessarily*—Why not?—*If I measure this one and that one it'll do*".

BAD (9; 10). "Do (F5 and F4) go together?—*Yes, but one is bigger than the other*—How can you tell exactly?—(He begins by putting the base of F4 against one side of F5, then superimposes them, makes the bases coincide along part of their length and notices the parallelism of the sides)—And do (F4 and F9) go together?—*No, not at all*—And (A2 and A3)?—(He superimposes them from the apex). *The points are the same*—Will the other corners be the same?—*Yes*—And (A1 and C1)?—(He superimposes their apexes). *No, they don't quite match*—Why?—*That is longer than this* (= the bases are not parallel)".

ROL (10; 0). Groups B1 with B2, then the first four A's, then compares the apex angles of D3 and C1 and separates them. Next he groups the first five F's by superimposing them two at a time. He separates D3 and C2 after

superimposing one angle and reconstructs the whole series of A's by checking the lower right-hand angle. "Do you have to measure several angles?— *You've got to measure the three which is all you can measure*".

ROM (10; 0) thinks otherwise, for after grouping the A's and then the F's together he says, "*You've got to measure two angles*—And with those over there (equilaterals)?—*One is enough*".

DOB (10; 7) first of all groups the figures by eye, then compares the apex angles of D2 and D3 and says, "*They don't match*—Why not?—*They're not sloping the same amount*. (He then takes two F's, makes the apexes coincide and notes that the bases are parallel). *Yes, that's all right. This strip* (the gap between the two bases when the apexes coincide) *is the same everywhere* (= of equal width, or parallel). *You've got to have one equal angle and an equal strip*". He then generalizes this method for all the pairs. "How many angles must you measure to tell whether it's all right?—*One*—And (F5 and F9, the latter not isosceles)?—*No, it isn't parallel at the bottom* (= the bases of F5 and F9 when their apexes coincide)".

VAIR (10; 9) also begins by superimposing the apex angles to check the similarity. "And (C2 and F7)?—*No, because the two sides don't run the same way*". He says exactly the same thing when comparing two A's. "And (F5 and F9)?— *Yes, they are in the same group* (he superimposes the apexes, both 60°, but notices that the bases are not parallel). *No, they're not alike*—How can you tell whether two triangles are the same shape?—*By the three angles*— Must you measure the three?—*Yes, all three*".

HIR (10; 11), on the contrary, says of A2 and A3, "*This gets thinner in the same way and here it's parallel* (the bases, when the apexes are superimposed) —When you look at the angles, how many do you have to measure?—*Three; no, two, because the third is obviously equal*".

The difference between these reactions and those of Substage IIIA is the difference between a state of equilibrium and the state leading to it. Instead of gradually working out the relations which determine the angles and link them together, the child now concentrates almost immediately on the results of this arrangement, on comparing angles as such. Some children (viz., Aug, Rom, Hir) even discover that it is enough to compare two angles, the third being "obviously equal".

As for the way these children arrive simultaneously at the concept of the angle together with the concept of similar triangles in terms of equivalence of angles, the findings of this level confirm what was suggested by the preceding one. The simplest method is that of noticing that when superimposed, the sides of the angles coincide. Now Bad shows us the link between this operation and that of making the two sides parallel. First, he checks the similarity of F4 and F5 by making the base of one coincide with part of the base of the other, and by making sure the sides are parallel. But in addition he shows that A1 and C1 are not similar by making their apexes coincide and seeing that the bases are not parallel. This amounts to fusing in a single operational whole the two concepts of equality between angles and parallelism

between sides, by applying the principle of parallelism to the sides opposite the angle which is judged equal.

Noticing that the sides of equal angles coincide when superimposed, Dob arrives at the same method. He is able to state this idea as a proposition to the effect that if one angle is equal and the sides opposite are parallel, then the triangles are similar: "You have to have an equal angle and an equal strip", this "strip" separating the parallel sides opposite the angle. Knowing nothing about Thales' theorem, or the way it has been used by geometricians to define proportionality in the absence of numerical relations, these children base their idea of similar triangles on a closely analogous construction which already contains the germ of the idea of proportionality.

Let us now try to unravel the operational mechanism underlying this concept. The child's discovery may be summarized in this way: if the sides of the first triangle, A_1 and A_2, determine the base A, then the sides of the second triangle, B_1 ($=A_1-A'_1$ where A'_1 is the difference between A_1 and B_1) and B_2 ($=A_2-A'_2$ where A'_2 is the difference between A_2 and B_2), determine the base B as parallel to A, when the two triangles are similar.

But in order to grasp this set of relationships the child has to realize that the lines A'_1 and A'_2 are extensions of A_1 and A_2, in other words, to see that there is a necessary connection between the equal inclinations of A_1 and B_1, A_2 and B_2, and the parallelism of the bases A and B. It is therefore a question of grouping the qualitative relationships of inclination and parallelism in such a way as to make clear that by the very fact of maintaining a constant inclination, the sides of the apex angle determine the constant increase of the interval separating them. These intervals can then be shown as lines of increasing length, parallel to each other, and each forming the base of a new triangle similar to, and enclosing, the preceding ones. Such a construction thus leads to the recognition of proportionality between A'_1 and A'_2, or between A'_1 and A_1, and A'_2 and A_2 (which is precisely what Thales' theorem states), though these proportions are sensed long before they can be expressed in the form of numerical ratios.

It is this qualitative approach to proportionality which is to be seen among the children of Stage IIIB in §3. of this chapter (see Gui and Ray, or Ino, who groups the twin relationships as early as Stage IIIA).

This fact clearly suggests that there is an overall "grouping"[1] taking place prior to the appearance of metrical concepts, and even before there is any extensive quantification. In its purely logical and intensive form, this process is nothing more than a multiplicative grouping of

[1] On the concept of 'grouping' see our work *Classes, Relations et Nombres, Essai sur les 'groupements' de la Logistique et la Réversibilité de la Pensée*, Paris, 1942.

co-univocal correspondences.[1] Thus, $\downarrow A_1 \times \downarrow A_2 = \underset{\longleftrightarrow}{A}$ and $\downarrow B_1 \times$ $\downarrow B_2 = \underset{\longleftrightarrow}{B}$, where if A_1 is a part of B_1 and A_2 the corresponding part of B_2, a correspondence exists between the differences A'_1 ($=B_1-A_2$) and A'_2 ($=B_2-A_2$). In such a case the symmetrical interval relation B is to B_1 and B_2 as A is to A_1 and A_2, and this forms the logical structure from which the similarities are derived. However, these co-univocal correspondences are sooner or later expressed quantitatively (or made 'extensive'), a step which enables the ratio to be kept constant as the sides of the angle slowly diverge, and which also transforms it into genuine proportionality, a metric and no longer merely logical concept.

But at what point is similarity thus defined, transformed into metric proportionality? The idea of proportions is already present in quantitative form in the construction just analysed, and it appears at the present level also in metric form as regards the simpler cases (see §3.). Not, however, until Stage IV is it formulated and applied universally, which will be seen in the course of Section II.[2]

SECTION II. THE SIMILARITY OF RECTANGLES

The study of how the child establishes the relationship of similar triangles completes the first part of our programme. In the course of it we saw how, having grasped the notion of parallel lines by Stage IIIA, the child discovers that triangles are similar when their sides are parallel. From this he goes on to find that their angles also are equal and finally arrives at the idea of proportionality. A parallel study could be made for similar rectangles, and this we are now about to do. However, its purpose will be not so much to confirm what has already been stated, as to complete the task outlined at the beginning of the chapter, namely, to examine the relations between 'perceptual transposition' and operational similarity.

By having children make visual comparisons of enclosed triangles as well as draw them (§2. and §3.) we showed that there is some sort of connection between perceptual judgements and drawings. But what sort of connection is it? Does development of perceptual transposition govern that of intellectual understanding (or vice versa), or are the two processes completely independent? To get an answer to this question it is worth while studying similarity of rectangles, because it is on the one hand a simpler case than that of triangles, since all the angles are right-angles; and on the other hand, more complex since the ratio of

[1] Ibid. Chapter X.

[2] We have already given at the end of §3. an example from Stage IV dealing with triangles.

length to width has to be estimated without the child being able to rely on any correlative change in angle.

Section I has already yielded some information on inscribed rectangles. The problem we are now concerned with, however, is more universal and involves not only inscribed but separate rectangles. By comparing this new data with the findings of Section I we hope to be able to solve this problem of the relations between perceptual transposition and operational similarity.

§6. *Technique and general results*

The method adopted was the simplest possible and covered the following points.

1. Perceptual Comparison. On separate pieces of paper, each one the size of an exercise book, are shown a horizontal rectangle 1·5 cm. ×3·0 cm., and larger rectangles, the same width (4 cm.) but varying from 6 to 15 cm. in length. The standard and comparison figures are presented together in random order. We simply ask whether the large one "looks like" the little one or not (and whether more or less than previous ones), and particularly whether it "is the same shape but bigger". With the youngest children we ask "which one is the daddy of the little one" and looks most like it. To help the child understand the task a magnifying glass can be used to enlarge the figure without altering its shape. The most important thing is to avoid the implication that the increase is confined to one dimension and yet avoid the direct suggestion that it should affect both dimensions at the same time. On this point one runs into a difficulty with the younger children which turns out to be quite instructive in itself.

To make comparison of the sides easier we often presented figures having only two lines at right-angles (L), the same size as those of the rectangles, which we called 'half-rectangles'. Even though the child does not always appear to understand the idea of similarity as such, there is a distinct advantage in keeping to fairly loose definitions; for the way the child comes to understand even these rough ideas gives some indication of the process of development taking place. Thresholds of judged equality were calculated in centimetres, and also the degree of error proportional to a length of 8 cm. (correct estimate), negative below and positive above this length.

2. Pictorial Construction. We present the same model 1·5 cm. ×3·0 cm. and ask the child to draw the rectangle, "box", "square" or whatever he chooses to call it, the same but larger on another sheet of paper. One can either avoid suggesting any particular size, or fix on some length for the base beforehand (double, triple or any multiple of the standard).

We often prefaced this procedure by handing out a number of different-sized rhombuses to be arranged in pairs, one large and one small, each

pair being similar in shape. The shapes varied from being about equal in width and height to long and narrow or wide and flat. When there is a marked difference between the shapes it becomes quite easy for children of all ages to classify them and the procedure helps them grasp more clearly the point at issue. We later began to wonder whether it might not be easier to recognize similarity in rhombuses than in rectangles, and carried out a few systematic experiments to check on this idea. However, for reasons of space, we shall only mention these in passing.

The results of this experiment were very interesting, both on perceptual comparison of ready-drawn figures, and on the way children set about enlarging the standard. But it should be understood right from the beginning that perception and intelligence are manifested in both types of behaviour. If the child's choice of sample figures expressed nothing but his perceptual ability, and his drawings his intellectual grasp of things, the problem of the relation between the perception and the operational conceptualization of proportions would no doubt be far simpler. As it is, one can only say that in visual comparison the perceptual factor tends more or less to predominate, whereas in drawing, intelligence appears to have the upper hand, though again, to a varying degree.

When an experiment only involving perception is performed on children, the subjects undoubtedly translate their perceptual reactions into words or concepts. But either of these express the perception fairly accurately, for the words "bigger" or "smaller" bear more or less the same meaning for the child and the experimenter (though the judgement of equality expressed by "the same" needs to be treated with some reserve). In contrast to this, when the child looks at two comparable figures and says "it's the same shape" or "it'll do", etc., he goes far beyond translating his perception into an estimate and makes an estimate of his perception. In fact the concept of 'same shape' is a complex interpretation of the perceptual data as it stands, and therefore an act of intelligence, capable of broadening its range of meaning as the child grows older.

Nevertheless, it is obvious that in making a choice between sample drawings, intelligence is governed by perception even though the latter is interpreted in terms of a 'free' rather than a 'literal' translation. In this case therefore we shall speak of a *perceptual estimate*. On the other hand, with the drawings that have to be made through measurement or comparison while maintaining a constant shape during the enlargement, it is intelligence which governs perception, so that we can speak of it as *intellectual construction*. It is the relationship between 'perceptual estimate' and 'intellectual construction' which is brought out by the raw data of this experiment and we have to derive the actual relations of perception and intelligence from it by inference. It is, of course,

taken as understood that this relationship is involved in both the situations studied.

We can now pass on to describe the successive stages of development. There are three of these in all, Stage I being omitted as outside the possibilities of experimentation. Each of these stages is marked by three distinct forms of interaction between the perceptual estimate and the intellectual construction.

During Stage II there is little or no difference between the perceptual estimates and the drawings. At this level the general tendency is for the comparison rectangle to be judged similar to the standard when it is actually too long, so that the error of estimation is positive. According to the child's way of thinking, the longer the rectangle, relative to the height, the more rectangular it is. Thus, there is a general transposition of the overall shape which is, in a manner of speaking, altered or improved upon, rather than a genuine transposing of the relative dimensions. This corresponds to a perceptual process which is still global or syncretic while analysis remains incomplete and concerned with only one dimension, in this case length.[1] As for the logical processes which the child deploys in making his drawings, they too are usually confined to the attempt to reproduce what he regards as the essence of a rectangle, to wit, an elongated square. Thus, his drawing also tends to exaggerate the length of the rectangle he wishes to enlarge. When it is brought side by side with a correctly proportioned enlargement he thinks the latter too high and wants to shorten it. He evinces no desire to measure the figure and any attempt to persuade him to do so fails completely. The very idea of proportions seems absolutely meaningless to him and he has some difficulty in understanding what he is supposed to do, though he is quite adept at sorting out rhombuses provided they differ widely in shape.

Stage III begins with spontaneous attempts at measurement and appears about the age of 7 or 8. One curious circumstance, probably due to the special problems raised by proportionality, is that at this stage, perceptual estimates are in advance of drawings and appear to guide the latter; or at any rate to serve as their most reliable aid (which, we must repeat, does not mean that no more than a simple act of either perception or intelligence is involved). In the perceptual estimates, negative errors now outnumber positive errors (based on length), or at least acquire greater importance than hitherto. Perception begins to function as a regulatory process embracing dimensional proportions as well as overall shape, the former exclusive centration on the length being countered by a corresponding decentration on the width. This stage can be divided roughly into two substages which appear to differ

[1] In the far less frequent case of the length not being overestimated, it is the height which is exaggerated.

more in degree than in kind, though in their extreme forms they are undoubtedly very dissimilar.

During the first of these substages, centration seems to alternate between length and width and the tendency to decentration or correction remains unconscious. Meanwhile, the child appears to be trying to take account of the two dimensions simultaneously and so arrive at a conscious comparison. As regards the mental processes concerned with making the drawings, Stage III begins, as already stated, with attempts at measurement. But these attempts fail precisely because the child does not yet realize that it is proportion rather than increase in absolute size which is involved, with the result that the length of the rectangle continues to be exaggerated just as in Stage II. During Substage IIIB both length and height are increased in an effort to obtain the correct ratio by adding an equal amount to each. Consequently, the child finds his perceptual estimates at variance with the results of his calculations, so he alters his construction to suit his perceptual impressions. Only in the case of simple proportions in the ratio of 1 : 2 are the correct answers given.

Finally, during Stage IV the relative predominance of perceptual judgement over constructive thought is reversed, for as the child begins to understand the nature of proportionality his thought grows independent of perception and eventually influences it in turn.

§7. Stage II (4–5 to 7–8 years). Global comparison resulting in over-estimation of length

As has already been stated, the same types of reactions are obtained at Stage II with either perceptual estimates or intellectual construction. It is the qualitative, global shape rather than the proportions which is transposed, the child concentrating his attention mainly on the length of the rectangle. The same result was obtained with the figure presented long side vertical.

GEN (5; 1) studies the collection of rhombuses. "They're all mixed up. I want you to bring together a big one and a little one, but they must be alike —(He makes pairs of large and small, paying no attention to their shapes)— Can't you do better than that? (They are mixed up afresh)—(Gen now puts each large rhombus opposite each small, similarly shaped one without any errors)—Why have you put them like that?—*Because they're the same shape*".

The model rectangle 1·5 × 3 cm. is now placed on the table. He is shown the 4 × 6 cm. enlargement. "Is it the same shape?—*No, they don't suit. It's not the same shape*—And this (4 × 12)?—*It's a bit like it but bigger*—And this (4 × 7)?—*It's nearly square so it's not the same shape at all*—(4 × 11)?—*That will do better*—Not altogether?—(Gen looks at the model which, of course, has been visible all the time). *No, not quite*—Why?—*It ought to be more like this* (pointing to the 4 × 12)—And this, (4 × 20) will this do?—*Yes*".

Next we show him the model of the "half-rectangle" having one side of 3 and the other of 1·5 cm. "Is this the same shape (4×6)?—*No, it's higher* (pointing to the shorter side)—And this (4×10)?—*It's not bad. This is rather big* (again points to the shorter side and cuts off half its height); *like this, but it would still be bigger than the model* (2>1·5)—And this (4×17)?—*It wouldn't be bad but it would still be bigger than the model* (again he points to the shorter side). *It's the same shape. It will do very well*—(4×9)?—*No, it's higher there* (he covers up the shorter side, reducing it to about 2×9 cm.). *It would be all right like this*".

Finally we pass to the drawings of complete rectangles. "I want you to draw me a rectangle the same shape as that one (1·5×3) but bigger—(He draws one 2×14). *It's a little bit too big.* (He corrects it to roughly 1·5×14, so that the width is the same as that of the model). *Now it's big enough*—Is that right? Is the shape really the same?—*Yes, the same shape in a bigger size*". We draw for him a base 7·5 cm. in length. Gen draws a rectangle 7·5×1·5; "*I made them both the same size*".

PIE (5; 3) starts off by making a random collection of the rhombuses as did Gen, and like him, ends up with a correct arrangement.

With the rectangles he begins by finding that the drawings of (4×6), (4×2) and (4×7) are "*all good*". "Now which of these two will be the best (4×8 and 4×12)?—*That one* (4×12), *because it's bigger*—And that one (4×4)?—*No, because it's square. It must be like this* (he points to the model)—And this (4×11·5)?—*That's all right too*—And which of these (4×8 and 4×10·5) will do best?—*That one* (4×10·5), *because it's longer*—And of these (4×8·5 and 4×10)?—*That one* (4×10)—And (4×9 and 4×9·5)?—*That one* (4×9·5)—Why not the other?—*Because it's too high* (he points to the width of 4 cm.!)—And of (4×6 and 4×8)?—*That one* (4×8) *is all right* (surprisingly enough, the correct proportion), *the other one is too high*—Aren't they the same height?—*That one is better* (4×8)—And this (4×8 and 4×12)?—*That one* (4×12) *will do better because it's not so high as this one*".

Half-rectangles: (4×8) "*is all right*", (4×10) "*is too high*". The best one seems to be the (2·5×8·5) "*because they have to be the same as this* (1·5×3)*".

Drawings of rectangles: He begins with all kinds of rectangles, but after agreeing that the model of 1·5×3 is "the baby" and that he must draw "a daddy" the same shape he constructs a rectangle 4·5×13, that is, too long by 4 cm.

BER (5; 5) arranges the rhombuses correctly at first attempt.

Rectangles: He is shown the standard and the 4×8 rectangle as the first comparison. "*Yes, it's all right* (he catches sight of the 4×12 drawing among the series and says spontaneously), *that's the one that's right*—And that (4×8·5)?—*It won't do, it's too wide*". But (4×11·5) and (4×10·5) are "*the same*" as the model. From (4×10) and (4×12) he chooses the latter. "*The other one is nearly right, but it's a bit too high*—And (4×20)?—*It'll do even better than the other* (4×12)".

Same reactions with the half-rectangles.

Drawings of rectangles: Ber makes the height of his copy roughly double that of the model and then draws a base of about 17 cm., saying, "*You put*

the same size here (across the width, therefore about 3 cm.) *and make this* (the length) *bigger*".

MAR (6; 6) arranges the rhombuses correctly at first attempt. "Why do they go together?—*Because they look alike*". But for a rectangle of 1·5 × 3 cm. he prefers (4 × 12) to (4 × 6), "*because it's longer*". The proportional enlargement (4 × 8) "*will do, but it's a bit short*". Mar will accept a rectangle up to 4 × 20 but beyond this "*it would get too long*".

For the drawing he produces a figure 2 × 20, "*It's the same thing in a bigger size*".

There is no point in giving further examples. We obtained many such between the ages of 5 and 7, and even up to 8; 2 and 8; 6 (one case even of 9; 1). The reactions of this stage are simple and straightforward. The transposition involved in the perceptual comparison affects only the qualitative shape of the figure and ignores the relative dimensions. Even the shape is transposed only in conceptualized form, and this fact becomes obvious with a little study. Everything tends to give the impression that the child is distinguishing between two related classes of figures; rectangles, whose sides are unequal; and squares, whose sides are equal or roughly equal.

Thus we find Gen rejecting the rectangle with shortish sides (4 × 7) saying, "It's almost square and so it's not the same shape at all". When the model is to be transposed into a larger figure the child seems to be looking for (under the verbal discription of "the same shape") one which belongs to the same class, is rectangular and not square, and is also "better" according to his notion of a rectangle; that is to say, more typical as regards the difference between length and width.

Hence it is fairly obvious that we are not dealing with a purely perceptual phenomenon. Comparing the present results with those obtained for inscribed triangles (§2.) we find that even though the former comparisons were aided by the standard being within the variable figure, estimates were equally poor at the same level, only improving slightly during Stage IIB. It is also true that the inscribed rectangles, with or without diagonals, which were given a brief examination in the same section, yielded errors comparable to the present ones (other than a few cases where the width is exaggerated instead of the length) and also errors which, unlike those of the triangles, do not lessen even by the end of Stage IIB.

On the other hand, similarity of inscribed rectangles (and separate rectangles even more so) raises special problems, since the angles of rectangles always remain the same, independent of changes in size and proportion. This means that the analysis of these figures must be based on dimensional relations. The height h must be compared to the length l and the ratio of h_1/l_1 applied to two new sizes h_2/l_2 so as to obtain the result $h_1/l_1 = h_2/l_2$.

These errors must therefore involve perceptual in addition to conceptual factors, so that if the perceptual phenomenon could be isolated from the conceptual process the threshold of equality would most probably be even larger, with a lower degree of accuracy for rectangles than for triangles. Even so, it would seem unlikely that variations in the threshold for transposition of a rectangle $1 \cdot 5 \times 3$ cm. should extend to 3×20 cm. and even further. It is therefore improbable that the perceptual estimates recorded above are the outcome of perception alone. Consequently we must conclude that since perceptual transposition of dimensional relations is extremely difficult at this level, it is supplemented, and even replaced to some extent, by transposition of the qualitative, global shape, together with the conceptualized shape in the sense indicated at the outset of this discussion. Regarded in this light, the reaction of the child who increases the length while forgetting to increase the height in proportion, is eminently understandable.

It should moreover be observed that in other fields children find great difficulty in effecting perceptual transpositions of any complexity. Thus the transposition of a difference in height B—A=D—C where C=B and the two pairs of elements AB and CD are a few centimetres apart is almost out of the question for a five-year-old child, since he has no understanding of the relations involved. From 6–8 years a considerable reduction of the difference takes place on transposition, if the standards which indicate the difference (A and B) are left unchanged. On the other hand, if the elements A and B are removed after each estimate and then replaced without the subject knowing that they are the same, the transposition becomes much more accurate.[1] This is analogous to our present experiments with rectangles, in that the child does not seem unable to transpose dimensional relations perceptually, except for the fact that his errors are larger than those of adults. Rather is it that his perception is subject to a perceptual activity which intelligence controls in a rather crude fashion, in the sense that the gradations between squares and rectangles are still too coarse.

It should also be noted that such perceptual estimates are based, not on logical inference, but on automatic regulatory processes. When the child exaggerates the length of the rectangle,[2] he does not correct the error as it would normally be checked in the process of reasoning, by cancelling or reversing it, but lessens the exaggeration in terms of the error itself. Thus the rectangle which is in fact too long (above 15 or 20 cm.) appears to him too thin and the correction is applied by way of partially compensating for this.

[1] See Piaget and Lambercier, M., 'La comparaison des différences de hauteur', *Arch. de Psychol.*, 1953, 54, pp. 73–107.
[2] Due to a centration which is, incidentally, mental rather than perceptual, since otherwise the length of the standard would merely be over-estimated perceptually, resulting in a negative error.

It is therefore hardly surprising that the constructive thought involved in making the drawing leads to a similar result. For in the first place, the same conceptual factors operating in the perceptual estimates, directing the child's perceptual activity in the way just described, also operate freely and independently in the production of the drawings. In the second place, once the drawing is actually made it exerts the same perceptual influence over the final estimate as did the comparison figures used in the first type of experiment. In both situations the child is influenced by what seems to him the typical example of a rectangle, distinguished from the square by its very elongation. Hence to enlarge the model he endeavours to construct the most elongated figure possible. Thus there is a simple repetition in terms of constructive thought, of what has already been seen in perceptual estimates (as distinct from direct perception).

It might have been thought that the exaggeration in the length of the rectangles by the younger children arose from a simple perceptual error, in which case direct perception would have led to drawings which diminished rather than increased the length, due to its being over-estimated in viewing the standard. To ensure that this was not the case we carried out the following experiments as a control.

Mlle. Prinzhorn presented rectangles of equal length (6 cm.) and varying height (1·5 to 2·5 cm.) or equal height (2 cm.) and varying width (4·5 to 7·5 cm.) to 17 children aged 5–7, 14 children aged 9–11, and 10 adults, having them estimate the relative length of the former and the relative height of the latter.

The results conform to expectation for size contrast phenomena, all subjects, children and adults, seeing the 1·5 × 6 cm. rectangle as longer than the 2·5 × 6 cm. one, and the 4·5 × 2 cm. one as higher than the 7·5 × 2 cm. In general, the error becomes less pronounced with age. In addition, several subjects below the age of 7 quite clearly perceived the relationship between the apparent dimensions. ER (4; 6) said, "*That one there is longer because it's thinner*", and DEN (5; 6) stated "*The fatter one is not so long, the thinner one is longer*", etc., which does not of course mean that they would have remained aware of this relationship in making a perceptual transposition.

These results tend to show that something more than perception is involved in the exaggeration of the length of a rectangle during its enlargement. If this were not so, the difference between young children who produce this effect, and adults who maintain the correct proportions, would also be repeated in estimating the proportions of figures very nearly equal in size. It can only be suggested that the young children, being less adept than adults at perceptual transposition, tend to supplement the operation of this mechanism, actually an aspect of perceptual activity, by means of a construct based on illusory notions (perceptual estimates) whose effects have already been described.

Thus the most striking feature of the reactions seen so far, is the synchronization between the evolutionary levels of perceptual judgement

and constructive thought. In other fields, such as children's spontaneous approach to measurement (see *La Géométrie Spontanée*), perception is ahead of intelligence from the very beginning, controlling it up to a point where reversal occurs and intelligence begins to govern perceptual activity. In the present case, however, the problem of comparing dimensional relations requires the direct participation of intelligence to aid perceptual activity, so that perceptual comparison and drawing are still at the same level of development during the second stage.

On this point, it was noted earlier that perceptual comparison and enlargement of shapes by drawing were somewhat easier in the case of the triangle than with the rectangle. For with the triangle, the qualitative overall shape is easier to recognize since, in the event of dissimilarity, the angles and inclinations of the three sides differ. With the rectangle, however, the angles and inclination of the sides remain unchanged so that the comparison must be based solely on the dimensional relations between four sides, equal in pairs. This raises the possibility of comparing the rectangle with the rhombus, for this shape also has four sides equal in pairs, but with differences as regards angles and inclinations. And in the preliminary experiments it was seen that all the children could pair a large rhombus with a similar shaped small one, so long as there was an appreciable difference in the shape of the two. But if the experiments on the rectangle described above are systematically applied to the rhombus it is found that when the difference in shape remains small, the child is not able to recognize similar rhombuses by taking account of the inclinations until Stage IIIA, which confirms the findings of Chapter XI as regards making opposite sides of the figure parallel. The reader will no doubt forgive our not reporting this series of experiments, which were in fact performed as controls.

§8. *Stage III. Intuitive transposition of dimensional relations in perceptual comparisons but not in drawings*

At this point, proportionality makes its appearance in the realm of perceptual comparison. The reasons for this we shall examine in due course but it is unlikely that they depend wholly on perception itself. In the realm of drawing and constructive thought, however, the child continues to exaggerate the length of the rectangle he is enlarging (Substage IIIA). Alternatively, though he now tries to take account of both dimensions, he is unable to find the correct answer except for simple ratios (Figs. 1–2) in the absence of a multiplicative schema (Substage IIIB).

Here are some examples from Substage IIIA:

DIA (7; 3) is shown the standard rectangle (1·5 × 3 cm.) and the enlargement (4 × 8 cm.)—"*It's just the same thing in a larger size*—And this (4 × 12)?— *That's no good, it's too long*—(4 × 6 cm.)?—*That's all right*—(9 × 7 cm.)?—

That's all right too—(4 × 11 cm.)?—*That's too big, too long*—(4 × 8·5)?—*That's all right*—(4 × 10·5)?—*That's too long*—And (4 × 9)?—*That's all right*—And this (4 × 10)?—*A little too long*—(4 × 9·5)?—*That too*". Thus, he will accept a shape ranging from 4 × 6 cm. to 4 × 9 cm., a threshold of 3 cm. with a negative constant error of ·5 cm. which means that the error is now perceptual and no longer intuitive. The threshold is eventually still further reduced.

Half-rectangle: He at first accepts 4 × 10 cm., but after a few trials only from 4 × 7 to 4 × 8·5 cm.

Drawing of the rectangle: "You're going to draw it (1·5 × 3 cm.) on a bigger scale?—*Yes* (draws it 2·5 × 8 cm.)—Is that right?—*Yes*—You're quite sure? —*Yes*—I'm going to start you off with one line (base of 7 cm.). Now finish it off—(He makes the width 1·5 to 2 cm., similar to the model)". On squared paper he still counts 6 × 21 for the same model. "Why 6?—*That's that!* (height) —And why 21?—*That's that!* (length)—And if you had counted 20?—*That would have been better because it would have been squarer*—Well then, start again—(He makes it 6 × 12, then adds two more squares making it 6 × 14)— Why did you add two more?—*So that it would be bigger*".

ERE (8; 0) accepts sizes from 4 × 6 to 4 × 8·5 cm. for the perceptual estimates, rejecting shapes larger than this.

For the drawings he constructs a rectangle about 3 × 8 cm. without measuring it; and on squared paper, one of 6 × 20 cm. Given a base of 24 squares he makes the sides 4 squares high.

SIM (9; 7). Perceptual estimate: he accepts shapes ranging from 4 × 7 to 4 × 9 cm., a threshold of 2 cm. with no error.

Drawing: using a ruler but not making any accurate measurements, he draws the side about 3 cm. and the length 17 cm. "And if you make the length as much as the whole ruler?—*You must add some more to the height, about 4 or 5, or rather 4 cm.*".

REN (10; 6) attains a threshold of 1 cm. for his perceptual estimates, with no constant error.

Drawing: he measures the width correctly and transposes it unaltered, then increases the length by 3 cm.

And here are some examples of Substage IIIB:

MAR (7; 6). Perceptual comparison: threshold of 1 cm. (4 × 7·5 to 4 × 8·5). He rejects all the rest as "*too long*" or "*too high*".

Drawing: he first constructs a rectangle 5 × 11·5 without the aid of measurement, thus enlarging it after the fashion of level IIIA. He is then shown a model (2 × 4) on squared paper. He counts the squares in both directions, doubles the number and ends up with 4 × 8. He is next given a model of 4 × 6. He produces a drawing (6 × 8) and says, "*I counted the squares of your drawing and to make it bigger and correct, I added two squares on the top and the side*— Why two?—(He attempts to show that 6−4=2).

CLAU (9; 6). Perceptual comparison yields a threshold of 1·5 with small negative error (·25 cm.). Of the comparison figure (4 × 8 cm.) he says, "*It's the same thing but bigger. I look at the height of the big one, then at the height of the little one. It comes to the same thing in a larger size*".

Drawing: on a large sheet of paper he draws a base of 8 cm., then hesitates

between 3·5 and 4 cm. for the width. He compares it several times with the standard but does not measure it. Finally, he makes it 4 cm. At this point he suddenly realizes, "*Four is half of eight! That means it's right*". Next he is given a model 1·5 × 4 cm. He measures out and draws a figure 1·5 × 8 cm.; "*I measured the first one, it was 4 so I added 4 to 4. Then I measured the height; it was 1·5 and I put that here*". He goes on to double the height as well. "And if you make it twice as big as 4 × 8 cm. ?—(He draws the rectangle 1·5 × 16 cm., thus relapsing into his original error, later correcting it by eye)".

GER (9; 8) reacts similarly with perceptual comparisons. Drawings: He is given the standard rectangle (1·5 × 3); "*I'll have to draw it double the height and width* (draws it 3 × 6 cm.)". He is given a base of 10 cm. to work from and measures the halfway mark, drawing the figure 5 × 10 cm.; "*I reckoned half for the height because it's the same in the model*". But given a model 3 × 5 cm. he also produces a proportion of 1 : 2 (5 × 10 cm.). Then he proceeds to measure the absolute difference between length and height (5–3=2) and adds it to the two sides, giving 5 × 7 cm. This he corrects by eye.

JEM (10; 2). His perceptual estimates are not very accurate at first, but later he checks them, taking account of both dimensions together, "*a little longer and a little higher*", "*not so long but higher*", etc., and achieves a high degree of accuracy for the half-rectangles (threshold of less than ·5 cm.).

Drawing: He doubles the 1·5 × 3 cm. figure to 3 × 6 cm. "Can't you make it anything else?— *Yes, you can treble it* (drawing it 4·5 × 9 cm.)—And with this (base of 10 cm.)?—*Now we'll have to see how much there is too much* (he marks out twice the base of the model, i.e., 6 cm.). *No, there's something left over . . . It must be made three or four times as big*". At this point he falls back on the trick of adding equal amounts to each side and adds 4 cm. to both height and base.

BER (10; 5). Perceptual estimates similar to Jem. Drawing: "*I'm going to double it* (drawing 3 × 6 for 1·5 × 3 cm.)—But you could have made it bigger— *Yes, as many times bigger* (as you like). *You could treble it*, (draws it 6 × 12) *I've made it four times as big*—And this one (4 × 7 cm.)?—(He adds 1 cm. to each side)—Don't you find it rather wide?—*It gives that impression when it's bigger* (!)—And (2 × 5)?—(He again adds the same amount to each side). *That's very annoying . . . let's try adding 2 cm. . . . it seems a little bit thin* (the model) *. . . If only I could cut it out and put it inside my drawing. It ought to be in the middle so that you could see the little bits on each side*".

These examples from Stage III raise a number of interesting problems about the way in which perception of proportions (perceptual transposition) is related to the birth of the concept of proportionality.

Starting with the perceptual comparisons, the immediately striking feature is the sharp contrast between these children and those of Stage II. The latter, under the sway of illusory ideas and without adequate means of effecting transpositions, enlarged the rectangle by lengthening it out of all proportion. But the children of Stage IIIA are able to transpose the figure, keeping fairly accurate account of the relative dimensions. The perceptual threshold declines absolutely, and what is most significant, does so during the course of the experiment (compare

Dia's estimates for rectangles with his subsequent ones for half-rect-angles), which indicates the growing influence of perceptual regulation. In fact, errors frequently become negative, suggesting that the over-estimation is now perceptual rather than intuitive. In accordance with the law of relative centration,[1] which accounts for these types of illusion, the length of the rectangle has the effect of reducing its apparent width, so that the length itself tends to be over-estimated. Consequently, as the child perceives the length as greater than it actually is, he tends to choose rectangles which are too short (since he is over-estimating their length). Thus the negative error is the effect of the child's concentrating his attention on the length as opposed to the width.

On the other hand, during Stage II the tendency to centration on the length was intuitive rather than perceptual, a predilection for increasing the length and not the width, and in no way a purely perceptual phenomenon. The frequent appearance of negative errors in Stage III is enough to show that these children's perceptual estimates are less coloured by preconceived ideas (in the direction of intuitive centration) and far closer to genuine transposition. However, we have yet to under-stand the cause of this advance, which by the very fact that it is new and marks a departure from the tendencies manifested in Stage II is evidently due to an improvement on the part of perceptual activity itself, and thereby to the effect of more mature thought on the capacity to transpose a figure accurately.

At Substage IIIB the perceptual reactions are basically similar to those of IIIA, except for two new features. These are slightly increased accuracy and, more important, an awareness of both length and width while the comparison is actually being made (on this point, if Mar appears somewhat backward, the remarks of Clau, Jem, and Ber are most illuminating). Here again it is evident that intelligence plays an active rôle, the perceptual transposition being accompanied by a true operational comparison.

Yet if we turn to the drawings produced by the same children it is immediately apparent that these are but poorly developed as compared with the perceptual estimates. All the children quoted as examples of Substage IIIA construct their drawings arbitrarily, extending the length of the rectangle out of all proportion, just as at Stage II (see Dia's remarks in particular), and it is only the subsequent perceptual estimate which enables them to correct the drawing rather than any reasoning about the proportions. This type of reaction can still be seen with Mar at Stage IIIB (at the beginning), though the children soon learn to double and treble the size of the standard, and even to transpose the ratio of 1 : 2. But beyond this they are completely lost and are reduced

[1] See Piaget. J., 'Interprétation probabiliste de la loi de Weber et de celle des centrations relatives', *Arch. de Psychol.*, Vol. XXX.

to adding equal amounts to each side as if $1\cdot5+2\times3+2$ was proportional to $1\cdot5\times3$. Once again it is the perceptual estimate made on the resultant drawing that enables them to correct their errors empirically.

This poses the question of why perceptual estimates are ahead of intellectual constructions throughout Stage III while at Stage II the two activities were at the same level of development. But is not the statement implied by this question at variance with our previous findings? For in Chapters VI and XI dealing with straight lines and parallels, we showed that perception does not precede operational thought during the solving of such problems, but is guided by it. Moreover, the cases referred to were at exactly the same stage of development; namely, the beginning of Substage IIIA.

There is no real contradiction here, because the operational treatment of proportion begins on the level of perceptual estimates before being achieved on that of intellectual construction—more difficult to master, since it deals with intangibles. At the lower level, conscious comparisons are based on concrete data, hence their success. On the level of intellectual construction, however, they depend upon imaginary constructions which anticipate the actual drawings and are therefore more difficult to carry through.

It must of course be realized, that the difference between judgement of size and judgement of proportion, between a simple comparison of two sizes (as when the child spontaneously starts measuring) and a dual comparison of four sizes ($h_1/l_1 = h_2/l_2$ where h and l are height and length of rectangles), is the difference between a simple visual 'transfer' and the 'transposition' of dimensional relations.

The 'transfer' resulting from eye movements is a relatively elementary perceptual reaction, whereas 'transposition' is part and parcel with 'perceptual activity' (see Chapter I, Section I). The latter is a complex process at a higher level than the former, at least, where the general dimensional or geometrical proportions and not merely the shape is involved.[1]

It is therefore hardly surprising that at Stage II perceptual transposition of the rectangle only applies to overall shape. If this primitive and distorting process becomes relatively accurate during Stage III it is because syncretic perceptual estimates are replaced by a genuine analysis of the figures. That is to say, the two sets of dimensions are compared in an intelligent and conscious way, even though they cannot yet be thought of together but only separately. Consequently, as was pointed out earlier, the development of perception which distinguishes

[1] It is interesting to note that simple perception itself obeys the laws of proportion (Weber's Law, Law of relative centration, etc.) while 'perceptual activity' demands awareness of proportionality as such, something which remains outside consciousness at more elementary levels of development.

Stage II from Stage III can only be due to a sharpening or refinement of "perceptual activity" as distinct from simple perception; in short, to the evolution of operational mechanisms peculiar to Stage III.

Hence, so far as the rectangle is concerned, dimensional transposition, the source of the idea of proportionality on the perceptual level, would appear to be the direct outcome of the reciprocal influence of thought on perceptual activity, thought which has become operational and able to carry out simple comparisons along two dimensions. Now though this situation may appear somewhat complicated, it does not really contradict the fact that in the realm of constructive thought the child is still unable to produce drawings exhibiting any intellectual understanding of proportions in general. Indeed, at the level of perceptual estimates, the beginnings of intelligent comparison can be explained simply on the assumption that as soon as the child attains the level of elementary, concrete operations, he can no longer perceive two rectangles $h_1 \times l_1$ and $h_2 \times l_2$ at the same time without simultaneously comparing them in terms of their two sides h and l, even though he has as yet no operational means of expressing the dual relationship qualitatively.

Given that one side of the rectangle (h) is seen as smaller than the other (l), the increase of this side in the enlarged rectangle (viz. $h' = h_2 - h_1$) is made to tally with the corresponding increase of the other (viz. $l' = l_2 - l_1$) in line with the same relationship. The variety of comparison figures given to the child enables him to see that among them there is one with sides $h_2 \times l_2$, such that when compared with the small rectangle $h_1 \times l_1$, the difference between their heights (h'), and the difference between their lengths (l') is $h' < l'$ in the same way that $h_1 < l_1$ and $h_2 < l_2$, and it is this rectangle he will choose as having the same shape.

On the other hand, when the same child is faced with the problem of enlarging a rectangle by means of a drawing, without the help of a perceptual model as a guide, he is unable to fix on any satisfactory relationship between the increases h' and l'. Although he feels that $h' < l'$ is like $h_1 < l_1$ he is unable to work out how much l' is greater than h', so that he loses the sense of disparity between these increases, or begins to imagine that equal increases added to unequal dimensions are equivalent to proportional increases.

In this connection it is extremely illuminating to study the various methods which the child adopts for enlarging the figure. Such an examination gives a clear insight into the origin of the idea of proportion and the place it occupies relative to perceptual transposition. During Stage IIIA the increases h' and l' are still purely arbitrary (Dia merely says "that's that"), the increase l' being much greater than h'. But from the beginning of Stage IIIB, four different sorts of reactions can be

distinguished. 1. The child adds the same absolute quantity ($h'=l'$) to the two sides h and l indifferently; for example, Jem (toward the end) and Ber (who adds 1 cm. to each side). 2. The child measures the difference $l-h$ and transfers it to the sides of the rectangle he is constructing; for instance Mar, who adds 2 cm. to a rectangle 4×6 cm. because $6-4=2$, and Ger who ends up with 7×5 cm., starting from 5×3 and transferring $5-3=2$ cm. 3. The child discovers that $h=l/2$ in the standard (1·5×3 cm.) and constantly tries to retain this ratio 1 : 2, even though this solution no longer holds good for other rectangles (cf. Clau and Ger). 4. For the rest, it is enough to double, treble or quadruple the two sides of the standard in order to obtain the enlargement. This answer is a correct one, but it does not enable the child to find the solution for a given base. Furthermore, those children who discover this solution when the ratio of h/l is equal to $\frac{1}{2}$ do not always apply it to other ratios (cf. Ber for the ratio of 4 : 7). Lastly, all the children correct their attempts empirically or want some visual proof, like Ber who wishes he could "put (the model) inside (his) drawing".

The process can be seen leading from the first answer, right through to the fourth. Each one of these children begins by noticing that the length l_1 of the standard rectangle is greater than its height h_1, alternatively $h_1 < l_1$. This yields three terms h_1, l_1 and the difference between them D. During Stage II (and Substage IIIA for the drawing), the enlargement of the rectangle consists simply of increasing l_1 alone (beginning of Stage II), or increasing it much more than h_1. Thus at this stage proportionality is not understood at all.

This understanding begins at the point where the child realizes that h and l are co-variant and that it is the difference D (hl) which must remain invariant (Stage IIIA for perceptual estimates and IIIB for drawing). But at first the child regards the difference as invariant in an absolute sense. Only later does he begin to consider it as relatively constant; that is to say, as an invariant ratio. Hence the peculiar reactions (1) and (2) consisting of adding to h_1 and l_1, either the same amounts h'_1 for h_1 and l'_1 for l_1, with $h'_1=l'_1$, or adding to h_1 and l_1 their difference itself, namely, D (h_1 l_1). These two solutions therefore both amount to regarding D (h_1 l_1) as an absolute invariant. Solution (3) evolves from solution (2) when the child notes that in the standard (1·5×3 cm.), D (h_1 l_1) is equal to the width h_1 so that $l_1=2h_1$ or $h_1=l_1/2$. With the ratio between h and l a simple 1 : 2, the child can now proceed to the crucial discovery that D (hl) is not an absolute value but a ratio, viz., D (hl)$=h/l$, so that when drawing the larger rectangle $h_2 \times l_2$, he makes $h_2=h_1+h_1$ and $l_2=l_1+l_1$. But this notion is as yet so unstable that when the child is shown rectangles in which $h<l/2$ he reverts either to making $l_2=2l$ and $h_2=2h$, or like Ger, relapses into solution (2). At the same time, solution (3) has itself already given rise to generaliza-

tions such as $h_2=3h$ and $l_2=3l$, or $h_2=4h$ and $l_2=4l$ (solution 4), though at this stage such generalizations remain inadequate and when l is no longer a simple multiple of h the child reverts to solutions (1) and (2) (cf. Ber).

In short, the distinctive feature of the drawings in Substage IIIB is the discovery of a constant difference D (hl), first considered as an absolute quantity $D=l-h$, then seen to be relative, $D (hl)=h/l$, though only for simple cases where $h=1/2$, $1/3$ or $1/4$ and not generalized for all cases.

The reason why perceptual transposition is ahead of drawing and operational thought at Stage III should now be apparent. "I look" says Clau "at the height of the big one, then at the height of the little one; at the length of the big one and then the length of the little one". Thus when the evolution of mental comparisons leads the child to compare the heights (h_1 and h_2) and the lengths (l_1 and l_2), the perceptual 'transfer' or 'removal' enables him to see h_1 h_2, and the increase (or difference) h' at the same time; and the same applies to l_1 l_2 and l'. Since perception itself invariably follows the laws of proportion (Weber's Law, Law of Relative Centrations, etc.), visual analysis, guided by intelligence, of both dimensions together automatically results in equilibrium as soon as the increases h' and l' are seen to be in the same ratio h'/l' as the sides h_1/l_1 and h_2/l_2. It is obvious that this is an entirely different state of affairs from Stage II where the child only concerns himself with comparing a single dimension, such as the length.

At Stage III then, the perceptual estimates are evidence of some awareness of proportionality, although the child is unable to envisage such relationships operationally until Substage IIIB, and then only in simple cases.

§9. *Stage IV. Proportions generalized operationally*

Having discovered that the enlarged rectangle $h_2 \times l_2$ must have the same ratio h_2/l_2 as the small rectangle $h_1 \times l_1$, regardless of whether l_1 is twice, thrice or four times h_1, during Stage IV the children begin to generalize this rather crude idea of proportions. They now begin to apply it in the case of more complex fractions by treating the difference between the length and the height, D (hl), as a constant ratio $D=h/l$ rather than a constant difference in size as previously.

PIR (10; 11) begins by making perceptual comparisons with a threshold of 2 cm., but eventually improves so far as to accept only enlargements ranging from $4 \times 7 \cdot 5$ to 4×8 cm. for the standard of $1 \cdot 5 \times 3$ cm.

Drawing: he at once measures the sides of $1 \cdot 5$ and 3 cm., doubling them to form a rectangle 3×6 cm. He is next given a model 2×5 cm. and asked to enlarge it on a base of 10 cm. "*You can't divide it* (the length) *in two* (equal

halves) *because it's 5 . . . but there* (1_1) *it's 5 and there* (1_2) *it's 10, so there* (h_2) *it's* $2 \times 2 = 4$". Shown a new base of 12 cm. he says, "*If you had drawn 12·5 cm. it would have made* $2·5 \times 5$ ($= 1_1$) *and I would have drawn* $2·5 \times 2$ ($= h_1$). *I reduce it by half a centimetre which leaves* 12 *for the length, and the same for the height which leaves 4·5 cm.*" (Thus he argues on a basis of multiplying the proportional ratio whilst also subtracting equal amounts just as at Stage III).

DAN (11; 0) makes his perceptual estimates by a series of adjustments and corrections. Drawing: for the rectangle $1·5 \times 3$ cm. he immediately produces a figure $2·5 \times 5$ cm. "*Why did you do that?*—*I took half because I saw it was half*—And if the length were 10?—*I draw 5* (for the height)—And with this (3×5 cm.)?—(He draws 6×8 then 5×8 cm.)—How did you work it out?— *First I thought the width was three quarters of the length, then I saw it was too much so I took one* (cm.) *away* (i.e., ordinary approximation)—(He is given a base of 10 cm.)—(Draws a height of 6 cm., and says): *The model is 3 cm.* (in height) *from 3 to 5 there are 2. From 6 to 10 is twice as much* (he is thus doubling the difference D (hl) because 1_2 is twice 1_1)—*And what would you do for 15 cm.?*—*I'd multiply by three. 15 and 9 because 9 from 15 leaves 6 and 3 from 5 leaves 2. And 6 is* 3×2". Thus, Dan reasons on the basis of the difference D ($h_1 1_1$) but considers as a constant ratio, D ($h_1 1_1$) = h/1.

AND (12; 1). Perceptual estimates as Dan. Drawing: ($1·5 \times 3$ cm.). He produces one of 3×6 cm. "*I doubled it*—And with this one (2×4, on a given base of 10 cm.)?—*The height must be 5 because that's half of* 10—But how did you work it out?—*I took 4, it goes twice* (into the length of 10 cm.) *and leaves 2 over. I took 2* ($= h_1$) *and that goes twice and leaves 1, that makes 5. There* (on the model) 2 ($= h_1$) *is half of 4* ($= 1_1$) *and 1 is half 2* ($=$ 1 and 2 are the two remainders he has just mentioned). *It's right because 1 is half 2*— Why do you need a half?—*Otherwise the remainders would not be the same*". In other words, the remainders R are defined as $R_1 = 1_2 - 21_1$, and $R_2 = h_2 - 2h_1$ and And accepts $R_1/R1 = 1/h$!

Model of 3×5 cm., on a base of 12 cm. He calculates that 12 : $5 = 2·4$ then, after hesitation, multiplies $2·4 \times 3$ giving 7·2.

These interesting examples show that in arriving at the right answer, the children generalize the method found at Stage IIIB, at least for the ratio 1 : 2 (see for example, Pir, who has grasped the principle correctly, despite the fact that he shows traces of the methods taken over from Stage IIIB). But the method pursued by Dan and And is particularly worth attention. Dan multiplies the difference D (hl) between the height of the model (h) and its length (l) by the ratio $h_1/1_1$, where the remainder is defined as $R1 = 1_2 - 21_1$ and $Rh = h_2 - 2h_1$. These two examples illustrate perfectly the transition from the erroneous method of Stage IIIB, based on analysing the absolute difference D (hl) = l—h, to that of Stage IV where the difference D (hl) becomes a function of the ratio h/l. By the end of the session And has arrived at the general expression $h_1/1_1 = n$ yielding a proportional enlargement as $h_2 = nh_1$, and $1_2 = nl_1$, which is no longer merely a qualitative but a genuinely quantitative expression of proportionality.

§10. *Conclusions*

When one tries to summarize the whole of this development from Stage II to Stage IV, one finds that it comes together in a way that is both simple and illuminating. To enlarge a rectangle $h_1 \times l_1$ and construct a similar figure $h_2 \times l_2$ the child at Stage II begins by concerning himself solely with the length l_2, which he increases out of all proportion, either ignoring the width h_2 entirely or increasing it only by a very small amount. In Stage III he discovers, first perceptually (IIIA) and then in actual drawing (IIIB), the relationship between the length l_1 and the width h_1. At first this takes the form of a difference D (hl) which remains constant in an absolute sense, D (hl)=l_1—h_1, and then takes the form of a constant ratio D (hl)=h_1/l_1. Having reached this point for simple ratios such as 1 : 2, he proceeds in Stage IV to formulate the discovery of proportionality under the expression h_1/l_1=h_2/l_2 and apply it to all cases, including ratios that cannot be expressed as whole numbers.

We now have to explain the transition from proportionality conceived as a constant ratio D (hl) to generalized proportions. Let h' be the difference between h_1 and h_2, that is, the heights of the standard and the enlarged rectangle; and let l' be the difference between l_1 and l_2, the lengths of the two figures. We then have h'+h_1=h_2 and l'+l_1=l_2. But these are merely qualitative relations deriving from a simple logical part-whole inclusion, so that if h_1+h'=h_2 the child can only know that $h_1 < h_2$ without knowing the actual relation of h_1 to h', and the same for l_1 and l_2. No doubt he can already say "h_1 is to h_2 as l_1 is to l_2" or "h' is to h_2 as l' is to l_2" but only in the sense of a logical, as compared with a mathematical correspondence, like saying "Marseilles is to France as Naples is to Italy"; in other words, a twofold comparison of the part and the whole.

But the discovery peculiar to Stage III is that the difference D (l_1 h_1) remains constant. In the realm of perceptual judgements this constant is regarded as a fixed ratio right from the start, whereas in the realm of drawing and construction it is at first treated as an absolute and only later considered as a constant ratio. It is the discovery of the invariance of this relationship which enables the logical correspondence of part to whole to be quantified and thus transformed into a mathematical ratio. If h' is to h_1 as l' is to l_1, and if h_1 is to h_2 as l_1 is to l_2 in terms of a constant ratio D (h_1 l_1)=D (h_2 l_2) this means, in effect that h_1 is part of h_2 to the same extent that l_1 is part of l_2, so that h_1 becomes a function of h_2 corresponding to h'; l_1 becomes a function l_2 corresponding to l' and the two functions are equal: h_1/h_2=l_1/l_2, resulting in the proportions h_1/l_1=h'/l'=h_2/l_2. The construction of proportions is therefore neither more nor less than a transition from qualitative correspondence be-

tween logical inclusions of the same "types" to equality between quantitative inclusions of the same order, or numerical value.

Now the most interesting thing to notice about the idea of proportions in the case of the rectangle,[1] is that it evolves in exactly the same way as with the triangle (discussed in Section I of the present chapter). There we saw that at Stage IIIB (the same as that at which mathematical proportion evolves out of correspondence between logical inclusions), the child discovers that in the case of two triangles having sides $A_1 A_2$ and $B_1 B_2$, such that $B_1 = A_1 + A'_1$ (where A'_1 is the difference between the corresponding sides of the two triangles), and $B_2 = A_2 + A'_2$ (A'_2 being the difference between the other pair of sides), then if the bases A and B are parallel the triangles are similar. At first glance there may appear to be little connection between this type of construction and the metric constructions needed for rectangles. However, it will very soon become clear that, on the contrary, they really amount to the same thing.

We may begin by noting that the sides of the standard rectangle h_1 and l_1, could be regarded as sides A_1 and A_2 of a triangle, considering only two of the four sides and ignoring the sides opposite for the time being. Similarly, the sides h_2 and l_2 of the larger rectangle may be compared with the sides of the larger triangle, B_1 and B_2, and the differences A'_1 and A'_2 likened to the differences h' and l'. Now the essence of the geometrical discovery made in the case of the rectangle is that h' and l' stand in the same relation to one another as do h_1 and l_1, and h_2 and l_2; in other words, that $h'/l' = h_1/l_1 = h_2/l_2$. Regarded from the purely graphic or figural standpoint, to say that two straight lines originating at the same point present a certain relationship means that their extremities could be joined by means of a third line. The relationship between A_1 and A_2 is therefore the line A which forms the base of the first triangle. Similarly, the relationship between B_1 and B_2 is the straight line B forming the base of the second triangle. Lastly, to say that the relationship between A_1 and A_2 is the same as that between B_1 and B_2 amounts to stating that A and B are parallel, the parallelism expressing precisely the identity of orientation and hence, the identity of the relationship. Thus the relationship of parallelism between the bases A and B amounts to stating that $A_1/A_2 = B_1/B_2 = A/B$ which corresponds exactly to the proportionality expressed by $h'/l' = h_2/l_2 = h_1/l_1$.

This correspondence between the spatial and the numerical concept of proportionality is well known mathematically, and it is all the more interesting to find that it occurs at the same level of development; namely IIIB, in connection with two aspects of the mental construction

[1] We have already discussed the question of proportionality in connection with the relations of time and distance in *Les Notions de Mouvements et de Vitesse chez l'Enfant*, Chapter IX, where it occurs in precisely the form outlined above.

of similarities and proportions which are at first sight very different. In this we have a further example of the close link between the psychological construction of space and the deductive axiomatics of geometry.

However, it is still the case that although present in a vague and sketchy form at Stage IIIB, the quantitative concept of proportionality does not attain a stable equilibrium until Stage IV; whereas the similarity of triangles on the basis of equality between angles, already suggested in Stage IIIA, is fully established by Stage IIIB. And in turn, the similarity of triangles based on parallelism of their sides is already achieved at Stage IIIA. Thus the parallelism of side of triangles, the equality of their angles and metric proportionality would appear to constitute three phases of the development of similarities and proportions in general, corresponding with the Stages IIIA, IIIB and IV.

To sum up. In Section I we endeavoured to show that the concept of similarity between triangles arose through the grouping of operations, at first merely qualitative in nature, later capable of extensive quantification based on co-univocal correspondence. As we have just seen in Section II, it is this relationship which enables the part to be linked with the whole. Two such relationships can be linked in the form of corresponding logical inclusions, and eventually in the form of proportionality. Hence the close association between the operational concepts developed by the child in the realm of similarity between triangles, and proportionality with respect to dimensional relations in general.

However, though co-univocal correspondence plays a vital part in the development of concepts for dealing with angles, similarities and proportions, when co-ordinate systems have to be constructed it is bi-univocal correspondence which plays the leading rôle. This will become apparent in the two chapters which conclude our study of the transition from projective concepts to those embodied in a euclidean metric.

ADDITIONAL NOTE:
PROPORTIONALITY IN THE CASE OF OPEN FIGURES

We performed a control experiment on the discovery of proportions in enlarging an open figure. However, we cannot describe this in detail since the present chapter is already rather lengthy.

To eliminate the rôle of strong configuration in figures such as the triangle and rectangle, and to see whether proportionality develops in the same way for other, non-gestalt, forms, we showed children a horizontal straight line (a) 6 cm. in length and another (b) of 3 cm., perpendicular to it and some 1·5 cm. distant (c) from the leftward extremity of the horizontal line. We proceeded in manner as previously, by means of both perceptual comparisons and enlargement by drawings.

The correct enlarged comparison figures were drawn with (a) = 10 cm.

(b)$=5$ cm. and (c)$=2\cdot5$ cm. In the comparison series (a) remained constant whilst (b) and (c) were varied. The drawings were carried out exactly as previously.

It is evident that this problem differs from those involving triangles and rectangles in that the child has to take account of three lengths (a, b, and c) without the aid of parallelism; and above all, because his perceptual transposition or enlarged drawing derives no support from any conceptualization of the figure, unlike the triangle which was made more acute or the rectangle which was elongated to conform to a mental stereotype.

The stages in the discovery of proportion appeared to follow the same order though without being identical in every respect. At Stage I it is of course even more impracticable to perform this experiment than that using closed figures. Similarly, Stage II appears to begin a little later, the younger children finding it very difficult to imagine what such an enlargement could possibly be like, and moreover, picking out a drawing with a pair of intersecting perpendiculars, or even three lines running from one point in any direction, ignoring the relative lengths; or else as soon as they do analyse the figure they simply "transpose" some absolute size. Thus for the perceptual comparisons the thresholds are either very large, due to the child accepting all the figures offered, or very small due to his accepting only one particular sample, though with errors resulting from his choice of an absolute size. Similar results are obtained with the technique of drawing. For example, Lil (5; 8) accepts any figure, provided the lengths (b) and (c) are not less than those of the model, while Jac (6; 6) compares only particular, absolute sizes.

Towards the age of 7 the beginnings of Substage IIIA can be seen, indicating a slight advance toward comparison of the lengths. This is accompanied, however, by exaggerated enlargement of either (a) or (b) ((c) being as a rule kept to its original length). But before he gets as far as analysing the various lengths, each child starts off with comparisons that are still purely global, or else confines himself to enlarging only one of the dimensions. Thus DAN (6; 10) begins with very large thresholds and a large positive error for the line (b). However, when he is given drawings with (b) much too small he starts comparing them methodically. In his drawing he makes (c) constant and (b) longer than (a). TEY (7; 10) does just the opposite.

At this stage there is no gap between the perceptual comparisons and the drawings, for the open figure does not encourage conceptualization and is as difficult to analyse by visual comparison as by drawing (except for exaggeration of a particular line being more accentuated in the drawing).

Towards 8; 5–9 years, Substage IIIB appears with more accurate comparisons of two dimensions, though not of three. In addition, the

child can get as far as metric proportions for simple ratios such as 1 : 2 and applies the twofold increase to the third length (c). For instance, BER (8; 6) maintains the proportions of (a) and (b) almost exactly, drawing them without measuring, but he transfers the length (c) unaltered. Eventually, he is able to double all three lengths systematically though he cannot enlarge to any other sizes. JOB (8; 11) begins by concerning himself with only two of the three lengths, goes on to add equal amounts to each of the three lines, and so on.

Finally, at about 11 years, Stage IV appears with metric comparisons applied to all ratios.

Taken as a whole, the development of these reactions is comparable with that found for perceptual and graphic comparison of the rectangle, minus the complications due to the child envisaging the global shape, and plus others due to the presence of a third distance to be compared along with the other two.

N.B. To conclude, it must be emphasized that everything stated in Section II as regards the exaggeration of the lengths of rectangles may also be found in varying degrees when the rectangle is presented vertically instead of horizontally.

Chapter Thirteen

SYSTEMS OF REFERENCE AND
HORIZONTAL-VERTICAL CO-ORDINATES[1]

AS distinct from elementary topological relations which are con-
cerned simply with the object as a thing in itself and with its
various features taken in turn, we have shown that projective concepts
imply a comprehensive linking together of figures in a single system,
based on the co-ordination of a number of different viewpoints. But
side by side with the development of this organized complex of view-
points there also takes place a co-ordination of objects as such. This
leads ultimately to the idea of euclidean space, the concepts of parallels,
angles and proportion providing the transition between the two systems.
Such a co-ordination of objects naturally assumes the conservation of
distance, together with the evolution of the notion of 'displacement' or
congruent transformation of spatial figures, culminating in the con-
struction of systems of reference, or co-ordinates.

Now in a subsequent volume[2] we shall study how the elementary
topological relations described in Chapters I–V of the present work are
extended in the form of euclidean concepts of distance and measure-
ment, and we have already dealt elsewhere[3] with the relations between
the concepts of order or 'placement' and the grouping of 'displace-
ments'. For the present therefore we may confine ourselves to the task
of relating the problem of co-ordinates to the notion of order (dealt
with in Chapter III); and the problem of the three dimensions (Chapter
IV §2.) to the concepts of straight lines (Chapter IV), parallels (Chapter
XI) and angles (Chapter XII). Finally and in particular, to developing
the analogy between euclidean and projective co-ordinates (Chapters
VI–X and especially Chapter VIII).

At the outset, the co-ordinates of euclidean space are no more than
a vast network embracing all objects and merely consist of relations of
order applied simultaneously to all three dimensions. Within this net-
work each object is linked simultaneously with the rest in three direc-
tions; left-right, above-below and before-behind, along straight lines
parallel to each other along one dimension and intersecting those
belonging to the other two dimensions at right-angles.

[1] In collaboration with Mlle. G. Ascoli, Mme. M. Denis-Prinzhorn, Mlle. M. Roth, and
M. G. Lewinnik.
[2] *La Géométrie Spontanée de l'Enfant.* In translation.
[3] *Les Notions de Mouvement et de Vitesse chez l'Enfant.* Paris, 1946, Chapters I–V.

It is due to the spontaneous construction of such a network that figures can be oriented and movements directed in space, and for lack of it that younger children are unable to make a straight line or a set of parallels, nor judge their inclinations or angles, as was seen in Chapters VI, XI, and XII. More precisely, the construction of these straight lines, parallels and angles constitutes the preliminary phase of the general co-ordination formed by a network of co-ordinates.

However, a reference frame is not simply a network composed of relations of order between the various objects themselves. It applies equally to positions within the network as to objects occupying any of these positions and enables the relations between them to be maintained invariant, independent of potential displacement of the objects. Thus the frame of reference constitutes a euclidean space after the fashion of a *container*, relatively independent of the mobile objects *contained* within it, just as projective co-ordination of the totality of potential viewpoints includes each viewpoint actually envisaged. It is in this sense that projective and euclidean space consist of comprehensive systems as contrasted with topological relationships which remain internal to each object regarded as an isolated thing in itself.

Let us consider a series of objects, immovable for the present, arranged along a straight line. Then, as we shall later see,[1] the intervals between these objects constitute 'distances' and each object is located or 'placed' relative to the others in a certain order and at a certain distance. Of course, such a one-dimensional system could be supplemented by other 'placings' and distances along lines arranged in other dimensions. Now, however, let us assume that some of the objects move, permutating their relative order, or else occupying previously empty spaces and leaving their own positions vacant. It would then be possible to arrange the positions themselves independent of the moving objects, and to mark off distances between these positions as well as between the objects. Finally, let us generalize this entire process by the further assumption that whilst all the objects are mobile, their successive positions are stationary. It is the organization of all these positions in three dimensions simultaneously which constitutes a frame of reference.

Now if such a system gives rise to a homogeneous environment common to all objects, it is not merely because this so-called 'container' consists of the entire assemblage of the relations of order and the intervals of 'distances' between objects. It is also because the 'container' differs from its 'contents' in that these relations are not confined to the objects at a particular moment, but include all their successive or potential positions, linking them all together and employing certain favoured positions as reference points or 'points of departure' for all subsequent positions.

[1] *La Géométrie Spontanée de l'Enfant*, Chapter III.

The reference positions which constitute the 'axes' within the system, no doubt refer to particular objects which are maintained immobile hypothetically, but then located in another plane. For example, the commonsense idea of space relates to horizontal ground level or to vertical objects perpendicular to it. Nevertheless, the essential character of a reference frame does not reside in the choice of stationary reference objects, but in the possibility of co-ordinating positions and intervals without limit, through constantly enlarging the original system.

We may therefore expect to find that after the age of 6 or 7, the concept of the straight line (as the maintenance of a constant direction of travel), parallels and angles, followed by co-ordination of their orientations and inclinations, leads sooner or later to some kind of reference frame, quite apart from the operations of positioning and displacement referred to elsewhere or the concept of distance which will be dealt with later.

On the one hand, whenever objects or parts of figures are linked by relations of order, or by straight lines, parallels and angles, and whenever these variously inclined lines are themselves oriented relative to each other, we have the preliminary outline of what invariably culminates in a complete frame of reference.

On the other hand, the grouping of displacements leads to the gradual replacement of positional relations between objects by relations of order and distance between the positions themselves. This 'clarification' or 'purging' of space (if the reader will forgive the metaphor), by progressively emptying it of objects in order to organize the space or 'container' itself, leads to exactly the same result. Now this dual process does not take place all at once. The systems of reference are at first limited and circumscribed in character, only gradually becoming more extensive and being consolidated by including ever more items, while at the same time becoming more abstract. Thus both the paths followed by this process invariably consist of anchoring the transformations to invariants, and in particular, basing the systems of displacements on an inter-linkage of objects assumed to be stationary, until permanent axes and points of reference are chosen.

In this connection, the first problem which arises is that concerning the choice of natural reference systems, such as the horizontals and verticals as part of the most stable, or least mobile, framework of everyday experience. Obviously it is not a matter of considering these ideas from the standpoint of their physical application (since they are physical and not mathematical concepts), but simply as co-ordinate axes deriving from or suggested by the external environment, independently of the limited equipment at the child's disposal. From this standpoint it is extremely important to find out whether or not the child can spontaneously utilize such a system of reference; and if so, under what

conditions. This is the main problem which we have to examine in this chapter.

Now it may seem to more than one reader rather naïve to raise the problem in this way. As adults we are so accustomed to using a system of reference and organizing our empirical space by means of co-ordinate axes which appear self-evident (like the vertical provided by the plumb-line and the horizontal given by a water level), that it may seem absurd to ask at what age the child acquires these ideas. It will be said that as a result of lying flat on his back the child is aware of the horizontal right from the cradle, and that he discovers the vertical as soon as he attempts to raise himself. The postural system would thus appear to provide a ready-made co-ordinate space, the organs of equilibrium with their only too-well-known semicircular canals solving the entire problem. In which case it would indeed appear odd to want to raise the problem all over again with the 4 to 10 year old child!

Here we touch on one of the worst misconceptions which has plagued the theory of geometrical concepts. From the fact that the child breathes, digests and possesses a heart that beats we do not conclude that he has any idea of alimentary metabolism or the circulatory system. At the very most he may have noticed his movements in breathing, or felt his pulse. But such perceptual-motor awareness does not lead to any understanding of the internal phenomena of which these movements are only the outward and visible sign. Similarly, from the fact that he can stand up or lie flat, the child at first derives only a strictly empirical awareness of the two postures and nothing more. To superimpose upon this a more general schema he must at some point go outside the purely postural field and compare his own position with those of surrounding objects, and this is something beyond purely empirical knowledge.

Now there is nothing to suggest that lying flat, parallel with the edge of the bed and the floor, or standing up parallel with the walls of the room leads directly to such a comparison. Nevertheless, let us assume that this comparison very soon occurs on the perceptual-motor level, through perceptual control of habitual movements. The question is whether it will lead automatically to a general perceptual co-ordination of objects with each other. On the contrary, as the result of Wursten's[1] work on the estimation of parallelity, tilt and length of variously inclined lines, we know that younger children react differently from children of 9–10 and 10–11, and from adults. Although at all ages it is easier to judge lines as parallel when they are vertical or horizontal—which gives some indication of the privileged character of these two dimensions from the elementary perceptual-motor standpoint—nevertheless, the younger children fail to judge tilt correctly and cannot arrange oblique lines in parallel. At the same time these children, oddly

[1] See Chapter XI, and for reference p. 47, Chapter II.

enough, are better than the older ones at comparing the lengths of non-parallel lines, even when one line is tilted and the other vertical. It is thus apparent that the younger children do not locate perceived objects in a spatial field possessing vertical-horizontal co-ordinates facilitating judgement of tilt. Even though the vertical and horizontal lines are perceived more accurately (but with the vertical-horizontal illusion at a *maximum*), the tilt of oblique lines is not judged with reference to such a framework. And it is precisely because the vertical and horizontal lines are not regarded as a reference frame that these children can judge the lengths of tilted lines whilst being unable to estimate their degree of tilt. In fact, it would seem necessary to wait until spatial co-ordinates are developed conceptually through concrete operations before such a reference frame can be exploited perceptually.

As for concepts proper, everyone has seen the kind of drawings which children produce between the age of 4 and 8, showing chimneys perpendicular to sloping roofs and men at right-angles to hills they are supposed to be climbing. In such drawings we have at one and the same time an awareness of right-angles inside the figure, together with a total disregard of the vertical axis. This suggests that the child has a long way to go in passing from a postural or sensori-motor space to a conceptual one. Nevertheless, the majority of authors cover this distance at a single leap by deriving a full-blown system of reference from these primitive notions.

Hence there is nothing absurd or unreal about the problems we are proposing to examine. On the contrary, it is in terms of genuinely operational concepts acquired around 7 or 8 years and not earlier, that the development of reference frames takes place, including those based on physical notions of horizontal and vertical.

§1. *Horizontal and vertical axes. Technique and general results*

The simplest and most natural reference frame available to the child is most probably that provided by the physical world in the shape of vertical and horizontal axes (in the frontal-parallel or the line of regard). Such notions are, of course, purely relative to our own scale of empirical approximation, since on a slightly more accurate scale the level of a liquid is no longer flat and plumb-lines are not parallel to each other! On the empirical level, the horizontal is given by the plane on which everyday objects rest, the earth itself (where flat), or the artificial planes of floors, terraces, and so on. Another important factor is the surface of a liquid, which for little children living in Geneva is illustrated daily by the surface of Lake Leman, to say nothing of the levels of drinks in cups and glasses. As for the vertical axis, this is provided by the walls of rooms and houses, by posts, chimney stacks, trees, and so on.

However, the study of the vertical and horizontal raises two distinct

problems simultaneously, which in a certain sense complicates our experiments and their interpretation. At the same time, the fact that these separate problems are unavoidably entangled is in itself highly significant in discussing the geometry of the phenomenon, both from the physical and the intellectual standpoint.

On the one hand, the concepts of vertical and horizontal are by nature physical rather than mathematical, indicating as they do, simply the direction taken by a freely falling body or a line perpendicular to it. Yet on the other hand, the elaboration of these concepts introduces a question independent of physics, or at any rate, a question whose independence is precisely the point at issue in the experiments about to be discussed; and this is the development of a co-ordinate system as a simple tool of geometrical orientation.

This, at least relative, independence is directly illustrated by the following paradox. As already stated, terrestrial verticals are not absolutely parallel and surfaces of liquids are curved. Yet, geometrically, the discovery of verticals and horizontals constitutes the particular case which leads to the concept of rectangular ordinates which are only approximate to the physical reality they express.

The dual nature of these physical and geometrical problems raises a question of obvious importance from the point of view of psychology, regardless of whether the answer lies in the direction of the independence or interdependence of these two factors—though in the latter case it would be necessary to establish the precise nature of this interdependence. The problem is in fact none other than that of the physical and experimental nature of mathematics as opposed to its being of an *a priori* and purely intellectual character, together with all the intermediate possibilities available between these two extremes. Now this problem constantly recurs in an extremely crude, but all the more impressive, form in each of the experiments we are about to describe. From the very outset, starting with the arrangement and organization of the experimental session itself, one finds oneself at grips with the interdependence of the physical and intellectual functions involved.

In putting the problem of co-ordinates before the child one is in fact compelled to make reference to the natural axes; namely, horizontal and vertical, since the child himself sooner or later introduces them of his own accord. To find out whether the child has any real understanding of these notions, however, it is necessary to study how he discovers real physical laws in drawing conclusions from his little experiments. That is to say, laws such as the constancy of the surface of a liquid whatever the angle of the container, or the constant direction of the plumb-line, whatever the angle of nearby objects, etc. But in studying how the child learns to interpret these empirical facts for himself one is led to analyse afresh the schema by means of which he is

able to record what he perceives, and this brings us back once more to the question of a co-ordinate system. Thus from the outset, we seem to be moving in a kind of circle between physics and geometry and the first task is to devise a technique which recognizes this basic problem without prejudicing the way in which it is to be, metaphorically speaking, straightened out.

For the study of the horizontal the following method was found best. The children are shown two narrow-necked bottles, one with straight, parallel sides and the other with rounded sides. Each is about one-quarter filled with coloured water and the children are asked to guess the position the water will assume when the bottle is tilted. Some empty jars are placed before the child, the same shape as the models, on which he is asked to show with his finger the level of the water at various degrees of tilt. In addition, the youngest children are asked to indicate the surface of the water by a gesture so that one can be sure whether or not they imagine it as horizontal or tilted. The experiment is then performed directly in front of them and they are asked to draw what they see. Children over 5 (on the average) are given outline drawings of the jars at various angles and asked to draw the position of the water corresponding to each position of the bottle, before having seen the experiment performed. Naturally, the various inclinations are presented in random order to avoid perseverative errors. Care is also taken to make the children draw the edge of the table or the support holding the bottle, in such a way that this horizontal, directly perceived, can assist in judging the position of the liquid. As soon as he has made this drawing the child compares it with the experiment which now takes place. He is then asked to correct it or produce a new drawing and so passes on to other predictions. Care was taken to have the level of the water at the height of the child's eyes, or a little above, so that he can see the edge of the surface clearly.

This basic method may be supplemented by others, such as giving the child a set of cardboard cut-outs representing the various bottles, with the level of the liquid drawn on them. He is then asked to set them at the angle appropriate to the water level. Alternatively, the child is given a set of postcards bearing pictures of the jars in different positions. Each card shows the water level, correct or incorrect, and the child has to sort them out, rejecting the incorrect versions. Some children were shown a large placard bearing pictures of the bottles in all positions, here again the task being to distinguish drawings showing correct water levels from others which are incorrect. Lastly, we made occasional use of a paper cut-out representing a cup, the contents being represented by a second cut-out. The child is then asked to fit the second to the first, taking account of the slope of the vessel.

For studying verticals the following methods were employed. Firstly,

381

during the preceding experiment on the jars of water, we floated a small cork on the surface of the water with a match-stick rising vertically from it. The child is asked to draw the position of the 'mast' of this 'ship' at different inclinations of the jar and then correct his drawing after seeing the experiment. Secondly, we suspended a plumb-line inside the jars (now empty), the plumb-bob being shaped to represent a fish. The child has to predict the line of the string when the jar is tilted at various angles. This done, the experiment of actually tilting the jar is performed and the child is asked for further drawings. Thirdly, the child is shown a mountain of sand, plasticine, etc., and asked to plant posts 'nice and straight' on the summit, on the ground nearby, or on the slopes of the mountain. It is very important to get him to make clear what he means by 'straight' and 'sloping' in referring to the posts (a selection of drawings helps the experiment along). The child is also asked to draw the mountain, showing the posts either "nice and straight" or sloping. Finally, we sometimes combined the experiment using the plumb-line with that of the mountain, by getting the child to predict the direction of the string when the bob was suspended from hooks projecting from posts planted on the sides or the summit of the mountain.

By means of these various methods we were able to demonstrate the following stages of development. (See Fig. 26.) During Stage I (up to 4–5 years) the child is unable to represent either the water or the mountain as a plane surface. As far as the water is concerned, not only has the child not the faintest idea of a horizontal plane, but he does not even grasp the notion of planes at all. He either represents the water by means of scribbles going outside the jar itself or, when he overcomes the motor difficulties causing him to do this, draws the water as a round blot or a little ball inside the jar, without defining the straight line or the plane surface, or locating the water relative to the jar. At this level, trees and houses are either drawn lying flat on the sides of the mountain (the house appears to be parallel to the slope), or else placed in arbitrary fashion, using the mountain as a background.

In contrast to this, at Stage II spatial orientation is determined by the particular configurations represented, rather than by an external system of reference. Horizontal and vertical axes are thus still undiscovered. At Stage IIA the lines indicating the surface of liquids and solids are undefined, except that when the bottle is tilted the child imagines the movement of the water, not only without regard to any external reference system, but without regard to the sides of the jar itself. Thus the liquid is imagined as simply expanding or contracting, increasing or decreasing in volume. The child imagines it as approaching or receding from the neck of the bottle, because he thinks of the liquid moving toward the neck as the bottle is tilted and away from it as the bottle is replaced

upright. The water level always stays parallel to the base of the jar, the mass of the liquid remaining in contact with it (though sometimes the opposite is shown, an empty space appearing between the base and

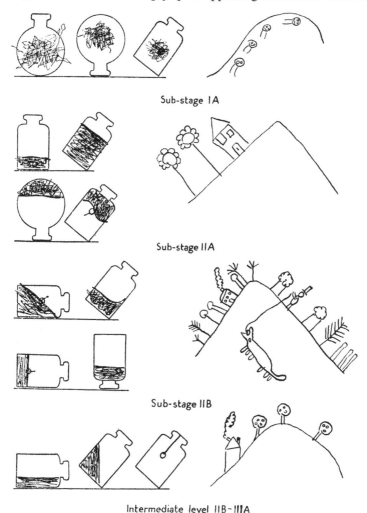

Sub-stage I A

Sub-stage II A

Sub-stage II B

Intermediate level IIB-IIIA

Fig. 26.

Stages in development of horizontal and vertical axes.

the water which is then, as it were, suspended in mid-air, its underside remaining parallel to the base of the jar). It is interesting to note that the children of this stage, like those of Stage I, are incapable of assessing

383

the experiment at its true value, even when it is performed before their very eyes, because they do not know how to make use of reference systems external, or even internal to the bottle. In the case of verticals, they draw the posts perpendicular to the mountain sides regardless of vertical axes and are unable to determine the direction of the plumb-line relative to the mountain.

During Stage IIB, however, we find that although the child cannot draw the water in the tilted jar as level (though he indicates its direction with his finger) he is nevertheless able to show it as no longer parallel with the base of the vessel. But he still fails to co-ordinate his predictions with any fixed reference system outside the jar (i.e., with the table or the stand) and merely connects the water-line with the corners of the jar, tilting it at an angle (and sometimes, accidentally, making it horizontal), though when the jar is inverted he makes the level horizontal. As for the verticals, children at this stage are usually able to stand the posts upright when planting them in the sides of the sand hill, though they continue to draw them perpendicular to the incline and often fail to predict the correct inclination of the plumb-line in the tilted jars.

Next comes a transitional stage between IIB and IIIA. Here the child is able to predict the level of the liquid only when the rectangular jar is inverted or lying on one side; that is, when the level is parallel with the sides. Subsequent to this comes the discovery of horizontal and vertical axes. This is achieved at Stage III, beginning around 7–8 years and divided into two substages. The first of these lasts from 7–8 until 9 years, during which the principle comes gradually to be applied to all cases, though at the beginning the level is often made oblique, ignoring the reference points external to the jar. Then, about the age of 9, Substage IIIB begins with the immediate prediction of horizontal and vertical as part of an overall system of co-ordinates.

§2. Stage I. Inability to distinguish surfaces or planes, in the case of either fluids or solids

The first stage lasts until about the age of 4 or a little later. When the children are asked to draw the level of the water in a bottle or the trees on the side of a toy mountain their reaction is extremely interesting, for they are unable to distinguish planes as such. Consequently, they show the liquid neither as a line, nor as a surface, but as a kind of ball (as soon as they get beyond mere scribbling). They think of the fluid in purely topological terms, merely as something inside the jar, and not according to euclidean concepts like straight lines, planes, inclinations, and dimensions. Here are some examples.

VIL (3; 0). Even with the bottle standing upright Vil can only show the water

n the form of scribbles extending beyond the walls of the jar, supposed to indicate the liquid inside the bottle (drawn by the experimenter).

DAN (4; 1) has a straight-sided bottle drawn for him. Asked to draw the contents he shows the water as a blot on the left-hand side near the neck. Yet he can copy lines when these are drawn in, though unable to orient them correctly, even with the bottle upright.

MAN (4; 6) draws the water inside the jar as a kind of little ball situated regardless of the sides or base of the bottle, whatever the angle of tilt. We then drew for him lines representing the horizontal level (or the horizontal and vertical axes) with the bottle in two positions, upright and sideways, asking him to put in the water. He draws his little round blots inside the bottle whether it is upright or lying down.

For the vertical axes, here are some equally amusing examples:

NIL (3; 11). Shown a mountain with a slope of about 45°, he draws the trees and men parallel to the edge, then two houses stuck to the slope by their side walls, the base of the building including the doors, which are carefully drawn, thus remaining suspended in mid-air.

GEH (4; 2) draws houses and trees, some lying along the slope, others against the background of the mountain but placed haphazardly so that it is impossible to tell whether he visualizes them as located on the slope seen full face or simply stuck to the object.

KUP (4; 11) draws the houses not only sloping with the mountain but turned at all sorts of angles, including one with doors, windows, chimney, and column of smoke, all upside down, the base in mid-air and the roof underneath with smoke descending from the chimney at about 20° from the vertical. Yet when Kup is asked what direction one must follow in order to climb the mountain he naturally points out the correct route.

BER (4; 8) draws the trees as did the previous children, more or less parallel with the edge of the mountainside but slightly inside the line as if he were afraid of locating them in empty space. He is asked whether they stand "Upright or slanting?—*They're all standing upright. I don't know how to make them sloping*". So he sees them as upright like his own body, though he draws them slanting. Moreover, the plumb-line (a button hung from a needle) produces the remark "*It's going to fall to the ground*" though the line he makes is only vertical when the thread is not influenced by the sides of the mountain but is perceived relative to his own body. In other cases the thread is drawn oblique, not because the button is imagined as rolling down the slope, but because seeing the needle in profile on a ledge overhanging empty space, the child refuses to let the thread pass out into empty space but inclines it slightly— as if the mountain attracted the object instead of letting it fall vertical!

AL (4; 9) shows the trees as a series of sticks with an oval on top of each, attached to each other and parallel with the slope of the mountain. The top of each tree is in contact with the foot of the next and they are placed inside the edge of the slope.

As for the button hanging from the needle, Al indicates a number of oblique lines radiating from the eye of the needle, even after having seen the button actually suspended in one or two positions.

JUL (4; 11) draws the water in the form of large blots near the necks of the jars (like Dan). He is then asked to draw the "boats with their masts". He puts them all over the place, some parallel to the sides of the bottle, though curiously enough, they are all drawn as if they were under the water rather than on its surface. Jul says they are "*on top*" but they are shown immersed in various positions.

JOS (5; 9) draws trees, posts, and men exactly parallel to the sloping edge of the mountain and inside the borderline, though with a technique greatly superior to that of the previous children. He is shown a selection of drawings containing posts vertical to the mountain, perpendicular to it or parallel with the sloping edge. Jos rejects the verticals ("*that one's wrong, it isn't straight*") but accepts the other two positions.

These results are highly significant for they explain the absence of any system of co-ordinates from the children's drawings. It is obvious that they embody topological rather than euclidean relationships; relations of proximity and surrounding as opposed to straight lines, planes, and above all, spatial orientation. In this respect, an outstanding feature of these drawings is what may be termed "the fear of empty space". Ber's plumb-line does not descend vertically when hung from a ledge but is attracted by the mountain, Jul's boats are under the water instead of upon it, and the trees are more willingly located inside the outline representing the mountainside than in empty space. Doubtless the trees are thought of as standing clear of the mountain just as the water is inside the bottle, nevertheless the primary relations of surrounding—and especially proximity—outweigh all considerations of tilt, orientation, or even shape—and precisely because of the lack of co-ordinates, or indeed of any relations applying to the empty space.

Hence it comes about that the water level is not shown as a line or a plane figure, but as a blot or closed figure placed inside the vessel regardless of its true position, or the shape it assumes relative to the sides of the jar. As for the trees and houses the child simply draws them lying on the mountain, in proximity with the surface but without regard for orientation. Some lie flat along the slope (seen in profile) which might be thought to indicate a search for parallelism but in fact denotes only proximity, the parallelism being only very approximate and due entirely to the exigencies of drawing. Others are placed in random fashion inside the outline of the mountain seen full-face. But whatever their mode of arrangement, they are never placed vertical. Indeed, they are not even properly arranged as regards their own top and bottom. Thus houses are attached to the mountain slope by their side walls, the bases jutting out into space, others placed a few millimetres inside the boundary and yet others upside down with smoke from the chimneys drifting down the mountainside!

Taken together, these reactions clearly indicate that absence of

vertical-horizontal co-ordinates is due initially to a general disregard for orientation of objects, because there exist as yet no relations applying to empty space. But it also derives from the difficulty of isolating or abstracting shapes and planes as such (just as was shown in Chapters I and II). In point of fact, such an abstraction is an essential pre-condition for any possibility of orientation, which, as will be seen, still remains somewhat primitive at the subsequent stage.

§3. *Substage IIA. Water level shown parallel with the base of the jar and trees perpendicular to the mountainside*

When the child learns to abstract the surface of the liquid as a plane and locate the trees relative to the mountainside he still fails to grasp the orientation of the water in a tilted vessel or that of the trees to an inclined slope. In the case of the water he thinks of it as moving toward the neck of the bottle, but not by simple displacement. He imagines it as expanding, increasing in volume, and it is because of this increase that it draws nearer the neck as the jar is tipped, while the surface remains parallel to the base.

WIL (5; 3). "We're going to tip the jar over like this. What will the water do? —*It will move*—How will it move; where to? Show it on the glass—(He points to a level 1 cm. higher than the present one, all round the bottle, parallel to the base)—And if we tip it the other way?—(Same reaction)". He is asked to draw the level on jars sketched in outline and tilted at various angles. He produces a water-line parallel to the base in each one. "Show me the position the water will move to with your fingers on the glass again—(He once more shows the water-line parallel to the base)—Now look and see if that's right. (The jar is tipped while he actually has his finger in the position he predicts for the water)— *Yes, it's right*—Is there any water actually near your finger?— *No*—And if we tip the jar more still, where will the water go?—(Once more he indicates a level tilted parallel with the base)—Look (we perform the experiment again). Is it right?—*No*—And if we tip it even more?—(Again he shows a level parallel with the base)—Now watch again (we do the experiment) and draw what you see—(He draws a line parallel to the base of the jar!)".

We now try the round flask to prevent his using the base as a parallel: "Draw what the water looks like (neck vertical)—(He draws a correct horizontal level)—Now we're going to turn it like this (45°). Draw what the water will look like—(He draws the water-line nearly vertical)—(We perform the experiment). Were you right?—... (He refuses to admit he was not)".

LIA (5; 7) shows the level of the water in the tilted jar in the same way, raising it by 2 or 3 cm., with two fingers, indicating a line parallel to the base. "Now let's see whether that's right (experiment)—*No* (he spontaneously moves his fingers to make them correspond with the true level)—Now draw what you see (he is given the outline sketches of the jars)—(He draws a level parallel to the base!)". Subsequent trials show that Lia cannot apply generally what he sees take place, nor even produce a correct level by directly copying the tilted apparatus.

387

HER (5; 3) is slightly ahead of the two previous children. "What will the water do when the jar is tilted? Will it stay where it is or move?—*It will stay where it is.* (He is given two diagrams, one showing the jar upright, the other inclined at 45°. He draws the water horizontal in the first and tipped at 45° in the second!)—Show with your fingers on the jar where the water will be— (He indicates a line slightly above the present level but parallel to it)—Now we'll see whether you're right—*No, here it's higher and there it's gone down*— And if we tip it still further?—*Then it will get higher still here and lower down there*—Can you draw what you're describing on this jar which is tipped over on its side? (Outline drawing of the jar tipped at 90°)—*Like this* (he draws a vertical level parallel with the base of the jar)—Now let's check it (experiment) —*No*—Well then, draw what you've just seen—(He produces a curious drawing which is a compromise between the vertical position conforming to his own schema and the horizontal position just seen. The water is shown adhering both to the horizontal side and the vertical base of the tilted jar, the waterline being curved)—(We now produce the spherical flask.) Draw what the water looks like—(Correct drawing)—Now we're going to tilt it. Make a drawing to show where the water will go—*It will come up here.* (On a diagram tilted at 45° Her draws the water adhering to one side in the form of a crescent, so that on the average the water is inclined at 45° also)—And if we tilt it the other way?—(Same drawing in reverse)".

PAD (5; 8) likewise invariably predicts that the water will remain parallel to the base whatever the angle of the bottle. When this is inverted he shows the water adhering to the base and suspended in mid-air. With the spherical bottle the position of the water is the same but the surface remains flat and turns with the flask, Confronted with the actual experiment, Pad reacts in three ways. Sometimes he continues to make the level parallel to the base, sometimes he divides it into two parts, one parallel to the base and one parallel to the sides (like Her), and at other times he draws the water adhering to the base and the walls of the jar.

These children are ahead of their colleagues in Stage I for they can indicate the water as a plane surface, although they remain incapable of seeing that this surface stays horizontal under all circumstances. This may be due to two causes, one physical, the other geometrical, which we shall endeavour to examine concurrently. From the physical standpoint, these children are ignorant of the vital fact that water always remains horizontal, though they all know that when the straight-sided jar is upright the liquid "lies flat", presenting a surface parallel to the base and perpendicular to the sides.

What is so extraordinary is the fact that not one of these children noticed the successive positions taken up by the water, or observed that the level remained horizontal; which, by the way, shows how poorly commonly perceived events are recorded in the absence of a schema within which they may be organized. Yet there can be nothing more common for children of all ages than watching a jug of water tilt until the spout touches the glass being filled, and nothing would seem easier

than noticing that the liquid remains horizontal. Notwithstanding this, our subjects all appear to think that the water-line stays constant, not in relation to external reference systems, of course, for this would amount to understanding that it remains horizontal, but in relation to the bottle itself. This is equivalent to assuming that the water tilts with the jar and can occupy any and every position, including the vertical! As the water stays parallel to the base, yet nevertheless reaches the neck when the bottle is tilted, the children simply imagine the surface of the water rising without changing direction, as if it expanded in order to leave the bottle (see Wil and Lia, also Her at the beginning of the experiment).

The second point to note, is how little these children are influenced by the outcome of the experiment, guided as they are by the 'false-absolute' of the permanent water level, always envisaged as parallel to the base of the jar. This fact is important both from the geometrical and the physical standpoint. For not only have these children failed to note that a water level is always horizontal in their everyday observations, but in addition and even more astonishing, they fail to note the result of the experiment when it is performed before their very eyes and when they have simply to check what they see against their earlier assumptions. As a result we find Wil refusing to accept the facts even though he actually has his fingers against the glass. Lia appears to admit the evidence of his senses, nevertheless his drawings continue to reproduce his original errors quite undisturbed.

Now these reactions, as they relate to the child's understanding of physical space, naturally raise a fundamental geometrical problem. To begin with, it is obvious that to take in the empirical facts the child must be able to relate the water level, as he sees it, to some system of reference. This he could do in two ways. The simplest would be to relate the surface of the water to some solid object outside the bottle, such as the table, or the stand on which it rests. But an alternative method is available. He has only to watch the way the surface of the liquid constantly changes direction relative to the walls of the vessel being tilted, without concerning himself about objects other than the jar itself. However, the actual results show that the children do not avail themselves of either means of comparison. They do not look to see whether the liquid stays parallel with the table top or whether it changes direction relative to the walls and base of the jar. On the contrary, they constantly assert that the water remains parallel to the base of the jar, and the reason they do so is simply that they continually repeat what they observed with the bottle in its original position and fail to note or deduce the subsequent positions properly.

This brings us to the basic problem of the geometrical horizontal. If these children cannot even establish the elementary correspondence which would enable them to interpret the facts correctly, is this not

merely because the question is beyond their capacity and has as yet no meaning for them? In other words, might not their difficulty in grasping the physical nature of horizontality be due to their inability to develop a geometrical reference system?

Now although it is doubtful whether failure to *predict* horizontality at this age is by itself proof of inability to conceive of a co-ordinate system—since it could be due to lack of interest, inattention, and so on—the repeated difficulty in appreciating the material facts themselves carries an entirely different implication. It undoubtedly indicates an inability to evaluate the perceptual data in terms of the orientation of lines and planes, and thereby suggests a failure on the part of co-ordination as such. What indeed is a system of co-ordinates but a series of comparisons between objects in different positions and orientations? If the comparison is not made it is because the problem of linking the various objects together in a system where stationary objects serve as reference points for mobile ones, does not even arise for the child. It is because he does not realize the need for such a reference system that he fails to interpret the perceptual or physical data correctly. In concrete terms, although tilting the jar alters the position of the water level, for this displacement to be located in physical space the mobile elements (the liquid surface) must be related to a stationary reference frame (the table, etc.). It is the establishment of this relationship which forms the basis for the geometrical operations basic to a co-ordinate system. And it is for lack of such operations that the child is unable to interpret the physical facts of horizontality.

This is not to deny, however, that these children have not made great strides as compared with the children of Stage I. For not only can they define the water level as a surface or a plane, but they can also relate this surface to the base of the jar. They are thus beginning to use a point of reference, though a mobile and not yet a stationary one. Now although these discoveries are by no means sufficient for building a frame of reference, nevertheless they constitute the preparation for it. The reference system appropriate to euclidean space represents the final outcome of a progressive series of comparisons made between objects located in empty space. This process begins with the construction of straight lines, planes, parallels and angles and culminates in the development of axes enabling these comparisons to be generalized. The children of the present level, in contrast to those of Stage I, have already mastered the use of straight lines and planes under certain conditions (such as when they serve as references to items parallel to them; see Chapter VI Section I), and the way these children relate the surface of the water and the base of the jar shows a rudimentary idea of parallelism (parallelism between planes or lines forming rectangular figures, as opposed to parallels associated with angles as in the rhombus, Chapter XI). Such

notions, though limited in scope, nevertheless indicate the first tentative approach to the conquest of empty space; in other words, to co-ordination of objects at a distance.

This process is even more apparent in the case of the vertical axis. It will be recalled that the child of Stage I did not dare erect trees and posts in the empty space above the mountainside. Instead, not knowing where to point them, he laid them parallel with the edge. Alongside the discovery of planes and parallels, as just mentioned in the case of the water level, the treatment of trees and posts suggests an analogous discovery, one equally important to the development of frames of reference. Trees and posts are now drawn, if not vertical—any more than the water is drawn horizontal—at any rate nearly perpendicular to the slope, the idea of the right-angle thus emerging to supplement the concepts of the plane and the parallel in rectangular figures.

MAC (4; 6). Puts posts, houses, trees, and men perpendicular to the slope of the sand mountain. In making a doll climb and descend the mountain he keeps him perpendicular all the time. He does the same in drawings of the man climbing the mountain. He is shown a doll representing a man on the roof of a house and asked how a stone dropped by him would fall (when not thrown). Mac draws an oblique line.

MAR (4; 7) reacts similarly with the doll on the sand mountain and in drawing trees and posts on a sloping mountainside. Plumb-line: when the needle is stuck into the side facing the child the thread supporting the bob is drawn vertical, but when hung from the slope seen as concave in profile the thread is not vertical but follows the curve.

Mar also drew a house on his own initiative. The chimney is perpendicular to the sloping roof. Finally, we showed Mar two slopes (shaped like half of a bell), one with lines perpendicular to the periphery, the other with lines vertical. Of the former he says, "*they are straight*" and of the latter, "*they are slanting*"!

VER (4; 8) makes a very good drawing of a mountain shaped like a triangle. On its slopes he places two large flowers with straight stems and a tall house with a pointed roof. All three objects are exactly perpendicular to the slope.

PIE (5; 1). Both with the toy mountain and in his drawings he places objects perpendicular to the surface. "What position are these men in?—*Upright*— When you're climbing a mountain, do you stand like this (perpendicular) or like this (we draw a man vertical)?—*Yes, like that* (perpendicular), *otherwise you're leaning over*". Draws the plumb-line the same as Mar.

JOS (6; 4). Similar constructions and drawings. On a bell-shaped slope we put a number of objects, some vertical and some perpendicular. On the slope itself Jos calls the vertical elements "*slanting*" and the perpendicular ones "*straight*". But at the summit, those which are vertical (and thereby perpendicular also) he calls "*straight*" and "*slanting*" those which are really inclined.

SPE (7; 1) draws a triangular mountain and in the space above the slope erects posts, houses and men perpendicular to the mountainside. A man is shown holding a rather elongated crocodile on a leash. This is drawn inside

391

the edge of the mountainside and parallel to the slope. The whole drawing can thus be reduced to perpendiculars and parallels.

This way of representing things, well known in the literature of child psychology since the studies of Kerschensteiner,[1] Luquet[2] et al. is of obvious importance from the geometrical point of view. Such a consistent and universal type of response shows that the concept of the right-angle, like those of planes, parallels, etc., which is essential to the development of a co-ordinate system, is acquired well before such a system comes into being.

If this is so, then why are the children able to draw posts, trees, and so on, perpendicular to the mountainside, but unable to show them vertical or draw the water horizontal in a tilted jar? For the simple reason that the right-angles, perpendiculars, and parallels (which in any case are only produced with rectangular figures) with which they are familiar, remain purely internal to a single object, or a number of closely adjacent objects forming a configurational whole (the mountainside with objects upon it, etc.). In order to conceive of vertical and horizontal, however, the child must have evolved more extensive and comprehensive relationships embracing not only nearby, but also distant objects. In particular, he must evolve relationships bridging the empty space which so deterred the children of Stage I, and which those of the present level are only now beginning to fill in, though without as yet crossing it in thought.

It is precisely because their spatial concepts remain confined to a single complex object or pattern that children such as Mar or Jos call 'straight' everything that is tilted (but perpendicular to the incline) and 'slanting', everything that is in fact vertical. In short, they fail to relate these objects to anything external to the system constituted by this restricted configuration.

§4. *Substage IIB. Intermediate types of response*

Midway between responses of the type described above and the gradual discovery of horizontal and vertical (Stage III) are a series of reactions which merit careful study. For it is the child's groping attempt to solve the problem through persistent trial and error which often provides the key to his subsequent construction of operational systems.

The first step forward occurs when the child indicates on the jar itself the direction in which the water will move when the jar is tilted. At this stage however, his drawings still show the water parallel with the base of the jar just as in Stage IIA. The vertical axis (as shown with the cork floats) also remains perpendicular to the surface of the water

[1] Kerschensteiner, *Entwicklung der Zeichnerischen Begabung*, Munich, 1905.
[2] Luquet, op. cit.

regardless of tilt. Here are some examples of these reactions, intermediate between Substages IIA and IIB.

PAG (5; 1). "Will the water stay like this if I tilt the jar?—*It will slant* (he indicates a level, higher on the right-hand side of the jar and lower on the left, a promising forecast)—Draw it (he is given a diagram of the tilted jar)—*It's slanting* (water-line parallel to the base)—And if I put this boat in the water?—*It will slope as well* (mast shown perpendicular to the water)—And if I tilt it still more?—(He draws the water still more inclined)—And if I lay the bottle flat?—(He draws the water-line vertical, the mast on the cork being horizontal!)—Just point it out with your fingers—(He at first shows the level correctly for a number of positions, but ends up by indicating levels above and parallel to each other as if the water merely rose in the jar whilst remaining in the same position)—Now just watch (the experiment is performed). Is that right?—*Yes*—Draw what you see—(He draws a level midway between horizontal and parallel to the base)".

AN (5; 6) also starts by showing the level of the water in the tilted jar by means of two fingers, but he mistakes the direction of tilt and reverses it every time. In his drawings An represents the water as if it were suspended in mid-air somewhere about the neck, the lower surface of the liquid being parallel with the base of the jar. "*That's because when you tilt it, the water begins to rise*". He next proceeds to draw the float, not on the water, but below the surface with the mast perpendicular to the lower surface of the water. With the jar horizontal the water level becomes vertical. The use of the spherical flask leads to the same results. When confronted with the actual experiment An argues that the drawings of the water in the jar are correct: "*Yes, it's right because the water reaches right up to the edge of the jar*". Nevertheless, he corrects his drawings towards the horizontal position (without ever quite arriving at it) taking the corners of the jar as reference points, thus anticipating the next stage.

UL (5; 2) is able to predict the direction in which the water will move, but for each tilt angle he still draws the water-line strictly parallel to the base of the jar. Furthermore, when asked to draw the plumb-line hanging from a fishing rod into the jar (having handled it to see that it hangs vertical) he shows it perpendicular to the water-line. As the jar is tilted, however, his line tilts also, departing from the vertical according to the inclination of the jar. The same result is obtained for the boats with masts.

MIC (6; 7) reacts in exactly similar fashion, though his behaviour is even more paradoxical. He indicates his prediction not by putting his fingers against the glass but by placing a pencil along the side of the jar to show the future water-line. "Good. Now draw what you've just shown—(He draws the water-line parallel to the base)—Now the jar is going to be tilted the other way. Show us with your pencil what the water will do—(His demonstration is more or less correct)—Now draw it—(Once again he makes the water parallel with the base)—Is it higher on one side than on the other in your drawing?—*No, it's the same on both sides*—Now, just let's take a look at the water (experiment). Is it right?—*Yes*—Just like you drew it?—*Yes* . . . etc." We are unable to convince him otherwise.

In the case of the boats and the plumb-line Mic constantly produces drawings showing the masts perpendicular to the water at various angles of tilt, paying not the slightest regard to the vertical axis. Lastly, with the spherical flask, Mic invariably draws the level of the water curved and close to the base, the water appearing to rise along the sides of the flask when it tilts. From a set of drawings he chooses those showing the liquid as slanting and curved, rejecting the horizontal pictures.

MUH (7; 0) behaves similarly to Mic, showing the way the water will move with a ruler, and then drawing it parallel to the base of the jar. Confronted with the actual experiment he tries to check his drawing by putting it against the jar but fails to correct it. "Show us how the water lies in the jar with your ruler (still tilted in front of him)—*Like this* (he puts it horizontal against the water-line)—Now put your ruler on the drawing and show the way the water ought to be there—(He puts it on his drawing parallel to the base of the jar)— Is it the same?—*Oh no!* (he tries to correct himself by making a compromise between the horizontal and the sloping parallel, then draws a curved level. Eventually part of the surface of the water is horizontal and part parallel to the base!)".

AL (6; 10) behaves generally in the same way as the previous children. He is then given a series of mobile cardboard models made to represent the level of the water in different positions and is asked to adjust them to the correct angle. Instead of tilting the jars at the appropriate angle Al arranges them all with their necks vertical, regardless of the water level which becomes oblique, vertical or horizontal as the case may be. As for the series of drawings to be separated into correct and incorrect, he judges them according to the angles of the bottles and not in terms of the relation between the water and the angle of the bottles.

The sole progress which the first few of these children appear to have made is that when indicating the direction in which the water will move by putting their fingers against the glass, they no longer imagine that it will rise toward the neck and also stay parallel to the base as the bottle tilts (with the exception of An, who reverses the direction). But this purely empirical discovery is not related geometrically to any external reference system, such as the table or the stand, even in observing the jar, let alone drawing it. The child simply knows that the water moves towards the neck and does not attempt any geometrical co-ordination of such movement with stationary objects. Indeed, when asked to draw the anticipated water-line, he shows it parallel to the base of the jar, just as he did at Stage IIA. This happens even when the underside of the liquid is drawn (see An) as if it were suspended in mid-air.

Could this retrogression be ascribed to the technical difficulties posed by drawing? Such an explanation seems unlikely, since when the children are given mobile cardboard models to adjust, or a series of drawings to choose from (see Al) they react in exactly the same way. Furthermore, they cannot even correct their drawings when the experiment is performed, being unable to make adequate comparisons (see Mic and Muh).

The same may be said of the vertical axis where all objects remain perpendicular to their immediate base without reference to external objects.

In short, these children are just as incapable of relating the water level to a fixed reference frame as were those of Stage IIA. This is all the more significant when it is remembered that they are more advanced than the previous subjects in being able to foresee that the water will move in the direction of tilt. Yet for all that, they remain unable to exploit their discovery, since they cannot interpret the physical data in terms of a geometrical system which can co-ordinate the horizontal-vertical axes of physical space. At the same time, these children (even more than those of the previous level) give visible proof of familiarity with the ideas of right-angles and perpendiculars—as witness the masts of their boats or the plumb-lines suspended in jars. However, these primitive geometrical notions, the mere beginnings of comparison between objects at different orientations, are altogether inadequate for determining the horizontal and vertical. For these last depend upon an overall process of co-ordination, and this can only be achieved through the development of a genuine system of axial co-ordinates.

Let us now turn to some cases fully typical of Substage IIB. These children provide evidence of considerable progress over those of Sub-stage IIA, for they no longer imagine that the water level remains parallel with the base, but regard it as moving relative to the jar. However, since they cannot relate the surface to a stable outside frame of reference, they draw it as an oblique line running from one corner of the jar.

MAR (5; 10) begins, just like a child of Stage IIA, by imagining that the water simply rises and stays parallel with the base of the jar, then tries to draw the water as moving in the direction of tilt. He joins the upper right-hand corner to the lower left-hand corner of the jar by means of a straight line, resulting in an almost horizontal surface. But he continues to do this for more sharply tilted positions so that the line departs more and more from the horizontal. In addition, the masts of the boats and the plumb-lines remain perpendicular to the water-line and thus get more and more tilted as the jar is inclined.

FEL (5; 11) shows on the glass that the water will move in the direction the jar is tilted. He then draws a line from one of the lower corners of the jar to some point along the opposite side. This results in a slightly tilted water-line which becomes more and more oblique in each successive drawing of the increasingly tilted jar. For the jar lying on its side he predicts a water-line running obliquely from one corner to the other. On the other hand, with the jar inverted he shows the water lying horizontal (because it is parallel to the base). When the experiment is eventually performed Fel is asked to hold a pencil on the empty jar parallel to the level before each tilting of the jar. He is then annoyed to find that the pencil remains motionless and '*straight*' (hori-

zontal). However, he fails to draw any conclusions from this to apply to his subsequent forecasts.

Gui (6; 3). "Show the water-line in the bottle (upright)—*It's completely flat* (he places his pencil horizontal)—And if the jar is tilted?—(He tilts the pencil, parallel to the base)—And when it's tilted the other way?—(Same reaction, but reversed)—Now draw where the water will be—(A series of drawings, the first showing the water-line almost parallel to the base of the jar, later ones showing a line which, as the tilt increases, tends more and more to join opposite corners together, so that the surface becomes more and more oblique)—And when the jar is lying flat?—(Draws a vertical water-line!)— And like this (inverted)?—*Like this* (horizontal because parallel with the base)".

Cha (7; 9) keeps the pencil horizontal to indicate the initial level. "What will happen if we tilt the jar?—*The water will be at the side. On one side there won't be any*—And if we tilt it the other way?—*It doesn't move* (thus he has a glimmer of the physical process). *No, it doesn't stay like that. There'll be a lot there and not much here, it will rise there and go down there* (he indicates a tilted surface)—Draw it—(The level starts at a lower corner and reaches the middle of the opposite side. It is oblique)—And if we tilt it more still?— (Draws lines more and more oblique, ending up by joining two opposite corners)".

Masts of boats and plumb-lines are shown perpendicular to the water and parallel to the sides of the jar.

Fis (7; 6) is an interesting subject because of his reactions subsequent to seeing the experiment performed. Before having seen the water in the tilted jar he behaves just like the previous children: "*It will be tilted* (drawings of the surface running from the lower corner of the jar)". He is given two drawings to choose between, one with the water tilted, the other with water horizontal (in jars inclined at 45°). He selects the one showing the water inclined. "Now we'll see whether your drawings are right. You keep a check with this ruler (against the side of the jar)—*It isn't right*—Why not?—*It stays straight* (=horizontal)—And now we're going to tilt it this way. What will the water do?—(He tilts the ruler)—Well, I think you ought to keep the ruler flat— *Oh no! That's impossible*—Just take a look (experiment)—*Oh yes, it's right!*— And if we tilt it a bit more?—*It will be higher* (he tilts the ruler again)", etc.

The progress made by these children, as compared with those of Stage IIA and the transitional cases quoted above, is clearly apparent. They are no longer content to say that the water moves when the jar is tilted but are able to indicate this movement in their drawings. Thus they can shift the water from its position parallel to the base of the jar, so that the water-line is no longer rigidly linked to the tilt of the bottle but can assume a new orientation.

But what is this orientation? This is where the boundary line dividing Stage IIB from earlier stages can be drawn. The child still fails to relate the orientation of the level he predicts to an external, stable reference system, such as the table or the support stand. He confines himself to

predicting that the level will alter relative to the sides of the jar and only seeks reference points inside the complex pattern it constitutes in order to determine the new position of the liquid. No longer content to regard the water level as remaining parallel to the base of the jar, he thinks to join the water-line to the corners of the jar or to some point along its sides. For having abandoned the technique of making it parallel with the base, he is compelled to relate it to some angle or other. Since he cannot relate these angles to a stable set of co-ordinates—for he does not refer to objects outside the jar—the child veers about in a chaotic and arbitrary fashion and is unable to establish the vertical and horizontal.

At this point it is necessary to distinguish between factors which derive from problems of drawing, and those which are truly geometrical, it being understood of course that the former occasionally throw light on the latter. Thus for example, when the children of this level want to draw both the tilted bottle and the stand on which it rests, it often happens that they are unable to separate the jar from the stand and form the angle between the base of the former and the top of the latter. In the event, they draw the sides of the jar correctly enough but extend them until they both touch the stand, as if the bottle protruded from the stand without a visible base, simply because they cannot represent the angles.

However, to come to the essential point, since the children do not know on what system of reference to base their picture of the water when it is no longer parallel to the base of the jar, nor how to determine the angle between the water-line and the sides of the vessel, they begin simply by relating the water to the corners of the jar. Hence we find Mar joining up opposite corners of the jar, no matter what the degree of tilt, producing water levels that become less and less horizontal. Fel does precisely the same and also joins the neck to one corner. Gui makes the water-line run from one corner to a point on the opposite side, indicating some attempt to relate the water-line to the tilt angle itself, but actually resulting in even more sharply tilted water levels, and eventually culminating in a vertical water level for a horizontal bottle. Only when the jar is completely inverted is a correct forecast the usual result, since in this case the water is once more parallel to the base.

In short, the horizontal is still quite beyond the children of this level. They are as yet so far from it, owing to their inability to use references external to the jar, that they derive hardly anything from the experiment when they see it. It is true that they expect the water level to tilt and, unlike the children of earlier stages, they even discover that it "stays straight" (Fis) when the experiment takes place. But their grasp of the data is so inadequate in the absence of any system of co-ordinates that they are unable to apply it in predicting the outcome of further experi-

ments. Thus, after Fis has made his discovery, he is most reluctant to keep the ruler straight for the next tilting of the bottle. "No, it's impossible" he says, as if nothing could be deduced from the result of the previous experiment. The inability to comprehend the notion of horizontal could hardly be better expressed!

As for the notion of vertical, some examples of which may be seen with the masts of boats and the plumb-line suspended in the jar, a comparison with the toy mountain and the drawings of trees on the mountainside shows a similar step forward. In general, the children of Substage IIB place the houses and posts vertical on the toy mountain but in their drawings still show them either perpendicular to the slope or somewhere between perpendicular and vertical.

JAC (5; 0) places all the objects vertical on the sides of the sand mountain, men climbing and descending, houses, trees, and posts. But when he has to draw them he makes them perpendicular to the slope and consequently at angles which vary with it. "It's the same as on the sand?— Yes—Sure?— Yes— Try to draw an upright tree, a slanting tree and one that's slanting a lot— (The first is perpendicular, the second tilts downwards and the third upwards) —Which one is upright?—That one (the first)".

After this we stick some pins along a slope and ask him to predict the direction of a plumb-line assumed to hang from them. Three times he predicts it as vertical, nevertheless the drawing shows two threads perpendicular to the slope and only one anywhere near vertical (he has a model before his eyes all the time).

MICH (5; 1) stands the objects vertical on the sand mountain without the least hesitation. The experimenter puts one perpendicular. "Are they fixed the same way?—No, yours is slanting, mine are straight—And who is right? —Me—Very good. Now draw these posts on the mountainside—(He makes them all perpendicular to the slope, save for one or two nearly vertical by chance)—Show me the ones which are straight—(He points to the perpendiculars)—And the sloping ones?—(He indicates the near verticals)—Which are right?—(The first ones)". Plumb-line: the same as Jac.

FRAN (5; 6) arranges all the objects vertically on the mountainside, then draws them all perpendicular to it. He is shown two drawings of similar slopes, one with vertical the other with perpendicular poles. "Are these two drawings alike or not?— Yes, alike—Just the same?— Yes—Aren't there some that are slanting?—No—Well, now look at these two drawings (a roof with a perpendicular chimney and a roof with a vertical chimney). The chimneys are the same?— Yes—Which is drawn the best?—There is one chimney which is slanting more, that one (perpendicular)—Add some more chimneys—(He draws a vertical chimney next to the vertical one and a perpendicular chimney next to the perpendicular one)".

NOR (6; 2) arranges all the objects vertical on the mountain and draws them all perpendicular to the slope. "Did you draw that properly?— Yes—What about having another try?—(This time he produces a medley of true perpendiculars and lines intermediate between perpendicular and vertical)—

Now look. Here is a very steep mountain (outline drawing). Make a drawing of a tree standing on it quite straight—(He draws it perpendicular)—And now draw one slanting—(He draws it leaning toward the foot of the slope at an angle of 45°)".

LID (6; 3). A plumb-line (string with a plasticine fish) is suspended from the centre of a wide, flat cork in a straight-sided jar. "How is the string hanging?—*It is straight* (vertical)—And if we tilt the jar, how would the string hang then?—*It would be slanting* (he draws it parallel to the sides of the jar) —Look at it with this ruler (placed vertical in front of the string)—*The ruler is upright*—But the string?—*It's upright as well.* (New position of tilt, newly drawn by Lid)—How is the string hanging?—*It's still upright*—But what about your drawing!—*It's slanting*—Is that right or wrong?—*Wrong*— Then put it right—(Lid finds this very difficult, because he is overwhelmingly influenced by the parallelism between the plumb-line and the sides of the jar, and again draws it at right-angles to the underside of the cork)".

We now pass to the problem of drawing trees on the mountainside. Lid makes them all perpendicular to the slope. We draw two for him, one perpendicular the other vertical. "Which one is drawn better?—*That one* (perpendicular)". In the same way he draws a chimney perpendicular to a roof. Finally, we revert to the jar and put a float on the water. He invariably draws the mast perpendicular to the water level in tilted positions (when the water is no longer shown horizontal).

KEL (6; 11). Float: mast perpendicular to the water and parallel to the sides of the jar. Plumb-line in the jar: same reaction as with Lid. Kel has great difficulty in checking his error with the vertical ruler, which he unconsciously tilts to make it parallel to the tilted string in his drawing. He maintains that his drawing shows the string "*upright*", without distinguishing between vertical and slightly tilted. The plumb-line is then suspended from the cork (a large disc several centimetres across) but outside the jar: "If I tilt the cork how will the string hang?—*It will be slanting*—Just look (experiment)— *It's straight*—Will it stay straight if I tilt the cork further?—*No*—Well then, you turn the cork so that the string isn't straight any more—(He turns it through 90°). *Oh no, it's still straight*—Now make a drawing of all this (he is given diagrams of corks at various angles and has to add the plumb-line) —(He draws them all perpendicular)—Is that right?—*Yes*".

These results are particularly interesting in view of their complexity, the outcome of a variety of perceptual, conceptual and graphic factors. Each of these children can reproduce the vertical in certain situations but not in others, and this is because in each different situation he bases his judgement on a different system of reference without realizing it. It is obvious that the child's idea of the vertical is not an operational concept, since even the straight line is not yet conceived in operational terms (cf. Chapter VI, Section I). As the idea of vertical is merely intuitive, it is naturally governed by the perceptual context—just as was found in the case of straight lines—and this is what the above results are consistent with.

The first important point to note is that, despite superficial appearances, the vertical is not mastered earlier than the horizontal. Comparison of the results obtained for the horizontal and vertical axes in similar contexts, such as jars at various angles of tilt, shows that the vertical is neither easier nor more difficult to conceive of than the horizontal. The truth of the matter is simply that we only quoted examples dealing with the water level in tilted jars to avoid unduly prolonging the discussion. But with the vertical axis, what was already known about children's drawing impelled us to study other situations as well. Consequently, the results seem to contradict one another, but as we have pointed out, the apparent inconsistency disappears when the comparisons are limited to similar situations.

Take the case of the cork float with the vertical mast, or more particularly, the plumb-line hanging from a cork, independent of either the level or even the presence of water in the jar. Here we find that both Lid and Kel (quite apart from their responses for the horizontal axis) hold fast to one orientation; perpendicular to the water in the case of the floating masts, and perpendicular to the cork in the case of the plumb-line (in the latter case, parallel to the sides of the jar also). Kel retains this idea even when the plumb-line is suspended outside the jar, although in these circumstances the problem is as a rule solved somewhat earlier. The difficulty these children experience in appreciating the result of the experimental demonstration, due to their lack of a frame of reference, is particularly apparent.

As against this, with trees, men or posts on the mountainside, the reactions vary according to whether the objects have to be arranged on a toy mountain or drawn on a diagram. Unlike children of Stage I who tend to arrange the objects parallel with the slope, and those of Substage IIA who place them perpendicular to it, the present children all locate the objects truly vertical. This is probably because the sand mountain is an object standing in the room, with the vertical axis suggested by the walls, legs of tables and chairs, etc. The drawings, on the other hand, invariably give rise to perpendiculars because they contain only the slopes of the mountain on which the objects rest (and which all these objects are related to), and not the sheet of paper itself, which is perceived simply as a 'ground'. Not until the beginning of the next stage can this method of representing the vertical be attributed to a habitual method of drawing.[1] On the contrary, at this level children constantly find difficulty in distinguishing perpendicular from vertical (see Fran), or even in making an estimate based solely on angles rather

[1] In drawing freely from imagination, the perpendicular is frequently used to express the vertical up to about 6–7 years (in Geneva). M. Lewinnek has made a collection of drawings from the Ecole Nouvelle of Mlle. Hamaide in Brussels which show mountains with trees, houses, etc., represented in the same way, up to about the same age.

than co-ordinates, the perpendicular objects being pronounced 'upright' and the vertical ones 'slanting' (Jac, Mich, Nor, etc.).

Thus by and large, one can say that there is still no general vertical axis by the end of this stage, since orientation is judged on the basis of partial reference systems which do not take all factors into account. Moreover, within the same type of situation, such as that involving tilted jars, the vertical is no better constructed than the horizontal, due to absence of any external reference frame; i.e., co-ordinate axes based on the most stable elements within the field.

§5. *Stage III. The discovery of the vertical and horizontal*

Our hypotheses are strikingly confirmed by the results obtained in Stage III. The children do not discover the vertical and horizontal at one stroke, as might well have been expected had they been unable to give correct answers merely for lack of skill in drawing. At Stage I the child cannot isolate straight lines and planes, and at Stage II he fails to make use of reference systems going outside the pattern he has in mind. At Stage III, however, he begins, though only very gradually, to master more extended reference systems and to construct co-ordinate axes embracing the entire spatial field.

In the course of this process, three main types of reaction may be distinguished. Firstly, one intermediate between Substages IIB and IIIA, comprising the discovery of the horizontal when the jar is lying on its side, together with partial discovery of the vertical. Next, Substage IIIA, marked by trial and error construction of vertical and horizontal axes for all positions. Lastly, Substage IIIB, in which this construction is formulated in operational terms and is applied directly to all situations.

First of all, the reactions which are midway between those of Substages IIB and IIIA merit particular attention. Though possessing but one novel feature distinguishing them from their forerunners, these reactions nevertheless mark an important step forward, since they indicate a widening of the rather limited system of reference with which the child has been satisfied so far. This new feature is the discovery of the horizontal when the bottle is lying on its side. The water is no longer drawn parallel with the base or joined to one corner (it will be recalled that at Substage IIB the child drew the water horizontal with the jar inverted, though here it remained parallel with the base). Naturally, the horizontal is discovered as a result of parallelism between the water and the sides of the bottle. Nevertheless, such a form of parallelism, which is entirely different from that of the initial position (surface of water parallel with base of jar), suggests that the child is beginning to establish a connection of some sort with a reference system external to the jar, at any rate in this particular position.

Ros (7; 2) begins as at Substage IIB: "*The water will be higher here* (in the direction of tilt) *and lower there*". He draws the level aslant, starting at the lower corner and running to the middle of the opposite side. He does the same for other tilted positions, but for the jar lying on its side produces a very curious drawing. The water starts to run obliquely from the lower corner, but on approaching the neck it begins to run horizontally, so that the outline of the water resembles a trapezoid.

The floating masts are sometimes vertical and sometimes perpendicular to the inclined levels.

CHAR (7; 6). With the spherical flask he draws an oblique water-line for all angles of tilt, except when the jar lies with the neck horizontal. In this case the surface is drawn horizontal also. "Why do you make it like this here (90°)?—*Because it's straight* (= horizontal)—Let's see if that's right (we carry out the experiment at all angles of tilt)—*No, the water is always straight and I drew it tilted. It should always be straight*—And like this (135°)?—*It'll still be straight*". Under the influence of the experiment Char seems to have made a general discovery of the horizontal axis. But with the rectangular jar he has to start all over again: for an angle of 45° he draws an oblique level. "Could the water lie like this (we show him a sharper incline)?—*Yes, if the bottle is tilted over more*—But you told me that the water would be straight?—*It's not straight*", etc. He again draws lines that are tilted more and more, except when the jar lies on its side. The masts of the floats remain perpendicular to the surface of the water.

WEB (7; 9). With the spherical flask he begins by drawing the level as increasingly curved ellipses until they form a kind of ball at the neck (for the steep inclinations). We perform the experiment and he observes that "*the water is straight*". In the drawings that follow he shows levels which are all horizontal, indicating that he has taken note of what he has seen. But when we pass on to the straight-sided bottle he again predicts levels which are every one oblique, except when the bottle is lying flat. We then begin the demonstration and he checks the levels with a ruler. "Is the drawing you've just made correct?—*No, it's wrong*—And if I make it tilt more?—*The water will tilt as well*—Check it with the ruler—*Sloping* (he has great difficulty in judging whether the ruler is horizontal)—Are you sure?—*No, it's straight*—And the water?—*It must be straight, because it's in the same position as the ruler*—Arrange these cardboard models in the right order (cut-outs representing the spherical flask with a variety of water levels)—He arranges them with the water-line inclined, save for the one lying at 90°)—But you said it was always straight?—*No, it's slanting*—Place your ruler against the jar. How is it?—*Slanting*—Do you really think so?—*Ah! no, it's straight!* (with an air of astonishment)". The masts of the floats are drawn sometimes vertical, sometimes perpendicular to the surface of the water.

DOR (7; 2). Using the method of movable cardboard cut-outs, he arranges correctly almost all those representing the spherical flask. With those representing the straight-sided jar, he succeeds in the case of the horizontal (90°) and inverted (180°) positions, but for the tilted positions he makes some of the levels oblique and says, "*It goes down*", after having already asserted, in the case of the round flask, that "*the water is straight; it never goes down*".

He is thereupon shown the actual jars and the experiment is performed. When the jar is but slightly tilted, Dor sees the surface of the water as inclined, while as the angle approaches 90° he sees it straight once more. He is asked to check with a ruler but begins to take measurements of his own accord, using his fingers with the table top as a reference guide. However, this method proves rather inaccurate and he sticks to his original opinion, "*sometimes it's sloping and sometimes it's straight!*".

CAB (7; 2) expects the water to slope except for the horizontal and inverted positions. In the latter cases, he says "*the water will be like this*" running the palm of his hand over the table, which clearly indicates that he is employing it as an external reference plane. For the tilted positions he asserts that "*the water will still be sloping*" (the use of the word "still" shows, by the way, that this belief is a survival from an earlier stage) whilst with the spherical flask he succeeds in predicting the horizontal level for almost all positions.

These reactions reveal the first, nascent awareness of the concept of "horizontal", and for this reason they deserve the most careful attention. The position in which the water is shown when the jar lies on its side constitutes the first authentic expression of this concept—as distinct from the inverted position where the liquid is shown horizontal only because it lies parallel with the base of the jar. How then do the children of this level come to make such a discovery in this one particular case, and why are they unable to extend it to other cases?

There can be no doubt whatever that the experiment itself plays a vital part in enabling the child to make the purely physical discovery that the water level remains horizontal. But this experiment presents two aspects, both of which entail a geometrical framework extending beyond immediate physical data.

In the first place, the child has to observe that the surface of the water retains a constant shape, that it is not curved in the way Web draws it, or bent like Ros's trapezoid, but constitutes a flat plane. Now from the beginning of Stage II, it is clearly the experiment which makes this apparent and thus enables Web and Ros to correct their errors—survivals of reactions found in Stage I. Elementary though this may seem, the ability to note this fact undoubtedly presumes that the child can envisage a plane surface.

In the second place—and this is something far harder for him to grasp—the experiment is a physical proof that the liquid surface maintains a constant orientation. In other words, that a ruler held against the jar, level with the water-line, will remain parallel with it even though the jar be tilted. It is this second aspect of the experiment which amazes Web and so many other subjects. Indeed, they are as yet by no means able to appreciate it fully, though they begin to accept it in the form expressed by Web: the water "is straight because it is in the same position as the ruler".

But what does an experiment such as this really involve? Basically,

certain specialized actions, such as checking up by eye or with a ruler, which bear upon specific features of the object (in this case its shape and orientation) and result in a particular abstraction. All of which amounts to abstracting from the object, certain specific features which the subject can record and incorporate within his conceptual schemata.

However, if the acquisition of such a concept required only a physical demonstration, one would be at a loss to understand why the process should be so difficult and protracted; consequently, other factors must be involved. Now an experiment is a practical possibility only if its result can, firstly, be observed (noting the experiment) and, secondly, interpreted (drawing conclusions from it). This inevitably presumes a deductive system whereby the experiment may be rationally understood. That is to say, in order to gain accurate knowledge of a thing, it is not enough to perform certain specialized actions on particular aspects or features of it. It is also necessary to co-ordinate these actions (whether they be successive or simultaneous). But the process of co-ordinating actions is no part of the physical experiment, but a part of intelligence mechanisms, and is therefore basic to logical and mathematical operations, geometrical operations included.

Now to co-ordinate actions is, in effect, to link them together on the basis of their consequences, or else to enclose their schemata one within another. In either case, the net result is to co-ordinate or link together the objects affected by such actions, so that it is no longer a question of abstracting a particular feature from an object as with specialized isolated actions. On the contrary, it involves adding new features to objects, features which are not abstracted from their physical nature, but exist in harmony with it. In this way, relationships like number, logical classes, or basic geometrical postulates are more closely linked with the actions whose co-ordination they express, than with the objects such actions bear upon (thus for example, it is enough to reverse the direction of an action to reverse the relationships). In the present instance, even the idea of a plane surface—which as we have just seen constitutes an abstraction from the object when it is simply a matter of observing that the surface of the water is flat—presupposes an abstraction based on this same co-ordination of actions. And in Chapters I and II we have seen time and again how largely 'shape abstraction' depends upon the co-ordination of actions as such, so that we need not dwell upon this any further here.

As for the constant orientation of the liquid surface, that is to say, the horizontal axis itself, this is clearly one of those concepts that cannot be arrived at solely on the basis of physical experiments, because it entails the formation of a rich network of interconnections which will culminate in a co-ordinate system. Now it is precisely the inception of this process which enables the children just quoted to discover the

horizontal axis in certain situation, whilst the obstacles they have to overcome in doing so explain why they are unable to apply their discovery to all situations.

Thus after trying to locate the water level parallel with the base of the jar during Substage IIA, at Substage IIB the children began to look for angles and then connected the water-line to the corners of the jar, continuing in this way to refer solely to reference systems inside the total configuration. In the transitional cases instanced above, this procedure is continued for all tilted positions of the straight-sided vessel, whereas in the horizontal position (and often for all positions of the spherical flask) the horizontal axis is represented correctly.

The reason for this is not very difficult to discover, and in the case of the round jar (thus shown to be from the present stage more favourable to prediction of the horizontal) it is perfectly obvious. In the absence of corners and angles the child begins by tilting his lines obliquely toward the neck of the flask, but because these offer no reference points inside the vessel he is quickly led to seek a system of reference external to it. From this point on, more or less consciously, according to each individual case, he refers to the table or the stand on which the flask rests and this helps him to discover that the water is "always straight" (Char, Dor, etc.), or in other words, parallel with the horizontal stand. In the case of the straight-sided jar, however, the sides and corners continue to provide an internal reference system for all angles except when it lies flat upon the stand. In this last position the sides are parallel with the stand and the child therefore refers to the stand or the table, i.e., to a system external to the bottle, consequently discovering the horizontal. This is how Cab comes to foresee that "the water will be like that", for he points to the table, indicating that he is seeking some reference independent of the jar.

At this intermediate level the child discovers the horizontal axis through attempting to relate the water level to points of reference outside the jar. He succeeds in locating the horizontal only in situations which involve comparisons of parallels and perpendiculars and is unable to do so when the jar is at an oblique angle. His discovery therefore remains incomplete. Although these reactions may appear to be of a non-deductive, trial and error kind, we have here, not just a simple physical discovery, but the very beginnings of the process of forming co-ordinates or frames of reference by relating the principal object of attention to others independent of it and more remotely situated.

The same holds true for the vertical axis. The present children are for the most part content to draw the masts of the cork floats perpendicular to the water-line, the reference system remaining inside the jar. In certain cases, however, they are shown vertical through being related to objects outside the configuration formed by the bottle.

405

As distinct from this transitional level, Stage III proper begins about the age of 7-8 on the average; that is, at the point where concrete operations first appear. The idea of the horizontal is now no longer a mere suggestion occurring in specially favourable positions of the jar, nor is the idea of the vertical any longer dependent upon the perceptual surround. On the contrary, Stage III is distinguished by practical and effective application of these concepts to all positions and inclinations. In other words, as a result of concrete operations which replace the simple connected notions of Stage II, the child can now interrelate the different parts of the patterns he is considering; the mobile reference systems within them, and the fixed systems outside them. But this ultimate goal, unlike the more elementary concepts (such as straight lines, parallels, etc.), which are completed about the age of 7 or 8, is not reached at a single stride. For the horizontal and vertical constitute a co-ordinate system, which entails an interrelation of the entire complex of objects lying within the field of action, and two stages are required for this to be achieved completely.

During Substage IIIA it is possible to see the concepts of vertical and horizontal gradually crystallizing out in the actual course of the experiment. Only from the beginning of Substage IIIB, about the age of 9, are they applied logically and consistently to all situations right from the start of the interview. Here are some examples of Substage IIIA.

WEI (6; 4 advanced) predicts the level as oblique for the straight-sided jar tilted through 45°. "Watch (experiment)—*Oh no!*—And if we tilt it a little more?—*Then the water will still slant a little bit* (experiment). *No, it's straight*—And if we tilt it a lot more?—*It will stay straight because it's only the jar that changes*—And if it's tilted towards me?—*The water will start slanting towards you* (he indicates this with a ruler which he then raises suddenly) *No, if we check it with the ruler the water stays straight. It is straight because you are tilting*—Draw it—(He draws the water slanting at first, then makes it horizontal)—And if we tilt it further still?—(He draws the surface very much inclined, then turns the paper round in all directions, looking for a point of reference). *Gosh! That's not right* (he corrects it to horizontal and says), *I drew the table first and then the water* (!)".

Spherical flasks. Begins with drawings that are sometimes horizontal and sometimes oblique, then; "*Oh, that isn't right, because it's always straight*". In the case of the toy fishing rod poised over the surface of a lake he produces a few correct drawings (line vertical and lake horizontal), but also a strange drawing in which the lake is oblique and the fishing rod is beneath the surface of the water; "Is the lake slanting?—*No. When there is a storm, yes. Otherwise it's completely flat*—What about this drawing then?—*It's slanting. But when you put it like this* (he turns it upside down) *it isn't*". He has thus made the drawing upside-down without worrying about the tilt of the paper. Nevertheless he knows how to put everything in its place by referring it to the edge of the table!

HEN (6; 11) draws plumb-lines for the vertical axis which are sometimes vertical and sometimes parallel with the sides of the jar. At the beginning he also puts the trees perpendicular to the sides of the mountain, then corrects them to vertical.

In the case of the straight-sided jar tilted at 45° he at first predicts that the water level will be parallel with the base, then oblique (joined to one corner) and finally, almost horizontal. He then applies the horizontal to nearly all positions.

With the cardboard models he arranges the spherical ones correctly but the rectangular ones still have oblique water levels in the tilted positions. Then suddenly he says, *"No, it's right when it's flat"*.

WIR (7; 3) begins by drawing the water levels obliquely on the diagrams of the rectangular jar. "Hold this ruler against the jar to see if you're right (experiment)—*My drawing isn't quite right because it's not straight*—(We continue tilting the bottle). And now?—*I just can't understand it. It ought not to be like this* (horizontal!)—Look, I am holding the pencil flat (meanwhile the jar is tilted still further)—*Oh yes! It's quite straight. But that's funny, the jar isn't straight!*—And if we tilt it a lot?—*It will be straight. There's something I don't understand. The water stays still* (= horizontal) *and the jar moves!*—And if we tilt it this way?—*It will still be straight*—And towards you?—*The same*". Nevertheless, he subsequently has difficulty in representing these various levels by horizontals but he gradually succeeds.

Spherical flask: *"It's straight all the time"*.

BOR (8; 6). Unlike Wir, he proceeds by trial and error rather than by conscious reasoning. Starting with oblique levels running from one corner of the jar, he arrives at the horizontal in the case of the jar lying flat. He is then asked to add boats to his drawings, and makes the masts vertical without bothering about the surface of the water. He is next shown the bottle tilted at other angles and draws the water *"a little bit tilted"*, maintaining that this is how he sees it when the experiment is being performed. He finally ends up with a complete and general understanding of the horizontal.

CONU (8; 6) begins with levels tilted at all sorts of angles, but when he has arranged the cardboard models he hesitates a moment, then puts all the levels in a horizontal series and says, *"It makes one single line"*. After this he corrects his drawings. Asked to check them by holding a ruler against the jar, he says, *"When the bottle is tilted, the ruler will be tilted . . . No, always straight. It's just the same as before"*.

BRAU (8; 6) at first draws oblique levels, then seeing the experiment he realizes that they remain horizontal. "Could the water ever be tilted?—*Yes, if the jar were tilted further*—Watch (experiment)—*Oh no, it stays straight*— How were you able to find that out?—*I looked at the table*".

FRO (9; 6) begins in the same way but then exclaims (in the case of a 20–30° tilt) *"No, my drawing is slanting too much, because the water cannot slant; it's always straight because water must always be straight!* (= horizontal)".

PAU (9; 10) draws an oblique water-line and a boat with mast perpendicular to it. He is shown the experiment. *"I did it all wrong. The water was like that* (gesture parallel with the table) *and the mast was straight* (vertical gesture)". But immediately following he again predicts an oblique level (experiment):

407

"*No, it's even more wrong*—And if the jar is tilted even more?—(This time he makes a horizontal drawing, using a ruler which he places parallel to the edge of the table)". But oddly enough, when he comes to deal with another inclination he reverts to a tilted level, repeating the same error with the spherical flask. However he finally succeeds in producing horizontals in all situations.

CHEU (10; 3) draws an oblique level at first. "*I don't know whether the water reaches the corner of the jar* (he joins one corner to the opposite side) *but the float is straight* (vertical)—And if the jar is tilted?—(He draws the water sharply inclined, the float perpendicular to it. On seeing the experiment he at first tries to explain it all away, and reconcile everything). *It will be slanting all the same. The water will be straight, but in the other direction it will be slanting, but it will be straight all the same* (he draws it slightly tilted)—Look at it and use this ruler—*It's straight*—And if we tilt it further?—*You must keep the ruler straight*—And in the other direction?—*It will be straight as well* —How do you know?—*I just think so*". Lastly, using the movable cardboard cut-outs, he achieves the horizontal for all inclinations, "*because otherwise the water would rise here* (on one side) *and go down there* (the other side)".

EIS (10; 7) hesitates at first. "*I don't know whether it should be straight or tilted*". He draws the water inclined and the mast perpendicular to it. He makes a series of drawings, all like this, then says, "*No, I must make it straighter* —And if I tilt it the other way?—*It will still be straight* . . . —How do you find the right answer?—*I look at the edges of the paper or the table*". Round flask: all drawings correct; "*I look at the table*".

TRIP (11; 4) hesitates in the same way up till the moment when, after watching the experiment, he says, "*It will stay straight all the time. It must always be straight* (he corrects his drawings)—How can you tell if it's right? —*I draw it parallel to the table*".

Finally, here are two examples for the vertical axis:

GEO (7; 9) begins by arranging the objects perpendicular to the slope of the sand hill. "Now draw them—(Again perpendicular to the slope)—Draw a few more posts—(Some vertical, other perpendicular)—Are your trees straight?—*No, they're slanting* (he alters them to make them vertical)—And the houses?—(Corrects these also)—Draw a man climbing up and coming down—(Mixture of vertical and perpendicular)—Which one is drawn best? —(Points to the vertical)—Can you add some trees?—(He draws them all vertical)".

CARL (8; 2) draws a mountain with rows of trees, men, etc. He starts off with a mixture of perpendiculars and near verticals but gradually corrects himself until he draws only vertical objects.

It is clear that by Substage IIIA it is at last possible to speak of the horizontal being recognized and applied in all positions of the bottle; likewise the vertical, either in the same situation or in drawings of the mountain slope. Yet at the same time one is faced with an astonishing fact. These children, ranging between the ages of 6; 4 and 11 years (with a few laggards of 12), only succeed in making this elementary comparison upon repeated attempts, after reproducing the same errors

as were seen in Stage II, and after having been made to note the result of the experiment with the jar. Pau is a particularly clear-cut example of this, although he is nearly 10 years old. Hence the concepts of horizontal and vertical are not constructed at the beginning of Stage III (that is, at the point where concrete operations first appear), save in exceptional cases, but during the actual course of this stage, at about the age of 9; in other words, not until these operations have been completely organized.

Having pointed this out, we must now enquire how the vertical and horizontal come to be discovered. This may seem a difficult question to answer, but we shall find that the children whose reactions we have just summarized will enable us to deal with it quite simply. In one sense, the discovery can indeed be said to derive from the fact that the water remains level and the plumb-line falls true. But these facts can only be noted and applied inductively through being incorporated in a network of co-ordinating schemata whose organization will result in a system of reference.

The most striking thing is, of course, the way in which the children infer the physical law from what they see, particularly as regards the horizontal in the case of the water level. Thus Wei finds his predictions constantly contradicted by the experiment and is eventually compelled to admit that the water "is always straight". Wir goes further and formulates the law empirically, "there's something I don't understand; the water stays still and the jar moves!" It is evident that without the experiments the child would not succeed in discovering that the liquid remains horizontal, for this is given empirically and not deduced *a priori*. But why is this experiment not effective until Stage III? Why does it take so long to produce, first a simple observation (not possible at Stage I), and then a general inference (not possible at Stage II)? In other words, why are these children the first to conclude that the water will 'always' be horizontal, on the basis of noting a few experimental facts?

It is at this point that one realizes the indispensable rôle of a frame of reference. In order to recognize that the water is permanently horizontal and the masts or plumb-lines permanently vertical, regardless of the tilt of the jar, it is necessary—even without drawing, but only by holding a ruler in line with the water or the plumb-line—to establish a relationship between the water or the thread, the ruler, and a set of objects external to the jar. For otherwise there is nothing to show whether the orientation of the water has or has not altered through being involved in the movement of the container (just as a relative movement cannot be understood without a system of reference). Now it is remarkable to observe that the children are, as a rule, more or less consciously aware of the need for an external anchorage. Thus Wei (the empirical nature of whose discoveries we have just commented upon), after having

produced the correct drawings, says, "I drew the table first, then the water". Brau states that he "looks at the table" in drawing the water-line; Pau clearly aligns his ruler with the edge of the table, though he does not say so; Eis admits openly, "I look at the edge of the paper or the table"; and Trip says, "I drew (it) parallel to the table". True enough, one could very well ask them what they compare the level of the table with, and this would, in the last resort, refer them back to the level of the water. But it is quite evident, so far as the second aspect of the child's reactions is concerned, that it is no longer the physical problem which is important, but rather the geometrical problem of comparing different inclinations in terms of angles, parallelism, order and distance. In short, by means of a comprehensive system, and this is precisely the beginning of a system of co-ordinate axes.

Before discussing this point, however, we must first study some examples of Substage IIIB. These children know that the water stays horizontal, the masts and the plumb-lines upright, and apply these concepts with the jar at all angles of tilt.

SAN (6; 6). "What will the water do if we tilt this bottle?—*It will stay like this* (marks a horizontal line on the glass with his finger)—Draw it—(Drawn horizontal). *It stays flat like this*—And if we tilt it still more?—*It will always stay flat*".

STEI (6; 7) draws the levels horizontal and the masts vertical right away. "Why do you draw the water like that?—*Because it always stays straight*". Drawings and movable cut-outs to be placed in rank order are all arranged correctly.

LEY (7; 0) hesitates for a moment when drawing the water level oblique, then exclaims "*No, no, the water never rises*". The movable cut-outs are at once arranged correctly. The plumb-line is drawn vertical for all positions of the jar.

HAN (7; 3) also hesitates for a moment, then says, "*It's the bottle that's tilted. The water stays straight, it doesn't stick to the bottle, it remains straight when you tilt it. If you turned this cupboard upside down, the animals inside would all fall down, but the water in the bottle always stays straight*". He then draws a few horizontal levels and in order to be sure that "*it is straight*" he measures the distance between the surface of the water and the side of the bottle (on the drawing of the bottle lying flat). With the next drawing he notices that this check is not adequate and employs the edge of the table as a guide.

WAG (8; 5). "*The water must always be straight; it stays like this*". Plumb-line, also correct.

PAS (9; 6). "*It stays horizontal*—And the plumb-line?—*Vertical*—How do you know that's right?—*I can tell at a glance*—Can you check it with this ruler?—(He moves the ruler from the table to the level of the water to indicate the parallelism, then draws the table on his sheet of paper and measures the distance between the water and the table at both ends of the water-line he has drawn)—And what about the plumb-line?—(He checks the vertical by eye, looking in turn at each right-angle between the line and the table)".

Coi (10; 7). "*It is horizontal*—What do you do to make sure of drawing it right?—*I look at the table*".

Cue (11; 1). "*The level is straight because the water always stays horizontal* —How can you tell for certain?—*You can measure it to see whether it's the same distance from the base on the right or the left*—And what about the plumb-line?—(He turns the paper round through 90°). *It makes a right-angle* (each side)".

Tis (11; 6). "*The level is always horizontal. I draw it like the table*—How can you see it is horizontal?—*I say the base is horizontal and I draw the water in relation to the base*". He makes an excellent drawing in full perspective on a level sheet of paper, then transfers it to a sheet placed in the skew, showing the horizontal parallel with the lower edge of the paper and the verticals perpendicular to it.

Here are a few examples dealing only with verticals.

Lai (6; 10) draws a mountain with objects placed vertical on the slopes. On an outline drawing of a mountain, the plumb-line is always placed vertical, independent of slopes and ledges. The fishing rod with a weighted line is drawn vertical for all positions.

Dan (7; 6), Clai (8; 6), and Fred (9; 3). Same reactions. Fred is shown a house drawn perpendicular to a slope; "*Gosh! the bricks will all come tumbling down. No-one ever saw a house like that!*".

As may be seen, these children range between the age of 7 (with a few as young as 6; 6) and the usual beginning of operational thought, averaging around 9 years. In the case of the most advanced children like Cue and Tis who are on the verge of abstract thought, we find that their system of co-ordinates has become virtually conventional or hypothetico-deductive. "I say that the base is horizontal" Tis decrees, "and I draw the water in relation to the base", after which he proceeds to arrange the whole affair according to a set of parallels and perpendiculars, whether the paper lies straight or askew. Physical horizontals and verticals have thus become no more than an occasion for making a finished drawing in terms of orthogonal co-ordinates. With the youngest children, from San to Coi, the core of their assertions still remains the physical law. However, a closer scrutiny of their statements reveals that it is no more than the starting point for their growing awareness, since this begins with actions performed on the object before passing on to deal with the actual mechanism of these actions. Only after an extensive process of co-ordination, similar in principle to that which Cue and Tis were able to describe explicitly, can these younger children be sure that the water always remains level. They too construct their physical or mental pictures of upright and horizontal by means of a system of parallels and right-angles, which is the essence of a geometrical, as opposed to a physical, system of rectangular co-ordinates. The case of Han is particularly impressive in this respect. With an immediacy

which contrasts sharply with the trial and error methods of Substage IIIA, he declares that "the water does not stick to the bottle" but remains horizontal no matter how the bottle is tilted. Then to justify his assertions he performs a series of measurements, at first dealing only with the bottle and consequently erroneous, yet showing his need to relate the level to the set of parallels and angles it forms with the sides —that is to say, to a complete system which is subsequently extended to include the surface of the table and hence, objects external to the jar.

In short, the distinctive feature of this final substage is the general co-ordination of all angles and parallels thoughout the entire field of objects under consideration. It is this process which enables the child to discover the physical constancy of the horizontal water level and the vertical plumb-line, a concept which is eventually independent of experimental observation.

§6. *The development of general systems of reference*

This chapter has so far dealt only with horizontal and vertical as axes of the natural system of reference provided by the physical world. Before concluding however, we shall endeavour to find out whether the child freely avails himself of reference systems independent of a given figure in attempting to reproduce particular arrangements of positions and distances, which would thereby imply an active process of construction.

To investigate this problem the following methods were used. 1. We place on the table a number of counters or heavy square beads and arrange them in arbitrary fashion (varying the number of beads and the complexity of the pattern from test to test). The child is then invited to reproduce the exact figure using similar beads or counters. After he has made his first attempt, which gives him some idea of the difficulty of the task, he is given a number of rectangular paper strips, 15 to 20 centimetres in length, and asked if they might be of any assistance. To help him we show (separately, of course) how a strip may be placed so that one counter is to its left, one to its right and a third in line with it, and that another strip may be placed similarly in relation to another set of beads, so facilitating the reproduction of the pattern. 2. Two small sticks are placed on an irregularly shaped piece of paper and the child is asked to arrange two similar sticks in similar positions on another equally irregular sheet of paper, using rulers and strips of paper as guides. The same test may be carried out using crossed sticks (like an X) on either plain or squared paper, or else with a drawing of a cooking pot hanging from two crossed sticks over a camp fire. In this case the children have to copy the drawing or imitate it with little sticks, on an irregular sheet of paper so that the sides cannot be used as guides.

The obvious weakness of these methods is their lack of precision. Nevertheless, they help us to obtain certain information which it is interesting to compare with the previous findings. The present experiment shows how indifferent are the younger children to systems of reference, and how as they grow older they become increasingly aware of the need to use co-ordinate axes.

At Stage II (the tests are ineffective at Stage I) the children are preoccupied with purely perceptual features in trying to copy the pattern, neither attempting to make use of reference systems nor understanding how to apply them when persuaded to do so.

MAR (6; 2). Three beads are arranged on one side of the table. Mar is offered strips of paper and shown how they may be employed. He arranges his own beads roughly symmetrical with the model and ignores the strips of paper. "You see, you can put these two strips near the beads (they are arranged in the shape of an X between the beads). Here you are, these are yours—(Mar places his strips quite differently). *Oh, it's more slanting here* (he moves a bead and puts the strips at an angle between the three)—Now here are some beads which I'm going to arrange like this (another pattern)—(Mar copies the figure by eye, again symmetrically without bothering over the strips)—Is that right? —*No*—If I put the strips like this (a cross) will that help you to copy?—(He crosses his strips carelessly, ignoring the fact that one of the four sections contains two beads whereas in the model there is one bead in each section)— And with these six beads?—(Makes a rough copy without using the strips)" etc. He thus derives no assistance from the available reference points.

AL (6; 10) already reported in §4. (Stage IIB) Method 2. He arranges the sticks by eye, not very accurately, rejecting the ruler as a guide. On squared paper he arranges them equally badly and finds it *"more difficult"* because of the squares. The idea of making use of the squares does not occur to him. He is then asked to reproduce on a nearby table, the tilt of a stick placed at an angle. He arranges it in line with the sides of the table, then sensing that there is something wrong, tilts it a little.

ROS (7; 2). Drawing of the saucepan hanging from crossed sticks. He copies them by sight using two sticks but makes the angle more obtuse, *"I couldn't manage it; it's too close to the fire*—How ought you to do it?— *I should need two rulers to see how they are spread out* (he is given the rulers but does not use them). *It would be to see whether these* (=the lines) *would be more level"*.

There is no need to quote any more examples. The main feature of these children's reactions is that only the figure itself is considered and any external reference system is ignored. Consequently they have no use for the guide strips, squares or rulers. It will also be noted that they are indifferent to inclinations and angles, a reaction already commented upon in Chapter XII.

During Stage III, on the other hand, one sees the children beginning to use references separate from the parts of the figure.

413

CHEL (8; 3) copies a pattern of five beads but does not at first use the strips of paper. "Is that quite right?—*No*—It's not so easy when you just look at it. Won't these bits of paper make it easier for you to tell?" He places a strip on either side of the model, one on one side of his copy, and adds a third to the model but then removes it and puts it on the other side of his copy. In this way both model and copy are flanked by horizontal strips, which enables him to make a few corrections. With ten beads (and a more complicated pattern) he again begins without using the strips, then flanks the model with two strips forming an acute angle, reproduces this for his copy and arranges the beads with the aid of these guides.

ICH (8; 8) also begins without making use of the strips, then takes two, places them crosswise in the middle of the model and then does the same for his copy. This enables him to correct it. But although the positions of the beads are now correct in relation to the four sections made by the cross, their relative distances are not taken into account. Several successive attempts yield the same result.

INE (9; 0) begins to copy the model by eye, then surrounds it on three sides, placing three more strips around his copy which he then proceeds to correct. Second attempt: two strips placed on the model, more or less parallel, the same on the copy but spaced differently.

JAC (9; 1) begins with parallel strips then puts two crosswise (X), "*that's easier; otherwise you haven't got the corners* (angles)".

GER (8; 9). Using the sticks, he measures each one and turns the paper so that one of the sticks becomes vertical, then guesses the direction of the other by eye. After this he makes a parallelogram with the ruler and one of the sticks which enables him to estimate the inclination of the second stick more easily (since it lies inside the parallelogram).

Thus during Stage III the child makes definite progress in applying, and even constructing, systems of reference. Nevertheless, he can only achieve qualitative comparisons of the position and orientation of the counters and cannot co-ordinate their relative distances and true positions in an overall way.

Only after the age of 11–12, during the stage of formal operations of thought, are true conventional reference systems developed, enabling positions and distances to be compared simultaneously.

CLER (11; 2) begins by arranging the strips parallel on two sides of the model and places his beads in a similar pattern. However, he notices that the two sets of parallels are not equally far apart. He is not allowed to use a third strip, so he rearranges them crosswise (+). "Is it more or less accurate than before?—*More accurate, because this way the distances are the same*—Why? —*Because you must have all the measurements*". He then arranges the beads in relation to the arms of the cross, taking the distances into account.

GIL (11; 4) immediately arranges the strips crosswise; "Why?—*Because then you can find the position of each bead*—What about like that (parallel), would that be all right?—*No, because you can't be sure whether the width is the same*—And when they're crosswise?—*Then you can, because it's divided up*".

414

He produces four compartments and arranges the counters with the same positions as in the model.

BERL (11; 10). Two sticks: he first measures the straight line joining their lower ends but is uncertain of their inclination. He then tries to measure their distances at other points, ending up by using one of the sticks as abscissa and extending the straight line at each end. Perpendicular to this he draws a straight line as an ordinate, basing his measurements on this system of reference.

These children are clearly attempting to reconcile the arrangement and distances of the counters, which amounts to forming a true co-ordinate system. But unlike the vertical-horizontal, this type of system is not achieved until the level of formal abstract operations is reached. This is hardly surprising, since it is not suggested by physical orientation (as given by the water level and plumb-line) but has to be assumed hypothetically.

However, there is little point in pursuing this discussion here, for in the next chapter the problem will be in a form more in line with the child's natural interests. This is the construction of maps or plans, such as the layout of a village or a garden.

§7. *Conclusions: The construction of frames of reference*

We will begin by recapitulating the course of the child's development investigated so far. In Chapter VI (Section I) we showed that the child acquires the concept of the straight line, by means of "taking aim", which enables items to be ranged along the line of regard, and by the euclidean method of maintaining a constant direction of travel. The idea of the straight line thus embraces the topological notions of order, continuity, etc., but subordinates them either to a point of view or a direction of travel. Subsequent to this, Chapter XI showed that once the child has acquired the concept of the straight line, he can arrange two or more straight lines in the same direction, and thus also acquires the concept of lines which remain parallel during the course of affinitive transformations. Lastly, Chapter XII showed that at Substage IIIA, where the child begins to understand straight and parallel lines, he also discovers the similarity of triangles, not only through the parallelity of corresponding sides, but also by noting the equality of corresponding angles in the course of superimposing and rotating the two figures. This latter process, fully developed by Substage IIIB, leads to a systematic grouping of operations on the basis of co-univocal correspondences, and this results in the concept of proportions as the necessary complement to similarity.

At the same time, and at the same stage of evolution, a second set of correspondences, also based on straight and parallel lines, is established between ordinate points of space. These however are governed by

another multiplicative principle, that of point-point correspondence along orthogonal co-ordinates in three dimensions.

Now at first glance nothing could seem more elementary than a space organized according to such a principle. When we view the familiar objects around us, they appear arranged within a grid of parallel straight lines, crossing each other perpendicularly in three dimensions. And if this view of things appears self-evident it is because physical experience itself seems to force upon us just such a structure, by virtue of all the verticals we perceive as parallel and appearing to cut the verticals at right-angles. Indeed, any piece of squared paper, parquet flooring, street crossings or groups of buildings suggest the same ubiquitous and ineluctable notion of co-ordinate axes. In short, a frame of reference may be likened to a double or treble entry table cross-referenced, with all the objects in space arranged in point-point correspondence by being entered in the appropriate columns, so that to co-ordinate such items would seem simplicity itself.

However, the findings of the present chapter show clearly enough that it would be a complete mistake to imagine that human beings have some innate or psychologically precocious knowledge of the spatial surround organized in a two- or three-dimensional reference frame. At the outset, the child has not even an awareness of physical or physiological notions of vertical and horizontal, and for a very simple reason, as these results show. The reason is that a perception covers only a very limited field, whereas a system of reference presumes operational co-ordination of several fields, one with another.

Far from constituting the starting point of spatial awareness, the frame of reference is in fact the culminating point of the entire psychological development of euclidean space, just as the notions of succession and simultaneity, synchronous and isochronous, defining a homogeneous time, mark the culmination rather than the starting point for the concept of time.[1] A co-ordinate system or frame of reference presupposes, in the first instance, the topological notions of order and dimensionality. That is to say, a set of relationships enabling objects to be ranged in series along 'n' dimensions. For example, $O \rightarrow A_1 \rightarrow B_1 \rightarrow C_1$. . . etc. along one dimension; $O \rightarrow A_2 \rightarrow B_2 \rightarrow C_2$. . . etc. along another dimension, and so on. But this is not all, for topological correspondence between pairs of series (a homeomorphism) takes no account of the distances between the members of the series. In contrast to this, the correspondence between 2 or 'n' series when they are incorporated within a system having 2 or 'n' co-ordinate axes $O A_1 B_1 C_1$. . . and $O A_2 B_2 C_2$. . . conserves the distances $A_1 B_1 = A_2 B_2$, $B_1 C_1 = B_2 C_2$. . . etc., and also introduces a metric equivalence between successive intervals; viz., $O A_1 = A_1 B_1 = B_1 C_1 = \ldots = O A_2 = A_2 B_2 = B_2 C_2 = \ldots$ etc.

[1] Cf. Piaget, J., *Le Développement de la Notion de Temps chez l'Enfant*. Paris.

For this very reason the dimensions introduced in such a system bring about a fundamental transformation of the topological concept of dimensionality, which was dependent initially on the simple notions of surrounding and enclosure (cf. Chapter IV). Such notions leave parallels and straight lines out of account, whereas the axes of the most elementary reference frames consist of straight lines cutting others at right-angles, the former being either parallel (zero angle) or at specific inclinations. A frame of reference is thus the product of logical multiplication applied to topological series which have been modified by the introduction of the concepts of straight lines, parallels, distances and angles, in 'n' dimensions. It entails, apart from elementary topological relationships, the employment of the entire set of euclidean concepts in order to link one object with another, thus constituting a global organization of euclidean space, which is precisely the reason its development occurs so late.

It should now be equally apparent why perception alone is unequal to this task. True enough, perception provides a rough estimate of order, distance, parallels and angles. And moreover, just as with intelligence, elementary systems of reference are always involved, so that every object is perceived in a 'setting', in terms of which it is oriented and its size and shape estimated. Nevertheless, perceptual data always remains sketchy and inadequate, a circumstance which becomes obvious whenever the occasion arises to compare perception with intelligence.

This was first seen in connection with recognition of shapes in Chapter I, where even this elementary process required the aid of 'perceptual activity' governed by intelligence. Again, the formation of straight lines was shown to depend upon operational thought, while Chapter XI showed that parallels were organized operationally at a point where accuracy of perceptual estimates remained low, a case in which the operational structure originally created by perception, reacted upon and corrected perception itself. Similarly, the study of angles, similarities and proportions in Chapter XII showed that perceptual 'transposition' remained extremely crude until linked with conceptual comparisons. As for the actual 'setting' of perceptual space, Wursten's experiments on judgement of orientation, and particularly on estimating the length of tilted lines, prove conclusively what we ourselves have constantly maintained, that the perceptual space of children below the age of 8 or 9 remains very poorly organized as far as concerns orthogonal coordinates. Thus, on the one hand, the younger children judge tilt less accurately than the older, because they do not know how to make use of the reference systems which would yield the necessary parallels and angles. On the other hand, they can estimate the length of differently tilted lines far more accurately than the older children (or even adults) precisely because they ignore orientation and fail to locate the tilted lines within a reference frame—which in this case would obstruct the

comparison between lengths of tilted and upright lines. Now it is most significant that co-ordination of the perceptual field reaches its maximum efficiency about the age of 9, the same age at which the concepts of vertical and horizontal finally emerge as potential co-ordinate axes.

This naturally raises the question of whether perceptual development is the cause or the effect of the intellectual progress. This question may be answered in the following way. Firstly, if the process of development were purely perceptual in character it would be difficult to understand what its rôle was, and why its development should be so protracted. On the other hand, the rôle of intelligence is perfectly comprehensible. It consists of establishing permanent relations spanning ever greater spatio-temporal intervals, not merely within each successive perceptual field, but between each of these fields in turn. In this way, perceptual activity can be given a potential orientation by means of an operational mechanism, enabling virtual as well as actual orientations to be taken into account. Secondly, the reason for the slow development of thought is equally comprehensible since, as we have seen, it not only assumes the completion of operations concerned with order (as distinct from the mere notion of order)—because co-ordinates are logical multiplications between relations of order in two or three dimensions—but it also assumes that the concepts essential to euclidean space (straight lines, distances and measurements, parallels and angles) are fused into a single operational whole.

To conclude this discussion, we may make these final observations. Topological relations are relations which remain purely internal to each object or pattern. As against this, euclidean relations, completed by the construction of reference frames, are essentially relations established between numbers of objects or patterns (though still influencing their internal structure) and serve to locate them within an organized whole forming an all-embracing system. This is why horizontal-vertical axes are constructed at the same time as perspectives are co-ordinated, for these latter also constitute overall systems linking together objects or patterns. But projective space is in essence a co-ordination both of viewpoints—actual or virtual—and of the figures considered in relation to these viewpoints. Co-ordinates, on the other hand, which express the structure of euclidean space, link together objects considered as such, in their objective positions and displacements, and at relative distances. The age of 9 or thereabouts, which lies midway through the period in which concrete operations first take shape, thus marks a decisive turning point in the development of spatial concepts; that of the completion of the framework appropriate to comprehensive euclidean and projective systems. And it is interesting to observe that the other great comprehensive system—that of time, co-ordinating movements and speeds—is also completed at exactly the same age.

Chapter Fourteen

DIAGRAMMATIC LAYOUTS AND THE
PLAN OF A MODEL VILLAGE[1]

IN the course of past chapters we have seen how the simple topological notions with which the child begins to construct the concept of space were transformed concurrently into projective and euclidean concepts. The first of these, embracing perspective, sections, projections and plane rotations, results from the co-ordination of viewpoints, while the second derives from the conservation of straight lines, parallels, angles, and lastly, general co-ordinate systems. Although we have not yet had occasion to make a detailed study of euclidean metrics,[2] it is nevertheless already clear that the concepts of projective and euclidean space develop together and are mutually interdependent. This conclusion was confirmed afresh by the findings of the last chapter. These showed that the construction of physical reference frames, the final stage in the evolution of basic euclidean concepts, proceeded side by side with the general co-ordination of viewpoints, the salient feature of projective space (see Chapter VIII).

To investigate this hypothesis in greater detail, and at the same time conclude the present series of experiments, we cannot do better than examine the way children set about making a plan or layout, in the sense of creating an accurate topographical schema. Such an activity is extremely important, both from the psychological aspect, considering the development of children's geometrical drawing; and historically, as regards the actual origin of geometry from land surveying as practised in ancient Egypt.

In this instance, as in previous experiments, we have tried to obtain the most natural and spontaneous reactions from the child by keeping our instructions to the absolute minimum, and we have therefore limited our enquiry to two problems only. The first experiment is a direct outcome of those studied in the last chapter and consists of placing an object in a given position with the aid of the natural reference system provided by the model of a landscape with paths and streams. The second consists of reproducing the model of a village and its environs by an identical arrangement, or making a scale drawing of it.

The first problem is intended mainly for the younger children. Shown

[1] In collaboration with MM. H. Aebli, A. Morf, and Mlle. B. Demetriades.
[2] Dealt with in *La Géométrie Spontanée de l'Enfant*, devoted chiefly to concepts of measurement (distance and size).

a pasteboard model of a piece of terrain comprising a stream, a road and a few cottages, the child is asked to place a doll on an identical model. The position of this doll has to correspond exactly with that occupied by a similar doll on the original model. The second model is turned through 180° relative to the first so that the child cannot place the doll with reference to his own position but is compelled to locate it relative to the parts of the model. Thus while the problem is again that of an elementary reference system it is less difficult than that of judging the water level in the inclined jar (Chapter XIII) or copying the pattern of beads (ibid. §6.); for in the former case it was necessary to ignore the proximity relations between the liquid and reference points within the jar and seek a point of reference outside it instead. On the contrary, in placing the doll correctly on the model, the proximity relations constitute a prime factor so long as they are supplemented by those of order and distance applied to other reference objects simultaneously. Furthermore, the present experiment differs from that of copying the arrangement of beads, inasmuch as the beads had all to be arranged starting from scratch (just as with the layout diagram in the second experiment here) whereas in the present case a single object has only to be placed in an existing setting. True, the setting is rotated through 180° so that the child is forced to co-ordinate the projective "points of view" as well as the euclidean relationships, but this is precisely where the interest of the problem lies.

On the one hand, younger children—who do not attempt to organize space in terms of a co-ordinate system—can often perceive an inverted picture or do mirror writing better than older ones, and this helps make the present test easier for them. On the other hand, the constant reversal of both left-right and before-behind relationships tends to make the problem more difficult.

As regards the layout diagram, this simply involves drawing on a slightly reduced scale, a model village comprising a few cottages, a church, some trees, and so on. These objects are disposed about the table or the floor and are seen in oblique perspective (about 45°) or viewed from above (bird's eye view). This second test is obviously more complicated than the first, since all the objects have to be placed relative to one another at the same time, though here there is no rotation (except with older children who were sometimes asked to make a plan from a different point of view). Nevertheless, just as with the placing of the doll, the layout presents a twofold problem, that of co-ordinating different points of view—seeing the village in a particular perspective— and employing euclidean co-ordinates in translating the direct visual experience into a plan based on axes, distances, and so on.

§1. *Locating the doll on the model landscape*

The apparatus consists of two identical models representing some open country (see Fig. 27). Model A is traversed by a stream from top to bottom. Along its right bank runs a hill on which stands a house with a yellow roof. The model is crossed diagonally by a road starting at the left-hand corner. To the left of this road stands a large house with a red roof and a path connects it with the yellow house, crossing the stream by a bridge. In the upper left-hand corner of the model stand three trees disposed about a small hillock.

Model B is identical in all respects but is rotated through 180° and separated from Model A by a screen to prevent the subject looking at both models simultaneously. The child is asked to place a small doll on Model B in the same position as a doll placed on Model A by the experimenter.

Fig. 27.

To start with the models are shown without the screen and without the replica being rotated. The child is asked to "put the man in exactly the same spot" using a few simple positions such as on the roofs of the houses. The duplicate model is then turned around and a fresh start made. Finally, the screen is placed in position and the child checks his guesses by looking alternately at A and B. After the child has placed the doll in a number of positions it is useful to have him close his eyes and attempt to explain just what he was trying to do. His explanation naturally remains at a lower level than that of his actions.

The doll is now placed successively in fifteen standard positions which, incidentally, vary greatly as regards the ease with which they may be copied. There is no point in giving a detailed description of these beforehand; it goes without saying that what is vital to the experiment is not just to find out whether the child can locate these positions on the duplicate model, but to observe the method he employs in trying to do so. In other words, to see what relationships he attempts to

apply and link together in finding the desired position. In this respect, the screen is a very useful accessory since it can be removed when checking errors and replaced to compel the child to think out the problem afresh.

The stages of development thus exhibited can only be identified on the basis of the whole of the child's responses, or his average response. For although the sequence of responses is the same in each of the fifteen positions, considerable disparities exist between different solutions offered, due to variations in the difficulty of the problem. Nevertheless, it can be generally stated that throughout Stage I (up to approximately 3; 6–4 years) the positions are located mainly through topological relationships of proximity and surrounding or enclosure. In psychological terms this amounts to saying that the doll is located in a similar "setting" or "ground" (in a field, etc.) or next to the same object without the child concerning himself with left-right, before-behind relations, distances, and so on. It is during Stage II (4–7 years) that disparities most frequently occur between answers for the various positions. The reason for this is that the responses of this stage are transitional in character and result from the interplay of perceptual and conceptual factors. During Substage IIA it is possible to speak of egocentric correspondence in the location of the doll, with no awareness of subjective viewpoint. That is to say, the child locates the doll relative to his own position and disregards the reversal of the landscape in his model. Nevertheless, he does take account of a number of relationships and no longer relies simply on the proximity of surrounding objects. In the course of Substage IIB his ideas become more effectively co-ordinated until with the appearance of Stage III (between 6; 6–7 years) all relationships are arrived at by logical multiplication.

Here are some examples of Stage I.

With the doll placed in the fourth sector (upper right-hand corner) on the right of the stream and to the left of the road, JEA (3; 0) places his doll in Sector 1 of Model B (in the lower right-hand corner) without reference to the road. AL (3; 0) also places the doll in the open but in the third sector, between the stream and the large hill (on his right).

MAR (4; 0) likewise places it in the open but near the intersection of the road and the stream.

When the doll stands between the large hill and the stream, close by the yellow house, Al starts by placing his own doll on his model in roughly the same position relative to himself, ignoring the effect of the rotation. He then puts it near the large hill (as on Model A) but does not bother about its position relative to the yellow house or the stream.

With the doll placed in the stream, but at the bottom of Model A, all subjects of Stage I place it in the stream on Model B, but Al puts it midway along the lower half of the stream while RUT (3; 6) places it exactly in the middle (above the intersection of the road and the stream).

The doll is placed next to the yellow house and on top of the large hill in

the lower right-hand corner of the model. Al places his doll on the lower part of the hill in his model, ignoring the yellow house entirely. PA (3; 0) begins to do the same, then moves the doll next the red house and finally brings it to the side of the yellow house.

The guiding principle which underlies these responses is not very difficult to perceive.[1] The position of the doll is determined solely by its relative proximity or the immediate surroundings and not through logical multiplication of other relationships, or even of several proximities taken together. Thus when the doll belonging to Model A is in a field, the child places it in a field in Model B likewise, though without troubling over which field, what objects happen to be nearby, or even the rotation of the model with all the changes it entails. If the doll is in the stream in A it will be placed in the stream in B as well, but anywhere along it, regardless of external reference points and the reversal of the model. If the doll is both next to the yellow house and on top of the hill, then the child will concentrate either on the hill and ignore the house (Al), or disregard the hill and put his doll somewhere near the house—in which event he may place it near the yellow or the red house without regard to the colour. In neither case does he attempt to logically multiply one property by the other and it is precisely the difficulty that he experiences in dealing with the relationships in this way which is the most striking feature of these reactions.

This inability to carry through a logical multiplication has three interrelated consequences. The first is the virtually exclusive reliance on the elementary topological relationships of surrounding or enclosure ('in' the field or 'in' the stream) and proximity ('near' the house). The second is the failure to co-ordinate projective viewpoints—the child ignores the rotation of the model with its attendant change of perspective. The third is the disregard of euclidean relationships (such as distances in a straight line, angles, etc.), the basis for a co-ordinate system.

As against this, at Substage IIA the child begins to establish a few relationships which, in greater or lesser degree, involve reference objects more distant than hitherto. However, the various points of view are still not co-ordinated, nor is the terrain given an organized structure.

When the doll is placed in the middle of the field in Sector IV of Model A (right of the stream and left of the road), CLA (3; 6), after first putting his own doll in some other field, just as at Stage I, corrects himself (the screen is not now being used) and places it in the same absolute position (i.e., in Sector II, as if Model B were not rotated). This attempt to correct an error, though mistaken in its outcome, indicates the commencement of Substage IIA. CHRI (4; 6), with the screen in position, immediately places the doll at the same point. JAC (5; 1) does likewise, then looks for the connection with the

[1] It should be noted that all responses for Stage I are obtained without using the screen in order to make it easier for the children to compare the models.

road (which is some way off) and places the doll to the right of it, finally replacing the doll on the left of the road.

With the doll placed in the stream (lower edge of Model A) Wil (3; 9) places his doll in the stream also, first towards the centre of model B, then right at the bottom of it. Chri and Mon (4; 0) both do the same.

When the doll is placed beside the yellow house, all the children belonging to this level succeed in reproducing the position, several attempting to determine whether the doll should be placed on the left or the right of the house. In this they are unsuccessful for they fail to take into account the rotation, and hence the reversal, of the model.

As for positions in the fields between the stream and the road, the children take these features into account but fail to locate the correct sector as a result of the rotation. Thus Ude (4; 0), trying to find a suitable position in sector I, places the doll in Sector IV of Model B because like Sector I it does not contain the large hill and is on the left of Model B (like Sector I in Model A).

The advance on Stage I is self-evident. The doll is no longer placed in relation to a single feature (such as a field or a house) but relative to two or three features (road and stream, stream and hill or house, etc.). The child begins to co-ordinate the relative positions of a number of items and left-right, before-behind relations influence his decisions increasingly. However, there is still a failure to co-ordinate the whole complex of these relationships in terms of a specific 'point of view', since the child does not yet understand the effect of rotating the model and judges the orientation of the objects relative to his own position. Moreover, there is no arrangement of the entire group of objects within a co-ordinate system, for reference is made only to two or three items.

In contrast to this, Substage IIB marks the transition from such early attempts at projective and euclidean co-ordination to the complete and universal co-ordination seen at Stage III.

The doll is placed in the field (Sector IV, top right-hand of Model A), to the left of the road and the right of the stream. Mon (5; 0) at first places his doll on the left but towards the top (Sector III) of Model B, then brings it down toward the bottom (Sector IV) and finds the correct spot between the stream and the road.

When the doll is between the large hill and the stream (bottom right-hand of Model A) in Sector III, the same child puts it on the right of Model B (Sector I), then moves it to the correct position on the left. Clav (4; 11) begins in the right sector but passes round the hill before he finds the correct place. Bar (5; 1) likewise begins too low down relative to the hill and the road but then moves the doll further away from the road and nearer the correct position. Pit (6; 3) begins at almost the right spot but when he compares the relative position of the road he is persuaded to move the doll away from it (a confusion induced by Model A), then returns it to Sector III but to the left of the yellow house (again by analogy with Model A). Finally he puts it on the right of the yellow house.

With the doll near the red house, Luc (5; 5) at first puts his doll on the

wrong side of the stream and then corrects his mistake. BAR (6; 6) begins by overlooking this proximity and merely moves the doll from the bottom to the top of the model to allow for the rotation, forgetting the left-right reversal. He then puts it on the right, opposite the house though on the wrong side of the stream. However, he eventually manages to find the right spot. Other children reverse the left-right relation correctly but forget about the reversal of top and bottom in the model (before-behind relation).

Unlike the children belonging to Stage IIA, who ignore the effects of rotation, the present subjects are able to take these effects into account, though only step by step, reversing a single relationship to begin with and only later multiplying it by another. The child's progress in logic often has somewhat paradoxical results, causing him to overlook obvious proximities (as does Bar with the red house) in the course of dealing with more distant features, so that the various relationships tend at first to remain disconnected and consequently incomplete. These momentary incongruities are particularly apparent when it is a matter of taking two distances into account at the same time. The child attends to the first and overlooks the second, then does the opposite. Only after a number of attempts does he hit on an acceptable compromise.

In short, the picture presented by this Substage is one of gradual progress in co-ordination. But this is achieved only through constant trial and error, often attended by sudden changes of mind leading to alterations, both of projective (left-right, before-behind) and euclidean relationships (order and distance along the two dimensions concerned). These early attempts at co-ordination of viewpoints and use of systematic comparisons both stem from the logical multiplication of increasingly numerous relationships. At the same time, this process remains purely intuitive and is not yet governed by set operations.

Last of all appears Stage III, characterized by complete mastery over all relationships. Out of 41 children taking part in these experiments we did not find any below the age of 7 who could determine the 15 positions at all accurately, whereas between 7 and 8 years of age correct answers are obtained for all positions.

From the very beginning of Substage IIIA the rotation of the model no longer has any effect on the child's judgements, the doll invariably being placed in a position determined in accordance with the dual system of reference provided by the two dimensions of the layout. The fact that these responses are forthcoming at such an early age as compared with the co-ordination of viewpoints (Chapter VIII) or vertical-horizontal ordinates (Chapter XIII) should occasion little surprise. In the present experiment there is only a single object to be dealt with, and this has only to be located within an already organized field turned through 180°. However, by reason of this very circumstance it is particularly interesting to observe how, after the initial predominance

of topological relations at Stage I, projective and euclidean co-ordinates develop simultaneously in the course of Stages II and III, reinforcing one another throughout their evolution.[1]

§2. *The layout of a model village. Technique and general results*

With the construction of layout diagrams we return once more to the general and more complex problem which the preceding experiment served merely to introduce. In this second experiment a varying number of objects have to be arranged at one and the same time, taking account of their positions relative to one another and within the general outline of the model or the sheet of drawing paper.

Two methods were mainly employed, the first being applied to children of all ages. This consisted of asking them to draw the object from a certain point of view and on a reduced scale. The second, aimed chiefly at the younger children and also used as a control, consisted of reproducing the model with the aid of real objects. To appreciate the reasons dictating the choice of these two methods it should be borne in mind that the main aim of this last chapter is to show that in the development of the child's idea of space projective and euclidean concepts are interdependent. In other words, to demonstrate the general synthesis of all the concepts investigated in the course of Chapters VI to XIII.

In practice, the construction of a diagram or plan entails: (1) the selection of a particular point of view, together with certain pictorial conventions intended to express it. For example, a map has South on the lower edge, West on the left, and so on. The plan of a village or a district may indicate buildings as seen from above or in oblique downward perspective, etc. Thus from the very outset, all topographical representation involves projective features. (2) A system of co-ordinates —whose function should be self-evident—along with the implied concepts of straight lines, parallels and angles. (3) Reduction to a specific scale, which entails the concepts of similarity and proportion. Hence the construction of a diagrammatic layout incorporates in a single entity all the concepts examined previously, and at the same time shows how they are related one to another.

However, for the very reason that these ideas are interdependent it is advisable to commence with the most flexible and wide-ranging methods of enquiry, together with specialized control experiments

[1] It is interesting to note that when M. H. Aebli placed Model A before adults, who were allowed only a fraction of a second ($\frac{1}{8}$ sec. on average) to decide on any one of the fifteen positions for the doll on Model B, all subjects reacted in exactly the same way as did the children of Stage II. Of course, the positions the doll was given were not governed by topological relationships (Stage I) since the adult's space is euclidean and projective in character. Nevertheless, the very short period of presentation prevents operational co-ordination being brought into play, with the result that in the course of the subject's trial and error reactions, the same mistakes of inversion, inability to take account of more than one relation at a time, etc., were apparent, just as with the children at Substage IIB —and even IIA.

enabling some of the factors operative to be investigated separately. The principal method employed here consists simply in arranging a number of objects (such as a church, houses, trees, etc.) on the table or the floor, and asking the child to draw them on a sheet of paper smaller than the model, either from a point directly above (a bird's eye view) or at an angle of 45°. As for controls, a number of supplementary experiments were performed, chosen entirely in accord with the needs of each interview. These ran roughly as follows.

Firstly, as soon as the child has completed his first drawing, all the objects are removed from the model base. He is then asked to replace them, using his drawing as a guide. This is an extremely useful control experiment and, if the model is restored and the original experiment repeated, often results in improved performance or alternatively, the nature of the errors is brought out more clearly. Secondly, the original model may be simplified, or the task reduced to drawing only three objects from different

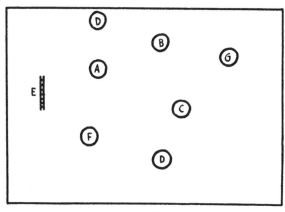

Fig. 28.

Arrangement of eight objects in the layout.

points of view and then examining the angles between those in the pattern thus formed. Finally, a number of drawings may be offered for comment and comparison.

Nevertheless, the chief difficulty present in these methods stems from the rôle played by the child's own drawing. It is therefore essential (especially with the younger children) to be able to replace this task by that of actual construction. For this purpose a model village is arranged on a cardboard base (see Fig. 28) and the child is given another piece of card and a set of identical objects to arrange in the same way. In this case the question of proportion can be ignored, or alternatively cardboard and objects can be made smaller than in the model. Obviously, the cardboard model must not contain any lines or reference points except for the edges of the card and the objects themselves. Furthermore, the child may be given the same number of objects as there are in the model or more, so that he has to choose from among them.

As regards the actual arrangement of the objects, this is best kept unchanged throughout for children of all ages (at least for certain objects should any simplification be necessary) to enable one stage to be compared with another without excluding variations, introduced as controls.

With the aid of these various methods the following reactions were obtained. During Stage I (lasting until approximately 4 years) neither spatial nor one-one correspondence is achieved between the two sets of objects. Thus if the child is offered more objects than are to be found in the model he does not pick out the same number from the collection, and those he does select and arrange are not given corresponding positions or placed in a similar order. At the most he observes certain proximities, though the objects are usually bunched up together or strung out in line in a different order to those in the model.

During Stage II (from 4 to 6–7 years on average) the child picks out pieces which do correspond to those in the model and tries to locate them in similar positions. Nevertheless, he fails to locate a single position according to a system of reference, because he cannot 'multiply' the relationships of distance and order along the three dimensions. Using the method of actual construction, the child creates small groups of objects which are not linked one with another but are organized within the group, usually in pairs. This growing organization results either from viewing the items one by one (sometimes producing reversals, when the child begins by looking to the right and then starts his construction on the left) or from resemblances between items (trees grouped together, for instance), or from bringing widely separated objects together, while occasionally the child takes a single object as a central point of reference and works outward from it. The drawings follow a similar principle, with objects arranged in the same order as in the model but only along one dimension, just as in Stage I (in this respect there is a disparity between drawing and construction). During Stage II distances are ignored as well as perspective. As for systems of reference, there is still no co-ordination between the arrangement of objects in relation to one another, and to the external surround provided by the card on which they stand. Thus a group of objects will be crowded together on the left-hand side or toward the bottom of the card while other items are placed in total disregard of the position occupied by the first group. This state of affairs may be taken as typical of Substage IIA, whereas by Substage IIB certain sets of relations are established in an intuitive way, thereby indicating the approach to Stage III.

During Stage III (from 7 to 10 years) a system of reference is gradually built up, first through logical multiplication of the qualitative relation of order, beginning with the orientation of left-right, followed by that of before-behind, distance being only partly taken into account. The general arrangement based on these two sets of relations soon

becomes roughly correct, though detail errors persist for some while. Moreover, whenever the drawing has to be altered to suit changes in the model or to incorporate new items, significant difficulties appear. The child also seems to find it hard to relate to other systems the particular set of reference points he has adopted to construct his drawing. The treatment of perspective also undergoes a gradual improvement.

Some rather odd compromises occur at the beginning of this stage which are well worth noting. When drawing the model in plan view the child only draws the roofs of the houses but he shows them in side elevation, while certain other objects—though not all—are shown in perspective. In addition, when a change of the observer's viewpoint suggests changes in the relative positions of different objects, the child still has difficulty in reversing the left-right, before-behind relations. On the other hand, during the next substage (IIIB), the frame of reference attains a stable form, so far as qualitative relationships (the twin relations of order) are concerned, together with the co-ordination of viewpoints, though precise judgement of distances is still lacking.

Not until Stage IV (in conformity with the conclusions of Chapter XIII §6. as regards conventional reference systems) is the concept of a diagrammatic layout acquired in a broad and general way. That is to say, complete with accurate measurement of distance and proportional reduction to scale, in addition to the relations already mastered.

§3. Stage I. No spatial correspondence except for a few elementary proximities

The initial reactions obtained at this stage are worth close examination since they form a link between purely arbitrary arrangements and a genuine attempt at spatial correspondence. Unfortunately, the child has as yet no means of achieving such correspondences except for the most primitive topological relationships.

JEA (3; 3) is shown a model with eight objects disposed about the four quarters of an oblong piece of cardboard. (Method used is that of simple reconstruction, the same scale, with more objects to choose from than in the model). Jea crowds 14 objects into the lower left-hand corner of his cardboard (that is, no more than an eighth of the total surface) without any order and packed together pretty closely. He would thus appear to be somewhat frightened of the empty space at his disposal. As for the six surplus objects, some are duplicates of others already on the board (there is no tally between the numbers of these in the model and in the copy) while others are absent from the model (so that there is no logical correspondence either). Some objects appear to be in correct proximity though this may well be accidental.

BER (3; 1) shows the same tendency, using the same method, to crowd the objects into one corner of the board, and a similar contempt for distances and points of reference. He too introduces objects not belonging to the model. On the other hand, he makes a distinct effort to reproduce the proximities

between corresponding objects. Thus, a fence standing near the left edge of the model is placed on the same spot in the copy, while two animals are placed near a tree, one of which is next to a tree in the model. But whereas there are only two trees in the model—not adjacent to one another—Ber lines up four trees in his copy since he fails to distinguish spatial and logical proximity in bringing together objects which are conceptually similar.

CLA (3; 11) exhibits two interesting responses to the same method (seen also in many other cases). In the model the fence stands close to the left-hand edge of the board. However, since Cla's card is on the left of the model he puts the fence on the right-hand side to bring it as close as possible to the fence in the model. This done, he forgets all about it and proceeds to stand all the other objects in a more or less vertical line, some proximities being reproduced (e.g., a pair of horses) but without any overall, systematic organization. He likewise includes in his collection several items not found in the model.

JAC (4; 0) is asked to make a drawing of a piece of countryside having a lake in the right foreground (with a stream crossed by a bridge running into it), some trees in the left background, a green meadow (to the right of them), a fence (left centre), a brown field (left foreground) and a road running diagonally across the whole layout, separating the lake and the brown field from the trees and the meadow. Instead of using the whole sheet of paper on which to portray the landscape he draws the items lined up in pairs; two trees, the field and the fence, the road and the lake, and so on, all along the lower edge of the paper.

These initial reactions corroborate what has been maintained all along, as regards the primitive character of the topological relation of proximity. In fact, this particular experiment almost makes it possible to identify the actual point at which the distinction is first made between topological and logical or pre-logical relations.

The choice of subject-matter has the effect of making the present chapter a summary of all that has been observed so far. Let us therefore begin our discussion by recalling the distinction between logico-mathematical and spatio-temporal relationships. The former deal with groups of objects solely in terms of resemblances and differences between their members (i.e., in terms of logical classes, relations or numbers) whereas the latter deal with objects as such, whether simple or complex (groups of objects being treated as complex objects within a single configuration). In this respect, the objects in the landscape which the child has to draw or copy may be considered either a logico-mathematical (classes or numerical collections of objects) or a spatial totality (objects within a single configuration). And in order that a copy or a pictorial diagram may be made, these twin aspects of the complete landscape have to be envisaged at one and the same time. In other words, the objects must be identical (logical correspondence) and arranged in an identical pattern (spatial correspondence).

Now the line dividing logico-mathematical operations (or correspon-

dences) from spatial operations (or correspondences) lies precisely between concepts of resemblance (or difference), the origin of logico-mathematical relations, and those of proximity (or separation), the origin of spatial relations. Thus two objects may belong to the same logical class, however far apart spatially, if they are similar. And two objects are spatially related so long as they are adjacent, however much they may differ.

From this standpoint, the chief importance of the reactions of Stage I lies in the fact that since these children cannot achieve either logico-mathematical or spatial correspondences (at least, as far as the present experiment is concerned) they are quite unable to distinguish between spatial proximity and logical resemblance (or between separation and difference). Thus Jea puts six surplus objects on his copy, some of which have no relation to those in the model, so that he fails to observe either logical or numerical correspondence, and he is then unable to arrange them in any sort of spatial order comparable to that seen in the model, whether in one or many dimensions. Instead, he packs all the items into one corner, covering only about an eighth of the available surface. Why does he crowd them together in this way? Is he trying to indicate that they form a logical and numerical collection, or is he trying to suggest that they are spatially related? It is impossible to decide in the case of each item whether or not he is actually trying to indicate proximities or whether those he does produce are the effect of pure chance. Nevertheless, it seems in general fairly clear that he is trying to express both spatial and logical relatedness, though without distinguishing between them. As a result he forms a collection which is midway between a logical group and a pattern of neighbouring items, while his distrust of empty space (cf. Chapter XIII. §6.) expresses an overriding need for both spatial and logical cohesion.

On the other hand, Ber, who at first reacts in a similar way, clearly endeavours to copy certain proximities in detail. He puts the fence next to the edge of the cardboard and an animal next the tree, just as in the model. But it is interesting to notice that he goes on to arrange a group of four trees (twice as many as in the model) on the basis of simple identity undifferentiated from spatial proximity. As against this, Cla and Jac introduce reactions indicative of a transition from simple proximity to sequential order (see Chapter III), though this is no more than a linear order and does not correspond with that seen in the model. These children, Cla in his construction and Jac in his drawing, merely arrange the items seen in the model (some being overlooked, some introduced from outside) in a linear series, some with correct proximities and others without. Here the spatial pattern is beginning to be clearly separated from the logico-mathematical structure, which is an indication that the lower limit of Stage II has been reached.

§4. *Stage II. Partial co-ordination*

Between the ages of 4 and 7 some advance toward co-ordination of small groups of objects takes place, though the child is not yet able to establish any general relationships. We may begin our discussion with some examples taken from Substage IIA, using the method of actual construction. The reactions so obtained are slightly more advanced than those resulting from the method of drawing.

MAR (4; 0). Given more objects to choose from than there are in the model, he responds at his first attempt just as did the children of Stage I, except for a tendency to make use of a larger expanse of the cardboard. One proximity is rendered correctly along the top-bottom axis of the card. In the course of a second attempt, when he is given the objects one at a time, he puts one house roughly central as in the model, and arranges a second house, a tree and an animal on the left of the first house, which he uses as a reference point, working from top to bottom of the model.

AEN (4; 1) likewise, after beginning in much the same way as the children of Stage I, succeeds in forming two separate groups of three objects. Each of these is aligned in the order in which the objects were perceived in the model and occupy the whole area of the board. But there is no overall relationship between each of the two groups, nor between them and the edges of the board. In one group, the fence, a house and a tree form an angle or a roughly curved line, which is more or less correct. In the second, a house, a tree and an animal lie in an oblique line across the board.

DEL (5; 3). Having placed the fence correctly on the left, he arranges the remainder of the items in a roughly circular order which corresponds to the movements of his eyes when looking at the items in the model. Several proximities are rendered correctly. However, the whole pattern lies on the left-hand side of the cardboard and thus bears no relation to the edges of the board. At the second attempt Del makes a notable step forward. Items located near the edge are lined up in the correct position from 1–5 before the central object, whose location appears to be determined by these five objects, is put in place. The remaining items are arranged without any order.

LIL (6; 9) fixes the position of one item and from this proceeds in two directions, first of all lining up three items (which is not the case with the model) and then bringing two other objects together to form a pair, thereby ignoring the fact that they are separated on the model. The whole arrangement is shifted down towards the bottom of the card and the two groups have no connection other than the common element from which they diverge.

GEN (6; 3) forms pairs of objects not co-ordinated with each other, one item being placed alone (in error) and three others placed in a vertical line (also incorrect), the whole collection being grouped on the left-hand side of the board.

Here are some examples with the method of drawing:

CHRI (5; 4). The model has a cottage in the foreground, a pine tree well to the rear and a house on the right, half way between the two in depth. These

have to be drawn "just as they are arranged in the model". The resultant drawing shows the large house on the right, the pine in the middle and the cottage on the left (in a single line). Similarly, three pine trees forming a triangle are rearranged in a line and a house standing behind them is simply added to the right of the line.

BAG (5; 4) uses the model described in connection with Jac´(§3.). He draws a grass border all round the paper, three trees in a vertical line, a lake with a stream on the right and a square field on the left. But he leaves large empty spaces between these items and does not reproduce the road which runs diagonally across the model, so that his drawing can hardly be described as a layout in depth.

PHI (6; 0). For the same model he arranges the following items, from left to right along the bottom of his drawing paper: a blue band (the lake) and a green band (the meadow), above which are two brown strokes (the road) and three trees. Asked why he does not use the rest of the paper, he replies "*It's too difficult; I don't know where to put them*".

KRA (6; 1). The first model he is shown has three houses ranged one behind the other, each with a pine tree on its right. To the right of this group is a church with a bridge crossing a river in the foreground. The bridge and the river lie in the foreground midway between the church and the nearest of the three houses. Kra is given a piece of paper some 30×40 cm. in size on which to copy this layout and he arranges the eight objects along its lower edge, from right to left thus: the three houses (on the left in the original), the bridge, the church and lastly the three trees. While he is thus engaged we ask him (pointing to the model), "Where is this house (the second)?—*In between the other two*—And that one (the first)?—*At the edge of the others*—Where is the bridge?—*Beside the church* (which is correct, leaving depth out of account), etc.". (See Fig. 29.) When the drawing is finished he is asked, "Is it drawn the way it's arranged here?—*No, because I can't draw like that*—Try again. (He is given another sheet of paper)—*No, I just can't manage it*". We then proceed to pull the village to pieces and invite Kra to reconstruct it as it is shown in his own drawing. He reproduces the row of eight objects just as he has drawn them, but without realizing it, places them in reverse order (just as he was able to execute a perfect signature in mirror writing).

Using a layout of only four objects (tree, church, house, and bridge) scattered from left to right and disposed in depth, seen from directly above, Kra again draws them in a straight line and seen in front elevation. "Is it possible to see a village from above looking like this?—*No, you can only see the roofs*—But what have you drawn there?—*I wanted to draw the whole house. And the church as you see it complete*—Look carefully and draw what you actually see—(he produces the same type of drawing again)."

Finally, he is shown a single house standing in the centre of the table, with a pine tree in one corner. Kra is asked to draw this pair of objects from each of the four sides of the table by moving around it and drawing what he sees (so that the problem of imagination is not involved as in Chapter VIII). He produces: (1) The tree on the left (correct) but in the foreground (wrong). (2) The tree on the left (wrong) and in the foreground (correct). (3) The tree on the right and in the foreground (correct). (4) The tree on the left and in the

foreground (correct). Thus, for the left-right relationship, there is one error out of four attempts and the tree is always shown in the foreground. As regards drawing 2 he is asked, "And the pine tree, where do you see it, before or behind?—*I see it further back but I can't draw it behind. I would have to pierce through the paper*". And for position 4 he exclaims, "*You've moved the house*—No, we haven't. We haven't touched anything. "*You've turned the table top round!*—No, no. Who turned? Didn't you yourself turn?—*Oh, of course!*".

PAC (6; 0) is a little more advanced than Kra for he progresses from merely lining up items to arranging them along a curve in depth. He is shown a model having a church (A) on the right. To the left of the church and to its rear stands a cottage (B). Further to the left but nearer the foreground is a large house (C), while further to the left is a third house (D), and on the extreme left, behind all the rest is a bridge (E). Pac forms a series midway between a simple line-up and the beginning of representation in depth. The church (A) is a little to the rear, then come items (B, C, D) and (E) standing adjacently in a slightly advancing curve.

Following this, (B) is placed on the left and in front of (A, C, D), which are

Fig. 29.

Example of a layout shown by simple alignment (Kra's drawing).

ranged one behind the other with (E) on the right and to the rear. Pac reproduces this order, placing (A, C and D) correctly behind one another, but draws (B) in the same depth plane as (A), and (E) in the same plane as (D).

These reactions show a distinct advance on Stage I in a number of ways, and are also in line with our general findings. In the first place, logico-mathematical correspondence is now established correctly enabling spatial correspondence based on proximity to be distinguished from the former. In the second place, and as a direct consequence of this, the child is now able to keep the true sequence of items in mind by combining proximities, which he does even when replacing the two-dimensional arrangement with objects placed in line.

In the third place, the petty groups which he forms indicate the presence, not only of relations of proximity, order and surrounding, but also of simple euclidean concepts such as straight and curved lines, parallels and angles, enabling some features of the model to be reproduced and certain projective relationships (left-right, before-behind) associated with the viewpoint of the observer. Yet these reactions, though an improvement over those of Stage I, are nevertheless subject to various limitations important to note.

Firstly, it is astonishing to observe the difficulty which the children experience at the beginning of this stage in using all the space at their disposal and spreading out the objects to the same extent as their counterparts in the original. This effect is apparent with the method of construction (in the case of Mar, Del, Lil, and Gen) where the whole collection is shifted to one side or toward the lower edge. In the drawings the effect is even more noticeable (the drawings always being slightly behind the constructions) since the child arranges the items either in a straight or curved line, or else spreads them over the entire sheet and leaves large spaces between them (see Bag).

This timorous attitude towards empty space, which the child seems loth to occupy, is no doubt due, not only to the need for cohesion distinctive of his early attempts at spatial organization (as noted in §3.), but also to the stronger influence of perceptual as compared with operational factors. In this connection, it will be recalled that children belonging to the same level (see Chapter VI, Section I) were able to form straight lines parallel with the edge of the table but could not break away to form a line across one corner. In the same way, the present children appear to grasp at the edge of the board or the paper and use the objects placed or drawn in relation to it as a kind of perceptual base which they dare not lose contact with in extending new relationships across the empty space.

However, this tendency is only the expression of a more serious shortcoming. Their failure to utilize the whole of the surface available means that they are not yet employing the surround as a frame of reference from which to obtain co-ordinate axes. It is true that they establish relations between one object and two or three others (in terms of angles, straight lines, etc.), but the little groups so formed are not linked with one another. As for the surround, it plays no part at all, except in the case of objects placed near the edge (and to act as a perceptual guide as noted above). Hence it is impossible to speak of such a thing as a diagrammatic layout existing at the present level. The child merely constructs a few incomplete groups composed of objects detached both from the general collection and its setting.

Only in one case are the objects co-ordinated in a single whole, and this is when they are placed in line. But this reaction is no longer seen in the actual constructions at this level (except for Del's circular arrangement), though it is often found in the drawings where it assumes a rectangular form (Chri and Kra) and later produces some curious curved patterns (Pac). The reason for the persistence of this reaction in the drawings is not difficult to understand, and it also explains the absence of co-ordinates and a general frame of reference. Although the child is familiar at this stage with three dimensions from the standpoint of the topological relations of surrounding (cf. Chapter IV), he has not

435

yet organized his euclidean concepts in terms of three dimensions. In other words, just as at the present stage he can only associate perpendiculars and parallels with particular figures and cannot isolate vertical-horizontal axes (Chapter VII. §3.), so with the items of the model that have to be rendered by a diagrammatic layout he is unable to deal with both the width and depth of the pattern and tends to reduce everything to a single dimension. Kra is perfectly well aware that his arrangement is not like the two-dimensional model but he "cannot manage" to "draw like that", though the curved line produced by Pac is a step towards two-dimensionality, a compromise between the straight line formed by Chri and Kra and a layout in depth.

A further difficulty, in addition to those connected with co-ordinates and dimensions, has still to be dealt with. This is the projective problem of arranging items in perspective and the choice of the pictorial convention locating the background at the top of the drawing. In this connection, although the children now make use of relations between 'left' and 'right' viewpoints they sometimes reverse them unwittingly (cf. Kra at the beginning) and invariably fail to co-ordinate the different points of view (cf. Kra at the end). As for before-behind relations, the same child Kra perceives that some objects lie in the background but cannot express this in his drawing. "I can see it further back", he says, "but I can't draw it behind. I should have to pierce the paper". Thus at this stage projective co-ordination makes no more progress than does the development of a co-ordinate system, for in the absence of general operations of thought, both remain confined to a few detail relationships.

The reactions obtained at Substage IIB are midway between this limited and incomplete type of co-ordination and the logical multiplication of relationships characteristic of Stage III.

CHEL (5; 10) reproduces the model with an actual construction. He begins by stationing four objects in the form of a quadrilateral, imitating the original pattern fairly accurately. He then places three more items in relation to one of the first four, thus making a second quadrilateral linked with the first. One item is left over and this he places on the right, with reference to the edge of the card alone, so that it is isolated from the other seven objects on the left of the card.

PIE (6; 8) is asked to draw the model which has a church on the right, a house on the left and another house in between but in the background. He draws all three in the correct order, but in line. On the other hand, during a second attempt with three new objects he places the object located in the background at the top of his paper. He succeeds again in a third trial, remarking of a house which he places at the top of the paper, *"It's near the sky"*, even though he sees it in the background and on the same level in the model. Despite success in indicating the depth when distances between objects are considerable, he fails to do so when they are slight. He is also unable to draw

an oblique series of increasingly distant objects, merely placing them along two planes.

As for reductions to scale, he draws the churches and houses smaller, not intentionally, but because his paper is smaller. "*I made them smaller, but it isn't right. You should make them the same size* (as on the model)—But if you make them as big can you get them all in?—*You can put them all closer together but not smaller*". However, when the sheet of paper is larger he signs his name in larger letters: "Why?—*Because the paper is bigger*".

PER (7; 0) begins, as did Per at Substage IIA, by drawing the items in a curve to suggest depth. After this, he places a pine tree behind the houses: "*It's further away, not next door, but further away*". On the other hand, he draws three items stationed one behind the other correctly except for reducing their size according to perspective. With three houses arranged in a triangle he fails to place the most distant far enough to the rear but afterwards points out where he should have placed it.

Nine houses arranged in the shape of an ellipse around a field in which are a few pine trees (bird's eye view). He draws the upper items in a straight line and the lower arranged in a gentle curve. Only the roofs of the houses are shown, but in front elevation.

It is apparent that although these children are beginning to link groups of objects together in their constructions and indicate the two dimensions in their drawings, they do not get as far as co-ordinating everything in a single whole, from either a projective or euclidean standpoint. This is due, in the former case, to failure to link the objects with the surround, and in the latter, to failure in distinguishing between different perspectives (vertical and oblique viewpoints, for instance, always being confused). In addition, the notions of similarity and proportion do not appear as yet, even in the case of children who, like Pie, reduce their drawings to scale without realizing it. This last observation is also in line with what has already been noted with regard to Substage IIB in other chapters.

§5. *Substage IIIA. Beginning of general projective and euclidean co-ordination*

The sum total of the changes which projective and euclidean concepts undergo at Stage III are already fully apparent by the age of 7 or 8. With the method of construction the child can now copy the model perfectly except for exact measurements and reductions to scale, whilst in the case of drawing he now begins to arrange items according to the two dimensions of the model and corresponding to definite points of view.

AR (7; 0) copies the model by means of a drawing on the same scale in which all the sub-groups appear to be linked together correctly. He works by arranging objects in pairs, linking each new set of relationships with those preceding, his procedure being more akin to a kind of inductive, rather than

simultaneous logical multiplication. He even attemps to make a few measurements on his own initiative, always starting from the edge of the cardboard and dealing with only one dimension at a time. After several trials he finally produces a more or less accurate diagram, though some of the distances are rather inaccurate, an error which is intensified when he tries to reduce the drawing to scale.

GON (5; 10) at once succeeds in locating six items in his drawing, though he is unable to preserve the correct distances. When one of the objects in the model is moved, however, Gon can only draw it in its new position by means of a series of approximations, using only a single object as a reference to begin with and then correcting by comparison with other items. "Watch where I'm putting the church now—*Behind the big house*. (He makes a drawing). *It's no good, I've drawn the house too far away and too high*. (He starts again)". For the bird's eye view he draws the roofs of the houses only, but with a perspective corresponding to a viewing angle between 45° and the zenith. When he is asked to walk round a house stationed in the centre of the board with a pine tree in the corner, drawing them from four different positions, he does so, reproducing the left-right, before-behind relationships correctly. "Has anything been changed?—*No, of course not. It was I, myself, who turned round*". He is asked to describe the position of the pine tree (in the foreground of the house). "How would you tell me where the pine tree was if I couldn't see it?—*It's at the beginning of the house*—In front?—*No*—Behind?—*No, at the beginning, I can't explain*".

TIS (7; 1) also arranges the items in his drawing along two dimensions, but makes a few mistakes. For instance, a pine tree is shown on the left and in the foreground instead of in the rear. On the other hand, left and right are no longer confused, distances from front to rear are roughly correct though slightly contracted. His verbal expressions include, "*Nearer the pine tree; the other side of the church; on the right; in the middle*". The bird's eye view is less detailed and more schematic, though it does not yet express the correct perspective. Relative positions of objects are indicated correctly.

LEP (7; 2) shows the two dimensions clearly with occasional errors and confusions of viewpoint in the case of some items. Distances are roughly correct for width but depth is much reduced. Verbal expressions, "*There between the two; it comes after and goes next to the church; to the left of; lower*". Asked to reduce the drawing to quarter scale, he brings the items closer together but leaves them full size. He endeavours to keep the relative positions unchanged but cannot find room for a pine tree and is forced to put it somewhere else. The scale drawing also lacks depth as compared with the full size original.

ANK (7; 4) draws the items as seen from 45° in correct relative positions but with the distances separating them rather inaccurate. In the bird's eye view these are somewhat more exact and he begins to evince some feeling for perspective as regards the roofs, though he cannot apply this generally. For the model with a house in the centre and the tree in one corner the four positions are correctly indicated. "*The pine tree is in front. The tree hasn't changed places, it's only I who have moved*—And for me?—*It's at the back because you are on the other side*".

SCHA (7; 5) still makes a few mistakes over before and behind (in the 45° perspective), though for the bird's eye view he produces a slightly more advanced perspective than the previous children. All the roofs are rectangular and are no longer drawn as front elevations or three-quarter views.

DAM (7; 6) draws the 45° position correctly and for the bird's eye view produces a perspective readily distinguishable from the former. He thus combines the achievements of Ank and Scha. On the other hand, he tends to under-estimate distance in depth (which alters the height of his drawing) and over-estimates the width so greatly that he has to call for another sheet of paper on which to complete his drawing.

FRAN (8; 6) reacts similarly to Dam. Verbal descriptions include, "*Nearer the bottom of the paper; further forward from the house; in the middle*".

PER (9; 0) similar reactions. Correct positions and perspectives. His verbal descriptions indicate the beginning of formal co-ordinates and judgement of distances: "*Just beneath the line of the house; above the roof; the "space between' is larger; just at the foot of, etc.*".

On the other hand, for the quarter scale drawing he makes the houses too large, though he notices it afterwards (which anticipates the reactions of Substage IIIB, as do the subsequent remarks): "*It would have been all right if everything had been slightly shorter*—Could the houses have been made four times as small?—*Yes, that would be quite easy*". But in making an enlargement of his first drawing he fails to increase the various distances sufficiently so that the resulting diagram is too small. Again he realizes his error, "*The things are too close together in my drawing. It would have been better to spread them out a bit more*".

GARD (9; 5). Positions shown roughly correct: "*The house is further forward as compared with the pine tree*, etc.". But in reducing to quarter scale he at first leaves the houses full size and merely draws them closer together, then strikes his head when he realizes there will not be enough room. He tries to overcome the difficulty by bringing them closer together still, but this leads to errors with the before-behind relations.

The difference between these children and those of Stage II is self-evident. Equally striking is the parallel between these relatively spontaneous reactions and those obtained in the various experiments dealing with projective space, co-ordinate axes of euclidean space, similarity and proportions.

In the first place, it is no longer simply a matter of arranging petty groups of objects unco-ordinated with each other or with the external surround. On the contrary, it is possible from now on to speak of all positions being co-ordinated within a single whole, embracing both the surround and the objects located in it. In this respect, Substage IIIA clearly forms the point of departure for constructing co-ordinates, just as in Chapter XIII it denoted the start of construction of horizontals and verticals.

Thus with the method of actual construction, the children arrange all the items without difficulty, simply by relating them to the edge of

the cardboard (see the case of Ar). Only the vertical distances and the reductions to scale remain inaccurate. As for drawing, whereas it has trailed in the rear of construction, it has now almost caught up, at any rate so far as the child's intentions are concerned. It will be noted that, unlike the children of Stage II (including those of Substage IIB), the present subjects can immediately arrange the items in their drawings in terms of left-right, before-behind relations (the top of the drawing indicating the background). Of course, detail errors still persist, especially with regard to depth. Nevertheless, these drawings are genuine two-dimensional representations, whereas at Stage II the items were merely strung out in a linear series (or slightly curved to indicate depth), or else dispersed over the whole sheet (see Bag.) with no distinction between foreground and background. Moreover, from the moment of starting to draw, it is evident that the present children relate the items to the surround and distribute them according to the size of the paper, just as they are arranged in the model. The tendency to relate the items to the surround whilst at the same time arranging them with reference to one another in two dimensions is a new and significant development. The earlier 'fear of empty space', explained as a perceptual clinging to one side of the surround, is therefore superseded by the establishment of conceptual relationships and this indicates the achievement of a co-ordinate system.

These children are naturally able to imagine spatial relations in a more developed way than they can depict in their drawings, and they constantly show that they are striving to master relationships which the drawings only express somewhat later. From Gon, who describes the position of a tree in the foreground of a house by saying, "It's at the beginning of the house . . . at the beginning . . . I can't explain", to Per, who locates an object "Just below the line of the house", all the children show, with varying degrees of clarity, that they are building up a real network of interconnections and cross-references which already comes close to a co-ordinate system.

Closely bound up with this comprehensive organization of euclidean space, the beginnings of differentiation and co-ordination of projective viewpoints (as studied in Chapter VIII) are likewise apparent at Substage IIIA. With each of these children, a distinct improvement in the treatment of perspective is evident, in that the bird's eye view begins to be clearly distinguished from the 45° perspective. In this connection the drawings illustrate every stage of development, ranging from roofs shown in lateral section (detached from the rest of the house) to others shown from above with the ridge running down the centre. Again, when changing their position (in the experiment with the house in the centre and the tree in one corner of the board), these children evince a growing awareness of the essential relativity of their own viewpoint

in exactly the same way as did the children belonging to the same stage in Chapter VIII (viz., "The tree hasn't changed its position, it's only I who have moved").

As for the connection between the developing projective co-ordination and the euclidean reference frame, the present situation is directly comparable to that seen in the course of the joint development of the concepts of duration and temporal succession.[1] In some cases, perspective is more advanced than systems of reference (Scha), while in others the reverse holds true (Tis). But for the most part, both groups of ideas develop at about the same rate. This is hardly surprising since, on the one hand, a system of reference embraces a view of the whole from a particular viewpoint (remote enough for perspective lines to be parallel). On the other hand, individual perspectives (45°, for instance) are relative to the positions of the observer and the objects, and this the subject can only express by locating them within a total spatial field defined by a co-ordinate system. Whether the first is achieved before the second or the other way round, sooner or later one will inevitably react upon the other.

Despite these important advances, however, there remain three major deficiencies which are not made good until Substage IIIB. This again is in line with our findings as regards similarities and proportions, and also with what may be seen elsewhere, in dealing with the subject of measurement in two dimensions.[2]

Firstly, the child cannot gauge distances accurately, even though he tries to do so in greater or lesser degree (cf. Ar, Gon, etc.). Apart from this difficulty, which forces him to rest content with rough estimates, the results quoted above illustrate a curious reaction, general enough to warrant being termed a constant error. While transverse (left-right) distances are rendered fairly accurately, the distances in depth (vertical in the drawing) are considerably underestimated. In the case of the 45° view such a distortion might be ascribed to lack of understanding of perspective applied to distance. However, the error is also present in the plan view, and furthermore, is too great to be explained as a perceptual illusion (vertical-horizontal illusion in drawing, etc.). Consequently, we are more inclined to think that what is operative here is a vestige of the tendency to place objects in line when reproducing the model, a reaction current at Stages I and II. The example of Dam, who requires an extra sheet of paper to complete his drawing, shows distinct traces of this earlier reaction. The actual tendency to rate width before height or depth is doubtless due to the normal mode of function for perceptual activity, lateral comparisons being simpler to achieve than vertical ones.

[1] Cf. op. cit., *Le développement de la notion de temps chez l'enfant.*
[2] Op. cit., *La géométrie spontanée de l'enfant.*

The second difficulty, most probably linked with the problem of measuring distance along two dimensions, arises when the child tries to reduce his plan to scale. He leaves the sizes of the objects unchanged, merely placing them closer together. Besides altering the proportions between the sizes of the items and the distances between them, it also results in impossible arrangements (cf. Lep, Per and Gard). It should be noted in addition, that when the child tries to reduce to scale, his tendency to arrange the elements in a single line becomes accentuated (cf. Lep), while with enlargement the objects remain laterally too adjacent (cf. Per). This is again what has already been seen in studying similarity of rectangles (Chapter XII. Section II), but the other way round. Whereas the children described there lengthened rectangles in course of enlarging them—as a result of their idea of an ideal rectangle—the present children do exactly the same in the course of reducing them—due to their tendency to arrange objects in line, itself an outcome of lateral comparison. Thus in both cases, the obstacles to full understanding of the concept of similarity, though operating in opposite directions, are nevertheless distinctly related.

Finally, if the position of some item is altered on the model, so that the child has to alter his diagram to suit (cf. Gon.), a curious reaction is obtained which reveals the difficulties under which he labours in developing his systems of reference or co-ordinates. The child can only modify the layout through a series of approximations, beginning by relating the new position to a single object, then relative to a second, and so on. He is unable to take account of all the relationships simultaneously. This type of behaviour is exactly like that found in connection with forming series, though occurring somewhat later since the problem of co-ordinates is considerably more complex. The child of $5\frac{1}{2}$–$6\frac{1}{2}$, though he can construct a series of heights mentally, finds it very difficult to insert later elements, because the order of the series rests upon a global perceptual pattern rather than an operational system. A system of co-ordinates is at first no more than a double series of sequential positions, one horizontal and the other vertical; in other words, a multiplicative rather than an additive system. But because the principle is the same, it follows that a similar difficulty is experienced over the mental configuration which at this stage still underlies operational co-ordination.

§6. Substage IIIB. Mastery of distances and proportions

Once the sequence of positions along the two dimensions has been determined, the next problem to be solved is that of the intervals between these positions; that is, the problem of distances. This problem is, of course, present at Substage IIIA also, but it will be appreciated that the child directs his main effort toward reproducing the items in

the proper order, especially in width and depth, before he brings it to bear on intervals as such. On the other hand, since the problem of order in two dimensions—in other words, the problem of co-ordinates —is usually solved by Substage IIIB, the main improvement centres around intervals or distances.

Along with more careful judgement of distances, another important advance is in reducing drawings to scale. Whereas the children of Substage IIIA simply push the items closer together without reducing their size, those belonging to Substage IIIB reduce the sizes of objects as well as the intervals between them. Now it goes without saying that a feeling for proportions lies very close to a regard for distances, since the transition from a model to the very simplest drawing implies a reduction, whilst a plan is deemed 'well-proportioned' if the distances found in the model are reduced to scale. And in fact, it was shown in Chapter XII that proportions emerge at this same stage, in the case of simple ratios such as 1 : 2 and 1 : 4, as a result of dimensional relations being integrated with qualitative similarities based on parallels and angles.

Here are a few examples of these new reactions.

BAN (9; 5) draws a plan with objects positioned correctly along both dimensions, and with the distances correct, although he is unable to explain satisfactorily what he is doing while making the drawing. Asked to draw it again on a sheet one-quarter the size (without being told the actual scale), he reduces the sizes of the objects as well as the distances by eye alone. The result is a plan similar to the first except for a few minor details.

DUB (9; 9) makes a drawing of the model seen from 45° with all positions correct in both dimensions. "What are you looking at?—*The house* (B), *because that* (the tree, C) *is a little higher* (more distant)—Why do you go on looking there?—*I'm looking at it because the distance separating it from the church is* . . . (he indicates an interval with a gesture) . . . *I begin here with the church because you can see the distance from the house to the church better. The pine tree is next to the house* (G) *on the right*—Why do you begin with the spire?—*I look to see what distance it is from the house* (G)". However, despite his seeming concern for distances, Dub still under-estimates the depth.

In the bird's eye view the perspective is correct, the roofs being shown from above, and so on.

Reduction to scale: he produces a similar plan, reducing both the size of objects and the distance between them.

ANC (10; 4). Same type of reaction. "*I look to see the distance between the house and the church, etc.*". Reduction to quarter scale: "*I drew it smaller, otherwise I wouldn't be able to get everything in*". After he has drawn the plan to reduced scale and maintained the correct proportions, we ask him to enlarge it again, without seeing meanwhile his original drawing or the model. But he is dissatisfied with the result, although the drawing is correct in principle; "*The spaces between the houses aren't large enough*" and "*I made this house*

longer so I ought to make it wider, because when you make a thing longer you ought to make it wider too".

The bird's eye view he draws correctly.

MAT (10; 6) begins with the church. "What are you looking at?—*The distance between the church and this house and the direction it's placed in*—Why did you choose this house?—*Because it's easier to judge the distance* (a nearly horizontal line)". Then, "*I look at the distance between these two trees so as not to leave too much space between them. Oh, there's too much space* (between G and H) . . . *there's a bigger space between them than between* (C) *and* (A)".

As for proportions: "*You put this sheet on the plan and you can see it goes into it four times*—How are you going to get everything in?—*I make the distances less and the* (objects) *smaller".* He is willing enough to measure; "*You must measure everything four times as small*" but prefers to work by eye. The bird's eye view is also correctly drawn.

BON (10; 8). Same reactions for positions and distances. He makes a scale drawing and re-enlarges it saying, "*It's just as though you had a big field with little houses. You have to draw them bigger".*

Thus by Substage IIB the child has mastered the task of making a pictorial layout both as regards position and distance (i.e., co-ordinates), and perspective and proportions. All that remains to be accomplished is the production of a purely schematic plan by substituting for the drawing of material objects a diagram of the area on which their positions are established by exact measurement. This is achieved at Stage IV, the level of abstract, formal operations. Nevertheless, even in its present form, the layout may be regarded as a threefold operational equilibrium of reversible relationships.

As was shown in Chapter XIII, from now on a co-ordinate system or frame of reference is the product of a comprehensive, three-dimensional organization or structuring of euclidean space. And as indicated by the results of Chapter XII, the reduction to quarter scale and the reverse enlargement is henceforth achieved with similarity and proportion of figures conserved. As a result, euclidean and projective relations can now function jointly in applying the concept, intermediate between metric and projective co-ordination, of similar shape or equal ratio—at least, for the simple tasks presented here. The comprehensive system of relations which have thus been elaborated is now ready to be expressed in an abstract or formal manner, as remains to be shown at Stage IV.

§7. *The abstract plan with metric co-ordinates*

In §6. of Chapter XIII it was shown that although the co-ordinates provided by physical experience have, by Substage IIIB, taken the form of a network of vertical and horizontal straight lines it does not occur to the child to employ conventional co-ordinates until Stage IV. This was shown by the experiment in which the child, to copy the pattern

formed by a set of counters, was able to use paper strips as co-ordinates to help organize the pattern.

In the case of layout diagrams a similar transition from natural to conventional, or rather, from physical to abstract co-ordinates, is once more apparent. However, since it is precisely the development of abstract operations which enables the child to understand maps and co-ordinate axes in his school work, the children of 11 and 12 years tend to exhibit a combination of individually worked out and formally learned concepts. Nevertheless, it is worth while giving three examples of such children.

ALB (11; 7) illustrates the transition from Substage IIB to Stage IV. "Supposing you have made this model village and you want other people to rebuild it exactly the same. What would you have to do?—*Make a drawing of the houses*—What kind of drawing?—*In perspective*—Would that be sufficient?—*No, you'd have to draw the outline of the houses*—Would you need to draw the height?—*No, that wouldn't be necessary*". He then draws a diagram in which each object is represented by a rectangle, a square, a circle (trees), etc., all in their correct positions and with the distances correct, though without exact measurements.

SAN (12; 4). Same beginning. "*You would have to look from above to see everything*—How would they look?—(He draws a few rectangles). *That could be the square with the church in it, and those the houses*—Before you start drawing, do you have any idea what would help you put everything in the right place?—*You could draw axes* (he folds the paper in four)—Why?— *There are some houses near the axes. You can find your bearings more easily* (he begins). *This house is about the same distance from the axis as that one* (he measures). *Between this house and the axis is about half. You can also compare it with the edge*—Is that accurate?—*Oh no, you would have to measure in both directions and reduce the sizes to scale*".

FAU (13; 0). Measures everything right away and decides to make his first drawing to quarter scale. "*You have to take a quarter of the house. No, that's a bit too large. No, it'll be all right*". He carries on in the same way, looking at "*the corners and the edges of the paper*" by way of reference. After he has made a few measurements we ask, "Is it right that this distance should be less on your drawing than in the model?—*Yes, because it's a quarter of everything*". The plan is purely diagrammatic, objects being shown as simple geometrical figures. As soon as it is complete we ask him to enlarge it on a second sheet. Fau begins by comparing the size of the new sheet with that of his drawing. "*You have to measure this sheet and that one* (he studies them). *I'll use one and a half scale*—If this house is 2 cm. long?—*Here it would be 3 cm.*—And the other side?—*You have to measure that as well*—And would it all be correct then?—*No, you have to measure the bigger distances in the same proportion*".

It is clear that the knowledge acquired at school and exhibited in these replies is integrated with the whole body of concepts whose development has been revealed in the course of the preceding experiments. For in truth, no learning can take place except by assimilation

to existing schemata. Just as the child can draw long before he receives drawing lessons, so in the course of his daily life, he develops a body of concepts dealing with co-ordinates, perspectives, and similarities or proportions. It is this which enables him, at a particular age, to crystallize this system of practical operations around various new ideas which he encounters at school.

The location of objects in a formal or abstract design, in other words, their schematic arrangement, which these reactions illustrate, not only forms the starting point, for everything the child will learn as he becomes ever more completely integrated to the collective tradition transmitted by the teaching of formal geometry; it is also the culmination of a long process of development. This began with elementary sensori-motor and perceptual activity, then evolved into symbolic images, then concrete operations, and eventually abstract or hypothetico-deductive operations. In this respect, the development of layout diagrams—a process quite spontaneous in its origins, since it is the product of everything the child has mastered in drawing—illustrates extremely clearly the gradual formation of the whole body of concepts, originally topological, eventually projective and euclidean, which we have here endeavoured to trace.

Chapter Fifteen

GENERAL CONCLUSIONS. THE 'INTUITION' OF SPACE

W HAT exactly is meant by geometrical intuition? Every mathematician will, of course, expect to find an answer to this question at the end of these experiments on the child's conception of space.

The ordinarily accepted view tends to treat geometrical intuition primarily as a 'reading' or direct perceptual apprehension of the external world, supplemented by images recalling past or anticipating future perceptions. "We have various kinds of intuitions", said Poincaré in a well-known passage, "firstly, those which are based directly on sensation and imagination, then those arrived at by the process of induction—on the pattern, as it were, of experimental scientific method —and finally, the intuition of pure number".[1] Geometrical intuition is usually considered as belonging to the first, or perhaps the first two, of these three categories; though this entails reducing induction to nothing more than anticipation of a possible perceptual experience. Yet, at the same time, it is perfectly true that the 'intuition' of space does depend partly on sensation and imagination. The point which we cannot help 'seeing' as a tiny round surface, or the line which we envisage as a fine thread, are hackneyed, yet nevertheless conclusive examples of this dependency of intuition on sense perception.

However, to reduce spatial intuition to no more than an outcome of sensation and imagination would be to misunderstand its true character in exactly the same way as the associationists distorted that of thought, reducing it to a series of images and treating them as the ultimate, if not the sole elements of thought itself. On the contrary, one of the clearest results of our present experiments has been to show that images and sense data perform exactly the same function in geometrical intuition as in other thought processes. Namely, that of symbols or 'signifiers' as opposed to the relationships they 'signify'.

It is perfectly true that when mathematicians describe intuition in terms of sensations and images, they generally do so with opposite intentions from those of the classical empiricists, since their aim is to condemn rather than to justify its demonstrative value. Intuition deceives us, they almost unanimously assert; thus after having distinguished three types of intuition in the passage given above, Poincaré adds, "the first two kinds of intuition cannot give us any certainty". Intuition, it is often said, is the instrument of invention, whereas demonstration or

[1] H. Poincaré, *La Valeur de la Science*, p. 22, Paris, 1914.

447

geometrical reasoning in the strict sense is a matter of logical analysis. And indeed, by developing axiomatic procedures, modern geometry has attempted to segregate the two processes as completely as possible.

However, the matter does not end here. Whether, by reducing it to sensation and imagination, it is intended to justify or condemn intuition, from the standpoint of psychology, any such tendency is wholly misconceived, and indeed, has often had a deplorable effect on attempts to discuss the general problems of geometrical epistemology. The radical separation of intuition from logic or axiomatics has never been achieved in practice; and in fact, is unattainable in principle. It would be inappropriate, in the present context, to attempt an exhaustive analysis of all the different meanings, to say nothing of the various categories of intuition which numerous authors have promulgated with the aim of bridging—post factum—this gap between intuition and logic. Thus there is the kind of intuition which, according to Poincaré, governs the general direction of thought (as opposed to particular logical operations) and which Brunschvicg[1] regarded as indicating merely the 'general groundwork of thought'. There is the "transintuitive intuition" of Winter,[2] and directly opposed to 'naïve intuition' there is Klein's 'sophisticated' intuition, which according to this great mathematician, "was not, strictly speaking, an intuition at all".[3] Finally, there is Brouwer's idea of intuition as an operational construct.[4]

In short, every possible shade of transition has been suggested to connect elementary intuition with logical operations; and what Brunschvicg has so subtly demonstrated is that in geometrical reasoning there always remains some link with intuitive experience. In converse fashion, from the outset of experience intelligence is operative in organizing intuition and giving it a definite structure. A similar view has recently been advanced by Gonseth[5] who suggests that the 'schema' formed by formal logic always retains traces of intuition, while the primary intuition requires some degree of schematization in order to possess a structure.

All of which goes to show that even for mathematicians, intuition is far more than a system of perceptions or images. Rather is it the basic awareness of space, at a level not yet formalized. But this raises afresh the developmental problem. How can consciousness confront the external world so directly as to appear its perceptual or symbolic image, and then proceed to loosen all ties with externality so completely that it is able to replace it by concepts belonging entirely to the subject himself?

[1] L. Brunschvicg, *Les Étapes de la Philosophie Mathématique*, p. 451, 2nd edn., 1922.
[2] *Revue. de Métaph. et de Morale*, p. 922, 1908. See also A. Reymond, ibid., p. 740, 1916.
[3] Quoted by Brunschvicg, *Étapes*, p. 450.
[4] Rolin Wavre, 'Mathématiques et philosophie', *Arch. Soc. Belge de Philos.*, p. 9, 1933.
[5] F. Gonseth, *Les Mathématiques et la Réalité*.

To this question, the experiments described in the course of the present work provide the simplest answer. The 'intuition' of space is not a 'reading' or apprehension of the properties of objects, but from the very beginning, an action performed on them. It is precisely because it enriches and develops physical reality instead of merely extracting from it a set of ready-made structures, that action is eventually able to transcend physical limitations and create operational schemata which can be formalized and made to function in a purely abstract, deductive fashion. From the rudimentary sensori-motor activity right up to abstract operations, the development of geometrical intuition is that of an activity, in the fullest sense; beginning with adaptive actions which link it with the object, and at the same time assimilate the object to its own functional structure, transforming it in the process as completely as geometry has transformed physics.

Action is first manifest in the form of sensori-motor activity regulating perception. Even at this stage the rôle of sense-data is confined solely to that of 'signifying' the relationships created by active, motor assimilation. Poincaré had some inkling of this when he envisaged movements as the source of basic spatial concepts, though instead of seeing the connection between these movements and the subsequent operations of thought (despite his well-known observations on the motor origin of the group of displacements) he went on to describe movements in terms of sense-data and postulated an intellectual *a priori* for the purpose of controlling them.

It is at the stage of nascent mental imagery which immediately follows, that action begins to exercise its formative rôle. The image is at first no more than an internal imitation of previously performed actions, then later, of actions capable of being performed. Our experiments have shown how important such actions are in the mental construction of shapes, based on elementary topological relations such as proximity, order and enclosure.

Finally, at the level, first of concrete, then of abstract operations, action is once more apparent, this time in the richer, yet purer form of the operations themselves. Richer, because in operational form actions are reversible and may be combined indefinitely; purer, because from now on they go beyond the physical objects with which they are concerned.

Now these operations on which the idea of space depends are important in three respects. Firstly, the order of their psychological development is in broad outline the same as that of formal geometrical construction. In both cases, topological relations precede projective and euclidean ones, and in both cases the latter are equivalent as regards the complexity of the basic notions from which they stem.

The second important point about these operations, from the psychogenetic standpoint, is that they introduce a new element into

the classical debate opposing intuition to logic. This is that to the extent that actions are internalized as operations, the initial perceptual and empirical intuitions become rational and coherent, even before having been formalized as propositions. Thus the rigour of the system of concrete operations exceeds that of elementary intuition without reaching that of abstract operations, the basis of hypothetico-deductive propositions. This makes it necessary to introduce new gradations between intuition and logic, the chief of which is the logic of concrete operations, superior to pre-logical intuition and inferior to formal logic.

But the third and most important point is that concrete operations reveal another aspect of the relations between intuition and logic. Concrete operations of a logico-arithmetical character deal solely with similarities (classes and symmetrical relations) and differences (asymmetrical relations) or both together (numbers), between discrete objects in discontinuous wholes, independent of their spatio-temporal location. Exactly parallel with these operations there exist operations of a spatio-temporal or *sub-logical* character, and it is precisely these which constitute the idea of space.

The term 'sub-logical' does not imply that these operations are in any way less rigorous than logico-arithmetical operations. It simply means that their function is to produce the concept of the object as such, in contrast to collections of objects (using the language of Russell's Theory of Types, they are beyond type O; which means precisely, that they are sub-logical). Such operations deal not with class-inclusion, but with part-whole inclusions for single objects. They substitute the concept of proximity for that of resemblance, difference of order or position (especially the concept of displacement) for difference in general, and the concept of measurement for that of number. Once expressed in propositional form they are indistinguishable from logico-arithmetical operations, of which they constitute merely a particular species, that of continuity as opposed to discontinuity operations.

At the stage of concrete operations, however, they form just as complete a system as do logico-arithmetical operations, constituting 'objects' of various kinds which it is the function of logico-arithmetical operations to arrange in sets or numerical collections. Since they constitute 'objects', sub-logical operations are accompanied by symbolic images (mental images or pictorial representations) which reflect them far more accurately (though not wholly adequately) than the images accompanying class or number concepts. This is why the persistence of a core of intuition is often admitted, even in the most abstract forms of axiomatic geometry, for this core is only the proof that the basic concepts of spatial proximity and succession are sub-logical in origin.

In short, there is complete continuity in what mathematicians term geometrical intuition, between the motor element originally controlling

perceptual activity and that which reappears at each successive stage of development, right up to the final operation. On the other hand, the sense-data simply function as 'signifiers' or pointers, right from the crude perceptual sign, up to the most abstract symbolic image.

§1. *Perceptual and conceptual space. The function of the image*

In examining successive stages in the child's development we drew a fundamental distinction between spatial perception and the earliest spatial imagery. Because spatial perception takes place in the presence of the object whereas the image arises only in its absence, perceptual space develops far more rapidly than conceptual space, the former even reaching a projective and quasi-metric level while the latter has barely begun. There is therefore an interval of several years between perceptual and conceptual construction, despite their pursuing a similar path of development. And moreover, should the existence of these two distinct levels be overlooked, the illusion arises that the idea of space begins to be worked out on the basis of simple euclidean shapes. The actual study of children's reactions to such shapes between the ages of 2–4 years showed that from the perceptual standpoint these reactions are not innate but developed (being preceded by an evolution beginning in the first few weeks of the child's existence), while at the same time such shapes are not yet conceptualized (since only the most elementary relationships are applied to them). Thus in arriving at a satisfactory theory of geometrical intuition it is essential to distinguish between perceptual and conceptual space.

Perceptual space itself appeared to be a complex product, resulting both from direct perception and from sensori-motor activity applied to the control and direction of the various movements determining perceptual centration. Sensori-motor activity at first embraces the whole of the child's behaviour. Then, with the appearance of imagery it becomes confined to the strictly motor and perceptual areas which continue to provide the foundation for spatial concepts throughout life. Thus during the child's first year it is sensori-motor activity which leads him, through handling objects, turning them over and moving them about, to grant them physical permanence (even when they are out of sight) together with constancy of size and shape. At a later stage, this same activity is specifically concerned with eye movements, controlling accommodation and convergence in estimation of size at a distance and shape in perspective.

To the extent that sensori-motor activity is already operative at the level of perceptual space it is possible to discern, though in a relatively undifferentiated state, the two complementary rôles of sense perception and motor activity. From the latter stem the spatial relationships themselves, while as soon as this process of development has begun

451

—and more so when it is complete—such relationships are indicated or 'signified' by 'signifiers', and these consist precisely of sensory signs or pointers. Consequently, with a shape seen in depth or in perspective, a whole series of 'virtual relationships' will be brought into play, going beyond the data recorded by the sensory receptors. These virtual relationships are the product of sensori-motor activity and the sense data merely act as pointers indicating them.

However, sensori-motor activity alone and unaided cannot extend beyond the field of direct perception. At most it can bring about certain anticipations and reconstructions enabling objects to be located when hidden behind screens, or movements to be 'grouped' according to particular paths, but this is the limit of its capacity. To extend space beyond the confines of the perceptual field is the task of imagination.

Sensori-motor activity is reinforced by imagination at the point where the symbolic function first appears. That is to say, when the 'signifiers' in the form of symbols (images) or signs (words) begin to be differentiated from what they 'signify' in the form of conceptual or pre-conceptual relationships.[1] It is at this point that conceptual space, the real object of our studies, may be said to begin.

Here, the first problem is that of the respective functions of imagination and of action proper. On the one hand, it might be suggested that the idea of space ceases to depend upon action and only involves re-calling to mind the results of an actual or potential action through signs and symbols rather than evoking the action itself as a memory image. Alternatively, that this idea is in fact an internalized action reproduced by means of signs and symbols, in which event the action evoked in imagination is a direct extension of the earlier sensori-motor activity, equally with a physical action. The image will, of course, perform a different function according to which of these two interpretations is adopted. With the first, the image supersedes the action; with the second it merely expresses it symbolically.

As regards action itself, we have time and again seen that it plays a far more fundamental rôle than does the image. Geometrical intuition is essentially active in character. It consists primarily of virtual actions, abridgements or schemata of past, or anticipatory schemata of future actions, and if the action itself is inadequate, intuition breaks down.

This is evident from all the experiments described above. Beginning with elementary serial relations (arranging things in two directions) and surrounding (knots), passing to projective relations (perspectives, shadows, sections, plane rotations) and affine relations (elongation of rhombuses) and ending with similarities, co-ordination of groups in layouts, etc., all the forms of spatial intuition which have been studied depend upon actions. And these have been actions like putting things

[1] See *Play, Dreams and Imitation in Childhood*, 1952.

next one another (proximity) or in series (order), actions of enclosing, of tightening or loosening, changing viewpoints, cutting, rotating, folding or unfolding, enlarging or reducing, and so on.

In deciding whether spatial concepts are really internalized actions or whether they are merely symbolic images in place of physical actions, two main points should be borne in mind. The first is that young children are unable to visualize the results of even the simplest actions until they have seen them performed. Thus a slack knot is neither 'perceived' nor thought of as homeomorphic with a taut knot until the child has actually tightened it by pulling the string. The child cannot picture the cylindrical section as circular until the knife has cut through the plasticine, nor can he reconstruct a perspective point of view until he has himself occupied the position to which it corresponds. This is because thought can only replace action on the basis of the data which action itself provides. Consequently, except under artificial conditions, it cannot be separated from its active context, any more than perception can be separated from its sensori-motor context.

But if this is the case, does it not follow that thought has nothing more to do with action, since it is restricted to observing it and recalling its outcome, just as external physical events of any kind are recalled in imagination? It is here that the second point becomes relevant. The experiments the child performs in modifying objects by his actions are not purely and simply physical experiments dealing exclusively with the intrinsic properties of objects as such. If they were it would be difficult to understand how geometrical thought becomes independent of objects and grows increasingly deductive in character. True, the child's geometry is experimental before becoming deductive, but not every experiment is a physical one. The first experiments which give rise to the idea of space are in fact experiments on the subject's own actions, and they consist of finding out how these actions succeed one another. For example, after placing B between A and C, the child discovers that he is bound to encounter it once more between C and A. Having passed the end of a string through a loop, preparatory to making a knot, the child discovers that by pulling it further he does not change the essential character of the knot, and so on.

Admittedly, in watching the experiment the child is at first concerned with the object as such, for to become aware of an action one must begin by seeing its outward result, and in this sense the experiment is indeed physical since it tells the child something about the properties of the object. But it is more than this, for it is only necessary for the observed facts to be slightly more complicated (as with the water level in Chapter XIII) for their interpretation to require a fairly advanced prior co-ordination of actions. As a result, besides learning something about the object, in the course of such an experiment the child also learns some-

thing of the way his actions are co-ordinated and how one determines another. And as the experiment becomes more advanced, so this happens more and more. For example, the action of putting B between A and C also implies that of putting it between C and A, and similarly, the character of the knot produced by surrounding the string in the loop remains unalterable until the reverse action of untying the string has been performed.

Consequently, first topological, then projective and euclidean relationships presuppose a growing number of increasingly complex co-ordinations between different actions. The determination of a straight line, of an angle, of parallels or co-ordinates entails not only a simple observation but its application to the precise adjustment of one action to another.

It will therefore be seen that spatial concepts are internalized actions and not merely mental images of external things or events—or even images of the results of actions. Spatial concepts can only effectively predict these results by becoming active themselves, by operating on physical objects, and not simply by evoking memory images of them. To arrange objects mentally is not merely to imagine a series of things already set in order, nor even to imagine the action of arranging them. It means arranging the series, just as positively and actively as if the action were physical, but performing the action internally on symbolic objects. This is why a child finds it quite easy to arrange counters on the table or cut a section in plasticine and far more difficult to imagine these things, while at the same time he finds it easy to imagine he is triumphing over an opponent in a game but more difficult to defeat him in reality. For spatial concepts are internalized actions (as are any logical concepts) whereas imaginary play is merely a substitute for actions.

Furthermore, actions are internalized in a series of stages which we have been able to follow step by step. Immediately following sensorimotor activity, tied directly to perception, we have action recalled in imagination subsequent to being performed physically. This gives rise to thought which reproduces action with all its concreteness and irreversibility. This is the elementary kind of intuition found at Stage I, up to and including the age of 4–5. With Stage II (from 4–5 to 7–8 years) the growing co-ordination of physical actions is accompanied by an internal co-ordination of their schemata (that is to say, of their schematic outlines), though this still proceeds by trial and error, anticipating potential actions in piecemeal fashion. At this point it is possible to speak of a progressive linking together of intuitions, the formation of trains of ideas. From this process arise concrete operations (from 7–8 to 11–12 years) when the schemata are co-ordinated sufficiently to be combined, and consequently, for each one to be mentally explored in alternate directions. This type of reversible combination represents the

initial equilibrium state reached by internalized actions and thus constitutes the first truly operational system. With the further development of operational co-ordination it becomes possible to conceive of several systems simultaneously. Thus the child now disposes (about 11–12 years) of abstract operations, capable of being expressed in propositional form. This marks the final stage in the development of intuition and the beginning of a type of thought which, whilst being the culmination of the continuous internalizing of actions, at the same time prepares the ground for the elaboration of abstract spatial concepts as a result of its increasingly logical discursive character.

To each of these stages in the process of internalizing actions there corresponds an equivalent stage in the development of the image. Thus from the initial appearance of thought right up to its ultimate, purely abstract form, the functional connections between the image (as 'signifier') and the relationships which it 'signifies' (the internalized actions) undergo continuous transformation.

In its actual origins, the image is no more than a record or a trace of the muscular adaptations involved in an action. Every action performed on objects is adapted or accommodated to them. That is to say, it receives the negative impression of the things whose form it explores. Of course, the most important feature of action is not this process of imprinting, but rather the assimilation of the object to the subject's schemata. However, every effective assimilation has as its counterpart a more or less effective accommodation. When this latter occurs at the sensori-motor level it consists of an imitation of the object by an action. More precisely, the imitation is merely the positive trace of the basically negative process of accommodation. Now at the conceptual or imaginal level, delayed imitation becomes possible (it is moreover just this transition from immediate to delayed imitation which forms the starting point for all types of representational thought) and this is internalized in the form of images or imitative schemata of the object. It is therefore evident that, alone and unaided, the image could not enable the subject to gain knowledge of the object, since it is not a tool of assimilation as such, but a by-product of the accommodation which accompanies it. It only plays the part of a 'signifier' or symbol in relation to the actual process of getting to know the object. Nevertheless, this is an important function, since it is to the extent that the physical action can be recalled by means of an image that it can be conceptualized. Yet though the image plays an essential part as a symbol it is not the image which constitutes the conceptual relationships. These are determined by the action assimilating the object to the subject's schemata. It is thus completely wrong to attempt to reduce spatial intuition to a system of images, since the things 'intuited' are, in the last analysis, actions which the image may symbolize but can never replace.

But if this is the function of the image, its relative importance will naturally vary with the degree to which the virtual actions it symbolizes have become organized. At the very beginning of intuitive thought, the idea of space is based solely on brief, irreversible memory images of actions simply reproducing previously performed physical actions. At this stage, the rôle of the image is at least as important as that of action, which is as yet only rudimentary. We have elsewhere termed this phase the level of preconceptual or symbolic thought.[1] In the present work it corresponds to Stage I where intuition is incapable of dealing with the very simplest transformations but is limited to recalling the results of previous actions.

At the next stage, ideas begin to be linked together. Since the actions recalled are more complex, and especially because they begin to be co-ordinated, the image functions as an adjunct, an essential auxiliary, though no longer as a permanent aid to thought itself, which already replaces it to a considerable extent.

At the stage of concrete operations, the reversible combinations characteristic of mental actions become logical and precise enough for the image to be no longer indispensable. Finally, with the emergence of abstract operations, the image is so outdistanced by thought that images such as those of points or that of the continuous line are no longer adequate for operational thinking.

The image, which from the very beginning is symbolic in character, plays an increasingly subordinate rôle as the active component of thought becomes better organized (its decreasing symbolic value being replaced by the sign system of ordinary and mathematical language). Nevertheless, it should be realized that throughout the evolution of spatial operations the image performs an entirely different function from that which it carries out in the case of logico-arithmetical operations. A spatial field is a single schema embracing all the elements of which it is composed and uniting them in one monolithic bloc, whereas a logical class is a collection of discontinuous elements linked by their resemblance, regardless of spatio-temporal location.

It is precisely because of its monolithic, unitary character that Kant was led to regard space as a form of 'sensibility',[2] to consider its intuitive character as fundamental. This does not, of course, rule out the treatment of space as operational—that is, intellectual—but only necessitates drawing a distinction between sub-logical operations concerned with mental construction of the object as such (and therefore, with a single schema) and logico-arithmetical operations dealing with collections of discrete objects.

[1] See op. cit., *Play, Dreams and Imitation in Childhood*, Chapter VIII.

[2] '*Anschauung*', generally translated as 'intuition', though this is not altogether satisfactory. It is difficult to convey the exact sense of the German word; 'sensibility' perhaps comes nearest to it, suggesting 'intuition by sense-perception'. (Tr.).

If this is the case, then it is obvious that the image performs a different function according to the different circumstances. It is perfectly true that the image acts as an auxiliary symbol in the case of classes, series or numerical collections. Thus an entire class may be envisaged by imagining one of its members, or by visualizing an empty framework in the shape of a figure such as a circle. Similarly, the series of numbers may be imagined as a row of sticks or a pile of counters. But in such cases the image cannot be compared with an operational schema since it only represents a general framework devoid of content, or deals with part of the content and not the whole. On the other hand, the image of a spatial system is more or less directly comparable with the schema, since such a system constitutes a single object and the image deals with this object as a product of the operations. Thus even though the image remains symbolic and does not replace the operations themselves, it is nevertheless comparable with the object, whereas the image symbolizing the product of a logico-arithmetical operation represents only a very incomplete part of the whole system.

This is the reason why, despite its obvious inaccuracies, the spatial image has so often been regarded as playing the main rôle in geometrical intuition, and in the spatial schema itself. And this despite the fact that the latter is operationally equivalent with the schemata of classes, logical relations and numbers, except that these operations are sub-logical and not logico-arithmetical.

§2. *Sub-logical operations and continuity*

Let us begin by removing a possible source of misunderstanding. Once they have evolved fully, all operations whether sub-logical (spatio-temporal) or logico-arithmetical (independent of proximity) can be performed abstractly. That is to say, carried out by formal deduction, independent of their application to material objects, and expressed in propositional language. At the level of hypothetico-deductive propositions there remains only a general logic of implication and incompatibility between propositions. This does not mean that such logic is independent of operations or actions, since propositions always describe operations (or the results of operations), and their implications and incompatibilities are still operations, but of the second degree. What it does mean is that to formalize geometry is to put it on the same level as any other axiomatic deductive theory, so that it becomes a system of propositions just like any other. However, before they can be expressed propositionally, spatial operations are based on physical actions and at this concrete level they differ markedly from operations concerned with numbers and logical entities such as classes or relations between discrete objects. This lower level, regarded by mathematicians as empirical and not yet axiomatic, is the only one we are at present considering.

From this standpoint, the operations on which the idea of space depends are not logical but sub-logical in character. This does not, of course, rule out the possibility of spatial entities being equally the concern of logical operations. A logical operation deals with individual objects considered as invariants and is concerned with linking them together or interrelating them, irrespective of their spatio-temporal location. For example, $A+A'=B$; $B+B'=C$, etc., or $A>B>C$: etc. B is then a distinct and recognizable class regardless of the distance between A and A', while the relationship $A>B$ is similarly independent of the spatio-temporal disposition of these elements. As against this, a sub-logical operation involves creating the object on the basis of its elements. Hence it leads, not to classes or non-spatial relations, but to complete objects of various kinds. For instance, it may be a matter of fusing the parts of an object into a single whole, or of arranging them in a specific order. Consequently, instead of linking objects one with another, or segregating them according to their similarity (the basis of classes and symmetrical relations) or difference (asymmetrical relations), sub-logical relations link or segregate objects in terms of proximity and distance. Thus a few elements in proximity will form a group α which, linked with an adjacent group α', will form the group β, etc. Each group in the sequence α, β, γ, σ, etc. forms a partial whole and these partial wholes are, in varying degrees, part of the total object making up the spatial field under consideration.

Can proximities or separations be regarded as relationships just the same as any others, and the parts of objects regarded as objects—their conjunction forming simple classes—so that sub-logical operations are simply a particular case of logical operations? The answer is no, since linking items together to form objects or classes of objects equally according to proximities or similarities entails a fundamental contradiction as regards their mode of conjunction. Linking items together on the basis of proximity results in unitary wholes whose ultimate outcome is continuity. For example, a series of points is continuous if the immediate proximity of each point contains at least one other point belonging to the series. On the other hand, items brought together on the basis of similarity result in discontinuous systems, so that sub-logical operations cannot be regarded as equivalent with logical operations. Thus if a number of items α form part of β, and if β forms part of γ; and if the object γ belongs to a logical class A, which is included in another class B, then it follows that γ is a B because it is an A, but neither α nor β are A's or B's. In this case, γ is at one and the same time the end point of the sub-logical operation linking it with α and β, and also the starting point of the logical operation linking it with A and B, but the two operations cannot be transitively combined.[1]

[1] To take a trivial example, if α is part of a line β, and β forms part of a square γ

458

GENERAL CONCLUSIONS

We have in fact seen (Chapter V) that the concept of continuity constitutes the final synthesis of all the elementary topological relationships lying at the root of the idea of space. Continuity is thus a complex notion and it is only at a rather advanced stage of the child's development that it comes to be applied to the projective and euclidean framework created by operational co-ordination. But from the standpoint of its perceptual origin, continuity is the characteristic, distinguishing feature of the object, as opposed to discrete collections. Since the notion of continuity is present, in a primitive form, at the starting point of sub-logical operations, it is hardly surprising that it should again be encountered at the culmination of their development, and in the precise form which serves to distinguish them from logico-arithmetical operations. In effect, beginning with perceptual continuity, the distinctive feature of the simplest types of proximity, the notion of continuity evolves in two complementary directions.

The first of these, as we saw in Chapter V, is that of the progressive subdivision of the object, first into a few elements, continuous and isomorphic with the whole, then their further subdivision into points, still finite in number; and lastly, the subdivision of these points into an infinite number of points having neither shape nor size. The second is that of increasingly extensive co-ordination. Beginning with the object itself, sub-logical construction starts by working out empirically the topological relationships within each configuration. Since at this level continuity is still purely intuitive, it is not yet applied to empty space, for as yet there exists no single space embracing all objects. On the other hand, with the construction of projective space through co-ordination of viewpoints, and the development of reference frames through euclidean comparisons, continuity comes to be applied to the whole of space, regarded as a universal framework valid for all objects and all observers.

Thus sub-logical operations, whose structure is based on proximity rather than similarity, as is that of logical operations, lead to the formation of continuous, unitary schemata. In other words, they lead to complete and continuous spaces, whereas logico-arithmetical operations lead to discrete wholes. It is true that continuity is involved at a certain stage in the formation of numerical series. This is when irrational numbers are added to rationals with the aim of filling the gaps between the latter. It is well-known, however, that irrational numbers arose from spatial considerations, and that they were introduced in response to the necessity of making the series of numbers correspond to spatial continuity. Irrationals are therefore not a natural and inevitable out-

γ may be said to belong to the logical class of squares A, and hence to that of quadrilaterals B. But neither the part α nor the whole of the line β belong to the classes of squares and quadrilaterals A and B.

459

come of logico-arithmetical operations but only the meeting point between these and sub-logical operations.[1]

§3. *The sub-logical operations constituting elementary topological relationships*

While remaining strictly within the realms of developmental psychology, that is to say, by studying the course of mental development without recourse to preconceived notions, we shall try to analyse our experimental findings and see what sort of sub-logical operations are involved in building up the idea of space. In addition, to see how they correspond with the logico-arithmetical operations involved in the child's conception of number.[2] In this subsection we will begin by analysing the operations which constitute topological relationships, since our experiments have shown that they are extremely primitive as compared with projective and euclidean relationships.

Now the most striking of our results has surely been to show that the operations which constitute topological relationships are, for a long period, purely qualitative and involve only 'intensive' qualities. This means that, despite the apparent contradiction, they must be regarded as spatial whilst not as yet mathematical! Only when these operations have been 'grouped' and co-ordinated with one another do they give rise to 'extensive' or quantitative operations; that is to say, mathematical whether metric or non-metric.

It is in fact possible to divide the operations which our subjects employ into three types; or rather, into two basic types of which the second is further divided into two sub-types (both for sub-logical and logical operations). This classification applies to all forms of thought and not merely to that of children. Let us take two sets A and A' whose conjunction forms the set B. When the operations only take account of the relations $A < B$ and $A' < B$, ignoring the relations between A and A', we can say that quantity is only 'intensive'. In other words, these operations merely tell us that the whole is greater than the parts. It does

[1] On the other hand, it is true that there are 'abstract spaces' which are discontinuous, and it is possible to speak of 'the space of whole numbers', etc. Proximity relations are thus exemplified by correspondences whose significance deviates further and further from the literal, physical meaning of this notion. But it should be noted that in addition to retaining something of a physical character, these spaces still depend on the idea of proximity, which tends to coincide with logico-arithmetical concepts rather in the way numbers coincide with spatial concepts (as in the case of irrational numbers). As for such proximities not leading to the construction of continuity, this corresponds with what was stated at the beginning of this subsection; namely, that at the hypothetico-deductive and axiomatic level, the distinction between sub-logical and logical loses its significance. Finally, as regards the actual application of these abstract spaces in specific fields, as in atomic physics where space is in certain respects discontinuous, it should be realized that spatial discontinuity arises from the circumstance that at this level the notion of 'object' ceases to have any meaning. Consequently, we are here at the lower limits of the sub-logical, and of operations as such.

[2] See op. cit., *The Child's Conception of Number*.

not tell us whether one of the parts contains more or fewer elements than the other. In contrast to this, we can say that quantity becomes 'extensive' if it is possible to state whether A contains more, less or the same amount of elements as A'. Lastly, we can speak of 'metric' or numerical quantity when A and A', or A (or A') and B are compared in terms of units, so that it is possible to state how many times A is greater or smaller than A' (or how many times A or A' goes into B). When no unit of measurement is involved and all that is known is that A is greater or smaller than A' without knowing by how much, we may speak of quantity as being non-metric.

In this connection, it is important to be clear about questions of terminology. Mathematicians usually divide spatial concepts into two categories only: metric and qualitative. Topology, in particular, is said to be qualitative since it takes no account of metric relations. It is also said that logic is 'qualitative', though not in the same sense. The logic of classes and relations is qualitative in the 'intensive' sense. For example, the theory of syllogisms deals only with part-whole relations such as $A < B$ and $A' < B$. It ignores the relations between the various parts, since it only utilizes the quantities 'all', 'none', 'a few', and 'one' (in the sense of 'some'). Topology, on the other hand, is qualitative in the 'extensive' sense. For instance, topologically, one may say that the set A contains 'nearly all' the elements of B. That is, 'all except a not very numerous group A'. Thus Cantor's well-known postulate defining continuity by means of a series of enclosed intervals ('cover') employs a series of relations of the type 'almost all'. It can be seen immediately that such a relation is extensive in character (since $A > A'$) whereas the logic of classes ignores relations of this kind.

Having made this point clear, it is striking to note that the sub-logical operations by means of which the child forms his rudimentary conception of space are purely intensive. They are thus comparable with those appropriate to the purely qualitative logic of classes and of relations defined solely in terms of their qualities. In other words, the topological relationships which the child constructs involve only simple enclosure or seriation. Since he is unable to deal with continuity, he can only achieve a sort of qualitative spatial logic (and hence, an 'intensive' sub-logic). Before being able to measure things, the child can no doubt perceive that one part of a whole is greater or smaller than another part. That his own slice of cake, for instance, is smaller than his neighbour's. But for a considerable time, these 'extensive' relations remain purely intuitive. Not until perspectives and similarities (proportions) have been mastered do they give way to precise operational systems. 'Intensive' relations, on the other hand, call forth intuitive notions at a far earlier stage and lead to more rapid groupings. The main point—and this is what interests us at the moment—is that the

461

child's elementary topology is purely 'intensive'. And this is perfectly natural, since only the emergence of the concept of infinity during the analysis of continuity renders topology 'extensive', and hence mathematical, whilst every one of the child's operations deal with finites until he reaches the level of abstract thought.

Let us therefore try to put in schematic form the various operational systems which, by about the age of 7, the child has constructed through the intensive relations of proximity, separation, order, surrounding and continuity. Proximity as such is not a developed notion but is given at the outset and thus serves as a starting point for the operational construction itself. In the discussion that follows we will designate two neighbouring elements by the symbols A and A' or B and B', etc.

In the case of separation, two elements A and A' are separated when they have no point in common: $A \times A' = O$. However, we have seen that the child is able to deal with the concept of separation far more subtly when he combines it with those of surrounding (enclosure) or boundary (closure). This is evident from the drawings produced by children around the age of 4, before they can form triangles, squares and other euclidean figures. These early drawings can show some item inside, outside or actually on the boundary of a closed surface. Such a notion may be expressed by saying that the environment of an element constitutes a set of proximities adjacent to one another (i.e., a sub-set of neighbourhoods), and that this element of its environment is enclosed by a boundary when it is possible to define the locations 'within A', 'outside A' or 'on the boundary (A_0) of A'. A point (or any element inferior to A) will be within A if its environment contains only points belonging to A, outside A if its environment does not contain a single point belonging to A; and lastly, on the boundary of A if its environment contains points inside and outside A. In the case of a boundary separating A from A', the separation is expressed by the double disjunction[1]: $(A+A_0) \times A' = O$ and $(A'+A_0) \times A = O$.

As for the notion of order, this is either constructed from a linear series of elements, or from a series of enclosures (lines enclosing a surface or surfaces enclosing a volume). Finally, at the stage of symbolic thought and concrete operations, continuity appears in a form intermediate between perceptual and mathematical continuity. That is to say, prior to formal operations enabling the concept of infinity to be grasped, and the appearance of extensive quantity as a result. Poincaré, it is well known, expressed perceptual continuity by means of the formula: $X=Y$ (X is indistinguishable from Y), $Y=Z$, but $X \neq Z$, and this describes very succinctly the irrational nature of perception. At

[1] See Kuratowski, *Topologie*, Warsaw and Lodz, 1933, pp. 99 and 101. The mathematical notions of closure and boundary imply as a consequence those of 'point limit' and 'point of condensation', and these are, of course, extensive notions.

the stage of symbolic thought and concrete operations, continuity may be said to assume a non-irrational form (though one which is mathematically inadequate). Thus X is adjacent to, but not separated (disjunct) from, Y; Y is adjacent to, but not separated from, Z; but Z is separated from X by Y.

Once these notions have been conjured up intuitively, the child is able to form the operational structures which follow. That is to say, as soon as these notions are linked together sufficiently to ensure their reversible combination, the level of concrete operations is reached.

I. *Partition of Sets and Addition of Sub-sets*

The results described in Chapter V showed that from the age of about 6 or 7 children can break up a continuous whole into neighbouring elements and bring them together again to form a continuous whole. Thus:

$$A + A' = B; \; B + B' = C \text{ etc. and } C - B' = B; \; B - A' = A$$

This appears to be the most elementary operational grouping which the child constructs. If it does not appear until about the age of 7, in the example of breaking up a continuous object, this is because of the mental conflict between the imaginary subdivision and the physical continuity. On the other hand, when the process is already suggested, as in squared paper or in a mosaic, the operations of both subdivision and addition appear considerably earlier.

It is obvious that in the sub-logical domain of proximities, this grouping is the exact equivalent of class inclusions (A, B, C, etc.) in logic.

II. *Order of Placement*

Chapter III showed that the notion of linear order is formed through progressive combining of proximities, resulting in the direct and reverse sequences of elements A, B, C, etc.:

$A \to B \to C - \ldots$ and $\to C \to B \to A$. The reverse order resulting from traversing the series in the opposite direction is in fact a displacement, not in terms of euclidean movements of the objects, but from the standpoint of the movements which the subject makes in traversing the series.

If $A \to B \to C \to \ldots \to X \to A \to B - \ldots$ etc., then the order becomes circular and the direction can be reversed here also.

The same grouping is involved when the environments or successive enclosures of a given element are being arranged in sequence. In this case, if A is the first enclosure (closed curve bounding a surface, or surface bounding a volume), and B is the second, etc.; then an order ABC... will be found which coincides with the addition of sub-sets in the grouping (I), except that the latter is independent of order in the sense that $A' + A = B$ is obtained equally with $A + A' = B$.

463

It is evident that this type of grouping, which results in order of placement, is equivalent to asymmetrical series in logic. That it is sub-logical in the present context, however, is shown not only by the fact that proximity is involved, but that it leads to operations of displacement in euclidean geometry.

III. *Reciprocity of Proximities*

Although this point has not been touched on in the present work, we know from past research on the notion of geographical proximity[1] that the child does not at first realize that proximity is necessarily reciprocal. However, at the level of the operations discussed above, it is obvious that this notion no longer presents any difficulty.

Thus if in Grouping I the child begins with the element A and regards A′ as its neighbour (expressed in the form A_1 and A_1') he can also begin with A′ (expressed as A_2) and regard A as its neighbour (expressed as A_2'). From then on he realizes that: $A_1+A_1'=A_2+A_2'$ $(= B); B_1+B_1'=B_2+B_2' (= C)$, etc.

This relationship (which holds equally for separations) is the sublogical counterpart of 'vicariances' in logic.

IV. *Symmetrical Interval Relations*

Just as in logical operations the grouping of vacariances (which is a grouping of classes) is designated the grouping of symmetrical relations, so in the sub-logical field the reciprocity of separations is likewise expressed by a system of symmetry relations; namely, interval relations. Elementary topological notions do not conserve distances, and here interval relations are distinguished from other groupings of order (Type II) simply by the relationship 'between'. For example, B is between A and C in direct order, just as it is between C and A in reverse order. This grouping is therefore derived from grouping II (and is developed from it in the same way that a system of symmetry relations is derived from a series):

$$A \leftrightarrow B (= O); A \leftrightarrow C (=B); A \leftrightarrow D (=B, C),\ \text{etc.}$$

We have seen in Chapter II that so soon as the child can form a linear series he understands the idea of 'between', whereas previously it presents numerous difficulties. And we have also seen how the child discovers that in a circular order ABCDAB . . . any element (for example, D) is always between two others (B and A) both in direct and reverse order (A and B). The same grouping also applies to a series of enclosures (cf. the experiment of superimposing pieces of laundry in Chapter III, or knots in Chapter IV).

[1] If A is 'near' B, is B necessarily 'near' A, etc? See Niculescu, Florea. 'Les idées de l'enfant sur le village et la famille: étude sur le pensé des enfants roumains'. Annemasse. 1936. (Thèse de Fac. Lettres. Genève, No. 79).

V. One-One Multiplication of Elements

In Chapter IV (§2.) we saw that the child comes to understand dimensions as topological enclosure relations long before he arrives at the euclidean concept of orthogonal co-ordinates. An object enclosed within a box can only be linked with another outside by passing through one side of the box; that is to say, by intersecting a surface. An element placed 'inside' a closed surface can only be linked with one outside it by crossing the boundary of the surface. An element B lying along a line between C and A can only be linked with another, D, beyond AC by crossing the point C. These three types of enclosure provide the simplest intuitive image of dimensions, a three-dimensional system having a surface as boundary (a two-dimensional system), a two-dimensional system having a line as boundary (one-dimensional) and a one-dimensional system having a point as boundary (zero-dimension). The development of these relationships leads to a multiplicative grouping as soon as the child passes from a singular to a plural dimensional system. In the case of the one-dimensional series ABCD the line joining B and D forms part of the line ABCD itself, since it only cuts points along this line (such as C). On the other hand, the line connecting a point inside a closed surface with another outside it cuts the boundary. If this boundary is represented by the series $A_1B_1C_1D_1 \ldots$ etc. and the line cutting it by the series $A_2B_2C_2D_2 \ldots$ etc., then the same point must be common to both. For example, let it be assumed that point C_1 coincides with point D_2 and is therefore expressed as C_1D_2. This constitutes a multiplicative operation expressed by the phrase "at the same time", for the point C_1D_2 belongs "at the same time" to the series $A_1B_1C_1D_1$, etc., and to the series $A_2B_2C_2D_2$, etc. In two dimensions the same operation can be applied to two sets of curves[1] and the child perceives this relationship intuitively in any network that can be explored simultaneously in two directions, like a cross-reference table.

Thus if the elements themselves are envisaged as enclosed in the manner of a Type I Grouping, a logical multiplication will result whenever the elements of two series analogous to Type I intersect, no matter what the combination: $A_1 \times A_2 = A_1A_2$; $B_1 \times B_2 = B_1B_2$, etc. and the same structure can be extended to three or n dimensions.

VI. One-One Multiplication of Relations

A similar two- or three-dimensional network may be constructed in terms of relationships. Although we have only examined the multiplicative grouping of elements in studying the development of dimensions, we have constantly encountered the same types of grouping in

[1] See op. cit. L. Godeaux, Les Géométries, p. 180.

dealing with relationships. These have taken the form of one-one correspondences (qualitative homeomorphisms) which the child establishes between pairs of ordered series. In practice, a one-one correspondence consists of a network such as the one just referred to above. Thus the elements $A_1B_1C_1$, etc., of one series are made to correspond with those of another series $A'_1B'_1C'_1$ so that some sort of connection is established between A_1 and A'_1, A_2 and A'_2, and so on. As to the precise nature of this connection, it is in general no more than the path followed by eye movements, though it is obvious that it could equally well be indicated by straight lines linking the corresponding elements. In this case the lines would cut across the two series $A_1B_1C_1$. . . etc. and $A'_1B'_1C'_1$. . . etc., forming a two-dimensional multiplicative system.

VII. and VIII.—*One-Many Multiplication, Either of Elements or Relationships*

Although we have not dealt with this question from the standpoint of topological relations (as we did with angles in Chapter XII), nevertheless, it is evident that children who can establish one-one will also be able to effect one-many correspondences. For example, in a matrix the element A may be in correspondence with several neighbouring elements $A_2B_2C_2$. . . etc. and this series $A_2B_2C_2$ may itself be in correspondence with a larger number of neighbouring elements $A_3B_3C_3D_3E_3$. . . etc. This continuous extension of proximities forms a topological structure which foreshadows the projective and euclidean systems we encounter in dealing with angles.

Such are the operational systems defining simple topological relationships which the child has mastered by the time he reaches the stage of concrete operations. Yet even though they express symbolically what is implicit in his actions, they all depend on enclosures, ordered series, or correspondences; that is to say, on concepts which do not involve the notion of extensive quantity. It follows that systems of this kind employ only qualitative reasoning proceeding by dichotomous distinctions, step by step. In mathematical language, they are only 'groupings' and not yet 'groups'.

§4. *Sub-logical operations constituting projective relationships*

Elementary topological relationships subsist between neighbouring parts of a single object, or between an object and its immediate environment, continuously and independent of distance.[1] Such a space is merely a continuous collection of elements which may be expanded or contracted at will, and conserves neither straight lines, distances, nor angles.

[1] Homeomorphisms, which at first sight might appear to involve comparisons at a distance, simply express the possibility of continuously altering one of a pair of corresponding figures.

Consequently, topological concepts do not lead to the construction of a stable system of figures, nor to fixed relations between such figures, like frames of reference determining relative positions or projective systems defining shape and orientation of figures relative to planes or viewpoints. Topologically, each continuous domain constitutes a space and there is thus no universal space operating as a frame and enabling objects or figures to be located relative to one another.

In the development of the child's conception of space the same process of evolution is therefore apparent as was investigated previously in the case of time.[1] Topological notions evolve earlier than projective and euclidean ones. These latter ideas are at first somewhat restricted in their application and only later do they lead to a single, all-embracing reference frame. It is therefore possible to draw an analogy between the development of the idea of space and that of time. For the child, time is at first purely local and applies separately to each movement. Only later are these separate notions fused together into a homogeneous and universal time. Similarly, there are, for the child, as many spaces as there are objects or distinct patterns, the intervals between more distant elements either belonging to the elements themselves or not being spatial at all. In this connection, projective operations perform a vital rôle in bringing about a global co-ordination of space, a rôle which must now be summarized from the standpoint of operational structure.

Projective concepts take account, not only of internal topological relationships, but also of the shapes of figures, their relative positions and apparent distances, though always in relation to a specific point of view. For example, a perspective drawing shows not only the parts of the figures related to one another in terms of apparent distance, but also the complete figures in relation to one another and the entire scene relative to a given perspective viewpoint. Whereas topological concepts develop step by step and without a reference system, projective concepts operate with reference to co-ordinate viewpoints and to the planes on which the figures are projected.

Unlike a co-ordinate system, a projective system does not conserve distances and dimensions, but it does conserve the relative positions of parts of figures, or figures relative to one another, and the whole in relation to an observer or the plane corresponding to his visual field. From the psychological standpoint, the essential feature of this process is the entry of the observer, or the 'point-of-view' in relation to which the figures are projected. From this aspect, projective geometry may be termed the geometry of viewpoints, granted that it presupposes the prior formation of topological relationships which are conserved at the same time as they are superseded.

Elementary projective concepts are therefore based on the same

[1] 'La Développement de la notion du temps chez l'enfant', 1946.

467

operations as are topological concepts, but with the addition of a 'viewpoint'. It is, for example, by linking this 'viewpoint' with operations of order (Type II) that the projective straight line is constructed. For as was shown in Chapter VI (Section I), the straight line is a series of points so arranged that from the 'end-on' viewpoint they are in alignment and are reduced projectively to a single point. Similarly, the notion of spatial dimensions can be defined more clearly in terms of a certain set of conditions specified by a given viewpoint. Thus topologically, the first dimension corresponds to a linear series, the second to the notion of inside and outside a closed linear boundary, and the third to the notion of inside and ouside a closed two-dimensional boundary (surface). But with the addition of a perspective viewpoint to which the figures are related, these same relationships can now embrace relative orientation as expressed by "on the left or on the right", "above or below", and "before or behind", thus denoting the three directions of three-dimensional space. As a result, the child can construct the straight line through the third relation excluding the former two; or the plane, through the two former excluding the third (for instance, in the case of abstracting the plane of the water surface in Chapter XIII).

The straight line having been constructed as a series of points one behind another, none being out of line either to the left, to the right, or above and below, it remains recognizable from other points of view, such as when it runs from left to right or from above to below. This is the result of two operations fundamental to projective geometry, projection and section. The straight line, moreover, becomes an essential element in the projection itself, for to project a figure means to transform it into another located on a plane by means of lines connecting points in the first figure to corresponding points in the second, these lines radiating from some point outside both figures. In the operations giving rise to the idea of space, it is naturally the projection of objects on the 'visual plane' (the frontal-parallel plane between object and observer) which plays the chief rôle. It is in mastering such operations that the child comes to understand projections independent of himself, such as shadows (Chapter VII), and this is why we are approaching these questions mainly from the standpoint of perspective projection (this being, geometrically, the projection of 'first order figures'). His chief problems are therefore those of co-ordinating successive viewpoints (or with more than one observer, multiple viewpoints) by means of the more elementary projections and sections used to relate the objects and the visual field, and also to imagine these projections cut along various sectional planes.

In all these processes the straight line enjoys a special status, not only as an instrument of projective construction, but also (and for this very reason) because its shape remains unaltered despite changes in

viewpoint, only its length varying with the point as a limit. The eight operational groupings described in connection with elementary topological relationships are again apparent in the elaboration of projective relations, though transformed by the introduction of the notion of 'viewpoint'. However, as with the preceding operations, this present development is not at first truly mathematical for it only involves 'intensive' sub-logical operations analogous to those of qualitative logic. Needless to say, such operations cannot cope with the precise 'extensive' relations used in projective geometry (for example, the conservation of harmonic quaternions) and it is only through a subsequent process of quantification that these basic projective concepts acquire a mathematical form. Nevertheless, it is most important to try and analyse the sub-logical basis of projective geometry since, as we have frequently pointed out, it pursues an independent course of development, as is evidenced by the appearance of perspective at a given stage in the evolution of drawing.

I. *Addition and Subtraction of Projective Elements*

At the level of elementary topological relationships, the only result of adding together neighbouring elements (such as $A+A'=B$; $B+B'=C$) is the notion that the parts are conserved irrespective of apparent distortion of the whole. And though referred to in §3. as the simplest of all spatial relations, its importance should not be underestimated in considering the problems and difficulties facing the child at the pre-logical stage. To revert to the main point, a topological object can expand or contract in any direction (like the elastic used in Chapter V) without its elements being obliterated or ceasing to maintain a term for term correspondence with those of a homeomorph. But such relationships cannot be used to define these expansions or contractions. They are restricted to describing the invariants persisting throughout the changes, and these must, in the absence of references outside the given configuration, be regarded as purely arbitrary.

As against this, the changes in a projective figure result from changes in point of view. This new feature, implying as it does a process of overall co-ordination, necessitates the development of combinations capable of dealing, not only the conservation of wholes, but with the series of changes throughout which they are conserved.

In the case of operations such as joining neighbouring parts of an object $(A+A'=B$; $B+B'=C$, etc.) the reverse projective operation involves suppressing one element $(B-A'=A$, etc.) which can no longer be seen through being hidden by another object acting as a screen. This subtractive operation expresses a section, whereas the conjunction of neighbouring parts (i.e., the direct operation) expresses the conserva-

469

tion of all the elements (or elements projected on the same plane) belonging to the object as seen from some point of view.

On the other hand, when part of one object hides part of another (which, with a reversal of viewpoint, can result in the complementary relationship), or when an element belonging to a single pattern sections another (and vice-versa for the complementary viewpoint), the ensuing additions and subtractions are not simple, like those of the type just described, but vicariant. This brings us directly to groupings of Type III. Thus grouping I only covers the construction of perspective drawings of objects, taking account of parts that appear connected and parts that are suppressed as a result of interposing other objects or parts of objects.

II. *Rectilinear Order*

When a series of points is projected on the first point, as in endwise alignment, the effect of the perspective viewpoint is to transform the linear series $A \rightarrow B \rightarrow C$, etc., given by the initial topological construction, into a rectilinear series. This basic operation, acquired through the practice of 'taking aim' (Chapter VI, Section I), is associated with the previous operation. In one sense it may be said to derive from it, since it is the reduction of a total length to a single point hiding the rest which facilitates the recognition of the straight line as such. Conversely, this operation conditions the preceding one, for it is precisely the sets of convergent and parallel lines constituting the perspective whole to be related to one another and to the observer. The result is that the straight line is the sole shape which remains unaltered throughout perspective transformations, while parallels, angles and curves are all transformed by changes of viewpoint.

III. *Complementary Perspective Relations*

In §3. we saw that initially, the operation $A_1 + A'_1 = A_2 + A'_2$, etc., expresses the fact that proximities and separations are interchangeable. In terms of perspective viewpoints this operation takes on a new meaning whose importance has already been stressed in Chapter VIII. This new aspect is the reciprocity (in the logical rather than the technical sense employed in projective geometry) of perspectives, the viewpoints determining these perspectives being complementary to each other. Take the case of a range of points $A_1 + A'_1$ running, from a given point of view, from left to right. For a second observer stationed opposite the first viewpoint (the range extending between these two positions), the same sequence seen from left to right will read $A_2 \pm A'_2$; A_2 being identical with A'_1 and A'_2 with A_1, giving $A_1 + A'_1 = A_2$, and the same holds for a sequence running from before to behind, and so on. If a single grouping of type I expresses the conservation of neighbouring

elements, the type III operation expresses the conservation of their relative position with reversal of viewpoint.

Chapters VI and VII showed that there is a short time lag between the appearance of type I and II operations, and those of type III. The former are grouped, for simple cases, at Substage IIIA, whereas the latter are only mastered at Substage IIIB when perspectives are co-ordinated in a global, comprehensive fashion.

IV. *Symmetrical Interval Relations*

Expressed in terms of relations, the groupings of type III just discussed constitute, in effect, symmetrical relations, not only in the logical sense, but also as genuine spatial symmetries, arrangements in which the middle terms retain their positions unchanged. For example, the combination $A_1 + A'_1 + B'_1 = A_2 + A'_2 + B'_2$ indicates that with reversal of viewpoint the left-hand element A_1 is replaced by the right-hand element B'_1 (now A_2), and the right-hand element B'_1 is replaced by the left-hand element A_1 (now B'_2). At the same time, the middle element included in the interval $A_1 \longleftrightarrow B'_1$ (or $A_2 \longleftrightarrow B'_2$) is conserved, remaining $A'_1 = A'_2$. The two pairs $A_1 + A'_1$ and $A_2 + B'_2$ are symmetrical in relation to this unchanged middle element.

From this type III combination it is possible to derive combination type IV. This is, in essence, $X \longleftrightarrow Y = Y \longleftrightarrow X$, which means that the terms lying in the interval between X and Y stay within it despite a reversal of viewpoints. The child grasps this fact as soon as he masters the problems of reciprocity posed in Chapter VIII.

V. *One-One Multiplication of Elements*

At the level of topological relations this grouping results in construction of dimensions based on the notion of enclosure (see §3.). With the introduction of the perspective viewpoint, the same operational system gives rise to projective dimensions. Thus relative to a given point of view there will exist relations which are not confined to an isolated pattern, such as 'inside' or 'outside', but holding between numbers of figures. These relationships correspond to the concepts 'left-right', 'above-below' and 'before-behind'. Together with perspective viewpoints and multiplicative groupings of type V, these overall relations result in the concept of the plane, or a set of planes (as distinct from a surface or a three-dimensional space). A plane is, in the first instance, no more than a network whose intersections (the product, that is to say, of a multiplication, not arithmetical but logical or sub-logical) are only established by means of two of the three relationships just mentioned. Thus the plane, seen from a given viewpoint, is reduced to a straight line—just as the line is reduced to a point—because all the straight lines constituting the plane run either from 'left-right' or 'before-

behind' and not 'above-below'. In similar fashion, the multiplication of planes gives rise to a set of planes; in other words, a projective three-dimensional space.

VI. *One-One Multiplication of Relations*

The above-mentioned operations constitute, in effect, double or treble cross-reference systems and give rise to projective spatial dimensions. Analogous with them is a system of operations dealing with symmetrical relationships and these play a fundamental rôle in perspective drawing, relating the height and width of the background with the dimensions of the foreground.

Let us take as an example the drawing of a landscape in perspective (such as the village seen from 45° in Chapter XIV, or the drawing of three mountains in Chapter VIII). The foreground begins with a long straight line running from left to right and the background ends with a straight line running parallel with the first (in actuality, the horizon line). Between these two lines objects are ranged from front to rear along convergent lines which are segments of perspectives, their apparent lengths being shorter than their actual lengths. And these same objects are finally ranged from top to bottom of the plane, horizontal in the euclidean sense, but here only in the sense of projective depth. In such a picture, all the objects may be related simultaneously in terms of three relationships, left \times right, front \times rear, above \times below. In other words, according to a treble cross-reference, the projective counterpart of a co-ordinate system but modified according to the particular perspective.

It is this type of multiplicative grouping of relationships in three dimensions (and consequently, three types of one-one correspondence between the objects) which enables the child to draw a slanting stick as foreshortened (as in Chapter VI, Section II), once he understands the projective decrease in length. If we term parts of the stick seen in profile, A_1, A'_1, and B'_1, recognizable by reference points (whence $A_1 + A'_1 = B_1$ and $B_1 + B'_1 = C_1$, i.e. the total length of the stick); then by inserting the obliquely perceived stick into the network described above, the child is able to realize that these parts correspond to reduced lengths A_2, A'_2, and B'_2 such that $A_2 < A_1$; $A'_2 < A'_1$; $B'_2 < B'_2$ whence $B_2 < B_1$ and $C_2 < C_1$. Similarly, when the stick is even more oblique its elements A_3, A'_3 and B'_3 will give $A_3 < A_2$; $A'_3 < A'_2$ and $B'_3 < B'_2$. Hence, independent of extensive quantity (which would graduate the change), and consequently without making any measurements, the child can bring all the successive perspectives of the rotated stick into correspondence, using this duel relationship of 'further \times shorter'. In this purely intensive multiplication of relationships we have the sub-logical starting point for the development of one-one projective correspondences or "homologies".

VII and VIII. *One-Many Multiplication of Elements and Relations*

The preceding system of operations constitutes an orthogonal system; that is, one involving a double or treble set of one-one correspondences along two or three given dimensions. As against this, one-many correspondences describe triangular structures, the simplest example of which is provided by a pair of perspective lines meeting at the horizon, such as the railway lines or fences drawn by the children in Chapter VI (Section II). Such systems are likewise two-dimensional, since along one dimension there are the sleepers linking the rails or the posts of the fence, and along the other, the rails themselves or the ground level and the top of the fence. But instead of being one-one, this correspondence is one-many, for each increase in length is now considered as involving the addition of a new element to the zero point 0. Thus the rails meeting at the horizon correspond to the smallest perceptible sleeper (A), to which corresponds a larger sleeper (B) up to the largest of all (T), which is also the nearest. This one-many correspondence may be expressed in terms either of elements (Type VII) or relationships (Type VII).

The gradual lengthening of the sleepers or posts from the horizon to the nearest point can result in an 'extensive' quantification, in all probability, the simplest kind the child can understand; namely, that which leads him to regard the enlargement as continuous and uniform. But the most important point about the reactions seen in Chapter VI was, on the contrary, that they showed how, between the stage at which the child fails to render perspective and leaves the length of the sleepers unaltered, and the stage where he expects the change to be continuous and uniform, there is a level at which he rests content with 'intensive' quantification. At this level, as the sleepers appear more distant their size decreases irregularly. In other words, if the lengths O, A, B, C, etc., are defined as lying between the horizon point O and the largest sleeper T, and their differences A (between O and A), A' (between A and B), B' (between B and C), etc., instead of having $A = A' = B' = C' \ldots$ etc. or even $A < A' < 'B' < C'$ etc., which would express the extensive quantification, one has simply $O < A < B < C$, etc., without quantification of the differences themselves (A, A', B', etc.). This small-scale examples hows very clearly that these sub-logical operations are at this stage comparable with the simple inclusions of qualitative logic (involving only the relationship $A < B$, when $A + A' = B$) as opposed to mathematical relationships which begin by comparing differences (i.e., relating parts to each other).

It is just this system of one-many relationships whose sub-logical schemata we have just discussed, which brings the child closest to extensive quantification; that is to say, to a mathematical treatment of perspective. Together with the one-one correspondences which enable him to recognize equivalent elements among the varying perspectives

of the same object, these one-many correspondences, expressing change in size with change in distance, but in pre-mathematical form, constitute one of the qualitative foundations of the future 'homologies'.

§5. *Sub-logical operations constituting euclidean space*

Intermediate between the projective and euclidean relationships produced by change of position (displacement) and subdivision (partition), there arise certain other relationships which children begin to understand at about the same time as they master the former.

Projective relationships conserve neither parallels, angles nor distances. Affine relationships, on the other hand, conserve parallels while angles and distances continue to vary. The transformation of the rhombus provided an example of this (Chapter XI) and we have also pointed out that once the child has grasped the idea of the projective straight line through the practice of 'taking aim', the notion of parallels (even when, as in the rhombus, presented obliquely) no longer offers any real difficulty. This may at first seem rather odd, since in perspective parallels appear to converge. But in the first place, the operation of taking aim suggests the idea of conserving direction in general, and this is applicable to two lines just as easily as to one. In the second place, when the child understands perspectives he can also co-ordinate different points of view. Although he does not begin to do this in an overall way until somewhat later (Substage IIIB), in the case of perspective lines it is not difficult to understand that the opposite point of view will reverse the relationships, so that two real straight lines correspond to a pair of receding perspectives. Here again it is possible to conceive of this concept developing in advance of either relative or absolute quantification.

In the case of similarities, however, the figure retains its shape unchanged (straight or curved lines, parallels and angles) but changes in size according to relations of proportionality. Now in Chapter XII we saw that before the child has grasped the meaning of proportionality, whether metric or extensive, he can nevertheless recognize a triangle as similar to another which encloses it, by means of the parallelism of the corresponding sides. Furthermore, having got thus far, by superimposing such figures and moving them about he can pass on to make the same discovery through the equality of their angles. In these cases, however, the child only makes very rough estimates. The shapes are merely judged more or less equal, more or less unequal, the estimate being, for a considerable period, made without any accurate measurement or comparison. Thus the child estimates the angles of similar triangles according to a system of one-many correspondences (§4. Operations VII and VIII) just as with the angles in perspective drawings. Even though this operational grouping does eventually lead to the

concept of proportionality, we have seen in Chapter XII that it remains at first purely qualitative, in the sense of 'intensive'.

As for the relationships constituted by physical displacements and euclidean measurement, these conserve distances in addition to straight lines, parallels and angles. Although we have earlier investigated the child's ideas about physical movements,[1] in the present work we have not been able to tackle the problem of distance, nor the major questions involved in measurement, and these will have to be dealt with in a further volume. Nevertheless, our study of the development of spontaneous co-ordinate systems (Chapters XIII and XIV), coupled with our existing knowledge of the child's conception of movement or physical displacement, enable us to outline the salient features of the 'intensive' spatial operations which, in this field too, prepare the way for true mathematical quantification (in the specific case of measurement). Now it might be asked, *a priori*, how the child can attain the conservation of distance or size except through metric operations, since the idea of distance would seem absolutely meaningless apart from the notion of measurement. And if this is so, one is of necessity compelled to pass beyond 'intensive', qualitative operations.

If one takes the trouble to follow the detailed psychological development of the idea of spatial measurement, one encounters a vicious circle, almost as difficult to comprehend as that met with in the problem of time measurement. And here the psychologist is, as so often, grappling with the difficulties and preoccupations of the physicist rather than with those of the mathematician. Measurement presupposes the conservation of size during displacements, for a measuring rod which varied in length while being moved about the object being measured would be of little utility. Now in point of fact, young children do not (if we may be allowed to anticipate the contents of a later work) believe in the conservation of lengths any more than in that of intervals or distances! Consequently, it has to be granted that at first it is the simple 'intensive' combining of parts into a whole ($A+A'=B$, etc.) which guarantees the conservation of such a whole before measurement is possible, and this is what was found to be the case in our earlier studies in conservation of quantities.[2] However, when we come to deal with space we find this operation already involved in the formation of a topological whole (as with an elastic object, or a knot, Chapters IV and V) and although it guarantees the conservation of this whole as the sum of its constituent parts, this does not entail constancy of size (length, etc.). The question therefore arises, as to how the child passes from conservation of a set of neighbouring elements (cf. §3.) to conservation of distances or lengths.

[1] See op. cit., *Les Notions de Mouvement et de Vitesse chez l'Enfant*, Chapters I–V.
[2] J. Piaget and B. Inhelder. *Le développement des quantitiés chez l'enfant*, Geneva, 1941.

It is this transition which marks off euclidean from projective and topological space, even while it illustrates its kinship with the latter. With topological space there is nothing outside any given configuration to act as a reference frame, and consequently, no conservation of size or distance. This latter property appears only with the formation of a stable, overall reference frame or co-ordinate system, of which distances form the basic constituents. In addition, contrary to the overall co-ordination of perspective viewpoints consistent with variation in size of objects (only their relation to the subject or the projection plane being considered), euclidean space presumes the co-ordination of the actual locations relative to which the objects are moved. It is the relationship between the mobile object and its successive positions that enables it to be granted a constant size at the same time as the distances it moves are maintained invariant. Conservation of distances and lengths is thus an essential preliminary to the development of an overall reference frame.

Although euclidean space is in this way distinct from projective space, we have constantly seen how these two overall constructs are fundamentally cognate. Axiomatically, it is possible to base both euclidean measurement (a particular case of metrics in general) and projective space on topology. Also the axioms required to construct a co-ordinate system are equivalent to those which give rise to projective systems. But from the psychological standpoint, it is to the degree that the subject can co-ordinate different viewpoints, and hence construct projective relationships, that he can also co-ordinate distances and thereby construct euclidean relationships. Thus the two systems are interdependent.

In effect, they both lead to figures or objects being related to one another, instead of this process being limited to the neighbouring parts within each particular configuration. The outcome is the conservation, either of certain abstract, formal relations which remain unchanged during changes of viewpoint; or of distances and sizes which remain constant during the course of physical displacement. Just as shape constancy is linked with size constancy in perception, since the object is perceived simultaneously in perspective and at its real size, so the operations which co-ordinate points of view are of a piece with those that guarantee conservation of size in terms of the object itself (i.e., from the point of view of an observer placed in or on it, or who traverses it). To link the visual image with the distant object by means of straight lines implies the possibility of bringing the object close to hand along these lines, or alternatively, moving towards it by the same route. In both cases, that is to say, to enlarge it by bringing it closer until its constant size has been established.

This is why the development of an overall projective system leads,

476

by means of a reciprocal or complementary construction, to an overall co-ordination of displacements (changes in position of objects rather than changes in position of the observer only), and consequently, an overall co-ordination of the various positions (or 'placements') relative to which size is conserved.

The sub-logical operations constituting a co-ordinate system are thus analogous to those already outlined. But they deal, not with the object relative to some point of view or with changes in point of view, but with the various features of the object relative to its 'placements' and displacements.

I. *Addition and Subtraction of Elements*

Consider an object (in one or n dimensions) occupying some position relative to other objects. It thereby defines some figure which may be regarded either as the shape of the object or as that of its position. That is to say, either as a 'spatial figure' or forming a definite portion of the positional system. These positions or 'placements' are therefore no more than certain relationships between objects, and these will be dealt with as such, beginning with operation II. But since, from the psychological standpoint, operations of type I deal with the shape of the object itself before passing on to consider its position, little purpose would be served by inverting the order of these operations.

Operations of type I, therefore, merely consist of linking or dissociating parts of a given figure : $A + A' = B$; $B + B' = C$, etc., and guarantee the conservation of a whole, both as regards the relative position and shape of an object.

II. *Placement and Displacement of Objects*

Let us now consider a number of separate objects and arrange them in any given linear order (operation II. §3.), or along a straight line (operation II. §4.) which will give $A \to B \to C \to$ etc. These objects may then be said to be 'placed' in relation to each other. But in the system of operations which constitute the notion of euclidean space, the reverse operation is no longer merely one of traversing the series in the opposite direction $\to C \to B \to A$. It involves a change in sequence or 'placement'; that is to say, a displacement entailing the inversion, either of the whole series or a single element relative to one or many others, e.g. $A \to C \to B$ as a consequence of reversing $B \to C$. As we have pointed out in previous studies,[1] this displacement introduces a distinction between the order of the elements and the order of their placements; and also between two analogous operations, according to whether they are applied to

[1] See op. cit., *Les Notions de Mouvement et de Vitesse chez l'Enfant*, Chapters III, IV, and Conclusions.

the mobile objects and their potential displacements, or the stationary placements traversed by their movements.

Prior to being integrated in the qualitative 'group' with six parameters generally termed the 'group of displacements', this concept of 'displacement' does not extend beyond these purely qualitative notions.

III. *Reciprocity of References*

Let us now consider several neighbouring figures (formed by the shapes or positions of objects), added together according to the operation of type I, starting from A_1 as a reference point. We may obtain, for example, $A_1 + A'_1 = B$ and $B_1 + B'_1 = C$. It will then always be possible to end up with the same term C by starting from either A' or B' as reference and calling it A_2, giving $A_2 + A'_2 + B'_2 = C$. Combined with groupings of order in several dimensions (type VI) operation type III leads to the establishment of reciprocal co-ordinate systems or reference frames, the element A_1 or A_2 being regarded as the 'origin' of each particular system being considered.

IV. *Inclusion of Intervals or Distances*

The interval between two points on a straight line constitutes a distance. The conservation of distance is guaranteed through the points and the straight line being part of the stationary placements, whilst they may at the same time be traversed by a moving object. Since displacement of this object between points X and Y constitutes an asymmetrical relation, the distance constitutes the corresponding symmetrical interval relation, symmetrical because from X to Y is the same distance as from Y to X: $X \leftrightarrow Y = Y \leftrightarrow X$.

V. *One-One Multiplication of Elements*

A linear series of elements $A_1 + A'_1 = B_1$, $B_1 + B'_1 = C_1$ multiplied by another series, $A_2 + A'_2 + B_2$, etc., constitutes a surface. The two series multiplied by a third, $A_3 + A'_3 + B'_3 +$, etc., constitutes a volume.

VI. *One-One Multiplication of Placement and Displacement Relations*

When these same operations are expressed in terms of asymmetrical relations (order of placement and displacement), they result in neither more nor less than a co-ordinate system. Such a system is in fact no more than a network of 'placements' arranged as points of reference, or objects regarded as stationary, occupying two or three dimensions simultaneously. One series ranged along one dimension constitutes one axis, the second series constitutes a second dimension along another axis. The intervals between the given placements consist of constant distances (as defined in operation IV). Such a co-ordinate system is not necessarily metric, as was demonstrated in Chapters XIII and XIV.

This point is readily grasped if the structure of this relational grouping is analysed in more detail than was done in §3. and §4.

Thus assuming a system of point placements arranged in two dimensions starting from 0 (represented by large points connected by dotted lines), let a_1; a'_1 and b'_1 or a_2; a'_2 and b'_2 be the relations linking them together (i.e., the dotted lines). These may be asymmetrical or symmetrical according to whether they express sequences or distances. We then have:

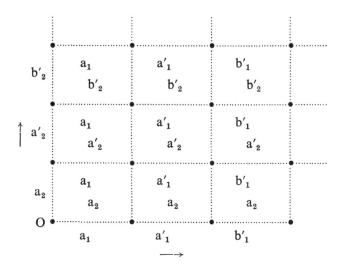

One can then see that each of the two series of sequence or distance relations, $a_1+a'_1=b_1$; $b_1+b'_1=c_1$, etc., and $a_2+a'_2=b_2$; $b_2+b'_2=c_2$ remain intensive, since there is neither a common unit nor a specific relationship between the successive elements a, a' and b'. Nevertheless, these intervals a_1; a'_1 and b'_1 or a_2; a'_2 and b'_2 are mutually identical by one-one correspondence (in each of the two dimensions), this 'intensive' equality being guaranteed by the parallelity of the straight lines along which the points are ranged.

This picture of multiplicative relations with one-one correspondences through parallelism accurately expresses the way in which children construct their frames of reference at Substage IIIB (Chapters XIII and XIV). So far as distance is concerned, the child can only derive it—in the absence of measurement—from the assertion $a < b_1$ or $a'_1 < b_1$ (if $a_1+a'_1=b_1$) together with mutual equality of the intervals between the parallels.[1] Yet it is obvious that to convert such a grouping into a

[1] As regards the relation of perpendicularity, it is not essential to the system but is given through the two dimensions being oriented in maximal opposition.

479

system of mathematical co-ordinates is to introduce the notion of measurement (such as that a' or b are metrically related to a).

VII. *One-Many Multiplication of Elements*

As against the one-one correspondences found in the above systems, one-many correspondence gives rise to the concept of triangle (in two dimensions) and the concept of the tetrahedron (in three dimensions).

VIII. *One-Many Multiplication of Relations*

The schema of this final grouping is that of an increasing symmetrical interval generated by two asymmetrical length relationships, viz.: As was seen in Chapter VII it is this operational system which is responsible for qualitative estimates of angle prior to measurement.

Such are the eight operational groupings which we have seen functioning in the sub-logical construction of euclidean space. It is obvious that they reproduce in outline the previous eight groupings described in §3. and §4. for topological and projective concepts. With each successive stage of overall organization, however, they acquire new significance, integrating topological relationships by giving them definite specifications.

It might perhaps be asked what this number eight corresponds to, and why it is neither more nor less. In the first place it is bound up with the affinity between sub-logical and logical operations. From the standpoint of operational grouping, to join, to relate and multiply, whether in terms of spatial proximities and differences, or in terms of general qualitative resemblances and differences, amounts to the same thing, even though the particular significance of each of these overall structures may be very different.

This way we find once again the eight types of grouping which we have already described on the level of operations dealing with logical classes and relations,[1] and this correspondence is very interesting as regards the functional unity of the various operations of thought. This being the case, there is nothing arbitrary about the number of groupings, for it represents simply the product of the following combinations—which seem the only ones possible for 'intensive' qualitative operations. Elements or classes (I), and asymmetrical relations (II) may be added in simple series. They may also be added in various directions, thus giving reciprocal systems of classes or elements (III) and symmetrical relations (IV). Finally, two or more additive series may be conjoined to form double or treble cross-references. In other words, may be multiplied, either by one-one correspondence of classes and elements

[1] *Classes, Relations et Nombres.* Étude sur les 'groupements' de la logistique et la réversibilité de la pensée, 1942.

(V) or relationships (VI), or else by one-many correspondence of classes and elements (VII) or relationships (VIII). This last distinction between one-one and one-many correspondence being itself the outcome of logical opposition between symmetries and asymmetries, one thus arrives at the following combinations : 2 (elements or relationships) $\times 2$ (symmetries or asymmetries) $\times 2$ (additions or multiplications) $=8$.

§6. *'Extensive' operations, metric operations, and the question of their order of development*

The sum-total of the preceding operations (§3–5) provides the 'intensive' or qualitative framework for the sub-logical conception of space, a preparatory outline to its being made mathematical, though not yet mathematical itself.

In at least two examples we have seen the child pass from 'intensive' relations to systematic, 'extensive' quantification. Firstly, in the case of regular decrease in size of an object with increasing distance (Chapter VI, Section II); and secondly, in the case of proportions (Chapter XII). The first, which is also the simplest of these transitions, takes place almost as soon as the child has understood the decrease in apparent size. He starts off with simple qualitative seriation, the sleepers between the rails or the uprights of the fence decreasing in length by sudden and irregular leaps. For example (arranging the series in the direction of increase), $A < B < C < \ldots$ etc., but without quantifying the differences A' (between A and B), B' (between B and C), etc. The result is $A' < B'$ or $A' > B'$ and also $A' = B'$, corresponding to simple intensive structures (these irregular differences being comparable with the seriation $A < B < C$, etc.). Subsequent to this, the child begins to concern himself with the differences themselves, keeping them constant; $A' = B' = C'$, etc. (giving, for instance, $A = 2$ mm., $B = 3$ mm., $C = 4$ mm., with 1 mm. difference at each step) or else increasing them regularly: $A' < B' < C'$ (the increase itself conforming to some law).

In this simple example, the nature of extensive quantification is clearly demonstrated. It is basically the relating of differences (to use the language of relationships) or the relating of the parts A and A' of a single whole B (using the language of elements). Naturally, these terms 'difference', 'part', 'whole', have no meaning except in relation to the groupings already discussed, in whose absence any sort of comparison or relationship might be regarded as concerned with differences or with parts of a single whole.

In the case of proportionality the process is more complex but all the more instructive due to the points of similarity with the previous example. Starting from the one-many correspondence (groupings VII and VIII) between the sides A_1 and A_2 of a triangle and with the width of the base A regarded as the interval between the sides of the apex angle,

the child discovers that by extending the sides, adding A'_1 and A'_2 (hence $A_1+A'_1=B_1$ and $A_2+A'_2=B_2$, where B_1 and B_2 are the new lengths of the sides) he obtains a base B such that it is parallel with base A. Sooner or later he grasps the fact that if A and B are parallel, i.e., constructed according to an identical relationship, then there must be some constant ratio between A'_1 and A'_2, A_1 and A_2. Thus here again is quantification of differences as such and comparison of the parts (A_1 and A'_1 or A_2 and A'_2) of a single whole (B_1 or B_2).

Extensive quantity therefore appears in the form of the comparison of the parts of a whole. This is, in one sense, simply a continuation of the previous intensive operations, but in another sense foreshadows measurement, since the differences may be subjected to specific relationships. For example, in the case of an approaching object, the increase in apparent length gives a simple intensive series $A>B>C.\,.\,.$ etc. But the differences may be expressed quantitatively by equivalences $A'=B'=C'=$etc. and we are then close to a metrical system as opposed to the simple expansion $A'<B'<C'$, etc.

Metric quantity or measurement appears in fact, as soon as a size is chosen as a unit and the different parts of a whole are related to this unit. For example, if $A=A'=B'$, etc., we may have $A+A'=2A$, and hence $B=2A$; $C=3A$, etc. But since the repetition of this unit assumes that the part A is applied to the parts A', B' etc., to equalize them by congruence, it is immediately obvious that measurement is a synthesis of the addition of sets ($A+A'=B$) and addition of displacements ($A\to B\to C$), just as whole number was found to comprise a synthesis of the addition of classes ($A+A'=B$) and addition of asymmetrical relations ($A\to B\to C$).[1] Thus physical measurement constitutes the synthesis of sub-logical operations in the same fashion as number constitutes the synthesis of logico-arithmetical operations. Naturally, this rough outline can hardly be regarded as a satisfactory treatment of the question. In order to show what actually occurs during the course of the child's psychological development a detailed study is necessary, and this we shall endeavour to carry through in the subsequent volume.[2]

Nevertheless, the construction of extensive and metric relations poses an immediate question as regards the chronology of psychological development, as indeed do all the operations outlined in this résumé, and we must therefore conclude by discussing this problem. Extensive and metric quantities presume the prior construction of the entire set of 'extensive' sub-logical operations (or at least, those of types I and II which constitute euclidean space). But we have frequently observed that measurement appears almost as soon as the child has mastered

[1] Op. cit., *The Child's Conception of Number.* Also op. cit., *Classes, Relations et Nombres,* 1942.
[2] *La Géométrie Spontanée de l'Enfant.*

482

these operations, whereas it takes several years for him to construct the earlier 'intensive' operations. Secondly, extensive and metric operations are formed concurrently and not one in advance of the other. Thirdly, and this is probably the most important of all these seeming paradoxes, projective and euclidean operations (as well as the intermediate affine operations) nearly all appear at the same level; namely, Stage III, the main ones appearing as early as Substage IIIA. Moreover, they all assume the prior construction of elementary topological operations. Yet this process is not complete until the beginning of Stage III (though admittedly, operations of order are slightly ahead of this schedule), and then only for finite quantities, since the child does not even glimpse the idea of infinity until Stage IV.

Would it not therefore be possible to reverse completely the order of development we have sought to demonstrate, or at all events, the order of presentation we have adopted?

Let us imagine an experimenter who has read nothing on the subject of geometry, about to investigate the 7-year-old child's ideas of space. That is, the child's conception of space at about the beginning of this Stage III which has been found such a crucial turning point in mental development. Would such an experimenter not discover euclidean, and possibly even metric operations, first of all, only later turning to projective and affine concepts, considering the few topological relationships last of all? And these last, by the way, he would find hard to recognize if he had never read Poincaré, Kuratowski, Godeaux, Gonseth, and various other authors. Furthermore, would he not regard topological relationships as temporary abstractions which the child produced only in addition to his more everyday ideas?

This kind of argument may be answered in three ways, all of which specifically vindicate the order of psychological development which begins with topology and continues jointly with projective, euclidean, and intermediate concepts.

The first point to note is the order in which the child's pre-operational ideas emerge. An operational system, and in particular a purely 'intensive' grouping (§1.), is simply the final equilibrium condition of a set of actions. These are in the beginning physical and irreversible, then internalized as intuitive images (though still incomplete and irreversible), culminating in the reversible combination termed a 'grouping' (or group). Consequently, in tracing a psychological development process as complex as that of space, one cannot be satisfied with describing the features of completed operational systems. It is necessary to trace their development right back to the original intuitions, and from this stand-point the primacy of topology is obvious. The child of 2–3 years reduces squares, triangles and circles indifferently to 'Jordan curves' and he is more concerned about whether they are closed before he starts con-

sidering whether they contain straight lines and angles. The notion of sizes based on being located inside or outside a surface or a box appears long before euclidean surfaces or volumes begin to be abstracted (cf. the drawings of the water level at Stage I in Chapter XIII). In short, topological operations exercise a formative rôle long before they attain a completely operational level, intervening early on in the form of symbolic thought or physical actions.

The second point is that although the formative period of an operational system may be rather long drawn out—for reasons we have just discussed—so soon as this system attains an equilibrium, that is to say, a reversible combination or 'grouping', it rapidly brings about a whole new series of regroupings entailed by its own implications.

This is why one should not be surprised by the co-existence of two situations during development which might seem contradictory but for the general reorganization precipitated by the completion of elementary topological operations. On the one hand, so soon as an operational system is complete, previously fragmentary projective and euclidean notions begin to crystallize out. This gives an impetus to their overall organization which will culminate at Substage IIIB. On the other hand, as soon as the completion of the topological basis makes projective and euclidean systems possible (in particular, by the grouping of order), the transition from 'intensive' to 'extensive' and metric takes place with great rapidity. This is because these latter concepts are the products of a simple synthesis, new only in so far as it represents a coming together of previously existing 'intensive' notions.

If there is a contrast then between the five years' preparation of Stages I and II (averaging from 2 to 7 years) and the two years' organization between the commencement of Substages IIIA and IIIB (averaging from 7 to 9 years), it is an entirely explicable one, the more easily so since it is not peculiar to the concept of space but has already been encountered in our studies of number, physical quantities and speeds. And this is to say nothing of the phenomenon of maturation which can reinforce the functional aspects of intelligence, accelerating the structural development which the former only partly covers.

Lastly, the third and fundamental point concerns the actual nature of operations. An operational system derives its content from a series of abstractions of the subject's actions, and not from particular features or properties of object. But this process of abstraction may be encouraged or obstructed by the material conditions in which the various groups of objects are encountered. Thus we find number understood before spatial measurement because the discontinuity of separate aggregates suggests the repetition of a unit more readily than a linear continuity in one or two dimensions. Alternatively, a squared pattern will facilitate understanding of spatial measurement more easily than a heap of beads which

cannot be estimated numerically but only as a rough 'more or less'. Thus tests and experiments of the kind used here always yield results which depend in part upon the experimental conditions, and this fact tends to complicate the task of analysing them.

But it also follows that an operation can function implicitly before it has become completely formal and explicit. For instance, let us suppose that an operation B (for example, a metric or extensive proportion) implies a prior operation A (multiplication of relations by one-one correspondence), but that B is studied in more favourable conditions than A (for example, in terms of the simple numerical relations suggested by squared paper, whereas questions bearing on A are framed in too abstract a fashion). In the event, one may well gain the impression that B precedes A, when a more careful investigation would reveal the true order of development and show that to avail himself of operation B the subject must in fact understand A.

These three considerations have, moreover, a relevance extending far beyond psychological studies of child development. They depend upon the precise interrelations between completely original developmental construction, and reflection after the event—the latter activity often reversing the order of the former. It is by no means a historical accident that topology or 'Analysis Situs' only appeared as a distinct and separate discipline in comparatively recent times; and the same may be said of the theory of sets, even though Cantor is supposed to have declared that it could be taught in elementary school. The explanation is that although the child may invent one-one correspondence every day and start drawing Jordan curves in nursery school, the discovery of the fundamental principles of arithmetic and geometry in these childhood activities required a highly abstract type of thinking.

Hence one should not be surprised to find that in the actual development of the individual the true order in which the operational mechanisms appear is sometimes confused and overlapped. For in these realms also this can be brought about by the conflicts which beset growing consciousness and abstract thinking, assisting it in some contexts and hindering it in others; similarly with the physical actions from which, by means of successive abstractions, the operations derive. This is why it has been worth endeavouring to combine experimental technique with a logical framework, despite the difficulties that ensue from such an approach, whose application throughout this work has served a purely psychogenetic purpose.

INDEX